Antioch

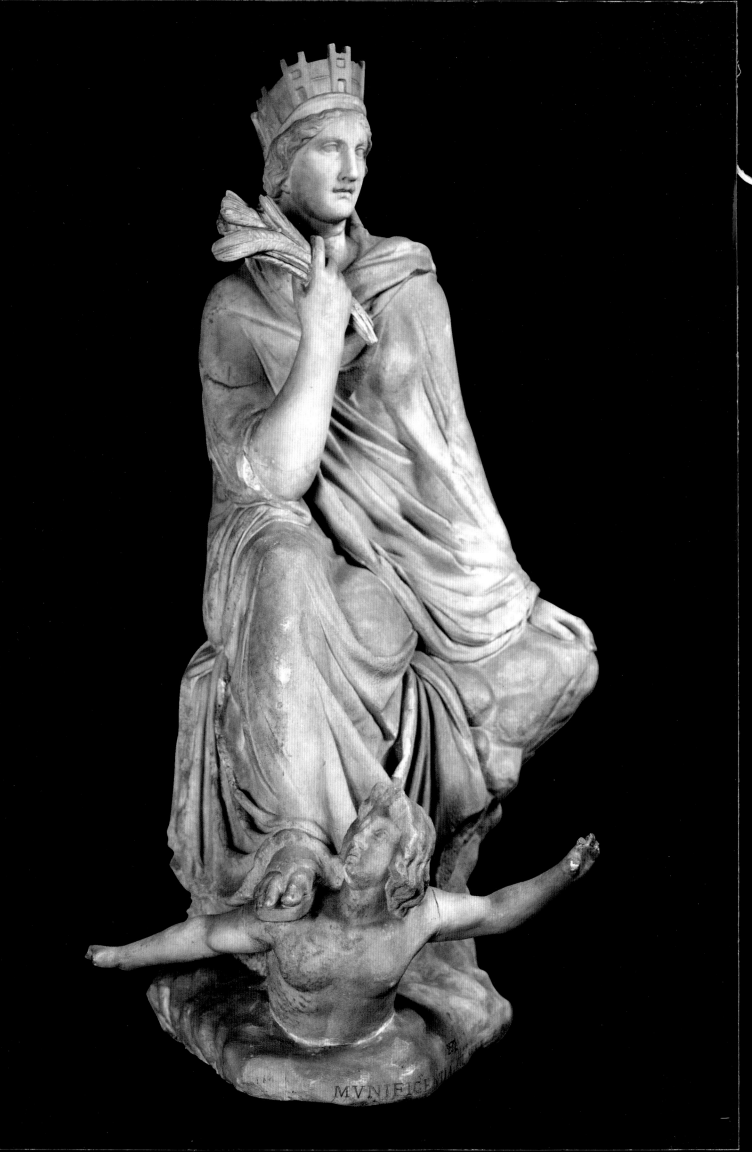

MVNIFICEN

Antioch

The Lost Ancient City

Christine Kondoleon

Princeton University Press
in association with the Worcester Art Museum

Published on the occasion of the exhibition *Antioch: The Lost Ancient City*

Worcester Art Museum
Worcester, Massachusetts
October 7, 2000–February 4, 2001

The Cleveland Museum of Art
Cleveland, Ohio
March 18–June 3, 2001

The Baltimore Museum of Art
Baltimore, Maryland
September 16–December 30, 2001

Antioch: The Lost Ancient City was organized by the Worcester Art Museum,
Worcester, with major support from the National Endowment for the Humanities,
the National Endowment for the Arts, the Rockefeller Foundation, and
Saint Gobain/Norton Company.

Published by Princeton University Press, 41 William Street, Princeton, NJ 08540
In the United Kingdom: Princeton University Press, 3 Market Place,
Woodstock, Oxfordshire OX20 1SY
Worcester Art Museum, 55 Salisbury Street, Worcester, MA 01609-3123

Jacket/cover illustrations: Mosaic with Peacocks, c. 526–40 C.E.
(details of cat. no. 96)

Frontispiece: Tyche of Antioch. Roman copy after Greek original by Eutychides.
Marble, height 33 in. (83.5 cm). Galleria dei Candelabri, Vatican Museum, inv. 2672

Design and composition by Bessas & Ackerman
Color separations and printing by Arnoldo Mondadori Editore,
S.p.A., Verona, Italy

Printed and bound in Spain
D.L. TO: 995-2000

Cloth 10 9 8 7 6 5 4 3 2 1
Paper 10 9 8 7 6 5 4 3 2 1

OCLC#
43977990

Library of Congress Cataloging-in-Publication Data
Kondoleon, Christine.
 Antioch : the lost ancient city / Christine Kondoleon.
 p. cm.
 Published on the occasion of the exhibition held at the Worcester Art Museum,
Worcester, Mass., Oct. 7, 2000–Feb. 4, 2001, at the Cleveland Museum of Art,
Cleveland, Ohio, Mar. 18–June 3, 2001, and at the Baltimore Museum of Art,
Baltimore, Maryland, Sept. 16–Dec. 30, 2001.
 Includes bibliographical references and index.
 ISBN 0-691-04932-7 (alk. paper)—ISBN 0-691-04933-5 (pbk. : alk. paper)
 1. Art, Classical—Turkey—Antioch—Exhibitions. 2. Antioch (Turkey)—
Antiquities—Exhibitions. 3. Antioch (Turkey)—Civilization—Exhibitions. I. Title.
 N5865.A75 K66 2000
 709'.39'43—dc21 00-032637

Contents

Contributors
to the Catalogue

Susan A. Boyd, Dumbarton Oaks
Bernadette J. Brooten, Brandeis University
John J. Dobbins, University of Virginia
Anna Gonosová, University of California, Irvine
Susan A. Harvey, Brown University
Florent Heintz, Worcester Art Museum
Faruk Kılınç, Hatay Archaeological Museum, Antakya
W. Eugene Kleinbauer, Indiana University
Sandra E. Knudsen, The Toledo Museum of Art
Christine Kondoleon, Worcester Art Museum
Michael R. Maas, Rice University
William E. Metcalf, American Numismatic Society
James Russell, University of British Columbia
Sarolta A. Takács, Harvard University
Cornelius C. Vermeule III, Museum of Fine Arts, Boston
Fikret Yegül, University of California, Santa Barbara

Individual catalogue entries are initialed by their authors:

SD Sophie Descamps, Musée du Louvre
HE Helen C. Evans, The Metropolitan Museum
 of Art
AG Anna Gonosová, University of California, Irvine
ACG Ann C. Gunter, Arthur M. Sackler Gallery,
 Washington D.C.
FH Florent Heintz, Worcester Art Museum
JH John Herrmann, Museum of Fine Arts, Boston
AvdH Annewies van den Hoek, Harvard Divinity
 School
WK Walter J. Karcheski, Jr., Higgins Armory
 Museum
SK Sandra E. Knudsen, The Toledo Museum of Art
CK Christine Kondoleon, Worcester Art Museum
SM Susan B. Matheson, Yale University Art Gallery
RM Rebecca Molholt, Columbia University
MP J. Michael Padgett, The Art Museum,
 Princeton University
SRZ Stephen R. Zwirn, Dumbarton Oaks

Lenders
to the Exhibition

The Art Museum, Princeton University, Princeton,
 New Jersey
The Baltimore Museum of Art
The British Museum, London
Rose Choron Collection
The Cleveland Museum of Art
Davis Museum and Cultural Center, Wellesley College,
 Wellesley, Massachusetts
The Detroit Institute of Arts
Dumbarton Oaks Collection, Washington, D.C.
Field Museum of Natural History, Chicago
Higgins Armory Museum, Worcester, Massachusetts
The Metropolitan Museum of Art, New York
Musée du Louvre, Paris
Museum of Art, Rhode Island School of Design,
 Providence, Rhode Island
Museum of Fine Arts, Boston
The Nelson-Atkins Museum of Art, Kansas City,
 Missouri
Arthur M. Sackler Museum, Harvard University Art
 Museums, Cambridge, Massachusetts
Arthur M. Sackler Gallery, Washington, D.C
Smith College Museum of Art, Northampton,
 Massachusetts
The Toledo Museum of Art
University of Pennsylvania Museum of Archaeology and
 Anthropology, Philadelphia
Virginia Museum of Fine Arts, Richmond
Worcester Art Museum
Yale University Art Gallery, New Haven, Connecticut
Private collections

Foreword

The exhibition and publication *Antioch: The Lost Ancient City* is the culmination of an effort begun in 1932, under the visionary director Francis Henry Taylor, when the Worcester Art Museum became a sponsor of the excavation of Antioch. As a result, the Museum was able to acquire between 1932 and 1939 numerous works of art, most notably America's largest and finest collection of Roman mosaics.

The Lila Wallace–Reader's Digest Fund provided a major grant that focused on the Museum's ancient Greek and Roman collections, including the Antioch holdings, which became the springboard for the current exhibition. We are extremely grateful to Christine Kondoleon, who spearheaded and oversaw every aspect of this ambitious international loan show. Her knowledge and enthusiasm have been a prime force in realizing this first exhibition of the art and culture of Antioch, which reveals for all of us the excitement of this important ancient city.

This catalogue and exhibition would not have been possible without the generous loans from institutions and individuals worldwide. We are particularly grateful to the two other institutions that will host the exhibition, the Cleveland Museum of Art and the Baltimore Museum of Art, one of the original partners in the Antioch excavation.

This exhibition received major support from the National Endowment for the Humanities, the National Endowment for the Arts, The Rockefeller Foundation, the Samuel H. Kress Foundation, The Andrew W. Mellon Foundation, and The J. F. Costopoulos Foundation. The French American aspects of the exhibition were supported by Saint-Gobain/Norton Company and The Florence Gould Foundation. The Thomas J. Watson Foundation supported the research and construction of the Roman bath model.

Additional support was provided by the following generous individuals: Euterpe Dukakis, Chris and Mary Cocaine, Paul and Nancy Morgan, Leon Levy and Shelby White, Christos and Jo Bastis. Indeed, we are grateful to all those who helped make this project a success.

Finally, a heartfelt thanks to the staff of the Worcester Art Museum, whose uncompromising standards of quality made this landmark exhibition possible. This is a tradition that we are very proud to carry forth into the Museum's second century.

James A. Welu
Director, Worcester Art Museum

Acknowledgments

Antioch, the city, the excavation, and the finds have long fascinated colleagues, but the idea of an exhibition was born in Worcester during conversations I had with the Director, James Welu, and the Chief Conservator, Lawrence Becker. The quality of the holdings at Worcester encouraged me to suggest an ambitious show, one that would introduce this great metropolis to the public and reunite some of the original finds. For their enthusiasm and willingness to support this ambitious undertaking, I shall always be grateful. My deep appreciation goes to our Director of Collections and Exhibitions, Elizabeth de Sabato Swinton, who has provided patient guidance to a cross-over from academia in the navigation of an exhibition from conception to birth. I would like to acknowledge an important mentor, Cornelius C. Vermeule III, who supplied his considerable knowledge and mirth to my endeavors. A special thanks also to him and his wife, Emily Vermeule, for their generous gift to the Worcester Art Museum of over ninety coins minted in Antioch.

Like the city of Antioch, this exhibition has its own Tyche or city goddess, and she is Victoria I, the artistic consultant, whose vision was consistently present and insightful. Her steadfast support was invaluable throughout the project. She was assisted by Mary Todd and Wes Chilton in computer graphics and map production, and James Stanton Abbott, modelmaker and CAD master. Discussions with Robert Segal, the designer of the exhibition, inspired not only the team, but the funders, to walk through Antioch. Travels with the project photographer, John Dean, provided great moments and shots for the catalogue and video.

Muses must also be invoked and they are the distinguished group of curatorial assistants: Rebecca Molholt, who worked with great faith and enthusiasm at the initial stages, and Courtney Mikoryak, whose organizational skills and unflagging focus were critical. Florent Heintz, first as a contributor and then as a Kress Curatorial Fellow, added immeasurably to the final stages of publication and undertook important independent projects, such as the unrolling of the lead tablets and their decoding, as well as numismatic matters.

The important "rescue" work done on many of the mosaics presented in this exhibition is due to the Worcester conservation team led by Lawrence Becker and Paula Artal-Isbrand, and included at various stages Suzanne Fonck, Sarah McGregor, Rebecca Molholt, Courtney Mikoryak, Sarah Nunberg, Diane Fullick, and Sari Uricheck. The

staff of the Registrar's Department, especially Nancy Swallow and Tim Johnson, and Christine Proffitt of the Development Department offered critical support.

For the publication of this catalogue, I am grateful to the staff at Princeton University Press, who capably rose to the many challenges the project presented. In particular I wish to thank Patricia Fidler, Curtis Scott, Ken Wong, Sarah Henry, and Kate Zanzucchi. The book was copyedited by Jana Stone and designed by Jo Ellen Ackerman, and the index was prepared by Kathleen Friello.

A special note of thanks for the hospitality and assistance of the staff of the Hatay Archaeological Museum in Antakya, especially Faruk Kılınç, Murat Süslü, and Lale M. Saraç. Fatih Cimok, publisher and native son of Antioch, generously shared his photographic archive and gave invaluable advice and assistance throughout the project.

Loan exhibitions are dependent on the goodwill of museum colleagues. The movement of objects as challenging as floor mosaics represents extraordinary faith and generosity. I am grateful to the following curators and staff at museums in the United States and in Europe for their assistance, their advice, and in several cases their contributions as authors to this catalogue: William E. Metcalf at the American Numismatic Society; Sona Johnston at the Baltimore Museum of Art; John Cherry and Christopher Entwhistle at the British Museum; Michael Bennett at the Cleveland Museum of Art; Susan Taylor at the Davis Museum and Cultural Center, Wellesley College; William Peck at the Detroit Institute of Arts; Susan A. Boyd and Stephen R. Zwirn at the Dumbarton Oaks Collection; Janice Klein at the Field Museum of Natural History; Walter J. Karcheski, Jr. at the Higgins Armory Museum; Alain Pasquier, Catherine Metzger, and Sophie Descamps at the Musée du Louvre; Robert Cohon at the Nelson-Atkins Museum of Art, Kansas City; Eunice Maguire at the Krannert Art Museum; Peter Barnet and Helen Evans at the Metropolitan Museum of Art; John Herrmann and Mary Comstock at the Museum of Fine Arts, Boston; Florence D. Friedman and Gina Borromeo at the Museum of Art, Rhode Island School of Design; David G. Mitten and Amy Brauer at the Arthur M. Sackler Museum, Harvard University Art Museums; Ann C. Gunter at the Arthur M. Sackler Gallery; Suzannah Fabing at Smith College Museum of Art; Sandra E. Knudsen at the Toledo Museum of Art; David G. Romano at the University of Pennsylvania Museum of Archaeology and Anthropology; Margaret E. Mayo at the Virginia Museum of Fine Arts;

and Susan B. Matheson at Yale University Art Gallery.

Finally, heartfelt thanks to a dear friend and colleague, Anna Gonosová, who was always willing to pitch in for Antioch. A personal thanks to my parents, Sophocles and Athena, who encouraged my Hellenic and early Byzantine journeys, and to my husband and son, Frederic and Lucas, who always travel with me.

Chronology

323 B.C.E.
Death of Alexander the Great

300 B.C.E.
Seleukos I founds Antioch as capital of Seleucid empire;
Eutychides creates Tyche of Antioch

246–244 B.C.E.
Brief occupation by Egyptians

188 B.C.E.
Seleucid empire pays tribute to Rome after military defeat

175–164 B.C.E.
Antiochos IV Epiphanes expands and beautifies the city

166 B.C.E.
Introduction of gladiatorial games

96–83 B.C.E.
Political instability: six kings in twelve years

83–69 B.C.E.
City occupied by Tigranes II of Armenia

64 B.C.E.
City becomes capital of Roman province of Syria; only
nominal autonomy is preserved

47 B.C.E.
Julius Caesar visits and beautifies city; basilica, amphithe-
ater, and theater are built

40–39 B.C.E.
Parthian occupation

31–30 and 20 B.C.E.
Augustus visits the city and continues building projects

37–36 B.C.E.
Antony and Cleopatra wed in Antioch (?)

37 B.C.E.–37 C.E.
Herod and Tiberius build the Great Colonnaded Street

c. 34 or 36 C.E.
Beginning of Christian mission in the city

41–54 C.E.
Foundation of local Olympic Games

c. 47 C.E.
City is base for Saint Paul's missionary journeys

66/67 C.E.
Outbreak of violence against Antiochene Jews

70–80 C.E.
Theater built at Daphne with spoils of Jewish wars

c. 80–90 C.E.
Gospel of Matthew written at Antioch (?)

98 C.E.
City becomes headquarters for war against Parthia

115–16 C.E.
Major earthquake; Emperor Trajan is slightly injured

117–38 C.E.
Hadrian improves water supply system

161–65 C.E.
Co-emperor Lucius Verus resides at Daphne

192 C.E.
Pescennius Niger, governor of Syria, with support of Antiochenes, challenges imperial authority of Septimius Severus; city is punished and Olympic Games suspended

212 C.E.
Caracalla returns imperial favors to city and restores Olympic Games

215–17 C.E.
Caracalla and his mother, Julia Domna, rule from Antioch; she starves herself shortly after his death in 217

256 and 260 (?) C.E.
City sacked by Persian troops

266–72 C.E.
Queen Zenobia of Palmyra takes over the city

272 C.E.
Aurelian defeats Zenobia and recaptures the city

306–37 C.E.
Emperor Constantine converts to Christianity and commissions the building of the Great Church on the city's island

338 C.E.
Constantius in Antioch as emperor of the East. City continues to be used as headquarters in the war against Persia

341 C.E.
Great Church completed

361–63 C.E.
Pagan revival under Julian II based in the city

379–95 C.E.
Reign of Theodosius I; Libanios and John Chrysostom active

387 C.E.
Tax riots; imperial portraits and statues destroyed

438 C.E.
Empress Eudocia has city walls enlarged

458 C.E.
Major earthquake destroys nearly all buildings on the island

459 C.E.
Death of Symeon the Stylite; relics brought to Antioch

484 C.E.
Pretender emperor Leontius reigns from Antioch; ousted by Zeno

507 C.E.
Circus riots; the synagogue at Daphne is burned

525 C.E.
Great fire

526 C.E.
May 29, major earthquake destroys almost entire city, leaves 250,000 dead

528 C.E.
Nov. 29, major earthquake leaves 5,000 dead. City is renamed Theopolis (City of God)

540 C.E.
Antioch is captured and sacked by the Persians. City destroyed and depopulated. Bubonic plague begins two years later

540–65 C.E.
Major rebuilding effort under Justinian, focusing on defenses and infrastructure

573 and 610 C.E.
Persians sack the city

637/38 C.E.
Capture by the Arabs

ANTIOCH AND SURROUNDING REGION

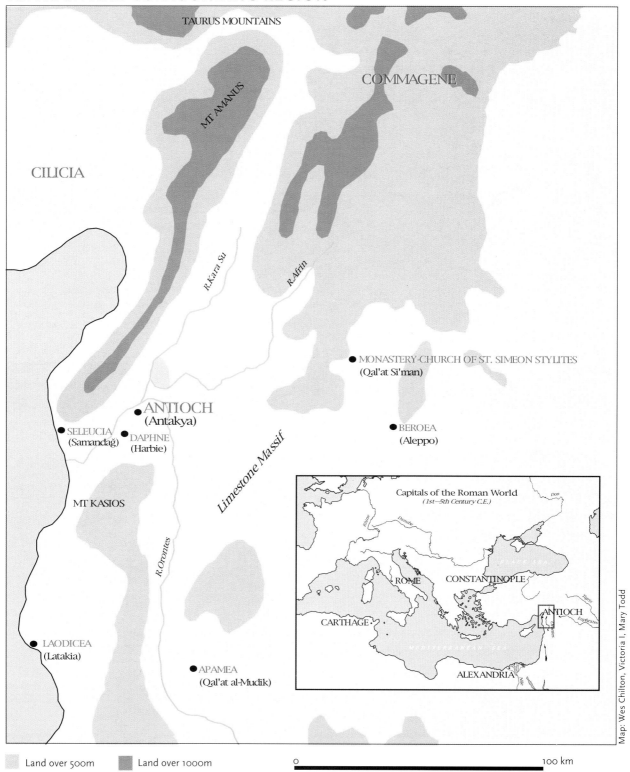

TAURUS MOUNTAINS

COMMAGENE

MT AMANUS

CILICIA

R.Kara Su

R.Afrin

● MONASTERY-CHURCH OF ST. SIMEON STYLITES
(Qal'at Si'man)

● ANTIOCH
(Antakya)

● SELEUCIA
(Samandağ)

● DAPHNE
(Harbie)

● BEROEA
(Aleppo)

MT KASIOS

Limestone Massif

R.Orontes

Capitals of the Roman World
(1st—5th Century C.E.)

Don

Rhine

Danube

BLACK SEA

ROME

CONSTANTINOPLE

Tigris

CARTHAGE

ANTIOCH

Euphrates

● LAODICEA
(Latakia)

MEDITERRANEAN SEA

● APAMEA
(Qal'at al-Mudik)

ALEXANDRIA

Nile

Land over 500m Land over 1000m

0 100 km

Map: Wes Chilton, Victoria I, Mary Todd

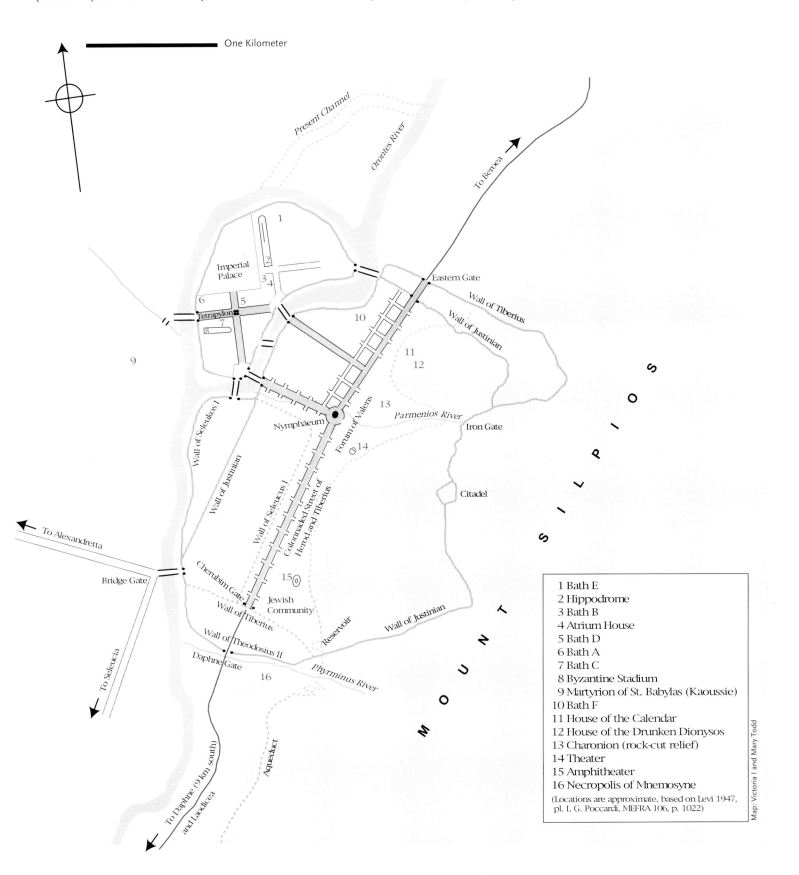

ANCIENT CITY OF ANTIOCH
(Restored plan based on literary texts and the excavations, adapted from Downey 1961, fig. 11, after Wilber)

One Kilometer

Present Channel

Orontes River

To Beroea

1

Imperial
Palace

2

3 4

6 5

Tetrapylon

7

8

9

Eastern Gate

Wall of Tiberius

Wall of Justinian

10

11

12

13

Parmenios River

Iron Gate

Nymphaeum

Forum of Valens

14

Wall of Seleukos I

Wall of Justinian

Citadel

To Alexandretta

Wall of Seleucus I

Colonnaded Street of
Herod and Tiberius

Bridge Gate

Cherubim Gate

15

Wall of Tiberius

Jewish
Community

Reservoir

Wall of Justinian

Wall of Theodosius II

Daphne Gate

To Seleucia

16

Phyrminus River

Aqueduct

To Daphne (9 km south)
and Laodicea

M O U N T S I L P I O S

1 Bath E
2 Hippodrome
3 Bath B
4 Atrium House
5 Bath D
6 Bath A
7 Bath C
8 Byzantine Stadium
9 Martyrion of St. Babylas (Kaoussie)
10 Bath F
11 House of the Calendar
12 House of the Drunken Dionysos
13 Charonion (rock-cut relief)
14 Theater
15 Amphitheater
16 Necropolis of Mnemosyne

(Locations are approximate, based on Levi 1947,
pl. I, G. Poccardi, MEFRA 106, p. 1022)

Map: Victoria I and Mary Todd

Antioch

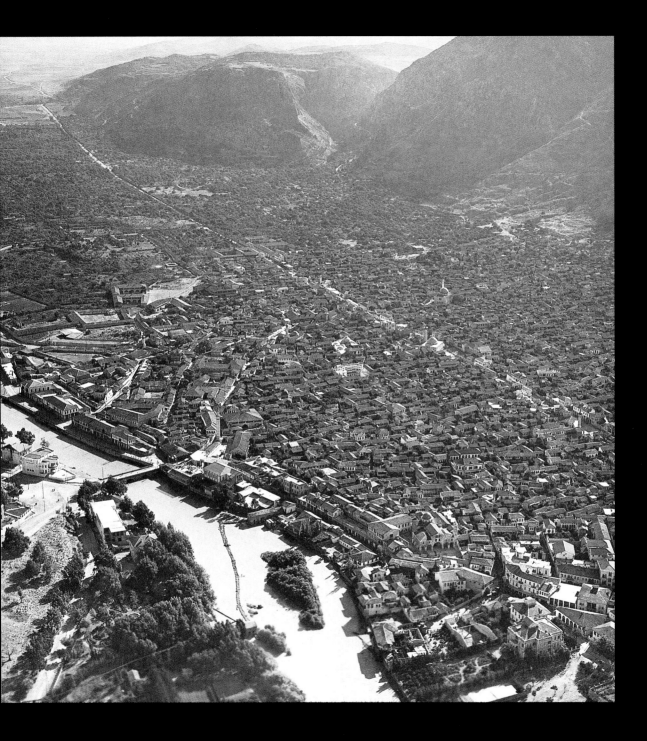

The City of Antioch:
An Introduction

Christine Kondoleon

How could they ever give up
their marvelous way of life, the range
of their daily pleasures, their brilliant theatre
which consummated a union between Art
and the erotic proclivities of the flesh?

. . . But they had the satisfaction of living
the notorious life of Antioch,
delectable, in absolute good taste.

C. P. CAVAFY, Julian and the Antiochians

Cavafy takes us back to a time when Antioch-on-the-Orontes was a star in the constellation of Roman Mediterranean cities, a city known for its sophistication, for the grand style of its buildings and broad avenues, for its markets filled with exotic and luxurious goods, and for its famous sanctuary of Apollo with its healing spring waters. Antioch "the beautiful and great"[1] ranked with Rome, Alexandria, and Constantinople as one of the four great cities of the Roman and Early Christian world, but it is by far the least known. Today called Antakya, it is located in the Hatay province of southeastern Turkey, near the border with Syria. Few visitors to the modest Turkish town would guess the extent of its vanished glory.

Fortunate in its topographic and geographic features, Antioch was envied for its temperate climate and fair winds. Built along the eastern bank of the Orontes River (today, the Asi River) and framed by a ridge of hills crowned by Mount Silpios (el. 1,660 ft.), the city was visually spectacular (see p. 2). Most important, the siting of the city on a navigable river about fifteen and a half miles (a day's sail) from its Mediterranean port at Seleucia Pieria, afforded great economic and strategic advantages (fig. 1). The fertility of the Amuk plain and the lower Orontes valley produced favorable climatic conditions for agriculture, and the city was well supplied with grain, fresh produce, oil, and wine. Fed by springs, Antioch's

Aerial view of Antioch from 1930s showing the city sited between the Orontes River on the lower left and the range of mountains capped by Mount Silpios. Also visible is the long modern street which follows the same lines as those of the Roman colonnaded north-south street

Fig. 1. Harbor of Seleucia Pieria (present day Samandağ, Turkey) with view of mountains into Syria

abundant waters were a source of pride and pleasure for its inhabitants. Their rushing torrents that were tamed by aqueducts, tunnels, and dams increased agricultural yields and brought the water that flowed freely in public and private buildings (fig. 2).

As the seat of a governor, Antioch was the administrative center of Syria and the leading city in the Roman East. From its founding in 300 B.C.E. by Seleukos I, who settled large numbers of Greeks in the region, Antioch was steeped in Hellenic culture, so much so that Roman writers often compared the city to Athens. And in the tradition of a Greek *polis*, Antioch had a famous school of rhetoric, led in the fourth century by Libanios, teacher of Roman emperors and Christian bishops, whose writings captured the flavor of life in the city.

Antioch was a vital metropolis set on the crossroads between the Euphrates to the east and the ports of the Mediterranean to the west, and between Ephesos to the north and Jerusalem to the south. It was a city where the cultural and economic forces of the East (as far as Persia) and the West (as far as Rome) met, and the major trends of the Roman and early Byzantine periods could be mea-

sured. As we know from contemporary accounts, Antioch, like New York or Los Angeles, was a consumer city, attracting ambitious entrepreneurs from all over the Mediterranean. From the comments of the Christian orator John Chrysostom, who stated that only 10 percent of the population was wealthy and only 10 percent was poor, we can deduce that the city had a large middle class in the fourth century.

Geography was key to the city's eminence, but also to its downfall. Antioch's access to the Mediterranean made it a perennial target of Persian conquest, and the city was struck by a series of earthquakes through its long history. An earthquake in December 115 C.E. nearly killed the emperor Trajan during his extended visit to the city. Floods, particularly flash floods, posed a constant threat, as they still do today in this region. A series of calamities in the first half of the sixth century, including a great fire in 525, two earthquakes in 526 and 528, a ruthless Persian invasion in 540, and the bubonic plague in 560, shattered the prosperity of the city. (The chaos and destruction of the 1999 earthquake in the densely populated area around Istanbul and Izmit was a bitter reminder of the immense

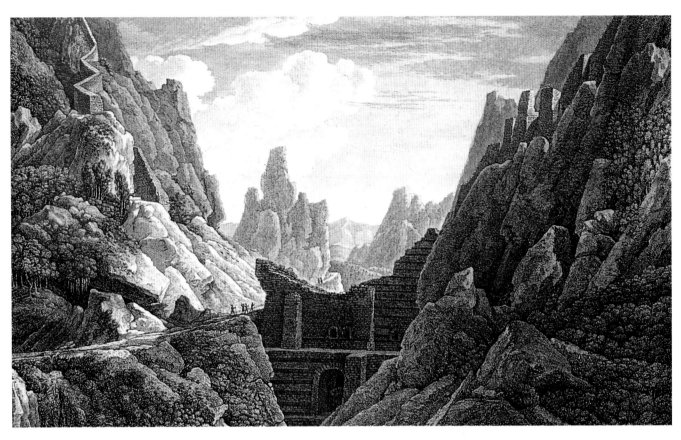

Fig. 2. View of "Iron Gate," a dam built by Justinian to control flooding from mountain torrents. Engraving from Cassas 1799, vol. 1, pl. 9. Harvard University Art Museums

costs of such natural disasters.) With its population decimated and the urban fabric in shambles, Antioch was hard pressed to recover its former glory, despite the major repairs and investments of the Byzantine emperor Justinian I. Although greatly diminished, Antioch survived as a city under Arab rule from 638 to the tenth century, after which it was revived as a Byzantine city and then a Frankish principality during the Crusades.

Excavation History

The search for Antioch began in 1932 under the direction of the Committee for the Excavation of Antioch and Its Vicinity, made up of representatives from the Musées Nationaux de France (Louvre), the Baltimore Museum of Art, the Worcester Art Museum, and Princeton University; in 1936 representatives from the Fogg Art Museum at Harvard University and its affiliate Dumbarton Oaks joined the committee. The excavations were undertaken with a concession from the Syrian government, then represented by the French High Commissioner, with the approval of M. Henri Seyrig, director of antiquities for

the Syrian government. The Ottoman territories Hatay including Antakya, and Cilicia just to the north, had been put under French mandate at the end of World War I.

The project originated among the colleagues and pupils of Howard Crosby Butler at Princeton University, who had done pioneering work on the early Byzantine monuments of Syria (fig. 3). An expert in late Roman and Early Christian art, Charles Rufus Morey of the Department of Art and Archaeology at Princeton served as chairman of the committee, which also included Francis Henry Taylor, then director of the Worcester Art Museum, Robert Garrett, a trustee of both Princeton University and the Baltimore Museum of Art, Professor Edward W. Forbes of the Fogg Art Museum, and Robert Woods Bliss of Dumbarton Oaks. The field director for the eight campaigns was William A. Campbell of Wellesley College; M. Jean Lassus, representing the French, acted as assistant director, and Richard Stillwell of Princeton served as director of publications. Work ended with the outbreak of World War II in 1939 and the annexation of the region to Turkey by a plebescite sponsored by the League of Nations. Negotiations for distribution of the finds were

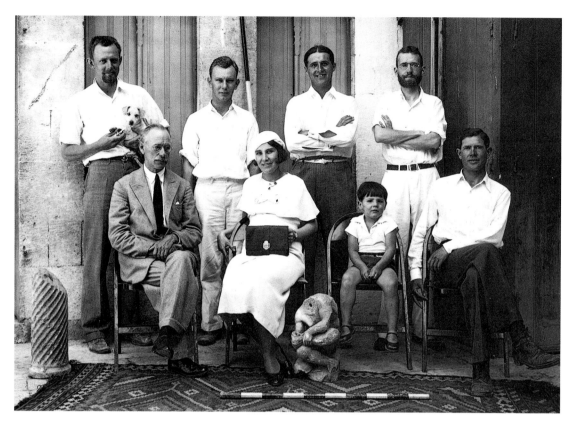

Fig. 3. Staff photograph of the 1933 expedition with William A. Campbell of Wellesley College seated at the far right and Jean Lassus standing third from the left (note the Thorn-puller [cat. no. 61] in the foreground)

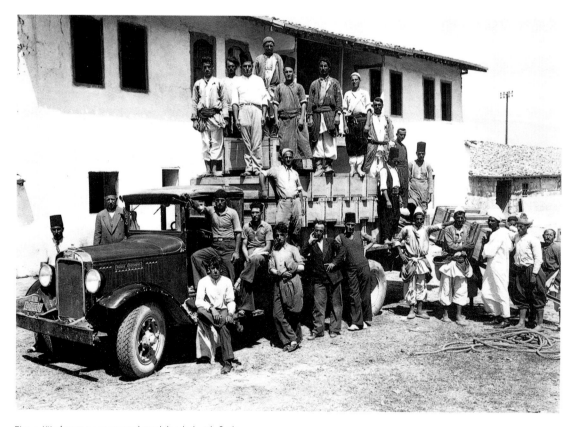

Fig. 4. Workmen pose around truck loaded with finds

then made with the newly formed Hatay government, which had Antakya as its capital (fig. 4).

In the course of the excavations several geographic areas were explored: Antioch proper; the garden suburb Daphne-Harbie, about five miles (8 km) south of Antioch (designated as Sector IV DH); the port city of Seleucia Pieria (Sector IV S); Yakto (Sector IV Y); and a few isolated sites (Feleet, Narlidja). Evidence was found for some eighty buildings and nearly three hundred mosaics. With only a few exceptions, including the remains of six baths, a theater at Daphne, part of a theater in Antioch, a hippodrome, two major churches, and a few tombs, the structures were designated as private residences. Given current research, scholars today might hesitate to presume that many of the fragmented remains (sometimes only one room or corridor) could be securely identified as domestic structures.

The team set out with the expectation of locating some of the great monuments mentioned in the texts of, among others, Libanios and the sixth-century historian Malalas, the single most important source for the topography of Antioch. Although the texts clearly mention many important monuments and urban features covering an area of about three square miles, especially a grand colonnaded avenue with bridges leading to the royal district on the island in the Orontes (no longer visible)—with its palace and hippodrome, the Forum of Valens, the octagonal Golden Church of Constantine, the round Church of the Virgin of Justinian—none of these was discovered. Indeed, even though the excavators knew the location of the palace, its ruins eluded them, largely because the city had been deeply buried in many feet of silt (fig. 5). Instead, an "extraordinary harvest of mosaics" from scores of private houses was revealed. [2] As a result, the lives of Antioch's private elite have been more clearly revealed than the public or religious dimensions of the city that still remain more vivid in written accounts.

The tensions created by this situation—namely, the disparity between the Committee's expectations and the archaeological team's actual findings—are felt in the account of Jean Lassus, the French archaeologist who served as assistant field director. According to Lassus, by 1935 field director William A. Campbell, after several disappointing stratigraphic soundings, was working on limited credit. It was not until the discovery of the "Boat of Psyches," depicting Eros in a chariot pulled by Psyches (see p. 73, fig. 6), that a supplemental check for a thou-

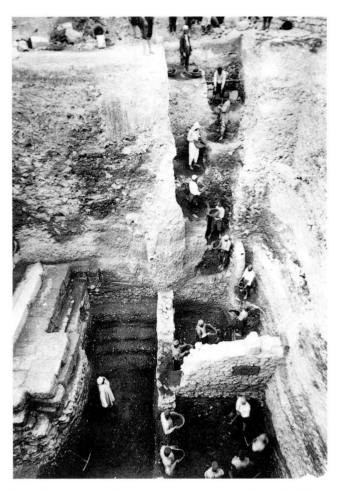

Fig. 5. Workmen excavating under modern street reveal the depth of silt deposits that challenged the expedition

sand dollars—enough to pay a hundred local workers for three weeks—was received and the mission was resumed. [3] The incident demonstrates the extent to which the excavation of Antioch became an excavation of mosaics. In fact, the Louvre representatives determined to continue excavations only after the Judgment of Paris (cat. no. 58) came to light and was promised to the Louvre; its value was estimated to be twice the sum of the French subsidy. Also poignant are Lassus's confessions about clandestine searches for mosaics and the regrets he expresses about the necessity to dismember a number of pavements in order to excerpt inscriptions and extract figural panels from an expanse of geometric or floral backgrounds.

Selected finds, including monumental floor mosaics, were dispersed to the sponsoring museums by agreement with the Syrian Department of Antiquities and subsequently with the Hatay government. While they were initially sent only to the major sponsors, in time, space restrictions prompted the sale or exchange of many to

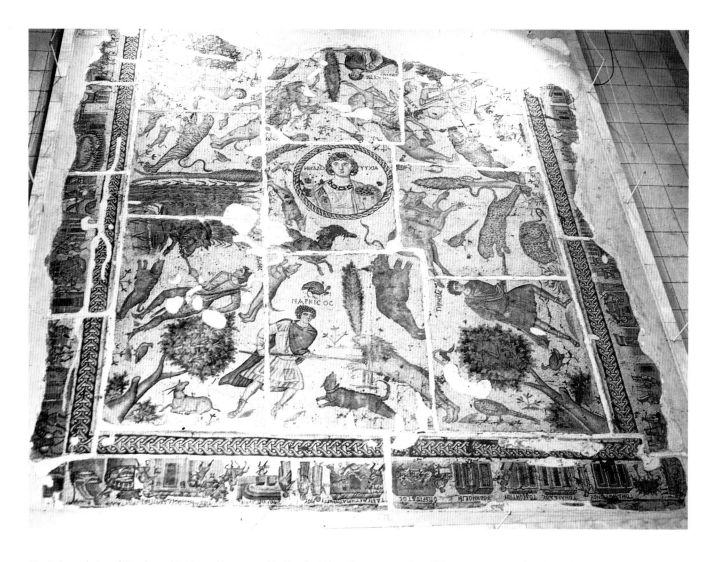

Fig. 6. General view of Megalopsychia Hunt with topographical border. Yakto village near Daphne, fifth century. Hatay Archaeological Museum, Antakya, 1016

locations as distant as Honolulu (cat. no. 43) and Seattle.[4] In fact, some are still in transit; most recently a mosaic of the sea goddess Tethys was sold by Dumbarton Oaks to the Harvard Business School. This Antioch exhibition reunites many of the finds for the first time since their discovery.

The retrieval of the city's historical narrative from the complex layers of textual and archaeological evidence was the monumental achievement of Glanville Downey, a member of the team. Inspired in part by the seminal study of Antioch by the early-nineteenth-century philologist Karl Otfried Müller, Downey wrote an exhaustive monograph of the city in 1961, followed by two abbreviated versions, in 1962 and 1963.[5] The exhibition and catalogue owe a great debt to his work. An important recent addition to the publications on Antioch is Ataman

Demir's architectural survey of the city from antiquity through the Ottoman period until modern times.[6]

The City

The city of Antioch occupied a narrow strip of land bordered by the meandering lines of the Orontes River to the west and to the east by "the mountain [which] rises up, stretched out beside the city like a shield raised high in defence . . ." (Lib. Or. 11.200). The dramatic silhouette of Antioch was outlined by a ring of walls and towers, rebuilt under Theodosius II and then under Justinian, which ascended to the heights of the high slopes of Mount Silpios (see Foss, p. 22). There were at least four gates that led into the city along its major avenues. One of these avenues was a grand colonnaded street that crossed Antioch from the north at the Aleppo Gate to

the south at the Daphne Gate and covered a distance of nearly two miles (3 km). Such grand streets were an essential feature of classical urbanism and provided the spine along which the major commercial, religious, public activities and structures were found. The great street at Antioch with its columns and porticoes probably resembled those preserved today at Apamea, Palmyra, and Ephesos, but it was among the earliest built. Pillaged for its stone and buried by a series of earthquakes, it remained lost until Jean Lassus undertook its excavation in the 1930s and published his results in 1972 in the fifth volume of the Antioch Reports. His investigations revealed several strata of paving and rebuilding from the reigns of Herod to Justinian. The street admiringly described by Libanios was the one built by Trajan and completed by Antoninus Pius. It seems that Trajan decided to rebuild the damaged street and expand it with broad porticoes or *stoas*.

Along each side of the roadway was a covered portico for pedestrians creating a broad thoroughfare about 118 feet (36 meters) wide. Between the columns were stalls for street vendors and probably, as at Pompeii, private houses, entered through narrow vestibules flanked by shops. To judge from the contemporary accounts, this was the busiest part of the city filled with crowds (Lib. *Or.* 11.173), probably similar in aspect with their covered passageways to the souks of today. Large open plazas were situated at the major intersections with secondary streets leading off to other sections of the city. For example, the Omphalos (the "Navel"), not yet located, was the plaza where the Temple of the Nymphs stood with its famed fountain.

Several of these secondary roads led to the five bridges that crossed the Orontes and connected the city with the crescent-shaped island to the north. According to textual sources this island, now covered over by deposits, was the site of the palatial complex established during the Seleucid era. Under the Emperor Diocletian, the imperial residence was rebuilt along with the Hippodrome and several baths; and, although it was not found, its appearance might be surmised from other tetrarchic palaces, such as those at Split and Thessalonika. Apparently, it was approached through a great tetrapylon gate adorned with elephant statues. Also on the island (but also not found) was the octagonal Great Church begun by Constantine the Great and completed by his son Constantius II. It was these monuments that inspired the 1930s expedition. However, the remains of a second-century house (Atrium House), bath buildings, a Byzantine stadium, and some parts of the Hippodrome (city plan, p. xv, nos. 1–8) were located and excavated.

Other streets began from the *stoas* and ran toward the "first slopes of the mountain, [rising] gently, extending the inhabited area to such a distance that it preserves harmony with the scheme of the remainder of the city but is not, by being raised too high, cut off from it" (Lib. *Or.* 11.198). From these remarks by Libanios and the excavations, it is clear that many private residences were terraced on the lower slopes, probably to take advantage of river views and breezes (city plan, p. xv, several houses were found in the area around nos. 11–12). The long narrow streets that wind up the hillsides in Antakya today must be close in their layout to the Roman and early Byzantine streets. Libanios also informs us that certain streets, which he likens to "canals," end along the banks of the Orontes (Lib. *Or.* 11.201). Probably, houses were also built along the river bank just as one could find in late-nineteenth-century and early-twentieth-century Antakya, preserved only in postcard images.

Just outside the city walls, today in a neighborhood called Kaoussie, a large cruciform-plan church was uncovered with rich geometric floor mosaics (city plan, p. xv, no. 9). It is believed to be the Martyrion of Saint Babylas and dates to 387 c.e. Burial areas could be found just outside the city gates, for example, the Necropolis of Mnemosyne southeast of the Daphne Gate (city plan, p. xv, no. 16). Undoubtedly the fertile plain of the Orontes supported a number of small farms and orchards that surrounded the city.

The People

The Roman emperor Julian called Antioch a "gay and prosperous city" (*Mis.* 343B). Indeed its citizens were reputed to be extravagant in their tastes and entertainments. The objects and floor mosaics brought together for the exhibition and catalogue demonstrate the exuberant and sensuous appreciation of life for which Antioch was famous.

The neighboring town of Daphne epitomized this ambiance. Just a short distance south along the river, terraced on a plateau of cool forests filled with gurgling falls and springs, Daphne provided wealthy Antiochenes with a summer retreat from the heat of Antioch (Lib. *Ep.* 419). The fresh breezes, the healing waters, and the sacred grove

of Apollo and Daphne, verdant with the laurel from which Daphne takes its name, attracted pleasure seekers then just as it does today. Many of the mosaics come from the concentration of elite residences in this suburb.

Yet it is the hectic and energized quality of life of the city that is most compelling for us. Antioch was a heterogeneous city, a melting pot of many cultures and faiths with a great variety of people. Population estimates run to about three hundred thousand citizens and freedmen, and this does not include slaves and children. Though Greek language and culture dominated, many other languages were spoken on the streets and read by the citizens of Antioch, including Latin, Hebrew, Aramaic, Syriac, Coptic, and Persian.

Despite tensions that sometimes flared up because of differences between the city's diverse communities and cultures, contemporary accounts reveal meaningful engagements between them as well. Nowhere is this better demonstrated than in the exchanges between the varied religious communities, namely, Egyptian (Isis, Harpocrates, Attis), Near Eastern (local Syrian cults) and Roman pagan cults, Judaism, and Christianity.

For example, the Jews of Antioch represent a particularly fascinating picture of Hellenized Jewish culture.[7] Many Jews were settled in Antioch around the mid-second century B.C.E. and by the Roman period a significant part of the Jewish population was counted among the city's elite and comfortable with the Hellenic culture of the late Roman Empire. Greek was the language heard in the synagogues that existed in several sections of the city; unfortunately, none of the synagogues was found during the excavations.

As the seat of a patriarch, Antioch was also an ecclesiastical capital and played a key role in the formation of Christianity.[8] Tradition and some scholars hold that Saints Matthew and Luke lived and wrote their gospels in Antioch. Several missions of Saints Peter and Barnabas are recorded. When Saint Paul went to preach in Antioch, he found a gentile population familiar with Jewish worship services conducted in Greek. And, it was in Antioch that followers of the new religion were first called "Christians" (Acts 11:26). By the late fourth century, John Chrysostom noted that there were a hundred thousand Christians in Antioch. In the fourth century, Alexandria, Antioch, and Constantinople vied for recognition as the premier ecclesiastical seat of the eastern churches. This rivalry underlines the power Antioch held both in real

terms and in the religious and cultural imaginations of Christians throughout the empire.

Antioch was at the center of a large network of villages extending about sixty miles into the limestone hills of northern Syria. Excavations have yielded remains of stone farmhouses dotting the countryside around the great city. The relations between such urban centers and their peripheries are of great interest in studies of late antiquity.[9] Christianity found fertile grounds in these small towns and agricultural enclaves. The region surrounding Antioch was noted for its unconventional and extreme expressions of Christian piety. It was in the hills to the east of Antioch that Simeon the Elder went to live atop a sixty-foot pillar in the early fifth century and gained international stature as a holy man, drawing pilgrims from Armenia, Persia, Iberia, and Britain. After his death his body was removed to Antioch for veneration. His namesake, Simeon the Younger, also set himself up atop a column only a few miles from Antioch; today the ruins of a limestone church can be found at the site.

The Exhibition

No doubt every city has a discourse, to borrow a phrase from Roland Barthes's "Semiology and the Urban." Barthes promotes the notion of a language of the city and the necessity for its multiple readings. And while every city is a structure, he warns, "we must never try and never want to fill in this structure."[10] Yet a museum exhibition by its nature must have structure, an installation strategy, and goals, all of which necessarily restrict the scope of the exploration and limit the readings of the subject—the city of Antioch. Obviously, it is not possible to reproduce the random paths that one might take through a city, particularly a buried ancient city. Yet somewhere between the words of the authors and the representations of the found objects, the spectacle of the city—its crowded streets and colonnaded avenues following the course of the Orontes River, its imposing edifices and private dwellings, and its teaming populations—takes shape and becomes legible.

The objects selected serve to introduce a variety of themes that evoke ancient life in a metropolis. They are intended to guide the visitor and reader through the world of Roman Antioch, to allow him or her to walk its bustling streets, take the waters at its famed spa, drink at its public fountains, attend its theaters and circus, visit

the baths, and banquet in its art-filled homes. In part, the goals of the exhibition are inspired by a most unusual document, the topographic border around the Megalopsychia Hunt of the fifth century, today in the museum in Antakya (fig. 6). A series of different vignettes records a walk between Daphne and Antioch with various buildings and activities labeled in Greek. The mosaic imparts a sense of immediacy in its depiction of the comings and goings along the streets of Antioch.

The essays in the first part of the catalogue serve to present aspects of the history of the city and its people, as well as to review and contextualize the excavation finds (houses, mosaics, furnishings, sculpture, coins). The second part of the catalogue is organized to follow the exhibition installation. The objects are divided into five thematic sections: "City and the People"; "Water"; "Entertainment"; "The Roman House" (with a reconstructed dining room); and "Religions: Pagan, Jewish, Christian." Short essays introduce concepts and provide a framework for the objects selected for each of the five sections.

The exhibition seeks to bring to life a city that in the diversity of its people, the rich textures of its material culture, and the complexity of its intellectual and spiritual life, serves as a mirror for the cities of today. At the start of the new millennium it is especially appropriate to offer the contemporary public a vivid model of an ancient metropolis that invites dialogue about ideas of civic community and diversity, both in the past and in the present, for the attitude of Antiochenes to foreigners and people of all backgrounds is illuminating. We learn much from Libanios in his lecture in praise of his native city Antioch, wherein he relishes the heterogeneous nature of his city and sets the tone for civic values worthy of our admiration:

It seems to me that one of the most pleasing things in cities, and one of the most useful, is meetings and mixings with other people.[11]

We [citizens of Antioch] too have done honor to foreigners in the greatest things, and have profited from foreigners, so that even now their families hold positions among the first.[12]

Indeed, if a man had the idea of traveling all over earth with a concern not to see how the cities looked but to learn their individual ways, Antioch would fulfill his purpose and save him journeying. If he sits in our market-place, he will sample every city; there will be so many people from each place with whom he can talk.[13]

Epigraph: Cavafy 1972, 66.

1. Lib. *Or.* 31.7.

2. Minutes of the annual meeting of the Committee for the Excavation of Antioch and Its Vicinity, 26 October 1935.

3. Lassus 1983, 253.

4. For a record of the current locations of the mosaics in American museums, see Jones 1981, 16–26.

5. Downey 1961, 1962, 1963; Müller 1839.

6. Demir 1996 includes many passages from early travel writings and an extensive photographic survey of vernacular architecture, including historic districts and houses.

7. See Bernadette Brooten's essay herein for a more detailed account of the Jewish community of Antioch.

8. On Antioch's role in early Christian history and theology, see the essays by Michael Maas and Susan Harvey.

9. Clive Foss's essay touches on this issue.

10. Barthes 1997, 171.

11. Lib. *Or.* 11.213.

12. Lib. *Or.* 11.168.

13. Lib. *Or.* 11.166.

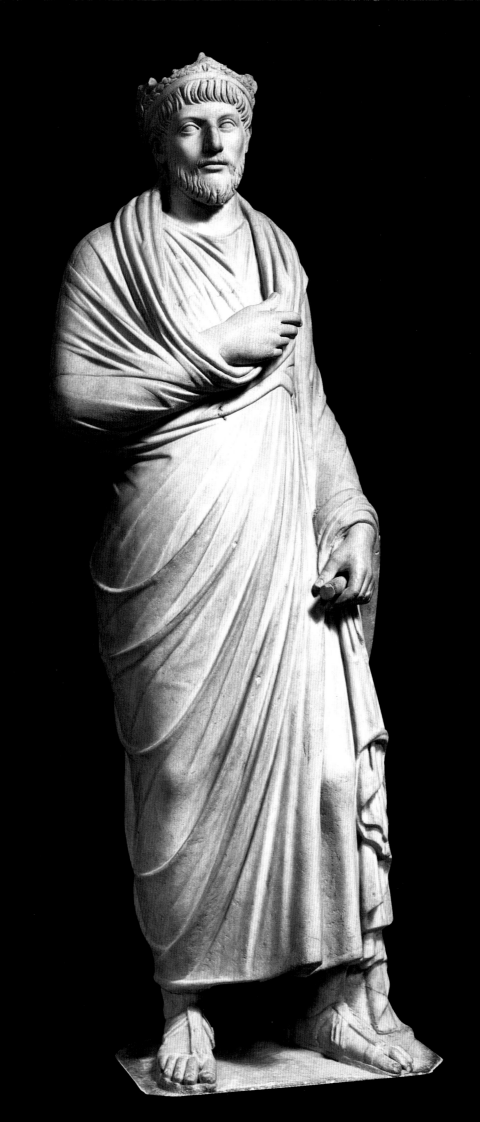

People and Identity in Roman Antioch

Michael Maas

For a historian of antiquity, this exhibition offers an irresistible invitation to reconsider why Antioch was one of the greatest cities of the classical world and to restore some of its luster in the public gaze.[1] Antioch has never been forgotten or abandoned, but in the American popular imagination it has not assumed the importance of lesser cities in the Roman Empire such as Athens or Pompeii. Because Antioch has remained an Islamic city for nearly all of its long life since Roman rule came to an end in the early seventh century, it has suffered from all the prejudices of a Eurocentric vision that marginalizes the Islamic world as alien, exotic, and inherently inferior to the Christian West. Unlike other cities within the Islamic orbit, such as Damascus, Baghdad, Cairo, and Istanbul, Antioch could not even claim to be the capital of an Islamic empire, and so it was further overlooked.

Antioch has slipped from our attention for other reasons as well. Though many know of the city through the New Testament account of Paul's visit there in the first century to help convert the Antiochenes and establish the first gentile Christian community, most of the ancient historical documents pertaining to the city were written in Greek, Syriac, and, later, in Arabic, which made them inaccessible to all but a few scholars. Only recently have translations appeared to bring this material to the general reading public.

There are several good reasons to take a fresh look at Roman Antioch. In recent decades the history of the Roman Near East has been rewritten. Scholars have reconsidered such issues as the transformation of urban traditions, the creation of ethnicities among the diverse populations of the region, the emergence of new ideas of spirituality and their expression in Christian, Jewish, and Islamic contexts, the interaction of Rome with Persia and other cultures beyond its eastern borders, and the military and social character of the eastern frontier zone itself. Antioch played a significant role in all of these developments, and so reevaluating the Roman Near East requires reevaluating Antioch.

The starting point of all investigations must be Antioch's urban identity. The Roman Empire used cities as centers of administration, and inevitably on the urban stage, Roman power confronted local cultural traditions. Interaction with Rome gave each city a special character. Antioch, with one of the most complex amalgams— Greeks, Jews, Syrians, Christians, Romans, and visitors

from many lands—developed a splendid cosmopolitan character. As mass culture seems about to displace the unique features that made American cities so different only a hundred years ago, the story of Antioch offers challenging parallels to our own urban "melting pots" and the aesthetics of cultural difference that arise from them.

The transition from the classical world to the Middle Ages in the eastern Mediterranean world was marked above all by the emergence of two great faiths, Christianity and Islam. Both were the heirs of Greece and Rome. Antioch reveals vividly the difficult birth of a Christian Roman culture. When Antioch passed into Muslim hands in the seventh century the Roman period came to an end. It would take another equally sophisticated exhibition—and perhaps a new set of excavations, for classical archaeologists have not always paid due attention to post-Roman material in their digging—to trace the transformation of Roman culture in an Islamic matrix.

Antioch-on-the-Orontes has a continuous history of twenty-three hundred years. For seven hundred years of this long life, from 64 b.c.e. to 636 c.e., Antioch was part of the Roman Empire, but the city had been world-famous for three centuries before Roman rule got under way. The story of Antioch begins when Alexander the Great died without naming a successor in 323 b.c.e. One of his generals, Seleukos, son of Antiochos, carved out a kingdom from Alexander's conquests in Syria and in 300 b.c.e. established Antioch as its capital. For the next three centuries Antioch stood out as the grandest and most beautiful of the new cities that anchored Hellenistic culture and political order to the older strata of indigenous Near Eastern societies. Antioch began as a Greek city superimposed on a far older, Semitic landscape. The expanding Roman state became embroiled in the political affairs of the Hellenistic kingdoms of the eastern Mediterranean, and Pompey the Great brought Seleukos's kingdom under Roman rule in 64 b.c.e. The fit of Rome's power with Antioch's splendor and strategic location was a snug one. Like all communities caught in the embrace of that world empire, Antioch's face and character were transfigured by interaction with Rome. Antioch evolved in step with the Roman state, and its people took on new identities under Rome's influence. When the Romans arrived in Antioch in the first century b.c.e., the population viewed them as foreign interlopers, but by the time Arab armies conquered the city in the seventh century c.e. Antioch's inhabitants had come to think of themselves not only as Romans but also as Christians—but they were first and foremost still Antiochene.

Roman civilization took hold in Antioch in three phases. In the first phase Rome established control of the urban center of Antioch by imposing the political institutions and architectural trappings characteristic of a great Roman metropolis. This Roman penetration and consolidation lasted from the end of the Roman Republic to 212 c.e., when Roman citizenship was granted throughout the empire. The second critical phase of Antioch's transformation ran from the late third through the fourth century c.e. The empire was restructured, and as a result of Christianity's emergence as a force in society, "culture wars" were waged between Christians, who challenged the basic assumptions of Mediterranean urban life, and polytheists, who defended traditional patterns of civic life. These struggles shaped the destiny of Antioch. The final phase of Antioch's Roman history lasted from the late fifth century until the Arab conquest in the seventh century. During this time Christian and Roman elements combined to create a new world order in which Antioch participated, although Antioch's independence of mind on matters of Christian doctrine resulted in uneasy relations with the imperial capital at Constantinople.

Rome Establishes Control

In 64 b.c.e. Pompey the Great put an end to Seleukos's kingdom and annexed Syria as a Roman province (see region map, p. xiv). Pompey recognized that Syria's strategic location between the Mediterranean, Armenia, and Persia, not to mention its wealth derived from the caravan trade and mercantile links to the Red Sea and the Persian Gulf, made it vital to Rome's expanding interests in the Near East.[2] Antioch, formerly the capital of the Seleucid kings, continued as the command post of Roman Syria. As the Roman Republic collapsed in the next decades in a spiral of violence and civil war, Syria suffered many misfortunes at the hands of rapacious Roman generals and rebellious soldiers. To make matters worse, forces of the Parthian Empire took advantage of Rome's political confusion and briefly occupied Syria in 40–39 b.c.e. Recovery began during the reign of Caesar Augustus, the first emperor of Rome, who put an end to civil war and inaugurated nearly three centuries of peace for Syria and the entire Roman world—the *Pax Romana*. Conscientious Roman emperors and magistrates sought

to ensure justice and protect the public welfare in their domain. Under these propitious auspices, Syria and Antioch could begin the business of becoming Roman.

Every Roman province was subdivided into pockets of territory controlled by individual cities. Since each city's territory retained its own laws and customs, a province might comprise a number of very different ethnic communities. This was the case in the province of Syria, which as configured by Rome in the course of this early period included a rich mix of different ethnic groups, languages, religions, and cultures in a variety of political formations. In the north were more than a dozen predominantly Hellenistic Greek cities, including Antioch, Apamea, Gerasa, and Scythopolis. Further to the east, Damascus, the oasis city rich in figs and profits from the caravan trade, was annexed in 62 C.E. Along the Phoenician coast were the manufacturing and maritime trading cities of Byblos, Beirut, Sidon, and Tyre. Syria absorbed several independent states bound to Rome by treaty, including Commagene on the west bank of the upper Euphrates, incorporated into the province in 72, and the Ituraeans dwelling in the Bekaa Valley in Lebanon; parts of the Nabataean kingdom, including Petra and portions of northern Arabia; Judaea, which became a regular province on its own after 70 C.E.; and the large Jewish populations in cities throughout the region. It was not a simple task to transform this polyglot, culturally diverse territory into a Roman province (see region map, p. xiv).

The unity, stability, and renewed prosperity made possible by the Augustan system allowed Roman culture to sink roots in Syria. As the capital of the province Antioch was the nerve center of Roman control in Syria and played a determining role in the transmission of Roman civilization to the region. Romanization occurred primarily through civilian and military administration, and through deliberate urbanization and expansion of Roman citizenship.

Civilian and Military Administration

Roman Antioch was first and foremost an administrative center. It was home to the provincial governor and his staff. Because of its great wealth and strategic importance, Syria became an imperial province, its governor a man of special loyalty and experience, a former consul or praetor, chosen by the emperor himself and not the Senate. As the chief Roman magistrate in Syria, the governor had two roles. His first responsibility was to command Rome's most important military resources in the Near East. Because of the constant prospect of conflict with the Parthian Empire and with Sasanian Persia, which supplanted Parthia after 224 C.E., four legions and an equal number of auxiliary troops—approximately forty thousand men in all—were posted to Syria in the early imperial period. Throughout its Roman history Antioch was the staging point for imperial campaigns against Parthia, most notably the wars of Trajan and Septimius Severus. In marshaling the resources of Syria for war and establishing border defenses for the province, the governor gave the peoples of the province a common cause and helped unify them as Romans. The army he commanded played an additional role in the diffusion of Roman culture. Recruitment of troops from Syria, largely but not entirely from the Greek-speaking urban populations, began in earnest in the Augustan age. Though service in the legions was officially limited to Roman citizens, non-Romans sometimes enrolled and earned citizenship. The emperor Claudius (41–54 C.E.) began the practice of granting Roman citizenship to non-Roman auxiliary soldiers when they retired, an added incentive to participate in imperial life. Military service inevitably resulted in greater exposure to Roman ideas and the spread of citizenship.

Second, as the civilian chief executive, the Roman governor supervised the law courts and the administration of justice throughout the province. He adjudicated squabbles between Syrian cities. He held absolute power over all non-Roman citizens in his province and could intervene in local government. He was ultimately responsible for the collection of all direct taxes and for maintaining order in the turbulent cities, where street fighting between Greeks and Jews occurred frequently. The governor also supervised the provincial assembly, which met in Antioch. This body was made up of Syria's leading citizens, who gathered regularly to discuss matters of provincial concern and to participate in the carefully organized worship of the emperor. Rome encouraged these assemblies and the imperial cult as a means of developing loyalty and unity among the province's city-based elites.

Men of authority and ambition gave Antioch a Roman look. Julius Caesar donated theaters, a pantheon, and an aqueduct. Augustus and subsequent emperors continued the tradition of public benefaction by giving even more lavishly: a great colonnaded street two Roman

miles long that ran through the city, a colossal temple of Jupiter Capitolinus with gilded walls and ceilings, and other temples to Roman deities. A stone statue of Rome's famous she-wolf nursing Romulus and Remus, a gift of the emperor Tiberius (14–37 C.E.), stood on a monumental arch. Baths, theaters, and residential districts constructed on the Roman model proclaimed to all not only that Roman power had come to stay but that the emperor was the most benevolent patron in the world.

Emperors and Roman magistrates were not the only ones to enhance the beauty of Antioch on a Roman model. Antioch's aristocrats, especially the members of the city's senate, emulated the emperor and the patterns of patronage established in Rome. They took great pride in gentlemanly competition to maintain public buildings and provide public games, horse races, and gymnastic competitions. Because loyalty to the city required loyalty to the gods who looked after it, they subsidized the important local religious cults, especially the cult of the emperor, for the benefit of the community and their own honor. Provincial aristocrats coveted the position of high priest of the imperial cult because of its enormous prestige and because it could be a point of entry to the Roman Senate.[3] One act of public generosity added tremendously to Antioch's international reputation. In 43, Claudius granted a petition of Antiochene notables to begin Olympic Games in their city, to be held every five years. These games became one of the most celebrated festivals of the Roman world. So important were these games that occasionally an emperor who grew angry with the citizens of Antioch put a halt to them, but they were always restored. For example, Caracalla (211–17 C.E.) restored civic pride to Antioch in 212 by reversing the decision of his recently deceased father, Septimius Severus (193–211 C.E.) to stop the games. In addition, he gave Antioch the coveted honorific title *colonia*.

As the locus of Roman power at the crossroads of the Near East, Antioch blossomed as a truly cosmopolitan city. Traders flocked to her bazaars, bringing merchandise from India, Persia, central Asia, and the Red Sea ports. Chinese annals make note of Antioch. Ambassadors from India on their way to Rome stopped there. Indigenous Greeks, Syrians, Jews, Phoenicians, and Arabs jostled with Roman legionaries enlisted in Italy and other western posts. The Roman imperial officials, tax collectors, and soldiers who filled Antioch's streets linked the city to the larger administrative and cultural grid of the empire.

Through them Antioch began to take its place as one of the empire's most glittering cities. "Who, seeing the city for the first time, would not think he had come to a festival?" wrote Libanios, a proud town father, in the fourth century (Lib. *Or.* 11.266).[4]

The aristocrats of Antioch, who constituted the city senate and held local magistracies, served another essential function in the empire. Rome governed its huge empire with a remarkably small bureaucracy because it relied on the cooperation of local elites to govern in Rome's name at the city level. It was their job to manage local affairs and above all to extract taxes from the masses of un-Romanized people who lived in the countryside. In this way cities, as points where local patronage networks intersected with imperial power, linked vast territories to the administrative center at Rome. This organization of the empire lasted through the sixth century.

Urbanization

In the Roman Empire a city comprised the urban center, enclosed by walls, as well as all the dependent countryside around it. It was in these agricultural areas, where most of the empire's population lived, that virtually all of the wealth of the empire was produced.

Rome's objective in the early empire was to maintain order and extract profit from her subjects, not to turn them all into Romans. There was no attempt to impose a uniform law throughout all Rome's vast territories;[5] there were simply too many different local and regional systems for this to be practical. Consequently, each urban center, together with its agricultural hinterlands, was permitted to keep its own customs and laws as long as they did not interfere with Roman rule. Of course, Roman officials had the final word in all matters of importance, but permitting cities to manage their affairs according to their own local customs fostered a degree of cultural independence in which citizens could take pride. What is today called "diversity," carefully controlled, had a place in the cities of the early Roman Empire.

The differences between a city's urban center and its dependent countryside could be quite profound. For example, the inhabitants of the urban center of Antioch were predominantly Greek in language, religion, and culture, and they looked to Rome for protection, whereas people in the outlying countryside had no entry to the international civilization of Rome. Instead of Greek, most

peasants spoke Syriac, a Semitic dialect. Throughout the Roman period Syriac was the main language of Syria outside of the cities, and it was the lingua franca of trade and communication over a vast area, reaching as far as Persia and India. Soldiers and merchants carried the Syriac language into the Latin West, as well. Thus the peasantry of Antioch was grounded in a widespread language-based culture that long predated the arrival of Roman armies. The Roman presence did little to bridge the gap between city and countryside in Antioch or anywhere else in the empire. In fact, it exacerbated the differences between urban center and hinterland because urban dwellers and their elites became more and more Romanized and bound to the empirewide culture of Rome, while rural peasantries, which had little direct stake in Roman urban civilization, remained relatively isolated.

In the Roman Empire the status of every individual was defined by law. This meant that rights and privileges varied in an organized fashion. Slaves had fewer rights than senators, women fewer than men, and foreigners fewer than citizens. Roman citizenship, which carried the greatest degree of advantage and presumed a degree of acculturation and identification with Roman civic values and social habits, became a prize eagerly sought by conquered individuals who wanted a greater degree of security and rights under the law. Roman citizenship was granted carefully and selectively, and it went first to local aristocrats as a reward for their loyalty. Citizenship helped cement the cooperation of local elites. It was the first step on their assimilation into the Roman system.

Citizenship spread slowly in Syria.[6] The chief enclaves of citizens in the early empire were urban communities called "military colonies," which Augustus and his successors established for citizen-veterans of the legions and that were largely composed of Italians. Antioch also attracted many former citizen-soldiers because it was a hub of military affairs. In Antioch and the other cities of Syria, Rome granted citizenship to her loyal friends. An inscription from the city of Tyre reveals that an official was selected to make nominations for citizenship. Similar cases must have occurred in Antioch. Evidently, Syrians were preferred to Arabs, who were always rather peripheral, as well as to Jews, whose loyalty remained questionable after their cataclysmic revolt of 69–70. By the end of the first century Antioch was sending men to the Senate at Rome.

Having the legal status of a Roman citizen was one thing; living and acting as a Roman, that is, adopting the trappings of Roman culture, was another. To adopt a Roman lifestyle—to wear Roman clothes, live in Roman houses, worship Roman gods, go to the gladiatorial games and the baths and the chariot races, and so on—was a matter of personal choice and not dictated by law. It was easiest to live a Roman lifestyle in cities, where these activities were a matter of daily life. This sort of slow transformation of foreign habits and customs is what historians call the process of Romanization. By the beginning of the third century a substantial percentage of the urban populations of the empire—precise figures are impossible to attain—had become largely Romanized. In Antioch, however, as in so many cities of the eastern Mediterranean, this Romanization occurred within a Greek-language matrix; Latin was used only in formal legal and administrative contexts. By the beginning of the third century, as Roman culture became dominant in cities throughout the empire, city dwellers within the boundaries of the empire shared a common way of life that distinguished them from the peoples beyond Rome's borders.

By 212, when the emperor Caracalla granted citizenship to virtually all free people within the empire, it was not easy to distinguish Roman citizens from noncitizens in the cities because the Roman way of life was so widely accepted. The gap between urban and rural, however, remained as great as ever. In the case of Antioch, the countryside still was primarily Syriac speaking; though bilingualism with Greek was considerable, Latin was virtually unknown there. The worship of age-old divinities continued, unaffected by Roman rule. Universal citizenship brought unexpected consequences and a subtle shift in emphasis. The city's honored role as a mediator between local non-Roman populations and imperial administration began to lose its logic, and the primacy of the city over the countryside began to diminish. The door stood open for a new universal ideology of inclusion to reconfigure old distinctions between city, countryside, and imperial center. Christianity seized the moment.

Culture Wars: Antioch Becomes a Christian City

The second critical phase of Antioch's transformation occurred in the late third and fourth centuries C.E., in step with changes occurring throughout the empire as a whole. During the half century from 235 to 284 the combined weight of military and economic disasters had brought the empire to its knees, but under the leadership of Diocletian

and his associates in the 280s the state regained a sure footing. They overhauled the structure of the state, stabilized the economy through ruthless fiscal policies, and greatly increased the size of the armed forces and civilian bureaucracy. The imperial administration became more centralized. One consequence was that Antioch, like other cities in the empire, began to lose its autonomy in the face of an expanding imperial bureaucracy.

During this same period the position of Christians in the empire radically changed. Not only did the church survive persecution under Diocletian but it achieved an undreamed-of prominence when the emperor Constantine accepted the religion in 312. When Constantine converted, the new faith was by no means broadly accepted in the Roman Empire, but by the end of the fourth century Christianity had become the official religion of the state and the numbers of adherents had vastly increased. Except for Judaism, all other forms of worship were forbidden. Christianity succeeded in winning large numbers of converts from the countryside as well as much of the empire's urban populations. This was true for Antioch, where believers in the city found new links with their country brethren.

United by Jesus' teaching and the promise of salvation, Christians initially understood themselves to be a separate—and universal—community, despite their wide dispersal and differences of opinion. In the time before Constantine, Christians often considered their community a clear alternative to Rome. After Constantine's conversion to Christianity in 312, however, close cooperation, even identification, with Rome became possible. Eusebius of Caesarea, a bishop active during Constantine's reign, tied the spread of Christianity to the Roman peace. Christian Rome would fulfill God's plan for human salvation by taking all peoples from their cultural isolation into full membership in the universal Christian Roman state. In other words, not only did Christian theories of salvation take the Roman Empire into account but the Roman theory of empire in turn assimilated Christian notions of community, mission, and historical destiny. A new culture was born that was Christian as well as Roman. And with this new culture there came into being a new kind of outsider, the pagan. Pagans were not simply the un-Romanized peasants in the countryside or even the hostile barbarians across the border; they were people not yet saved. From this perspective, civilization's true worth no longer lay primarily in traditional Roman urban values,

citizenship, language, or any of the other categories enshrined in city life. Full participation in society became a matter of faith, but this did not happen overnight.

Christianity challenged the fundamentals of Roman urbanism. "Culture wars" intensified between champions of the newly empowered religion and defenders of traditional forms of civic and religious life. The warriors on both sides belonged to the educated urban elite. They argued fiercely about sacrifices in temples, sexual conduct and gender relations, the uses of public space, and a host of other issues pertaining to the fundamentals of everyday urban life. The stakes were very high. What did this mean for Antioch? Without doubt Christianity did eventually prevail and did set different terms for full participation in society, but it would be a mistake to think that Antioch changed utterly because of Christianity. Many habits of life fell away as a result of the Christianization of Antioch, but Christianity itself had matured within an imperial context, assimilating a great deal of classical thought along the way. A Christian lifestyle represented a new interpretation of Greco-Roman civilization, not an absolute alternative to it. In the course of the fourth century a Christian elite emerged in the cities of the empire from the same upper echelons of society that produced defenders of traditional culture. Under the leadership of strong, well-educated bishops and determined clergy, Christian communities achieved a powerful political voice; good connections enabled them to be influential at court, while their championing of the urban poor gave them a power base in cities throughout the empire at a time when the financial pressures on urban communities were mounting.

Several anecdotes illustrate these tensions in Antioch. When the emperor Julian, "the Apostate," came to the throne in 360 C.E., he threw aside the Christian faith in which he had been raised—he was Constantine's nephew—and attempted to reestablish the vigor of polytheist worship (p. 12). The Christian church was too powerful to be destroyed directly, but Julian clipped its authority and tried to present a cogent alternative, especially through the restoration of traditional public rites, a kind of "pagan church." When the emperor arrived in Antioch in 362 to prepare for his invasion of Persia, he expected to find enthusiastic support among the population because Antioch was famous for its worship of Apollo and the other Greek gods. Instead, the citizens of Antioch mocked Julian for his excessive sacrifices and

humorless religiosity; they had little interest in solemn temple ritual. He alienated the luxury-loving city fathers when he scolded them for spending their money on jolly public festivals instead of the cults of the gods. He lost the support of the land-hungry poor of Antioch when he gave away public land to rich men. Christians, of course, despised Julian. When Julian died on campaign in Persia in 363, no one in Antioch mourned.

Antioch's most eloquent advocate of classical culture and polytheist worship in the fourth century was Libanios, an aristocratic rhetorician and extremely influential advocate of the elite senatorial class in Antioch who also spoke out about social injustices. He wielded great patronage and influence, and despite his religious beliefs, he received honors from the pious Christian emperor Theodosius I (379–95 C.E.). An atmosphere of fragile tolerance in Antioch let him be the friend and teacher of Christians, including the native-born Christian orator John Chrysostom, and non-Christians alike. When gangs of hymn-chanting, black-robed monks went on a rampage in the surrounding area in 386, raiding temples and tearing down statues of the old gods, Libanios wrote an angry letter of protest to the emperor (Lib. *Or.*, "On the Temples"). But John Chrysostom, whose invectives encouraged monks to pillage sanctuaries in the countryside, had more influence, and Libanios's letter fell on deaf ears.

In the year 387 Antiochenes provoked Theodosius I. When the people of Antioch learned that the government had ordered a heavy new tax of gold from the city, even though the city had just undergone a serious food shortage and could not bear the burden, they began to riot.[7] In their rage they toppled statues of the emperor and empress and dragged them through the streets, an act of high treason. Theodosius had to exact punishment, but upon whom? A general massacre was a horrible possibility. When the imperial investigators arrived in the city, Antioch's Bishop Flavian brought a band of Syriac-speaking monks in from the desert and from their caves on Mount Silpios, just outside of the city, to intervene on Antioch's behalf. Their leader, an independent and irascible old holy man named Macedonius, spoke no Greek, but through an interpreter he reminded the emperor that he was a man just like the rioters and warned him not to strike out with undue force. So impressed were the imperial agents by the holy man's confident, otherworldly authority that they returned to Constantinople with a recommendation of mercy. Theodosius allowed himself

to be swayed by this report. Instead of ordering a bloodbath, he merely shut down Antioch's baths, hippodrome, and theaters and revoked (temporarily) the city's prized honorific rank of metropolis. A handful of rioters were put to death. Antioch could breathe easily again. This frightening episode highlights not only the terrible power the emperor wielded in daily affairs but also the extent to which Christian discourse predominated in Antioch's public life as the fourth century neared its end. The intercession on the city's behalf of the Syriac-speaking ascetics shows how Christianity brought city and countryside together and how Christian models of authority had taken grip of the imagination. Antioch's political profile had become Christian.

Despite the deep penetration of Christianity into Antioch's life, vestiges of polytheist worship lasted throughout the fifth century. For example, Isocasius, a believer in the old gods, owned land and headed a school of philosophy in Antioch. He held many public offices and was a friend and correspondent of important churchmen. In 468, however, he was accused of various crimes, including the worship of false gods. At his trial in Constantinople he defended himself with a philosophical speech—and then accepted baptism.[8]

At the same time that bishops and monks found themselves in a struggle with polytheist traditionalists like Libanios over the shape of city life, they also confronted in a new way another portion of Antiochene society: the venerable and highly respected Jewish community. Jews had lived in Antioch since its earliest days, and the Jewish community was important throughout the Roman period. By the fourth century Antioch was home to Jews at every social level, from urban grandees to tenant farmers in the countryside. Roman law protected Jewish life, as it did the customs of all subject peoples, but from the time of Constantine Jews ceased to be merely one of many subject peoples; in Christian eyes Jews had a special role to play in God's plan for human salvation. A diminished role in society would be the punishment for the crucifixion of Jesus. As Roman law came to be exercised by Christian authorities, the legal standing of Jews suffered.[9] There had always been tensions, sometimes outbreaks of violence, between Jews and Greeks in Antioch, as there were in many Hellenistic cities, but in the fourth century Christianity gave those antagonisms a renewed force and a new logic. The continued presence of the synagogue threatened Christian claims to have

superseded it. John Chrysostom ("the golden-mouthed"), a presbyter in Antioch at the end of the fourth century, preached a fierce polemic against the Jews and against Christians who still maintained respectful ties with the synagogue. His venom reveals not only hostility to the "enemies of God" but insecurity about the position of the Christian community in Antiochene society. The steadily rising fortunes of Antioch's Christian community paralleled the declining fortunes of its Jewish community.

Christianity offered new definitions of community based on faith and identities shaped by doctrine. However, fierce divisions over theological doctrine divided the faithful and created rivalries among regions of the empire in which Christian doctrine flourished differently. Antioch held religious primacy over the Diocese of the Orient, of which it was also the administrative capital, and was one of the four great episcopal sees of the empire, along with Rome, Jerusalem, and Alexandria. The city emerged as a major center of doctrinal interpretation, and its clergy were often in the thick of religious debate about the divine and human natures of Jesus and the relation of Jesus to God and the Holy Spirit within the Trinity. Through the middle of the fourth century the teachings of Arius—that Christ was not coeternal with God the Father—prevailed at Antioch. Religious politics fluctuated at Constantinople, and Antioch was sometimes supported and sometimes persecuted for its Arianism. By the end of the century Antioch had returned to the orthodox belief of cotemporality and complete equality of Father and Son. From the end of the fifth century to the advent of Islam, however, Antioch's clergy propounded the belief, known as Monophysitism, that Christ had only one nature that was at the same time divine and human. This challenged orthodox doctrine, articulated at the Council of Chalcedon in 451, that Christ had separate divine and human natures that were at the same time one and indivisible. Various attempts at compromise and accommodation between the orthodox and Monophysite doctrines failed, and during the reign of Justinian (527–65) a separate Monophysite church with its own clergy and institutions came into being. Monophysitism spread rapidly in Syria under the leadership of Jacob Baradaeus (c. 500–578 C.E.) and throughout the Christian East as far as the Euphrates.

These currents of Christian doctrinal affiliation ran through Antioch and shaped how people understood themselves. They were indifferent to distinctions between urban center and countryside. Adherence to one doctrine or another became more important than citizenship, language, or dwelling place. Christianity won the culture wars by undercutting and displacing traditional poles of identification within a city.

From Rome to Byzantium

The final phase of Antioch's Roman history lasted from the fifth century until the Arab conquest. Although Antioch's size and economy were smaller during this period, it enjoyed a general prosperity. Antioch continued in its role as a Roman military center. The Master of Soldiers of the East, the commander in chief of the eastern armies, was stationed in Antioch, and numerous emperors began their campaigns against Persia from there. During this time Christianity deeply saturated all aspects of Roman life and government to produce a vigorous and resilient culture that modern historians call Byzantine.

The reign of the autocratic emperor Justinian was a watershed in the shaping of this new Roman-Byzantine society. Justinian vigorously asserted the empire's right to universal rule in terms that were both Roman and Christian. He tried to establish orthodox Chalcedonian Christianity everywhere in his dominions. Unlike rulers of the early empire, who accepted cultural diversity within the state, Justinian tried to impose one Roman law throughout his realm as a way of pleasing God. His goal was uniformity of culture, religion, and law to create a universal imperial community of faithful orthodox Christians. All the indigenous populations and cities in the empire were viewed as communities of believers subject to the emperor—the defender of orthodoxy, who ruled them with one law.

More systematically than any of his predecessors, Justinian referred to Romans, whether they lived in the city or the countryside, as subjects, not citizens. All Romans would have equal status before the law and be subservient to Justinian. Religious tests determined full participation in the state: Chalcedonian orthodoxy was required of officeholders in the bureaucracy, while heretics, pagans, and Jews were persecuted and excluded from public life to different extents. Local laws and traditions had to conform to imperial standards. No city in Justinian's empire had significant laws of its own by the end of the sixth century.

Justinian strengthened imperial control of cities by reducing the financial and administrative autonomy of

the city councils. Imperial officials were assigned to each city to oversee tax collection by the city senates. The real rulers of cities were no longer the aristocratic elite who had filled the city senates for centuries. Now city rulers were simply men of influence—bishops, imperial officials, or other "notables" whose primary allegiance was not to the cities but to imperial service, the new source of honor and prestige.[10]

Instead of an empire comprising a honeycomb of cities and their hinterlands with local laws and customs, as had been the case under Augustus, there stood one empire that claimed to be defined by a common orthodox faith. At its center was Constantinople, the New Rome, which claimed to be the image of the divine realm on earth. However, as a center of Monophysite opposition to Constantinople, Antioch and its Christian citizens and clergy rejected the Chalcedonian orthodoxy advocated by Justinian.

A series of staggering disasters began to hit Antioch in Justinian's reign. Earthquakes leveled parts of the city in 526 and 528. The next year a confederation of Arab tribes besieged the city. Justinian had weakened the eastern defenses of the empire by sending the bulk of Roman troops usually stationed in Syria to aid in the reconquest of Italy, and in the early summer of 540 the Persians captured, pillaged, and burned Antioch. The amount of loot taken back to Persia was enormous, and many of Antioch's citizens were resettled in a town near the Persian capital. Justinian spent great sums on rebuilding the city, but on a smaller scale. Just as Antioch began to recover,

an even worse enemy struck: the bubonic plague. Originating in Ethiopia, the plague swept through the empire and into western Europe, killing many millions. Antioch lost perhaps half of her population. There were recurrent outbreaks for decades. Four severe earthquakes occurred between 551 and 578, and then in 606 and 607 Persian forces overran Syria, during which time Antioch may have been sacked again.

The ambitious general Herakleios (610–41 C.E.) devoted his reign to a life-and-death struggle with Persia in which he was ultimately victorious. Antioch suffered greatly in the conflict. In the spring of 611 Persian troops occupied Antioch and stayed there until Herakleios triumphed over Persia in 628. Evidence for the Persian occupation is very thin, but it is recorded that the Persians plundered all the church gold and forced the Christians of Antioch, who were Monophysites, to become Nestorians, a form of Christianity popular in Persia.[11] After his victory Herakleios, like Justinian, attempted to find some compromise between the Monophysites in Antioch and the orthodox believers in the rest of his realm, but he too was unsuccessful. Antioch served as Herakleios's headquarters in his defense against the Muslim Arab invaders, but after the battle of the Yarmuk River in 636, when it became clear that Syria was a lost cause, Herakleios abandoned Antioch to its fate. When Arab troops reached the city they met little resistance. The troops of Islam established a garrison, and the story of Roman Antioch came to an end.

1. This essay draws freely upon a number of studies. The following works are fundamental: Downey 1961, 1962, 1963; Bowersock 1994; Jones 1940, 1964, 1971; Liebeschuetz 1972, 1992.

Detailed essays in the Cambridge Ancient History series provide significant reevaluations of relevant material. The following chapters were most useful: Gruen 1996, Bowman 1996, Kennedy 1996, Ward-Perkins 1998, Isaac 1998, Fowden 1998, Brown 1998, and Brock 1998.

For the Roman Near East, Heather 1994 and Millar 1993 are necessary starting points. For issues of Christianity, I consulted Markus 1990 and Harvey 1990; on Jews in Roman legislation, Linder 1987; and on citizenship and political identity, Chrysos 1996; Galsterer 1986; Greatrex 2000; Roueché 1998; Thurman 1970; and esp. Sherwin-White 1972, 1973. Specific references are cited in the notes below.

2. Bowersock 1994, 147.
3. Ibid.
4. Downey 1959.
5. Galsterer 1986, 23–27.
6. Kennedy 1996, 724.
7. Brown 1992, 105–6.
8. Bowersock 1990, 39.
9. On the legislation against the Jews, see Linder 1987; and Wilken 1983.
10. Liebeschuetz 1992, 29–30; Whittow 1990; Jones 1964, 757–66; Roueché 1998.
11. Theophanes 1963, a.m. 6116; Mango, Scott, and Greatrex 1997, 445. See also Downey 1961, 575.

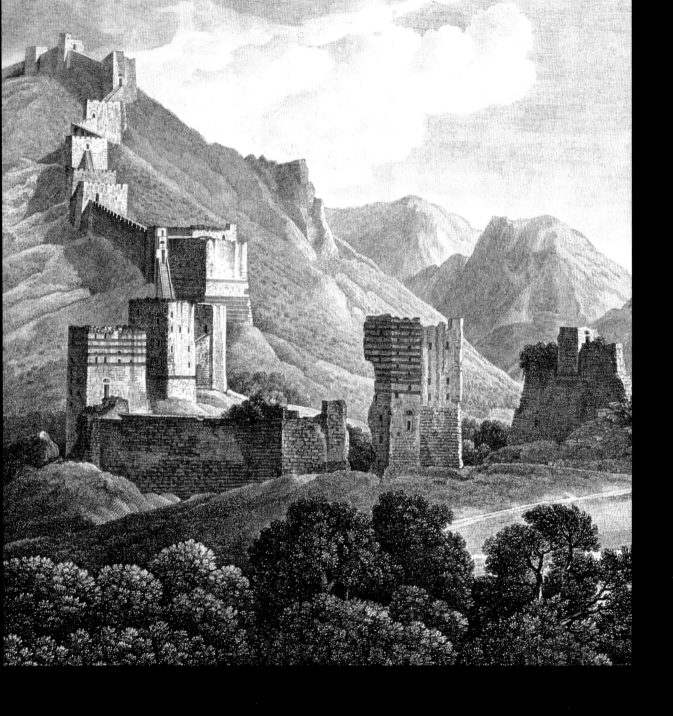

Late Antique Antioch

Clive Foss

At the beginning of the sixth century Antioch was a thriving metropolis, one of the three greatest cities of the eastern Empire. Its extensive territory was filled with prosperous villages, while the city shared northern Syria with other large cities, among which the most impressive was Apamea. By the end of the century the whole picture had changed: Antioch and Apamea were in ruins, and the overpopulated villages were stagnating.[1] This dismal transformation was the result of a series of unparalleled catastrophes that reduced the metropolis to a wrecked and impoverished shadow of its recent glory. Although history and archaeology present many of these disasters only in bare outline, two were described in detail that reveals the tremendous destruction they caused.

Troubles began in October 525, when a fire so devastated the central parts of the city that the government sent two hundred pounds of gold for relief. This was only a prelude to the greatest blow. On 29 May 526, when crowds of pilgrims had arrived to celebrate Ascension, a violent earthquake struck during the evening meal, catching most of the people indoors. The greatest part of the city was destroyed in the convulsion and succeeding fires. The Great Church of Constantine stood amid the rubble for a few days before it too collapsed. The suburb of Daphne and the port of Seleucia were also ruined. Altogether, 250,000 are said to have perished. The widespread looting that followed the disaster only added to the tribulations of the local people. Although the government rushed in with emergency aid of three thousand pounds of gold, especially for the necessary infrastructure—water supply, baths, bridges, and churches—Antioch never recovered, and from this time many people began to leave the city for good.

Reconstruction had hardly begun when another quake hit on 29 November 528, ruining whatever had been left standing, as well as the repairs that had begun, and claiming some five thousand victims. The following severe winter made life even harder. Once again the government sent massive aid, along with remission of taxes for three years. The worried population now officially changed the name of the city to Theopolis, "City of God," in an effort to secure badly needed divine protection.

The same year saw the beginning of the long intermittent war with the Persians that was to plague the Roman East. As its first sign, a band of Arabs ravaged the suburbs of Antioch in March 529, and, more ominously, the Persian king Kavad planned an attack on the city in

531. His Arab ally, al-Mundhir, described a suitable route he had learned from his spies and reported that Antioch was virtually unguarded. It would be especially easy to capture because its unsuspecting citizens cared only for luxury, festivals, and races (Procop. *Wars* 1.17.36–38). As it turned out, this plan was checked, but the idea remained. For the next years, though, the district was secure, so that rebuilding could proceed, with the cathedral rising from its ruins in 538.

Archaeology provides a fleeting view of the damage and restorations, less substantial than might be hoped because the site has long since been buried in several feet of silt and now is covered by a modern city. Excavations reveal that a large bath below the acropolis was destroyed by the earthquakes and was finally restored in 538; however, the new edifice was built on a smaller scale than the original, for several rooms were left in ruins. Similarly, buildings on the island in the Orontes, including a palace, a hippodrome, and colonnaded streets, were severely damaged and hardly repaired at all. The main streets of the city, however, were restored after the earthquakes: a new pavement was laid, and the colonnades and shops were rebuilt.

The work was all in vain. In the spring of 540 King Chosroes of Persia violated the "endless peace" he had recently concluded with Justinian and led a massive army in a lightning strike across the Syrian frontier. This was the ideal moment for attack since the emperor was deeply involved in the reconquest of Italy. After capturing and destroying the fortified border town of Sura, Chosroes advanced into the heart of Syria. He held Hierapolis to ransom, then approached Beroea (Aleppo), destroying the city but allowing the citizens to leave. Many of the garrisons, long unpaid by the imperial authorities, deserted to join Chosroes. The Persian army now crossed the limestone hills toward Antioch. Chosroes had earlier sent a messenger to demand a huge ransom as the price of sparing the city, but the emperor's emissary forbade the locals to pay anything. The king therefore determined to attack. As he approached the city, many of the rich departed, taking their money with them. Others would have followed had not an imperial force arrived to give them hope of resistance.

Chosroes, camped on the banks of the Orontes, offered the citizens one last chance to escape attack by paying him one thousand pounds of gold. When they replied with insults, he decided on severe punishment.

His army attacked the wall at a vulnerable point, temporarily strengthened by the defenders with a large wooden platform built onto the wall. When it collapsed, the Roman troops rushed back into the city, causing tremendous panic among the population. Chosroes at first feared a trap, not believing his luck in capturing "the first of all the Roman cities in the East, in wealth, size, population, beauty, and prosperity" (Procop. *Wars* 2.8.23). He let many flee through the Daphne gate before sending his forces into the center of the city, where they met serious resistance from the young men of the circus factions, racing organizations that also served a political role in promoting and defending Roman imperial power. The Persians, though, pushed forward, massacring everyone they met. Chosroes enslaved the rest of the population, looted the churches (which were vast stores of wealth) and everything else, and ordered the city burned to the ground. The cathedral was left standing amid the ruins, and many houses in outlying districts escaped destruction, but most of the city was destroyed and depopulated. It was an unparalleled calamity.

From Antioch, Chosroes went down to the coast and, in a gesture symbolic of his far-reaching conquests, bathed in the Mediterranean, then proceeded to Apamea, where he collected a huge ransom and visited the city, next to Chalcis, which also paid up, and then across the Euphrates to the great stronghold of Edessa. All the while the captives from Antioch were following in his train. At Edessa he proposed to sell them. Although the people of Edessa contributed generously, the imperial general would not allow them to hand over the money. The captives were constrained to follow the Persian army into Mesopotamia, where Chosroes built a city for them one day's journey from Ctesiphon, his capital, and named it Antioch of Chosroes. He provided the Antiochenes with baths, a hippodrome, entertainments, and special privileges. They were subject to him directly, and anyone who succeeded in escaping Roman captivity would be given sanctuary there (Procop. *Wars* 2.5–14; on Antioch, 2.8–10).

Justinian refused to abandon the now devastated, empty city. After the Persians withdrew the imperial government undertook a complete reconstruction, paying special attention to defenses and infrastructure (Procop. *Buildings* 2.10). The walls were rebuilt along a new trace contracted from the large area they formerly enclosed and following the Orontes, which was directed into a new course. Cisterns were built into the towers of the acropolis,

where baths and reservoirs were added. New bridges spanned the Orontes. Justinian also dealt with the ravages of nature. A massive dam constructed in the neighboring hills helped to solve one of Antioch's greatest perennial problems, the overwhelming runoff from the spring rains, which brought masses of debris from the heights into the center of the city. In later centuries, under less activist regimes, the runoff has continued on an enormous scale, burying most of ancient Antioch under many feet of silt.

The Persian attack had virtually converted the city into heaps of rubble, piled in such confusion that people could no longer recognize the sites of their own houses. Colonnades and marketplaces had collapsed; even the street pattern could no longer be discerned. The government brought in teams of artisans and craftsmen to undertake a complete reconstruction. They cleared the land, covering it with massive stones. A new network of colonnaded streets rose, with marketplaces, aqueducts, fountains, and drains, for the water supply was always a primary concern. Theaters, baths, and residential districts stood again, as did a new cathedral, other churches, and charitable institutions. In other words, Justinian made an enormous effort to restore the city to its ancient glory.

Archaeology confirms both the extent of the devastation and Justinian's ambitious repairs. Excavations of the main colonnaded street revealed a completely new street built above the ruins of the old, which disappeared as its paving was removed and its course covered with rubble. This formed the base for a new paving of regular blocks of basalt. A new sidewalk with drainage below abutted new colonnades adorned with cut marble laid over the old mosaics. The reconstructed street was narrower than the old one but was still a monumental eighty-five feet wide. Elsewhere a circular plaza was restored with a new paving.

Antioch stood again, perhaps less grand than before but with a substantial population devoted to the rivalries of church and chariot races. Yet the rest of the century offered only constant tribulations that left even the reduced Antioch in ever-deteriorating condition. The bare record speaks for itself. Only two years after the Persians the bubonic plague arrived, in 542. Although no figures are available, there is no doubt that it decimated the urban population. It recurred four times in the next decades. There were earthquakes in 553, 557, and 588. The last of these, which was the worst, caused widespread loss of life and destroyed whole districts, including baths, the walls, and the cathedral, whose dome somehow remained

standing. By 573 the Persians had reappeared, still led by the same Chosroes. This time the inhabitants fled because the walls were in ruins—presumably as a result of one of the earthquakes—and the Persians burned the suburbs.

By the end of the century the countryside had also suffered: in 553 a plague killed all the cattle, in 599 a drought finished off the olive trees, and the next year an infestation of weevils ruined the crops. When the Persians returned in 610 to conquer Antioch and the whole Near East, they found a country already devastated by man and especially nature.

Before these disasters, though, city and country had flourished together. One source of Antioch's great prosperity was the extensive territory it controlled, stretching about sixty-two miles from east to west and a comparable distance from north to south. It comprised a fertile plain around a marshy lake northeast of the city and an extensive hill district between the city and Beroea that stretched south toward Apamea. Although the plain probably contained the best agricultural land, its continuous occupation has obscured remains of this period. The hills, on the other hand, are extremely well known as a remarkable example of a highly developed district covered with a network of villages that reached their greatest prosperity in late antiquity.

These hills, which consist of several seemingly barren limestone ranges, rise more than twenty-six hundred feet above the plain.[2] They are not inaccessible mountains suitable for refuge but comprise a remote area reached only by paths suitable for pedestrians or beasts of burden; the Roman highways skirted them altogether. Lack of water defined the hill country as a marginal area, to be settled after the plains. The limestone was porous, there were no lakes or streams, and all water had to be stored in cisterns. Yet the hills were relatively safe from attack and offered suitable soil for growing olives and fruit and for raising some livestock.

The most spectacular evidence of the wealth of late antique Antioch includes not only the city's mosaics but also the elegant solid stone villages of the hills. Some seven hundred of them have been identified, some on the adjacent territory of Apamea, ranging in size from a few houses to a few hundred. Spaced two to three miles apart, the villages form a tight network; each has a clearly demarcated territory and stone walls that mark out the fields. The fields were used primarily for growing olives, whose fruit was crushed in the olive presses that surround

many of the villages. In addition, the villagers grew fruit and raised livestock. Profits from these crops generated the surplus that is still visible, immobilized in stone.

Each village contains a large number of carefully built and elegantly decorated stone houses, most of three or four rooms in two stories with verandas overlooking a central courtyard. They vary in size from one to thirteen rooms, but all follow a similar plan. The houses are so finely built that the first descriptions portrayed them as the abode of a sophisticated aristocracy, an idea strengthened by the presence of impressive and richly adorned churches. Subsequent research, though, has shown beyond a doubt that these were the homes of peasants.[3] The verandas surveyed not formal gardens but courts used for domestic activities and the animals who occupied the ground floor, while their owners slept upstairs. The houses contained no baths or latrines, only undifferentiated rooms. Likewise, the villages had no urban aspect: virtually every structure was a house, church, or, less often, a defensive tower. In the whole region there are no public buildings and only five baths. Nevertheless, the ensemble is one of the most impressive in the entire Roman world.

Archaeological and architectural studies have produced an outline of the history of this region and confirm the impression of its wealth. The whole district grew in late antiquity, reaching a peak in terms of construction in the late fifth century. Activity continued until about 550, when the area was more densely populated than ever before, yet not at the expense of wealth: the new construction was of even higher quality than the old. It seems that the country generated a sufficient surplus to support a large population living in finely constructed houses.

These rustic people could also afford to build large and sophisticated churches and to store their wealth in the form of silver plate for church use. A remarkable treasure from Kaper Koraon, an obscure village of Antioch, illustrates this aspect with some fifty-six silver objects of all kinds. Inscriptions show that the treasure was accumulated in the century after 540, that is, after the Persian attack that looted much of Syria. Some of the silver presumably replaced objects lost then, while others were dedicated after the second Persian invasion, in 573; accumulation continued until the mid-seventh century, around the time of the Arab conquest.

If the silver shows continuing prosperity, the villages themselves had reached their peak by the sixth century. The decades after 550 were marked by a stagnation in which only churches received repairs or additions, while the number of houses remained constant. Apparently, the hills had all the people they could support, or there were no resources available for further construction. The last dated activity is of 610, the year the region fell to the Persians. Although the villages continued to be inhabited for a long time, archaeology indicates that they entered a period of slow deterioration. The specific archaeological evidence comes from an undistinguished village called Dehes, in the hills east of Antioch.[5] Excavations here have shown that the place reached the height of its development in the sixth century. At that time it was using a great deal of pottery, mostly cooking ware. That is not as remarkable as the coin finds, which show that the village was on a money economy and therefore connected with the outside world. Although coins continued to circulate, the physical condition of the houses began to deteriorate seriously in the seventh century. Thereafter, decline replaced stagnation as the houses became ever more dilapidated and squalid, at a time when the cities were undergoing similar changes.

The countryside of Antioch reflects the vicissitudes of the metropolis, and of its neighbor Apamea. Apamea flourished and had a happier time than Antioch in the reign of Justinian. It was the home of an exceptionally rich aristocracy that lived in huge mansions and patronized the construction of large churches in the most advanced architectural styles. Apart from local earthquakes and fires, Apamea prospered until 573, when it shared the fate of Antioch. Chosroes attacked, looted, and devastated the city. It, too, was burned and never really recovered. Despite a valiant attempt at restoration, Apamea was only a poor remnant of its former self in the early seventh century, when the Persians returned, soon to be followed by the Arabs. The sufferings of these neighboring cities, which between them controlled the whole hill country, are reflected in the fate of the villages. Like the cities, the villages prospered in the first part of the sixth century, then entered a period of stagnation that eventually led to an irreversible decline. By the early seventh century an ancient way of life in this part of Syria was at an end, soon to yield to a completely different age.

1. For the historical record, see the detailed survey in Downey 1961, 520–71, on which the following remarks are based. The archaeology is discussed in Foss 1997.

2. On this region and its villages, see Tate 1992.

3. For changing views of this region, see Foss 1995 or, more briefly, Foss 1996.

4. See Mango 1986.

5. See Sodini 1980.

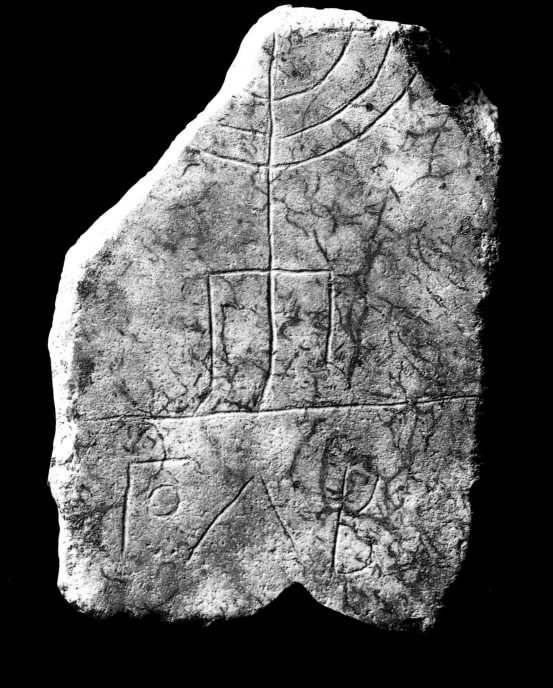

The Jews
of Ancient Antioch

Bernadette J. Brooten

Jews participated in the founding of Antioch in 300 B.C.E.
and may have been among the native Syrian population
present in the region before that. In Hellenistic and
Roman times, the peak periods of Antioch's prosperity
and political centrality, Jews belonged to all social and
economic classes, from the educated Greek elite through
Greek-speaking or bilingual (Greek/Aramaic) artisans and
farmers and down to the very poor. Although their for-
tunes waxed and waned during these periods, Antiochene
Jews were able to maintain a strong presence in the city
and its environs. The demise of the Jews began under the
Christian Roman emperors, who promulgated more
restrictive legislation than their predecessors, so that by
the time of Benjamin of Tudela, a twelfth-century Jewish
traveler, only ten Jewish families still lived in Antioch
(*Itinerary* 26). To be sure, earthquakes and Arab and Per-
sian invasions had contributed to Antioch's overall
decline; nevertheless, the demise of this particularly pros-
perous and well-integrated Jewish community is striking.

During Antioch's peak periods various ethnic and
religious groups commingled in the city and maintained
close ties with members of their groups even beyond the
boundaries of the realm. Educated Jews who spoke Greek
would have had contact with their counterparts in
Jerusalem, Sardis, Alexandria, and Rome. Jews who spoke
Aramaic and were trained in the Jewish law had close ties
with the rabbis of ancient Babylonia, Galilee, and Judaea.
Antioch provides an excellent example of a Diaspora Jew-
ish community that probably had strong rabbinic influ-
ence. Scholars often look to Rabbinic Judaism (e.g., the
Mishnah or the Babylonian Talmud) in order to fill in
the considerable gaps in our knowledge of the Jewish
communities of Asia Minor, Italy, or Egypt. Antioch,
however, does offer a case of a rabbinically influenced
community. In contrast, the communities of Sardis,
Rome, and Alexandria seem to have functioned more
independently of rabbinic authority.

Present political circumstances hinder people of
today from even imagining the fluid boundaries around
ancient Antioch. Today's borders separating Syria,
Lebanon, Israel, and the Palestine National Authority are
potentially and intermittently dangerous, which makes it
difficult to imagine that the ancient eastern Mediter-
ranean could have been different. But there are many
indications that it was.

Peter, the Galilean-Jewish disciple of Jesus, and later
the Jewish-Christian apostle Paul both made their way to

Antioch, where they sometimes collaborated and sometimes clashed over Jewish dietary laws. Rabbis came from Palestine, and pagan Antiochene intellectuals had contact with Palestinian rabbis. Jewish leaders in Antioch had their remains reinterred in Galilee. All of this occurred within the context of a lively east-west traffic that included Jews from the East and perhaps from Rome and other parts of the West, as one extraordinary case demonstrates. During the governorship of Saturninus (9–6 B.C.E.) a Babylonian Jew named Zamaris came to Antioch with five hundred armed horsemen and one hundred men who were relatives, along with women and children. He settled in Ulatha, probably the "Hulath" mentioned in the Talmud as an area in which Jewish farmers raised rice. Herod the Great later offered Zamaris a tax exemption if he would move into his kingdom, where Zamaris built a fortress and a village (Josephus *AJ* 17.23–31). This case provokes speculation about the east-west traffic of less wealthy Jews, and it also provides evidence that Aramaic-speaking Jews living outside Antioch's city walls were not necessarily poorer than the Greek-speaking Jews within them.

Jews were well integrated into the life of Antioch from the very beginning. Jewish mercenaries who had fought under Alexander the Great's general Seleukos were rewarded with land in the Hellenistic city named after Seleukos's father in 300 B.C.E. In later centuries Jews stratified Antioch's social and economic classes. In the countryside around Antioch Jewish peasants, perhaps Aramaic-speaking, grew rice and worked the land for wealthy estate owners. Within the city Jewish artisans crafted silver, gold, leather, and textiles. Wealthy Jews, some in the elegant suburb of Daphne, ran large households, provided an elite Greek education to their sons and perhaps sometimes also to their daughters, and associated with other elite families.

Flavius Josephus, a first-century Jewish historian, writes that many Greeks in Antioch were attracted to Jewish worship. In the fourth century the Christian preacher John of Antioch, known as Chrysostom ("golden-mouthed") because of his tremendous rhetorical abilities, railed against Christians' going to the synagogues and participating in Jewish festival celebrations. In an effort to dissuade his congregants from going to the synagogues, Chrysostom argued against the Jewish view that the Bible sanctifies the synagogue. He claimed that the Jews were Christ-killers and that their demon-infested synagogues were as impure as pagan temples. His main goal was to keep his Greek-speaking congregation away from the synagogue services that they found so meaningful.

Ancient Antiochene Jews were neither ghettoized nor apparently assimilated at the cost of their Jewish tradition. Middle- and upper-strata urban Jews navigated their way smoothly through Greek culture while maintaining their ethnic and religious particularity. Sometimes, however, non-Jewish Antiochenes were repelled and angered by their Jewish neighbors. In the wake of the First Jewish Revolt against the Romans (66–73 C.E), non-Jewish Antiochenes appealed to the emperor Titus to rid the city of Jews, but Titus, under whose direction the Roman army had destroyed the Jewish Temple in Jerusalem and killed thousands of Jews there, did not respond to their request.

History of the Jewish Community in Antioch

Seleukos I Nikator, a general under Alexander the Great, founded Antioch in 300 B.C.E. as part of a strategy to settle Greeks and Macedonians where they could help to ensure his military control. Jewish mercenary soldiers who had served under Seleukos I were apparently among those who received the right to settle in Antioch. According to the first-century C.E. Jewish historian Flavius Josephus, Seleukos had granted Jews the same rights as those granted to Macedonians and Greeks, that is, full citizenship (*AJ* 12.119; *Ap.* 2.39), but Josephus, in an attempt to improve the situation of Jews in his own time, may have distorted the past.[1] In addition to retired soldiers, there may have been Jews among the slave population brought into Antioch, and there were almost certainly Jews among the native Syrians. The Greeks and Macedonians occupied a quarter protected by city walls, while the indigenous population lived in another quarter, perhaps outside the walls. The Jews lived in the southeastern corner of the city, outside Seleukos I's walls but inside the walls of Tiberius and later those of Justinian.[2]

Antiochos IV Epiphanes (175–163 B.C.E.) saw unified religious practice within his realm, especially the worship of Olympian Zeus, as essential for promoting his Hellenistic, universalistic ideal: "All should be one people . . . all should give up their particular customs" (1 Macc. 1:41–42). Jewish nonparticipation in the cultic activities required of other subjects impeded Antiochos's goal. The conflict escalated in Judaea (which had been under Syrian Seleucid rule since 200 B.C.E.), where Antiochos attacked the Jewish Temple in Jerusalem in 169 B.C.E.,

carrying its sacred treasures off to Antioch (1 Macc. 1:20–24). After this first assault, Antiochos rededicated the Jewish Temple to Olympian Zeus. In 167 B.C.E., when Antiochos ravaged Jerusalem and established a military garrison there, Judaean nationalists under the direction of Judas Maccabaeus and his brothers (centered in Modein, northwest of Jerusalem) led a successful revolt against Antiochos, ushering in the Hasmonean dynasty (165–64 B.C.E.). Although we do not know precisely how Antiochos IV's actions and the Maccabean Revolt affected the Jews of Antioch, there must have been some tensions. Antiochos's successors restored to Antiochene Jewry temple treasures made of brass to be placed in their synagogue (Josephus *BJ* 7.44; Josephus does not mention the return of gold and silver objects). This gesture demonstrates that the Seleucids viewed Antiochene and Judaean Jews as closely tied.

The Syrian Seleucid ruler Demetrios II Nikator allied himself with the Judaean-Hasmonean ruler Jonathan (160–142 B.C.E.). After an extended battle between Demetrios and Alexander Balas over the Seleucid throne, Demetrios was able to establish himself, but the Antiochene populace, angered by Demetrios's ill-treatment of them, mounted an armed siege against him. Three thousand Judaean-Jewish soldiers supplied by Demetrios's ally Jonathan helped to quell the revolt, killing Antiochenes (1 Macc. 11:47 puts the number at about 100,000; see also Josephus *AJ* 13.135–43) and plundering and burning their property. Since neither the first book of Maccabees nor Josephus mentions Antiochene Jews involved on either side of the conflict, we can only speculate on whether the more Hellenized and elite Antiochene Jews sided with their fellow Antiochenes, on the position of the rural Aramaic-speaking Jews, or on whether the Judaean-Jewish soldiers' behavior caused pagan Antiochene antagonism against Antiochene Jews in subsequent years. In his report on the Judaean Jews burning and plundering Antiochene homes Josephus probably would have mentioned that this included Jewish homes, if in fact it had. Thus, his report may give further indirect evidence that Jews did not live in the areas around the palace, that is, not within the area enclosed by the original city walls of Seleukos I.

During Seleucid rule the Jews of Antioch apparently gained the right, as a group of aliens, to reside in the city, along with a certain political autonomy *(politeuma)*. This right to govern themselves and to adjudicate disputes among themselves did not, however, place them on an equal footing with Antioch's Greek citizens. Both the Seleucid and, later, the Roman rulers required citizens to carry out state religious rituals, in which only those Jews willing to transgress the Jewish law could have participated. Thus, although individual Jews may have gained full, that is, Greek, citizenship, the Jewish community as a whole never did.[3]

According to Josephus, the Jewish population grew and flourished in the years following the Hasmoneans and beyond. The Judaean ruler Herod the Great (37–4 B.C.E.) paved a long street in Antioch with polished stones and adorned it with colonnades on either side (Josephus *AJ* 16.148 and *BJ* 1.425; Malal. *Chronicle* 9.17). This was apparently a street that was outside of the city walls erected by Seleukos I but later included within the city walls erected by Tiberius. Under Tiberius, the main Jewish neighborhood was enclosed for the first time within Antioch's city walls. Indications of Antiochene Jewry's increased prosperity in the Roman period include the expensive gifts they gave to the Jerusalem Temple (Josephus *BJ* 7.45) and the collection early Jewish-Christians took up for their fellow Jewish-Christians in a famine-stricken Judaea, probably in 46 C.E. (Acts 11:27–30). This was also the period during which many non-Jewish Antiochenes who were attracted to Judaism began participating in Jewish religious services and became integrated into the Jewish community (Josephus *BJ* 7.45). The Acts of the Apostles mentions one of these Greek proselytes to Judaism, Nikolaos, who later became a Christian (Acts 6:5).[4]

The Christian historian John Malalas (*Chronicle* 10.20) records a conflict during the reign of Gaius Caligula between two circus factions, the Blues and the Greens, in which Greeks and Jews—or Judaeans—in Antioch fought against each other and many Jews were killed and their synagogues burned. Malalas presents Phineas, priest of the Jews in Palestine, as gathering together 30,000 Judaean and Galilean citizens who marched on Antioch and killed a number of people there. Since the Roman rulers would hardly have allowed such a major military attack, Malalas's whole story may be wrong. Josephus and other contemporaneous sources do not report it. But the story may have a kernel of truth, especially since tensions were high during Gaius's reign. In 39–40 C.E. Gaius ordered a statue of himself in the form of Jupiter to be placed in the Holy of Holies in the Jerusalem Temple. The Roman governor Petronius, who ruled the province from Antioch, did his best to forestall

Jewish unrest over Gaius's plan, which in the end was not carried out.[5]

During the First Jewish Revolt against Roman rule in Judaea (66–73 C.E.) tensions spilled over into Antioch and affected Jewish religious life there, as illustrated by the case of the Jewish renegade Antiochos, who may have obtained Greek citizenship within Antioch. In 66–67 Antiochos took advantage of his respected position as son of the Antiochene Jewish chief magistrate to accuse his fellow Jews of trying to burn down the city. In order to prove his lack of allegiance to Judaism and to strengthen his credibility with the assembly, Antiochos carried out an animal sacrifice according to pagan Greek customs and recommended that other Jews be forced to do the same. Some Jews submitted, but others refused and were massacred. Antiochos gained the support of the Roman military and tried to force the Jewish population to abandon such Jewish customs as Sabbath observance (Josephus *BJ* 7.46–53).

Antiochos exemplifies how, during a period of crisis, one person could throw off the Jewish population's delicate balancing act between maintaining religious practice and seeking full integration into non-Jewish society. The prominence of Antiochos's family enabled him to enter the theater and address the assembly meeting there. One can imagine that Antiochos's father had provided his son with the excellent Greek education necessary to give a proper speech before an assembly of rhetorically trained persons. Undoubtedly the family lived in an elegant house with expensive mosaics, like those excavated in the 1930s. Did the decorations within the magistrate's house include pagan motifs or other representations that transgressed against the biblical prohibition of images?

When a great fire actually did break out at Antioch in 70–71, the non-Jewish Antiochenes were ready to believe Antiochos's charge that Jewish arsonists were responsible. Though Roman officials succeeded in restraining their fury and, after an investigation were able to demonstrate that non-Jewish debtors had set the fire to destroy the public records of their debts (Josephus *BJ* 7.54–62), the atmosphere of hostilities engendered by the Jewish revolt in Jerusalem did little to quell anti-Semitic feelings in Antioch. Josephus reports that after the Romans had put down the revolt and destroyed Jerusalem, non-Jewish Antiochenes pleaded with the triumphant military commander Titus to banish Jews from Antioch. But Titus refused the petitioners for reasons of justice (Antioch's Jews had been exonerated from all arson charges) and

practicality (with Jerusalem destroyed, there really was nowhere they could be sent). They then asked that he revoke certain Jewish privileges, which he likewise refused (*BJ* 7.110–11). These privileges included the right to collect money to be sent to Palestine, to abstain from the pagan religious rituals connected with the cult of the Roman emperor, and to obtain their own oil (to avoid oil produced by gentiles).

After the Jews' military defeat in Palestine their status in Antioch suffered. The Romans sought to humiliate them by sharing spoils of the Jewish war with the Antiochene populace, which included placing bronze figures that supposedly were the Cherubim from the Jerusalem Temple at the southwestern city gate, near the homes of Jews.[6] The Romans imposed a special tax on Jews (*fiscus iudaicus*) after the Jewish war, and the emperor Hadrian's (117–38 C.E.) prohibition of circumcision (along with castration, both of which the Romans considered barbaric) also would have lowered the status of Jews in Antioch. Little is known about Antioch's Jewish community during the next two centuries, although the rabbinic literature and the inscriptions cited below show that Jews continued to remain a presence there.

At the onset of the Christian Roman Empire, in the fourth century, the Jews of Antioch retained their traditional privileges and status, but with increasing Christianization they gradually lost ground. Previously, with the principal exceptions of Antiochos IV Epiphanes and Gaius Caligula, the Jews had been able to maintain their customs and avoid a ruler cult that clashed with the Jewish law. Christian Roman emperors, however, presented a more formidable challenge, for an increasingly Christian populace accustomed to an imperial cult responded to Christian emperors in a way that Jews could not. And as Antioch became a center of Christian theology, the pressure to conform dogmatically increased, and common ground between Jews and Christians was lost. For example, the Council of Nicaea in 325 C.E. prohibited Christians from calculating the date of Easter from the Jewish Passover Festival, and the Synod of Antioch in 341 reiterated the prohibition. The emperor Julian's (361–63 C.E.) attempt to rebuild the Jewish Temple in Jerusalem met with the support of Antiochene Jews who were ready to resume blood sacrifice in a rebuilt temple, but his attempt failed, and his reign was short.[7]

The legislation of the Christian Roman emperors is ambivalent toward Jews, both opposing the Christian

destruction of synagogues and prohibiting conversion to Judaism. An early-fifth-century law prohibited Jews from mocking Christianity on Purim by crucifying Hamman's effigy on a cross. This law is possibly related to the charge raised against Jews, in a town near Antioch in 415 or 416 C.E., that they had mocked the crucifixion of Jesus by hanging a Christian boy from a piece of wood and killing him.[8]

Libanios, the leading pagan intellectual in the fourth-century Mediterranean world, reports on a legal conflict with the Jewish tenant farmers who had been in his family's employ for four generations. Libanios claims that these farmers were trying to alter their working conditions. When he took them to court, the Jewish farmers sought the help of a military patron and eventually won (*Or.* 47.13–16). These farmers may have been native speakers of Aramaic whose ancestors had lived on the outskirts of Antioch with the native Syrian population, but we cannot know for certain.

Synagogues, Worship, Theology, and Community Life

The synagogues of ancient Antioch and its environs probably reflected the diversity of the Jewish community. The major synagogue in Daphne, the Matrona Synagogue, must have been elegant and richly decorated to serve the wealthy inhabitants of this lush garden suburb of Antioch, whereas the synagogues of Jewish artisans and peasants were most likely much simpler. The Princeton excavations at Antioch did not reveal any remains of synagogues, but future excavations may well do so. John Chrysostom mentions a Jewish synagogue in Antioch, as well as the synagogue in Daphne (*Against Judaizing Christians* 1.6). Perhaps the Greek-speaking Chrysostom mentions only these two synagogues because the Aramaic-speaking synagogues were beyond his cultural orbit.

The remains of other Syrian synagogues can help us to imagine how the synagogues of Antioch may have looked. The lovely, richly colored wall paintings in a third-century C.E. synagogue at Dura-Europos, which lay to the east on the border between the Roman and the Persian Empires, depict human figures, some in Greek and some in Persian clothing. A fourth-century C.E. synagogue mosaic found in Apamea, south of Antioch on the Orontes River, includes a number of donative inscriptions and geometric designs. At Misis (ancient Mopsues-

tia, near modern Adana) excavators have uncovered ornate mosaics, one representing Noah's ark and another a cycle depicting the biblical Samson, in what may have been a synagogue basilica.[9]

We know the names of two Antiochene synagogues, the Matrona in Daphne and the Ashmunit in the southeastern quarter of Antioch, outside the original walls of Antioch but inside the later ones. The scholarly debate over the Synagogue of Ashmunit illustrates the challenges in understanding the Jewish history of Antioch. An early medieval Arabic description of Antioch notes the presence of a "Synagogue of Ashmunit" that had become a Christian church of Saint Ashmunit and was located at the foot of Mount Silpios and toward the west (that is, in Antioch; *Arabic Vatican Codex,* no. 286). The medieval Arabic Jewish writer Ibn Shahin states that the "Synagogue of Hashmonit" was the first synagogue built after the destruction of the temple in Jerusalem in 70 C.E. (*Book of Comfort* [ed. J. Obermann], 28). The Christian church claimed that it housed the remains of Maccabean martyrs tortured to death under Antiochos IV Epiphanes for refusing to transgress the Jewish law.

Before turning to the scholarly debate, some background on the story is necessary. The famous martyrdom of a priest named Eleazar and of a mother and her seven sons at the hands of Antiochos IV probably occurred in Judaea rather than in Antioch, although some traditions, especially Christian ones, place the martyrdom in Antioch. This martyrdom is described in the Fourth Book of Maccabees, which may have been composed in Antioch.[10] The author wrote in a polished Greek and used Greek philosophy to illuminate the Jewish law. This combination of a strong Greek education with close adherence to the Jewish law may well typify those Jews of Antioch who spoke Greek. They apparently maintained close contact with their non-Jewish Greek neighbors and with Judaean Jews. The Fourth Book of Maccabees shows some striking similarities with the letters of the apostle Paul, perhaps because Paul spent time in Antioch (Acts 11:25–29), possibly as long as eight or nine years.[11] Moreover, according to the Acts of the Apostles, Paul was born in Tarsus, a city in the Cilician Plain just northwest of Antioch (Acts 9:11, 30; 21:39; 22:3).[12]

In 1931 Julian Obermann argued that the "Synagogue of Hashmonit," built soon after 70 C.E., was created as a memorial to the Maccabean martyrs, drawing upon the eulogizing of them found in the fourth book of Maccabees,

which had been written just a few decades earlier. Obermann responds to the problem that a synagogue containing human bones was a Jewish legal impossibility since priests and Nazirites would become impure through such proximity by noting that religious practice is often more complex than official religious teachings. Obermann sees the memorialization of ancient heroes, kings, and others as firmly rooted within ancient Israel. He argues that the medieval *Itinerary* of Benjamin of Tudela contains reference to a number of sepulchre synagogues, thereby documenting the ongoing practice of such memorialization in spite of biblical restrictions on contact with the dead. The Talmud's silence on a sepulchre synagogue memorializing the Maccabean martyrs represents for Obermann rabbinic suppression of a practice contrary to Jewish purity law. Christian veneration of the Maccabean martyrs would have made the early rabbis even more hesitant to mention it as Jewish. Thus, according to Obermann, we cannot view Antiochene Jewry through the lens of early rabbinic literature; we must see it as containing popular practices more diverse than the Bible or the Talmud would have us believe.[13]

In sharp contrast to Obermann's view of Antiochene Jewish practices, Leonard V. Rutgers argued in 1998 that "the Jews of Antioch never venerated the tomb of the Maccabean martyrs."[14] Instead, Rutgers believes that Antiochene Jews had a synagogue that the Christian church later took over, bringing bones that they had collected and that they designated as the bones of the priest Eleazar, the valiant mother, and the seven sons. According to Rutgers, the Jews would not have worshiped in a synagogue built over a sepulchre because the bones would have made priests and Levites impure. Rutgers sees no reason to assume that Antiochene Jews had radically different notions of purity than other Jews of the time. He examines early Christian interpretations of the martyrdom account, noting that Christians found in these Hasmonean martyrs a model of steadfast piety, even though they were steadfast to the Jewish law and not to the church. Augustine saw these Jewish martyrs as prefiguring early Christian martyrs (*Serm.* 300). In contrast, ancient Jewish sources exhibit little comparable interest in the Maccabean martyrs, and if there had been such an interest in Antioch, we would have expected Chrysostom to mention Judaizing Christians celebrating Hanukah with Jews since Chrysostom was very explicit in his opposition to their celebration of other Jewish holidays. Further, the

Jewish practice was to bury persons outside the city rather than within it, and excavators have never discovered an ancient synagogue built over a grave. Thus, for Rutgers, the Church of Saint Ashmunit provides no evidence for an Antiochene Jewish cult of the Maccabean martyrs. This debate shows that scholars have much to untangle before we can understand Antiochene Jewry on its own terms.

Ancient inscriptions give us yet another angle from which to view the Jews of ancient Antioch. Unfortunately, only one Jewish inscription has been found to date in Antioch. The small marble stone is inscribed with a menorah and contains the Greek letters ΓΟΛΒ (GOLB), which do not make sense in Greek (see p. 28). They could represent an Aramaic or Hebrew proper name or a word designating a person's trade, such as *barber* or *sculptor*.[15]

Inscriptions mentioning Antiochene Jews found in other locations provide valuable evidence on the organization and religious priorities of the Jewish leadership of Antioch in late antiquity. The Jewish leadership of Antioch probably comprised a governing council, headed by a chief magistrate (Gr., *gerousiarchēs*), with representatives from the various synagogues. Aidesios, head of the Jewish governing council in Antioch, had purchased a burial chamber in the necropolis of Beth She'arim in Galilee, and he and his family were buried there, or rather, their bones were reburied there.[16] According to an early rabbinic teaching, being buried in the Land of Israel was like being buried beneath the altar of the Jerusalem Temple (Tosefta, *'Avoda Zarah* 4:3). The tomb of Aidesios and his family provides material evidence for the Land of Israel's religious importance to Antioch's Jews. Beth She'arim's particular significance lay in the fact that Rabbi Judah the Prince (Rabbi Yehuda Ha-Nasi) worked on editing the Mishnah (the first major collection of rabbinic legal teachings), presided at the Sanhedrin, and was buried at Beth She'arim.[17] This may further explain why Aidesios and his family, along with heads of synagogues from Beirut, Sidon, and Tyre, as well as many rabbis, were buried there. The cost of transporting the bones to Galilee and reinterring them would have limited burial at Beth She'arim to prosperous persons in the Diaspora and probably increased its prestige.

A funerary inscription from Tiberias in Galilee further illustrates the close connections between Antioch and regions to the south: "[Here lies] Leontina / [daughter of Sam]uel the chi[ef magistrate (*gerousiarchēs*)

/ wife of] Thaumasios [leadership title] / of the Antioch[enes] / seventy [years]."[18] Leontina probably lived in Antioch with her husband, Thaumasios, when he was a Jewish official there. We can only speculate on whether Leontina was born in Tiberias, where her father, Samuel, had been a Jewish official and to which she had returned to spend her last years with relatives. Since seventy was an unusually old age, she probably outlived her husband.

Donative inscriptions found in a synagogue in Apamea show Antiochene religious leaders demonstrating their largesse. Perhaps Jews, like others living in the patron-client social system of the Roman world, expected their wealthier neighbors to share their wealth through institutional benefactions. The mosaic pavement of this synagogue included a donative inscription that demarcated the precise portion each donor had contributed. The number of female donors in this synagogue is notable.[19] The Antiochene Ilasios, who made the substantial contribution of the mosaic entryway, is commemorated in two inscriptions:

At the time of the most honored heads of the synagogue Eusebios and Nemios and Phineos, and of chief magistrate [gerousiarchēs] Theodoros, and of the most honored elders Eisakios and Saoulos and the rest, Ilasios, head of the synagogue of the Antiochenes, donated the mosaic entryway, 150 feet, in the year 703, the seventh of Aydynaios [7 January 391 C.E.]. Blessing on all.

Ilasios, son of Eisakios, head of the synagogue of the Antiochenes, for the salvation of Photion his wife and his children, and for the salvation of Eustathia his mother-in-law, and in memory of Eisakios and Edesios and Hesychios, his ancestors, donated the mosaic entryway. Peace and mercy on all your holy people.[20]

We can discern in these inscriptions both the collaboration of Jewish communities and the collaborative character of Jewish synagogue leadership. More than one officeholder, including more than one head of a synagogue, could serve at the same time.

Jewish liturgical life in ancient Antioch and the vicinity must have been both varied and vibrant. Perhaps more than in any other Diaspora city, Jews in Antioch seem to have maintained Jewish tradition while being fully integrated into the city and attracting non-Jews to their worship services. Flavius Josephus writes that the Antiochene Jews "were constantly attracting to their religious ceremonies multitudes of Greeks, and these they had in some measure incorporated with themselves" (*BJ* [trans. H. St. J. Thackeray] 7.45). In the fourth century John Chrysostom bitterly attacked members of his congregation who attended Sabbath synagogue services, fasted with Jews on Yom Kippur, went to watch the ceremonial ram's horn (shofar) being blown on Rosh Hashanah, and helped to erect the outdoor huts in which Jews eat during the festival of Sukkoth. Since some of the Christians attending Jewish services were freeborn women and slaves, John counseled the Christian husband and slaveowner to assume his proper role as master of his wife and of his slaves, keeping them at home and disallowing their attendance in synagogues or the theater *(Against Judaizing Christians)*. The attractiveness of Jewish worship services seems to have been long-lived; Chrysostom's vehemence shows that he was quite at a loss how to keep his Christian congregants from participating in Jewish worship.

Although there are no direct sources for Greek-speaking Jewish liturgical traditions in Antioch, there may be some indirect ones. Many scholars believe that the *Apostolic Constitutions*, a fourth-century Syrian Christian writing, contains synagogal prayers that early Christians had slightly altered and then adopted into their own worship services, which further attests to close contact between Christians and Jews. Those reciting these Greek prayers praised, thanked, and appealed to God in a manner reminiscent of Hebrew prayers, but they also spoke of natural law, a concept popular among Stoic philosophers and among educated people generally. One prayer thanks God, who, when humans "had corrupted the natural law," gave through Moses "the written law, as an aid to the natural (law)" (*Apostolic Constitutions* [trans. R. Darnell] 8.12.25). Such a formulation would have enabled Greek-speaking Jews in Antioch and elsewhere to maintain the value of their culturally specific traditions while establishing the common ground of belief in a universal set of ethical precepts. The positive view of the law expressed in the *Apostolic Constitutions* also suggests respect for Jewish religious thought, even though the work attempted to limit Christian observance of the Jewish law in such areas as the menstrual laws. Apparently, some Christian women were abstaining from sexual intercourse during menstruation on the basis of Jewish law (*Apostolic Constitutions* 6.28).

Relations with Early Rabbinic Sages

Antioch's proximity to Galilee, Judaea, and Babylonia helped to promote contact with these rabbinic centers. Some Antiochene Jews, especially those on the outskirts of the city, spoke Aramaic, which would have facilitated communication with Jews throughout the former Persian Empire; some rabbis, especially those in Roman Palestine, also spoke Greek. Rabbi Akiva, Rabbi Eliezer, and Rabbi Joshua visited the Hulath district, outside the city walls of Antioch, in the second century c.e. for the purpose of collecting money to support rabbinic studies. The Jews there, many of them rice farmers, had little to spare, but the Jerusalem Talmud holds up the Antiochene Abba Yehuda as a model for sharing what he had (Jerusalem Talmud, *Tractate Horayot* 3.48a, lines 39–41). The ancient rabbinic discussion on whether the rice grown by Jews in Hulath was subject to the laws of tithing that applied only to Israel provides evidence for their conceptualization of the Levant (Tosefta, *Dema'i* 2.1). The phrase "as big as Antioch,"[21] used to illustrate how far one may walk on the Sabbath, shows that the early rabbis saw Antioch, and not, for example, Alexandria, as *the* major metropolis (Rome was perhaps too far away to be considered). Further, early rabbinic literature includes teachings by the fourth-century Antiochene Rabbis Isaac Nappaha and Ephas (Babylonian Talmud, *Kethuboth* 88a; Midrash *Genesis Rabbah* 10.4). In spite of these rabbinic contacts, Antioch never became a major center of rabbinic learning on the level of the great rabbinic academies of Galilee or Babylonia.

Ancient Antioch provides us with a rare historical example of Jews fully integrated into the life of a city while maintaining their own ancestral traditions. To be sure, assimilation always posed a danger to Jewish tradition, as the case of the renegade Antiochos illustrates. But Antiochene Jewry both attracted and welcomed non-Jews into its community over a period of centuries. Specific Jewish traditions and practices apparently inspired many pagans and Christians. Political tensions arising from the incompatibility between Jewish belief and practice, on the one hand, and certain forms of Hellenistic universalism, the Roman emperor cult, and Christian supercessionism, on the other, resulted in violence between Jewish and non-Jewish Antiochenes. Likewise, Judaean Jewish participation in suppressing the Antiochene revolt against the hated ruler Demetrios II and the Judaean Jews' own revolt against the Romans led to animosities between Jews and non-Jews in Antioch. But in spite of such incidents, the Jews of Antioch spanned the social spectrum of the city and maintained close contacts with Jews and non-Jews throughout the Mediterranean and Persian regions. Future archaeological excavations and future research, especially on Jewish and Christian works written in Syria, may help us to understand how Antiochene Jews were able to maintain their flourishing community for so many centuries and why it eventually declined.

1. See Smallwood 1976, 359–61.

2. See Downey 1961, 77–80 and fig. 11. My suggestion that Jews may have been among the native Syrian population goes beyond Downey.

3. Scholars debate this point. Josephus presents the Jews of Antioch, Alexandria, and elsewhere as citizens on an equal footing with Greeks (*AJ* 12.119–21, 19.278–91; *BJ* 7.43–44; *Ap.* 2.39), but he may have been tendentious in so doing.

4. See Kraeling 1932, 147.

5. See Philo of Alexandria *Embassy to Gaius* 188, 198–348; Josephus *AJ* 18.261–309 and *BJ* 2.184–87, 192–203; Smallwood 1976, 174–80; and Kraeling 1932, 148–50.

6. See Downey 1961, 206; and Malal. *Chronicle* 10.45.

7. John Chrysostom *Against Judaizing Christians* 5.11. For further sources and analyses, see Levenson 1980.

8. *Cod. Theod.* 16.8.18, 21, 25–27 (408–23 C.E.). For more on Roman law, see Linder 1987. On the charge of ritual murder, see Sokrates *Church History* 7.16; Theophanes the Confessor *Chronicle* 83.11–14; and Evagrios *Church History* 1.13.

9. See Kraeling 1956; Frey 1952, nos. 803–18 (Apamean synagogue inscriptions); and Kitzinger 1973, 135–44, figs. A, B, illus. 1–6.

10. For the view that 4 Maccabees was probably composed in Antioch, see Hengel and Schwemer 1997, 191; Klauck 1989, 667; and Kraeling 1932, 148. For a more skeptical stance, see Anderson 1985, 537, which tends toward the coastal cities of Asia Minor. On the theological significance of the representation of the mother in 4 Macabees, see Young 1991. See also Peterson forthcoming, on a Syriac Jewish text concerning the Maccabean martyrs.

11. See Hengel and Schwemer 1997, 179.

12. The relations between Tarsus and Antioch might be extended to include mosaics as well. The style and technique of the representations of Orpheus, Ganymede, and Lycurgus in the grand mosaic that was discovered in Tarsus and is today on display in Antakya indicate that they were produced by the Antioch workshop.

13. Obermann 1931.

14. Rutgers 1998, 287–303, quotation on 302.

15. Antioch II 1938, 150–51, no. 24.

16. For the text of the inscriptions commemorating Aidesios and his family, see Schwabe and Lifshitz 1973–74, nos. 141–44; or Meeks and Wilken 1978, 55.

17. See Mazar 1973, 4–6, 10.

18. Meeks and Wilken 1978, 56.

19. See Brooten 1982, 158–59, nos. 7–15; 162–63, nos. 30–34; and the discussion on 141–44.

20. For the texts, see Meeks and Wilken 1978, 53–57.

21. See, e.g., Tosefta, *'Eruvin* 3(2).13; and Jerusalem Talmud, *Ta'anit* 3.66d, line 15, and *'Eruvin* 5.22d, line 36. For further discussion of Antioch's rabbinic contacts, see Kraeling 1932, 130–60.

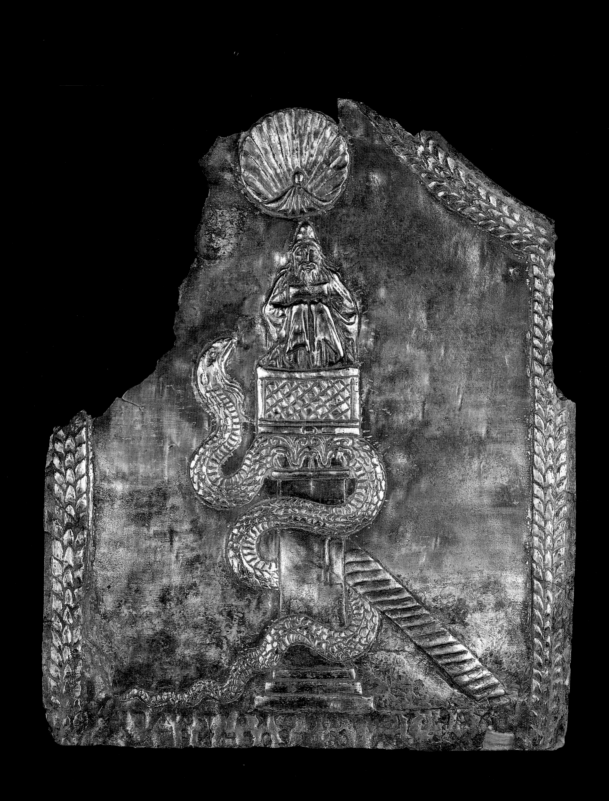

Antioch and Christianity

Susan Ashbrook Harvey

Antioch was a city of near mythic status for Christians of the eastern Roman Empire. Its significance had come within the first generation of Christians, and in its religious authority it remained unique among eastern cities, though in time it would be rivaled first by Alexandria and later by Constantinople and Jerusalem.

From Apostolic Roots to Legalization

In the aftermath of Jesus' death and resurrection, as the apostles took up the charge to "Go forth and make disciples of all nations" (Matt. 28:19), Antioch provided an important base for the emerging church. Significant missionary efforts took place within the city itself, with substantive preaching to Jewish and gentile communities alike (Acts 11:19–30). Further, in the earliest missions conducted by the apostle Paul and others Antioch was a major center for planning, organizing, and refurbishing their efforts (Acts 13:1–3, 14:21–28, 15:22–41, 18:22–23). The missionary work within and outward from Antioch was tremendously important for the new religion at the very moment of its independent identification: it was in Antioch that followers of Christ were first called "Christians" (Acts 11:26). Antioch was also the place where Paul and Peter clashed over the question of gentile converts, a crisis that led to the first council of the church summoned in Jerusalem (Acts 15:1–21; Gal. 2:1–21). Because of its early association with both Saints Peter and Paul, Antioch would represent the whole vision of Early Christian institutional authority: through Paul, the power of charismatic leadership divinely granted, and through Peter, the indisputable claim to apostolic succession of those taught by Christ himself.

Most scholars would agree that the Gospel of Matthew was written in Antioch, probably between the years 80 and 90 C.E. Matthew is the most ecclesiastically oriented of the four canonical gospels, with considerable attention given to problems of church organization and structure; it is the only one of the New Testament gospels to use the term *ekklesia,* meaning "assembly," which Christians would take as the term for "church" (although Paul had used it in his letters). Matthew also contains the famous charge to Simon Peter, whom Christ chose to be "the rock" upon which he would build the church and to whom he granted the power of the keys of the kingdom of heaven (Matt. 16:18–19). Although the bishops of Rome would later apply these verses to the Roman

papacy, Rome is nowhere mentioned in this gospel incident, which locates special authority in the person of Peter rather than in a place.[1]

The ecclesiastical and Petrine themes of Matthew's gospel substantiated the image of Antioch as an authoritative base of apostolic activity. The image would be indelibly confirmed in the correspondence of the bishop Ignatius of Antioch surviving from the early second century. During the reign of the emperor Trajan (98–117 C.E.), perhaps between the years 107 and 110, Ignatius was arrested as a Christian and sent to Rome for trial. En route he wrote letters to the Christian churches in Ephesos, Magnesia, Tralles, Rome, Philadelphia, and Smyrna, with an additional letter to Polycarp, the bishop of Smyrna, who collected and circulated the correspondence. From these seven letters we learn that Ignatius was the leader and bishop of the Christians in Antioch; that he fully expected to be executed in Rome, condemned to face wild beasts in the stadium; and that he understood his own authority as bishop to bear upon the life and work of Christian churches throughout the empire. Hence, his letters were a forum in which he argued for particular ecclesiastical and theological understandings. In so doing, Ignatius articulated a distinctly "Antiochene" tradition rooted in the city's apostolic past and determinative of its role for subsequent Christian history.[2]

Ignatius was the earliest proponent for an ecclesiastical hierarchy revolving around the singular authority of the bishop. In his presentation, the bishop's ministry was fulfilled with the necessary assistance of deacons and presbyters—a threefold ministry. Ignatius argued that what makes Christians a *church,* what lifts them from being a group of believers into being the body of Christ, is the presence and activity of a bishop. In and through the person of the bishop, Ignatius declared, Christ himself was present. Moreover, the model for the relationship between believers and clergy was that divinely instituted by Christ: the church was to the bishop as Jesus Christ was to God the Father, the presbyters stood in the place of the apostles, and the deacons stood as images of God's commandments. Nothing pertaining to the church was to be done apart from the bishop. According to Ignatius only those sacramental activities performed by a bishop or committed by him to the hands of another official were valid—baptism, Eucharist, agape-feast, and solemnizing of marriage. Allegiance and obedience to the bishop should be the source of Christian unity, as well as a protection against division (e.g., *Smyrn.* 8).

To the episcopacy, as a divinely instituted office, Ignatius added the charismatic authority of prophetic teaching. Describing his own episcopal leadership, he refers to incidents of teaching in which he also spoke under divine inspiration in ecstatic utterance (*Philad.* 7). Thus, in Ignatius's view, the bishop represents in his person both the charismatic ministry of Paul and the apostolic authority of Peter, offering the direct revelation of God as well as the historical witness of the church. Such was the view that would ultimately prevail for the Catholic and Orthodox churches. But in the early second century, as Ignatius traveled overland from Antioch to Rome, a diversity of Christian organizations and practices surrounded him. His was a voice for uniformity of worship and belief, of structure and activity, in the midst of a bewildering array of different types of Christian communities. Long after his death, his letters would provide a major tool (and indeed a vision) for unifying churches across the empire.

Ignatius's letters not only defined the meaning of episcopal office but also further demarcated the dominant themes in what would become a distinctively Antiochene theological tradition. Clearly, just as diversity characterized early Christian communities in their organization, many versions of Christian teaching circulated during the second century. Some were characterized by gnostic or docetic views—that Christ was a divine savior who had appeared to his followers in the likeness of a human being but whose humanity had been a mere illusion, as had his death on the cross. Others expressed views closer to traditional patterns of Judaism—that Jesus was a pious man who was divinely inspired, perhaps like the prophets of old. Ignatius sought to articulate a Christian faith that defined its truth over and against such understandings. He argued that Jesus Christ was truly the Son and Word of God in terms that in no way compromised the monotheistic claims of Christianity (*Eph.* 7; *Magn.* 8–10). More than this, he insisted repeatedly on the full integrity of Christ's humanity, claiming that if Christ's birth, suffering, death, and resurrection were not real, then he himself had no reason to suffer martyrdom in witness (*Trall.* 9–10). Insistence on the fullness of Christ's humanity no less than his divine Sonship would become the hallmark of Antiochene theology; in Ignatius we find an early and eloquent expression of this teaching that laid the foundations for later doctrine.

Ignatius's perspective that his office as bishop of Antioch granted him a spiritual authority in the wider church

was repeatedly affirmed in subsequent generations, as bishops of Antioch continued to be cited or consulted by provincial churches of the East. When the church of Edessa (today the town of Urfa in southeastern Turkey) sought to prove apostolic continuity for its episcopal tradition, it was its early connection with the bishop Serapion of Antioch, himself consecrated by Zephyrinus of Rome, that it cited. By Serapion's consecration around the year 200 of its bishop Palut, the church of Edessa was thus linked indisputably to the Petrine episcopacy.[3] In Eusebius of Caesarea's monumental *Ecclesiastical History,* composed early in the fourth century, the bishops of Antioch are listed along with those of Rome and Alexandria for each era.[4]

A paragon of cosmopolitan splendor, Antioch continued to draw Christian intellectuals and charismatic leaders, just as it had drawn the first apostles. The famed gnostic teachers Basilides and Cerdo, with their dualistic doctrine that the flesh is incapable of salvation because inherently evil, taught there in the second century. The city also attracted Tatian, the pupil of Justin Martyr, whose views would take a sharp turn from those of his teacher toward an encratite, or extreme ascetic, understanding of Christianity. Tatian attempted a solution to the apparent dilemma of reconciling the different gospels by producing a work known as the *Diatessaron* (literally, "out of four") or the Gospel Harmony. This was a version of the New Testament in which he wove the four gospels into a single narrative, deleting contradictions and differences in the accounts and adding an asceticizing flavor to the overall narrative (Euseb. *Hist. eccl.* 4.29.6–7). In the East, and especially in the regions around and beyond Antioch, Tatian's *Diatessaron* remained the most commonly used form of the gospels until the authoritative Syriac version of the canonical New Testament, the *Peshitta,* gradually replaced it over the course of the fifth century. But Antioch did not draw only the traveling teachers of heterodoxy. When the empress Julia Mammea was staying in Antioch in the mid-third century, she sent an armed guard to bring the famed scholar-theologian Origen of Alexandria to confer with her there on exalted matters (Euseb. *Hist. eccl.* 6.21).

Brilliant leaders or great teachers do not operate in a vacuum. Antioch was also a city where Christianity flourished in a popular sense. During the second century the legend of Saint Thecla, companion of the apostle Paul, began to circulate throughout the Roman Empire, and

Antioch was again upheld as a place of central importance for Christianity's growth. Thecla's story is one of the great adventure tales of the early church, and one that reminds us of the important roles women often played in the spread of Christian teaching. The narrative appears as a section in a larger apocryphal work, the *Acts of Paul.*[5] Thecla, a young virgin in the city of Iconium and betrothed to be married, was converted to Christianity when the apostle Paul passed through her city preaching the new religion. Abandoning her family and narrowly escaping execution, Thecla followed Paul to Antioch, where her new faith brought her into violent and spectacular collision with the government. Warding off lustful suitors, brutal soldiers, lions, bears, seals, raging bulls, and hostile officials, Thecla converted many in the city (especially among the women), baptized herself, cut her hair and dressed as a man, and set off, at last commissioned by Paul to work as a missionary throughout the eastern empire. A shrine built at her place of death in Seleucia (today Silifke in Cilicia) became a major pilgrimage center, as Thecla's cult grew to become one of the most popular in the Christian East. She was granted the title "Equal-to-the-Apostles" in the Orthodox Church, and her model was often called upon by women pursuing religious vocations within the church of late antiquity. Her shrine was a place of numerous miracles.

Although according to her legend, Thecla managed to escape martyrdom, she was counted among the great martyrs of Antioch because of her dazzling victory when the governor sought to execute her in the city's public stadium. Other martyrs both historical and legendary added to Antioch's luster as the church survived the great persecutions of the third and early fourth centuries, continuing a legacy identified with Ignatius and Thecla. Babylas, bishop in Antioch between c. 237 and 251, was said to have required the emperor Philip himself to serve penance for the murder of his predecessor. Babylas was executed during the Decian persecution of 250–51, and his relics became a source of fame and glory for the city in the fourth and fifth centuries. In the final persecutions that commenced under Diocletian early in the fourth century, Antioch was upheld as a place of extraordinary witness while its Christian population suffered torture and execution. Eusebius praises Antioch's women, above all, for their conduct during these dark times (*Hist. eccl.* 8.12). A young virgin of the city named Pelagia, who jumped from a roof rather than allow soldiers to arrest her, to this day

is venerated as one of the most beloved martyrs in the Orthodox Church.

To the authoritative fame of Antioch's bishops and the enormously popular cults of her martyrs must be added the far-reaching influence of Antioch's liturgical developments. For the rites of the eastern churches, save only Alexandria, all stem (to greater and lesser degrees but always distinctively) from the ancient liturgical usages of Antioch. It is clear that by the fourth century Antioch provided the basic pattern for the litanies, for antiphonal psalmody, and for the epiclesis, the consecratory invocation of the Holy Spirit prayed over the bread and wine in preparation for the Eucharist. But the earlier patterns for these reach all the way back to the church's first foundations in Antioch and the interaction between Christians of Jewish and gentile communities that characterized its emergence.[6]

In the second half of the third century bitter controversy erupted in the church of Antioch and among bishops across the eastern empire over the teachings and practices of Paul of Samosata, bishop of Antioch from 260 to 268. It is interesting that the council of bishops that deposed him was as scandalized by his liturgical reforms as they were about his Christology; on both fronts, our evidence regarding Paul's "heretical" views is not unequivocal (Euseb. *Hist. eccl.* 7.28–30). In a position that would take Antioch's traditional emphasis on Christ's humanity to an extreme, Paul taught that there was no preexistent Son, that God's Word was inseparably part of the divine essence. Jesus, he said, was a man born in time from Mary and divinely inspired to a unique degree, more so than even the greatest of the Old Testament prophets. Thus, Paul "destroyed" the Trinity and disallowed Christ's divine nature. In the same source, Paul is reported to have preached with drama and flair, to which his congregation responded in like manner, "clapping their hands and waving their handkerchiefs." He reformed the use of hymns, rejecting "new" compositions for the Psalms and canticles of the Bible, and cultivated a women's choir. It is difficult to sort out what was genuinely problematic about Paul's flamboyant liturgical style. In some respects he seems to have followed practices that would endure in the Syrian churches east of Antioch for a long time. For example, women's choirs, and their particular responsibility for chanting the Psalms and sacred hymns, characterized the church of Edessa and others from at least the mid-fourth century on. While Paul of Samosata was one of Antioch's most notorious heretics,

the problems he represented both theologically and liturgically were in keeping with Antiochene traditions that emphasized the importance of Christ's humanity and placed profound emphasis on the details of liturgical expression.

By 313 the emperor Constantine had succeeded in granting Christianity legal status in the Roman Empire. Over the course of the fourth century Christianity would move with remarkable speed from being a small, often persecuted and generally despised religion in the empire to its triumph as the state religion under the emperor Theodosius I (379–95 C.E.). Because of its apostolic legacy of leadership in the eastern church, its fame as a center for theological activity, and its continual tradition of renowned martyrs, Antioch held a place of indisputable honor during this era of triumph. At the Council of Nicaea, in 325, Antioch was ranked with Rome and Alexandria as an episcopal see of exceptional authority in the church (canon 6). At the Council of Constantinople, in 381, the imperial city of Constantinople itself was added to this list (canon 3), and during the councils of the fifth century Jerusalem, too, would gain its place. Thus the sees of Rome, Constantinople, Alexandria, Antioch, and Jerusalem gained their ranks of honor as the pentarchy of the Great Church.

Christian Antioch: A City and Its People

In the fourth through sixth centuries Christian Antioch was a city of turbulent greatness. At times rival bishops claimed its episcopal throne. Its theological school rose during the fourth century to singular prominence, in competition only with the school of Alexandria, leading to one of the great theological crises of the ancient church: the Christological debates of the fifth century. Holy men and women of Antioch's regions made the cult of saints a living treasure of the city, adding to the famed devotional cults of its earlier martyrs, whose popularity continued to grow. Its martyrs and saints alone made Antioch a center of pilgrimage traffic.

Culturally the city was an uneven blend of differing ethnic groups and languages. Dominated by Hellenic intellectual and artistic traditions, Antioch's primary language was Greek. But east of Antioch, in cities like Edessa, Amida, Emesa, and Nisibis, the main language of Christians was Syriac, a dialect of Aramaic, the language Jesus had spoken, and a strongly Semitic culture was

everywhere evident. Syriac literature, especially its exquisite hymnography and lyrical hagiography, contributed significantly to the cultural and religious life of the eastern empire. The Christian spirituality one finds in the sources for late antique Antioch derives its distinctive quality from the rich, sometimes uneasy blending of the Hellenic and Semitic cultures. The most renowned of Antioch's preachers, John Chrysostom, noted that there were those in his congregation "from the countryside" who could not understand the sermons he preached in Greek but who themselves were preachers of truth in their own provincial churches (*On the Statues* 19.2).[7]

John himself represented the diverse treasures of Antioch's greatness.[8] A native of the city, born about 347, John came from an undistinguished but not impoverished background. Although he was educated by Antioch's brilliant pagan rhetorician Libanios, John chose to turn to the church and received baptism in 368, studying under the bishop Meletius. For a few years John lived in ascetic solitude under the tutelage of a monastic elder in the countryside outside Antioch; perhaps because of excessive zeal, his health suffered to such an extent that he was forced to return to the city. From this point on he devoted himself to the service of the church as assistant to Antioch's bishop. When in 398 John was forced to take up the office of patriarch in Constantinople, it was because of the work he had done at Antioch: his reputation had gained him an authority far beyond his own territory. Surnamed Chrysostom ("golden-mouthed") by later church fathers, John is held to be the greatest of all patristic preachers—a public spokesman, biblical exegete, spiritual guide, and Christian advocate of singular power.

First as deacon, then as presbyter, John went about the city of Antioch preaching in various churches; in his sermons as nowhere else we find details of the daily life of the late antique city and the economic well-being of its residents. Although very few were rich, the majority were prosperous. According to Chrysostom (Hom. 66 on Matthew), a tenth of Antioch's population was rich, a tenth very poor, and the rest "of the middle sort." John repeatedly castigated his congregations for allowing the poor to suffer hardships in a time of such prosperity. In his sermons he moved back and forth between speaking to the well-to-do in an effort to forge a Christian way of living in the midst of thriving city life, and attempting to change the conditions of poverty and injustice that confronted him at every turn.

What were John's themes? Although a fervent advocate of monasticism as the best Christian calling, John preached on marriage and family life with a genuine warmth, infusing a sense of dignity and worth into this most basic of civic units. Marriage was not a sacrament of the church at this time (and would not become one until the tenth and eleventh centuries), yet John treated it as a uniquely sacred human institution. The relationship between the couple was, he insisted, patterned on the relationship between the church and her Heavenly Bridegroom, Christ; and in their joining, a coupling physiologically ordained by God and thereby sacred, the child produced held the husband and wife together in a relationship that was nothing less than an icon of the Trinity itself (Hom. 12 on Colossians). The family, John taught, is the church in miniature. Therefore John preached strictly on the moral obligations of husband and wife to each other, insisting, for example, that the husband cannot follow a different sexual ethic than the one followed by the wife and that fear and threats have no place in the marital relationship (Hom. 20 on Ephesians). Moreover, the family as church implied a wider web of obligations in John's eyes. Slaves and servants must be treated with absolute dignity. And one's neighbors, above all the poor, are also members of one's own household, deserving of one's hospitality, care, and attention.

A scathing critic of material wealth, Chrysostom abhorred the social structure of his times. He insisted that private property was the mark of the fallen order, for God had not created some rich and others poor in the Garden of Eden. John disdained the notion of inherited wealth, which he declared to exist only because it had been earned unjustly by the sweat of a slave's back (Hom. 12 on 1 Timothy). He was merciless in his critique of slavery as an institution. In the Stoic tradition he admonished slaves to use their slavery to learn freedom from the transience of material wealth or earthly condition and to manifest a perfection of faith that their owners would do well to emulate (Hom. 19 on 1 Corinthians).

In the dazzling oratory of classical tradition at its finest, John preached of family values and social justice, of civic responsibility and moral obligations. From it we learn something of Antioch's habits and the real challenges of being Christian in a late antique city. Because of the sanctity of marriage, John admonished, one ought to ban strippers from one's wedding party (e.g., Hom. 12 on Colossians). Similarly, one ought not spend more money

on the theater or on prostitutes than on the poor (Hom. 66 on Matthew). In John's eyes, communion was a meaningless sacrament if one walked away from the chalice snubbing the poor and hurrying past the hungry as if they were not there (Hom. 23 on 1 Corinthians). John was scandalized by the popular craze for elaborately and colorfully embroidered men's sandals, whose very purchase, he insisted, caused a double sin: the unethical work conditions forced upon the laborers to produce these "glittering" sandals at an unholy pace to satisfy the public fad and the money wasted on vain adornment while people starved in the streets (Hom. 49 on Matthew).

John Chrysostom described the wealth of the church of Antioch at its height. He claimed that the church financially supported more than three thousand widows and virgins, as well as persons in prison, the maimed, sick travelers, healthy pilgrims, the altar servers and all the clergy, and those who came daily asking for food and clothing (Hom. 66 on Matthew). In fact, John advised a fledgling priest that one ought to pay out this support quickly and often, for the poor become brazen and problematic for a priest when their hunger grows severe, especially the poor widows, whom John claimed were one of the most difficult responsibilities for the clergy (*On the Priesthood* 3.16). In the early sixth century the patriarch Severus of Antioch (512–18) would find the financial strain almost unbearable. He begged for a restriction on ordinations because he could barely support the clergy Antioch already had (e.g., *Select Letters* 1.8, 17).[9] Yet Severus reported that a delinquent bishop from the provinces who had been disciplined for extorting money from his flock had remarked bitterly that he had been living in utter poverty while the clergy of Antioch received a generous stipend (*Select Letters* 1.4). If John Chrysostom portrayed the burdens of the priesthood as crushing (*On the Priesthood,* esp. 3.15–18), Severus described himself when he was bishop as "much harrassed with many affairs and not able even to breathe" (*Select Letters* 10.5).

According to John Chrysostom, the priesthood was the primary meeting place of the divine and the human. The priest, he said, performs on earth the works of heaven and hence ought not fill the churches with murder nor split cities into factions (*On the Priesthood* 3.4–6, 10). Indeed, the degree to which the liturgical and devotional activity of the church brought the whole people of the civic community into frequent and common connection across the lines of class, gender, and ethnic group is strik-

ing. But while John provides a moving image of the church gathered at the communion chalice—rich and poor, young and old, male and female, slave and free—he also makes clear that the divine and human intersected in the life of the church through other holy channels. The cult of saints, both dead and alive, was a vivid example.

The martyrs of Antioch had borne witness to their faith in the dangerous times of Christianity's fight for legitimacy. Yet their work was not done. Around 350 the bones of the martyr Babylas had been moved to Antioch's suburb of Daphne and there laid in a new martyrion in hopes of silencing the still revered oracle of Apollo. When the pagan emperor Julian had passed through the city in 362, finding to his dismay that paganism was on the decline, he had moved the bones back to the city's cemetery. When soon afterward the temple of Apollo was badly burned by lightning, Christians claimed divine vengeance. As John Chrysostom solemnly pronounced, "It is possible to move the bones of a martyr, but not to escape his hands." John describes the new cruciform church built by the bishop Meletius across the Orontes to honor the relics of Babylas and how the whole city turned out for the internment of the bones, "as if to receive a father long absent who was returning from sojourn far away" *(On Babylas).*[10] So, too, does John portray the great ceremony that attended the return of the relics of Ignatius, who, John said, having honored Rome with his martyrdom, honored Antioch again with a greater glory than his episcopacy. For "as some perpetual treasure," the relics of Ignatius, like those of Babylas or the other great martyrs, provided the city a continuing place of divine witness, as well as of succor for those in need of healing, whether bodily or spiritual *(On Ignatius).*

Occasions in honor of the saints and martyrs brought the Christians together in elaborate processions that filled the streets of the city. With lighted candles, swinging censers, glorious hymns, and the chanting of psalms, the people moved through the city led by the clergy in magnificent vestments, processing from the great cathedral to other churches and shrines throughout the districts. In an urban setting that was still dominated by classical culture and pagan traditions and had a flourishing Jewish community as well, such public displays of Christian devotion heightened the sense that Christianity was gaining the city, and indeed the empire, as its own.

Nor was the presence of the holy available only through the cult of saints who had died. Antioch was a

center of activity in the dramatic emergence of monasticism in late antique life. Christianity had always known those in its communities who practiced their faith with special devotion; voluntary celibacy, generous almsgiving to the poor, and a life of simplicity had been the marks of the best Christian life since the first generation of Christians. In the fourth century, in the wake of legalization, as the church gained political and economic power, many took such practices into separately located communities—monasteries and convents—and added more rigorous ascetic discipline to their devotional practices in an effort to gain a more perfect, single-hearted devotion to God. As the monastic movement gained momentum throughout the empire, Antioch and its territories were seen as a beacon of spiritual light, so crowded was the region with holy men and women. These living saints generated a public following every bit as fervent as the devotional piety lavished on the martyrs of old.

To be sure, Syrian asceticism was characterized by its visible impact on the daily life of the church. In this tradition, the ascetic was viewed as one whose body imaged the redemption the church preached, as both an individual and collective experience. Through the harsh discipline of extreme asceticism—rigorous fasting and vigils, wearing heavy iron chains, living in the wild without shelter—the ascetic succeeded in defeating in his or her own body the human weaknesses of hunger, weariness, and pain. People looked to the ascetics not only to image the human body redeemed from its fallen, needy condition but also to heal the collective body of the human condition. People of every walk of life flocked to the holy men and women for their counsel or their blessing; for cures for illness, handicap, or sterility; for intervention in family and civic affairs; for redress against unjust landlords, tax collectors, governors, or city officials; for direction in foreign policy or guidance in doctrinal decisions.

John Chrysostom makes frequent mention of the monks living in the mountains and wilderness just outside Antioch. He describes a situation in which church officials and monks worked together in the religious life of the city, a blending of institutional and charismatic spiritual authorities. In 387, when the city was torn by the Riot of the Statues, over a new imperial tax, this blending was evident. Antioch's bishop, Flavian, went to Constantinople to plead with the emperor Theodosius I for clemency on behalf of his flock. In Antioch itself, John Chrysostom preached daily, attempting to calm and bring

to order the terrified populace. At the same time, the monks and hermits from the mountains outside Antioch began to pour into the city "as if they had been so many angels arriving from heaven" (John Chrysostom *On the Statues* 17.1–2). John describes them moving through the city offering consolation and comfort to the populace, and more. For as Theodoret of Cyrrhus also confirms, the monks were eloquent advocates for the city, interceding with the imperial officials and their troops who had been sent to quell the unrest (Theo. *History of the Monks* 13).[11] Speaking bluntly and boldly to the public authorities, often in Syriac rather than Greek, the monks proved to be effective patrons with worldly powers as well as heavenly ones.

Nor was this holy patronage demonstrated only in times of crisis. Theodoret had grown up in Antioch in the late fourth and early fifth centuries. In his *History of the Monks of Syria* he recalled his mother's frequent visits to the holy men who lived in tombs, caves, or huts in and around the city. As a young wife she had been healed of an eye ailment as well as sterility through the prayers and advice of monks. She often took Theodoret with her so that he too might gain the blessing and counsel of these "luminaries of piety" (*History of the Monks* 14). He describes his visits to Peter the Galatian, who lived in a tomb: "He often sat me on his knees and fed me with grapes and bread; my mother, who had had experience of his spiritual grace, ordered me to reap his blessing once each week" (9.4). The monk Aphrahat, who came from Edessa and settled just outside Antioch around the year 360, barely spoke Greek. Yet he vigorously instructed the city against the continuing presence of the Arian heresy that taught that Christ was not coeternal with God but rather was created by Him. Theodoret reported the steady stream of visitors to Aphrahat's cave: "One could observe hastening together concilors and officials, those with some military rank and manual laborers, in a word civilians and soldiers, the educated and the uninitiated in learning, those inured to poverty and those flourishing in wealth" (8.2).

Most famous of all the Syrian holy men was the monk Simeon the Stylite (from the Greek word *stylos*, meaning "pillar").[12] Born in the late fourth century and raised as a shepherd in northern Syria, Simeon converted to the ascetic life as a teenager. After spending some years in monasteries, Simeon settled on a hilltop in the wilderness southeast of Antioch, taking up his stance on a pillar

about sixty feet high (see p. 38). Atop the pillar on a platform about six feet square, with no shelter of any kind, Simeon stood in ceaseless prayer midway between heaven and earth for forty years, until his death in 459 at more than seventy years of age. It was a spectacular career. Standing in the sight of all, Simeon weathered the extremes of heat and cold, of sun and storms. More than once his life was endangered by illness and infection; he nearly died of gangrene. Tended by disciples who approached him by ladder, bringing the sparse food he ate once each week when not fasting, protected from falling by means of a fence around his platform, Simeon stood in rigorous prayer routine.

From sunset to sunrise Simeon stood immobile, hands stretched heavenward. During the day he dealt with a vast crowd of visitors, "a human sea" of pilgrims, from emperors to bishops to peasants. When a poor cucumber farmer, a widowed father with children, found his fields vandalized by village bullies, he came to Simeon seeking not only help for his lost livelihood but justice for what he had suffered. When a corrupt civic official in Antioch imposed a tripled tax on leather workers who used red dye, a guild of three hundred men, the workers came to Simeon's pillar begging his intercession. Simeon healed, judged, oversaw the distribution of food and water during famine and drought, preached, exhorted, and worked on behalf of the poor. In effect, this holy man ran an extensive social-service network from the top of his pillar. Whatever one might think of Simeon's ascetic practice, one thing is clear: his contributions to society were concretely constructive and belie the apparent "uselessness" of a life of self-mortification.

When Simeon died, his body was moved to Antioch in an extraordinary procession, for the people of Antioch "had petitioned and besought the governor with many groans and tears to transport him there so he might be its fortified wall and it might be defended by his prayer" (*Syr. vit.,* sec. 125).[13] The bishop of Antioch, along with six other bishops, the military governor of Syria, and an escort of six hundred soldiers, accompanied the body to its resting place in the cathedral. So large were the crowds en route that the procession took five days to travel the forty miles from the pillar to the city. When the emperor Leo petitioned to move the body to Constantinople so that the empire itself "might be guarded by his prayer," Antioch rose up in anguished opposition and succeeded in keeping the relics for their own. Meanwhile, the hilltop where Simeon's pillar stood was transformed into one of the major pilgrimage sites of late antiquity, with a magnificent church, now called Qal'at Si'man, or "Simeon's Castle," in present-day northern Syria to house the relic of the saint's pillar.

Simeon's practice was taken up by monks who came after him. In the sixth century, his namesake Simeon the Younger (d. 592) climbed on his first pillar at the age of seven.[14] On a series of different pillars on what became known as the Wondrous Mountain, on the outskirts of Antioch, this Simeon directed the religious life of the large monastic complex around his pillar as well as that of the city and its regions (fig. 1). The bishop Ephrem of Antioch, one of the sixth century's leading neo-Chalcedonian theologians, was a frequent visitor to the pillar. So holy that incense burned beside him without fire, Simeon the Younger was ordained a priest, requiring a pillar top large enough to accommodate the many who came to receive the Eucharist from his hands. As in the case of his namesake, many pilgrims purchased small souvenir tokens made from the earth at the pillar base and stamped with the image of the stylite saint. These were held to be enormously potent "blessings" *(eulogiae),* which could bring blessings or healing to the faithful when they returned to their homes. The earth was hallowed by its direct contact with the stylite's ascetic practice; just as the hemorrhaging woman had obtained healing simply by touching the hem of Christ's cloak, a token touched by the saint could also convey holy powers.[15]

The monastic movement held up an ideal whose emulation late antique preachers encouraged. The monks and nuns were a constant reminder that people had the capacity to change their lives—to convert to a "more perfect" devotion. In one sermon, John Chrysostom referred to an unnamed holy woman who had recently died in the city of Antioch. At one time a renowned actress and prostitute, she had converted to the ascetic life and spent her final years in the city in virtuous and deeply penitential seclusion. John used her as an example of the human capacity for free will and change for the better (Hom. 67 on Matthew). From this passing, if rather lurid, reference seems to have come the tremendously popular legend of Saint Pelagia the Harlot. In this romantic tale, Pelagia was a courtesan of Antioch notorious for her wealth, her beauty, and her pleasure in the life of harlotry. Converted in spectacular fashion by Bishop Nonnus of Antioch, Pelagia received baptism, freed her slaves, gave her wealth

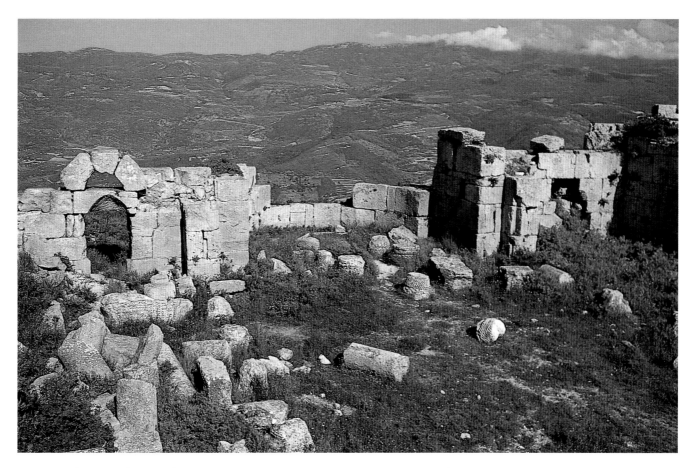

Fig. 1. View of the ruins of Church of Saint Simeon the Younger. "Miraculous Mountain" in vicinity of Antioch

to the poor, and disappeared. Years later the bishop sent his humble deacon Jacob to seek the blessing of a eunuch hermit named Pelagius dwelling in a cell on the Mount of Olives. Suspecting nothing, Jacob found a radiant holy man whose face showed the suffering of severe ascetic practice. Then the hermit died and was found upon burial to be not a eunuch monk but a woman, indeed, the former harlot Pelagia. All marveled at this extraordinary event, in which a woman had gained true sanctity in the guise of a man. The captivating story of Pelagia went on to be translated into virtually every language of the medieval Christian world, east or west. In the image of the redeemed harlot—Pelagia's story was only one such tale—the church found one of its most profound and enduring symbols for the relationship between the human and the divine: the tragic situation that results when love is wrongly exploited and the unending grace of divine forgiveness when a person genuinely repents.[16]

John Chrysostom was famed not only for his elegant and forceful sermons but also for his training at the great theological school of Antioch. In the late fourth and early fifth centuries the school was at the peak of its brilliance. Under the guidance of Diodore of Tarsus (died c. 390) and Theodore of Mopsuestia (c. 350–428), it developed a distinctive tradition of biblical exegesis that stressed the importance of a historical and ethical interpretation of Scripture over and against the allegorizing trends at the theological school of Alexandria. At the same time, the school would continue the earlier themes of Antioch's theological traditions, above all by emphasizing the full humanity of Christ in a Christological understanding that held the two natures of Christ, human and divine, to be clearly distinct from one another (a Dyophysite position, stressing the two natures, or *physeis,* of Christ). The teachings of Diodore and Theodore were explored and developed by John Chrysostom and subsequently by the great fifth-century theologian and exegete Nestorius (c. 381–451). Nestorius was consecrated bishop of Constantinople in 428. From that pulpit he chose to do battle with Cyril, bishop of Alexandria, and indeed the entire Monophysite

school of thought (stressing one nature *[physis]*, united out of two) that had developed from Alexandria's theological school. In Cyril's formulation, Nestorius posited too sharp a separation between Christ's two natures, thus making nonsense of the full reality of the incarnation; Cyril preferred to speak of "one nature [united] out of two." The ensuing theological crisis led to Nestorius's exile in 431 and the expulsion of Antioch's theological school. Yet the school was able to continue its work, joining the school of the Persians in Edessa. When suppressed by the emperor Zeno in the 580s, the school relocated across the border in the Persian city of Nisibis, where its tradition of scholarship and theological study continued to serve the eastern church well into the Middle Ages. Nestorius himself, although exiled, lived to see the substance of his theological position incorporated into the Christological definition of the Council of Chalcedon in 451 even though that same council continued the condemnation of his name.[17]

In the aftermath, the Christians of Antioch, like those throughout the eastern empire, continued to be deeply divided over the Council of Chalcedon. Advocates for and against the council held Antioch's episcopal throne in succeeding decades. In the sixth century matters came to a head. The finest and most sophisticated of the Monophysite theologians, Severus of Antioch, served as the city's bishop from 512 until 518. His exile came about with the initiation of imperial persecutions against all who opposed Chalcedonian orthodoxy. Between 527 and 545 the renowned neo-Chalcedonian theologian (and former count of the East) Ephrem served as bishop, returning Antioch to its leading role in upholding Chalcedonian faith. Under the bitter weight of persecution, the situa-

tion hardened irrevocably. By the century's end the Oriental Orthodox churches (the Syrian, Coptic, Ethiopian, and Armenian Orthodox churches) had formally separated from the Eastern (Chalcedonian) Orthodox. Only in the late twentieth century has the work of theological reunion finally begun to heal relations between these long tragically divided eastern churches.

The ecclesiastical battles of the sixth century coincided with a terrifying series of natural and political disasters. In 526 Antioch, Daphne, Seleucia, and all the surrounding regions were crushed by a series of mammoth earthquakes. Among the victims was Antioch's reigning bishop, Euphrasius, whose residence collapsed into the wine factory that had operated beneath it. Euphrasius's body was found in a cauldron of burning pitch, destroyed but for his head hanging over the rim.[18] In 540 the Persians sacked the city. In 542 bubonic plague descended on the East, bringing extended famine and death rates of 40 to 60 percent. The Persians returned to burn Antioch's suburbs in 573 and again took the city in 611.

By the time of the Arab conquests in 637–38 little of Antioch's former splendor remained. The city was never fully rebuilt after the extensive destruction suffered in the sixth and seventh centuries, and her position as a leading eastern city passed to other, more prosperous cities. Yet her Christian tradition continued. To this day Christians worship in the city now called Antakya (and now within the borders of eastern Turkey), while the bishops of Antioch, both Eastern Orthodox and Syrian Orthodox, continue their patriarchal service from their residences in Damascus. Through their leadership, Antiochene Christianity remains a beacon of light known and appreciated throughout the Christian world.

1. Brown and Meier 1983.

2. Schoedel 1985.

3. The episode is recounted in the fifth-century Syriac work *The Teaching of Addai* (Howard 1981).

4. A table of Antioch's bishops from Peter through the late eighth century is conveniently available in Frederick Norris, "Antioch," in Ferguson 1997, 1:69. The table includes rival bishops (there were three in the 360s, for example), as well as the separated Melchite (Chalcedonian) and Jacobite (Syrian Orthodox) patriarchs starting in the sixth century.

5. The narrative *Acts of Thecla* has been translated into English as a section of the *Acts of Paul* in Hennecke and Schneemelcher 1963–65, 2:353–64.

6. See esp. Shepherd 1961.

7. See esp. Brock 1994.

8. On John Chrysostom, see Wilken 1983; and Kelly 1995. His works are widely available in English translation, esp. in *NPNF*.

9. Severus 1902–4.

10. *NPNF* 9:143.

11. Theodoret 1985. All quotations are from this source.

12. See the convenient collection of hagiographies with discussion in Doran 1992.

13. Ibid., 192.

14. See Van den Ven 1962 for the critical edition of the Greek hagiography, a French translation, and indispensable commentary.

15. Vikan 1982.

16. There is an English translation of the Syriac version of the life of Pelagia in Brock and Harvey 1997. On the theme of the penitent harlot, see esp. Ward 1987.

17. The theological conflict between Nestorius and Cyril was a complex and devastating experience for the eastern church. For a lucid account of the theological issues, see Young 1983, ch. 5.

18. Various sources report the incident. An English translation of the primary witness, the contemporary historian John of Ephesos, appears in *Pseudo-Dionysius* 1996, 44–48.

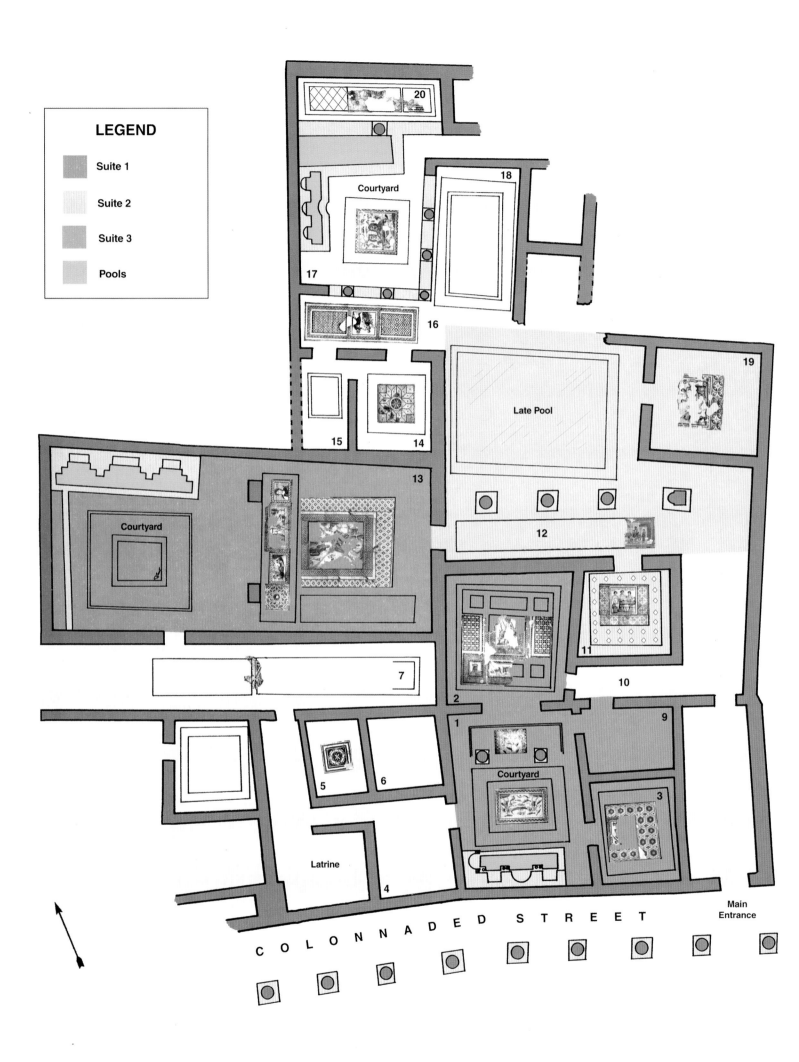

LEGEND

Suite 1

Suite 2

Suite 3

Pools

20

Courtyard

18

17

16

15 14

19

Late Pool

13

Courtyard

12

11

7

10

2

1 9

5 6

Courtyard

3

Latrine

4

Main
Entrance

C O L O N N A D E D S T R E E T

The Houses at Antioch

John J. Dobbins

The elite of Antioch fashioned an opulent domestic realm for social rituals that displayed classical learning and evoked what must have seemed to be the eternal tradition of Greco-Roman culture.[1] Some houses exploited bold vistas toward mountain and shore; others harnessed the rushing streams of Daphne to infuse their domestic space with nature's energy. Through the artifice of mosaic they presented images that connected viewers to timeless myths. And, through ephemeral but culturally laden activities, primarily the banquet, or symposium, the houses asserted the identities of their occupants as citizens of a city that was heir to Athens. While the famous *Oration* II of Libanios emphasizes the Hellenic, that is, Greek, strain of Antiochene culture,[2] the houses and the manner in which the Antiochenes shaped domestic space for social ritual display an equally strong Roman legacy.

Broad general claims such as those above are easily made. In truth, our entry into the domestic world of Antioch is hampered by numerous conditions that frustrate attempts to reconstruct the specifics of any individual house. For example, although we know much about Antioch houses in general, it is impossible to trace in detail the history of a single house at the site. For this reason there is no definitive study of the structure, chronological development, artifact contents, or social history of the Antiochene house. In the sixty years since the excavations at Antioch only one general article has treated its houses, and that was nearly forty years ago.[3] The excavation volumes and Doro Levi's *Antioch Mosaic Pavements* create the impression of an extensive treatment of the houses, but the focus is really on the mosaics. In the publications the houses are merely the framework for the mosaics and never form the center of an architectural discussion. While the excavation volumes provide a great deal of information about the houses, the preservation of critical features, such as walls and doors, was so poor that it was often impossible to locate the boundaries of individual houses or even to identify doorways between rooms. The published plans create the impression that boundaries and doorways are known, but they are misleading. A fresh examination of the evidence often proves that the excavators themselves were making educated guesses. A further irony is that the excavations that produced the information have themselves been an impediment because they were conducted in an era that did not engage in the thorough documentation that is now considered routine. The result is that much evidence is lost. In instances where some clues survive in the form of mosaic

design and orientation, excavation photographs, or excavation notes, we can offer some speculation. In other instances it is better just to admit that we do not know.

The reasons for the incomplete preservation of such fundamental architectural features as house walls are familiar to field archaeologists. A house in use for generations, possibly by several different owners, undergoes numerous changes as walls are taken down or added, rooms are expanded, divided, or reoriented, adjacent property is acquired or sold off, and doorways and entrances are altered. The more permanent mosaic floors may remain in place as walls come and go around them. Furthermore, when the houses were abandoned or seriously damaged by earthquakes of the sort that frequently struck Antioch, their standing or fallen walls became ready sources for stones for building new houses. In other words, the earlier houses became quarries for builders in need of supplies. Archaeologists use the term "robber trenches" to refer to the trenches used by later builders to dig out walls and foundations in their quest for stone.

In defense of the excavators it must be acknowledged that such extensive stone robbing deprived them of much evidence. Moreover, local residents in the 1930s occasionally reported that mosaics had been revealed by winter rains. In a kind of unanticipated salvage operation the excavators uncovered those mosaics and their associated buildings. In cases where houses were so shallowly buried, it was most unlikely that walls and the associated evidence for doorways would be preserved. Sometimes parts of houses have been lost due to the erosion of hillsides; whole rooms have slid downhill. In other cases the remains were buried deeply beneath orchards, rendering lateral expansion of excavation trenches difficult or impossible. All of these factors contributed to the incomplete excavation of individual houses. For example, unlike at Pompeii, where hundreds of houses and scores of city blocks have been disinterred, not one single whole block of houses has been uncovered at Antioch. This means that we cannot address such questions as: Where did the poor live? Were elite houses located in mixed-use neighborhoods as they were at Pompeii? Where were shops and light industry located? For six decades these conditions have discouraged investigators from incorporating Antiochene houses in more general studies of Roman architecture, interior decoration, and social history. The ultimate irony is that a wealth of information survives, but it has remained hidden because we have not made the effort to find it.

As part of the exhibition that presents anew the lost city of Antioch this essay strives to be a beginning in a renewed study of Antiochene houses. The time appears to be propitious for inspiring a new interest in the houses of Antioch because of the current interest among scholars in Greek and Roman domestic spaces. As one Roman archaeologist put it, "Houses are back on the archaeological agenda."[4] Many recent studies look to Pompeii and Herculaneum because the evidence there is ostensibly complete and so vivid. A short time spent with some recent publications will show that the proverbial grass is not always greener in Pompeii, that the problems at Antioch are seen elsewhere, and that scholars interested in Roman domestic life have a lot in common no matter what the geographic focus of their work.

We begin with the reassembled pavement of the *triclinium,* or dining room, of the Atrium House in order to examine the banquet and its social role in the domestic realm. We then undertake an examination of three third-century C.E. houses that express both the standard features and the rich variety of domestic settings at Antioch. One is from the port of Antioch, Seleucia Pieria; the other two are from the suburb of Daphne. This is not the place for an exhaustive treatment of chronology and development, nor is it the place to distinguish between town house and villa or between the port at Seleucia and the suburb of Daphne. We shall use the evidence that we have to establish general principles.

In the *triclinium* reconstructed in the exhibition three dining couches, or *klinai,* are arranged in a U to accommodate nine banqueters, three per couch (see p. 62).[5] Nine diners—the ideal number for a dinner party—reclined on cushions on their left elbows and partook of the dishes with their right hands. As knives, forks, and the practice of sitting upright lay still in the future, Antiochene diners ate in the manner of all elite Greeks, Etruscans, and Romans. The lavish floor mosaics, arranged in a T-shaped pattern that is found at Antioch as elsewhere in the empire, are reunited for the first time since their excavation. The high quality of the workmanship testifies to the importance of this room and by extension to the importance of the banquets that took place within it. The geometric pattern that surrounds the framed figural scenes indicates the location of the three couches. The two figural panels that form the stem of the T are oriented so as to be seen by those reclining in the *triclinium;* the three panels forming the top of the T face persons entering the room. This basic arrange-

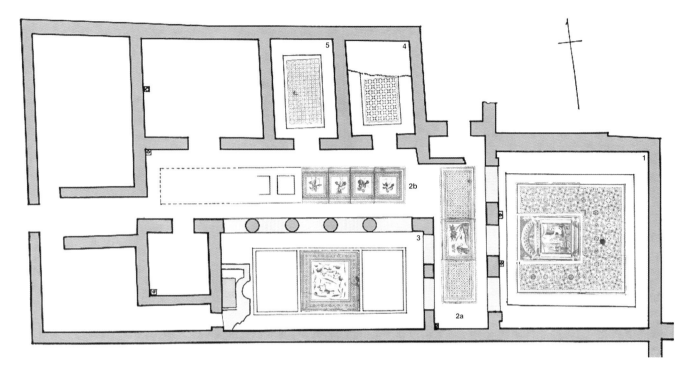

Fig. 1. House of the Drinking Contest, Seleucia Pieria, third century (plan: Victoria I and Mary Todd)

ment, seen again and again in the *triclinia* at Antioch, indicates that the mosaics were part of an ensemble that recognized room use, viewing angles, and movement within architectural space.

Extensive literary and archaeological evidence from throughout the Greco-Roman world proclaims the primacy of the symposium among elite social rituals. Far more than just a repast to nourish the body, the lavish banquet nourished the mind through the philosophical and literary conversations it encouraged. Status was displayed through the architectural setting, the interior decoration, the tableware, the entertainment, one's position at the table, the menu, and the learned dialogue among guests. Even though there was a hierarchy of seating, the symposium was fundamentally an assembly of equals who mutually reaffirmed their status as a group each time they met. The prevalence of *triclinia* among the residences testifies to the importance of these events, and the profusion of classical imagery, especially in *triclinium* mosaics, appears to be a conscious assertion of Antiochene continuity with an unbroken tradition that extended back to classical Greece. To the extent that the Antiochenes actually pursued philosophical and literary discussions at banquets, they further defined themselves as heirs to the classical tradition. Although undoubtedly an exaggera-

tion, Libanios's *encomium* in praise of Antioch supports such a reconstruction of domestic life.

The House of the Drinking Contest

The House of the Drinking Contest at Seleucia Pieria, which allows us to see the *triclinium* in a more complete architectural context, presents several typical components that define Antiochene domestic space (fig. 1). The drinking contest between Herakles and Dionysos is a thematically appropriate figural mosaic in the *triclinium* that provides the name for the house.[6] This elite residence exploits internal and external vistas to lock the building, its mosaic program, and the social activities it housed into a system of architectural, iconographic, and landscape coordinates. The architecture and the iconography are of purely human design. The landscape reflects the Roman fascination for both linking and contrasting the built environment and the natural environment. This residence also illustrates a basic principle of Antiochene domestic design that links *triclinium,* portico, and *nymphaeum,* or fountain. In addition, on the level of social meaning we can discern through various cues that the *triclinium* is the key room in the house and that the events performed there must have been commensurably important.

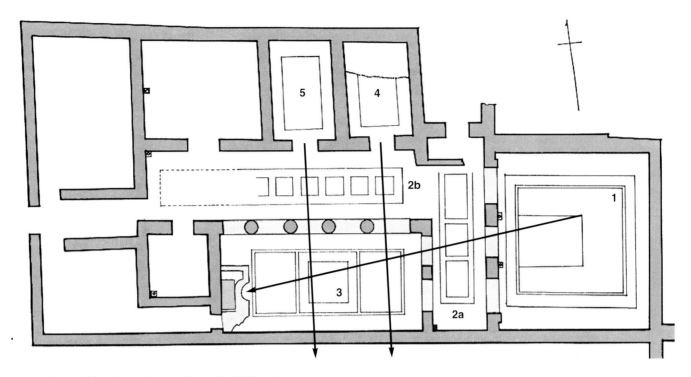

Fig. 2. House of the Drinking Contest. Plan with sight lines drawn

The plan (fig. 1) reveals a large *triclinium* at the eastern end of the house (1), two porticoes (2a and 2b), a fountain court (3), and two possible bedrooms (4 and 5). All of these rooms were decorated with mosaic pavements. The unnumbered rooms to the west, which may have functioned as a service area, were not decorated with mosaics. The richly decorated *triclinium* (fig. 3) communicates with portico 2a by means of a large door framed by columns.[7] The portico, in turn, is amply decorated with a mosaic "carpet" whose figural panel is centered on and oriented toward the *triclinium*, thereby emphasizing the close association between the *triclinium* and the space in front of it. The relationship between the spaces is reciprocal. The portico conveys one to the *triclinium* and by means of its figural mosaic announces the *triclinium*'s doorway; from within the *triclinium* the doorway directs one's gaze to the portico, through the colonnade, and ultimately to the open courtyard with its *nymphaeum*. This Roman practice of linking spaces by sight lines and emphasizing those visual coordinates through floor mosaics and three-dimensional architecture is universal and can be seen most easily in Pompeii, where sequentially arranged domestic spaces establish a dominant visual axis in many of the grand houses (fig. 2). Although the spatial structure is different at Pompeii, this empire-wide principle is the same and

receives a particularly Antiochene twist in the frequent linkage of *triclinium*, portico, and *nymphaeum*.[8]

Our understanding of the spatial relationship between the *triclinium*, the portico, and the courtyard with its fountain is enhanced when we take into account the order of seating on the three couches. The couch on the right as one looks into the *triclinium* is the high couch, or *lectus summus*. That in the center is the middle couch, or *lectus medius*, and the one on the left is the low couch, or *lectus imus*. The presence of a large door that provides a vista and diners' practice of reclining on their left elbows means that some positions were better than others for engaging fellow diners in conversation and looking from the *triclinium* to the fountain court. The two best positions were the left side of the middle couch and the right side of the low couch. The guest of honor occupied the former, and the host, the latter. When we examine the plans of Antiochene houses we frequently find that the optimal vantage point extends from this inner left-hand corner of the *triclinium* to the center of the fountain. The arrow on the plan shows that one's view from this corner leads directly to the center of the *nymphaeum* in courtyard 3.

If we physically follow the optimal sight line from the *triclinium*, we find ourselves in the small courtyard that measures approximately thirty by seven and three-quarter

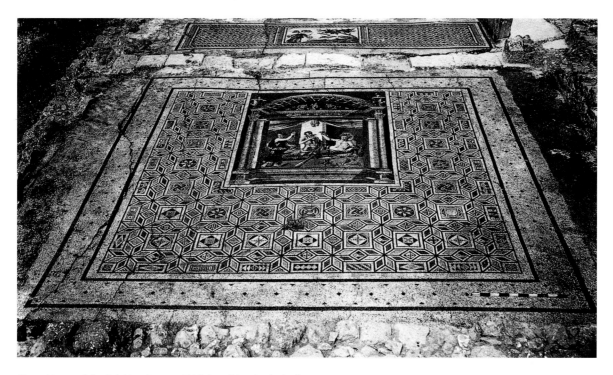

Fig. 3. House of the Drinking Contest. *Triclinium.* Mosaics *in situ* from east

feet (9.40 × 2.60 m)(fig. 2). At the center of the mosaic pavement is a marine panel that can be viewed from all sides as one walks about the courtyard. In the mosaic, erotes are fishing on the backs of dolphins; several species of fish are accurately depicted. This panel establishes a thematic connection between the house and the nearby sea. A wonderful excavation photograph (fig. 4) allows us to see beyond this courtyard to the mountains in the distance, but it raises an important question: Did the ancient Antiochenes enjoy this view from the house, or did the southern wall of courtyard 3, now completely robbed out, close the view? Although we lack definitive information, a case can be made for the vista and for a low terrace wall or a wall with a large window whose shutters could be flung open. An a priori aesthetic judgment suggests that the carefully constructed vistas *within* the house are part of a larger pattern that also includes the dramatic *external* vista to the distant mountain peak.

More solid evidence comes from portico 2b, decorated with figures representing the four seasons, which runs along the northern side of the house in front of rooms thought to be bedrooms. Its mosaics are oriented to be seen from the northern rooms, whose own pavements were of geometric design. As the overview of the uncovered parts of the House of the Drinking Contest

(fig. 4) amply demonstrates, the season panels draw one's view into the portico, whose screen of columns would have allowed that view to continue to the courtyard. Although the colonnade does not survive, markings on the stylobate between portico 2b and courtyard 3 reveal that its columns were irregularly spaced, as the plan indicates. Such an irregular spacing can best be explained as an accommodation to the view that extended to the portico and into the courtyard. As the trajectory of this view extends across the coastal plain, past the eastern end of the Mediterranean, and to the peak beyond, it would be very difficult to argue that the designers did not consciously create an ensemble in which architecture, mosaic, and nature were all components.

A similar arrangement of domestic space to highlight views can be found in the nearby House of Dionysos and Ariadne, where the extant rooms are steeply set on the slopes of Musa Dağ. The excavators and Levi suggested that perhaps the guests sitting in the *triclinium,* with the mosaic of Dionysos discovering the sleeping Ariadne, could look out beyond the corridor and its windows down to a panoramic view of the harbor.[9] Such an appreciation of vistas and such a linking of the controlled environment and wild nature are typically Roman and occur repeatedly in Pliny the Younger's famous description of his villas. For

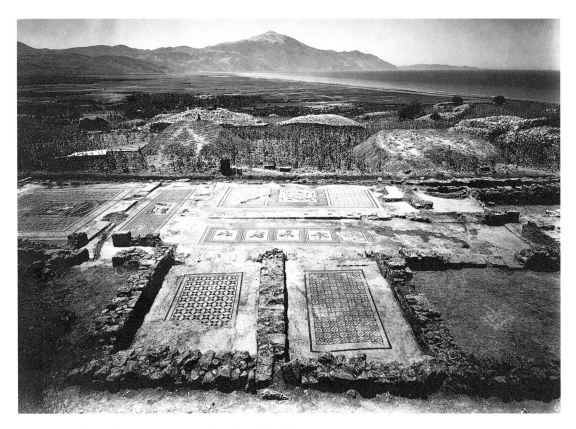

Fig. 4. House of the Drinking Contest. Overview from the north with the mosaics *in situ*

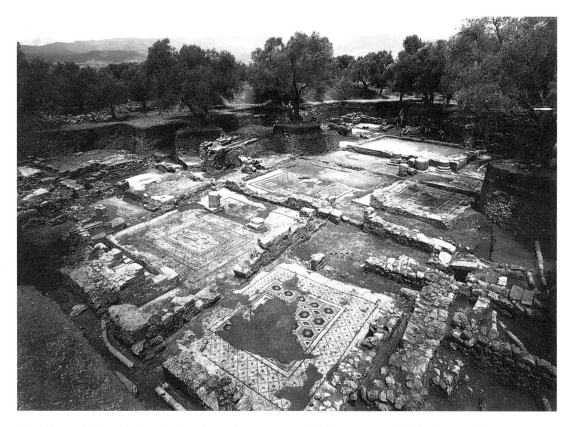

Fig. 5. House of Menander. Overview from the southeastern corner of the house; room 3 is in the foreground

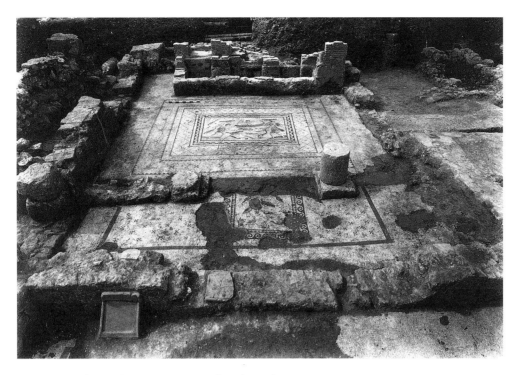

Fig. 6. House of Menander, room 1. Overview from the north

example, in his Laurentine villa Pliny delights in the long view that passes through his house and extends to the forests and different mountains, while in his Tuscan villa he juxtaposes the porticoed terraces accented by topiary creations and various trained plants with the wildness of the fields and meadows beyond the confines of the formal garden (Plin. *Ep.* 2.17.5, 5.6.16–18).[10]

If this interpretation of the House of the Drinking Contest is right, the courtyard is the place where the visual axes intersect and where acute observers would most fully appreciate the interconnected architecture, mosaic imagery, and natural vistas. In short, the House of the Drinking Contest at Seleucia demonstrates a sophisticated spatial construct.

The House of Menander

Named for the mosaic in room 11, the House of Menander is rich in information but also fraught with problems of interpretation (see p. 50).[11] This illustration of the ground plan with mosaics inserted provides an overview of the house before the mosaics were lifted. In many ways the house illustrates both typical aspects of Antiochene domestic architecture and decoration and characteristic problems that the researcher faces in wrestling with the preserved evidence. To begin, the walls have been so

extensively robbed that evidence for doorways and property divisions is almost completely lacking. Fundamental questions such as what the connections are between rooms and where this house stops and the adjoining properties start must be addressed before larger issues of room use, traffic patterns, the meaning of the mosaic programs, and the historical development of the house can be discussed. This ground plan provides a tentative answer to some of those fundamental questions.

The main entrance to the house appears to be from a colonnaded street to the south. Although the house is large and complex, its interior design is focused on three dining suites and one possible living area.[12] The three dining areas are suite 1 (rooms 1, 2, 3, 9), suite 2 (rooms 11, 12, 19, and whatever was under the "late pool"), and suite 3 (room 13, a *triclinium,* and a fountain courtyard to its west). The residential section may have comprised the rooms around courtyard 17, including rooms to the north and northeast that are not defined. Such a multiplication of dining rooms is not unusual in the home of a Roman of high political and social status and in fact constitutes part of the evidence for recognizing the symposium as a critical social event.

Room 1 is the focus of the first dining suite. It is a courtyard with a *nymphaeum* onto which *triclinia* 2 and 3

open. The view from the inner left corner of each *triclinium* extends to the central niche of the *nymphaeum*. Clearly, room 2 is the more prestigious dining room, for it enjoys a more direct relationship with the *nymphaeum* than room 3, and more of its diners could see the fountain. Nonetheless, the fact that the host and honored guest occupying *triclinium* 3 could see the display of water underscores the principle of seating individuals of status in the best positions at the banquet.

Room 1 is a product of at least two periods of development. Figure 6 shows that the main mosaic of the courtyard overlies an earlier mosaic whose northern edge was incorporated into a later configuration that includes two columns whose plinths rest on the earlier pavement. A person leaving *triclinium* 2 would traverse the lower mosaic in a space that served as a kind of vestibule and then step up to the main space of room 1. Rather than being centered along the courtyard's southern wall, the *nymphaeum* is pushed into its southwest corner. In addition, the circular niche at the western edge of the *nymphaeum* is not balanced by a pendant at the eastern edge. This asymmetrical design and placement of the *nymphaeum* at the courtyard's southern end seems to accommodate sight lines originating at the optimal viewing points in rooms 2 and 3 (fig. 7).[13]

The fountain itself was an elaborate affair in some ways resembling the *nymphaeum* in the well-known fourth-century C.E. House of Cupid and Psyche at Ostia. The similarities are the height of the *nymphaeum,* the statue niches, and their flanking columns. A closeup of the Menander *nymphaeum* shows the ample water basin that still retains much of its interior waterproof plaster (fig. 8). At the rear of the basin are statue niches of alternating rectilinear and curvilinear forms. Projecting into the basin in the areas between the receding niches are plinths for three pairs of columns. The *nymphaeum* terminates in single columns.[14]

The above information evokes some of the splendor of the whole ensemble of suite 1. Rich food and drink from the sea and from the fertile land were served amidst mosaics, elegant couches, and walls whose treatment we can only imagine. As people moved about this busy space, conversation touched on many subjects, while the eye was drawn to statues set in a columned fountain and one's ears heard the play of water and no doubt the sound of musical instruments played by entertainers.

There were practical considerations too. The western door of the courtyard provided access to the nearby latrine,

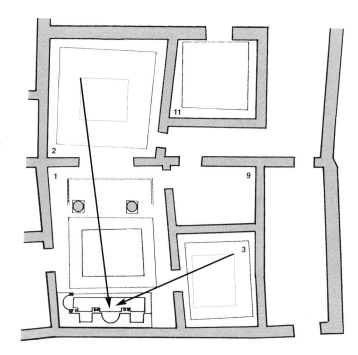

Fig. 7. House of Menander, plan. Detail of Suite 1 with sight lines drawn

which must have served *triclinia* 2 and 3. Diners in *triclinium* 11 of suite 2 could also reach the latrine by cutting through the corner of room 9 and crossing room 1. Rooms 4 and 9 are without mosaic pavements and appear to have been service rooms. It is impossible to conceive of a banquet without staging areas for final food preparation and presentation. Both could serve *triclinia* 2 and 3, while room 9 could also have served room 11. The kitchen was not uncovered. Rooms 5 and 6 may be related to the service area, but doorways cannot be reconstructed, and very little can be said about them. The rooms to the west of the latrine have not been documented.

Suite 2 cannot be discussed in such detail because the late pool located to the north of portico 12 covers the parts of the plan that were originally associated with rooms 19 and 11, a *triclinium* whose mosaic depicting the poet Menander (cat no. 40) provides the name for the house. It is likely that from this *triclinium* the host and honored guest could look between the columns of portico 12 to a now-vanished fountain. Such a sight line would require a *triclinium* door wider than that now reconstructed on the plan.

Suite 3 consists of *triclinium* 13 and a fountain court, but the poorly preserved walls and the absence of a detailed account in the excavation records make discussion of this ensemble very difficult. This suite is anoma-

Fig. 8. House of Menander, room 1.
Nymphaeum from the northeast

lous in many ways, especially in the atypical relationship between the ostensible *triclinium* and the fountain. This entire suite appears to be experimental and cannot be forced into a standard mold. If the east end is indeed a *triclinium,* it is unusual in abandoning the framed figural mosaic *emblema* in favor of an overall design more typical of spaces in which the spectators were ambulatory and not reclining on couches. Moreover, the asymmetrical geometric surround of the couches and the adjacent long carpet mosaic, typical of porticoes, form a composition that is without parallel. The asymmetrical arrangement of the entrance panels appears to relate poorly to both *triclinium* and courtyard. And finally, the fountain relates more closely to the courtyard than to the *triclinium.* Clearly, there are many interesting features here, but at this stage of analysis it is impossible to provide an adequate explanation of this suite and its evolution.

The presence of so many dining suites makes one wonder if this is truly a "house." Could it be a dining club? Only when several entire blocks of houses or several villas have been fully and carefully excavated, studied, and published will we be able to address such a question adequately. It is possible that the rooms surrounding courtyard 17 are the residential rooms of this lavish complex, but here we confront a major problem that plagues the study of ancient houses, namely, the identification of

room functions. *Triclinia,* porticoes, and fountain courts are easy to identify, and their functions are readily assigned, but the rooms surrounding courtyard 17 could have served various functions. Perhaps they and suite 2 constituted the residential part of the house, but that is pure speculation and does not take into account problems related to the adjacent house to the west, which cannot be introduced here. The House of Menander is a treasure from antiquity that gives us interesting spaces, splendid mosaics and finds, and a reason to speculate on ancient life. At the same time, it provides frustrations because our evidence from the ancient world is always incomplete. The role of this essay is to present evidence and offer cautious interpretations.

The House of the Boat of Psyches

Named for the main figural mosaic in room 3, the House of the Boat of Psyches at Daphne (see p. 72, fig. 5) presents some of the same problems as the House of Menander but offers individual variations.[15] The core of the excavated portion of the house is a suite of three rooms that open onto a portico beyond which lies a *nymphaeum.*[16] To the east of this primary unit are three additional rooms. All these rooms have mosaic pavements that are so closely integrated into the architectural design that in the absence of walls

and thresholds they constitute our primary evidence for reconstructing the main doorways. The familiar T-pattern of figural mosaics surrounded by geometric panels for the placement of couches indicates that rooms 1 and 3 are *triclinia*. There are three indications that we are justified in restoring doors between these rooms and portico 4. First, since *triclinia* are typically entered at the open part of the U-shaped configuration of the couches, there must have been doors from portico 4. Second, both rooms have entry panels oriented so as to be seen by those entering the rooms through doors from the portico. Third, if we employ the principle discussed regarding the mosaics of portico 2a in the House of the Drinking Contest, the two figural panels in front of rooms 1 and 3 must also mark entrances. Some of these arguments can also be applied to room 2, for which I would reconstruct a door to the portico; however, it is not included in the plan because of the lack of excavated evidence. The reciprocal nature of the standard spaces and their decorations is thus a great aid in reconstructing the basic traffic patterns.

There is less to go on in determining whether there were entrances to the northern and southern ends of the portico. What was the relationship between rooms 6, 7, and 8? Did room 7 connect with room 1 so that one could look and walk along the axis of the house when room 1 was not in use? Did the house extend beyond the basically squarish unit that we are discussing? Was this really a residence, or was it a facility for communal dining?

The special character of this house derives partly from the intimate relationship between architectural design and mosaic decoration. The typical linking of spaces is enhanced here as the architectural forms and mosaic decoration emphasize the central axis of the building. Turn the plan (see p. 72, fig. 5) so that the five-niched *nymphaeum* is at the top and imagine walking along the axis of the house from *triclinium* 1, over the central figural panel in the portico, and between the columns in order to view the *nymphaeum* and its mosaics. Here the erotes fishing from the backs of dolphins are actually under water and appear very real in their fountain setting; even the fish are accurately portrayed. The two dolphins at the left swim northward to the center, and the two at the right swim southward toward the center. The central dolphin dives straight down and points to the architectural axis on which the viewer stands. The orienting force of the architectural design and the decoration inevitably place the viewer in front of the central niche of the *nymphaeum*. Even the frag-

mentary portico panel in front of room 2 leads the ambulatory viewer leaving room 2 toward the central axis through the ithyphallic dwarf, who strides in that direction. The visual cues are so vivid that it is easy to imagine moving about the House of the Boat of Psyches.

In addition, these spaces are linked by the water themes in the three main rooms and in the *nymphaeum*—Europa and the Bull in room 1, Pegasus attended by nymphs at a spring in room 2, the Boat of the Psyches in room 3, and erotes fishing from the backs of dolphins in room 5.[17] The Roman practice of incorporating water into the house here extends to the mosaic themes, which may allude to the springs of Daphne, the elegant suburb where this house and the House of Menander are located. This house becomes a tour de force of water displayed in the mosaic imagery and actual water harnessed to enliven the house.

Urban allusions become apparent when we recognize that we can read the house in the same way that we read the larger city. We should see the public and the domestic as two complimentary halves in the lives of the leading Antiochene citizens; we should not use a modern paradigm and imagine the public and the private to be two unrelated and separate wholes.[18] A key component of the urban armature is the thoroughfare that leads one to the main plazas and public buildings. Visual signals in the form of architectural components inform the visitor to a city of options at intersections, announce important buildings or major plazas, such as the forum, and subtly encourage pedestrian traffic to move toward important places. Three-dimensional viewing corridors are constructed via arches that direct views and via facades and colonnades that mark edges. Way stations are spaces opening onto thoroughfares where people can pause in their movement through the city. Public benches, humble fountains, and grand *nymphaea,* such as one finds at Apamea or Ephesos, line the great colonnaded streets. Libanios emphasizes that the porticoes of Antioch are among its great amenities (Lib. *Or.* 11.214–17). He praises not only their urban but also their social role in shaping the city.

At the core of the House of the Boat of Psyches we find many elements familiar from this urban armature (see p. 72, fig. 5). Portico 5 is like a thoroughfare in a city in that it connects the public spaces of the house and is defined by a colonnade. We might think of the portico as a three-dimensional city street onto which the main entrances of three buildings open from the left. The central doorway is the grandest, and it is this doorway on

which the *nymphaeum* focuses. The equation is clear. The domestic portico functions like the colonnaded street; the entrances to rooms are like the entrances to public buildings; and the domestic *nymphaeum* functions like the grand public *nymphaeum*. By the time this third-century house was built the practice of shaping elite domestic spaces with public architectural elements may have been commonplace.

Nonetheless, whether it was self-conscious or unconscious, the appropriation of grand public architecture for domestic space and the presentation of ancient classical themes in mosaic art linked the Antiochene houses and their inhabitants to the vibrant urbanism of Antioch itself and to the larger world of classical culture and learning that extended across the empire.

1. I say "what must have seemed to be the eternal tradition of Greco-Roman culture" because in hindsight we know that the long classical period at Antioch and throughout the Roman Empire was about to end and the new Christian era was about to begin. Those who lived in these houses would not have known this even though Christianity was well established at Antioch during the period dealt with here. At the same time, we might ask if Christians who were classically educated might decorate their houses in the traditional manner while being committed to Christianity. On this very interesting question we have absolutely no information.

2. Libanios's *Oration 11* is translated in Downey 1959.

3. Stillwell 1961.

4. This is the opening line in the introductory essay, "Space and Text," by Ray Laurence, in Laurence and Wallace-Hadrill 1997, 7. See also Clarke 1991; Ellis 1997b, 38–50; Gazda 1991; Kondoleon 1995; and Wallace-Hadrill 1994.

5. Antioch I 1934, 18, pl. 4, 42–48; Campbell 1988, 19–22; Levi 1947, 15–25.

6. Antioch III 1941, 31–33, 208–11; Dobbins 1982, 2–13; Levi 1947, 156–63.

7. The *triclinium* is the largest and most exquisitely decorated room in the house. Floor-level bedding surfaces are the basis for the columns flanking the door's inner side, indicated on the plan. It is possible that the actual door treatment resembled the colonnaded opening that appears in the room's floor mosaic.

8. Stillwell 1961, 48. Similar connections between domestic spaces are known from other late Roman sites. A town house at Sardis has rooms grouped into discrete wings featuring "conspicuous water display" and "long vistas" within the house (Rautman 1995). The "villa over the theater" at Ephesos exploits external views of the theater and the even longer vista down the colonnaded street, the Arkadiane, to the port (Ellis 1997b, 41). In the Roman West, the House of Cupid and Psyche at Ostia is quite similar to Antiochene houses in its arrangement of *triclinium*, portico, and *nymphaeum*.

9. Antioch III 1941, 4; Levi 1947, 141–42.

10. Pliny could just as easily be describing Antioch. Pliny's emphasis on a vista that begins within his villa and then extends to distant landscapes could equally well characterize the arrangement at the House of the Drinking Contest. The point is that within their unique settings Antiochene houses display a universal penchant for linking the house and its users to the larger natural environment. The "villa over the theater" at Ephesos exploited the theater and the colonnaded street to lead the eye to the harbor and the expanse of sea beyond (Ellis 1997b). This kind of evidence supports the interpretation that reconstructs a view from the House of the Drinking Contest to the distant mountain peak as intentional.

11. Antioch III 1941, 25–26, 119–21 (nos. 285–96), 183–92; Levi 1947, 66–67, 198–216.

12. It is possible that our current plan represents features from different phases of the house that never functioned together simultaneously. One of the frustrations of the Antioch material is that we cannot reconstruct in detail the chronological development of the houses.

13. This asymmetrical placement to accommodate a visual rather than an architectural axis is also seen in the location of the *nymphaeum* in courtyard 3 of the House of the Drinking Contest.

14. The footing for the eastern end column is visible near the scale in fig. 8. On the plinth next to it are the footings for a pair of columns. The western end column was located where a section of conduit now stands on a footing.

15. Antioch II 1938, 183–87; Levi 1947, 167–90.

16. The colonnade has been restored on the basis of unpublished comments of Richard Stillwell in the 1934 Field Report, Antioch Archives, Department of Art and Archaeology, Princeton University: "To the west of the hall [i.e., portico 5] was a colonnade through which one viewed a small pool with five niches in a row along the back wall. At a later date the colonnade was pulled down and the columns split and rebuilt into a wall which replaced the colonnade" (14). I have not been able to discover how column placement and spacing were determined.

17. See, in this catalogue, Christine Kondoleon's essay "The Mosaics of Antioch," where the water theme is further explored.

18. The works of Andrew Wallace-Hadrill and William L. MacDonald have direct bearing on these issues. Wallace-Hadrill (1994) examines the public nature of Roman domestic space and argues that elements of public architecture are intentionally quoted in the domestic realm to underscore the status of the Roman elite. Although his focus is on the Bay of Naples, the general principles would seem to apply at Antioch. More important for the arguments being made here is MacDonald's study of "urban armatures" (1986), which identifies a structure of urban design and establishes a language for discussing that structure that can be equally well applied to the Roman house. This latter point would seem to be of some significance in interpreting the overall meaning of Antiochene domestic architecture.

Mosaics of Antioch

Christine Kondoleon

The discovery of some three hundred pavements in and around Antioch during the excavations of 1932–39 was a landmark event in the studies of floor mosaics and for our knowledge of the pictorial arts of the Roman East. While many of these floor mosaics were found in public buildings such as baths and churches, for the most part they came from private houses in Antioch and its surrounding area, the nearby lush garden suburb of Daphne, and the port city of Seleucia Pieria. Jean Lassus, the archaeologist representing the National Museums of France on the Antioch excavations, recalls that "the Antioch excavations turned into a search for mosaics."[1]

The original intent of the excavation team was to locate major sites known through classical and Early Christian writings, such as the imperial palace and the octagonal Church of Constantine ("Golden House"). However, as the excavations proceeded, the team was repeatedly diverted by random finds on local properties. Moreover, heavy rains revealed many pavements scattered around Antioch and not in the urban center. The wealth of floor mosaics was wholly unexpected, and their contents opened a new chapter on private life and domestic art in the Roman East. Because it is impossible in this essay to do justice to all the discoveries, I will attempt only to review briefly what is characteristic of the products of the Antioch workshop and then to propose a method for reading the mosaics in their architectural and cultural contexts. It must also be admitted that we are limited in our assessment by the serendipity of finds which, however impressive in number, represent only a fraction of the original inventory of floor mosaics produced in Antioch. General observations about the Antioch mosaics, therefore, must be tentative.

Mosaics from the Antioch Workshop

The Antioch mosaics date from the first decades of the second century to just after the earthquake of 526 C.E. The chronology was established by Doro Levi in his seminal publication of 1947. Although sometimes arbitrary and not always based on archaeological data, his dating scheme based on an intricate assessment of the iconography, decoration, and style of the mosaics, serves as a cornerstone in mosaic studies.

As a group, the Antioch mosaics demonstrate a remarkable continuity with Hellenistic artistic tradition, as in the preservation of classical subjects and decorative

Mosaic floor of the Atrium House dining room, 23 ft. 6 in. × 15 ft. 9 in. (720 × 480 cm). Computer-generated photo composite in which surviving figural panels are recombined with geometric patterns (reconstruction: Wes Chilton and Victoria I)

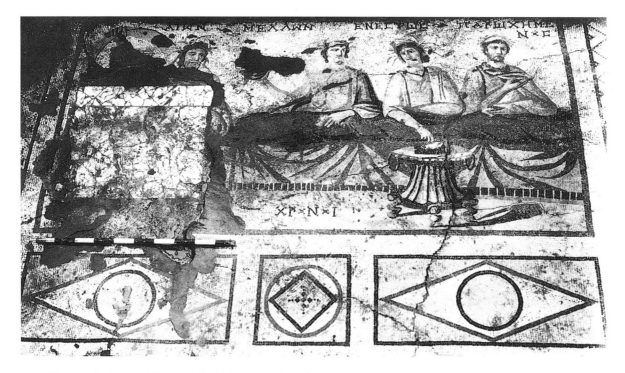

Fig. 1. Aion mosaic, House of Aion, Antioch, third century, reburied

devices such as the illusionistic treatment of vine scrolls inhabited by human and animal figures or ribbon borders. The common use of multiple borders to frame figural panels is also reminiscent of the framing of Hellenistic *emblemata,* or portable mosaic inserts. The three-dimensional treatment of interiors and landscapes, the naturalistic representation of the human anatomy, and the variety of colors employed in the Antiochene compositions demonstrate the influence of painting styles. Such skill in the production of stone "paintings," not to mention their physical relationship to the room itself, effectively denies the solidity of the floor and tricks the eye of the viewer. Finds from other Syrian sites—Apamea, Shahba-Philoppopolis, and Palmyra—are similarly traditional and point to the existence of a school of Eastern art beyond that of the Antiochene workshop. The excavators of Apamea, the Belgian archaeological team of Janine and Jean Christophe Balty, have done the most to further the study of Near Eastern mosaics. Yet even in their careful studies of the region's pavements the Antioch mosaics remain somewhat isolated and not adequately integrated, creating a false impression of singularity for the Antioch workshop.

A prevalent feature of Near Eastern mosaics is the use of Greek inscriptions to label figures and provide titles for scenes. Unfortunately, very few of these provide internal evidence for dating the mosaics. Labels appeared in the third century C.E. but were most common in the fourth, when scenes were even titled (cat. no. 9). The reasons for their use are not clear. Some scholars suggest that the written cues were needed because the compositions were less familiar, but labels are not applied consistently, which undermines this argument. In the case of personifications, for example, the similarities in a series of fifth-century female busts required labeling to distinguish the various abstract concepts portrayed, such as luxury or renewal. In the fourth century an increase of multifigure compositions of an allegorical nature necessitated labels to identify individuals, such as KPICIC (Judgment), whom the viewer could not otherwise identify. At Antioch a random find that was reburied consists of a figure labeled as AIWN (Eternal Time) and three male figures, identified as Past, Present, and Future (fig. 1)—a rather sophisticated visual meditation on time. The naming of places and topographic features, such as rivers, also prompted the use of labels (cat. no. 38).

Greek inscriptions sometimes named the artists responsible for the mosaics. Since the ancient sources do not mention any individual mosaicists (whereas several painters are named), signatures on pavements are our main source for their identity. At Antioch, however, no names of mosaicists were included on the large number of pavements discovered. But a Dionysiac mosaic of the third century from Chania, Crete, includes part of an

inscription that seems to identify a mosaicist as coming from Daphne, near Antioch.[2] This important find confirms the far-ranging influence of the Antioch workshop and suggests that mosaicists traveled to practice their trade. Thus the close parallels in the style and iconography of mosaics discovered in Paphos, Cyprus, or Sepphoris, Israel, with those of mosaics in Antioch may be attributed to direct contacts.

The inscriptions also provide us with some insights into the production of floor mosaics and the organization of the workshop. At sites other than Antioch, inscriptions were found that name a designer as well as the person responsible for laying the *tesserae* (tiny cut pieces of stone, usually limestone or marble gathered from local sources such as quarries or beaches, and glass, used primarily for highlights). Looking to the practices of ancient wall painters, it is instructive to note that the work team was made up of several specialists—a figure painter, an ornament painter, and a plasterer. It seems likely that floor mosaics were laid with similar levels of specialization. The discovery of a few sinopia, or red line underdrawings, in the setting beds indicates a preparatory process for the laying of the pavements. Great skill was needed to work directly on the site, laying the *tesserae* into wet plaster beds. Despite the widespread supposition among scholars that pattern books were used, there are very few identical mosaics, suggesting a more dynamic process of training involving memory and improvisation on standard themes. Surely the patron had a significant role in the selection of themes for his house; in fact, some signatures seem to name both the owner and the maker of the mosaic. Curiously, according to Diocletian's price-fixing edict of 301 C.E., the wages paid to mosaicists of walls and floors were substantially lower than those paid to other artists. Despite low wages, it was undoubtedly expensive in terms of both time and materials to commission floor mosaics, especially the polychrome figure panels so popular in Antioch. Nevertheless, at Antioch many houses were filled with mosaics, often of a grand scale, attesting to the level of affluence of many Antiochenes.

Near Eastern mosaicists were slower to incorporate the range of themes explored almost two hundred years earlier in the Latin West and best demonstrated in the pavements from North Africa and Spain, namely, those drawn from life on agricultural estates, game hunting, and events in the Roman arena. Comparable subjects did not appear until well into the fifth century in Antioch,

especially in the large hunt mosaic series (fig. 2). The notion of self-representation through such scenes and the documentation of life in the city and countryside around Antioch is best illustrated by the inscribed border surrounding the Megalopsychia Hunt mosaic (see p. 8, fig. 6).

Extant wall paintings and floor mosaics demonstrate a persistent emphasis on Dionysos and Aphrodite as the preferred deities for representation throughout the Roman Empire. At Antioch, images of Aphrodite are surprisingly rare. Unusual compositions, such as the Peddlar of Erotes or the Boat of the Psyches, indicate a rather creative imagination around the sphere of Aphrodite, but none of the extant Antiochene mosaics focus on her alone. Far more developed is the iconography of Dionysos and his domain of wine drinking and merrymaking. This preference is also evident in the mosaics produced under the influence of the Antioch workshop, for example, at Paphos on Cyprus, at Chania and Knossos on Crete, and at Sepphoris in ancient Galilee.

Certain Persian elements also characterize the mosaics of Antioch. Beribboned birds (cat. no. 25) and lions, not to mention the foreparts of rams posed on spread wings (cat. no. 21), can be traced to the influence of Persian art, most likely through portable arts such as textiles and silver.[3] In addition, the mosaicists of Antioch were especially predisposed to and inspired in the creation of female personifications in order to express concepts such as ΚΤΙϹΙϹ (Foundation) (fig. 3) or ΓΗ (Earth) or ΒΙΟϹ (Life). Yet not a single muse was found, even though Calliope was one of the tutelary deities of Antioch; her statue was in the Theater of Trajan, and her temple was in the central part of the city. These anomalies in the repertoire of excavated Antioch mosaics may indicate certain local predilections, but they also make clear the breadth of the lacunae, which is the result of the limited area of excavation relative to the original size of the city.

It is not my intention here to enumerate or comment upon the three hundred or so mosaics uncovered to date. In light of current Roman scholarship, however, it is desirable and timely to reevaluate these remarkably vivid witnesses of a bygone era. The lack of completely excavated houses in Antioch, and the uncertainty of whether the various spaces uncovered were in fact domestic remain problematic. I have selected three of the best preserved domestic spaces: the dining room in the Atrium House, the core of the House of the Boat of Psyches, and the House of Menander. In the first case, we enter into a room that can be certainly identified by its design for dining and which

retains its original ensemble of mythological panels. In the second case, we lack the complete plan of the House of the Boat of the Psyches, but the extant grouping of rooms and their decorations indicate their use for convivial occasions. The House of Menander, the largest domestic complex with mosaic floors in almost every room, offers a walk through a relatively complete Antiochene house.

Working with the original plans, as well as excavation reports and photographs, the artist Victoria I directed the production of reconstructions with the floor mosaics inserted, permitting us to revisit these structures with an eye to furthering our understanding of how floor decor functioned in the context of eastern Roman architecture. To be sure, the variety of responses experienced by the Roman viewers to the rich array of images found on the ceilings, walls, and even the floors can never be fully understood. However, the Antiochene houses with their mosaics suggest that the viewers selected and interacted with pictorial signs in a sophisticated manner.

The Dining Room of the Atrium House

The visually complex ensemble set on the floor of the Atrium House dining room will serve as our first example (see p. 62). By assuming the point of view of those who entered, we can map an itinerary that accounts for the viewer's visual, spatial, and mental experience. The visitor perceived the wealth of imagery underfoot in many ways.

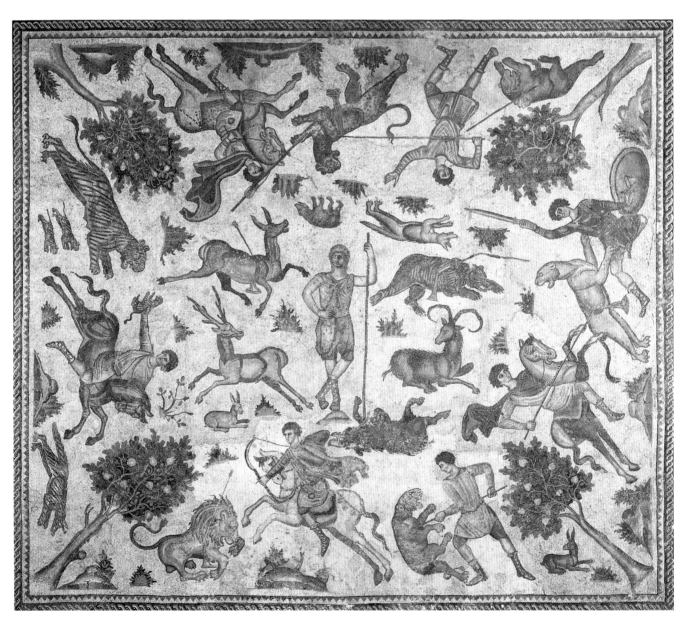

Fig. 2. Hunt mosaic, House of the Worcester Hunt, Daphne, sixth century, 20 ft. 6 in. × 23 ft. 4 in. (625.8 × 710.6 cm). Worcester Art Museum, 1936.30

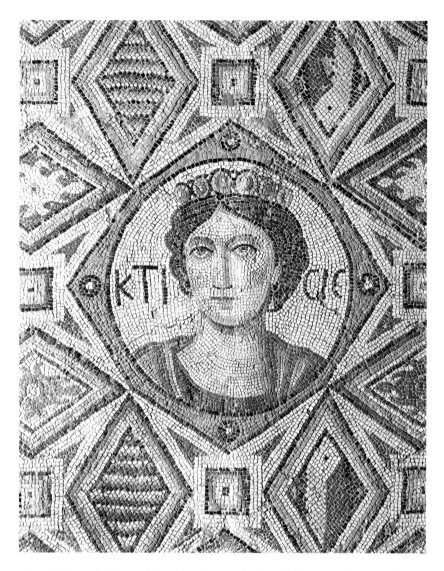

Fig. 3. Kticic mosaic, House of Ge and the Seasons, Daphne, fifth century, 9 ft. 4 in. × 9 ft. 1 in. (284.8 × 275.6 cm). Worcester Art Museum, 1936.35

On first encountering the room the guest must surely have been dazzled by the sheer density of ornamentation and figural forms. One is immediately conscious of the wealth required to commission these mosaics and the virtuosity of technique employed in the creation of painterly panels of tiny stone *tesserae.* Even today any one of these mosaics elicits a response of awe from museum visitors. The assemblage of this picture gallery framed by multiple polychromatic borders was spectacular.

When the guests were invited to enter this grand room, they crossed the threshold and proceeded toward the far end where they sat on one of the three dining couches arranged in a U-shaped configuration around the figural panels. These panels were arranged in the traditional T: the crossbar containing three panels, the Drink-

ing Contest in the center and a dancing maenad and satyr on either side, and the vertical shaft formed by the Judgment of Paris at the top and a seated Aphrodite and Adonis at the bottom. The compositions of the latter two panels were oriented toward the rear of the room for viewing by the diners on the couches, while the Drinking Contest faced those who entered.

What exactly did the ancient visitor *see?* The visual effects of the ensemble are worth noting both for dating purposes and to understand how the imagery was received by the viewer. The date of the Atrium House pavement is not secure, but the weight of both archaeological and stylistic evidence places it in the early decades of the second century C.E.[4] The artistry of these panels harks back to early periods, as evidenced by the exquisite, inhabited

vine scroll that surrounds the two inside picture panels, clearly evoking late Hellenistic models.

The artistic style of the Atrium House panels was characterized as "impressionistic" by Doro Levi, who noted that the compositions were filled with coloristic effects and the play of light and shade found in Fourth Style Pompeian painting. The multiplication of frames and the realistic spatial treatment within each panel break open the ground itself by creating "window pictures" on the floor. The illusionistic expansion beyond the architectural bounds of the room is the essence of Fourth Style wall paintings. The Atrium House floor mosaics display the same visual disorientation. The artificial world created within both painted and mosaic panels, which obeys some semblance of reality, forces the spectator to be conscious of a construction and to partake wittingly in a perceptual manipulation. Yet because all is play and illusion the viewer is also denied the world into which he or she is invited.[5] This teasing quality of Roman house decoration engenders a shifting view of the world within the architectural enclosure.[6] Surely the visitor sensed the boundaries' shifting even more acutely as he or she walked over the floor, a solid foundation, an opaque surface whose very tangibility is denied by the setting of tiny stone and glass *tesserae* into cement.

These pictorial fictions were laid out across the very foundations of the Roman house. One not only sees these spaces, one moves through them and acts in them. Clearly, the spectator plays a role, along with the mosaicist and house owner, in controlling the viewing process. Given the variety of producers, a variety of readings must be admitted, and any act of reconstruction or interpretation is necessarily only "an assemblage . . . of partial integrations, guesses, and recognitions."[7] The evidence from other media with known contexts, especially mural paintings and sarcophagus reliefs, encourages renewed efforts in interpreting floor mosaics.

The idea of thematic ensembles within one room or a series of rooms has been explored for Campanian houses.[8] Mary Lee Thompson's extensive survey showed that "the logical combination of paintings to form one-room programs is found throughout Pompeii . . . in modest, as well as luxurious houses."[9] While scholars often overlook the possibility of meaningful connections in the selection of pavement decorations, the three cases examined in this essay suggest otherwise.[10]

At the very entrance of the Atrium House dining room is the three-panel ensemble comprising the Drink-ing Contest between Herakles and Dionysos at the center and a maenad clashing her cymbals and a dancing satyr on the lateral ends (cat. nos. 55–57).[11] These Dionysiac celebrants, together with elements in the central scene, namely, the foregrounded drinking vessels, the female flute player, and the saluting Silenos, compose a pictogram with the message, "Eat, drink, and be merry." Yet there is another message embedded here. The way in which Herakles, a mortal hero, is depicted as brought to his knees, swaying back as he finishes his wine, while the immortal Dionysos calmly holds up his empty cup from a reclined position, is telling. On one level, the message is fairly obvious and direct: one should be mindful and drink in moderation. However, just as the perspectives shift on the floors and walls, so does meaning. The pictorial analog to a convivial toast simultaneously reads as a plea for *sōphrosynē,* a Greek term meaning "moderation in desires." Aristotle and Plato focus on this virtue of self-control in their writings, where they promote the model of an individual who desires to a moderate degree and who has mastery over the excesses of pleasure. In a city as steeped in Hellenic culture as Antioch was, *sōphrosynē* was surely much discussed, if not conscientiously embraced. In fact, we learn from Plutarch (*QC* 7.8.711A) that one form of dinner entertainment in vogue in Rome was the acting out of Plato's dialogues; why not in Antioch?

An exploration of texts on the banquet, such as Plutarch's *Convivial Questions,* Athenaeus's *Sophists at Dinner,* and other writings of the second and third centuries, offers insights into the cultural world in which the pavements were conceived. Much is written about drunkenness, a state to be avoided, according to the ancient authors, who treated "the properly conducted symposium [as] an index of civilized behavior."[12] Excess was something brought on by too much revelry, or *komos,* which needed to be checked at the door, as it were. The recent discovery of a spectacular Dionysiac floor mosaic in a third-century house in Sepphoris, Israel, underlines this ancient preoccupation with drinking.[13] Of the fifteen panels, at least three show the mortal hero Herakles out of control, and two are labeled with the Greek word *methē* (drunkenness); the large central panel features the Drinking Contest, with several more attendants than are shown in the Antioch mosaics (fig. 4). The varied scenes of the entire pavement, many of which are identified by Greek inscriptions, reflect Dionysiac celebrations and cult practices. Contrasts between a tired Herakles lying on his

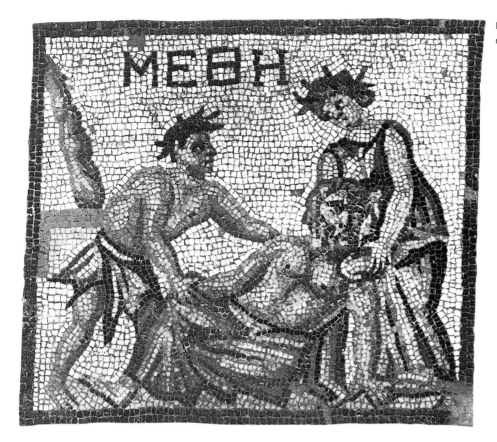

back and the triumphant Dionysos are popular in the mosaic repertoire, as seen in the opposing medallions found in the grand reception room of the fourth-century Constantinian Villa at Antioch (cat. no. 92). The imagery also appears to set the rules for correct rituals and propriety in honor of the god. The repetition of the drinking scenes in a dining context allows us to read their moralizing message with some confidence.

Guests at an Atrium House banquet would take their positions on the three couches set on the diamond-pattern mosaic (see p. 62). The geometric mosaic marks out the arrangement of the dining couches in a U around the two mythological scenes oriented toward the rear wall for the better viewing of the reclining guests. The Judgment of Paris, in the middle of the room, is by far the most elaborate of the figural mosaics, with the three goddesses grouped together at the right and Paris conferring with Hermes in the left foreground (cat. no. 58). The simplest explanation for its inclusion in this house at Antioch is the one offered by Libanios, the famed fourth-century teacher and native son, who believed that the contest took place in Antioch rather than at Mount Ida, as was commonly held (Lib. *Or.* 11.241). But given the meanings

inherent in the other panels, local pride is probably not the point.

A sampling of some of the writings contemporary with these mosaics reveals the tastes of the sophists, intellectuals of the second and third centuries C.E. from Hellenized cities of the East who wrote about things ancient—topography, myth, history. Lucian, a Syrian writing in the mid-second century, employed dialogue to talk about art, myth, and religious subjects. One of these, *The Judgment of the Goddesses,* dramatizes the plight of a mere mortal, Paris, who is tempted by the seductions of Hera, Athena, and Aphrodite. In trying to imagine the settings of the myths and the dialogues between the protagonists, Lucian engages in a rhetorical exercise that might be seen to have its visual parallel in these mosaics. In other words, the mosaicist imagines the settings for the same myths and in place of dialogue employs gesture to communicate the story. The writings of the sophists and the material evidence of the mosaic pictures attest to an elite culture that nurtured and revived all things Greek. Both offer insights into the intellectual life of the elites inhabiting these houses and perhaps suggest the tone of their dinner talk.

Similarly, Athenaeus's *Sophists at Dinner* is almost anthropological in its recording of recondite lure, as he also evinces an acute fascination with earlier Greek customs. In the twelfth book Athenaeus breaks into his own voice, revealing a contemporary rather than an antiquarian sentiment: "I for one affirm also that the Judgment of Paris, as told in the poetry by writers of an older time, is really a trial of pleasure against virtue."[14] Aphrodite lures Paris, the son of Priam, to choose her as the most beautiful of the three goddesses by offering Helen, the most desired of all mortal women. Paris selects Helen over the worldly power offered by Hera and the military glory offered by Athena. When pleasure *(hēdonē)* is given preference, all is thrown into turmoil: the Trojan War begins and the lineage of Priam is destroyed. In at least two of the Atrium House mosaics the mortals are no match for the gods, for just as Herakles succumbs to drink, Paris succumbs to desire.

Greek writers such as Plato and Euripides attribute the greatest power to Aphrodite, crediting her pleasure as the most maddening in human affairs. In the last panel in the Atrium House (cat. no. 59) the enthroned goddess sits beside her beloved, the mortal Adonis, shown nude with his hunting dog beside him. Even the powers of Aphrodite could not prevent her handsome hunter from meeting his fate, a mortal wound inflicted by a wild boar. The moment shown—the seated couple with arms draped about each other—is a common image in mythological compositions. Most likely, the scene takes place before Adonis's departure for the hunt, which he pursues against the wishes of the goddess. Here the scene occurs outside of a continuous narrative and depends on the recognition of the tragic outcome for its significance to be understood by the viewer.

There may be multiple reasons for featuring the divine couple at this location in the room. A formal relationship exists between the mythical lovers represented on the floor and the guests of rank and privilege seated opposite them on the middle couch *(lectus medius)*. For just as on sarcophagus reliefs, where the enthroned couple can signify the deceased, in a domestic space the diners can "see" themselves reflected in the divine pair.[16] The spatial context provides a meaningful framework in which the barrier between the real and the represented is challenged and dissolved.

Local traditions and religious practices also influenced literary and visual references. Another explanation for the prominence of Aphrodite and Adonis might be the popularity of the cult of the dying Adonis in the Semitic Near East and in Antioch itself. In *The Goddesses of Syria* Lucian describes how the women of Byblos lament the death of Adonis at an annual festival held in July: they playact that he comes alive and carry him in effigy to the Temple of Aphrodite, where they place him upon a couch beside his lover.[16] Ammianus Marcellinus, a native of Antioch writing in the later part of the fourth century, tells us that the women of Antioch lament and beat their breasts over the death of Adonis and interprets the festival as "a kind of symbol of the ripened grain" (22.9.14).

Either reading of the Aphrodite and Adonis mosaic—in terms of its placement in a reciprocal relationship with the guests of honor or as a record of local religious beliefs—by itself does not account for the mosaic's juxtaposition with the Judgment and the Drinking Contest. Each panel retains its own multiple allusions and meanings, but studying them in combination allows us to understand how they were received by the Roman viewer. Although guests would have focused attention on each panel singly, they could also have responded to the pictorial signs, such as repeated figures, parallel compositions, and thematic links. For example, in each panel a mortal—Herakles, Paris, or Adonis—face the trials of fate and the deities.

Similarly, the Beauty Contest between the mortal Cassiopeia and the divine Nereids appears in three mosaic panels found in three houses within the Syrian orbit, at Paphos, Apamea, and Palmyra. In each of these mosaics KPICIC, the personification of Judgment, appears and underlines the significance of the concept of a trial. Aside from the many rather recondite explanations inventively researched by scholars, including the Syro-Phoenician roots of the myth and its reflections of the Neoplatonic school in Apamea, surely it was the beauty contest itself pitting the lovely mortal against the divinities of the sea that the inhabitants and their guests found most compelling. Lessons embedded in myth are a commonplace of the ancient world. Myths were used in the education of youth as exempla in rhetorical exercises called *progymnasmata*.[17] For example, students might be given a theme, often a trial, from myth and asked to argue a different outcome, to debate the verdicts. We could postulate that the appearance of contest myths cast into pictorial forms, such as the Judgment of Paris, the Contest of Cassiopeia, or the musical contest between Marsyas and Apollo, functioned to stimulate memory and commentary at banquets and the like.

Can the three myths in the dining room of the Atrium House be understood as such rhetorical exempla? When they are taken as an ensemble, multiple readings and meanings emerge. Some diners might contemplate the different outcomes of the Drinking Contest and the Beauty Contest and in so doing reflect on their own conduct in relation to the pleasures of the senses. Issues of fate and how the gods played in the affairs of man might be explored in all three figural panels. Desire can be seen to motivate both gods and mortals. That Aphrodite figures in two of the panels surely speaks to the dominance of desire, while the tragic ends of Paris and Adonis warn about the failure to control it. The first lesson, to drink moderately, was encountered at the entrance to the room. The myths on the floor of this Roman-period banquet hall seem to be a reminder of a Greek past in which the ancient sensual appetites for sex, drink, and food were a subject for philosophical debate and their management was a matter of personal honor. Such scenes must have stimulated dinner discussions and a rehearsal of the lessons implied.

The House of the Boat of Psyches

The large percentage of mosaics from Antioch that focus on water—multiple representations of river deities (cat. no. 38), busts of Tethys (cat. no. 39), and fishing erotes—seem to almost echo the words of Libanios, whose oration on his native city extolls its rushing streams, its natural springs at Daphne, and its location on the river Orontes with nearby access to the Mediterranean as key factors making Antioch a city renowned for its physical beauty (*Or.* 11.244–48).

Water seems to be the underlying theme for a group of mythological mosaics found in the House of the Boat of Psyches at Daphne (fig. 5).[18] The core of the partly excavated house comprises a series of three large rooms oriented toward a fountain composed of five semicircular niches and a colonnaded portico at its western end. At the fountain (area 5), viewers could look down through pools of water and see a mosaic of erotes fishing from the backs of dolphins. They could then walk into the portico (area 4), where two panels show the contorted bodies of a satyr and a hermaphrodite locked in an erotic tangle (a *symplegma*)[19] and a third at the north end, the sign of good luck, the ithyphallic dwarf.[20] From the portico visitors could enter the main *triclinium* (room 1), where they would be greeted by the busts of Oceanus and Tethys, and then take their seats to gaze down upon Europa on the Bull, the central

panel of the mosaic pavement. Alternatively, guests might enter room 3 to gaze upon three panels, the central one showing Lycurgus entangled by the vine, the one on the right a fragmentary panel showing Apollo and Daphne, and the one on the left a most inventive panel, the one for which the house is named, showing Eros driving the boat of the Psyches (fig. 6). Guests would be seated on couches to either side of this last panel. On the other side of the grand dining room, room 2 features the winged horse Pegasus attended by nymphs beside a spring.

At the rear of the plan, in the eastern part, a sequence of three rooms includes a long narrow room (6) with a large bust of Tethys surrounded by fish and erotes (cat. no. 39). Significantly, room 8 presents a unique scene in which three figures are identified by Greek labels as ΟΠΩΡΑ (Harvest or Vintage), a female, and ΑΓΡΟΣ (Fields), a male, recline for dinner as ΟΙΝΟΣ (Wine), represented as a Silenos, serves them drinks (fig. 7). Given the lack of any parallels for this banquet scene, it is likely that artistic invention was motivated by the function of this group of rooms. The banquet and its allusions to the fertility and abundance of the land would have special meaning for this agriculturally rich region. Although room 8 is not arranged in the manner of a *triclinium*, its subject matter and the single geometric carpet, perhaps for a single couch, on the north side strongly suggest that it functioned as a more intimate dining space.

Of the eight excavated rooms in the House of the Boat of Psyches, five feature illustrations of myths that take place in or near water. Even the background colors chosen for the two most prominent figural panels evoke an aqueous element: the eponymous mosaic of the Boat of the Psyches from room 3 is filled with blue-gray water (fig. 6), and Europa on the Bull from room 1 is set against an unusual green ground, indicating the sea into which the bull plunges with his victim. Beyond the obvious topographic associations with water in the various myths, there may also be an underlying significance to their selection. For example, not only does the Pegasus scene take place near a spring but the immortal horse is said to have created many springs by the stamping of his hooves.[21]

Rather than trying to decode single scenes, it might be more profitable to ask what the significance of water was to the Antiochene hosts and their guests. Marine scenes have been interpreted as symbolizing the sea in cosmographic schemes devised for sequences of rooms in Roman villas of the fourth and fifth centuries, wherein the earth was repre-

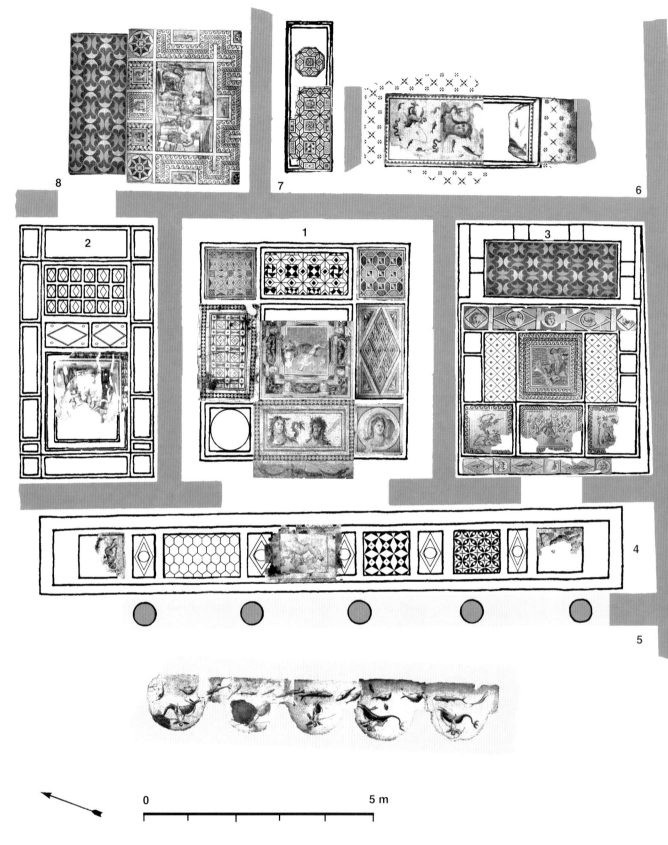

Fig. 5. House of the Boat of Psyches, Daphne, third century. Ground plan with mosaics inserted. Plan drawn to show walls as found by excavators; all entrances are hypothetical (plan: Wes Chilton and Victoria I)

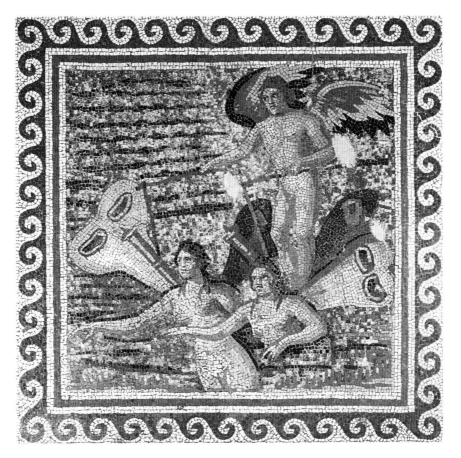

Fig. 6. Boat of Psyches, room 3, House of the Boat of Psyches, Daphne, third century. Hatay Archaeological Museum, Antakya, 846

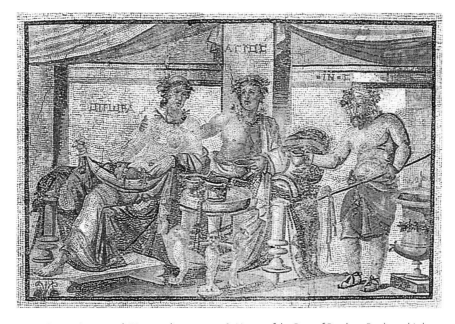

Fig. 7. Opora, Agros, and Oinos at dinner, room 8, House of the Boat of Psyches, Daphne, third century. The Baltimore Museum of Art, 1937.127

sented by hunting scenes or agricultural produce and the air was represented by birds.[22]

We must turn to a more earthly realm in order to elucidate the significance of water. A repeated metaphor for the symposium in Greek art and literature is the ship: drinking parties are likened to ships steered by Dionysos, and the drinkers to sailors.[23] The metaphor of the unsteady ship, of "going under" in wine, and the effects of the hallucinations induced by wine can be found in these texts. Anxiety about the deleterious effects of overdrinking permeates the writings about the symposium, especially Athenaeus's *Sophists at Dinner*. Athenaeus relates the tale of King Amphictyon, who was taught by Dionysos to drink wine mixed with water so that men might stand upright, that is, "be civilized" (2.38). Thus, water was a necessity for the ancient banquet because the mixing of wine and water could vary the intensity of the drinking.

The recurrence of water as a theme in writings about symposia is striking and may be used to shape our reading of some mosaics.[24] Perhaps watery themes underscore the importance of drinking in moderation, that is, of drinking mixed wine, and simultaneously evoke the interplay between the ship and the banquet, wine and the sea. By bringing antiquarian lore on dining into the household we can begin to piece together a framework for the selection of myths. This interchange between text and image can hint at lost dinner conversations and other ephemera of the banquet.

The House of Menander

Three dining suites dominate the last of the reconstructed plans, those in the House of Menander at Daphne, the most complete of the excavated houses from the Antioch region (see p. 50). The mythological mosaics reflect the same preoccupations as those found in the neighboring House of the Boat of Psyches. Each suite comprises a *triclinium* with sight lines through a porticoed court area to a fountain, and the mosaics that decorate these areas have dining, desire, and water as themes.[25] Near the main entrance is the suite with Narcissus in the dining room (room 2) overlooking fishing erotes (area 1) and a multiniched fountain. An almost life-size figure of Narcissus occupies the center of a room-sized mosaic pavement (fig. 8). The panel depicts the handsome youth sitting on a rocky outcrop in a lush woodland gazing into the pool. The scene captures an erotic moment, namely when Nar-

cissus falls in love with his own reflection. At the same time that Narcissus is seduced by the illusionary effects of the reflection in the water, so too are the viewers taken in by the naturalism of the scene. Perhaps, because of its sylvan setting beside the pool, the Narcissus scene is popular for domestic decoration. Narcissus, associated with fountains and a cool landscape, functions as a sign of refreshment and luxury. In addition, it is the awareness of the tragic outcome, as with the Aphrodite and Adonis scene in the Atrium House dining room, which draws the beholder into the implications of the scene. The moral message of the myth is that we should not be taken in by appearances, otherwise fateful delusions await us.[26] Narcissus is a trope for desire, for the delusions of love, or perhaps even as a warning about seduction—by the host, by the banquet, and by art.

Adjacent and to the east of the Narcissus room is room 11 (see p. 50), with the mosaic of Menander and Glykera reclined on a dining couch (cat. no. 40). The scene and the overall composition of the pavement, as well as its location off another large portico and courtyard, indicate that it was used as a secondary dining room.

Stepping out of room 11 into the adjoining corridor 12, the guest was directed to the grandest complex of all, suite 13, with a *triclinium,* a corridor, and a courtyard with pool. It is here that the "loves of the gods" are featured in four quadrants (two depicting Eros and Psyche, one featuring Leda and the Swan, and one with Argos and Io[?]) around the central figure group, Ganymede and the Eagle. This figure group faces the rear wall, where the guests of honor were seated, from which they had a spectacular view of the large courtyard and its fountain to the west. A long narrow mosaic comprising four panels precedes the main composition of love. Three of them are figural panels that face into the room rather than out because guests were meant to enter through the door on the east side, effectively setting this quarter of the house apart for entertainment. The three panels differ in subject matter but are obviously intended as an ensemble. At the north end of the dining room is the bust of a female identified as ΤΡΥΦΗ (Luxury; Lat., *otium*) wreathed and holding a cup (fig. 9), similar to the bust at the entrance to room 2, the room with Narcissus. The female busts with their raised cups signal a kind of toast and an invitation to partake in the generosity of the host and his household. The label of Luxury proudly announces the bounty of the region surrounding Daphne. This message is

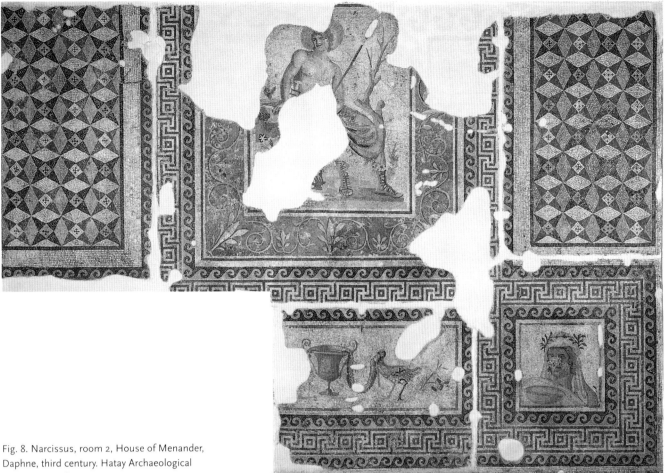

Fig. 8. Narcissus, room 2, House of Menander,
Daphne, third century. Hatay Archaeological
Museum, Antakya, 1008

underscored by the center panel, showing four figures engaged in the olive harvest. On the other end are two reclined water deities, labeled ΛΑΔWN (Ladon) and ΨΑΛΙC (Psalis). The Ladon River, according to Syrian sources, flowed near the famed Temple of Apollo at Daphne, and Levi suggests that while unattested as a river, the nymph representing Psalis may well refer to the rushing falls or springs in Daphne.[27] The three panels together form a triad of welcome and allude to the wealth (ΤΡΥΦΗ) of the land and sea that enriches the environs of the House of Menander. Indeed, these are polysemic images that gain depth and meaning from their combination and their location.

There are a number of thematic linkages between these suites, such as the repeated water imagery (rooms 1, 13, and 17) and the duplication of symposium scenes (rooms 11 and 19).[28] In its topographic reference, the Ladon and Psalis panel also relates to the Apollo and Daphne panel at the center of corridor 16, at the rear, or northern, end of the house. Here Daphne, desperate to resist the amorous advances of Apollo, transforms herself into the laurel bush (Gr., *daphne*). Libanios credits Daphne with giving the waters to the suburb named after her; he notes how critical it is to have natural local waters and not be dependent on foreign sources (Lib. *Or.* 11.243). The agricultural wealth of the region and the luxurious appointments of the houses depend on it. Moreover, the episode of Apollo and Daphne is retold by Libanios as key to the Hellenistic foundations of the city and the sacred precinct of Apollo at Daphne (11.94).

In summary, the number of reception suites in the House of Menander is striking given the size of the house, and the same seems to be true for the House of the Boat of Psyches. The prevalence of water both in the multiple pools and fountains and in the mosaics suggests a program that operates on many levels. Water evokes the wealth of the household, which in turn depends on the sources in Daphne. Both Antioch and Daphne are celebrated for their abundant waters (Lib. *Or.* 11.244). Water imagery is used as a topos for luxury, including representations of

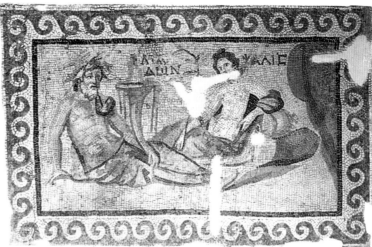

Fig. 9. Bust of TRYPHE and panel with LADON and PSALIS, from dining room 13, House of Menander, Daphne, third century. Hatay Archaeological Museum, Antakya, 1015

the much-prized Mediterranean fish; it also alludes to the sea metaphor for drinking parties and functions as a reminder to the guests to mix water with their wine, surely a necessary "sign" for the many reception suites of the House of Menander. Finally, the decoration of the three plans discussed above—for the Atrium House *triclinium,* the House of the Boat of Psyches, and the House of Menander—seems to formulate a pictorial discourse on the excesses of desire with regard to love and wine. The manifestations of desire are evident in the two panels featuring Aphrodite in the Atrium House dining room and in the large-scale panels of Europa on the Bull and the Boat of the Psyches in the house by that name, as well as in the grand Narcissus panel and the "loves of the gods" in the House of Menander. Drinking or wine is present in the replication of symposium scenes in all three houses. The dominance of Aphrodite and Dionysos in the Mediterranean mosaic repertoire reveals an all too human preoccupation with pleasure—and why not, given the domestic context?

The Antioch mosaics are significant in part because of their outstanding technical achievements, the brilliance of their decorative and naturalistic effects, and their grand scale. Their sheer quantity and localization offers a rare opportunity to study the iconographic and stylistic changes over four hundred years of Roman and early Byzantine art history. Their production in a thriving metropolis reveals much about the tastes and cultural habits of its citizens. They allow us to follow the adaptations and transformations from pagan to Christian contexts, as well as the philosophical formulations and the ideals of living projected onto the floors by members of Antioch's society. The dialogue between the visual evidence and the contemporary texts helps to animate the multifigure pavements, which, undoubtedly owing to their expense and the care with which they were produced, were the pride of the householders and the envy of their guests.

1. "La fouille d'Antioche est devenue une fouille de mosaïques." Lassus 1984, 362.

2. I wish to thank Stavroula Markoulaki, of the Chania Museum, for this information.

3. Anna Gonosová discusses the Persian features of Antioch mosaics in greater detail in her essay on Persian art in this catalogue.

4. The pastoral scenes found in the basilica of the residence at Hadrian's Villa at Tivoli and now in the Vatican offer close stylistic parallels especially to the Judgment of Paris panel.

5. For an extended discourse on the interplay of desire, the viewer, and imagery in the Roman house, see Elsner 1995, 74–87.

6. As Norman Bryson puts it, "Reality is playfully invaded by its fictions; the room is gathered and absorbed into the space of simulation" (Bryson 1990, 45).

7. John Winkler used these words in his presentation of the varieties of readings of Apuleius's *The Golden Ass* (Winkler 1985).

8. See Thompson 1961; and, more recently, Bergmann 1994, in which Bergmann offers a method for the interpretation of the atrium murals in the House of the Tragic Poet at Pompeii.

9. Thompson 1961, 246.

10. A recent study supporting a meaningful combination of images is Daszewski 1985, which "decodes" a room with six mythological panels. For a study of the interactions between the functions of the room and the meaning of the imagery of the floor decorations for an entire house, see Kondoleon 1995.

11. Although the drinking contest is not a common theme in Roman art, two mosaics from Antioch have this theme; the other is located in the Princeton University Art Museum.

12. Paul 1991, 166. On drunkenness, see D'Arms 1995.

13. For the Dionysos mosaic at Sepphoris, see Nagy, Meyers, and Weiss 1996, 111–15, esp. fig. 49.

14. Ath. 12.510c (trans. Gulick).

15. See Koortbojian 1995, 23–62, for a discussion of the sarcophagus reliefs depicting the Adonis myth.

16. Burkert 1985, 176–77, reviews the Semitic origins of Adonis.

17. According to Koortbojian 1995, 36, these exercises produced minds that were "predisposed to think in terms of these formulae." Libanios wrote his own *Progymnasmata* for his fourth-century pupils. Balty 1995, 45, suggests that rhetorical training offers an approach for contextualizing the Apamean mosaics.

18. See "Houses of Antioch," John Dobbins's essay in this catalogue, for an analysis of the relationship between the rooms and the *nymphaeum*. Moreover, Dobbins observed in a lecture in 1989 that water was a theme for the mosaics in the House of the Boat of Psyches. However, Dobbins and I draw different conclusions from our shared observation.

19. The presence of two panels with the *symplegma* scene in a colonnade strongly suggests that the mosaicists copied sculptural groups, which were often installed in pairs within the peristyles and gardens of Roman houses (see Bartman 1991, 80). The reflection of a sculptural arrangement in the mosaic was noted by Levi (1947, 183–85). The *symplegma* of a hermaphrodite and a satyr is a popular sculpture group derived from a Hellenistic model as seen in the fragments two groups found in the theater at Daphne (see Cornelius Vermeule's essay in this catalogue).

20. The dwarf and its accompanying inscription, ΚΑΙ CY (And You), are an apotropaic formula found at the entrance to the House of the Evil Eye in Antioch. Its location at the north end of the portico strongly suggests that this was a point of entry into the core of the House of the Boat of Psyches. It warns the visitors that whatever ill will or good wishes are felt toward the household are sent back to them.

21. Libanios, in his discussion of the natural springs of Daphne, mentions that the spring on Helicon was produced when Pegasus struck the rock with his hoof (*Or.* 11.97).

22. Schneider 1983. Similarly, in late Roman texts, e.g., those of Paulinus and Fortunatus, the topos of the banquet was the produce of the whole world set on the table (Roberts 1995). Early Byzantine church pavements also seem to follow this scheme (Maguire 1987).

23. See Slater 1976, where it is noted that the metaphor persisted into Roman times; Davidson 1997, 44–46; and for the extension of the marine metaphor to artifacts of the symposium, Lissarague 1990, 107–22.

24. For example, in the House of Dionysos at Paphos, Cyprus, three mosaics depict myths that take place near water—Pyramos and Thisbe, Apollo and Daphne, Amymone and Poseidon. They are set around a longer panel with Ikarios and Dionysos illustrating the Invention of Wine. Placed as they are in the portico that precedes the grand dining room, they can be read as a discourse on how one must mix wine with water for proper drinking, see Kondoleon 1995, 147–90.

25. In his essay on the houses of Antioch in this catalogue, John Dobbins discusses these spatial units within the House of Menander.

26. In an insightful essay on what the ekphrastic literary tradition can reveal about the reception of Narcissus in ancient art, John Elsner asks, "Can we be sure that we are not subject to the seduction and desire that cost Narcissus his life?" (Elsner 1996, 253).

27. For a discussion of the Syrian version of the Apollo and Daphne myth that includes the Ladon River and the various related imagery, see Kondoleon 1995, 170–74; and on Psalis in particular, see Levi 1947, 205.

28. Although the figural panel in room 19 is fragmentary, we can discern a couple reclined for dining attended by a female servant and a musician playing the lyre.

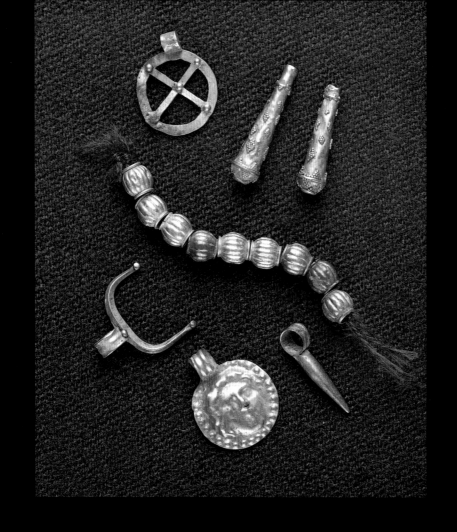

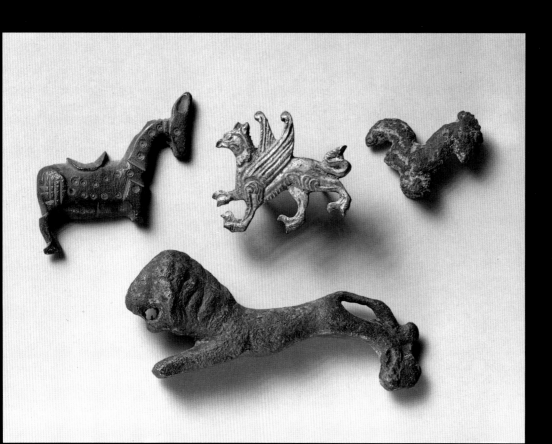

Household Furnishings

James Russell

Gold jewelry, surface finds from Antioch: *top row, left,* gold pendant, open circle with cross bar, 1940.321; *top row, right,* gold pendants from earrings, 1940.323 and 1940.324; *center,* nine gold beads, 1940.322; *bottom row, left and right,* gold wire and rod for bracelets and earrings, 1940.325 and 1940.326; *bottom row, center,* gold pendant with male face, 1940.320. Worcester Art Museum

Bronze animal figurines probably detached from furniture: *top row,* horse, griffin, and cock; *bottom row,* lion; gilded bronze griffin appliqué decoration for furniture. The Art Museum, Princeton University. Gift of the Committee for the Excavation of Antioch to Princeton University

Although the floor mosaics are the premier finds of the excavation of Antioch-on-the-Orontes, they should not be seen in isolation from the buildings to which they belonged.[1] In order to appreciate fully their role in the society that created them, however, it is important not to lose sight of the fact that they were only one element in the furnishing of these buildings, most of which were the private residences of Antioch's more prosperous citizens. The same debris that protected the mosaic floors for centuries also yielded rich rewards of a very different sort. In the course of removing the fill accumulated over and around the mosaics the archaeologists came upon evidence that enabled them to elucidate the history and function of the buildings being excavated. For example, small copper coins inadvertently lost in drains or fountains can date the period when a building or room was in use; shards of terracotta lamps and tableware too insignificant to be swept away when new foundations were laid or before roofs collapsed often supply vital clues to when a mosaic floor was laid or when a building was abandoned. This explains why careful attention is paid to seemingly humble genres of evidence and why their publication has received preferential treatment.[2]

Besides coins, lamps, and pottery, however, another, much less favored class of objects share the same domestic context, and often in considerable quantity. Frequently referred to generically as *instrumenta domestica,* these objects include the miscellaneous pieces of household equipment, usually broken or useless or else too trifling to merit attention when owners were evacuating their premises in troubled times, or enemy forces were sacking the city, or later occupants of the site were scavenging what was left of the building. Made in a wide range of materials, such as stone, metal, bone, glass, terracotta, and doubtless also wood and cloth, long since decayed, they were essential in the daily lives of their owners as tools, articles of dress, furniture, and even expressions of their religious beliefs. Viewed out of context in their broken and useless condition, these items appear as little more than the inconsequential detritus of the occupants of the premises where they were found. When, however, their context is known and properly recorded, they are capable of recreating something of the physical environment and lives of the same occupants. Thanks to the careful reporting of the archaeologists who excavated Antioch in the 1930s, it is possible to accomplish this with some success. As the houses were cleared of their overburden, anything of

significance was recorded, its content and date of discovery noted both in the excavation daybooks and on a label attached to the object itself.[3] Unfortunately, along with the hundreds of items reported in this way, there remain a very large number of heterogeneous uninventoried pieces, such as copper and iron nails, short links of chain, nondescript bronze rods and rings, bone pins, lumps of lead flashing, as well as numerous fragments as yet unidentified. Apart from the very small number of items that have found their way to other collections or have been selected for display in temporary exhibitions, this entire collection has languished in storage largely ignored and completely unpublished since these objects were excavated.[4] Organized according to their material and loosely according to their function, they now occupy twenty-five drawers of a cabinet in the Princeton University Art Museum, the more interesting items still ensconced in the match- and cigar-boxes in which members of the excavation team placed them more than sixty years ago.

Even from a cursory examination of these drawers, in all their variety, it becomes apparent how vividly their contents illustrate almost every aspect of domestic economy and society in Antioch. To be sure, in terms of beauty they cannot compare with the city's mosaic floors, marble sculpture, ornate jewelry, or silver plate, but it is surprising how many of these humble objects are pleasingly crafted considering their strictly utilitarian functions. Their real significance, however, lies in what they can tell us about the mundane activities of daily living. The *instrumenta domestica* discussed below belong to various periods of the city's history, although the majority can be dated to a time when Antioch enjoyed great prosperity, from the fourth century until the second quarter of the sixth, when the city was engulfed by a succession of both natural and military disasters. It is for their cumulative variety and their ordinariness that they deserve our attention, for they constitute a remarkably detailed picture of what went on within the walls of the typical household in one of the Roman Empire's most important cities.

Furniture

Ancient society differed considerably from contemporary North American society in how it measured the wealth and elegance of a well-appointed house. In contrast to modern taste, which places much emphasis on the quantity and quality of the movable goods that a house con-

tains, Roman and Byzantine society was content with far fewer household effects and in much less variety than most people would find acceptable today. This is perfectly clear both from the physical remains of domestic interiors at well-preserved sites such as Pompeii and from the limited evidence of household inventories that survive from antiquity.[5] The aversion to filling one's home with movable furniture was evidently a matter of fashion, for wealthy individuals displayed no hesitation in expending large sums on the luxurious appointment of more permanent aspects of their homes, such as paving floors in mosaic, facing walls in marble revetment arranged in elaborate patterns and colors, and adorning gardens with elegant fountains and channels. To these features may be added a much more lavish use of curtains and tapestries than would be countenanced today. Domestic interiors illustrated in contemporary wall paintings and mosaics (cat. no. 9) suggest that these curtains and tapestries functioned principally as a flexible means of closing off and opening up spaces, especially in peristyle courtyards, to accommodate the varying needs of the household for privacy and public space and for light and warmth.[6] With the exception of the magnificent mosaic floors, the excavation of the houses of Antioch yielded barely a hint of the former sumptuousness of their interiors. Small fragments of colored marble revetment discovered lying where they had been broken off by those who had stripped the walls of their decoration at the end of the city's life and a sizable quantity of bronze pegs and staples employed to attach the marble paneling to the walls only hint at their vanished elegance. Of the cloth hangings themselves nothing survives, but it is more than likely that many of the thick, plain bronze rings found in large numbers in the excavation were employed to suspend curtains from vaulted ceilings and portico colonnades.

Given the sumptuous character of the permanent features of the floor decoration and wall facings, it is hardly surprising that the owners of well-appointed houses at Antioch preferred not to clutter their rooms with movable furniture, which could only detract from the appreciation of the larger scene. Nevertheless, some articles of furniture were essential for comfortable living, such as couches, which in different forms might serve for reclining at meals, studying, or sleeping. A small number of chairs of various kinds, from simple stools to cathedrae with their high curved backs, would also be required, along with a selection of tables, including small side-

boards *(abaci)* for displaying silverware at dinner parties, low side tables from which the guests ate their food, and occasional tripod tables distinguished by the costly materials employed in their design (see p. 73, fig 7). The only other items of movable furniture regularly found in a typical Roman home were various containers to store household equipment when not in use, such as cupboards for tableware, large chests for linen, and smaller caskets for jewelry and other valuables. Since most furniture was wooden, its survival from antiquity is rare except where extremely dry conditions prevail, as in Egypt or the Judaean desert. However, decorative elements made from other materials that were attached to wooden furniture have survived in considerable quantity from Antioch. These include various forms of inlay, such as carved plaques of bone, small panels of marble and colored glass appliqué, and a wide array of bronze attachments, such as bosses, finials, handles, hasps, hinges, and bases.

The ornaments of carved bone are thin rectangular plaques attached by pins for decorating the borders of couches and tables and the sides of chests. Their designs range from simple concentric grooves and ridges to figured scenes such as the one that appears on a fragment depicting a panther in profile with its head turned to the viewer (fig. 1). The most popular motifs at Antioch, however, probably derived from more sophisticated examples produced in Alexandria, depict continuous scrolls of vegetation such as vines and palmettes enclosed within a raised border (fig. 1).[7] Thin sheets of bone were used to produce fretwork patterns as elements in marquetry decoration for tabletops and the like. Bone was also incorporated in wooden furniture in short lengths of highly polished circular rods ornamented with finely turned moldings such as bead-and-reel or spiral fluting. In some instances these pieces may have served as handles for knives or mirrors, such as one fragment that includes a carved female head with elaborate coiffure (fig. 2, center), but the majority must have functioned as balusters for various articles of furniture, such as supports for the railing of the armrest of a chair or the coping of a side table. They were fitted into the wood by means of dowels (fig. 2, left).

Many of the miscellaneous bronze objects found at Antioch obviously belonged to articles of wooden furniture, and it is also safe to assume that many of the ambiguous fragments as yet unidentified would have served some role in the furnishing of the city's houses.[8] The fixtures whose function is most obvious are the vari-

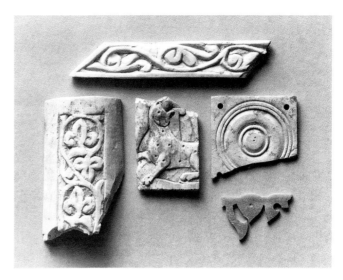

Fig. 1. Decoration for wooden furniture: carved bone plaques and, *lower right,* fretwork fragment for marquetry decoration. The Art Museum, Princeton University. Gift of the Committee for the Excavation of Antioch to Princeton University

Fig. 2. Fragments of carved bone: doweled baluster rod *(left)* and handles (?) for knives and mirrors. The Art Museum, Princeton University. Gift of the Committee for the Excavation of Antioch to Princeton University

ous studs and bosses that decorated the surfaces of wooden doors or chests and the lifting rings for heavy boxes, in many cases equipped with long bolts that would penetrate the wood to hold them in place. The edges of more delicate pieces of metal decoration were pierced with holes to hold the rivets that attached them to the wood. Many of the more ornate bronze accessories found at Antioch may originally have belonged to bronze furniture. This must certainly have been true of miniature

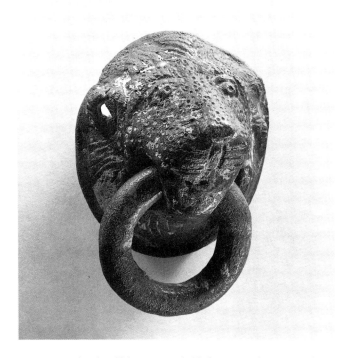

Fig. 3. Bronze lion-head lifting ring probably from a wooden storage chest. The Art Museum, Princeton University. Gift of the Committee for the Excavation of Antioch to Princeton University

Fig. 4. Locks and keys: *top row,* two copper alloy key plates probably from storage chests; *bottom row, right and left,* bronze turning keys; *bottom center,* copper alloy padlock box. The Art Museum, Princeton University. Gift of the Committee for the Excavation of Antioch to Princeton University

architectural fragments such as the lower portion of a Corinthian capital and a wreath ornament cast in relief. This category would also include a number of finials and spikes, which may have become detached from bronze lamp standards. The number of such items found detached from the objects to which they originally belonged points to a generally low level of competence in the soldering technology of ancient metalworkers.

The most remarkable feature of these metal accessories, even the most humble pieces, is the extent of their decoration. Hasps and hinges, for example, are regularly adorned with punched circles and dots; lids terminate in elegantly turned knobs; animal paws are de rigueur for the bases of chair legs, tripods, braziers, lamp standards, and many other items of furniture. The round handles of chests are regularly suspended from the mouths of lions (fig. 3). Solid cast bronze miniature figurines of animals and birds seem to have been a favorite form of adornment for handles and finials or simply as appliqué decoration to enliven flat surfaces. The range includes a charging lion, a saddled horse with an impossible head, the entire surface decorated with punched holes, and a finial in poor condition in the shape of a cock (see p. 78). None of these

pieces, however, can compare to the fine workmanship of a gilded bronze appliqué of a winged griffin with long sharp spikes projecting from its underside probably for insertion into a wooden surface (see p. 78).

Locks and Keys

Security was an important concern for the prosperous householder at Antioch.[9] This is well illustrated by the number of keys and lock plates discovered during the excavations (fig. 4). All the keys from Antioch are turning keys, so named for the rotating action required to ensure that the notches of the bit engage the bolt in order to retract it. Usually made of iron or bronze, the essential components of a key are a shaft, either round or rectangular in profile, and a toothed panel, also known as the bit, which projects at right angles to the shaft. Most keys are attached at the opposite end of the shaft to a ring that is sometimes of a piece with the shaft, but in some cases the key was attached by a loop so that it could swing freely, both types being found at Antioch. The smallest keys could easily fit on the finger for safekeeping, whereas the larger keys could be attached to a single chain from which several keys might be

suspended. The smallness of the keys found at Antioch suggests that they were used for chests or caskets rather than for doors or large cupboards. Key plates were also found, thin circular copper alloy panels fastened by nails around their outside circumference to the wooden side of the object to be secured and having a central vertical aperture to receive the key (fig. 4). Both examples illustrated are quite typical in the simple ornament they exhibit, one with its edge cut in rounded serrations, the other with three pairs of incised concentric circles.

Another interesting item related to security is a rectangular box composed of two halves, a top and a bottom, with their open sides turned inward, forming a closed hollow box to house the locking apparatus (fig. 4). Round holes at the corners received the nails that joined the halves together. The precise function of the two larger oblong slots, one aligned vertically near the right edge and the other horizontally near the center, is unclear, but if the box served as a padlock, they may have served to hold the ends of a chain secured by the bolt within.[10]

Lighting

Although candles were used for lighting in some parts of the Roman world, the oil lamp was the natural choice for the citizens of Antioch, a city lying at the center of a countryside where the production of olive oil was one of the major industries. At its simplest, a lamp consists of a closed container to hold the oil, a hole into which to pour the oil, and a projecting nozzle at one end with a hole to hold the wick. Often a handle was added to the other end. Since the light dispensed by single-nozzle lamps was very limited, lamps with one or more nozzles were sometimes employed to enhance the illumination of a room. The clay lamp is one of the most commonly found artifacts in any domestic context throughout the Roman world, and Antioch is no exception. The large number of lamps recorded from the excavation includes not only locally made products but also imported lamps, usually imported for their superior quality from workshops in other parts of the Roman world. The clay lamps from Antioch illustrate a full range of development from Hellenistic times until the city's capture by the Arabs in 637, and because lamps were especially susceptible to changing methods of production, design, and decoration, they are also extremely valuable for dating archaeological contexts.[11]

A much more luxurious version of the oil lamp, obviously intended for a wealthier clientele, was also produced in bronze. Though in general appearance the bronze lamps resemble clay ones, they tend to be more elaborately decorated and frequently form part of a larger set with elegant accessories. The most common of these had a bronze stand with a finely turned shaft with elegant moldings surmounted by a long spike to hold the lamp in place. A more complex variety of stand was equipped with multiple brackets from which several lamps were suspended by chains. Examples of complete bronze lamps from Antioch are rare, but there is no lack of various accessories that have become detached from the bodies of lamps. These include hinged filling-hole covers with knobbed finials or in the shape of scallop shells and the decorative cross frequently attached to the handles of some early Byzantine lamps.[12]

Another method of lighting that came into vogue in late antiquity with the potential of providing much brighter illumination than even a set of hanging bronze lamps could supply was the polycandelon, a circular metal frame or disc open at the center with a series of round apertures around the perimeter. Into each of these holes was inserted a glass vessel in the shape of an inverted cone. When filled with oil these vessels functioned as lamps, the wick floating on the surface of the oil. The lit end of the wick was contained in a hollow copper tube from the top of which extended two thin strips, each bent at the end to hang firmly over the rim of the glass vessel, thus holding the wick in place and preventing it from drowning in the oil (fig. 5). The polycandelon was then suspended from the ceiling by hooks and chains or, as illustrated in a fine example from Antioch, a

Fig. 5. Drawing of three copper alloy wicks for use in glass polycandelon lamps; *bottom left*, diagram showing how the wicks functioned. The Art Museum, Princeton University. Gift of the Committee for the Excavation of Antioch to Princeton Univerity

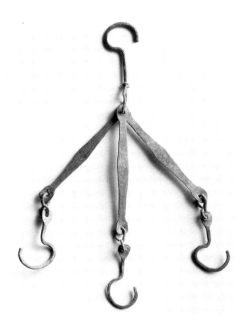

Fig. 6. Copper alloy triple-suspension apparatus of hooks and bars for polycandelon. The Art Museum, Princeton University. Gift of the Committee for the Excavation of Antioch to Princeton University

triple arrangement of copper bars and rings (fig. 6). Traditionally the polycandelon has been regarded exclusively as an item of church furniture, and the finest surviving examples in silver certainly belonged to churches, but the frequent occurrence of fragments of both the distinctive conical glass lamp and the equally distinctive copper wick-holders in the houses of Antioch suggest that this was a regular means of lighting domestic premises as well.[13]

Dress

Although neither the woolen and linen fabrics that draped the people of Antioch nor the leather of their belts and footware have survived, the excavations have produced a considerable variety of dress accessories, especially those intended for fastening garments, such as pins, buttons, toggles, brooches, and buckles.

A large and somewhat enigmatic group of objects found in the houses takes the form of small flattish discs made from various materials, bone, ivory, and steatite. Most are thin, and many have a slightly convex profile. All have a single hole in the center, and they are usually decorated with incised designs ranging from simple concentric grooves to quite complex arrangements of circles and dots within bands. Frequently encountered in large quantities in the excavation of urban sites of the eastern Mediter-

ranean, they are usually classified as spindle whorls. Their weight, however, which seems far too light for them to be effective in this role, their decorative appearance, which seems superfluous for something as utilitarian as a spindle whorl, and their large numbers suggest that most of them fulfilled some less specialized function, such as to fasten articles of dress.[14] Less equivocal as an instrument for fastening clothing but considerably rarer at Antioch is the fibula, or brooch, the ancient counterpart of the modern safety-pin. The best preserved is a late antique crossbow fibula, a type much favored by soldiers, in which the arch bow ends in a finial with terminal knob and projecting crossbars, also with terminal knobs (fig. 7). A much more common dress accessory at Antioch was the buckle employed to fasten the leather belts men wore to fasten the tight-fitting trousers that constituted the standard male garb for all but the most elevated ranks of society in the later Roman Empire.[15] Though buckles were produced in gold and silver, bronze buckles were the norm. Like their modern successors, in their basic design they are remarkably uniform, comprising a buckle frame to house the tongue that fastened the belt and joined to it, either as a unit or with a hinge, the plate that was attached to the belt by lugs on its underside. The surface of the plate provided ample scope for a variety of ornamentation, which might even include an expression of the owner's identity in the form of a monogram. The examples from Antioch offer a representative selection of the various incised and openwork plate designs popular on buckles of the sixth and seventh centuries (fig. 8).[16]

Jewelry is another form of dress well represented at Antioch. It is obvious from the large quantity of pierced glass and stone beads in many shapes and sizes that stringed bead necklaces were popular with women for their personal adornment. Finger rings also appear in abundance, for the most part of bronze and generally quite plainly decorated. A small number with vacant bezels or cloisons that once contained precious stones, however, suggest a higher level of luxury. This is confirmed by the presence in another drawer of a small number of polished stones and gems with intaglio designs that presumably once decorated finger rings. Other dress accessories worth noting are a group of copper-wire earrings, a small cross pendant with the circle-and-dot design so common in late antiquity, and a varied selection of bracelets in glass and copper, including one formed of twisted strands of wire (fig. 7).

In marked contrast to the cheaper and often mutilated scraps of jewelry found during the excavation of the houses is a small collection of gold objects acquired at the time of the excavation and now housed in the Worcester Art Museum (see p. 78). Although they are described in the museum's records as surface finds, it is more likely that they were found by local inhabitants robbing tombs and then sold to the excavators as casual finds. They illustrate well the various techniques practiced by even the average goldsmith in the Roman world. The objects range from the simple pendant circle of sheet gold enclosing a diagonal cross of two strips held in place by rivets (see p. 78, upper left), to delicate granulation decoration in the form of lozenge-shaped clusters of beads adorning the two hollowed tubes with rounded ends, perhaps pendants from a pair of earrings (see p. 78, upper right). Repoussé work, involving the embossing or beating of sheet metal, is represented in the features of a human face that adorns a pendant medallion (see p. 78, bottom center) and the grooved decoration of the barrel-shaped beads of a necklace (see p. 78, center). The creative manipulation of gold wire and rods could produce a wide variety of simple but pleasing designs for bracelets and earrings (see p. 78, bottom left and right).

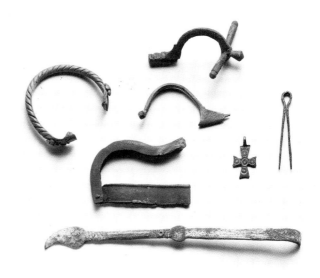

Fig. 7. Bronze articles of dress and toilet: *upper center,* brooches; *lower center,* razor; *left,* twisted-wire bracelet; *right,* pendant cross with punched decoration and tweezers; *bottom,* cosmetic spatula. The Art Museum, Princeton University. Gift of the Committee for the Excavation of Antioch to Princeton University

Toilet Articles

Besides articles of dress and jewelry, the excavations produced a considerable quantity of objects associated with various aspects of personal grooming. The sculpture and painted portraits of Roman women bear ample testimony to the changing fashions in hairstyle. The complicated structure of some of these creations must have required the hairdresser to have an ample supply of bone hairpins on hand while arranging a woman's hair, and doubtless a fair number would remain in place to keep the hair in order even after the coiffure was completed. Bone hairpins are present in abundance among the material excavated at Antioch, many of them unadorned but a surprising number quite ornate, especially at the ends exposed to view. Finial decorations take a variety of forms, from elaborately turned moldings to various figured designs such as a pine cone, a female head, and a finely carved dolphin.

Another essential feature of female adornment at Antioch was a dark paste for lining the eyes. It was made from a powder called kohl, which is still in widespread use for the same purpose throughout the Arab world. The paste was mixed in small glass or bone vials with copper

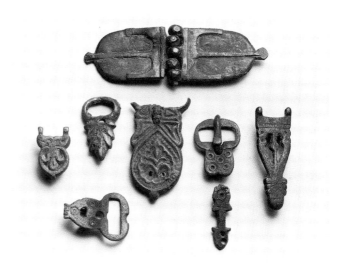

Fig. 8. Bronze belt buckles of various designs and hinge for leather belt *(top).* The Art Museum, Princeton University. Gift of the Committee for the Excavation of Antioch to Princeton University

alloy instruments variously equipped with spoonlike scoops or flat-bladed spatulas at one end. The opposite end terminated in a bulbous swelling that was used to apply the paste to the eye. Antioch has produced a wide range of examples. Three other items that would have been essential to a women's cosmetic set are a one-sided bone comb, a set of tweezers (fig. 7), and a compact mirror, all of which are recorded from domestic contexts at Antioch. The teeth of the comb are broken off, but the

central panel with incised linear decoration has survived. Each side bears a monogram with the message "Oh Lord, help thy servant. . . ."[17] The mirror consists of a bronze frame with an incised wave decoration on the rim and a series of latticework triangles projecting outward. The reflecting disc originally enclosed within the frame is now missing but was probably of glass with polished tin backing.[18] In contrast to the variety of female cosmetic apparatus from Antioch, the only evidence for male grooming is a single well-preserved copper razor with a blade that could rotate around a pin to fit into a grooved casing when not in use (fig. 7).

Domestic Entertainment

From earliest times one of the favorite pastimes in ancient society was gambling and gaming in a wide variety of forms. A number of finds from Antioch illustrate this enthusiasm (fig. 9). The simplest games of chance involved merely the throw of a knucklebone *(astrogalos)* shaped into an approximate rectangle. When thrown it would land on one of four sides, designated with the values 1, 3, 4, and 6, respectively. Normally each player threw four knucklebones, the winning throw being a "royal" *(basilikos)*, in which each of the four knucklebones registered a different value. Somewhat more sophisticated games were possible with a die *(tessera)*, a six-sided cube whose sides numbered from one to six, exactly like its modern counterpart. Dice in the Roman world were usually of bone, and this is the case with those found at Antioch. Antioch, however, also produced an extremely rare variant in the form of an elongated rectangular die with values indicated on all four long sides and on the two ends. It is difficult to imagine how such a die could have functioned effectively.

Besides simple games of chance, dice were also essential for board games played with movable counters (see cat. nos. 46–48). A wide variety of board games are known from literary sources. The best known of these board games, known as *Duodecim Scripta,* seems to have resembled modern backgammon (see p. 114, middle). In the comfort of their homes the citizens of Antioch presumably used movable boards that could be brought out when needed and stored along with the counters when not in use, much like a modern chess set.[19] Movable boards of wood and ivory for various games are known from other sites—they even accompanied their owners to the grave after death (see cat. no. 44)—but none survives

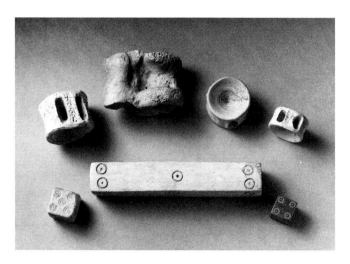

Fig. 9. Bone gaming pieces: *top center,* knucklebone *(astrogalos); top left and right,* fish vertebrae employed as counters in board games; *bottom left and right,* cube-shaped dice; *center,* elongated rectangular die. The Art Museum, Princeton University. Gift of the Committee for the Excavation of Antioch to Princeton University

among the finds from Antioch. On the other hand, the moving pieces used in playing board games survive in considerable quantity from Antioch, ranging in quality from something as simple as fish vertebrae (fig. 9) to polished flat bone discs decorated with incised concentric grooves and ridges and small bone cylinders with beveled tops, also sometimes decorated.

Family Industry and Commerce

There is much evidence from domestic contexts at Antioch that individual households engaged in various industrial and agricultural activities to earn income for the family. The evidence includes a large quantity of implements, mostly of iron, employed in conducting a broad range of trades and crafts. Unfortunately, because most of these pieces remain in uncontrolled conditions, they have become so seriously oxidized that they have either disintegrated or can no longer be handled without exacerbating their condition. Nevertheless, a broad selection of agricultural tools may be recognized, including curved sickles, billhooks, and various types of picks and mattock blades. Carpenter's tools, such as chisels and awls, were also noted, along with large punches, perhaps part of a blacksmith's kit. Although Antioch is at a considerable distance from the sea, a few bronze fishhooks and a primitive lead fishing weight suggest that some households at Antioch engaged in fishing. Two stone molds for casting flat discs

indicate that some metalworking, probably in copper, was carried on, while heavy needles and thick-walled thimbles perhaps signify leatherworking. To judge from the numbers found, households also regularly exercised economy by repairing broken vessels with lead clamps. As was normal in ancient society, the manufacture of cloth was presumably a female activity in Antioch, its practice well represented in the quantity of stone loom weights and terracotta spindle whorls noted.

Scraps of equipment connected with weighing have also been encountered frequently at Antioch and other Roman-Byzantine urban sites. As one would expect, these tend to appear in contexts clearly associated with commercial activity, such as the Byzantine shops that fronted the major colonnaded avenue at Sardis.[20] At Antioch, however, most of the material pertaining to weighing was found in the excavation of houses. There were two common types of weighing apparatus in the Roman world, both of which are still widely employed throughout the Middle East today.[21] Evidence of both types has been found at Antioch. The first is the steelyard beam *(stratera),* designed for measuring larger market commodities such as fish, meat, and vegetables. The important elements of this apparatus are a horizontal beam divided into two unequal arms. Suspended from the shorter end is the scale pan with hooks attached by chains to a υ-shaped collar hanging from the beam. The longer arm of the beam was marked with a graduated scale on two or three faces, depending on the number of fulcra. The counterweight was moved along the arm until the point of equilibrium was reached, thus establishing the precise weight of the object being weighed. The counterweight, suspended from the beam by a large hook, normally consisted of a lead mass enclosed within a casing of bronze depicting either the bust of an empress or the goddess Athena. Complete steelyards and weights are well documented from other late Roman sites in the eastern Mediterranean, but only fragments have appeared at Antioch.[22] They include a bronze suspension υ-shaped collar and part of a beam, as well as some of the larger hooks and suspension bars found in the excavation (fig. 10).

The other form of weighing apparatus is the simple balance scale, which was usually much smaller than the steelyard. It consists of a thin, round horizontal rod tapering at each end and tiny rings attached to the ends. From these are suspended three or four chains to hold the scale pans, each slightly dished to accommodate the item being weighed in one and the appropriate weights in the other

(fig. 11). Projecting above the center of the beam was a movable two-pronged fulcrum with a pointer to indicate the tipping of the balance (fig. 10). Fragments of several sets of equipoise scales, all of modest size and suitable only for weighing fine objects such as jewelry or coins, are among the bronze finds from Antioch (fig. 11).

The weights found at Antioch, mostly small and evidently intended for use on small balance scales, fall into two groups. The first consists of lead weights of Hellenistic or Roman date, the smaller pieces being round flat discs with the weight indicated by numerical letters in relief (fig. 11). The largest of this group, a square piece with a raised serrated margin, is identified as an official weight and bears a device of crossed cornucopiae. The lower legend specifies its weight as one-eighth of the standard civic measure, in this period presumably the Antiochene *mina* (fig. 11, top center).[23] By late antiquity the citizens of Antioch were using the standard flat bronze weights that were in general use throughout the Byzantine world. The predominant shape was square, but circular and polygonal weights were by no means uncommon. In every case both the lettering and the cross and other decorative features that sometimes enclose them, such as a wreath or column and arch, were incised, and they were normally inlaid with silver. Two systems of denomination were in use, ounces, designated by the letter Γ (abbreviation for the Greek *oungia*) and *nomisma,* indicated by the capital letter N, signifying a standard weight employed in

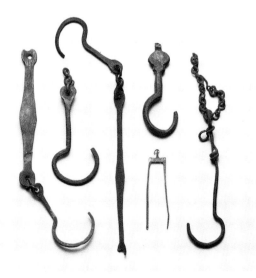

Fig. 10. Copper alloy suspension hooks and bars from polycandela or steelyard scales; *bottom right,* two-pronged fulcrum (pointer missing) from balance scales. The Art Museum, Princeton University. Gift of the Committee for the Excavation of Antioch to Princeton University

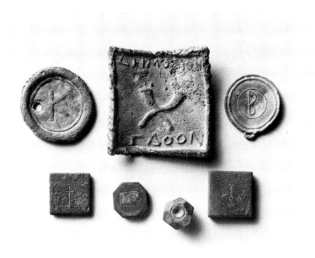

Fig. 11. Selection of weights for balance scales: *top row,* lead weights of Hellenistic-Roman date; *bottom row,* early Byzantine bronze weights. The Art Museum, Princeton University. Gift of the Committee for the Excavation of Antioch to Princeton University

measuring gold coins. Both kinds of weights have been found at Antioch. Since gold coin was the official medium for paying public taxes, its fiduciary status was readily accepted also for transactions in the private sector. Given the fineness of the units involved, however, even the slightest discrepancy in measuring the weight of a coin could have serious commercial consequences for the parties affected. Thus a miniature set of scales of the sort represented by the fragments found at Antioch and elsewhere became an essential piece of equipment in any household receiving rents or paying taxes to ensure the genuineness and exactness of the sums paid.[24]

Family Worship

An important feature of Roman life in all periods was the practice of private religion within the home. This assumed many aspects, some of which are illustrated among the *instrumenta domestica* from Antioch. In pre-Christian times a small household shrine was a standard fixture even in quite humble homes. Originally intended to house miniature images of the gods of the household (Lares), these shrines, especially in the Greek-speaking eastern Roman Empire, would regularly include other deities as well, thus reflecting the eclectic religious tastes of their owners. This accounts for the widespread production of diminutive bronze figures representing the traditional gods not only of the Hellenic tradition but also of the increasingly popular mystery religions originating in

the eastern provinces and even deified abstractions such as Victory (Nike) and Fortune (Tyche) (cat. no. 8). Household shrines could sometimes assume elaborate proportions, appearing quite pretentious, as may be seen in the Syrian example from the Louvre (cat. no. 85). At Antioch more modest versions have appeared, with figures mounted in small groups on miniature bronze semicircular platforms with four steps at the center, probably intended to simulate the entrance to a temple. Two examples survive, with traces of the solder that attached the images to their base still visible on one (fig. 12).

Also among the finds are two bronze figurines discovered in separate contexts of a size suitable for such a base. One appears on first inspection to be a rather clumsily executed image of a nude Aphrodite with an elaborate headgear, of which only the lower portion survives (fig. 12; see also cat. no. 87). Enough is visible, however, to identify the solar disc that frequently appears in the headdress of the Egyptian goddess Isis, whose mystery cult attracted a large following at Antioch.[25] The blending of the attributes of these two deities illustrates well the syncretism that was such a distinctive feature of religious life during the Roman Empire. The second figurine, a headless,

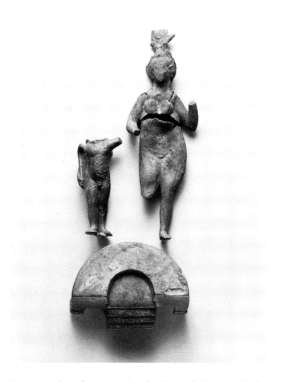

Fig. 12. Bronze podium for supporting figurines of a household shrine; two bronze figurines detached from altar platforms of household shrines: *left,* perhaps Attis as Eros; *right,* Isis as Aphrodite. The Art Museum, Princeton University. Gift of the Committee for the Excavation of Antioch to Princeton University

winged nude Eros, is perhaps a further example of syncretistic blending of traditional iconography with another eastern mystery religion, that of Magna Mater (Cybele), a cult originating in Asia Minor. Instead of the familiar bow, this Eros carries in his right hand a shepherd's crook *(pedum)*, an attribute of Attis, Cybele's young consort, who elsewhere exhibits many affinities with Eros.[26] A pair of bronze cymbals *(crotala)* discovered at Antioch is perhaps further evidence for the practice of mystery cults among the residents, for cymbals played a prominent part in the orgiastic ceremonies that attended the worship of both Attis and Dionysos.

Christian motifs and iconography are present in abundance in the ornamentation of the humble paraphernalia of daily life at Antioch, for example, the cross and Chi-Rho on clay and bronze lamps, Christian invocations on combs, the incised cross on lead weights, and the cross as the principal element in pendant necklaces, to name but a few. Side by side with Christianity, however, the inhabitants of Antioch probably continued to maintain their superstitious belief in the unseen power of the Evil Eye to wreak havoc in one's life and in the need to apply instruments to counter its malign influence (see p. 163–67). This may account for the considerable number of small bronze bells *(tintinnabula)* among the finds from Antioch. The handsome quality and decorative touches on some of the finer examples suggest that they were used as apotropaic devices above cradles to protect infants or suspended from doorways to secure the entrance to the home rather than for more mundane purposes, such as on sheep.[27]

1. This article is based on two brief inspections of the small objects from the Antioch excavations now housed in the Princeton University Art Museum. I am grateful for the warm hospitality extended by the curators in charge of the collection on each occasion, the late Frances Follin Jones in 1979 and Michael J. Padgett in 1999. The present text has benefited greatly in both information and ideas from exchanges with these individuals.

2. For coins, see Waagé 1952; for clay lamps, see Waagé 1941; and for pottery, see Waagé 1948.

3. For detailed reports of the excavations conducted from 1932 to 1939, see Antioch I 1934; Antioch II 1938; and Antioch III 1941. Much information on archaeological contexts also appears in Levi 1947.

4. A number of Byzantine bronze weights and a fine silver lampstand found at Antioch are on permanent display in the Byzantine Collection of Dumbarton Oaks (see Ross 1962, 20–21, no. 15 [lampstand]; 64–68, nos. 75, 77, 81, 84 [weights]). On a temporary exhibition including small artifacts from the Antioch excavations, see Ćurčić and St. Clair 1986, 65–66, 68, nos. 34, 36 (bone objects, carved plaques), 37 (comb), and 41 (pendant cross); 88, no. 82 (bronze pendant cross); 123, nos. 153 and 154 (terracotta pilgrim seals).

5. Besides the evidence of excavated sites, an excellent impression of a wealthy woman's taste in home furnishing can be gained from the reliefs carved on the interior of her sarcophagus discovered at Sipelveld and now in the Leiden Museum (Liversidge 1955, 65–66, figs. 68–69). For a senatorial household inventory from republican Italy, see Cato *Agr.* 10–11. Although they are much later in date, it is quite likely that the sparse furnishing of prosperous households of medieval Byzantium listed in detailed inventories were similar in quality to furnishings in the houses of late antique Antioch (see Oikonomides 1990, 205–14).

6. Thébert 1987, 387–92.

7. The decorated bone plaque with vine scroll (fig. 9.3, center) seems to be the only one from Antioch that has been published (see Ćurčić and St. Clair 1986, 66, no. 36).

8. For *comparanda* for metal objects from well-documented archaeological contexts at Sardis, see Waldbaum 1983.

9. For a clear introduction to locks and keys with the emphasis on late antiquity, see Vikan and Nesbitt 1980, 1–9.

10. This possibility is suggested by Waldbaum 1983, 70.

11. Waagé 1941 discusses lamps in detail.

12. For complete examples, see Miner 1947, 64, nos. 250–52, pl. 38; and Campbell 1985, 50, nos. 42, 44.

13. For complete silver examples, see Campbell 1985, 58–59, nos. 56–57; and Ross 1962, 40–42, nos. 42–44.

14. For an excellent discussion of whether these discs served as spindle whorls or buttons, with copious illustrations, see Davidson 1952, 172, 196–98.

15. The prevalence of leather and cloth tights as standard male garb in late antiquity is discussed in Russell 1982, 133–63.

16. For a broad selection of late antique bronze buckles from Anemurium, many from well-defined archaeological contexts, see ibid., 137–45, figs. 6–8.

17. For details, see Finken in Ćurčić and St. Clair 1986, 66, no. 37.

18. For parallels and discussion, see Simpson 1997, 33–34, no. 127.

19. For a good introduction to the subject of board games in the Roman world, see Balsdon 1969, 156–59.

20. Crawford 1990, index, s.v. "balances," "steelyards."

21. For a good account of weighing apparatus, see Vikan and Nesbitt 1980, 29–37.

22. For examples of complete steelyard, weights, and accessories, see Gonosová and Kondoleon 1994, 242–49, nos. 83–84; Ross 1962, 60–64, nos. 70–74; and Weitzmann 1979, 344–45, nos. 327–28.

23. For the system of weights at Antioch in the Hellenistic period and in the early Roman Empire, see Seyrig 1946–48, 37–79.

24. For good illustrations of the legal significance of weighing coins and other small precious items, see Vikan and Nesbitt 1980, 29–37.

25. For Isis's introduction to Antioch in the reign of Antiochos II and the subsequent popularity of her cult, see Downey 1961, 91–92, esp. n. 23. For Isis depicted on coins of Antioch, see Waagé 1952, 11, no. 12.

26. Vermaseren 1977, 123, 207–8, n. 747.

27. On *tintinnabula* as apotropaic devices in early Byzantium, see Russell 1995, 42–43.

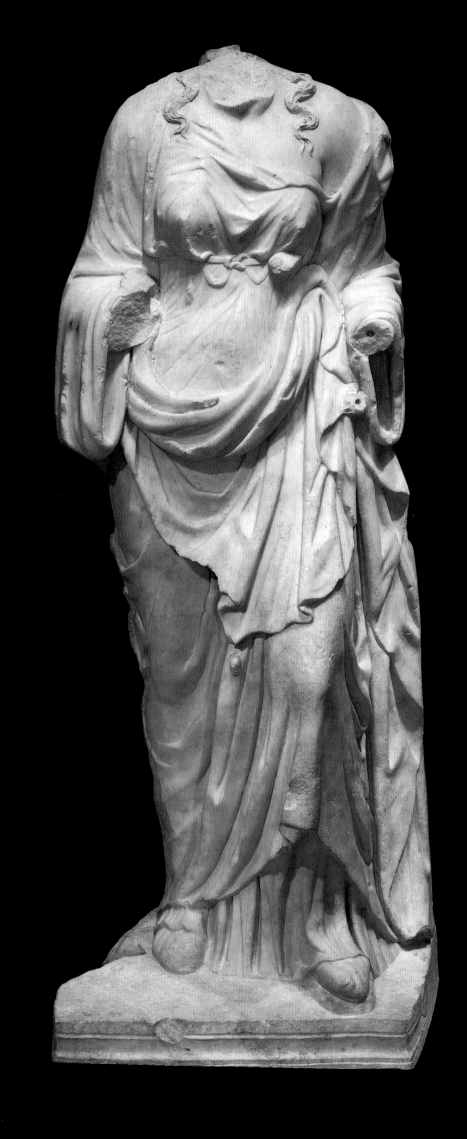

The Sculptures
of Roman Syria

Cornelius Vermeule

Roman Syria can be roughly divided into the coastal cities, which were strong in the Hellenistic traditions of the Seleucids, Antioch-on-the-Orontes and nearby Daphne foremost among these; and the eastern centers, Palmyra and Dura-Europos, where the sculptural legacies were very mixed, Parthian meeting and fusing with Greek and Roman to form a new visual experience from which various antecedents can be extracted. The artistic worlds of Palmyra, on the caravan routes, and Dura, on the edge of Mesopotamia, are so distinct from the traditions along the Syrian coast that the observations set forth here deal with the cities of Antioch, Seleucia Pieria, Laodikeia, and inland, Emesa and Damascus, which sent citizens to Athens in the second century C.E. The art of Palmyra did not affect Antioch until after the Roman emperor Aurelian's capture of the city and its famous queen, Zenobia, in 273.

Time has dealt harshly with Antioch's monuments from the Hellenistic period. The Tyche of Antioch, by the sculptor Eutychides, apparently of bronze, and the seated Zeus in the modernized Pheidian style are evidences of what could be created for the early Seleucid kings, Seleukos I Nikator (312–280 B.C.E.) and Antiochos I Soter (280–261 B.C.E.), in the heart (or more properly, on the doorstep) of their vast kingdom. There are no great sculptured altars in the Antioch area like the altar of Zeus at Pergamon. There are no impressive Hellenistic temple friezes like those dedicated to Dionysos at Teos, to Artemis at Magnesia-on-the-Maeander, and to Hekate at Lagina. The monumental bronze statues, such as the Dionysos from Epipheneia, are all Augustan or Julio-Claudian at the earliest. The same is largely true for marble statues, such as the copy of the Doryphoros of Polykleitos recently brought to the National Museum in Damascus from the coastal city of Laodikeia. Future excavation or chance finds at Antioch might add to our knowledge of sculpture from before the end of the Seleucid dynasty and might, at any time, produce more Greek and Roman statues like the near-complete Doryphoros after the famous Peloponnesian bronze statue of about 440 B.C.E. Lacking only the right forearm, the left hand, and the lower part of the legs, below the knees, this careful, precise copy is dated 70–80 C.E.

All the surviving sculptures from Antioch, Seleucia Pieria, and Daphne seem to belong to the Hellenistic period, which ended with Octavian's conquest of Egypt in 31 B.C.E., or to the Roman imperial centuries until the artistic denouement of Antioch in the great earthquakes of 526 C.E. and 528 C.E. A good overview of the phases of Greek and Roman

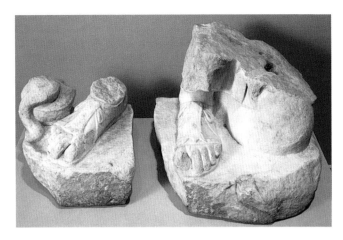

Fig. 1. Feet of Asklepios. From Antioch. White marble. Worcester Art Museum, 1939.80A/B

sculpture from the fifth century B.C.E. to the time of Julian the Apostate (361–63 C.E.), can be constructed from the surviving "copies" and originals. The quality is often high, and the sculptors used considerable imagination. This is true to the extent that we can call the sculptures creations in the older traditions, rather than mechanical copies in marble, such as are found in sites around Rome, most notably Hadrian's villa at Tibur (Tivoli).

Among the sculptural finds, those originally intended for public display, namely, statuary placed in baths, theaters, gymnasia, libraries, and the like, were fewer in number than those intended for private display. Of the former, the Hygeia and Asklepios (feet only) now in Worcester, from a public bath at Antioch, are of exceptionally high quality and monumentality, suggesting major sculptors who conceived their ideas and carved their statues in the city, albeit after Pergamene and related models (fig. 1). These statues are truly memorable and grander than the widely circulated commercial imports or conventional household decorations for small niches and garden courtyards.

The Asklepios and the Hygeia are without doubt the grandest surviving contributions of Antioch to the sculpture of Greco-Roman Syria. The curls, the flesh, and the complex drapery of the Hygeia are breathtaking in concept and execution (see p. 90). With many frills and embellishments in the wrinkles of the drapery, the Hygeia is an imaginative, Pergamene version of the original of the Hera Borghese, as best seen in the headless statue from the stadium of the Domus Augustana (Palace of Domitian) on the Palatine in Rome. The Antioch Hygeia stands on a plinth with complex molding, which must be a signature of

work in the first and second centuries of our era. It is easy to speculate that this great image was carved by a sculptor from Pergamon, Smyrna, Kos, Samos, or Ephesos who came to create at Antioch or whose creation was shipped from a Mysian, Ionian, or Carian city with traditions of representing the divinities of medicine and health.

Excavations in the theater at Daphne-Harbie yielded several fragments belonging to two sculpture groups that are copies of a popular Hellenistic type, the *symplegma,* or entanglement of a satyr and a hermaphrodite. One telling fragment of the head and upper body of the satyr, now in the Antakya Museum, reveals the intensity of the struggle; the hand of the hermaphrodite pushes against the face of the lecherous satyr as he grabs her with his right arm (fig.2). The discovery of several pairs of sculptures of an entwined satyr and hermaphrodite, now in Rome and Dresden, reminds us that these groups could be sculpted in mirror reversals for placement in opposite corners of a room or garden court. The erotic theme of nude figures wrestling could be adapted for both public and private settings.

Muses belong in theaters dedicated to Apollo, surely the principal deity of Daphne. The find of a striking female head, most of whose face unfortunately is lost, in the theater at Daphne-Harbie identifies her as a Muse. The mass of hair in this ruined masterpiece, done up in a topknot above and a floppy bun behind, is forcefully carved. The surfaces of the skin appear to have been lightly polished, making a svelte contrast with the slightly rough, deep carving of the heavy hair. This magnificent fragment, which must date from the second century C.E., is today located in the Princeton University Art Museum. Also at Princeton is a draped female figure discovered in Seleucia Pieria who might be a Muse. Although only the lower half of a statue, with plinth and the front of the right foot (made separately and added), survive, the figure retains considerable elegance. Indeed, the source seems to be Praxitelean, going back to the traditions of the Mantinaea Base, showing various Muses and their costumes in relief on the flat surfaces below where statues once stood.

The most impressive imperial portrait from Roman Syria is the cuirassed statue of Hadrian, worn and weathered but nearly complete, from Seleucia Pieria, founded by Seleukos I in 300 B.C.E. as the port of Antioch, north of the mouth of the Orontes River. Either this portrait shows the emperor Hadrian (117–38 C.E.) in his old age or the whole statue is a Severan copy, influenced by the iconography of Septimius Severus (193–211 C.E.). The longish, curly beard

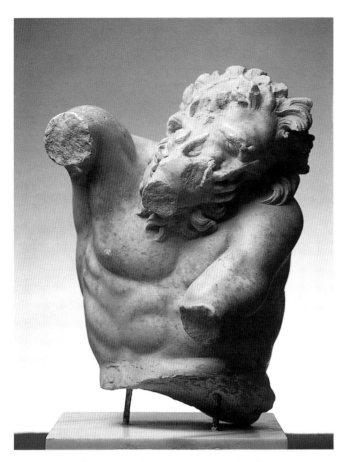

Fig. 2. Head and upper torso from satyr and hermaphrodite group. From Daphne. White marble, height 18½ in. (47 cm). Hatay Archaeological Museum, Antakya, 1327

has been added to a conventional portrait type of the year 128. The cuirass is a late variation on the standard Hadrianic, Pan-Hellenic type of design and iconography. Here we have griffins flanking a *Palladium.* The tabs *(pteryges)* at the bottom of the breastplate appear to have the facing Ammon and other heads peculiar to the cuirassed statues of Hadrian found in Greece and on Crete. The statue from Seleucia Pieria must have been carved to join a dynastic group of portraits of the imperial family from, say, Trajan (98–117 C.E.) to Septimius Severus, as the long, pseudo-genealogical inscriptions on big imperial statue bases and buildings such as the Severan theater at Ostia, port of Rome, must have been. The overall size of the statue is awesome, a sculpture created for a basilica, bath, or large imperial shrine. That a statue of Septimius Severus in the same style was found in Tunisia opens up many possibilities for the location where these imperial monuments were manufactured, southern Asia Minor (most likely the city of Perge) being a good urban candidate.

Two impressive white marble busts (along with a head in red porphyry, discussed below) were uncovered in a cache of sculpture comprising twenty-two fragments from a private house (Building 25–H) near the gate to the road south to Daphne and Laodikeia. The other pieces in this cache are more typical of private sculpture collections. These remarkable heads have been given the names of Roman emperors. The first two may be private citizens, a high-ranking elder statesman or man of intellect and a tough middle-aged general in military costume. The bare-chested old man with a full beard and the start of an impressive belly has been termed Pertinax, the good but too-severe emperor who was murdered by the Praetorians of Rome after a few months of rule in 193 (fig. 3). His portraits were popular under the Severan emperors; Septimius Severus even subscribed to the dynastic fiction that he was a brother of Pertinax. Since Septimius Severus married Julia Domna, of an old Syrian Hellenistic royal family, and since Julia Domna's sister, Julia Maesa, was grandmother to the last two Severan emperors, Elagabalus (218–22 C.E.) and Severus Alexander (222–35 C.E.), Severan ancestors, like the cuirassed Hadrian or Pertinax, were very much at home along the Syrian coast. The Julias all came from Emesa (Homs) in the northern Syrian heartland.

The bronze bust of Julia Domna (cat. no. 17) is rather different from her portraits modeled or carved in Italy. Its thin, elongated qualities seem to anticipate one aspect of late antique and Byzantine art in Constantinople, Asia Minor, and Syria. Another aspect of regionalism appears in a life-sized bronze head of a man with curly hair and beard, albeit a sculpture of high quality (cat. no. 18). He begins, ever so slightly, to manifest the fixed, frozen facial expression that will become a signature of Roman art in Syria from 250 C.E. until the Arab conquest. He is not an imperial person, but he is remindful of Marcus Aurelius (161–80 C.E.) and public or private individuals, including men of letters, of the decade 175–85 in the eastern part of the empire. Both of these portraits show that there was no lack of imagination and technique in the Roman imperial styles of the region under the Antonines and the Severans.

The bust of a stern man in a cuirass with a sash *(cingulum)* around his waist and the cloak of command *(paludamentum)* on his left shoulder has been labeled Gordianus III (238–44 C.E.), but his features seem too mature and somewhat too sharp for that boyish emperor, who was murdered in the East by his military chief of

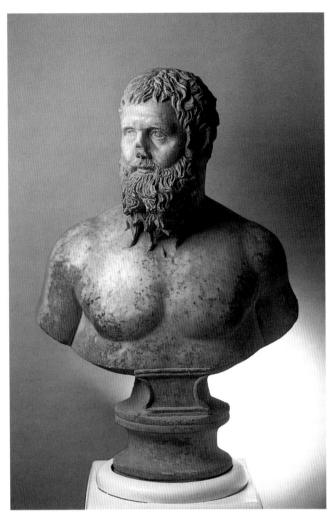

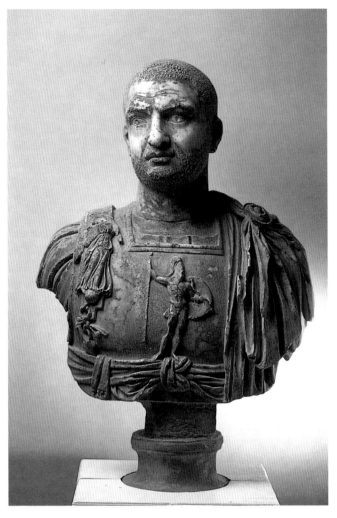

Fig. 3. Elder statesman or man of intellect. From Antioch. White marble, height 35 in. (89 cm). Hatay Archaeological Museum, Antakya, 1221

Fig. 4. Man in military costume. From Antioch. White marble, height 25¼ in. (64 cm). Hatay Archaeological Museum, Antakya, 1218

staff, Philippus I, "the Arab" (244–49 C.E.) (fig. 4). Philip the Arab came from a Syro-Arabian city, Bostra, capital of Roman Arabia, to the southeast of Antioch. Neither Philip nor his son, Philippus II, seems to be represented in this bust, which suits the military temper of the times.

Whether or not these two marble portraits are of emperors, they belong to the highest levels of Roman portraiture of their times, the rich, curly-bearded age of Septimius Severus on the one hand and the austere, militaristic features of Philippus I on the other. Both portraits and their subjects have been shown to have political and personal connections with Roman Syria. The first portrait could have been an import to Antioch from Athens or Ephesos. The second portrait could have been brought to the great Syrian city from Rome. Perhaps these busts traveled to Antioch with their subjects, the sitters, or with members of their respective families. Portraits in

private collections associate their owners with historic personages, and if imperial, they connote loyalty to the Roman authorities and generally the social connections of the householders.

By far the largest number of sculptures found at Antioch were intended for private use as part of domestic collections and garden or fountain decorations. If one source can be singled out for the decorative sculptures of houses in Antioch or Seleucia Pieria and villas at Daphne, it is the workshops of the Ionian and Carian coast, Smyrna, Ephesos, and Aphrodisias and their way stations to the east, at Attaleia (Antalya) on the Pamphylian coast and at Tarsus in Cilicia. Some finished (or nearly finished) small statues seem to have found their way down from the Dokimian quarries of Phrygia, but not many. From these coastal sources came the small Aphrodites, the frolicking erotes, the thorn-extracting boys, old rustics, and the animals asso-

ciated with minor mythological figures. It is very likely that the cities with numerous sculptural workshops and good avenues of transport had sales galleries and showrooms in Antioch, just as the Florentine and Neopolitan sculpture replicators do nowadays, both in their own cities and overseas, from London to Boston to Los Angeles.

Several small heads found in Antioch may have adorned small herms or tabletops or household shrines. A fascinating find from Antioch is the small head of Alexander the Great in the Baltimore Museum of Art (fig. 5). The conqueror's celebrated dreamy expression is evident, with traces of red (the ground color) in the eyes and in the hair. Everyone with a town house or a villa in the Antioch area likely had such a small, thematic statue of the divine Alexander, with his head turned slightly to the side and with the dreamy expression of death and deification at an early age. After all, without Alexander there would have been no Seleukos I to inherit the major share of Alexander's conquests and to rule them from the city named for his own father and also for his son, Antiochos I.

A miniature black stone head of a bearded god, Dionysos or possibly Hermes, in the Baltimore Museum of Art probably came from a herm-shaped figure placed in a garden courtyard or at the door of a house (cat. no. 67). Such heads, however, were also used for statues of the fully clothed Dionysos, worshipped in cities of Lydia, western Phrygia, and inland Ionia in Asia Minor. The eyes are soft and sleepy; the hair, where preserved, and the beard are worked out with flowing modeling and linear precision.

The miniature white marble head of a male is characterized by severely parted, wavy hair held by a fillet around the crown of his head (cat. no. 66). This Baltimore head has a heavy mustache and a long beard that must have reached well down his chest. He too would appear to be a god, probably a Dionysos or perhaps a Priapos, another patron of agrarian fertility. The style is again magisterial, harkening back ultimately to Athenian grave stelae of the mid-fourth century B.C.E. The fillet could mark this as the face of a man of intellect, but a certain otherworldliness places him among the gods, great or small. Priapos, a child of Aphrodite, was a god of fertility in the broadest sense, his presence making the gardens grow in the suburbs and countryside around the Bay of Naples and points as far east as Antioch and Daphne.

A gathering of small-scale Olympians could be found in any number of private houses in Antioch. The impor-

Fig. 5. Alexander the Great. From Antioch. Island marble, height 4½ in. (11.4 cm). The Baltimore Museum of Art, 1938.714

tant cache of late Roman sculpture found in Antioch (Building 25–H) included a variety of subjects ranging from the historical portraits, already discussed, to Meleager, Ares, Aphrodite, a sleeping Silenos, satyrs and nymphs, and a resting grouse. All these were executed in varying sizes and styles, some harking back to models of the fifth to the third centuries B.C.E. Although the house is dated to the mid-fifth century C.E., the mix of the mythological with the historical and the decorative should probably be viewed as typical of earlier domestic collections. In the case of many of these small statues it is hard to speak of them showing anything of the Syrian style or any special characteristics of Antioch and its surroundings. They are the best of what Roman imperial gardens and peristyle courts sought from the shippers and importers supplying such sculptures from workshops all around the eastern Mediterranean, that is, the coasts of Asia Minor and the bigger islands of the area, from Crete to Rhodes to Cyprus.

Among the fragments of statues in the cache from Building 25-H is a small-scale Roman replica of the Ares Borghese, a work of the late fifth century B.C.E. (fig. 6). The helmet with two confronted hounds and palmette is identical to its Attic model. The copyist added the drilled and staring eyes, thereby creating a more restless god of war, conceivably a head from an architectural ensemble in freestanding relief.

Fig. 6. Head of Ares. From Antioch. White marble, height 10 in. (25.5 cm). Hatay Archaeological Museum, Antakya, n.a.

phylian coast or Tarsus in Cilicia, down to Laodikeia, and, further along the same coast, to Caesarea Maritima in the Holy Land. This old Silenos could be imagined as snoozing atop a garden pool in the courtyard, a humorous counterpoint to the fleshy charms of Aphrodite.

One of the livelier figures from Greek mythology is the mischievous satyr. The head of a youthful satyr still in Antioch (fig. 9) and a coy nymph now in the Princeton University Art Museum (fig. 10) are all that survive of a local version of a famous group, the Invitation to the Dance, both from the same sculpture cache encountered above. Judging from better-preserved versions, the nymph sits opposite the satyr as he snaps his fingers and steps on a footclapper. The lusty look on the satyr's face and the anticipation of pleasure in the nymph's eyes provide everything that the banqueters of Antioch would wish to see as they gazed up from their incomparable mosaics toward their miniature waterfalls.

Many sites around the Mediterranean have produced small statues of Aphrodite, and there must have been quite an industry associated with their creation. From the same cache as the helmeted Ares came a crouching Aphrodite, a copy of the statue identified with Doidalsas of Bithynia in the third century B.C.E. (fig. 7). Set on an oval base with a dolphin at her left side, she evokes a watery setting; most likely she is at her bath. The Antiochene copy underlines this association by adapting the piece as a fountain ornament. The kneeling goddess with fleshy folds is supported by a plinth in the form of a rocky outcrop near her left hip. The water flowed out from the pipe hidden below this rocky prop. Such figures exemplify the rococo charm of similar types found in Delos, Rhodes, Side, and even Ostia and Pompeii. The production, shipment, and purchase of Aphrodites by well-to-do householders in Antioch must have been as well defined as the import, display, and sales of Italian garden ornaments in the United States today.

The Dionysiac repertoire offered many entertaining options for household displays. The pot-bellied old Silenos snoring away in a blissful stupor after a drinking contest between Dionysos and Herakles was found in that same late antique cache of Building 25–H (fig. 8). He has counterparts all over the Roman world, from the cities on the Bay of Naples to Ilium (Roman Troy), to the Pam-

Fig. 7. Crouching Aphrodite. From Antioch. White marble, height 29⅛ in. (74 cm). Hatay Archaeological Museum, Antakya, 1227

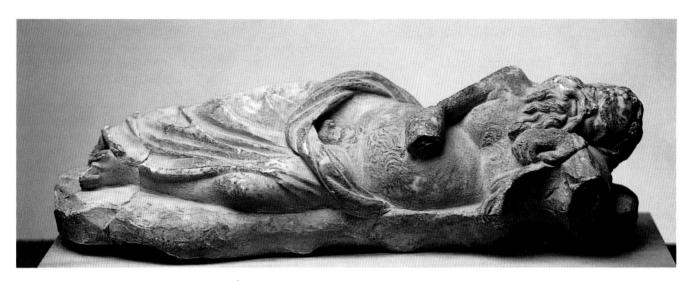

Fig. 8. Sleeping Silenos. From Antioch. White marble, length 21 in. (53.3 cm). Hatay Archaeological Museum, Antakya, 1228

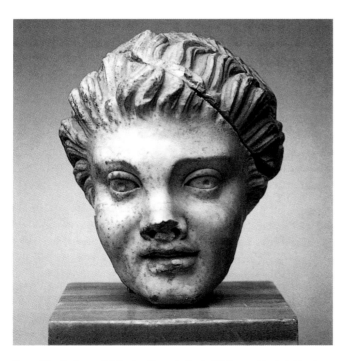

Fig. 9. Head of a youthful satyr. From Antioch. White marble, height 9 in. (22.9 cm). Hatay Archaeological Museum, Antakya, 1220

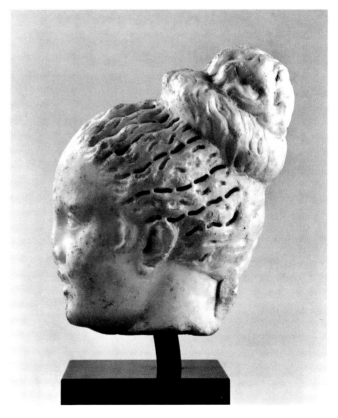

Fig. 10. Nymph. From Antioch. White marble, height 11⅜ in. (28.9 cm). The Art Museum, Princeton University. Gift of the Committee for the Excavation of Antioch to Princeton University, 4324-S191 y1992-49

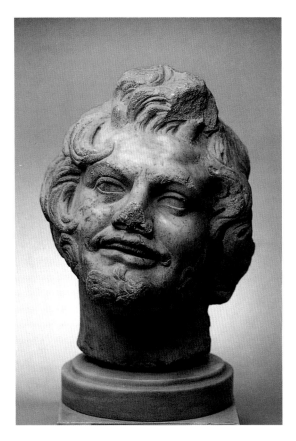

Fig. 11. Head of an old, bearded satyr. From Antioch. White marble, height 12½ in. (31.8 cm). Hatay Archaeological Museum, Antakya, 1223

From the same cache came an old, bearded version of a satyr, its slightly open mouth fashioned into a smirk (fig. 11). The powerful head appears to have been carved for insertion in a muscular statue wearing an animal-skin cloak around the shoulders. The hair is brushed upward on the crown, almost creating the effect of horns just over the forehead. The heavy locks curl downward on either side of the cheeks. Mustache, tuft of hair on the chin, and beard churn about in designs created to echo the locks on the upper part of the head. This satyr of the first or second century C.E. seems almost too worldly, too powerful, too lusty for the courtyard of a house at Antioch, but he might have looked out in anticipation of various pleasures from the hedges of an Antiochene garden. This sculpture is a superior example of work at the height of the Roman Empire, in the traditions of Hellenistic Pergamon around 200 B.C.E.

The last piece to be discussed from the cache of Building 25–H is an intriguing disc of dark gray stone (basalt?) carved with a sphinx of Grecian form (fig. 12). One can imagine it hanging between the colonnades of the peristyle gardens and twisting in the evening breezes. The find

confirms that Romans living at nearby Daphne or at distant Pompeii on the Bay of Naples were equally enthralled by all things Egyptian, whether imitated directly or presented in Hellenistic and Greco-Roman guise.

Egyptomania may also account for the proliferation of small images of the child god Harpocrates. An example of a possible Harpocrates from Daphne appears to be modeled on likenesses of Eros, Aphrodite's favorite infant (cat. no. 62). His childlike appearance is natural because Harpocrates was the Hellenistic and Greco-Roman representation of the infant Horus, the Egyptian god, often shown being nursed on the lap of his mother, Isis. The topknot of the Antioch boy is exaggerated in keeping with the elaborate headgear of the divinities of the Nile. Harpocrates, who liked to suck his thumb, is most often shown with his fingers close to his mouth, but this is not shown in the Antioch piece. He appears to hold a bird against his chest in his right hand, a gesture based on a popular Greco-Roman statue of a boy holding jumping weights.

Roman collectors throughout the Mediterranean prized sculptures that projected their social clout and learning. Just as their floors were densely covered with myths, so their sculpture collections included many mythological figures. The Dionysos from Daphne in the Worcester Art Museum is a Greco-Roman decorative version of a standard Praxitelean Dionysos, half-draped and leaning against the trunk of a vine that has clusters of grapes at the top (cat. no. 63). Other versions of this small statue, which was meant to provide a decorative backdrop for leisurely repasts, have been found all over the Greek

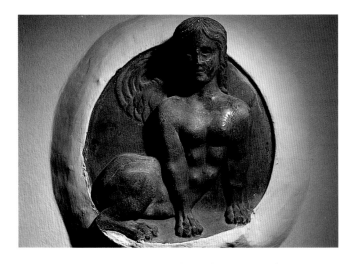

Fig. 12. Disc with sphinx. From Antioch, Building 25–H. Dark gray stone (basalt?), diameter 17¾ in. (45.1 cm). Hatay Archaeological Museum, Antakya, 1225

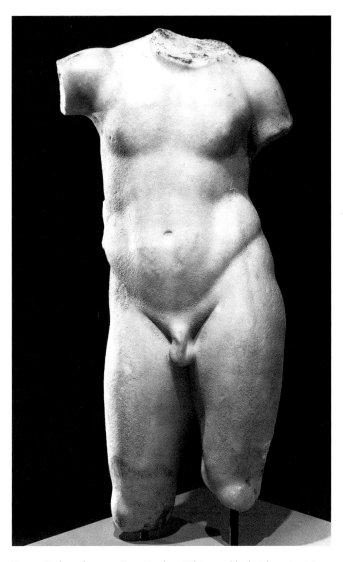

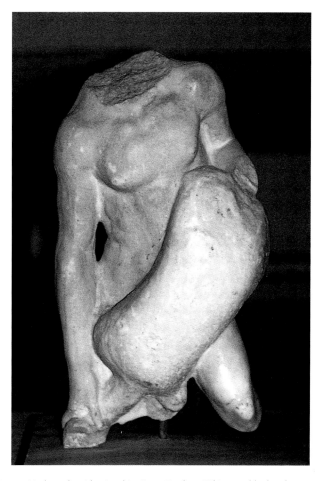

Fig. 13. Nude male torso. From Daphne. White marble, height 23 in. (58.4 cm). The Baltimore Museum of Art, 1937.150

Fig. 14. Nude male with wineskin. From Daphne. White marble, height 15 in. (38.1 cm). Hatay Archaeological Museum, Antakya 1371

world. Dionysos was also at home as a patron of Daphne, a resort town so wide open (like towns in the Wild West) that it was off-limits to the Roman army.

A nude torso of a preadolescent male that is on extended loan to the Worcester Art Museum from the Baltimore Museum of Art offers all the possibilities inherent in the rubbery statuary carved from blocks of lesser-quality white marble from southwestern Asia Minor and found in the Antioch area (fig. 13). Soft in the torso and large in the hips, the youth could have been Dionysos holding a pinecone staff and cup or grapes, or possibly even a young Herakles placing a wreath on his head with his raised right hand while holding a club and lionskin in the now broken off lowered left hand. Young gods and heroes were adored by the landowners of the Orontes

valley, much as they were by their Victorian counterparts who crowded their parlors and gardens with Hellenistic and Roman rococo. Might this torso even belong to Adonis, beloved of Aphrodite?

A nude torso from Daphne might well belong to the popular realm of Homeric heroes (fig. 14). While headless, he does carry a wineskin and assumes a position similar to one of the companions of Odysseus in the cave of Polyphemos as seen in the famous Sperlonga group, set in a cave on the coast of Italy southeast of Rome and northwest of Naples. In Italy and areas to the east the Cyclops Polyphemos and other figures, the companion bringing wine to make the giant drunk, were popular as single sculptures in settings where the full collection of subjects would have been overwhelming.

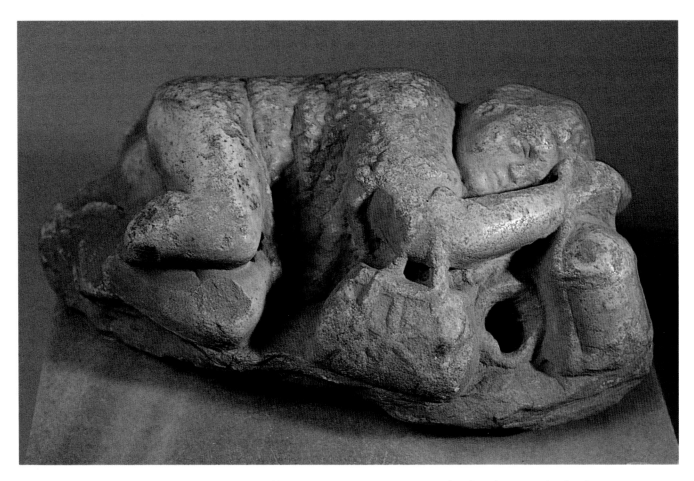

Fig. 15. Sleeping boy with lantern. From Daphne. White marble, 4½ × 12 in. (30.5 × 11.4 cm). Hatay Archaeological Museum, Antakya, 8940

Aside from the requisite divinities, domestic sculpture collections included delightful genre figures. A classic example from the Hellenistic repertoire of genre subjects is the thorn-puller *(spinario),* usually a nude young boy seated and pulling a thorn from the sole of his foot. A small marble figure of a short, compact, muscular man—not, as is so often the case, a boy—extracting a thorn from his own left foot has also found its way from Antioch to Baltimore (cat. no. 61). The Antioch figure, a nude squatting on a rock with an overturned urn or jug at his right side, seemingly therefore a fountain figure, is much more rustic and sturdy than the youthful versions of thorn-extractors. The head and neck were made separately and fastened by means of a dowel. As a rustic of the Dionysian countryside who stumbled on a thorn on his way to the Agora or Forum, the Antioch thorn-extractor is the counterpart of the Old Fisherman copied in white and colored marbles from Iconium (Konya), Aphrodisias in Caria, and the gardens around Rome. He was a perfect fit for the agrarian people or their rustic

mythological equivalents in the diverse worlds of the Roman Empire.

Similarly quaint and even cute are two sleeping rustics from Antioch. One, wrapped in a heavy hooded cloak and carrying a lantern, represents a slave boy who has fallen asleep while waiting to guide his master home. Many parallels exist in all media for the Slave Boy with Lantern. The other piece, a figure from a fountain, was found in Daphne and represents a boy stretched out on his side in sleep (fig. 15). He wears a sheepskin tunic and has a satchel under his arm. An overturned urn between the lantern and satchel was the source for the fountain. A strikingly similar statuette of a small boy wearing a traveler's hood was found in the garden of the House of the Little Fountain in Pompeii (VI, 8.23), indicating that such genre figures were used as fountain and garden ornaments.

The statues from baths, gymnasia, theaters, and lavish private houses or villas seem to have two sources. The better Greco-Roman statuary comes from the big cities of Ionia (Ephesos, Miletus, Magnesia-on-the-Maeander) by

way of Perge or Side in Pamphylia and Salamis on Cyprus. The lesser decorative, "garden" pieces can be found at a variety of urban centers from Ilion to Sinope on the Black Sea to Ephesos to Side and Salamis. Carian Aphrodisias and the quarries of Dokimion in Phrygia are represented more at Laodikeia than at Antioch, although several small sculptures echo the workshops of the sculpture-producing city dedicated to Aphrodite. Tarsus, to the west of Antioch on the Cilician coast, and Caesarea Maritima, farther south, on the eastern Mediterranean coast, seem to share some sculptural influences and choices of subject with the Antioch region. The East Greek grave stelae of Antioch and its vicinity have ties to Asia Minor and the Greco-Roman settlement of Byzantium.

As already stated, this essay deals with the Greco-Roman sculptures of Roman Syria, not the sculpture identified with Palmyra and Dura-Europos, carved mostly in limestone, or the Tigris Valley basalt sculptures, mostly funerary stelae, found in northern Syria along the borders of the Commagene and Armenia. The tastes of the people of Antioch-on-the-Orontes may have leaned toward the silks and spices of the caravan trade, but until the fateful reign of the emperor Aurelian (270–75 C.E.) the very linear styles of Palmyra and Dura-Europos stayed outside the truly Mediterranean world. In those years two widely separated events brought disaster, albeit temporary, to the classical tradition in the Mediterranean. The artistic community of Rome was wiped out in the revolt of the artists, artisans, and workers who took refuge in the fortified building that was Rome's mint. The conquest of Queen Zenobia's Palmyra by Aurelian's legions displaced countless Palmyrene sculptors and painters, not to mention mosaicists and metalworkers, who migrated westward to impose their linear, richly jeweled styles in the vacuum of Mediterranean creativity.

The immediate result was the Tetrarchic style in imperial portraiture, the major commemorative art of the years from about 286 to 315 C.E. The new, frozen-faced linearism, a recollection of Palmyrene and Durene physiognomies, is evident in the bearded head of a Tetrarch from the famous Building 25–H cache at Antioch. This portrait in imperial porphyry from along the Red Sea in Egypt has been identified as Constantius I Chorus (Caesar, 292–305 C.E.; emperor, 305–6 C.E.), a junior and then a senior ruler in the West. And more than that, he was the father of the future universal ruler, founder of the new Rome on the Bosphorus, and eastern saint Constantinus

Magnus (Constantine the Great, 306–37 C.E.). Constantius I's features are truly awe-inspiring: picked-out hair and beard and large staring eyes, the latter seemingly able to foresee the demise of the great metropolis that was Antioch-on-the-Orontes in the sixth century C.E.

Sculpture and Coins of Antioch

Both pictorially and sculpturally the coins of Antioch tell us much about the arts in the city and along the Syrian-Phoenician coast. Portraits of Seleucid kings and then Roman emperors dominate the obverses (see p. 104). The kings try to imitate the portraits of Alexander the Great and his immediate successors, but beginning in the second generation, with Antiochos I, individual profiles emerge, the more pronounced as the rulers become weaker and more inbred. Near the end, Tigranes II the Great of Armenia provides a refreshing contrast with his eastern mountain features and his traditional regalia.

From the strong, large head of Augustus to the incisive profile of Nero, at the end of the Julio-Claudians, the Romans reached a new level of noble, no-nonsense verism with Hellenistic heroic traditions. This level intensified with the portraits of Vespasian and his sons, Titus and Domitian. There was no looking back, from Trajan, the Antonines, and Caracalla to Decius and Tribonianus Gallus, military emperors shortly before the Greek imperial issues of Antioch terminated with the invasions and turmoil under Valerian and his son Gallienus. The portraits of Diocletian and the Tetrarchs through the house of Constantine the Great into the fourth and fifth centuries from the mint of Antioch parallel the styles that swept back and forth across the Eastern and the Western Empires.

The reverses of the best Seleucid silver *tetradrachms* (equivalent to four *drachma* coins) present freely conceived miniatures of the famous temple statues of Antioch and nearby Daphne. The seated Zeus of Phedian ancestry was commissioned by Seleukos I Nikator as endowment for his city (p. 106, fig. 1). Seated and standing young Apollos have left their traces in other arts from the cities around the Orontes (p. 106, fig. 2). They are comfortably Praxitelean on the *tetradrachms* of the first four or five Seleucids. The standing Athena Nikephoros on later Seleucid reverses is worthy of temple images from Pergamon to Priene to Side in the traditions of the Athena of the Parthenon.

Tychai are synonymous with Antioch. A seated example on Seleucid *tetradrachms* clearly echoes a major

image in the city. The most famous Tyche of Antioch, seated above the swimming Orontes in a bronze statue by Eutychides of the family of Lysippos, first appeared on *tetradrachms* of Tigranes the Great (p. 107, fig. 5). The designers of *tetradrachms* of Augustus introduced the most famous of all Antiochene images to the Roman imperial world. In the third century C.E. the statue was very popular in its shrine on big bronze coins and was widely imitated as a Tyche of other cities.

When the coins of Antioch became just one mint of many around the Roman Empire, the reverses no longer carried particular reference to the Syrian city. Even the pair of city goddesses supporting the imperial votive shield of Constantine the Great's successors are Roma and Constantinopolis.

By the year 400 the pagan temples were closed, and the reverses of the coins identified with the mint of Antioch were given over completely to the glorification of the Christian emperor, holding aloft the standard of Christ and trampling barbarians. As the century progressed, even the triumphant emperor gave way to Nike-Victoria holding a large cross, the imperial angel of Christianity. When Antioch struck big bronze coins of Justinian, the mintmark being the city's sacred Christian symbol, the facing bust on the obverse was an icon like the mosaics of Hagia Sophia in Constantinople, and the reverse consisted only of letters, dates in Roman numerals, and Christian symbols (p. 110, fig. 14).

To recapitulate, artistically the coins of Antioch fall into three broad categories. There are the elegant silver *tetradrachms* of the Seleucid kings, the designs only growing sloppy under Philip Philadelphus as the Romans arrived. The quasi-autonomous *tetradrachms* and big bronzes from Augustus to Valerian more often than not combine what might be perceived as dull reverses with powerful portraits. But upon closer observation, one sees that the eagles are often imaginative, and the busts of Tyche manifest many small ornaments and details, such as little running animals above and below. Coins minted after Diocletian turned Antioch into one of many mints in the Roman Empire. The portraits command interest and the reverses are sometimes unusual, but the numismatic art of Antioch is all part of a much wider framework.

For additional information, see Bartman 1991, Bieber 1977, Brinkerhoff 1970, and Hill 1981.

New Find:
The Antakya Sarcophagus

Faruk Kılınç

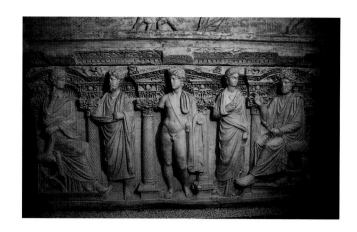

An especially fine example of a columnar sarcophagus was recently put on display in the Hatay Archaeological Museum, Antakya, Turkey. It was found in 1993 during construction along the axis of the ancient colonnaded street, immediately outside the Daphne Gate and the walls of Tiberius. The presence within the marble casket of burial gifts of gold coins from the reigns of Gordianus III (238–44 C.E.) and Gallienus and his wife Cornelia Salonina (253–68 C.E.), as well as some women's jewelry, confirms that this was one of the rare burial sites to escape ancient looters. Of massive dimensions, the sarcophagus is also impressive for the skill of its carving. The decoration of the sarcophagus with columns and niches places it with the group produced in western Asia Minor and named for examples found in the town of Sidamara, halfway between Ephesos and Antioch. The Antioch find is a late example of the Sidamara series (others are on view in museums at Konya, Ephesos, and Istanbul), as evidenced by the coin of Gallienus minted between 260 and 268 in Rome. The marble is creamy and of a very fine grain, perhaps from Aphrodisias.

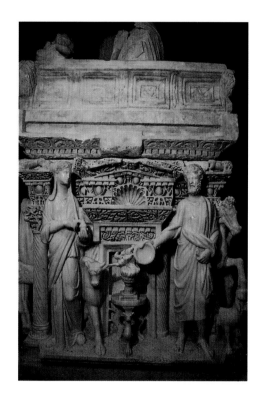

The deceased couple, carved lifesize, recline on the couch-shaped lid. Only an unfinished portrait of the woman survives, but it attests to the practice of leaving the final carving for the mass-produced caskets until the time of purchase. Several unfinished lids indicate incomplete commissions.

The Sidamara sarcophagi were meant to be freestanding, for they are carved on all four sides. Along the front side of the Antioch example are five figures, including a seated male at one end and a seated female at the other end who represent the deceased couple. A muse-like female stands behind the husband, a philosopher-like male stands beside the wife, and at the center is a nude youth (Apollo?). The Dioscuri, with their horses, stand in attendance at either end of the back side; between them is a hunt scene with three hunters; the one on a horse, who spears a lion, possibly alludes to the deceased as a brave youth. On one short side is a scene that appears to be an offering before the Gates of Hades with a woman holding a *pyxis* and a man offering the contents of a *phiale* over a flaming altar.

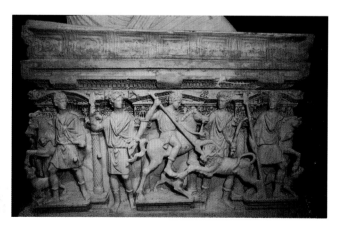

Sidamara-type sarcophagus found in Antakya, third century. Marble, 47¼ × 97¼ × 48 in. (120 × 247 × 122 cm). Hatay Archaeological Museum, Antakya, 18153. *Front side:* Deceased couple seated at either end; *short side:* Scene of sacrifice; *back side:* Hunter on horseback flanked by Dioscuroi

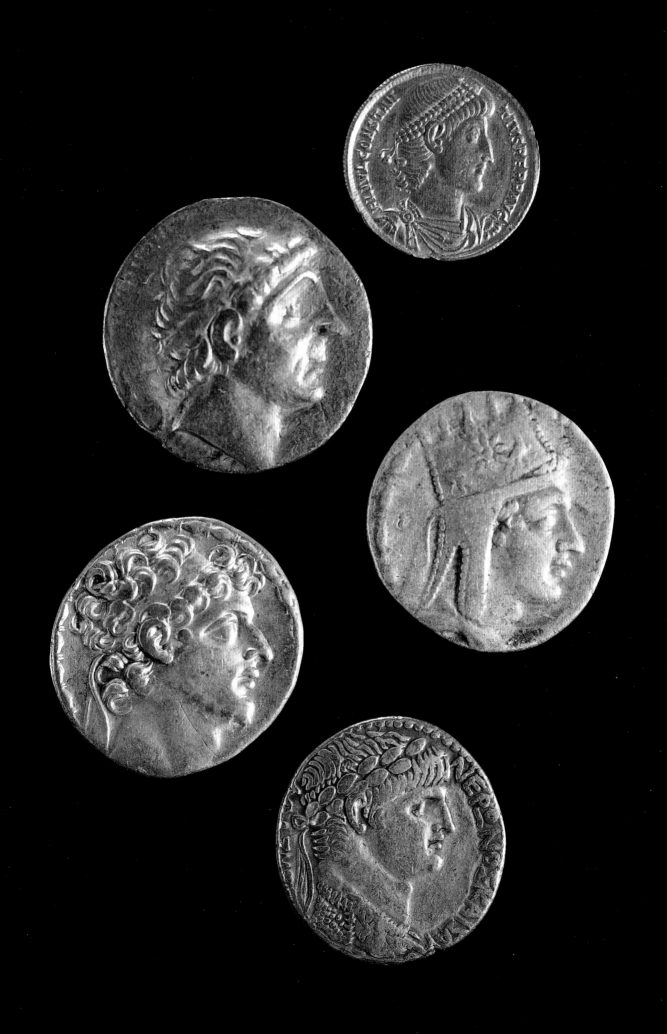

The Mint of Antioch

William E. Metcalf

Gold and silver coins struck in Antioch. Worcester Art Museum. Gift of Emily Townsend and Cornelius Vermeule in memory of Francis Henry Taylor, 1999.373, 321, 401, 338, 342. *From top to bottom,* gold *solidus:* Constantius II (337–361 C.E.); silver *tetradrachms:* Antiochos I Soter (280–261 B.C.E.), Tigranes II of Armenia (83–69 B.C.E.), Seleukos VI Nikator (98–94 B.C.E.), Nero (54–68 C.E.)

Coins are one of the most important guides to the history of cities in antiquity. For some towns they are the only surviving evidence; in other cases they are the modern keys to identification of ancient sites. Their abundance can signal economic or political domination, as in the case of the famous "owls" of Athens. Their beauty can define the artistic standards of an age, as do the magnificent *dekadrachms* of fifth-century Sicily.

We tend to forget that whatever else they did, coins served a utilitarian purpose: they were mass-produced in order to *be* the money used by classical man. Virtually from its founding in 300 B.C.E. and for the next nine centuries Antioch had a mint where coins were produced under government authority, and as the city grew to be one of antiquity's most important so did its coinage. Antioch never produced a coinage as dominant as that of Athens or as beautiful as that of Sicily, but the longevity of its mint is unmatched, even by Rome's.

In fact Rome and Antioch struck their first coins at about the same time, though they were very different kinds of coins. The chronology of the Antioch mint is more secure because its first coins were royal: they bear the name of Seleukos I, founder of the dynasty that bore his name, and like other early Hellenistic coins they derive from those of Alexander the Great. The types are the familiar Herakles head on the obverse and the seated Zeus on the reverse. The only variation is in the details: instead of an eagle Zeus holds a small figure of Nike in his outstretched hand, and the inscription is ΒΑΣΙΛΕΩΣ ΣΕΛΕΥΚΟΥ ([a coin] of King Seleukos) in place of ΒΑΣΙΛΕΩΣ ΑΛΕΞΑΝΔΡΟΥ ([a coin] of King Alexander) (fig. 1). This first royal coinage was small. The first portrait on Seleucid coins, at Antioch and throughout the empire, did not appear until the reign of Antiochos I (280–261 B.C.E.), who also asserted the individuality of the dynasty by placing its patron deity, Apollo, on the reverse of his coins. The god is shown seated on an *omphalos* (navel), which has religious significance of its own but which here represents the center of the cult of Apollo at nearby Daphne.

How can we know the coins were struck in Antioch? The identification of mints is one of the numismatist's jobs, and the criteria vary from period to period. At a site that has been excavated, the huge numbers of bronze coins, which seldom traveled far from home, are conclusive for attribution, and the style of these issues can be compared with the silver, which itself is rarely found in excavations. The first Seleucid silver issues can hardly

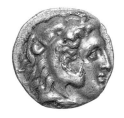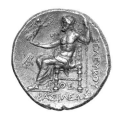

Fig. 1. Silver *tetradrachm* of Seleukos I (300–280 B.C.E.). Head of Herakles / ΒΑΣΙΛΕΩΣ ΣΕΛΕΥΚΟΥ Zeus seated left holding Nike and scepter (1st ser.). American Numismatic Society, 1944.100.74793

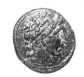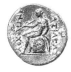

Fig. 2. Bronze unit of Antiochos I (280–261 B.C.E.). Head of Antiochos diademed right / ΒΑΣΙΛΕΩΣ ΑΝΤΙΟΧΟΥ to right and left of Apollo, seated left on *omphalos*. American Numismatic Society, 1944.100.75049

have come from anywhere but Antioch, and there is clear continuity of style and treatment down to the end of Greek coinage with Augustus. As capital of a Roman province, Antioch was the principal mint for silver *tetradrachms*. The repeated use of the Tyche of Antioch as a favorite reverse type is a giveaway for attribution. In the later Roman period beginning around 293 C.E., from the time of the tetrarchy, the mint mark ANT or some variant is used until Justinian, who substituted THEUP (olis), "city of God." Both the reverse imagery of the Tyche and the abbreviated name of the city help numismatists identify coins struck in Antioch.

Where did the coin metal come from? For most of history the need to destroy a coin to determine its metal content prevented large-scale analyses, and many modern techniques are insufficiently precise to allow meaningful tracing of the source of coin metal. During the period of Seleucid conquest silver no doubt came from booty and tribute, and that coinage in turn must have provided much of the metal (melted) from which the Romans struck their own silver. In addition, we know that there were silver mines in Cilicia and northern Syria.

The settlers of Antioch would hardly have handled these coins very often, though: the 17 grams of silver in a typical *tetradrachm* (four-*drachma* piece) would have represented a substantial amount of money. Their change would have consisted of bronze coins, of which over one thousand were found in the excavations at Antioch. These excavations—conducted in the 1930s and published in 1952—provide a unique insight into the city's petty currency, the coins that passed most frequently from hand to hand. The excavations turned up little silver and no gold, which would have been recovered in antiq-

uity or modern times. But the loss of smaller-denomination coins was less easily felt, and they were harder to recover, and so they survive for excavators to find.

The excavations revealed an articulated system of denominations in the royal coinage (fig. 2) as well as occasional "municipal" issues, produced with or without the portrait of the king but on the authority of "the Antiochenes." These denominations anticipate later Roman coinages, which were also produced on varying authority.

The mint of Antioch became the most important of the Seleucid empire, but its output was not huge in any absolute sense. A detailed study of its coinage suggests that only about thirteen hundred obverse dies were required for its coinage over the 235 years of the mint's Seleucid incarnation; this compares with an equal number of dies consumed *in a single year* by the moneyers of 82 B.C.E. at Rome. But the important message, constantly reinforced, was that of royal dominion. In these same 235 years thirty kings, some of them reigning more than once, proclaimed their rule from the mint.

The first coins are very attractive and lifelike and simple in design, befitting the products of the mint of the capital. With a few exceptions, such as the splendid *tetradrachm* of Cleopatra Thea and Antiochos VIII (fig. 3), the formula is: royal portrait/royal name *plus* divinity. Later ones, on reduced weight standards, were often less successfully executed. While the first of the kings were content with simplicity (ΒΑΣΙΛΕΩΣ ΣΕΛΕΥΚΟΥ [of King Seleukos]; ΒΑΣΙΛΕΩΣ ΑΝΤΙΟΧΟΥ [of King Antiochos]), the titulary becomes increasingly elaborate (ΒΑΣΙΛΕΩΣ ΣΕΛΕΥΚΟΥ ΕΠΙΦΑΝΟΥΣ ΝΙΚΑΤΟΡΟΣ [of King Seleukos, famous, victor] for Seleukos VI [fig. 4]; ΒΑΣΙΛΕΩΣ ΑΝΤΙΟΧΟΥ ΕΥΣΕΒΟΥΣ ΦΙΛΟΠΑΤΟΡΟΣ [of

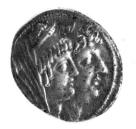
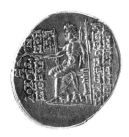

Fig. 3. Silver *tetradrachm* of Cleopatra and Antiochos VIII. Jugate busts of Cleopatra (in front) and Antiochos VIII facing right / ΒΑΣΙΛΙΣΣΗΣ ΚΛΕΟΠΑΤΡΑΣ ΒΑΣΙΛΕΩΣ ΑΝΤΙΟΧΟΥ Zeus seated left on throne holding figure of Victory in extended right hand and scepter in left. ΙΕ to right. ΑΙ under throne. Worcester Art Museum. Gift of Emily Townsend and Cornelius Vermeule in memory of Francis Henry Taylor, 1999.400

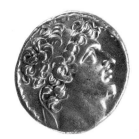
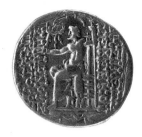

Fig. 4. Silver *tetradrachm* of Seleukos VI Nikator (98–94 B.C.E.), Antioch. Head of Antiochos diademed right / ΒΑΣΙΛΕΩΣ ΣΕΛΕΥΚΟΥ ΕΠΙΦΑΝΟΥΣ ΝΙΚΑΤΟΡΟΥ, ΓΝ below throne. Zeus Nikephoros enthroned to left. Worcester Museum of Art. Gift of Emily Townsend and Cornelius Vermeule in memory of Francis Henry Taylor, 1999.338

King Antiochos, pious, he who loves his father] for Antiochos X). At the same time a simple, linear style of epigraphy gives way to a broader stroke capped by a large circular punch. The verbiage overwhelms the image, and the effect is unattractive.

The coinage of the first century closely reflects political events at Antioch. Both the empire and the coinage were in decline. The reign of Philip Philadelphus (89–83 B.C.E.) saw a huge coinage in silver that was to have a long afterlife. He was involved in a series of wars with his brothers, and eventually the Antiochene populace called in Tigranes of Armenia to give them some peace (83–69 B.C.E.). Tigranes's coinage is significant for its introduction of the Tyche type, the goddess seated facing right resting her foot on the river god Orontes (fig. 5). This type lasted even longer, appearing sporadically to the end of local coinage under the Romans. The Seleucid coinage came to a formal end with the issues of Antiochos XIII, which, except for the royal name, are indistinguishable from those of Philip.

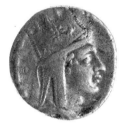
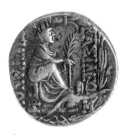

Fig. 5. Silver *tetradrachm* of Tigranes II of Armenia, as king of Syria (83–69 B.C.E.), Antioch. Draped bust of Tigranes right, wearing high Armenian cap / ΒΑΣΙΛΕΩΣ ΤΙΓΡΑΝΟΥ Tyche of Antioch seated right on rock, holding palm branch in right hand. Young Orontes swims to the right, at her feet. Worcester Art Museum. Gift of Emily Townsend and Cornelius Vermeule in memory of Francis Henry Taylor, 1999.401

The Romans

Pompey the Great took Syria in 64 B.C.E., but there was no immediate effect on the coinage in circulation. Even when Roman presence began to be evident, the new coinage was virtually indistinguishable from the earlier. This is no surprise. The Romans liked to leave in place institutions that worked, and this was particularly so with coinage, which was familiar to the populace. The same phenomenon can be observed in the *cistophori* of the province Asia that were taken over from the royal coinage of the Attalids when their kingdom was bequeathed to the Romans, and in Egypt, when it fell to Rome after the death of Cleopatra, as well as other formerly autonomous coinages.

The first silver coins, in the name of the proconsul Gabinius, are distinguishable only by the addition of his monogram to the types and image of Philip II, whose coinage must have dominated the currency of the day. Even Augustus made no significant alteration in the reverse until 6 B.C.E., when the Tyche of Antioch reappeared and became the standard reverse for the remainder of his reign (fig. 6). It would recur sporadically on silver throughout the mint's history, and it became more and more prominent on the civic copper.

Silver was struck extensively though sporadically through the first century, less frequently after the time of Trajan. Once again the Antioch excavations show us the pocket change of the Antiochene: mostly chunky copper coins with a large s c within a wreath, reminiscent of Roman *asses* and reinforcing the idea that however much

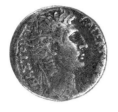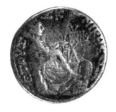

Fig. 6. Silver *tetradrachm* of Augustus, Antioch (5/4 B.C.E.). ΣΕΒΑΣΤΟΥ ΚΑΙΣΑΡΟΣ Head of Augustus laureate right / ΕΤΟΥΣ ΙΚ ΝΙΚΗΣ Tyche of Antioch right wearing turreted crown and holding palm branch in right hand, river Orontes swimming right beneath. Worcester Museum of Art. Gift of Emily Townsend and Cornelius Vermeule in memory of Francis Henry Taylor, 1999.341

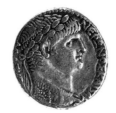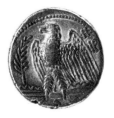

Fig. 8. Silver *tetradrachm* of Nero (54–68 C.E.), Antioch. ΝΕΡΩΝΟΣ ΚΑΙΣΑΡ (ΟΣ) Head of Nero laureate right, wearing an aegis / Η over ΙΡ at right. Eagle, wings spread, standing left on thunderbolt, to left palm branch. Worcester Art Museum. Gift of Emily Townsend and Cornelius Vermeule in memory of Francis Henry Taylor, 1999.342

Fig. 7. *Orichalcum* municipal *semis* struck under C. Ummidius Durmius Quadratus, governor of Syria (51–60 C.E.). ΑΝΤΙΟΧΕΩΝ Tyche head turreted right / ΕΠΙ ΚΟΥΑΔΡΑΤΟΥ Ram running right, looking back; below ΕΤ ΕΡ (year 105 of the Caesarian era, 56/57 C.E.). American Numismatic Society, 1961.154.40

the city might be noted for its independence, it was always subject to Rome. But just as the inhabitants of Seleucid Antioch had dealt with coins struck nominally by different authorities, the Roman residents, too, had a mixed bag of coins: "Archieratic" bronzes struck under Augustus, proconsular issues struck through the first century (fig. 7), and even Roman-standard issues struck by Trajan.

Rome's influence was most often evident in the silver coinage. An earthquake in the city in 37 C.E. resulted in the dispatch of a trio of imperial legates, and revived silver coinage may be connected with their presence. The coins of Caligula (37–41 C.E.) owe much to Roman prototypes: they commemorate Agrippina and Germanicus, just as do *aurei* and *denarii*. The coins of Claudius are dynastic in another way: they honor Agrippina and the young Nero, his designated successor. It is under Nero that the silver takes its classic form, with the head of the emperor on the obverse and an eagle, wings spread, on the reverse (fig. 8). This type continues through the year of the four emperors (69 C.E.).

Tacitus (*Hist.* 2.82) reports that a mint was opened in the city soon after the investiture of Vespasian in 69 C.E.,

and there are good reasons for believing that he was right. The mint seems to have produced both traditional-standard *tetradrachms* (fig. 9) and *aurei* (fig. 10) and *denarii* on the Roman standard; the *denarii* are fairly common today. There seems to have been more than one mint producing *tetradrachms,* but they were struck on the now-familiar emperor/eagle motif. These are confined, for the most part, to the first years of Vespasian, though some are known for Domitian and a very few are known for Nerva. The *tetradrachm* coinage revives in size under Trajan in his early years, and an imperial visit in 116 coincided with yet another earthquake. The impact on the coinage is seen in the striking of *orichalcum asses* and *semisses* and in a significant improvement in the emperor's portrait on the s c bronze. The use of identical countermarks on both groups of coins proves their common origin: the laurel branch may be connected with Daphne, since the Greek word δάφνη translates as "laurel."

Coinage in the second century is known under Hadrian, Antoninus Pius, Marcus Aurelius, and Commodus, but the issues are insubstantial. The bulk of the city's currency needs were met by a huge outpouring of s c bronzes and probably also by an increasing dependence on Roman-standard silver.

Antioch served as the capital of Pescennius Niger, the governor of Syria who claimed the throne after the death of Commodus (193 C.E.), and the Antioch mint was surely his major mint (fig. 11). Similarities in execution suggest that it was taken over directly by Septimius Severus when he defeated his rival. It was probably one of his *denarius* mints, and its production was large enough that its coinage is well represented even in Western hoards. But just as under the Flavians, the experiment proved to be

Fig. 9. *Tetradrachm* of Vespasian (70/71 C.E.), Antioch. ΑΥΤΟΚΡΑΤΩΡ ΟΥΕΣΠΑΣΙΑΝΟΣ ΣΕΒΑΣΤΟΣ Head of Vespasian laureate right / ΕΤΟΥΣ ΝΕΟΥ ΙΕΡΟΥ Β [year 2 of the new era] Eagle, wings spread, standing left on thunderbolt, head right on altar; to left, palm branch. Worcester Art Museum. Gift of Emily Townsend and Cornelius Vermeule in memory of Francis Henry Taylor, 1999.345

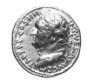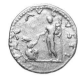

Fig. 10. Gold *aureus* of Vespasian, Antioch. IMP VESPAS AVG P M TR P P P COS IIII Head of Vespasian laureate left / PAX AVGVSTI Emperor standing left raising turreted female figure *(Orbis Terrarum?)* with right hand. American Numismatic Society, 1944.100.39966

temporary, and it was not until the reign of Caracalla (211–17 C.E.) that coinage was struck there again.

Caracalla traveled extensively in the East, and mints in both Syria and Phoenicia struck large issues of *tetradrachms* for him and his successors Macrinus (with Diadumenian) and Elagabalus. The pieces are debased and less regular in weight than the earlier *tetradrachm* coinage, and their execution is correspondingly shoddier. Both Macrinus and Elagabalus used the mint to strike silver (and possibly, in the latter case, gold) on the Roman standard as well; Antioch thus became the first regular Eastern mint in what would become a massive system encircling the Mediterranean.

Caracalla had introduced a denomination that is conveniently if improperly called the *antoninianus,* a double-*denarius* struck at only one and a half times the weight of the *denarius* itself. It appears not to have been successful and was soon suppressed, but it was revived in 238 C.E. Gordianus III, who took the throne and himself campaigned in the East, reintroduced the coinage, and there are extensive issues from Antioch right from the beginning of his reign. These echo types in use at Rome. Gordianus also struck yet more debased and lighter-weight *tetradrachms,* and the mints of Antioch and Caesarea in Cappadocia (the other major Eastern silver mint) seem to have shared personnel.

This was only a foretaste of events during the reign of Philip I, whose *tetradrachm* coinage was produced on a huge scale. It is necessary to distinguish between coins produced at Antioch itself and those produced for the province of Syria at Rome. The first bear the novel legend ANTIOXIA, the others MON VRB (for *Moneta Urbis*, which must mean "Metropolitan mint" [of Rome, that is]). The reason for this episode is not entirely clear, but possibly

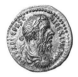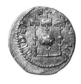

Fig. 11. Silver *denarius* of Pescennius Niger, Antioch (193–94 C.E.). IMP CAES C PESC NIGER IVST AVG Bust of Pescennius Niger laureate draped and cuirassed right / FIDEI EXERCITVI Three legionary standards, center one with tablet inscribed VIC AVG. American Numismatic Society, 1984.112.1

the provincial silver resources were inadequate to Antioch's monetary needs and coinage was supplied directly from the capital.

The Persian menace grew ever stronger, and with it no doubt military expenses specific to Syria increased. Both Trajan Decius (249–51 C.E.) and Tribonianus Gallus and Volusian (251–53 C.E.) struck huge quantities of silver as well as local bronze, and it is clear that in the last years of Gallus and Volusian the imperial and local mints had merged or at least employed the same personnel.

Antioch fell to the Persians in or about 256 C.E., as part of the same campaign that saw the fall of Dura-Europos. By the time it was reoccupied by the Romans the coinage had undergone further debasement, and there were to be no more *tetradrachms:* Antioch became part of the larger imperial minting system and its distinctive identity as a provincial mint was lost. The imagery of its coinage up to the reform of Diocletian has a decidedly military cast (fig. 12), but afterward its types are hardly distinguishable from those of other mints.

Rome had ceased to be the center of the empire even in the third century, and the trend was recognized as

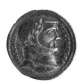

Fig. 12. Silver *argenteus* of Galerius Maximianus Caesar, Antioch (293–305 C.E.) MAXIMIANUS CAESAR Laureate bust of Maximianus right / VIRTUS MILITUM Camp gate/city wall. ANTN in exergue. Worcester Art Museum. Gift of Emily Townsend and Cornelius Vermeule in memory of Francis Henry Taylor, 1999.371

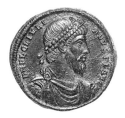
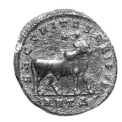

Fig. 13. Bronze unit of Julian II, Antioch (361–63 C.E.). D N FL CL IVLIANVS P F AVG Bust of Julian diademed, draped, and cuirassed right / SECVRITAS REIPVB around bull right, two stars above; in exergue ANTΔ. American Numismatic Society, 1984.146.576

Fig. 14. Copper half-*follis* (20-*nummi* piece) of Justinian I, Antioch (529–33 C.E.). D N IVSTINIANVS P P AVG Seated figure of Constantinopolis facing, holding *globus cruciger* in left hand and scepter in right / Large к; to left, large cross with T-H/E-UOP in angles; to right, Γ. American Numismatic Society, 1948.8.28

much as promoted by the foundation of Constantinople. But in effect Antioch often functioned as the eastern capital, so frequent was the need for military activity against the Persians. The mint has what is probably the most extensive gold coinage of the later fourth century. Particularly remarkable is the coinage of the pagan emperor-philosopher Julian (fig. 13), who spent considerable time at Antioch and formed a low opinion of its people, who made fun of his coins:

Once upon a time the citizens of Tarentum paid to the Romans the penalty for this sort of jesting, seeing that, when drunk at the festival of Dionysus, they insulted the Roman ambassadors. But you are in all respects more fortunate than the citizens of Tarentum, for you give yourselves up to pleasure throughout the whole year, and instead of foreign ambassadors you insult your own Sovereign, yes even the hairs on his chin and the images engraved on his coins. (Mis. 355 B [trans. W. C. Wright])

By the end of the fourth century it is impossible to speak of a single mint, for there were really two (though no physical evidence survives): the *moneta publica* was static and quasi-permanent, striking bronze coins; the *moneta comitatensis* rarely functioned when the emperor was not present and struck gold and silver. The fifth-century coinage of Antioch consists almost exclusively of copper coins of decreasing artistic quality and literacy. There are only two episodes of gold coinage, one probably in the period of the emperor Zeno's exile from Constantinople and the other in the twelve days in 484 when the usurper Leontius occupied the city. The coin of Zeno is unique, and the issue of Leontius is known in only three examples.

Byzantine Coinage at Antioch

The reign of the emperor Anastasius I (491–518 C.E.) is conventionally regarded as the dividing line between Roman and Byzantine coinage. The coinage had fallen into disarray during the fifth century, with virtually no coins struck between the tiny copper *nummus* and the pure gold *solidus*. It took 14,400 (or according to another source, 16,800) *nummi* to purchase a single *solidus;* the inconvenience of doing business in such a system can easily be imagined. The *nummi* were abysmally produced, widely imitated, and intrinsically worthless. It was necessary to produce a coin that was recognizable as the product of a legitimate and

solvent government and one whose substance inspired confidence in its value and made it easy to handle.

In 498 Anastasius introduced the *follis,* or forty-*nummi* piece. With a weight of 8 grams and a diameter of 20 millimeters it was a substantial coin, though at first 360 of these had to be exchanged for a *solidus.* Anastasius then doubled the weight, increasing the diameter as well, and halved the tariff to 7,200 *nummi* per *solidus,* or 180 *folles.* The innovation would last as long as there were Byzantine copper coins in Syria.

In late 512, in the last stages of Anastasius's reign, Antioch began to strike a full series of copper denominations. The great earthquake of 528 had its effect on the coinage as well as on the life of the citizenry. The name of the city was changed to Theopolis ("City of God") in hopes of securing heavenly protection, and this is reflected in the mint markings of the coins (fig. 14).

The city would continue to coin, even occasionally in gold, up to the reign of Herakleios, when the Persians invaded. Finally, the Arab conquest in 641 C.E. put an end to the city's coinage and participation in the life of the empire. It would never again be a Byzantine mint. The last early Byzantine coins recovered in the excavations were coins struck by Constans II (641–68 C.E.) and imitations of them; thereafter but a single *follis* of Leo VI interrupts a hiatus of more than three centuries. Such was the end of one of the longest and most vital traditions of ancient coinage.

For additional information, see Bellinger 1940, Burnett, Amandry, and Ripollès 1992, Houghton 1990, Metcalf 1977, and Newell 1978.

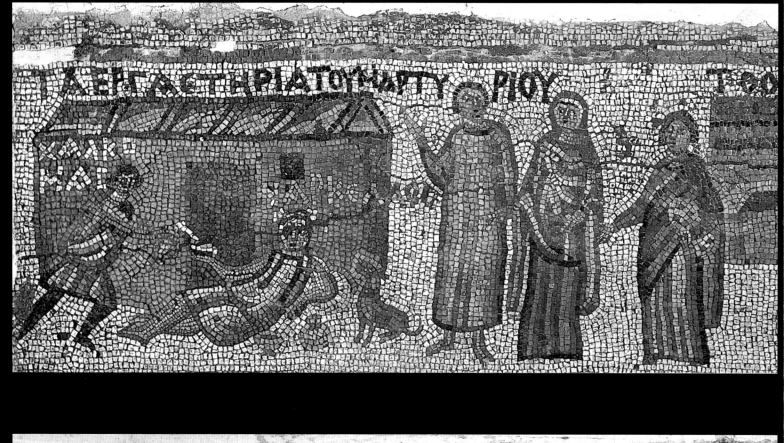

ΤΑΕΠΙΓΑCΤΕΡΙΑΤΟΥ ΡΙΟΥ · ΤΟΘ
ΧΑΛΚ
ΚΑΙ

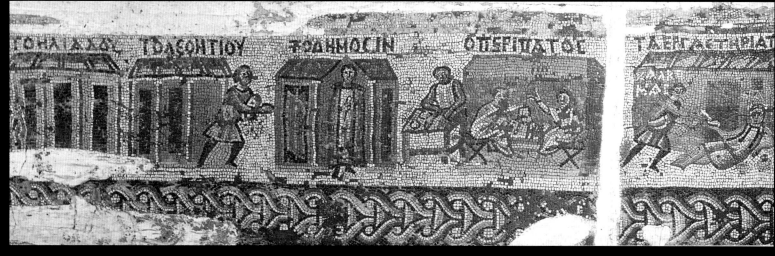

ΤΟΗΑΙΑΧΟC ΤΟΛΕΟΝΤΙΟΥ ΤΟΔΗΜΟCΙΝ ΟΠΕΡΙΠΑΤΟC ΤΑΕΠΙΓΑCΤΕΡΙΑΤ
ΧΑΛΚ
ΚΑΙ

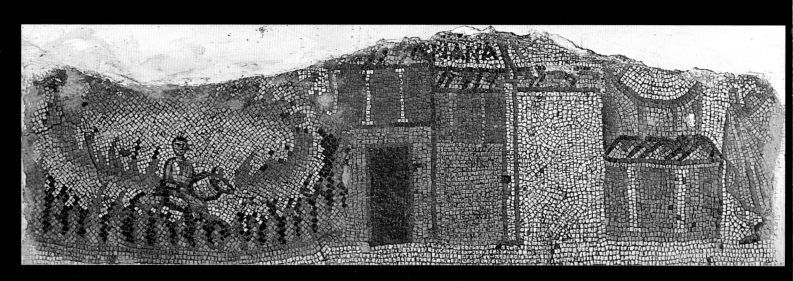

I City and the People

There is no more vivid introduction to the urban pulse of Antioch than the series of topographic vignettes with buildings and scenes identified by Greek inscriptions around the Megalopsychia Hunt mosaic, today in the museum in Antakya (p. 8, fig. 6, and p. 114). From the village of Yakto near Daphne and dated to the third quarter of the fifth century, the mosaic appears to follow an itinerary which can be read either as the start or end of a long walk between Daphne and Antioch laid out around the four sides of the hunt mosaic. It would appear that the mosaicists set out to capture a day in the life of the city, depicting a variety of individuals in contemporary dress walking past major monuments and interacting with street vendors and their fellow citizens.

At the lower end of the mosaic toward the southeast, a shorter side of the border begins at the springs of Daphne (Castalia and Pallas) and takes us by the Olympic stadium at Daphne, proceeds past women buying votives from a workshop for their visit to a martyrion, goes by two men playing a dice game, and a series of private houses with the names of the owners written above them. As we turn the corner to the northeast, a longer segment begins with a fish vendor and men cooking meat on skewers in a public area, perhaps a city square or forum, adorned with statues. Unfortunately, the upper end of the mosaic border is completely lost. The longer segment on the southwest side is especially interesting because it appears to record several major buildings from the island in the Orontes, or "New City." A cloaked man seems to be in the posture of prayer beside a central planned building with a white cupola and porticoed entrance, identified by scholars as the famous octagonal Church of Constantine. Adjacent to it is a group of buildings, including a racetrack, thought to represent the imperial palace. Reinforcing the idea that this segment represents the island, a woman and child cross a bridge over the Orontes River. Various other figures are shown riding on horses or donkeys, still others walk laden with heavy loads. The writings of Libanios and the vignettes of this mosaic offer a flavor of the mixings and meetings of people along the crowded passageways of Antioch.

Megalopyschia Hunt Mosaic.
Top: Figures (veiled women) approaching the workshop of the Martyrion; *middle:* Private houses with names of their owners and two men playing a dice game; *bottom:* Island in Orontes with octagonal Church of Constantine, imperial palace complex, and race track. Yakto village, near Daphne, fifth century. Hatay Archaeological Museum, Antakya, inv. 1016

1 **Tyche of Antioch**

2 **Tyche of Constantinople**

3 **Tyche of Alexandria**

4 **Tyche of Rome**

Late fourth century C.E.
Silver gilt, height 5½ in. (14 cm)
British Museum, London, 66.12-29, 21-24

Found in 1793 on the Esquiline Hill, Rome

PUBLISHED: Dalton 1901, 74–76, nos. 332–35, pl. 20; Dohrn 1960b, no. 12, pl. 3; Weitzmann 1979, 176–77; Shelton 1981, 26, 86–88, nos. 30–33, pls. 35–43; Milan 1990, 349, no. 5b.2e.b; Buckton 1994, 35–36, nos. 13–14

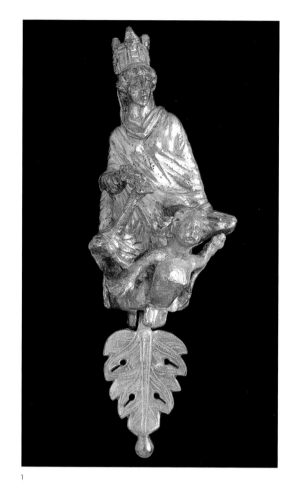

1

In the ancient world a Tyche was a female deity personifying and guarding the "fortune" of a particular city. Tyches were worshipped as talismanic city goddesses, complete with temples and cult images. Because they functioned as topographical allegories, their images easily survived the advent of Christianity.[1] In the late fourth century C.E., groups of Tyches representing the major cities of the Roman Empire emerged as a central theme of official imagery. They appeared on the reverses of coins as a pendant to the emperor's portrait, on official maps and calendars, and, later on, on the ivory diptychs that Roman consuls offered their colleagues in the senate upon their accession. The message promoted by sets of city personifications was one of unity, emphasizing the geographical breadth of the Empire. It was also a message of political diversity, depicting the late Roman state as a commonwealth of autonomous urban centers. The foremost pair of personified cities in the late Roman repertoire was that of Rome and its eastern counterpart, the "New Rome": Constantinople.

The four Mediterranean capitals are distinguished by their attributes, which were recognizable to the ancient viewer. Rome is shown in Amazonian garb with helmet, shield, and spear, the way she usually appears in Roman art (cat. no. 4). Constantinople wears a helmet similar to that of Rome but holds a horn of plenty and a libation bowl (cat. no. 2). Alexandria's massiveness, and mural crown, as well as the fruits and grain she holds, make her Antioch's closest visual match (cat. no. 3). She displays her maritime orientation as a seaport through the ship's prow projecting from under her foot. The city statuettes also have several traits in common. They share the same elongated proportions and generic facial features; they are all seated, and gilding on their surfaces covers only certain parts (hair, headgear, garment, and attributes), with silver left ungilded wherever the body is exposed. Three of the four figures (cat. nos. 2, 3, 4) wear a similar type of dress and are cast in the same frontal posture with a slight s-shaped curve. The Tyche of Antioch, on the other hand, has a more voluminous mantle, her legs crossed, a more pronounced inclination of the torso (cat. no. 1).

In addition, it is the only Tyche to have a secondary figure, namely a swimming male under her feet who is the personification of the Orontes River. She is the miniature version of the most famous Tyche in the Hellenistic era, a statue created for Antioch in Hellenistic times and widely imitated thereafter (see cat. nos. 6 and 8).[2]

Each of the four figurines is cast in one piece, each with a rectangular socket at the back. The socket was pierced on its top and bottom plate to accommodate a removable silver pin with attached chain (preserved only on the Tyche of Alexandria, cat. no. 3). Essential to the Tyches' function was the fact that they could be easily removed from whatever object to which they were once fastened. It has been proposed that the silver statuettes were fitted onto the ends of two wooden rods which were used to carry consular chairs in public ceremonies. The large gilded hinged leaves under each figure would have swung back and forth during the procession. After the chair was deposited on the floor, the pins would have been pulled out and the figurines removed, allowing the rods to slide out of their own sockets.[3]

The British Museum set of Tyches from Rome is exceptional, not only because they are the most precious (in silver gilt) of extant Tyches, but also because all four leading cities of the late Roman Empire are represented. In addition to the stan-

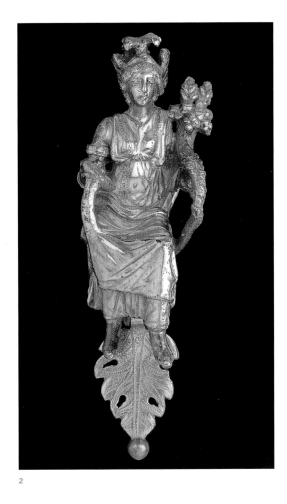

2

3

dard Rome and Constantinople pairing, this set includes Antioch and Alexandria, the two great cosmopolitan centers that vied for domination of the Levant under the successors of Alexander the Great. Epigraphic evidence suggests that the Esquiline Treasure belonged to one of the prominent families of late fourth-century Rome. These precious statuettes were the most public of the dozens of silver objects found with it, and their imagery has led scholars to presume that their owner was a high-ranking civil or military official. FH AND CK

1. On the cult of Tyches, see Matheson 1994.

2. For a recent discussion of the Antioch Tyche type, see Stansbury-O'Donnell 1994.

3. Bühl 1995, 140–41, figs. 73–74; see Shelton 1981, 26, who deems the suggestion that the Tyches were fittings for a *sedes gestatoria* "an attractive but not necessarily justified conclusion."

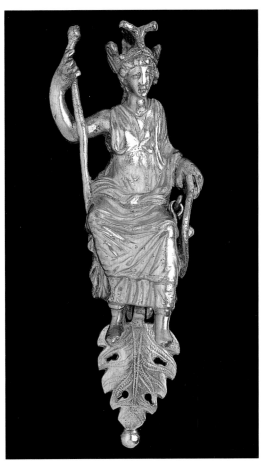

4

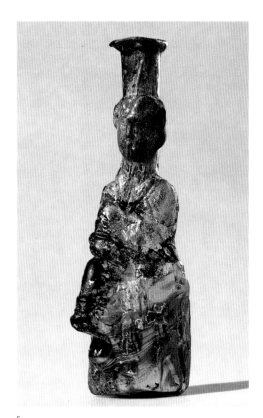

5

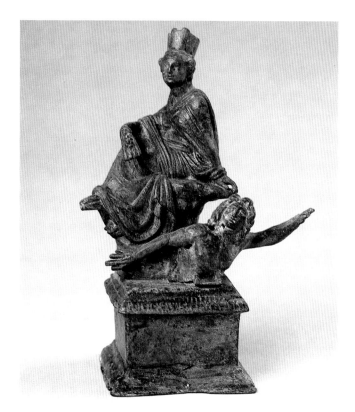

6

5 Tyche Bottle

Second or third century C.E.
Syria
Mold-blown glass, height 6¼ in. (15.8 cm)
Yale University Art Gallery, New Haven. The Hobart and Edward Small
Moore Memorial Collection, 1955.6.81

EX COLL.: Mrs. William H. Moore; Kouchakji Frères, New York, 1925

PUBLISHED: Matheson 1980, 102–3, no. 276, with earlier references and
parallels; Matheson 1994, 54, fig. 31, no. 49

Small images of the goddess Tyche were produced as commem-
orative glass bottles, apparently for sale to individuals as sou-
venirs or for use in household shrines. Seven such bottles are
known to survive. Created by a process of blowing glass into a
mold, the bodies of these bottles repeat the seated pose of Euty-
chides' famous statue of the Tyche of Antioch. The goddess's
mural crown on the statue becomes the bottle's neck, tooled by
hand after the glass blower removed the bottle from the mold.

The Tyche of Antioch statue was adapted by other cities for
the images of their own civic Tyches, many of which appear on
coins. Although the pose remained the same as that of Eutychides'
statue, different attributes were often added to distinguish local
Tyches from that of Antioch. The small figure of Eros bearing a
torch that appears on the side of Tyche's seat on the glass bottles
may be such a local symbol. Tyche and Eros are associated other-
wise only on a coin of Caracalla from Midaeum in Phrygia and in
a third-century wall painting from Dura-Europos in Syria. SM

6 Tyche of Antioch

Second century C.E.
Antaradus (modern Tartus, Syria)
Bronze, overall height 6½ in. (16.5 cm); height of Tyche alone
4½ in. (11.5 cm)
Musée du Louvre, Paris. Gift of Boisgelin, Br 4453

EX COLL.: De Clercq-de Boisgelin, Paris

PUBLISHED: De Ridder 1905b, 228–32, no. 326, pl. 51; Dohrn 1960b, 17,
18, 21, 30, 33, 37, 39, no. 10, pls. 8, 9-1, 32-2; Parlasca 1961, 90; Balty 1981b,
843, no. 2; Stansbury-O'Donnell 1994, fig. 30

This statuette echoes the famous statue of Tyche made around
300 B.C.E. by Eutychides of Sicyon for the city of Antioch,
which had been recently founded on the eastern bank of the
Orontes River. It is part of a series of small-scale replicas that
bear witness to the fame and popularity of the original work.

Tyche wears the turreted crown of the city that she both
protects and personifies. She sits on a rock with her legs crossed.
In her right hand she holds four sheaves of grain, a cluster of
grapes, and a flower bud. She is dressed in a loose chiton, its
thin network of folds especially visible at the back of her right
leg. A himation covers part of her hair, which is gathered into
a bun, and wraps around her entire body down to the middle
of her thighs. The garment sometimes restrains her movements,
as shown by the occasional stretching of the cloth—between
the left thigh and right arm. The Orontes is personified as a
swimmer whose upper body seems to emerge above the water
and move toward the right. The metal is torn to the right of

both the neck and the torso and to the left of Orontes' head, which is cast separately.

In the original group, Tyche's right foot rested on the right shoulder of Orontes. This is confirmed by many other examples of the group, including the bronze from Antequera, the numerous coin types issued by Antioch following those issued by Tigranes II the Great in the early first century B.C.E., as well as gemstones.[1] The way the two figures relate to each other in this statuette is therefore secondary and probably due to some modern intervention. The base, which does not belong with the original group, was too small for it and led the restorer to shift the river toward the rock. Moreover, the tip of the sole of Tyche's right sandal stands one and a quarter inches (3.2 cm) above ground, while Orontes's shoulder is only about one inch (2.7 cm) high in relation to the same plane. One has to conclude that the two statuettes, although both verifiably ancient, belonged to different compositions that were only later brought together. SD

1. For the Antequera bronze, see Balty 1981b, 843, no. 1; for coins and gemstones, see ibid., 845, nos. 33 and 98.

7 Orontes

Second century C.E.
Bronze, height 2¼ in. (5.5 cm)
Musée du Louvre, Paris, Br 520

EX COLL.: Rémusat, sold at auction in Paris on 17–18 May 1900

PUBLISHED: De Ridder 1913, 77, no. 520; Dohrn 1960a, 70, 71; Dohrn 1960b, 37 n. 70; Balty 1981b, 843, no. 16

Although isolated today, this small bronze of good workmanship originally belonged to a group showing the Tyche of Antioch. The Orontes is represented as a male figure whose upper body is moving toward the right in the attitude of a swimmer; a fillet on his head partly conceals his thick locks of hair. The U-shaped bronze device attached to the lower abdomen may allude to his placement in a pool fed by the Orontes River. The missing figure of Tyche rested her right foot on the swimmer's shoulder, as is evidenced by many renditions of the original group both in sculpture in the round and in the two-dimensional sphere of gems and coins. SD

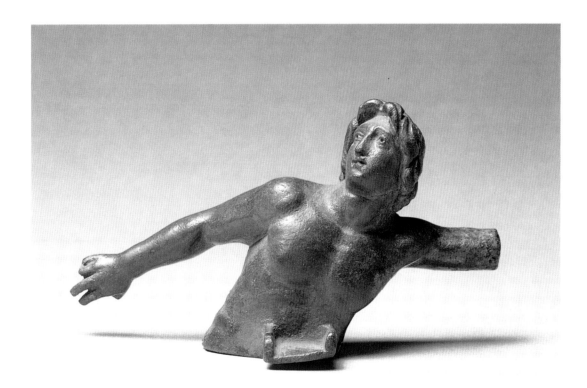

7

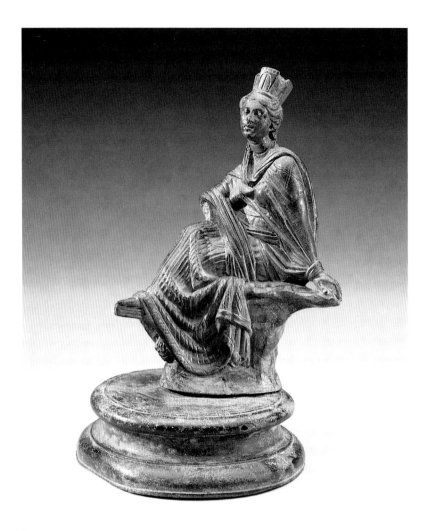

8

8 Tyche of Antioch

Second century C.E.

Bronze, eyes overlaid with gold, height 6 ¾ in. (17.2 cm)

Worcester Art Museum. Purchased with funds from the Stoddard Acquisition Fund, 1999.7

EX COLL.: Possenbacher

PUBLISHED: Manchester 1994

In both pose and drapery the Worcester statuette is very close to the Louvre example (cat. no. 6), and together with the Orontes from the Louvre (cat. no. 7), they suggest the replica series based on the popular Hellenistic model of the Tyche by Eutychides (Paus. 6.2.6).[1] It is clear from markings on the base that the Orontes, now lost, was part of the original Worcester piece. In fact, it is the only known example in the series with its original base and traces where the Orontes River was attached and thus provides evidence for the practice of joining separately worked pieces depicting the goddess and the river god. The Tyche's gold eyes also set her apart from the other bronze copies (about twenty-nine reproductions in bronze are documented). Although

now broken, her right hand would have held a sheaf of wheat. The fluid treatment of the parallel and criss-crossed folds of drapery, especially along the goddess's back, makes the Worcester version especially fine. The outcropping of rock on which she sits is attached to its original base, articulated by convex moldings.

The Antiochene version was the model for many other city Tyches and seems to have been a Hellenistic invention that offered a local city god (Tyche) for the new cities founded in the Hellenistic East. The Tyche type is conflated with many different goddesses and attributes depending on the locale of its production. For example, in Rome she is fused with the Roman fertility goddess Fortuna and deemed to control not only individuals but also cities and events. At Dura she is conflated with the Syrian goddess Atargatis, a symbol of beliefs of both the city's Seleucid founders and the local Semitic cults. CK

1. According to Dr. Marion Meyer, who is preparing a publication on these female figures with mural crowns, the Worcester Tyche "does not belong to the group of statuettes that render the original most exactly (the Louvre statuette does)" (e-mail message to author, 3 September 1999). I am indebted to Dr. Meyer for her observations on this series of statuettes.

9 Mosaic of a Funerary Symposium

Late fourth century C.E.
Antioch, Necropolis (sector 24-L)
Limestone, marble, and glass *tesserae*, 5 ft. 10 in. × 8 ft. 10 in.
(177.8 × 269.2 cm)
Worcester Art Museum, Worcester, 1936.26

PUBLISHED: Morey 1937, no. 5; Antioch II 1938, 193, no. 76, pl. 55; Levi 1947, 295–304, pl. 66; Campbell 1988, 77–78, pls. 217–21

Two women recline on a curved couch *(stibadium)* decorated with stripes of red and green. A third woman, holding a scroll, sits on a low stool to the left of the dining couch. Behind her, two women enter with wineskins slung over their shoulders. Through a wooden door visible at the far right a serving girl offering a jug and basin for washing hands has just entered the room.[1] Another bowl is held by one of the reclining diners. Additional tableware is displayed in the right foreground: a krater and a tall pointed amphora set into a metal stand. The multilobed, sigma-shaped table is of a type popular in the eastern Mediterranean; in fact, one like it was excavated from a house in Daphne.[2] The hanging curtain *(parapetasma)* fastened to the back wall by circular bosses recalls similar devices used to frame deceased couples on Roman sarcophagi and may allude to apotheosis.[3]

The pavement was found in a necropolis south of the city, in a small chamber surrounded by tombs.[4] What may be *loculi* or perhaps benches for meals around the perimeter of the room were found in the excavation. A wide geometric border punctuated by ten personifications surrounded this central scene. The corners were anchored by the turning points of the year, the Tropai. These busts were accompanied by standing personifications of the Seasons. Only Winter and the Winter Solstice are extant, at the Mead Art Museum at Amherst College. To the left and right of the central banquet scene are two personifications, one of Agora (the Marketplace), the other of Eukarpia (Fertility), at the Worcester Art Museum. The funerary banquet was framed by time—seasonal, calendrical, and eternal.

Though this pavement was the only figured mosaic found in the cemeteries of Antioch, the funerary banquet was a common scene for Roman tomb decorations. The scene is accompanied by an inscription giving the name of a woman, "Mnemosyne," and the word ΑΙΩΧΙΑ, which may be understood as an alternate and corrupt spelling of ΕΥΩΧΙΑ (banquet). The tomb chamber

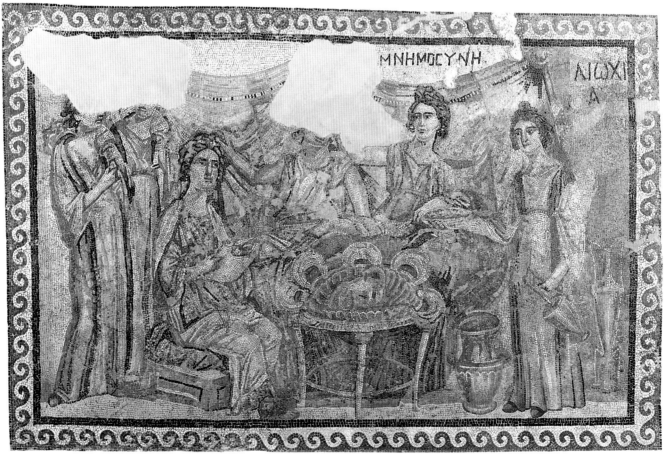

9

may have been owned by a woman, Mnemosyne. Or perhaps it records a group of women in a funerary *collegium* who used the space for regular funerary banquets. In the latter case, the inscription "Mnemosyne" may be understood more generally as "Memory." The pavement is a compelling combination of reality and aspiration: banquets were the centerpiece of Roman rituals surrounding death, but the feast also represented the eternal bounty of the afterlife. At this wake the deceased woman holds an unfurled scroll, but her attention is directed to the scene's inscription, which we read with her. RM

1. That the servant girl is holding vessels for the washing of hands is suggested by Dunbabin 1993, 120.
2. From Daphne-Harbie 27-P (Antioch II 1938, 178, no. 226, pl. 21).
3. Koortbojian 1995, 52 n. 10.
4. Jean Lassus, Antioch excavation field books, 12–30 April 1935, Antioch Archives, Department of Art and Archaeology, Princeton University.

10 Funerary Monument of Umm'abi

C. 200 C.E.
Palmyra (modern Tadmor)
Hard cream-colored limestone with traces of pigment,
20½ × 13 in. (52 × 33 cm)
The Toledo Museum of Art. Purchased with funds from the Libbey Endowment, gift of Edward Drummond Libbey, 1962.18

PUBLISHED: Mackay 1949, 174; Hoke 1974, pl. 52; Vermeule 1981, 380, pl. 381

INSCRIPTION: "Alas, Umm'abi, daughter of Maggi, [son of] Male, [son of] La'ad"

This bust-length portrait belongs to a series of limestone slabs carved in high relief and used to seal individual graves in family tomb towers that still line the roads into Palmyra, the great Roman caravan city in northern Syria 170 miles southeast of Antioch. The approximately four hundred known Palmyrene funerary portraits of women are marked by such a homogeneous style that it is likely they were mass produced, their inscriptions added after purchase.[1] The inscription on this relief identifies the deceased as Umm'abi, the daughter of Maggi.

The citizen-merchants of Palmyra were successful, cultivated, and rich. For more than three hundred years they dominated land and sea trade in silks and spices from the Han Empire and the Indies to the Mediterranean. Umm'abi's clothing and jewelry accurately record contemporary Palmyrene fashions. She wears a short-sleeved tunic under a cloak fastened at the left shoulder. On her head is a turban, over which is draped a veil. Her rich jewelry includes a diadem, a stiff band of ornately decorated metal, across her forehead and a head chain of cabochon jewels looped over her temples. Dangling from the center of the turban are a series of plaques and four pendants. Dumbbell-shaped earrings hang from her earlobes, and similar

ornaments are fastened in her hair. Around her neck are four necklaces. A jewel-encrusted brooch with three ivy-leaf pendants on chains is pinned to her shoulder. Multiple rings, repoussé cuff armlets, and twisted spiral bracelets complete her ornaments. Recent conservation and technical examination revealed that the relief was painted.[2]

Compared with their counterparts in the funerary banquet mosaic from Antioch (cat. no. 9), Palmyrene ladies like Umm'abi seem to be more elaborately adorned. However, in the Syrian "Life of Pelagia" a famously beautiful prostitute in fourth-century Antioch is described as "decked out with gold ornaments, pearls, and all sorts of precious stones, resplendent in luxurious and expensive clothes. On her hands and feet she wore armbands, silks, and anklets decorated with all sorts of pearls, while around her neck were necklaces and strings of pendants and pearls."[3] Clearly, some Antiochene ladies dressed in fashions comparable to those of the Syrian desert. SK

1. See Colledge 1976; and Ploug 1995.
2. The dark red pigment in the inscriptions is protein-based. Examination also revealed traces of dark pigment inside the incised circle of the iris and the edges of the upper and lower lids, as well as traces of red, blue, green, and yellow pigment on the necklaces, turban ornaments, and brooch.
3. Brock and Harvey 1987, 42.

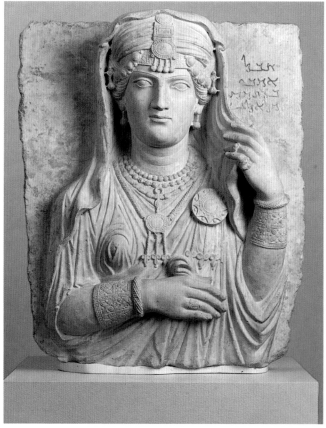

10

11

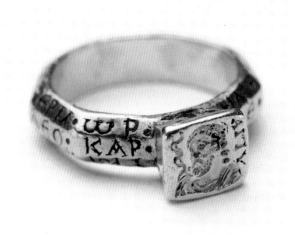

12

11 Inscribed Ring

Fourth century C.E.

Antioch

Gold, outer diameter 1½ in. (3.8 cm); inner diameter 1⅛ in. (2.9 cm)

Virginia Museum of Fine Arts, Richmond. Purchased with the Adolph D. and Wilkins C. Williams Fund, 67.52.15

EX COLL. De Clercq-de Boisgelin, Paris

PUBLISHED: De Ridder 1911, 756, no. 3417, pl. 28; Ross 1967–68, 12, fig. 1; Gonosová and Kondoleon 1994, 38–39, no. 4

This massive gold ring, which is solid cast, is elaborately decorated with foliage. Large acanthus leaves emerge from younger, smaller leaves at the base of the hoop and frame the oval bezel. The bezel has a grooved border and is inscribed in Greek: "ΕΥΤΥΧΙ / ΑΣΥΝΚΡΙΤΙ / ΣΥΝΚΑΤΑ / ΦΡΟΝΙΩ" (Be fortunate Asynkritios with Kataphronius).

The use of the salutation of good fortune followed by two names suggests that the ring was a gift of friendship between two men. Both names are rare but occur in the correspondence of Libanios, the renowned pagan rhetorician. These letters, over 1600 survive, were written in the course of the fourth century in Antioch to leading figures of Mediterranean society. For example, Kataphronius was a prefect in Egypt 356 to 357 C.E.

The great weight of the Virginia ring (over seventy grams) is further evidence of the importance of the named individuals. Emperors made gifts of jewelry, including rings weighing sixty grams, to members of their inner circle.

The impressive size, rich foliate decoration, and inscription make this a significant example of late Roman jewelry. Whether it was made in Antioch or any part of Syria is not clear because similar rings were found at western sites (e.g., Thetford Treasure in Britain and in a treasure from Reggio Emilia in Italy). Such items are highly portable and were exchanged as gifts between elite citizens in various parts of the Roman Empire. CK

12 Ring with Bust of Asklepios

c. 340–400 C.E.

Antaradus (modern Tartus, Syria)

Gold, niello, diameter 1 in. (2.4 cm)

Virginia Museum of Fine Arts, Richmond. Purchased with the Adolph D. and Wilkins C. Williams Fund, 67.52.11

EX COLL.: De Clercq-de Boisgelin, Paris

PUBLISHED: De Ridder 1911, 662, no. 3075, pl. 23; Ross 1967–68, 13, no. 2; Weitzmann 1979, 302, no. 274; Rea 1980, 155–58; Frankfurt 1983, 557–58, no. 162; Gonosová and Kondoleon 1994, 40–43, no. 5

This is an especially unusual and elaborate version of a personalized ring from the late Roman world. It consists of a square bezel engraved with the bust of Asklepios and an octagonal hoop of three faces, which results in twenty-four facets; each facet is inscribed in niello with Greek letters.

Asklepios, bearded and with a moustache, appears in three-quarter view, beside him on the left is his symbol, a serpent coiled round a staff. On the other side are the Greek letters ΑΙΓΥ, the Greek word *hygieia* (health) written in reverse. The bezel has a cone-shaped base with a drilled hole that contains an iron filling.

The Greek letters around the hoop can be read if the bust of Asklepios faced the wearer. The key to deciphering these letters is given by the ωΡ (omega rho) to the left of the bezel which stands for *horoscopos*.[1] The letters around the first line of the hoop are abbreviations for the heavenly bodies; the second line on the flat face of the hoop gives the signs of the zodiac; and the third line gives the position of the heavenly body within the respective zodiac sign in degrees, for example: Moon in Capricorn, 27°. By following the standards of ancient computation, the horoscope belongs to someone born in the tenth hour of the night of 16/17 August 327. Because the diameter of the ring indicates an adult wearer, the ring was probably made between 340 and 400 C.E.

The iron placed in the hole in the base of the bezel was most likely considered a precious substance by the wearer. Perhaps it was collected during a visit to one of the healing sanctuaries dedicated to Asklepios. If so, it strengthens the talismanic power of the other imagery on the ring. Although many rings and gemstones were engraved with protective deities, prophylactic inscriptions, and symbols of the zodiac, the Virginia Museum ring is unique for its combination of all these elements. Its highly individualized decoration offers a fascinating insight into personal beliefs and the meaning of jewelry in everyday life. CK

1. The proposed decoding of these letters follows the work of Rea 1980.

13 Armband

Third or fourth century C.E.
Openwork gold, emeralds, and sapphires, outer diameter 4½ in. (11.6 cm); inner diameter 3⅜ in. (8.5 cm)
Virginia Museum of Fine Arts, Richmond. Purchased with the Adolph D. and Wilkins C. Williams Fund, 67.52.31.1

PUBLISHED: De Ridder 1911, 224, no. 1272, pl. 11; Ross 1968, 18, fig. 16; Deppert-Lippitz 1993, 116, fig. 7; Gonosová and Kondoleon 1994, 68–71, no. 16, pl. 7; Yeroulanou 1999, 241, no. 206

The beauty and richness of this gold armband would have been much appreciated by the refined and luxury-loving Antiochenes. The armband, one of a pair now in the Virginia Museum of Fine Arts, belonged to a larger set that included at least two additional bracelets. They were found in Syria and most likely were made in that region.[1] The armband is made in the *opus interrasile* technique by which the openwork design is achieved

by drilling and chiseling. Such pierced work was popular in the late Roman and early Byzantine periods.[2] The armband consists of two sections joined by a hinge and a clasp. The round hoop of the armband carries the openwork design combined with sapphire cabochons and halved emeralds in plain setting. The openwork design is arranged in bands: a stylized and linear ivy scroll with swirls and variously shaped leaves is used on two outer registers; the center register—the crest of the hoop—has in the longer sections a band composed of roundels and lozenges alternating with gems. The shorter hoop sections have the crest with three parallel bands of scroll motifs and lyre guilloche with a sapphire. The design elements are decorated with dense and small-scale motifs carefully composed and characteristic of the *opus interrasile* technique.

The Virginia armband can be dated through comparisons with similar jewelry found with coins or decorated with coins, which were often used with the *opus interrasile* borders, from the late third through the middle of the fourth century. Moreover, the overall effect of the tightly organized design finds parallels in other media, including floor mosaics. The careful compartmentalization of the design, in particular, resembles the multiple borders of many floor mosaics from Antioch. This was the design composition preferred all through the third and fourth centuries. AG

1. All four pieces were once in the De Clercq Collection that was formed in Syria around the middle of the nineteenth century (De Ridder 1911, 8, 224–25, nos. 1272–75, pl. 11); one of the bracelets is in the Römisch-Germanisches Zentralmuseum in Mainz (Yeroulanou 1999, 241, no. 208). A related bracelet, also from the De Clercq Collection, is in the Ashmolean Museum, Oxford (Buckton 1994, 52–54, no. 37).
2. Ogden and Schmidt 1990; Yeroulanou 1999, 94–95.

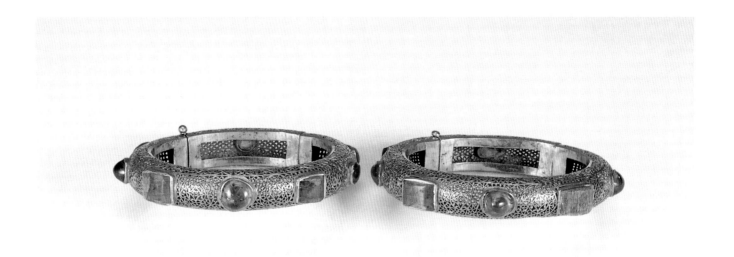

13

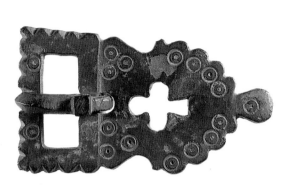

14

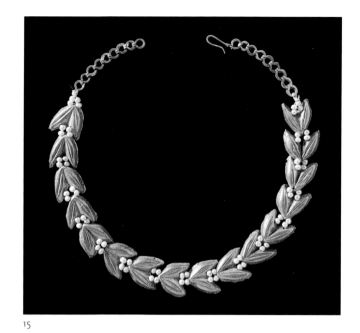

15

14 Belt Buckle

Sixth century C.E.
Daphne, House of the Red Pavement (DH 26-M/N), room 5
Bronze, 2⅜ × 1⅜ in. (6 × 3.3 cm)
Dumbarton Oaks, Washington, D.C., 40.29

PUBLISHED: Dumbarton Oaks 1955, 96; Ross 1965, no. 40

Jewelry can serve many purposes, from purely decorative to predominantly utilitarian. Belt buckles fall into a category about halfway in between; serving a specific functional use, they might be embellished with anything from precious stones to a simple incised pattern. Because bronze, in comparison with both gold and silver, was very inexpensive, bronze objects could be bought cheaply; and in terms of durability bronze was the metal of choice.

This modest bronze belt buckle was cast in one piece, the tongue added separately. Its applied decoration consists of sets of stamped circles playing off both the straight edges of the buckle and the curved contours of the tab. Discovered lying on the ground, along with a sewing needle and eighteen coins mostly from the sixth century, the buckle probably dates from the sixth century as well. SRZ

15 Necklace

Third or fourth century C.E.
Syria or Egypt (?)
Gold, pearls (modern), length 13⅝ in. (34.5 cm)
Dumbarton Oaks, Washington, D.C., 50.12

Reportedly found in Antioch

PUBLISHED: Dumbarton Oaks 1955, no. 160; Ross 1965, no. 9; Dumbarton Oaks 1967, no. 162

The golden representations of double grains of wheat were found as individual pieces and subsequently strung with modern pearls to form a necklace. This type reflects, although it does not reproduce, the kind of necklace worn by wealthy women in Syria in the late Roman period, as seen in the elaborate ensembles of jewelry on the sculpted funerary portraits from Palmyra. Several necklaces, sometimes as many as four or more, were worn at one time, their lengths varying according to their placement.

Further evidence for the wearing of more than one necklace, along with other pieces of jewelry, comes from numerous painted funerary portraits from Egypt. These well-to-do women wanted to be adorned for the afterlife in their finest jewelry. The Egyptian mummy portraits offer evidence of an alternative reconstruction of the gold elements on the Dumbarton Oaks necklace: they may have been part of a diadem. Such diadems are not seen on Syrian representations, but local tastes may have been influenced by examples from Egypt. SRZ

16 Head of Constantius II (?)

Fourth century C.E.

Syria

Marble, 11½ × 6¾ in. (29 × 17 cm)

University of Pennsylvania Museum of Archaeology and Anthropology,
Philadelphia, L-51-1

EX COLL.: Von Oppenheim. Purchased at Bab, near Aleppo

PUBLISHED: Müller 1927, figs. 1–2, pl. 1; Dohan 1936; Jucker 1959, 275–80,
pl. 1; Wrede 1972, 94–95 and n. 30, pls. 61.1, 62.1; Stichel 1982, 47–48, pl. 9;
L'Orange 1984, 86, 134, pl. 57b; Meischner 1990, 320–21, fig. 15

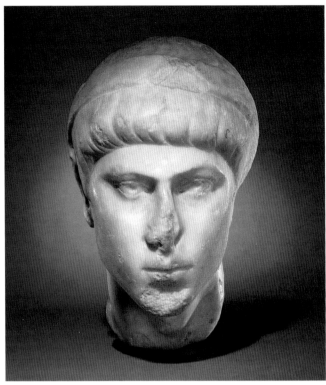

16

In this portrait of a young man, the thick hair cap offers a striking
contrast to the soft oval of the face. The head is turned slightly to
the left with eyes cast upward. The pupils of the eyes are drilled
and the irises carved in shallow circles. The back of the head was
chiseled down to a vertical plane sometime in antiquity for reuse
as building material. Damage to the head is visible in protruding
elements such as the chin, nose, lips and Adam's apple.

Encircling the head is a broad diadem, or headband, which
signified royalty since Hellenistic times. The right earlobe has a
hole drilled underneath it and below it on the neck is a piece
broken off from what might have been an earring. Equally pos-
sible, this fragment might have been part of the loose ends of
the diadem, which was tied at the nape of the neck, but is now
lost. While never remarked upon in the literature, the head
might well be unfinished especially because of the flat unarticu-
lated headband.

The head comes from the environs of Aleppo, ancient
Beroea in Syria, a city located on a main road about 105 miles
(170 kilometers) due east of Antioch. The date of the portrait
has been an object of controversy ever since the piece was first
published. Originally, it was characterized as provincial and
dated to the Trajanic and then to the Severan periods. It has
been pointed out that the prince's head combines abstract fea-
tures and softer, classicizing ones, a blend typical of the "subtle
style" of Theodosian court portraiture around the turn of the
fourth century.[1] Some scholars, however, identify the head as
that of the young Constantius II, placing it in the fourth
decade of the fourth century. This identification is based on the
facial features, the find-spot near Antioch, and the simple head-
band characteristic of the coin portraits of Constantine's sons
before their accession to the throne.[2] It is likely, however, that
the headband of our portrait was embellished with a row of
pearls and jewels, as are many comparable fourth-century por-
traits and as in the early imperial coinage of Constantius, which
shows a pearl diadem (see p. 104).

As a Caesar, or junior emperor, nominally in charge of the
plans for war against Persia, Constantius resided in Antioch
between 333 and 337, while in his twenties. After the death of his
father Constantine, he returned to Antioch as emperor of the
East in 338 until 351. Although Constantius spent about half of

his reign away from the eastern capital, dealing with Gallic rebel-
lions, coup attempts, and Persian attacks, his presence was felt in
the city. His governors embellished Antioch on his behalf with
several structures, including porticoes and public fountains. Lav-
ish imperial benefaction led the citizens of Antioch to rename
their city after him (Julian, *Orat.* 1.40d). While it is not attested,
Downey suggests *Antiochia Constantia* as the probable name.[3]

Early in his reign, Constantius completed the Great Church
of Antioch, also called the Golden Church, a renowned ecclesi-
astical complex that his father had started; it has not yet been
located. Constantius presided over the Council of Antioch
(341 C.E.), which coincided with the dedication of the Great
Church. During his reign, the city was caught up with the
Arian controversy, in which Constantius himself sided against
the Orthodox elements. In May 361, Constantius returned to
Antioch from yet another aborted Persian campaign, and set
out westward from there to reach an agreement with Julian. He
died on the way, but not before appointing Julian as his legiti-
mate successor. FH AND CK

1. For the Trajanic date in the early second century, see Müller 1927. For
the Severan date, see Schweitzer 1954, 178. For the Theodosian date, see
Jucker 1967, 126, n. 38, Wrede 1972, 94 (380s C.E.), Stichel 1982, 47
(388–92 C.E.), Özgan-Stutzinger 1985, 257 (c. 400 C.E.), Meischner 1990,
320–21 (380–405 C.E.).

2. For the identification as Constantine: Jucker 1959, 279–80; L'Orange
1984, 134.

3. Downey 1961, 149, n. 15.

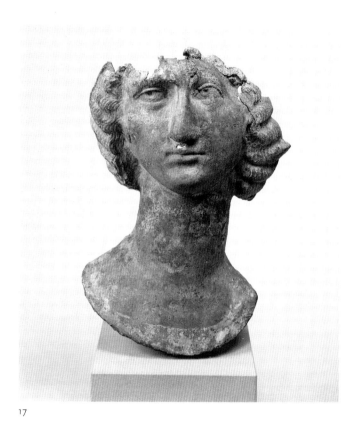

17

17 Portrait of Empress Julia Domna

C. 200 C.E.

Syria

Bronze, height 14¼ in. (36.2 cm)

Arthur M. Sackler Museum, Harvard University Art Museums, Cambridge, Massachusetts. Gift of Mr. C. Ruxton Love, Jr., 1956.19

Reportedly found in Salimiyeh, Syria

PUBLISHED: Cambridge 1954, 29, no. 178, pl. 54; Hanfmann 1955–56; Hiesinger 1969, 39–44; Schlüter 1971, 37–42, 130–31; Vermeule 1981, 348, no. 299; Mattusch 1996, 302–5.

The empress is shown with her head tilted to the right. Her hair is parted in the middle and descends in tubular waves on either side of the face in the hairdo typical of the Severan period. Ancient damage to the head, maybe inflicted in a single episode such as a violent fall, includes a split on the upper part of the forehead, a bend of the nose and mouth, and general distortion in the left side of the face.

The head was cast with its back left open; the hole would have been covered by a separately cast flat bun similar to the hairstyle found on her coin portraits. Fitted with earrings and maybe a veil or diadem, the head was originally gilded and its lower part was soldered to a draped garment. It was probably part of a complete life-size statue of Julia. The portrait is said to have been found in Syria at ancient Salaminias (modern Salimiyeh), a Roman military outpost thirty miles east of Emesa, which is itself located in the highlands 125 miles due south of

Antioch, upstream of the Orontes River. It is generally agreed that the piece is the product of a Syrian workshop.

A native of Emesa, Julia Domna was the daughter of the high priest of the Syrian sun god Elagabalus. The future Roman emperor Septimius Severus might have made her acquaintance while stationed in a legionary camp in the environs of Antioch. Legend has it that Septimius asked for her in marriage because astrologers had foretold that she was destined to wed a king. She bestowed honors and riches on her native Syrian town. Both the bronze head's find-spot and its elongated neck characteristic of cult images make it likely that Julia was, if not worshipped, at least honored under one of her many divine guises (Atargatis, Ceres, Tyche, etc.).[1] Perhaps, the bronze statue to which this head belonged commemorated a visit of the imperial couple to Syria in 197 or 198 C.E. during which they would have resided in the imperial palace at Antioch. Julia might have also been honored for her learning, as scholars place her at the center of a circle of learned men— Philostratus, Aelian, Oppian—from whom she commissioned literary works.[2]

Julia had considerable political power during the reigns of her husband (193–211 C.E.) and that of her elder son, Caracalla (211–17 C.E.). In fact, by the time she received news of Caracalla's assassination, she had managed to have virtual control over the East. Despite assurances of goodwill by her son's successor Macrinus, she plotted to overthrow him. When Julia's plot was exposed, Macrinus condemned her to leave Antioch and choose a place of exile. Instead Julia chose to end her life in Antioch through voluntary starvation. FH

1. For a study of her portraiture organized by divine types, see Ghedini 1984.
2. Bowersock 1969 suggests that the notion of a learned circle is a nineteenth-century fabrication. Yet Apollonius of Tyana and Dio Cassius note a group of sophists and philosophers as part of her group.

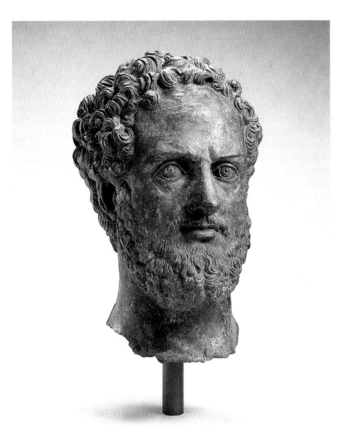

18

18 Portrait of a Man from the Eastern Empire

C. 180–90 C.E.

Syria (?)

Bronze, height 12⅛ in. (30.7 cm), weight 13 lb. (5919.5 g)

The Toledo Museum of Art. Purchased with funds from Mr. and Mrs. Leon Levy, gift of Edward Drummond Libbey, 1986.26

EX COLL.: Elias Bustros

PUBLISHED: Toledo 1986, 11; Chronique 1987, 20, fig. 122

This life-size bronze head is intact to the bottom of the neck, where it was originally inserted and welded into a drapery or cuirass neckline. The head seems to have been cast as a complete section to be joined to the body at the bottom of the neck; there are numerous ancient casting repairs, many still in place. The head is evenly modeled and finished on all sides. The face is clearly of a specific individual, for it is a bit walleyed: the eyes bulge slightly, and the right eye seems to roll a bit lazily outward and upward in comparison with the level gaze of the left eye. Both pupils are modeled and incised as complete but slightly irregular circles. The lean cheeks, the bony asymmetry of the features, the hairless eyebrow line, the narrow lips, the rather sharp nose, and the level gaze are very direct and appealing. The crown of the head with its billowing hair, the more tightly curled beard hair, and the dividing middle part of the beard recall some of the portrait fashions set by the Antonine emperors of the later second century.

Although the individual is unidentified, the bronze head probably belongs to the large group of public portraits that filled the great cities of the Roman provinces. The custom was to treat only the head as a portrait, which sometimes led to what modern eyes might see as an incongruous combination of youthful, athletic bodies with the wrinkled visages and fashionable hairstyles of middle age. The Toledo head of cast bronze was likely fitted into a full-length draped figure or a heroic nude.[1] Similar statues were set up on pedestals in the fora, temples, theaters, and along the colonnaded streets; pedestals were inscribed with the name and career of the person represented.

As one of the highest honors bestowed by an ancient city upon its distinguished men and women, such portraits constituted a marble and bronze *Who's Who?* of civic life. Many represented officials who were sent out from Rome. For example, from such portraits the names of eighty-one governors are known for the province of Syria.[2] But the most common portraits in the Greek East, and probably in the great city of Antioch, were those awarded to local citizens for service to their city.[3] SK

1. Oliver 1996, 146–49.

2. Rey-Coquais 1978.

3. Sometimes an inscription records details of the honor. For example, a marble pedestal from Sardis dated to the mid-first century C.E. records the awarding of fourteen portraits to an important official named Iollas: one gilded statue, one gilded colossal statue, one gilded equestrian statue, four bronze statues, three marble statues, and four painted portraits (see Oliver 1996, 144, fig. 3).

19 Palmyrene Head of a Man

Late second or early third century C.E.
Palmyra (modern Tadmor, Syria)
Whitish limestone with dark gray patina, 9¼ × 5¾ × 6¼ in.
(23.5 × 14.6 × 15.7 cm)
The Art Museum, Rhode Island School of Design, Providence, 71.167

PUBLISHED: Ridgway 1972, no. 4, 21–22, 136–37 (figs. a–d)

This portrait of a bearded man, slightly under life-size, has lost its left ear and the ridge of its nose. Carved in the schematic style characteristic of mass-produced funerary sculpture in Palmyra, the head is not a true portrait. It may nonetheless echo the looks of a typical Near Eastern male, with his wavy, curly hair, large eyes, and high cheekbones. The asymmetry of the eyes and eyelids and the slanted break pattern at the back suggest that the head turned to the left.[1] The carving is characterized by the use of engraved pupils, eyebrows, and beard that is associated with a group of bearded male figures, perhaps executed by the same workshop.

The head is likely to have been broken off the upper section of a rectangular relief panel, which would have served to seal the individual's grave *(loculus)* on the wall of a family burial-chamber (underground) or of a tower-tomb (above ground).[2] A complete slab can be seen in the portrait of Umm'abi (cat. no. 10). On the background of the slab, now lost, there was a brief inscription engraved and filled with red pigment, which identified the deceased and bid the family's farewell.

Even though Palmyra inherited the custom of carving funerary reliefs with bust-length figures from the Romans, an overwhelming majority of the deceased males are clad in Greek dress, wearing a tunic (chiton) as an undergarment and a long mantle (himation) wrapped around their shoulders and arms. Flattened and elongated hands emerge from under the drapery folds; the right hand usually rests on the chest, sometimes clasping a small object (palm leaf, tablet, etc.), while the left one below rests across the abdomen. FH

1. For a Palmyrene funerary portrait of a bearded man with his head turned to his left, see Tanabe 1986, 338, no. 307.
2. On the architecture and decoration of Palmyrene tombs, see Schmidt-Colinet 1997.

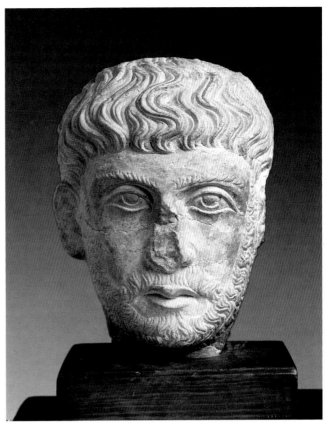

19

Exotic Taste:
The Lure of Sasanian Persia

Anna Gonosová

The Antioch floor mosaics have long served as a useful gauge of iconographic and stylistic tastes and trends (visual and thematic ins and outs, expected as well as unexpected) of the Roman and early Byzantine periods because of their nearly five hundred years of uninterrupted production. A powerful lion on one of the many floors would have counted among the expected representations of the king of beasts had it not been for a long ribbon, identified as a *pativ*, a Sasanian royal symbol, fluttering around its neck. This Antioch lion is not the familiar animal of the lion hunts and Roman amphitheater games but a captive of the royal hunting preserves of one of the empire's powerful neighbors and adversaries to the east, the Sasanian Persians (fig. 1).[1] The mosaic, assigned to the early fifth century, was made during a rare pause in the centuries-long conflict between the two empires marked by the Sasanian sacking and destruction of Antioch by Shapur I in 256 C.E. and by Chosroes I in 540 C.E.[2] It is also an instance of the direct influence of Sasan-

ian art on Roman art. Sasanian Persia was the most important intermediary for luxury goods such as silk and spices reaching Rome from as far east as China, and from the early fifth century on it was also a source of both artistic motifs and luxury goods, among which textiles, especially silks, would have been much sought after.

The appearance of the Sasanian motifs in the Roman and Byzantine repertory coincided with the maturing of Sasanian art in the course of the fourth and fifth centuries. The Sasanian state came into existence with the overthrow of the Parthian Arsacids by the founder of the dynasty, Ardashir of Fars, in 224 C.E. and lasted until its collapse by the advance of Islam in 651. The Sasanian kings ruled over a vast territory between Mesopotamia in the West and the Indus River to the East, which at times included Syria, the Holy Land, and Byzantine Egypt (fig. 2). The Sasanian dynasty, ideologically allied with the ancient Persian line of the Achaemenians, ruled over a highly centralized state in which all the power was in the hands of the divinely chosen kings and the princes of the royal family. The purity of the ideological line was maintained by a powerful Zoroastrian priesthood.[3]

Sasanian art grew out of the successful merging of several Near Eastern traditions with roots extending back to the Achaemenian period. The Hellenistic-Roman presence is fur-

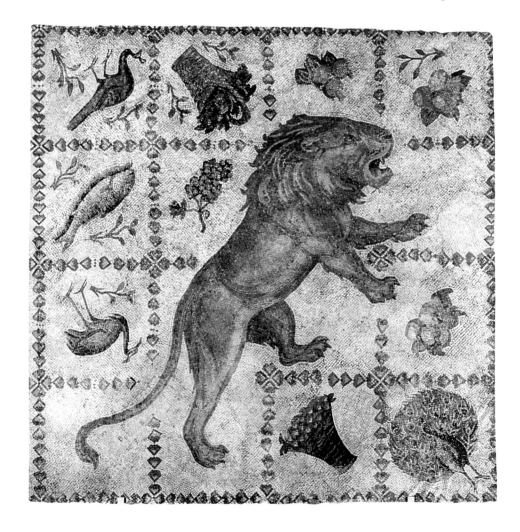

Fig. 1. Striding Lion Mosaic, Antioch (building in Sector 10-Q), fifth century. The Baltimore Museum of Art, Antioch Subscription Fund, 1937.139

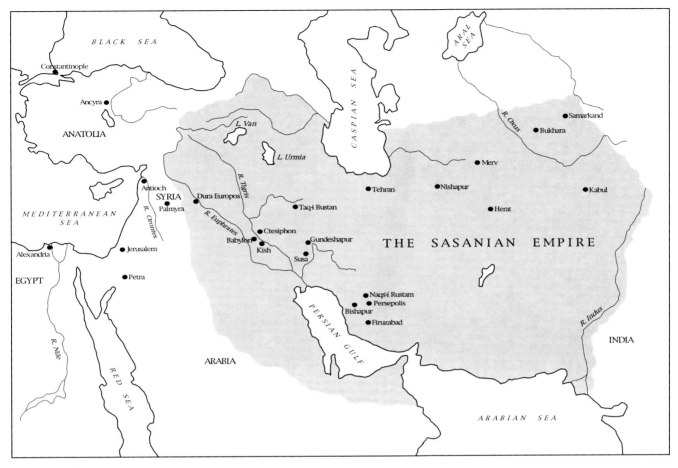

Fig. 2. Map of the Sasanian Empire

ther explained by the direct participation of Roman craftsmen in the creation of Sasanian art. The Hellenized Roman style was brought into Sasanian Persia by the Syrians captured in periodic territorial raids. These raids not only brought plunder and other gains but also led to the founding of the new cities Vek-Andiyok-Shapur of Gundeshapur (Better than Antioch Shapur Built This) and Vek-Andiyok-Khusrau (Better than Antioch Chosroes Built This). The Roman-style floor mosaics and other classically inspired architectural decoration of Bishapur, another city founded by Shapur I, clearly demonstrate the appeal of Roman art to Sasanian kings. A similarly strong Roman overtone has been recognized in the decorative system of Sasanian coinage. The resulting Sasanian art can be best understood as reflecting both the complex history of the vast Sasanian-controlled territory and receptivity to new and different artistic forms and ideas suitable for assimilation into the dominant culture.[4]

The extant Sasanian art primarily chronicles royal patronage and communication of the royal ethos and glory, xvarnah, as represented through royal investitures and triumphs. The most important in this respect are the rock reliefs commemorating the investitures and victories of Sasanian rulers. Shapur I's victories over the Romans, including the capture of Antioch, were celebrated in no less than five reliefs; a trilingual inscription in a sanctuary at Naqš-í Rustam mentions the capture of Antioch. The royal themes are communicated by hierarchical compositions in which the centrally placed king and the god are the largest figures. As the most important expression of the king's xvarnah, each king wore a distinctive crown, as seen on numerous coin issues. The royal crowns combine the attributes of several protective deities, such as the eagle and wings of Anahita or the ram's head of the war god Verethragna worn by Shapur II at the siege of Amida in 359.[5] The kings and deities also wore multiple pleated ribbons whose fluttering surrounded them with a visual and physical aura.

Concern with royal themes also dominates the imagery of the best-known category of Sasanian art, silver plates: the kings, on foot or mounted and identifiable by their unique crowns, triumph over their prey, be it lions, boars, or tamer rams and wild goats. On several plates a royal banquet is represented (cat. no. 24). Such plates were produced in royal workshops and functioned as official gifts and display pieces.[6]

Stucco, the main medium of architectural decoration, is another important source of information for the appearance of Sasanian art. Although Sasanian kings founded many cities, Sasanian architecture is known only through several excavated

royal palaces, whose splendor is alluded to in the Byzantine accounts of Emperor Herakleios's victorious advance against Chosroes II in 626 c.e. The palaces, built of brick and rubble masonry, contained multiple courtyards and vaulted areas; throne rooms or audience halls were particularly prominent. In the Parthian tradition, brick walls were profusely decorated with figural and ornamental stucco designs in the form of molded and carved panels. These panels were painted and formed large framed fields of repeat patterns enclosed in multiple borders. Extant animal and figural fragments hint at thematic compositions similar to the early-seventh-century royal hunts of the Taq-i-Bustan rock-cut reliefs of Chosroes II. Most panels, however, consist of alternating geometric and vegetal patterns with figural and animal motifs unique to Sasanian art. Many motifs are associated with Zoroastrian divinities and auspicious powers, amplifying the royal and ceremonial function as well as the sacredness of architectural spaces. The Worcester beribboned ram panel (cat. no. 20) and the ram's protome-and-wings pattern block from Kish (cat. no. 21) were used in this way. The ram and wild boar, another common motif in stucco, were sacred animals of the war god Verethragna, while the wings, arranged in pairs were shared with the goddess Anahita. The fluttering ribbons in both reliefs signal sacred and royal associations.[7]

Floor mosaics from the palace of Shapur I in Bishapur doubtless belong to the Hellenistic-Roman tradition and might even be the work of craftsmen exiled from Antioch. The heads of maenads and satyrs and other motifs from the Dionysiac *thiasos* and geometric ornament are especially Roman. The half-nude female musicians and dancers and the richly dressed court ladies, on the other hand, reflect stylistic adjustments to the Sasanian formal mode that correspond to the court and royal representations in other media of Sasanian art.[8]

Two categories of Sasanian art, the jewelry and rich vestments of Sasanian kings and courtiers, are most frequently commented on by Roman and Byzantine sources. It is in these categories that the art of display and luxury arts can be seen as signs of sociopolitical status within the Sasanian hierarchies. Only a few examples of jewelry survive—rings, necklace pieces, and belts. Representations on Sasanian coins, seals, sculpture, and silver plate are our main sources of what was worn by the Sasanian royalty, nobles, and courtiers.

The art of Sasanian weavers is often mentioned in Roman and Byzantine sources, with the clothing of Persian men in one source described as "gleaming with many shimmering colors."[9] Until recently knowledge of Sasanian textiles was based mainly on literary sources and on the representation of elaborately patterned textiles of the king and the courtiers of the royal hunt reliefs at Taq-i-Bustan; and many textiles, some woolen but mainly silks, found in the Byzantine graves of Antinoë in Egypt were also assumed to be Sasanian primarily on the basis of their exotic patterns and their similarity to the Taq-i-Bustan reliefs.

Comparisons of the late antique weaving techniques has confirmed that many of the Antinoë silks belonged to the costume worn by the Sasanians.[10] The silk filament is particularly suitable for dying, and this property was fully exploited in these weavings. Because weaving was mechanized, designs with repeated patterns could be produced. The repertory of motifs includes many elements known from Sasanian stucco and silver: rams and rams' heads, winged horses, birds, especially cocks and peacocks, and *senmurws* (fantastic creatures). Beaded borders resembling pearls are known from jewelry and the written sources. Specifically Sasanian are composite forms arranged in self-contained units, such as an elaborate flowerlike palmette or an animal arrangement with only the heads and foreparts, finished with a crest motif such as pairs of wings or floral or foliate finials (cat. no. 20). These composite forms may be repeated in rows, alone or combined with framing. The presence of potentially meaningful elements, such as wings, sacred animals, and plants, suggests that even this patterned decoration may have had a significance beyond simple ornamentation. Many of these motifs were imitated in a variety of media outside the Sasanian culture, from floor and wall mosaics to architectural sculpture and silver vessels, in the late Roman and Byzantine periods.

The Sasanian motifs found in late Roman and early Byzantine monuments fall into two categories. One comprises motifs imitating the official royal art using sacred motifs such as wings and animal protomes. This is not surprising because portable luxury objects with royal symbols were exchanged through court gifts and embassies. The Antioch mosaics are among the earliest extant examples in Roman art to carry these "exotic" motifs. The evidence of Sasanian art in Antioch is demonstrated by the mosaic of the beribboned lion, the borders with rams' heads and wings from two neighboring houses in Daphne (cat. no. 20), and the mosaic of beribboned parrots (cat. no. 25), all three dating from the late fifth or early sixth century. In all of these examples Sasanian elements, such as the fluttering ribbons and ram's-head protomes with wings, can be identified.

The second category of motifs is more likely found in the patterns of textiles (silks and wools). Many examples of such borrowings exist, especially in Byzantine textiles, which are best found at Byzantine burial sites in Egypt. Many less direct cases of borrowings from Sasanian art are evident in the popular "diaper" patterns, which are rich with floral filling motifs. Such all-over designs may well have been inspired by patterned woven textiles, specifically silks produced by the Sasanian state. The closest example to a putative silk model would be the Louvre mosaic of the beribboned parrots (cat. no. 25). In the case of the parrot mosaic, the parrots' regular arrangement in the main field undermines their naturalistic appearance. The arrangement of the birds recalls a silk from Antinoë that employs peacocks rather than parrots to similar effect.[11]

Although Sasanian motifs did not appear in the ornamental repertory of Roman and early Byzantine art until the fifth cen-

tury, their impact was long-lived. The attraction to Persian art can be found in many examples of medieval Byzantine textiles, jewelry, and architectural sculpture.[12] The fifth-century vault mosaics in the Saint George Rotunda in Thessaloníki and the architectural ornamentation in the Church of Saint Polyeuktos in Constantinople of 528 demonstrate the influence of the Sasanian decorative repertoire on early Byzantine artists. But by far the richest selection of these is found among the fifth- and sixth-century floor mosaics of Antioch.

1. Levi 1947, 313–15, pl. 70. On the presence of Sasanian motifs at Antioch, see Levi 1947; and Morey 1938, 41–45.
2. Yarshater 1983, esp. 124–62 and 568–92.
3. Ibid., 359–83.
4. For an overview of Sasanian art, see Ghirshman 1962, 119–254; Harper 1978; and Brussels 1993.
5. Yarshater 1983, 324–26, 345–47. For Shapur II at Amida, see Amm. Marc. 9.1.3 (trans. Rolfe).
6. Brussels 1993, 95–108; see also Harper 1981.
7. For a useful survey of Sasanian stucco decoration, see Harper 1978, 101–4; see also Kröger 1982.
8. Ghirshman 1962, 140–47, figs. 180–86; see also Brussels 1993, 67–69.
9. Amm. Marc. 23.6.84 (trans. Rolfe).
10. The best recent survey is Brussels 1993, 113–22.
11. Martiniani-Reber 1986, 52–53, no. 19.
12. Mango 1977, 316–21; Grabar 1971, 679–707.

20 Floor Mosaic of Rams' Heads

Late fifth or early sixth century C.E.
Daphne, House of the Rams' Heads
Marble and limestone *tesserae*, 30 × 82 in. (76.2 × 208.3 cm)
Worcester Art Museum, 1936.33

PUBLISHED: Morey 1937, 21, no. 11; Antioch II 1938, 188, no. 60; Levi 1947, 350, 478–79; Teitz 1971, 17, fig. 7

This is one of four extant parts of an elaborate wide border that presumably framed a large central panel now lost (see p. 134, fig. 1). The design is made up of the repeated motif of two confronted rams' heads (actually the foreparts or protomes of the rams) set on a pair of open wings with gray ribbons fluttering below. The rams' heads are mainly in shades of yellow, ranging from dark to light, with some white and flesh-colored *tesserae* as well; their horns are of light and dark gray, indicating striations, and the horns of every second pair of rams are outlined

in black; they wear red collars. Red-pink roses with gray stems punctuate the spaces between the confronted rams' heads and again between the pairs. Only the part now at the Baltimore Museum of Art preserves the outer band of a lush foliate scroll of vine and acanthus leaves filled with fruit, erotes, and animals.

Several features of the design have led scholars to connect this mosaic and a related pavement found on the upper level of the House of the Phoenix, also from Daphne and today in the Louvre (see p. 134, fig. 2), to Sasanian art.[1] The motifs of wings with a fluttering ribbon and ram protomes above wings, distinctive to Persian art, are found on the textiles, rock carvings, seals, and metalwork of the Sasanian period.[2] The juxtaposition of the borders featuring rams' protomes and the two stucco pieces decorated with rams in this exhibition (cat. nos. 21 and 22) reflects the close correspondence between the Antioch mosaics and Sasanian art, but the path of transmission remains unclear. Although the individual components of the border are distinctly Sasanian, their specific use is not. In Sasanian art the

20

 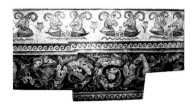

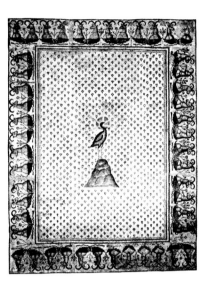

Fig. 1. The Worcester rams' head fragment *(far left)* originally formed part of the elaborate border of a large rectangular composition. Other border fragments from this mosaic, one of which includes a section of a second border of lush acanthus leaves on a black ground, are at *(left to right)* the Baltimore Museum of Art, the Hatay Archaeological Museum, Antakya, and the Princeton University Art Museum

Fig. 2. Rosebud "Carpet" Mosaic, from the House of the Phoenix in Daphne. 19 ft. 8¼ in. × 13 ft. 11⅜ in. (600 × 425 cm). Musée du Louvre, Paris (Ma 3442). A large "pattern" like this filled the central rectangular area bordered by the Worcester rams' head fragment

protome motifs appear either singly, as in the case of the Worcester pattern block, or in pairs rising from a shared base, though almost always facing outward, stressing their more abstract and ornamental aspect.[3] Can the confronted Antiochene version of the motif be an illustration of the innate naturalistic tendencies of Hellenistic-Roman art? Since there is evidence for the borrowing of Greco-Roman artistic vocabulary, especially in Sasanian metalwork, we might assume that Antiochene workshops had a reciprocal interest in Sasanian motifs. The two Daphne borders demonstrate such an interest. Undoubtedly, motifs and designs were carried through the exchange of portable arts, most likely coins, textiles, and metalwork. CK

1. On the House of the Phoenix, see Levi 1947, 313–15, pl. 70; and Baratte 1978, 92–98, no. 44, figs. 86–93. On the Sasanian aspects of these mosaics, see Levi 1947, 478–79.
2. For the significance of these features, see the entries for the Chicago and Worcester stucco reliefs, cat. nos. 21 and 22.
3. This is illustrated by several Sasanian and Sasanian-inspired textiles from Antinoë, Egypt (see Martiniani-Reber 1997, 62–63, no. 16).

21 Pattern Block with the Forepart of a Ram above Wings

Fifth century C.E.
Kish (Iraq), Palace I
Stucco, 13 × 13 × 5½ in. (33 × 33 × 13.5 cm)
Field Museum of Natural History, Chicago, 228840

PUBLISHED: Grabar 1968, 148–49, no. 70; Harper 1978, 101–4, 110, no. 43; Brussels 1993, 149, no. 8

The thickness and the grip holes on the side of this stucco panel indicate that it was a pattern block used as a mold for casting decorative wall plaques. Such pattern blocks and molds facilitated the production of thin plaques, often of repeated designs, that covered the walls of important areas in Sasanian brick or rubble masonry buildings.[1] The stucco reliefs originally were brightly painted. This pattern block was found in one of the noble palaces at Kish, a few miles east of Babylon.[2]

The Kish pattern block carries a motif of the protome, or forepart, of a ram wearing a collar with fluttering ribbon shown in profile above a pair of wings tied together by another long

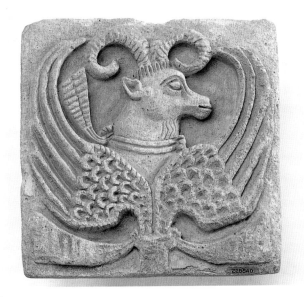

21

around them grows freely, the panels must have been part of an architectural frieze with a file of identical rams. The naturalistic form of the foliage and the rams also recalls similarly naturalistic stucco decorations in the palaces and houses at Ctesiphon.[2] These traits have been credited to the influence of the Roman craftsmen resettled near Ctesiphon by Chosroes I in "the New Antioch of Chosroes" after the Persian sack of Antioch in 540.[3] In the Worcester panel there are traces of a creamy white slip on the ram's body.

A full ram wearing a collar with the familiar fluttering ribbon, or *pativ,* a symbol of kingly glory, is seen in the representations of Sasanian kings on rock-cut reliefs, metalwork, and coins. Single rams are popular motifs for seals, textiles, and metalwork probably because of the ram's association in Zoroastrian writings with the warrior god Verethragna and with royal glory or fortune.[4] CK

1. Musée du Louvre, inv. no. OA 26174; Brussels 1993, 147, no. 6.
2. See esp. Kröger 1982, 3–136.
3. Ghirshman 1962, 200, notes that the plan of Khusrau's city duplicated that of Antioch.
4. See Gunter and Jett 1992, 136–37; and Harper 1978, 103. Particularly similar are the beribboned rams from a silk found in Antinoë in Egypt (see Martiniani-Reber 1997, 111–12, no. 60).

ribbon. In Sasanian art all three motifs carry sacred and royal significance: the ram is associated with the warrior god Verethragna, and the wings and ribbons, frequently used in a royal context, are also sacred symbols.

These three motifs are also found in Antioch mosaics. The ram protomes and the wings appear as a mosaic border design in two early-sixth-century houses in Daphne, near Antioch (cat. no. 20), while the fluttering ribbons decorate the parrots in the Louvre mosaic from Daphne (cat. no. 25) and the border of the Dumbarton Oaks Hunt from Antioch proper. The Sasanian religious and royal associations of these motifs were lost or neutralized when the motifs entered the ornamental repertory of the mosaicists of Antioch. CK

1. For a useful survey of Sasanian stucco decoration, see Harper 1978, 101–4; see also Kröger 1982.
2. Kröger 1982, 140, 190–93, pl. 81.3–4.

22 Relief of a Ram

Sixth century C.E.

Sasanian

Stucco, 11 × 10¼ × 3¼ in. (28 × 26 × 8.3 cm)

Worcester Art Museum, 1938.102

Reportedly found in the vicinity of Varamin, Iran

PUBLISHED: Cott 1939, 167, fig. 1; Worcester 1948, 30, fig. 37; Kröger 1982, 208 n. 1515

The Worcester relief and its companion piece at the Louvre,[1] like the Chicago stucco pattern block (cat. no. 21), were used for the architectural decoration of Sasanian palaces. Because the Worcester and Paris rams face to the right and the foliage

22

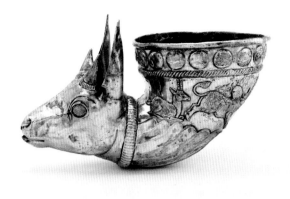

23

and this antelope, appear as quarry on some of the Sasanian silver and gilt plates depicting a royal hunt. With its zoomorphic forepart (protome) joined to a compact horn and furnished with a spout through the animal's mouth, this is an extremely rare example dating from the Sasanian period. This type of vessel embodies an important image and concept: a special liquid, probably wine, was contained in and dispensed from the mouth of an animal that itself held powerful, royal connotations. ACG

24 Plate Depicting Banqueting Couple

Seventh century C.E.
Sasanian
Silver and gilt, 1⅞ × 7½ in. (4.8 × 19 cm)
Arthur M. Sackler Gallery, Washington, D.C. Gift of Arthur M. Sackler, S1987.113

PUBLISHED: Gunter and Jett 1992, 131–35, no. 18

The decoration subject on this plate, a couple seated on a couch and grasping a wreath or diadem, is also found on Sasanian seal stones. The male figure wears a mural crown, indicating that this is a scene of a royal or princely banquet. Late in the Sasanian period silver plates with interior decoration were fashioned for a noble clientele. Most depict subjects with religious meaning; this plate is therefore unusual in the repertory of late Sasanian silver plate.

Below the couch is the head of a ram in profile, facing right. In Zoroastrian writings the ram, or mouflon, is associated with the Iranian god Verethragna and with royal glory or fortune *(xvarnah)*. The animal appears frequently in Sasanian art—on silver vessels, as a stucco pattern (cat. nos. 21–22), on textiles, and on seal stones. Depicted as an isolated head, this animal image can be found on other examples of Sasanian and Central Asian silver. On a silver plate in the Walters Art Gallery, Baltimore, for example, a banqueting couple is seated on a couch below which appears a row of boars' heads. If intended to symbolize Verethragna and thus also valor, the animal head would then emphasize the heroic aspect of the royal banquet. ACG

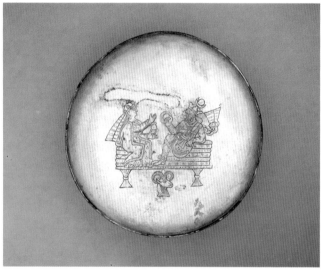

24

23 Zoomorphic Vessel (Horn Rhyton)

Fourth century C.E.
Sasanian
Silver and gilt, 6½ × 5½ × 10 in. (16.5 × 14.1 × 25.4 cm)
Arthur M. Sackler Gallery, Washington, D.C. Gift of Arthur M. Sackler, S1987.33

PUBLISHED: Shepherd 1966, fig. 11; Harper 1978, 36–38, no. 5; Gunter and Jett 1992, 205–10, no. 38; Seipel 1996, no. 81

Vessels made entirely or in part in the shape of an animal, in both metal and ceramic versions, have a long history in ancient Iran. However, only a few examples of this vessel type have surfaced among artifacts of the Sasanian period. Chiefly influenced by Roman and Byzantine prototypes and to some extent by Central Asian sources, Sasanian silver plate seldom drew on traditional Iranian vessel forms. Horned animals, such as the ram

25 Floor Mosaic of Beribboned Parrots

Late fifth or early sixth century C.E.
Daphne, isolated pavement in Sector DH 27-O
Marble, limestone, and glass *tesserae*, 57½ × 63⅜ in. (146 × 161 cm)
Musée du Louvre, Paris, Ma 3459 (related fragment now in the Baltimore Museum of Art 1937.147)

PUBLISHED: Antioch II 1938, 200, no. 89; Levi 1947, 358, pls. 35c, 137d; Baratte 1978, 123, no. 49, fig. 131

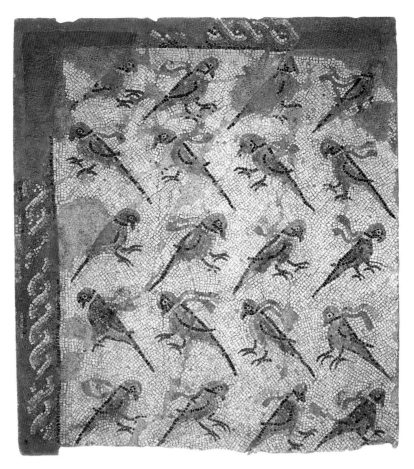

25

This pavement fragment was found in a room in the suburb of Daphne. The Louvre mosaic shows five of the original eight rows of beribboned birds resembling parrots. In each row all the birds face in one direction—to the left in one row and then to the right in the next. They are rendered in light and dark gray varied with green; their beaks are red, and they wear yellow collars with undulating ribbons of pale gray and red. Rows of the same birds are employed as a border design for the mosaic of the Dumbarton Oaks Hunt from Antioch.

The design of repeated birds against a neutral field is similar to patterns found on Late Roman, Byzantine, and Sasanian textiles of roughly the same date, especially silk and wool textiles woven on more mechanized looms. Birds of all varieties appear frequently in floor mosaics and other arts of the Roman and Byzantine periods; however, beribboned birds are rare. The fluttering ribbons gives the Antioch parrots a distinctly Sasanian flavor.[1] Similarly beribboned birds, often more stylized than the Antioch examples, appear scattered across Sasanian silver plates and bowls and on the robes of the royal entourage seen on the rock reliefs of Taq-i-Bustan.[2] Although actual finds of Sasanian textiles are rare, a related design of beribboned rams arranged in horizontal rows and facing in alternating directions was used for a Sasanian silk found in Antinoë, Egypt.[3] Such

silks were quickly copied by the weavers in Roman and Christian Egypt (see cat. no. 26).

The overall correspondence between the Antioch parrots and other textile designs on Sasanian costumes and metalwork indicates a Persian source for the Antioch mosaics, most likely a patterned silk. Furthermore, the fluttering ribbon, *pativ* in Persian, is associated with royal glory, and the Zoroastrian religion teems with beneficent birds protecting mankind from evil and malice.[4] It is unclear whether such symbolic and benevolent associations were maintained in the intercultural transfer and adaptation of the motifs for the mosaic repertory in Antioch or if the motifs were adopted for their exotic appearance and overall visual appeal. CK

1. Similar beribboned parrots are used in a textile-related pattern on a mosaic floor from a church in Soran, near Hama in Syria, of ca. 490 C.E. (Donceel-Voûte 1988, 305–6, fig. 299).
2. For a review of the interrelationships between textiles, rock carvings, and metalwork, see Ghirshman 1962, 226–30. For the Taq-i-Bustan textile patterns, see Brussels 1993, 114, fig. 99.
3. Martiniani-Reber 1997, 111–12, no. 60.
4. Boyce 1975, 88–91.

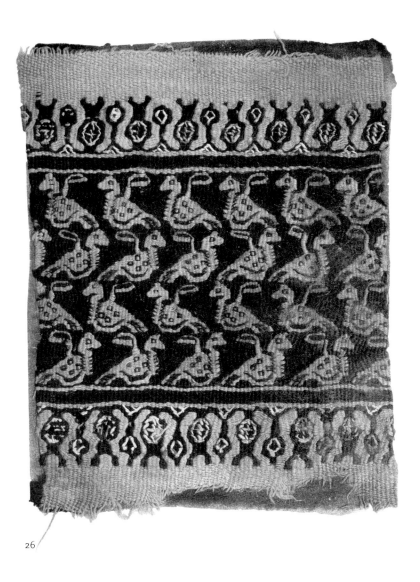

26

26 Textile Band with Birds

Tenth or eleventh century C.E.
Wool and linen, 6¼ × 5 in. (15.9 × 12.7 cm)
Rose Choron Collection

PUBLISHED: Maguire 1999, 65, no. A22

This is a fragment of decorative band from a woolen tunic or cover: four rows of beribboned birds lined up in profile and facing alternatingly to the left and to the right are enclosed in borders of stylized beading and seedpod-like pendants. The band, woven in tapestry technique, is purple and undyed wool.[1] The repeat designs, like the bird pattern of this fragment, originated in the mechanized weaving of Early Byzantine and Sasanian textiles, especially silks, sometime in the fifth century. Silks with exotic motifs, such as the beribboned birds, were made in Sasanian Iran and reached the Late Roman world through trade and as gifts.[2] Silks with a variety of repeat patterns, believed to be of Sasanian origin, were also found in graves of the Byzantine period in Antinoë in Egypt.[3]

The designs of imported silk were soon imitated in other weaving techniques, including tapestry, used in this fragment, as well as in other media, as seen in the beribboned parrots floor mosaics from Antioch (cat. no. 25). This textile is a medieval version of the design, and probably comes from one of many graves uncovered in Egypt.[4] Although the medieval design is more abstract than earlier versions due to the generations of copying and improvisation, the motifs of the original silks are still retained: the exotic origin of the birds is recognizable in the dotted rendition of their wings and the ribbons—Sasanian *pativ*, a symbol of royal glory—looped behind their heads. AG

1. Technical information: warp: undyed wool; weft: undyed and purple wool; weft wrapping: bleached linen.
2. The knowledge of Sasanian textiles is based on literary sources and on the costume of the King and courtiers of the rock-cut reliefs; see Anna Gonosová's essay herein (pp. 130–33).
3. For example, the beribboned rams silks show a similar composition into horizontal rows and alternating directions. See esp. Martiniani-Reber 1997.
4. For related textiles, see Baginski and Tidhar 1980, 155, no. 242; Stauffer 1991, 213, no. 107.

Grave Reliefs of Antioch

A large number of inscribed gravestones found in the Antioch region can be assigned to a workshop active in northern Syria from the first to the third century C.E.[1] Because these reliefs were mostly purchased by the Antioch excavation team rather than unearthed by them, their provenance and dating are unknown. The reliefs were carved on slabs of grayish marble, polished on both sides, from Asia Minor. The relative thinness of these slabs suggests that they may have functioned as *loculus* lids in underground tomb chambers. Most of the stelae were probably produced from the late first century to the early third century, when Antioch was prosperous and the urban middle class was expanding. Sometimes internal evidence such as depictions of hairstyle or clothing offers clues as to date, but such evidence is largely unreliable in the case of these reliefs because they bear depictions of Hellenistic modes of dress and pose.

These simply carved marble plaques, showing a variety of seated, standing, and reclining figures, ostensibly representing the deceased, were used to commemorate them. The lower portion of each plaque was reserved for the inscription, almost always in Greek, including the name of the dead person and a greeting, for example, "Free of care, farewell," or the one particular to Antioch, "Be of good cheer." The Antioch stelae stand apart from the products of other Syrian workshops, such as those of Palmyra, and provide us with a large corpus (approximately 150 examples) of eastern Greek funerary reliefs that developed from traditional Hellenistic (Seleucid) types (see the Tryphê stele, cat. no. 27). Many of these grave reliefs represent the deceased at a banquet, either alone or in a group, near food-laden tables and holding drinking cups. The "good cheer" inscription, so popular at Antioch, suggests that the deceased continue to enjoy the pleasures of life after death and that the tomb is an eternal house. CK

1. These comments summarize the work of Robert Weir, forthcoming.

27

27 Grave Relief of Tryphê

C. 150–100 B.C.E.

Seleucia Pieria

Marble, 23⅝ × 10⅝ in. (60 × 27 cm)

The Art Museum, Princeton University, y1992-4B

PUBLISHED: Antioch III 1941, 123, no. 344; Ridgway 1994, 34–37

INSCRIPTION: ΤΡΥΦΕΙΗΓΙΟΥ / ΑΛΥΠΕΧΑΙΡΕ (To Tryphê [daughter, or wife] of Egias / Farewell, you [who are now] without pain)

The deceased woman on this gravestone wears a heavy cloak that covers her head and arms. She is seated in a way that is reminiscent of a famous Hellenistic statue, the Tyche of Antioch, made shortly after the founding of the city of Antioch in 300 B.C.E. (see cat. nos. 6 and 8). Leaning forward on the folding chair with her knees crossed, she rests her chin on her right hand while supporting herself with her left arm, stretched out behind her. This pose is a direct quote of the Antioch Tyche type, known from several Roman replicas.

Other funerary reliefs of the Hellenistic age also represent women in the pose of the Tyche of Antioch, but this reference would have had instant recognition and significance for the inhabitants of Antioch's port city, Seleucia Pieria. CK

28

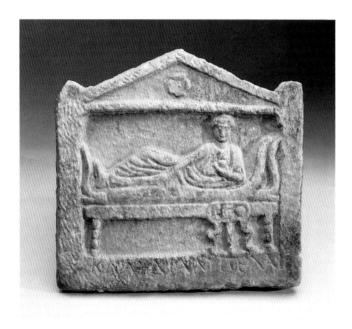

29

28 Grave Relief of Caesianus

First or second century C.E.
Antioch, from Northeast Cemetery, tomb 3 (Antioch 7/8-Y)
Marble, 14¾ × 11¼ in. (37.5 × 28.6 cm)
Worcester Art Museum, 1936.41

PUBLISHED: Antioch II 1938, 156, no. 57

INSCRIPTION: ΚΑΕCΙΑΝΑΙΑΛΥΠΕ / ΧΑΙΡΕ (Caesianus, free of care, hail
and farewell)

The vertical relief is crowned by a pediment with a rosette.
A draped male figure stands below holding a bottle. CK

29 Grave Relief of Claudius

First or second century C.E.
Antioch, from Southeastern Cemetery or Necropolis of
Mnemosyne, corridor 6 (Antioch 24-L)
Marble, 13½ × 14¼ in. (34.3 × 36.2 cm)
Worcester Art Museum, 1936.42

PUBLISHED: Antioch II 1938, 153, no. 41

INSCRIPTION: ΚΛΑΥΔΙΑΛΥΠΕΧΑΙΡΕ (Claudius, free of care, hail and
farewell)

The horizontal relief crowned by a pediment with a rosette shows
the deceased, a male dressed in a Greek tunic and long cloak. He
reclines on a dining couch beside a three-legged table with cakes;
he may be holding a cup. The scene belongs to the funeral ban-
quet, a popular type among the Antioch reliefs. CK

30 Grave Relief of a Reclining Diner

Late first or early second century C.E.
Antioch, purchased
Marble, 8 × ¾ in. (20.3 × 2 cm)
The Art Museum, Princeton University, Pb42-S508:I264

PUBLISHED: Antioch III 1941, 123, no. 347

INSCRIPTION: ΕΥΨΥΧΙΕΥΒΟΛΑ (Be of good cheer, Eubolas)

More roughly cut than the Worcester examples above, this ped-
imented stele provides a good example of the reuse of marble
revetment slabs for gravestones. The deceased is reclined on a
cushioned *kline* (couch) before which is a single-footed table;
he supports himself up on his left elbow in the manner of a
Roman diner and looks out as if to speak to us. CK

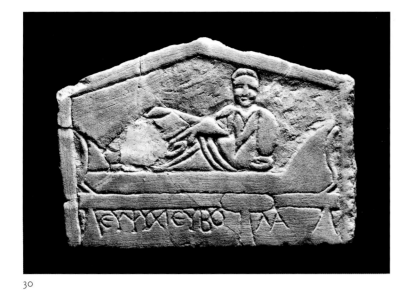

30

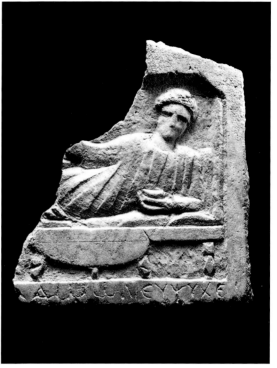

31

31 Grave Relief with a Reclining Man and Cup

Second century C.E.

Antioch, purchased

Marble, 8 × 7½ × ⅞ in. (20.3 × 19 × 2.2 cm)

The Art Museum, Princeton University, P3783-I70

PUBLISHED: Antioch II 1938, 163, no. 106

INSCRIPTION: []ΔΑΙΜΩΝΕΥΨΥΧΕΙ (Eudaimon, Be of good cheer!)

The left side of the relief is broken, but the traditional pedi-
mental outline is still discernible. Above, a draped male reclines
on a couch before which is a three-legged table. He holds a cup
in his left hand and holds his right hand out toward the viewer.
The inscription is crudely cut on the lower raised border. CK

32 Grave Relief with a Table

Second century C.E.

Daphne, purchased

Marble, 4⅜ × 3½ × 1⅛ in. (11 × 9 × 2.9 cm)

The Art Museum, Princeton University, Pb75-I268:S514

PUBLISHED: Antioch III 1941, 102, no. 207

INSCRIPTION: []ΕΝΗΑΛΥ / []ΧΑΙΡΕ ([Hel]ene, free of care, hail and
farewell)

Only the lower right corner of this relief remains. A three-
legged table displays a cup and a rectangular object; the legs are
decorated with representations of the foreparts of animals.
Behind is part of a *kline* (couch) with a lathe-turned wooden
leg. Below this, on a plain raised border, are the remains of two
lines of an inscription, the beginning of which is missing. CK

32

Stone Inscriptions

Some 260 marble inscriptions and reliefs with inscriptions were found or purchased during the excavations of Antioch. Of these, the largest number were gravestones (99), and more than half were in Greek; the others were in Latin or Kufic (18). Aside from the documentation by name and gender of local inhabitants, the group includes a curious list of foods on columns, perhaps an inventory or menu; boundary markers indicating the names of villages and properties; a single Jewish relief with a menorah; a statue base; Christian inscriptions from martyria; a government decree; and graffiti. Although some were found in buildings, a good number were purchased by members of the Antioch excavation team. CK

33 Greek Inscription (Epitaph)

Second century C.E.
Daphne, purchased
Marble, 11½ × 9 × 1½ in. (29.2 × 22.9 × 3.8 cm)
The Art Museum, Princeton University, 3775-I67

PUBLISHED: Antioch II 1938, 162, no. 98

INSCRIPTION: ΕΥΨΥ / ΧΙΑΡΙ / CTΕΙ / ΝΕ (Be of good cheer, Aristinos)

This type is similar to the grave stele of Eudaimon (cat. no. 31). It is a plain rectangular marble plaque with the lower right corner broken away. CK

34 Greek Inscription (Epitaph)

First or second century C.E.
Seleucia, purchased
Marble, 5½ × 8⅛ × 2½ in. (14 × 20.6 × 6.5 cm)
The Art Museum, Princeton University, Pa1010-I226

PUBLISHED: Antioch III 1941, 105, no. 217

INSCRIPTION: ΚΑΛΛΩ / ΑΡΙΣΤΩΝΟΣ / ΦΙΛΟΣΤΟΡΓΕ / ΑΛΥΠΕΧΑΙΡΕ
(Kallô [daughter] of Aristôn, tenderly loving one, free from care, hail and farewell)

This relief joins that of Tryphê and Helene in commemoration of the deceased women of Antioch. Only the upper edge is preserved. CK

33

34

35 Latin Inscription (Epitaph)

Second or third century C.E.
Marble, 6 × 5⅜ × 1 in. (15 × 13.7 × 2.5 cm)
The Art Museum, Princeton University, P6260-I212

PUBLISHED: Antioch III 1941, 108, no. 232

INSCRIPTION: DM / C TERE[] / RVFVS M[] / MISIM M[] / []
(D[is] M[anibus] / C[aius] Tere[ntius] / Rufus, m[il(es)] cl(assis)] / Misim[ensis] m[ilitavit] / [])

This is the epitaph of Caius Terentius Rufus, believed to have been a sailor in the fleet of Misenum. A group of similar texts from between 129 and 212 C.E. attests to the presence of various naval forces at Antioch's harbor in Seleucia Pieria. CK

35

37

36

36 Greek Inscription (Fragment of a Decree?)

Antioch, purchased
Marble, 11¼ × 5 × 1 in. (28.5 × 12.7 × 2.5 cm)
The Art Museum, Princeton University, P6242-I208

PUBLISHED: Antioch II 1938, 164, no. 110

This fragment is broken on all sides. Some parts of the words δίκή *(dikē)* and στρατηγία *(stratēgia)* can be seen. CK

37 Byzantine Inscription (Epitaph)

Middle Byzantine
Antioch (Kharab area)
Marble, 11⅛ × 4½ (at top) × 8¾ (at bottom) × 2⅛ in.
(28.3 × 11.4 × 22.1 × 5.3 cm)
The Art Museum, Princeton University, Pb 15-I257

PUBLISHED: Antioch III 1941, 94–96, no. 158

This inscription of Byzantine calligraphy is broken on the right side and retains traces of blue and red paint. The name might be read as "Nicephorus," the name of a man supposedly martyred in Antioch during the reign of Valerian, in the third century. Although modern scholars have disproved his existence, the people of Antioch during the Byzantine era would have believed in his existence and named their children after him for safekeeping. CK

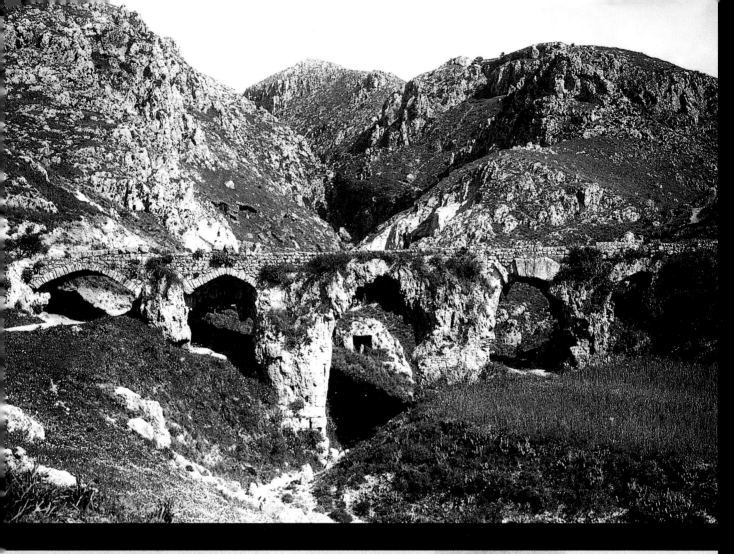

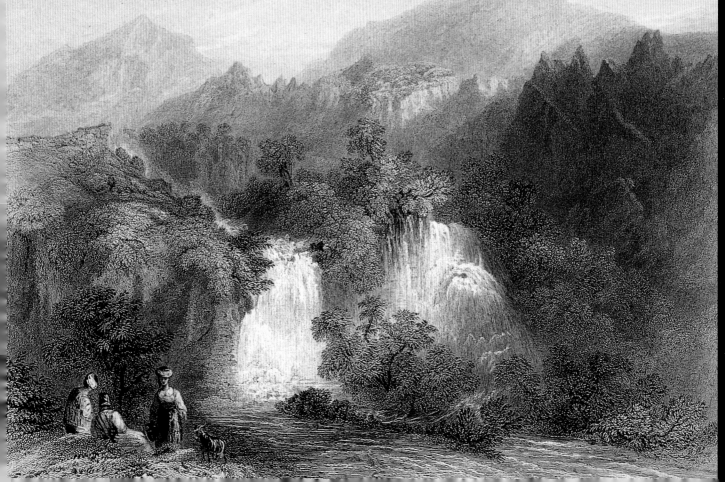

II Water

Water defined Antioch—its pleasant climate, its mythic legends, its physical beauty, and even the luxurious lifestyle of its inhabitants. Libanios reveals a fourth-century perspective on the significance of water in his famous speech about his native city, *Oration 11*:

Indeed the thing by which especially we are supreme is the fact that our city has water flowing all through it. (244)

And then the rivers which run through the country, who could number them, some large, some small, some flourishing at all seasons, others created by the winter, some flowing from the mountains, some rising in the plains . . . and others still journeying to the sea? (27)

The chief of the beauties of Daphne, and I think of the whole earth, . . . are the springs of Daphne. . . . These are the palaces of some Nymphs, and it is their gift that the waters are of the purest and clearest. (240)

The main springs were called Castalia and Pallas and they were part of the famed sanctuary of Apollo, noted for its thermal springs. The sweet and plentiful water of the springs in Daphne issued forth from crevices in the limestone plateau some one hundred feet higher in elevation than Antioch: ". . . the springs and their unfailing riches are truly a unique characteristic of ours" (28). These were the waters that flowed, at the rate of about 1,500 liters per second, into channels along two aqueduct lines built by the Romans, one under Caligula and another under Trajan and Hadrian. The aqueduct system conveyed water from Daphne across valleys on arcades and along the mountainsides about the city in high galleries, parts of which can still be traced today.

Several extant examples of Roman engineering attest to the dangers posed by flooding, which still threatens the modern region. The most impressive is a canal, partly in the form of a deep tunnel, of about 1300 meters dug out of the mountain to divert a stream that crossed the port of Seleucia Pieria. An inscription credits its construction to Vespasian and Titus.

Top: View of the remains of Trajan's Aqueduct; *bottom:* W. H. Bartlett, *Springs of Daphne.* Engraving from Carne 1836–38, vol. 1, facing page 31

Baths and Bathing in Roman Antioch

Fikret Yegül

Rather than be virtuous,
you prefer fancy clothing and warm baths.
JULIAN, Misopogon, 342C

Bathing in the Roman world involved far more than the functional and hygienic necessities of washing. It was a personal regeneration and a deeply rooted social habit, a cultural *institution*. For the average Roman, whether in Rome or at a military town along the Rhine or the Euphrates, a visit to the public baths in the afternoon was a necessary part of the day's routine. Not to bathe would have been un-Roman.

Ordinarily, hot bathing would be preceded by games and physical exercise in the palaestra. As the direct inheritors of the Greek gymnasium and the Greek ideal of a balance between body and mind, the Romans sought to incorporate even a quasi-intellectual dimension into the wide scope of their bathing activities. Many of the bathing complexes in the West and in Asia Minor contained lecture halls, libraries, cult rooms, promenades, and exercise courtyards. In the Roman baths in Syria and the eastern provinces, however, the palaestra increasingly disappeared, even before the well-known Christian opposition to nudity and exercise. It is instructive that among the six baths uncovered in the Antioch excavations none seems to have had an exercise courtyard, nor is there any clear mention of a palaestra among the copious ancient references to baths and bathing in Antioch. The reason for this may be that in Eastern societies the gymnasium had always occupied a relatively superficial position. It may also be that open courtyards and physical exercise were considered unsuitable in a hot climate.

Another distinguishing characteristic of Eastern baths, especially in the late Roman period, was that the *frigidarium* tended to be reduced in size and importance, transformed from a major hall with cold-water plunges to a spacious lounge-*apodyterium* combination serving as a place for gathering and entertainment. Only the largest, "imperial" baths, such as Bath C at Antioch and the South Baths at Bosra, seem to have followed Western examples in the creation of monumental vaulted or domed spatial sequences and traditional *frigidaria*.

In Roman society bathing was rooted in the rhythm and structure of the day. The warm, clear water, the shiny marble surfaces, the steamy atmosphere of vaulted rooms, the intimacy of massage—all created feelings of relaxation, comfort, well-being, and happiness. The cozy warmth of the baths and their apparent classless world of nudity encouraged friendship and intimacy. Bathing also was a prelude to and part of the preparation for the pleasurable experience of dinner, an artful and highly social affair that was the culmination of the Roman day.

The civilized, urban Roman world, whether in the West or the East, was essentially one in which physical, social, and mental pleasures were sought after, welcomed, shared, and savored. The dream world created by the public baths, large or small, was open to and enjoyed by all. Even in the remotest provinces the baths enabled the individual to escape the dusty streets for a few hours a day, feel a part of the system, and share in the empire's wealth and, perhaps, ideologies. Bathing gave the Romans the world they wanted, a world in which one was pleased to linger.

In fourth-century Antioch a councilor was openly flogged for failing to provide sufficient funds for the heating of public baths. As recorded by Libanios, the plight of Hermeias, if not the form of punishment, was quite common in the late classical world, when shrinking budgets and hard times made the time-honored tradition of civic munificence increasingly burdensome (Lib. *Or.* 26.5–6, 27.13).[1] Yet the remarkable nature of the punishment meted out to Hermeias only underscores the city's extraordinary pride in its many baths and its genuine distress at their being neglected.

If anecdotal history is to be believed, the city's passion for its warm baths and their world of luxury (criticized by Julian in the fourth century) goes back to the days of the Seleucid rulers. According to a story recorded by Polybius, King Antiochos Epiphanes (c. 175 B.C.E.), known for his habit of frequenting public baths, once had a large jar of expensive perfumed oil poured over the head of a man who had expressed his happiness for the privilege of bathing with a king (Polyb. *Histories* 26.1.12f). Since Antiochos had lived in Rome for a long time and grown fond of Roman customs, this may have been a bath created to introduce and popularize the Western bathing habit among his culturally mixed subjects.

As in other Roman cities, Antioch's delight in its baths was reflected in the population's reaction to baths being closed or damaged. The restoring and rebuilding of damaged bath buildings and aqueducts were high on the agenda of civic-minded public officials. In the great riot of 387 C.E., when Antiochenes angrily reacted to the newly imposed taxes, the violence, especially the breaking of the imperial images, started at the public baths. Among the punitive measures, the revocation of the city's rank as the metropolis of Syria and the closing down of all its baths were the harshest and the most humiliating (John Chrysostom *On the Statues* 13.2–6, 17.2; Lib. *Or.* 22.2–7). Nearly two centuries before this, Antioch's misfortune in supporting Pescennius Niger, Septimius Severus's rival in the race for emperorship, also had ended in the loss of its coveted rank. The first symbol of the new emperor's clemency toward the city was the gift of bathing: a new imperial bath called the Severianum (Malal. 294.17–19). The great earthquake of 458 C.E. destroyed all of the buildings on the island in the Orontes except the "palace bath," dating from Diocletian's reign (c. 300 C.E.). This old bath, which was quickly repaired and put

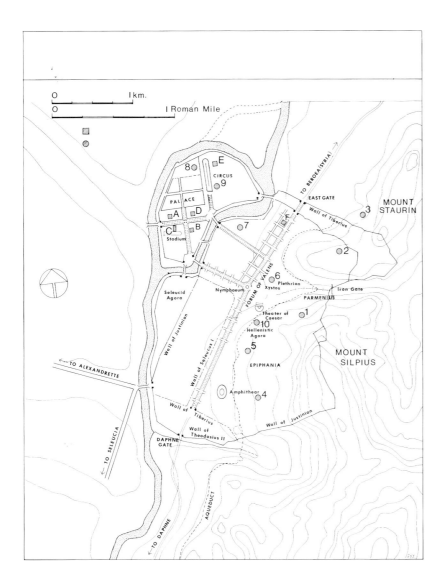

Fig. 1. Restored topographical plan of Antioch with real and hypothetical locations of public baths.

Baths excavated by the Princeton expedition:
A. *Bath A*
B. *Bath B*
C. *Bath C*
D. *Bath D*
E. *Bath E*
F. *Bath F*

Baths mentioned in Malalas:
1. *Baths of Julius Caesar*
2. *Baths of Agrippa*
3. *Baths of Tiberius*
4. *Baths of Domitian*
5. *Baths of Trajan/Hadrian*
6. *Baths of Commodus*
7. *Baths of Septimius Severus*
8. *Baths of Diocletian*
9. *Baths of Valens*
10. *Baths of Governor Olbia*

back to use, "rendered important service for the health and comfort of local survivors . . . who must have sorely needed an opportunity to rid themselves of the dust and dirt produced by the earthquake."[2]

The mosaic floors of the Bath of Apolausis, a small suburban bath uncovered in the Antioch excavations on the slopes of Mount Silpios, east of the city, illustrate two young women identified as Soteria (Salvation) and Apolausis (Enjoyment), the latter delicately smelling a flower. These minor deities had the power to deliver people from danger, and were popularly associated in late antiquity with baths, whose salubrious warm waters could give pleasure and soothe pain. The good times and good life offered by public baths reflect favorite themes of Libanios in his praise of Antioch (Lib. *Or.* 11.242). Although a moralizing trend in ancient and modern scholarship has unfairly characterized the Antiochenes as fickle and hedonistic, such images, as well as formulaic verses that typically allude to the pleasures and "dangers" of baths, were quite common throughout the Mediterranean.[3]

In the early fifth century Constantinople had 153 small baths

(Notitia Urbis Constantinopolitanae) and Rome had an astounding 856 *(Not. Dign.).* Just how many were there in Antioch? The historian John Malalas, writing in the mid-sixth century, named a dozen or so dating from the imperial period, and another four or five were added in late antiquity. Unlike the comprehensive census records of Constantinople and Rome, Malalas did not provide official numbers. He seems to have chosen his examples at random, but mainly from those built or subsidized by emperors or local administrators. There is little doubt that the actual number of baths in Antioch by the end of the fifth century far exceeded those mentioned by Malalas.

Our information, literary or scientific, is sketchy, but apparently the baths were well distributed within the city, from the slopes of Mount Silpios, to the flat ground along the river and on the island, and along the famous colonnaded street from gate to gate (fig. 1). Literary texts mention primarily the larger baths, the imperial gifts. There must have been dozens of smaller, neighborhood baths throughout the city, such as the eighteen baths belonging to the eighteen tribes of Antioch, "each tribe trying to

OLYMPIC STADIUM BATHS OF ARDABURIUS - DAPHNE

FKY '99

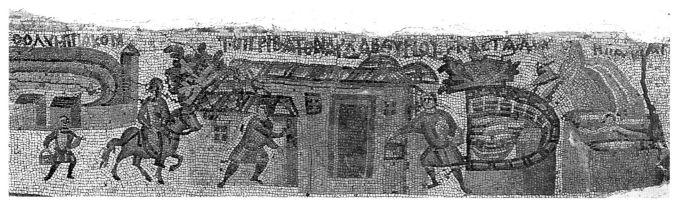

Fig. 2. (A) Baths of Ardaburius adjacent to *Olympiakon* in Daphne; (B) Detail of actual mosaic in Hatay Archaeological Museum, Antakya

make its baths the finest" (Lib. *Or.* 11.245), and the handful excavated in the Antioch excavations. There were also many baths outside the city walls. At least one was a suburban bath of extraurban importance: the Baths of Ardaburius, a quasi-private establishment between Antioch and Daphne, next to the Olympic stadium, built by a military commander in the mid-fifth century. It is illustrated, as well as identified by an inscription, on the elaborate topographical border of a mosaic found in a house in Daphne (fig. 2). The border depicts in linear fashion what appears to be a tour of the city and its main monuments.[4] The Baths of Ardaburius are depicted as a substantial building with an imposing door, tiled roofs, and many domes. The topographical border is an extraordinary document not only for Antioch but for all studies in late antique urbanism. At about the same time, halfway across the Mediterranean, there was a brisk tourist trade in souvenir glass flasks, whose etched illustrations took one on a sightseeing tour of the architectural landmarks of popular thermal resorts in the Bay of Naples, particularly Puteoli and Baiae, some of whose structures are inscribed as *thermae* (baths).[5]

The building of baths in Antioch followed the general pattern of urban expansion seen elsewhere in the Roman Empire, their numbers increasing from the time of Augustus onward and their fortunes closely tied to the development of water-

supply systems.[6] Augustus visited Antioch twice, in 31–30 B.C.E. and 20 B.C.E.; he elevated it to the rank of metropolis and gave impetus to brisk building activity. The two baths built by Agrippa, his trusted friend and lieutenant, were probably occasioned by these visits. One was located in a quarter named after Agrippa, roughly north of the city; the other was near a spring, in a lush, quiet setting on the slopes of Mount Silpios (Malal. 222.17, 20) (fig. 1.2). Tiberius built baths near the East Gate, at the northeast end of the colonnaded street, probably served by the mountain spring called the Olympias, named after Alexander the Great's mother (fig. 1.3). Domitian's baths were located on the slopes of the same mountain but in the southern quarter of the city, near the amphitheater of Caesar (Malal. 263.11–17) (fig. 1.4). The Baths of Trajan, probably the establishment rebuilt by Hadrian after the earthquake of 115 C.E., were the first connected to a major aqueduct, bringing water from Daphne, the lush suburb south of Antioch (Malal. 276.1–3, 277.20, 278.19) (fig 1.5). Under Commodus a large area at the north end of the colonnaded street, between the river and the mountain, which later became the Forum of Valens, was developed as a kind of Olympic center in association with the newly inaugurated games of Antioch. The bath built by Commodus, the Commodiana, appears to have been the centerpiece of this new

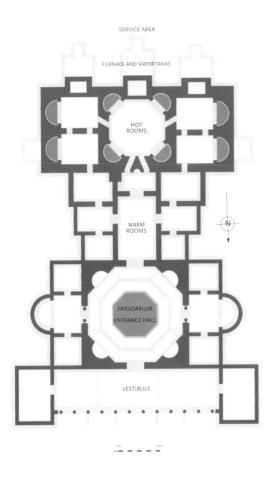

Fig. 3. Plan of Bath C at Antioch (Sector 11-L), 270 × 150 ft.

complex, which included the Xystos, the Olympic running tracks (fig. 1.6); the Plethrion, an athletic building of considerable fame (probably a wrestling school); and a temple to Olympian Zeus (Malal. 290.14–20; Lib. *Or.* 10).

When Septimius Severus visited Antioch in 202 C.E., he gave the city, as a gesture of forgiveness, a gymnasium, the previously mentioned Severianum, and a smaller bath, the Livianum, located on flat ground near the river (fig. 1.7). Malalas credits Diocletian with no fewer than five bathing establishments (306.22, 307.2). The nature and the approximate location of at least one of them is known; named after the emperor, it was part of the palace Diocletian built on the Orontes Island.[7] It was probably situated on the flat ground next to the circus, with possible connections to the palace but not part of it (fig. 1.8). The palace, a four-square complex like Diocletian's palace at Spalato, must have had its own private baths. The grouping of a major bath with a palace, circus, and athletic facilities is not unusual and recalls the Baths of Zeuxippos at Constantinople, built a century earlier. How Diocletian's baths were related to the one built by Valens some sixty to seventy years later, also near the circus is unknown (Malal. 339.17–18) (fig. 1.9). The Baths of Governor Olbia, situated next to the Constantinian basilica of Rufinus, were associated with the Hellenistic agora, another important topographical landmark whose location remains controversial (Malal. 395.20, 398.4) (fig. 1.10). Justinian is the last emperor whose name is connected to baths, not for establishing new facilities but for restoring and rebuilding existing ones that had been damaged in the devastating earthquake of 526, just one year before Justinian assumed the throne. Antioch never quite recovered from this calamity, and bathing customs probably were never the same.

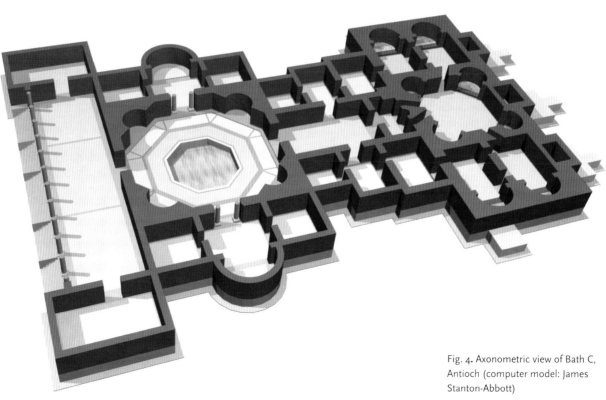

Fig. 4. Axonometric view of Bath C, Antioch (computer model: James Stanton-Abbott)

Although the Antioch excavations uncovered no less than half a dozen baths—"Somewhat to our disappointment it was another bath," lamented C. H. Fisher, the principal architect for the expedition, upon finding Bath B in 1932—none can be firmly identified with any mentioned in the literary sources. The largest and most opulent of these baths, Bath C, has a distinctive plan and is the only "imperial-type" bath whose design we know (fig. 3).[8] Like the Baths of Diocletian, Bath C was located next to an exercise field; it was immediately north of a rudimentary stadium named by the excavators the Byzantine Stadium. The plan is distinctive: twenty vertically congruent rooms are grouped symmetrically about the main north-south axis crossed by a pair of east-west axes. Two large octagonal halls, each flanked by clusters of smaller apsidal rooms, create two clearly defined spatial zones in a perfectly balanced composition (fig. 4). The northern octagon, approached from a conjectural east-west street by way of a columnar porch, had a large pool in the middle; it served as the *frigidarium* and entrance hall. The southern octagon, at the end of the main axis, was the *caldarium*. Domical vaults constructed of light aggregate roofed the octagons. The mosaic paving that covers the floors of the unheated zone like a sumptuous carpet has been dated to the mid-fourth century, the last phase of a major renovation. With its broad flight of stairs and open colonnaded porch between towerlike vestibular blocks, the monumental facade of Bath C, an extroverted and memorable facade that invited the Antiochenes to indulge in their much-beloved bathing habit, projects a sense of civic grandeur. The plan of Bath C bears a relationship to the mid-second-century South Baths at Bosra. The colonnaded porch recalls the Caracallan propylon of the sanctuary of Zeus (Ba'al) at Baalbek. However, the peculiar manner in which the octagon, an architectural form developed essentially in the West, has been isolated and monumentalized in Bath C appears to be more characteristic of Eastern usage and suggests a date in the early or mid-third century.[9]

Among the smaller baths uncovered in Antioch, Baths E (c. 305–50 C.E.) and A (c. 220–40 C.E.) correspond to a group of baths in Greece and Asia Minor as well as others in Syria, such as Bath E-3 at Dura-Europos (figs. 5–7).[10] These similarities can be noted not only in the tightly packed grouping and quasi-axial formation of the small, vaulted apsidal units of the heated zone but especially in annexed spaces that appear to have functioned as halls for reception, entertainment, and lounging; some even served as *frigidaria*, such as the main hall of Bath E (named the Main Social Hall by the excavators) and one of similar size, proportion, and architectural disposition in Bath A. A direct comparison can be made between the annexed halls of the Antioch baths and those of Bath E-3 at Dura as well as their architecturally distinguished counterparts in other northern Syrian sites. These tall and boxy basilical halls, which often form the core of a social complex, become the most distinctive and characteristic design feature in late antique, early

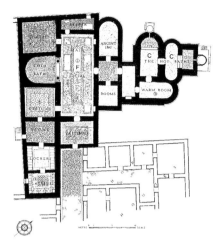

Fig. 5. Restored plan of Bath E

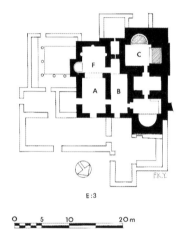

Fig. 6. Restored plan of Bath E-3, Dura-Europos

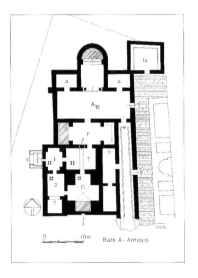

Fig. 7. Restored plan of Bath A, Antioch

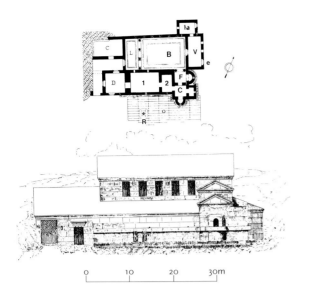

Fig. 8. Plan and south elevation of the Roman baths at Serdjilla

Byzantine, and Islamic baths of Syria, such as those at Serdjilla, Babiska, and Qasr al-Amra (fig. 8).

What was Antioch's special role in the creation and development of a late antique Eastern bath type? As an artistic and cultural metropolis that always maintained close contact with Western capitals, Antioch must have been a more accessible and immediate center for southeastern Anatolia and northern Syria than Rome or Constantinople. A regional center such as Antioch was able to sustain a cultural arena in which cross-fertilization between local and imported traditions and practices could occur. A small bathing establishment, such as Bath E, was as much the product of convergent traditions straddling centuries and continents as it was a product of its own time and place. Its curvilinear, vaulted spaces and apsidal projections are deeply rooted in the formative history of baths in the West. Yet the design is also a very vital part of widely diffused contemporary tendencies and tastes: structurally expressive spatial clusters proliferate in late antique architecture across Italy and the Mediterranean. Its boxy, spacious, high-roofed "social halls," on the other hand, have a strikingly regional flavor. More importantly, these halls functioned as community centers and reflected a new emphasis on political and cultural concerns for assembly and entertainment functions. These were the functions of public baths almost from their inception, but in the late antique period they were elevated to a new level of sophistication and dignity at the edge of a rising desert culture.[11]

1. Liebeschuetz 1972, 148.

2. Downey 1961, 476–78; Evagrios *Church History* (ed. Bidez-Parmentier) 2.12, 63–64.

3. On the Bath of Apolausis, see Levi 1947, 304–6, pls. 67–68. On "charms" associated with baths, see Dunbabin 1989; and Yegül 1992, 318. See also Haddad 1949, 153–86, esp. 160–62.

4. According to Downey 1961, 659–64, the scenes in the border show the same route as the itinerary described by Libanios's eleventh oration, in praise of Antioch. See also Lassus 1934, 114–56, figs. 1, 2, 11; Levi 1947, 323–26; and Morey 1938, 18–19.

5. Ostrow 1979; Painter 1975.

6. Downey 1961, 169ff.; Moffatt 1990; Ward-Perkins 1981, 325.

7. Berger 1982, 52–53; Liebeschuetz 1972, 98, 133–36. For the topography of the Orontes Island and the location of these baths, see Downey 1961, 323–25 n. 31.

8. For Bath C, see Antioch I 1934, 19–31, pl. 5; and Levi 1947, 289–91. For Bath B, see Antioch I 1934, 8; Yegül 1992, 325–26; and Campbell 1988, 13–14, 23–24, 36–38, 15–17, 7–11, 49–50, fig. 2. The Antioch excavations uncovered six public baths (designated A–F); all except Bath C are small. For a general account of these, see the Antioch archaeological reports; and Levi 1947.

9. Princeton excavators suggested that the present building (c. 350–400 C.E.) was rebuilt on the foundations of an early-second-century bath. I am quite skeptical at this reading of the elusive archaeological traces of the early foundations and consider the building a third-century original (probably Severan) with a major fourth-century renovation.

10. Brown 1936; Levi 1947, 260–76; Yegül 1992, 338. For the hall-type baths in Greece and Asia Minor, see Yegül 1993, esp. 101–3. Fisher believed that Bath A was built in two phases, an early, unheated zone built c. 200 and the main, heated zone, built c. 350–400 C.E. (Antioch I 1934, 4–7, pl. 3). That is not the way a Roman bath works. In the excavations in Bath A and elsewhere in Antioch, architectural dating is often based on overinterpretation of the materials and techniques of construction. Roman buildings in general and baths in particular may display different "styles" of construction in the same phase. I would like to suggest that Bath A in Antioch was constructed mainly in a single period, c. 220–40 C.E., as a coin of Elagabalus found in a sealed context supports.

11. Kennedy 1996, 181–98; Yegül 1992, 326–38, 347–49.

38

38 Mosaic Bust of the Pyramos River

Mid- to late second century C.E.
Seleucia, House of Cilicia (S19-K), room 1
Marble and limestone *tesserae*, 56 × 57 in. (142.2 × 144.8 cm)
Smith College Museum of Art, Northampton, Massachusetts, 1938.14

PUBLISHED: Antioch III 1941, 214, pl. 88, no. 177, panel B; Levi 1947, 57–59; Jones 1981, 21

The bust is identified by a Greek inscription as "Pyramos." It is one of four medallions with busts personifying rivers. Only two are extant; the other, representing the Tigris River, is in the Detroit Institute of Arts. As part of a dining-room composition, the four rivers framed a large central panel with personifications of provinces; the one that is preserved is labeled "Cilicia." Pyramos is framed within a medallion inscribed in a yellow square with a green foliate motif. He is shown as a beardless youth, in contrast to the bearded Tigris, and in his hair are green and grey river reeds. He wears a black chlamys off one shoulder.

Another bust of Pyramos was discovered in the House of the Porticoes, also in Seleucia, dated to the Severan period. Personifications of place, topographical images, were found at other sites in Ancient Syria and seem to have been a specialty of the mosaic workshops. A mosaic of the Euphrates as a full seated figure was found east of Aleppo and is firmly dated by inscription to 228 C.E. As for the missing parts of the original House of Cilicia pavement, scholars have suggested that the missing province was Mesopotamia, and the missing rivers, the Euphrates and the Kydnos.[1] Whether in baths, houses, or pub-

lic fountains, the rich imagery of marine deities personifies water and evokes the pleasures and benefits associated with it.

The stylistic character of the entire composition, especially the inclusion of panels that imitate coffered ceilings, can more comfortably be assigned a date in the later second century rather than the Hadrianic/Antonine date assigned by Levi. CK

1. Levi 1947, 58.

39 Mosaic of Tethys

c. 250–75 C.E.
Daphne, House of the Boat of Psyches, room 6
Marble and limestone *tesserae*, 76 × 54 in. (193 × 137.2 cm)
The Baltimore Museum of Art, 1937.118

PUBLISHED: Antioch II 1938, 185, no. 51, pl. 39; Levi 1947, 186, pls. 39b, 157b; Jones 1981, 16, M50, A; Wages 1986

The bust of a long-haired sea goddess with wings sprouting from her forehead marked the center of a long vertical panel that decorated room 6 of the House of the Boat of the Psyches. A sea creature with a dragon head and snake body (*ketos* in Greek mythology) wraps around her neck. Scattered throughout are various fish, a crab, an eel, and below, a winged Eros rides a dolphin and casts his fishing line. Stylistically the marine scene is treated as a free-figure composition with fish scattered across a neutral white ground. Yet the fish are carefully rendered and can be identified with real species. The complexions and bodies of the figures are naturalistic.

Similar female busts appear in mosaics from the Greek East, especially in ancient Syria. At Antioch alone five mosaics dating from the second to the fifth centuries include representations of sea goddesses.[1] They have been variously identified as Thetis, Tethys, and Thalassa, the latter a more generalized personification of the sea, usually shown with a rudder. Although the Baltimore goddess does not have any other attributes or label, she is convincingly identified as Tethys, goddess of the seas.[2] She appears as a full-bodied figure in a second-century mosaic from the House of the Calendar at Antioch, in which she and her consort/brother the god Ocean are paired as the rulers of the waters. This identification is confirmed by the Greek label ΤΗθΥC (Tethys) beside a winged female bust surrounded by fish in a mosaic that decorated the octagonal pool of Bath F at Antioch.[3]

While more female marine figures survive from Antioch, Ocean was surely equally popular. We know from a passage in the *Chronicle* of Malalas (11.282) that Marcus Aurelius built a *nymphaion* called "Okeanon" in Antioch, which is taken to imply that it was embellished with a representation of Ocean. A relief with Ocean, probably from a waterspout, was found in Seleucia Pieria (Samandağ) and is today in the Hatay Archaeological Museum.

Antioch's many sources of water—the Mediterranean, the Orontes River, and the natural springs and pools at nearby

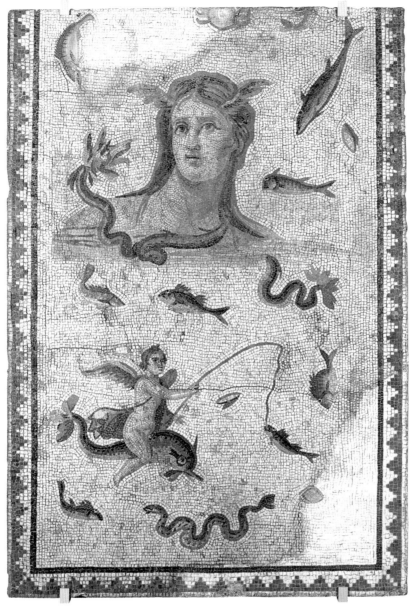

39

Daphne, with their healing properties—greatly added to its reputation for an enviable climate and a luxurious quality of life, indicated by its many baths and fountains. A second bust of Tethys, paired with a bust of Okeanos, decorated the entrance into the *triclinium* of the House of the Boat of the Psyches. In the same house, the motif of the fishing Eros is repeated in each of the five niches of the *nymphaeum*.[4]

This taste for watery themes in the houses of Antioch corresponds to the many references in the writings of Libanios to the abundance and beauty of Antioch's waters. Because hunters and fishermen "lived by the . . . favor of Fortune," it is also possible that the fishing and hunting imagery popular in Roman houses functioned as symbols of luck.[5] In addition, fish were a

luxury commodity in the ancient world, and one can imagine that the representation of a rich marine life connoted status. Undoubtedly, multiple meanings were intended and understood by such imagery. CK

1. See Wages 1986, 127–28, for a listing of the sea goddesses.
2. Levi identified her as Thetis without much evidence, but Wages makes a good argument for identifying her as Tethys (see Wages 1986, esp. 123–24).
3. Formerly on display at Dumbarton Oaks, the mosaic is now installed at the Harvard Business School.
4. See p. 8, fig. 6.
5. Purcell 1995, 23–24.

III Entertainment

Mosaic of Theatrical Masks, detail from House of the Triumph of Dionysos, dining room mosaic, Antioch, second century. Hatay Archaeological Museum, Antakya, inv. 873

As in all major cities of the Roman Empire, dozens of religious festivals and civic holidays filled the calendar year of the Antiochenes. Games and public entertainments of many varieties accompanied these celebrations, including theatrical performances, gladiatorial fights, staged hunts, chariot races, and athletics.

Greek tragedies and comedies, as well as the increasingly popular mime plays, with their acrobatics and lewd jokes, were performed in the theaters of Antioch. Two theaters are known: the Theater of Dionysos (known only from texts) and the Theater of the Olympian Zeus in Daphne. The Theater of Dionysos in Antioch, probably built by Seleukos I, was a typical Greek theater built into a curved hillside on the slope of Mount Silpios, with a semicircular seating area and an open view beyond the stage. During the course of the first and second centuries C.E., the seating area was enlarged several times to accommodate the growing population, and it was made into a Roman theater by the addition of a colonnaded stage building. The Daphne theater was built by Vespasian in the 70s C.E. with the spoils of the Jewish Wars. Excavations yielded evidence that the orchestra was flooded with water, undoubtedly to stage mock naval battles.

Gladiatorial fights, first introduced to Antioch by Antiochos IV, were held primarily in the amphitheater, an ellipse-shaped structure built by Julius Caesar in the Jewish quarter near the southern end of the colonnaded street (city plan, p. xv, no. 15). After combats to the death were outlawed in the fourth century, the Antioch amphitheater underwent significant remodeling to accommodate staged hunts that pitted professional hunters against wild beasts.

Roman-style chariot races, with four-horse teams and seven-lap runs, became especially popular in Antioch in the late Roman period and were held at least once a week. The hippodrome, probably of the second century C.E., was enormous and formed part of a palace-circus complex similar to those at Constantinople and Thessaloníki (city plan, p. xv, no. 2).

The Antioch Olympics, founded in the first century C.E. and modeled after the Pan-Hellenic games at Olympia, were held every four years and were the most elaborate of all the festivals in Antioch. The event featured Greek-style athletics (javelin- and discus-throwing, footraces, and wrestling), as well as theatrical performances and chariot races. The Olympic stadium *(Olympiakon)* in Daphne was probably horseshoe-shaped with a monumental gate on the side (p. 148, fig. 2).

40 Mosaic of Menander, Glykera, and Comedy

c. 250–75 C.E.

Daphne, House of Menander

Marble and limestone *tesserae*, 53⅛ × 88¾ in. (134.9 × 225.4 cm)

The Art Museum, Princeton University, 40.435

PUBLISHED: Friend 1941, 248–51; Levi 1947, 201–3; Jones 1981, 4, fig. 3

Identified by a Greek inscription, the playwright Menander and his mistress, Glykera, recline on a dining couch, accompanied by Comedy. To the left, the female personification of Comedy holds conventional theater props, namely, a mask and a staff with a curved handle typically held by the narrator/messenger on stage. The representation of Menander and Glykera is rare, appearing only one other time in Antioch, in a mosaic from the House of Aion, where the pair are juxtaposed with the Homeric lovers Achilles and Briseis. This combination may indicate how such compositions were perceived by their contemporaries, namely, as analogous types, lovers drawn from the literary sphere.

The New Comedy of Menander was first staged in Athens in the late fourth century B.C.E. and continued to be performed throughout the Roman period. Portraits of Menander and scenes from his plays are reproduced most notably in wall paintings at Ephesos and Pompeii and in floor mosaics from Mytilene (Lesbos). However, the closest parallels to the composition of the Princeton mosaic are a marble relief in Princeton and one in the Vatican (Lateran Collections) which date to the late first century B.C.E. or early first century C.E., and represent the playwright, seated and draped only in a mantle around his lap, contemplating the masks of New Comedy. The Vatican relief includes a standing female identified as Glykera.[1] The variety of representations of Menander and his plays attest to his popularity both as a literary type for artistic representations and to the continued fashion for his comedies throughout the Roman Empire. Most likely, the people of Antioch could see his comedies performed in their theaters.

The mosaic was found in room 11 of the House of Menander (see p. 50), in a part of the house that appears to have been dedicated to dining and entertainment. The convivial scene with the reclined lovers may well reflect the function of the room. As comedies regularly ended in a revel, and as Plutarch tells us that "New Comedy is so bound up with symposia that you could more easily regulate the drinking without wine than without Menander," the pavement may well allude to the types of entertainments or discussions that took place in this very room.[2] CK

1. Both reliefs are discussed in Ridgway 1994, 100–106, no. 32.

2. Plut. *Quaest. conv.* (O.C. 712B); Jones 1991, 191–93.

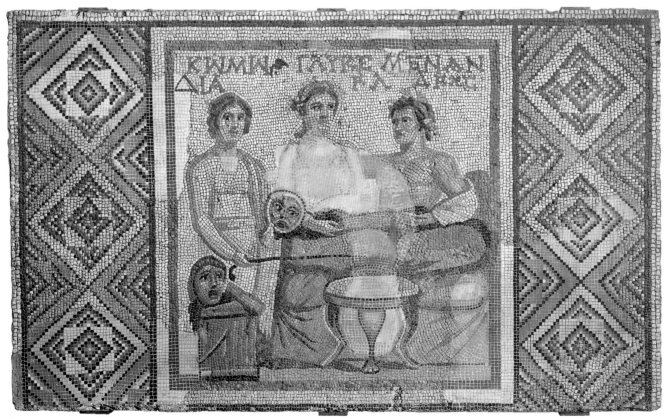

40

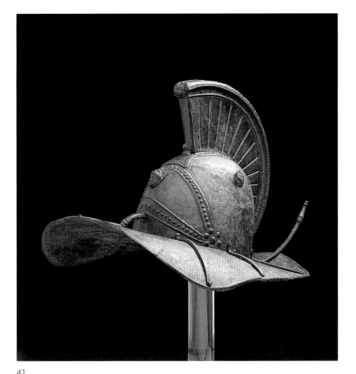

41

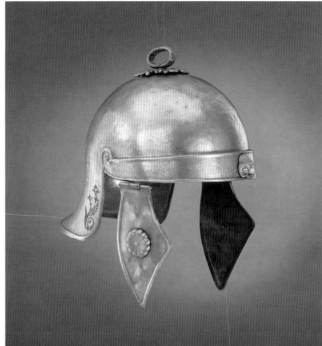

42

41 Helmet for a Gladiator

First century C.E.
Italy
Bronze, 13 × 14½ × 22½ in. (33 × 36.8 × 57.2 cm)

Higgins Armory Museum, Worcester, Massachusetts, 1129

Reportedly found at Orvieto

PUBLISHED: Miner 1947, no. 348, pl. 47; Grancsay 1961, 22–23

This helmet, constructed of plates of hammered bronze riveted
together, was once brightly polished and ornamented with a
prominent horsehair crest. It appears to be a unique form of the
type used by a *hoplomachus,* a gladiator who wore shin defenses
and carried a circular shield *(hoplon)* and short sword in the
fashion of classical Greek heavy foot-soldiers *(hoplitai).*

Such helmets may have been worn by combatants imported
from the Roman West for the first gladiatorial shows to be held in
the East, those held by Antiochos IV in Antioch in 166 B.C.E.
(Polyb. 30.26). Although the Hellenized audience in Antioch ini-
tially found these shows shocking, before long this Roman blood
sport had taken hold throughout the Roman East. While it is gen-
erally believed that this form of entertainment was in decline
because of the 326 C.E. prohibition by Constantine the Great,
Libanios recalls his enjoyment of gladiatorial combats in Antioch
as late as the second half of the fourth century (Lib. *Or.* 1.5). WK

42 Parade Helmet

C. 50–100 C.E.
Syria
Silver with incised decoration and bronze ornaments covered with
gold leaf, height 12⅜ in. (31.4 cm), weight 1.3 kg

The Toledo Museum of Art. Purchased with funds from the Libbey
Endowment, gift of Edward Drummond Libbey, 1958.45

Reportedly found in 1936 at Tell Abou Saboun, in a group of tombs in the
necropolis of Emesa (modern Homs), Syria; George Asfar, Damascus (1937–47)

PUBLISHED: Vermeule 1960; Korres 1970, 5, 161 nn. 2 and 6, 162–63,
276, 282, 292, pl. 45a; Oliver 1977, 146, no. 98; Toledo Museum of Art
1995, 48

This helmet resembles the bronze or iron helmets issued to sol-
diers of the Roman legions from the first century through the
early third century. They consist of a hemispherical crown with
hinged cheek pieces, a forehead visor, and a ring or knob on
top. The precious metal indicates that this helmet was owned
by a Roman officer, or possibly a soldier who received it as a
military award. Because the silver could not have withstood a
blow from a weapon, it must have been worn only on ceremo-
nial occasions, which may explain why the visor is in one piece
with the helmet. The gilt bronze ring on the top is attached to
a base in the form of an oak twig, loosely riveted so that it
turns, allowing the helmet to be hung up when not in use. The
helmet resembles one worn by a Syrian archer on the Column
of Trajan, dedicated in 113 C.E.[1] This is the only surviving silver

helmet of this shape; Roman legionary parade helmets, with face masks made to represent divine patrons of the legion, are both less sturdy and more flamboyant.

The gilded bronze ram's head riveted to the forehead may help to pinpoint the Syrian connection. The helmet is said to be associated with a rich tomb outside Emesa in which a remarkable silvered iron helmet with face mask was found.[2] Heavy gold jewelry was also found in the tomb, including a massive gold appliqué with a ram's head.[3] Although the styles of the rams' heads are not the same, the repetition of the motif is suggestive. The iron helmet may have been a gift from a Roman to the head of the Sempsigerami family, which ruled Emesa, or the ruler may have commissioned it for himself.[4] The kingdom of Emesa was probably incorporated into the Roman province of Syria at the time of the Jewish Revolts or soon thereafter. In 72 C.E., Sohaemus of Emesa, the last known king of Emesa, assisted the Romans to conquer the kingdom of Commagene, on his northwestern border.[5]

The ram is also associated with the goddess Minerva and her aegis, or protective cloak, made of a wild goatskin. Following this interpretation, the ram may mark the helmet as belonging to a member of the *legio I Minervia*, whose soldiers are shown on the Column of Trajan marching under a ram's-head standard. The legion was formed by Domitian in 83 in Germany, which remained its base, but it fought in the East, commanded by the future emperor Hadrian during Trajan's First Dacian War, in 101–2, and by Lucius Verus in the Parthian War, in 165.[6] SK

1. Robinson 1975, 7, fig. 111. The archer is identified as Syrian because on the column only Syrian auxiliary archers wear *lorica squamata* (scale armor).

2. Damascus inv. no. 7.084, H. 9½ in. (24.1 cm): Abdul-Hak 1951, 169, no. 38, pl. 64, nos. 1 and 2; Seyrig 1952, 204–27, pls. 21–23.

3. Inv. no. 7.204: Abdul-Hak 1951, 168, no. 10 (with turquoise eyes); Seyrig 1952, 240–44, figs. 18–19, pl. 27, no. 1.

4. Robinson 1975: "The skull and the mask are of iron, the latter most skillfully sheathed in thin silver and, though conforming to the average Roman model of a Semitic cast of features that does suggest an attempt at portraiture." Robinson dates the helmet to the early first century C.E.

5. Millar 1993, 84 n. 17. A Greek epitaph dated 78/79 from a funerary pyramid at Emesa, destroyed in 1911, records that "Gaios Ioulios Samsigeramos" as a member of the Roman tribe Fabia, also called Seilas, son of Gaius Iulius Alexion, constructed the tomb; he may have been a relative of Sohaemus, but no royal or other rank is inscribed.

6. Vermeule 1960, 8–11.

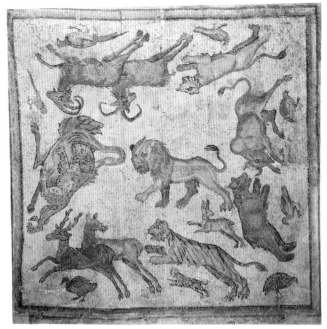

43

43 Honolulu Hunt Mosaic

c. 450–520 C.E.
Daphne, House of the Worcester Hunt, room 3
Marble and limestone *tesserae*, 9 ft. 6 in. × 9 ft. 3 in.
(289.6 × 281.9 cm)
Honolulu Academy of Arts, 4672

Not exhibited

PUBLISHED: Antioch II 1938, 202, no. 92, pl. 74; Levi 1947, 365, pl. 90b

The Honolulu Hunt was found in a partially excavated house, three adjacent rooms of which were uncovered, each paved with mosaics having related themes (see p. 159). The Honolulu Hunt was adjacent to a large reception hall decorated with the Worcester Hunt mosaic (p. 66, fig. 2). Both floor mosaics are executed in what is known as the carpet style, an innovative phase in the development of late Roman mosaics in which figures and landscape elements are spread across a neutral ground. As in textiles, the backgrounds in these mosaics are treated as uniform surfaces (in this case, a white scale pattern), denying any spatial illusion or depth. Because of the flexibility of such compositions, visitors to these rooms were afforded multiple views. Two of the most impressive products of this new style were the hunt carpets found in the House of the Worcester Hunt.

Arranged around a central striding lion, the Honolulu Hunt includes four groups of beasts in combat along the perimeter of a roughly square composition. Although the walls were robbed down to their foundations and the original entrances are lost, it is likely that the central lion, walking to the left and turning his head in three-quarter view, faced the entrance from the larger

Fig. 1. Partial floor plan of the House of the Worcester Hunt in Daphne, showing the original locations of the Honolulu Hunt *(upper left)*, the Worcester Hunt *(center)*, and the Mosaic of Ge *(lower right)*, now in the Hatay Archaeological Museum, Antakya. Shaded areas indicate the remains of original walls; dotted lines represent reconstructed walls (plan: Mary Todd)

room with the Worcester Hunt. Immediately below the lion are a leaping hare and a tigress with a cub under her belly about to attack a stag and doe running to the left. Continuing clockwise, a leopard jumps on a huge ostrich, followed by a lioness chasing after two rams. In the fourth section, a bear and zebu are in head-to-head combat. Various birds (a duck, a pheasant, a guinea fowl, a parrot) walk and peck along the groundline.

Similar figure carpets were produced two centuries earlier in Roman houses of North Africa.[1] The general chronology of floor mosaics would suggest that floors depicting great hunts were produced by North African workshops as early as the third century, entered into the artistic repertoire of the Latin West later in that century, and appeared in the Greek East only sometime in the mid-fifth century.[2]

While the stylistic conception of the Honolulu Hunt may have been influenced by Western artistic sources, could the scene represent one actually viewed by the inhabitants of Antioch? The selection of animals recalls the venue of the Roman arena, where wild-beast hunts *(venationes)* were part of the fare of Roman spectacles. In most Greek cities, existing theaters were converted to accommodate the taste for Roman spectacles, gladiatorial games, and staged hunts. While Antioch had theaters—one was excavated in Daphne—it is clear from textual

sources that Antioch also had an authentic Roman amphitheater. Malalas notes in his sixth-century *Chronicle*, a major source for the history and topography of Antioch, that Caesar built an amphitheater on the slope of the mountain during his stay in Antioch, in 47–46 B.C.E. (Malal. *Chronicle* 9.5).[3] Although such a structure was not found in the excavations, the construction of an amphitheater in Corinth under the supervision of Julius Caesar around 44 B.C.E. indicates a similar campaign to impose an essentially Roman building type and its entertainments, namely, one having no Greek precedent. The building of amphitheaters in Greek cities was rare, but their insertion into the urban fabric indicated an adoption of Roman cultural identity. This process had already begun when Antiochos IV introduced Roman gladiatorial combats to the Greek East at Antioch in 166 B.C.E. (cat no. 41).

In the Christian era, Valens (c. 370 C.E.) converted a building used for gladiatorial shows, outlawed by Constantine in 325, into one for animal displays (Malal. *Chronicle* 13.3).[4] The building is referred to as a *kynegion*, a place where hunts and combats of animals could be held. Although the location of the building of Valens is not specified, a structure with curved sides seemingly intended for spectacles was found in the excavations near the Forum of Valens.[5] We know from the letters of Libanios that the

44

45

Syriarch, usually an official at Antioch, served as impresario of public entertainments, especially wild-beast shows, throughout the fourth century. These shows clearly were enormously expensive, for Libanios writes that some of the beasts were brought from Bithynia and the hunters were brought from Pamphylia.[6] Wild-beast shows continued into the sixth century and may well have been seen by the inhabitants of the House of the Worcester Hunt.

The motivation of the owners to commission two grand hunt floors may not be fully understood; however, that one includes human hunters and the other does not suggests an intentional juxtaposition. Libanios in his oration on Artemis opines that "hunting is an effective teacher of war" and "counts those who have been hunters as blessed and worthy of admiration" (Lib. *Or.* 5.20–21).[7] These hunt mosaics are vivid testimony to the passion with which the ancient world pursued hunting as entertainment, leisure activity, and virtue. CK

1. Examples include the third-century mosaic of beasts and hunters covering the floor of the *triclinium* in the House of the Ostriches at Sousse and the contemporary mosaic of amphitheater beasts found in the quarter of Carthage where the amphitheater is located (see Dunbabin 1978, cat. Sousse, 32c, i, p. 271, fig. 60, and cat. Carthage 3a, p. 250, fig. 57)

2. For the stylistic and chronological scheme of this development see Lavin 1963; for the Honolulu Hunt see ibid., 189, 190 n. 20, 192.

3. Malalas 1986, 114.

4. Ibid., 184.

5. Antioch II 1938, 3; Downey 1961, 407–10.

6. For a discussion of the Syriarch and public entertainments, with references to the letters of Libanios, see Liebeschuetz 1972, 141–42.

7. Downey 1961, 683.

44 Mosaic of a Gaming Board

c. 400 C.E.

Antioch, Necropolis (sector 24-L)

Limestone *tesserae*, 37⅞ × 48 × 2¾ in. (96 × 122 × 7 cm)

The Art Museum, Princeton University, 65.616

PUBLISHED: Levi 1947, 291–95; Campbell 1988, 79, pls. 222–23

This panel is part of what was once a long geometric pavement covering a corridor in an area of several tombs. The design of the rectangular panel, three lines of twelve small black squares divided into two groups by three large central disks, corresponds to a Roman game board *(tabula lusoria)*. We know very little about how such games were played, but they seem to have included a board, dice, and counters (see cat. nos. 46–48). The Greek word for such games, τάβλα, is derived from the Latin *tabula*; today backgammon is called τάβλι in Greece. One such Roman game, *Duodecim Scripta* (Twelve Notes), seems to have resembled backgammon. Similar boards are inscribed on the paving stones of main avenues in Roman cities and towns, such as Ephesos and Pompeii, where, just as in this cemetery in Antioch, they offered a welcome diversion from the day's activities. From the topographic border of the fifth-century Yakto mosaic we learn that men played such games along the streets of Antioch (see p. 114). In a funerary context perhaps they allude to the parallel between games of chance and life itself. CK AND MP

45 Funerary Relief: Men Playing a Board Game

C. 225 C.E.

Palmyra

Limestone, 18¼ × 21¼ in. (46.4 × 54 cm)

Museum of Fine Arts, Boston. Edwin E. Jack Fund, 1970.346

PUBLISHED: Comstock and Vermeule 1976, 259

In the style of its carving, its material, and its composition this relief corresponds closely to the reliefs that were inserted into the chambers of family tombs at Palmyra. The linear drapery and the curly hair and beards are close to those of the head at The Art Museum, Rhode Island School of Design (cat. no. 19). Here we see three men seated around a gaming table: two bearded men move the pieces around the table, while the central figure holds a stack of game pieces in his left hand and gestures with his raised right hand. The space in the relief is tilted forward in order to show more of the scene, a feature typical of late Roman art, as seen in the Funerary Banquet mosaic from Antioch (cat. no. 9).

The relief, although rare, corresponds in intent to the burial of actual game boards with their owners. Like the drinking and dining scenes on so many Antiochene grave reliefs (cat. nos. 29–32), the scene depicted in this relief attests to the practice of representing the deceased in a favorite pastime of the living. It may also speak to the symbolism of gaming in Roman society, namely, that "the whole of life could be thought aleatory, at the mercy of the divinities who control Luck."[1] CK

1. Purcell 1995, 22.

46 Game Counter

First or second century C.E.

Antioch (sector 17-O), 1937

Bone, 1¼ × ¼ in. (3 × 0.4 cm)

Obverse: basket and shoulder bag filled with fruits; reverse: VI/S

The Art Museum, Princeton University, 1999-170 (Antioch no. 271-B186)

47 Game Counter

First or second century C.E.

Bone, 1¾ × ⅛ in. (4.2 × 0.3 cm)

Obverse: hippodrome, reverse: XVI

The Art Museum, Princeton University. Museum purchase, gift of Steve L. Rubinger, 1996-178

48 Game Counter

First or second century C.E.

Bone, 1¼ × ⅛ in. (3.2 × 0.3 cm)

Obverse: tragic mask; reverse: blank

Rhode Island School of Design, Providence. Georgianna Sayles Aldrich Fund, 1996.14

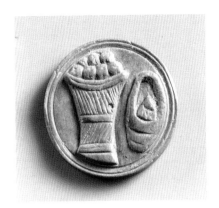

46

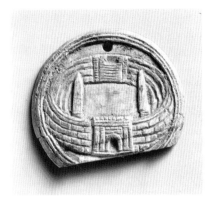

47

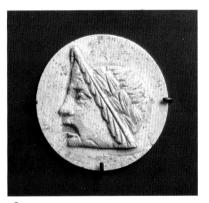

48

Board games were a popular pastime among Romans of all ages, but we know very little about how they were played. Cicero mentions a game called *Duodecim Scripta* (Twelve Notes), while another favorite was known simply as *Latrunculi* (Bandits). Makeshift game boards are found scratched on the pavements of many public buildings throughout the Roman Empire, and other boards were manufactured in the more elegant medium of mosaic (cat. no. 44).

These three bone disks, all previously unpublished, functioned as counters in a board game apparently invented at Alexandria in the early days of Roman rule, since many exam-

ples feature carved depictions of Alexandrian buildings or monuments. Such counters normally have a number from 1 to 15 incised on the reverse, although one of these (cat. no. 47) has the number 16. This same counter, which is nearly identical to one in the Cabinet des Médailles, Paris, is carved with a perspective view of a hippodrome that has a monumental entrance on its long axis, an imperial box *(pulvinar)*, and a pair of obelisks that functioned as turning posts in the chariot races. The counter from Antioch (cat. no. 46) shows a basket and shoulder bag filled with fruits, the symbols of autumn. Other counters of this type have heads of gods, athletes, or members of the imperial family, as well as a variety of objects, such as victory wreaths. One large class features human hands with the fingers diversely arranged, possibly related to a system of finger calculus.

The third counter (cat. no. 48), featuring a mask of a young wreathed male, is typical of a large class depicting actors or theatrical masks. In the past these often were identified as theater tickets, with the numbers on the back (lacking in this case) designating the particular section where one was to sit. This interpretation, however, has long been abandoned as both unsupported and anachronistic, and we are left to wonder about the exact meaning of such imagery in a gaming context. MP

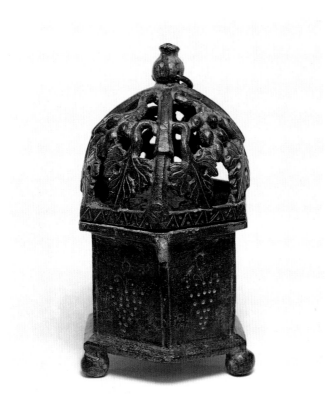

49

49 Censer

Sixth century C.E.
Laodicea (modern Latakya, Syria) (?)
Bronze, 7⅛ × 3¼ in. (18.1 × 8.3 cm)
Dumbarton Oaks, Washington, D.C., 50.31

PUBLISHED: Dumbarton Oaks 1955, no. 93, and 1967, no. 122; Barag 1971, 57 n. 126

Extant censers display a wide range of decoration. This hexagonal example uses two techniques to represent bunches of grapes: on each side rows of punched dots are arranged in the shape of a bunch of grapes, while the domed lid is cast and engraved in the form of grapes and leaves. The smoking incense was released through the openwork vine trellis of the domed lid, suggesting ideas of refreshment and pleasure. Vines and grape clusters are commonly associated with Dionysos, the god of wine, but they may also suggest the Christian Eucharist, as in the case of the openwork vine decoration in which the Apostles are seated on the Antioch Chalice (cat. no. 104).

A censer might be found in a home in Antioch. Burning incense would produce a pleasing, perfumed environment and also cover less desirable odors in the house in an age that had no plumbing and only the most basic sewage systems. Incense might be burned in the performance of any ritual magic that involved the invocation of spirits. Censers were also used for the consecration of curses, such as those inscribed on the lead tablets found in the Antioch excavations (cat. nos. 50, 51, 53, 54). Christians in the Antioch region invoked the protection and healing of their saints through prayer and the burning of incense.[1] SRZ

1. *Life of St. Symeon Stylites the Younger*, miracles 53, 70, and 231.

Magic Tablets
and the Games at Antioch

Florent Heintz

In 19 C.E. the young crown prince Germanicus fell suddenly and inexplicably ill in his residence at Daphne, a suburb of Antioch. Sent to the East as an imperial envoy with extraordinary powers, he had just had a major falling out with Piso, the legate of Syria, whom Tiberius had secretly appointed to keep his adopted son in check. Members of Germanicus's retinue suspected foul play and searched the house: "It is a fact that exploration of the floor and walls brought to light the remains of human bodies, spells, curse tablets, leaden tablets engraved with the name Germanicus, charred and blood-smeared ashes and other implements of witchcraft by which it is believed that the living soul can be devoted to the powers of the underworld" (Tac. *Ann.* 2.69). This attack of witchcraft was immediately blamed on Piso, his wife Plancina, and a professional magician hired by them. Germanicus died shortly thereafter at the age of thirty-three.

Tacitus's text provides the first detailed description of binding spells and curse tablets in antiquity.[1] Ancient magicians primarily used the remains of people who had died an untimely or violent death, people whose angry ghosts, incapable of crossing over to the underworld, hovered about their earthly remains. By appealing to powerful infernal deities, magicians could redirect these ghosts to "bind" other living beings. The intended victim could be made to fall in love, get sick and die, remain silent in a lawsuit, sustain injury during athletic events, and so on.

The main implement for a "binding spell" ritual was the curse tablet, a sheet of lead engraved with magic formulas, symbols, and prayers enjoining the spirits to perform the required deed. Once rituals of consecration, involving incantations and sacrifices, were performed over the tablet, it was folded or rolled, or both, and activated by depositing it in the grave of one who had died prematurely, or in a body of water (e.g., a drain, a well, or a river) believed to facilitate communication with the powers of death. In anthropological terms, curse tablets were both spirit-embodying and spirit-directing devices, just like certain types of spells used in African cults. In order to maximize the efficacy of the spell, magicians could devise a "proximity spell" and literally bring the grave to their intended victims. It was this type of witchcraft, coupled with the alleged use of poisons administered orally, that led to Germanicus's death.

Three or four centuries later, Antioch continued to live under the fear of binding spells. Practicing magic was still punished as a capital offense under Roman law: convicted magicians, as well as their accomplices and customers, faced death by fire or exposure to wild beasts. But magic workshops, run

mostly by men, not by the female witches of Greek and Roman literature, continued to produce curse tablets and catered to a wide array of clients. Magic was a phenomenon that pervaded every stratum of society in late antique Antioch. Professional orators and teachers of rhetoric were routinely subjected to attacks of witchcraft and magically silenced by their enemies and competitors: the body of a ritually bound chameleon, with its limbs and mouth tied, turned up in Libanios's own lecture hall (Lib. *Or.* 1.243–50). There is evidence of superstition even in the domestic realm, for example in the graphic mosaic representing the Evil Eye attacked by a spear, a trident, a snake, a scorpion, a centipede, and a barking dog accompanied by an ithyphallic dwarf and the Greek inscription ΚΑΙ CY (And You) (fig. 1). Located at the entrance to the so-called House of the Evil Eye in Antioch, this early-second-century mosaic reflects the vulnerability felt by the inhabitants around doorways and passageways, where the misfortunes of the envious eye could be brought in by outsiders.

Even high-ranking magistrates, at the risk of losing their lives, would hire magicians to predict who would succeed the current emperor. In a well-publicized trial in 371–72 eleven people were executed after being convicted of consulting a diviner on such matters, and soldiers were ordered to comb the city for books of magic and their owners (Amm. Marc. 29.1). The zealous Christian orator, John Chrysostom himself, only a child at the time, narrowly escaped execution after fishing out of the Orontes a magic book that someone had discarded in fear (*PG* 60.275).

During the Princeton excavations of 1934 and 1935 a total of thirteen curse tablets, most of them from the late antique period, were retrieved from various locations in Antioch and Daphne.[2] Two of the tablets, dated to the third and fourth

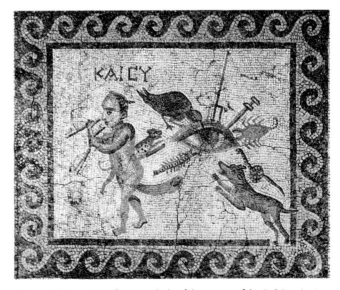

Fig. 1. Evil Eye mosaic from vestibule of the House of the Evil Eye, Antioch, second century. Hatay Archaeological Museum, Antakya, inv. 1024

50 Curse Tablet

Third or fourth century C.E.
Antioch, House of the Calendar, found in a well with cat. no. 51
Lead, 4½ × 2⅝ in. (11.5 × 6.8 cm)
The Art Museum, Princeton University, 4740-I130 a,b

51 Curse Tablet

Third or fourth century C.E.
Antioch, House of the Calendar, found in a well with cat. no. 50
Lead, 4⅜ × 2⅝ in. (11.2 × 6.7 cm)
The Art Museum, Princeton University, 4740-I130 c

52 Amulet (Phylactery)

Fourth or fifth century C.E.
Syrian
Silver, 10 × 1⅛ in. (25.3 × 2.8 cm)
Arthur M. Sackler Museum, Harvard University Art Museums. McDaniel
Collection, TL 33416

53 Curse Tablet

Late fifth or early sixth century C.E.
Antioch, hippodrome
Lead, 10¼ × 3½ in. (26 × 9 cm)
The Art Museum, Princeton University, 3603-I56

54 Curse Tablet

Fourth to sixth century C.E.
Antioch, hippodrome
Lead, length 3½ in. (8.8 cm), pierced with an iron nail
The Art Museum, Princeton University, 3608-I57

50

51

52

53

54

centuries C.E. (cat. nos. 50, 51), were found together in a well under a villa in the northeast quadrant of Antioch, at the foot of Mount Staurin. Both are aimed at a greengrocer named Babylas, a typically Antiochene name made popular by a local bishop and martyr saint of the mid-third century. Their Greek inscriptions give the demon in charge of carrying out the spell precise genealogical and topographical information concerning his target: the three different aliases the shopkeeper's mother assumed, as well as the city block and even the precise location on a colonnaded street of his vegetable stall. The demon is repeatedly asked to "bind" Babylas, to "lay him low," to "sink him like lead," to destroy his animals and his house in general.

Shopkeepers and craftsmen in Antioch were organized in professional guilds, and greengrocers were no exception (Lib. *Or.* 54.42).[3] Such organizations could stand up against magistrates who tried to make them observe overly stringent regulations. But professional guilds were not exempt from bickering, and factions would develop within their ranks, as the bakers' corporation in Antioch demonstrated more than once (Lib. *Or.* 29.9). In fact, it is quite possible that the curse tablets aimed at Babylas were commissioned by one of his fellow, and rival, greengrocers.

In order to understand exactly how they reflect the social realities of late antique Antioch, we must view these two business spells within a larger, integrated system of ritual power. A magician or ritual specialist could help individual shopkeepers boost their business by providing their boutiques with powerful talismans designed to attract customers (*PGM* 8.1-63). As part of a complete magic package, he would also offer his client protection against the Evil Eye and the binding spells of magicians hired by competing shopkeepers; finally, he could stage a witchcraft attack of his own, targeting the economic rivals of his client. These three magical operations—performance-enhancing, protective, and aggressive—although functionally distinct, were closely interdependent and ultimately served the same purpose: to enhance both the economic position and the social status of the magician's client.

Magic workshops were responsible for manufacturing and activating power objects that could work in conjunction with one another and in opposition to those produced by rival workshops. For instance, protective, or apotropaic, inscriptions on amulets would explicitly state that they were meant to cancel the effects of aggressive magic. On a fourth- or fifth-century Syrian silver phylactery, a protective sheet of metal originally rolled up inside a tubular case to be worn as a pendant (cat. no. 52),[4] the Greek inscription starts with an invocation to thirty-six magical names; they are hailed as "holy, mighty and powerful" and asked "to preserve and protect from all witchcraft and sorcery, from curse tablets, from those who died an untimely death, from those who died violently and from every evil thing, the body, the soul and every limb of the body Thomas, whom Maxima bore, from this day forth through his entire time to

come."[5] Not surprisingly, both the amulet's opening list of names and its overall formulaic language are remarkably close to those of certain curse tablets. In turn, phylacteries such as Thomas's forced magicians engaged in cursing operations to take countermeasures: they would include special clauses in their curse tablets urging the demon to break through the amuletic shield surrounding his target.

Competitive magic in late antique Antioch, as in all major cities of the empire, permeated not only the world of politics, academia, and retail. Public spectacles, such as pantomime, theater, wild-beast shows, Greek-style athletic events, and especially the enormously popular chariot racing generated their own fair share of magical activity.[6] Of the thirteen curse tablets brought to light at Antioch, five were excavated in drains located along the central barrier and turning posts of the hippodrome. The circus at Antioch, connected as it was to the imperial palace, was one of the largest and most important in the East.[7] To impress their sovereign, charioteers would try to make their rivals' vehicles overturn directly opposite the imperial box. A bit of magical cheating could only help to maximize the efficacy of their maneuvers.

One of the curse tablets from the Antioch circus (cat. no. 53), only recently unrolled and read, opens with a lengthy invocation mixing divine epithets and magical names; it is addressed to Hekate and other deities of the underworld. Then comes the curse itself: "Bind, lay waste, and overturn the horses of the Blue [faction]." Thirty-six Greek names of horses follow, many of them praising the animals' particular qualities: endurance (Marathonian), cunning (Know-it-all), divination powers (Prophet), and above all propensity to win (Victory-bearer, Worthy-of-victory, etc.). Usually, curses aimed at circus competitors target charioteers as well as racehorses; the Antioch example is one of the few exceptions to the rule. Another curse tablet, retrieved from the same set of drains, still rolled up but probably also related to chariot racing, is pierced with an iron nail (cat. no. 54). In some cases a ritual piercing, designed to seal or lock the spell into place symbolically, was performed prior to or during burial.

Because it mentions the Blue faction, the unrolled tablet from the Antioch hippodrome could not have been composed before the fifth or sixth century C.E., when the Blue and Green factions, two imperially sponsored organizations, took over the staging of public entertainment in the East, including chariot racing. The presence of circus factions in Antioch in particular is first attested to in 490 (Malal. *Chronicle* 389). They imposed their own centralized bureaucratic system on organizing, funding, and advertising the entertainments, which previously had been left to local magistrates.[8] However, literary sources on circus magic in Antioch come to us mostly from the late fourth century, prior to the factions' rule.

By the end of the fourth century chariot racing had been transformed from a contest of horses and drivers to one of

magicians (Amphilochius *Iambi* 179). Magistrates responsible for the upkeep of their teams, individual charioteers, and fans, either in a group or alone, would all use the services of magicians and thus extend the physical race into an invisible battle between supernatural forces. Just as they did for their merchant clients, magicians provided their circus customers with a single magical package comprising performance-enhancing, aggressive, and defensive devices.

Powerful victory charms boosted the energy of racehorses and made them run faster. These could be mysterious symbols and formulas engraved on their hooves or wolves' teeth strung about their neck in double bands. Charioteers wore gemstones engraved with potent symbols and, around their necks, papyrus sheets inscribed with magical words and prayers for victory. Racing teams designed their own homemade devices, branding lucky signs on their horses' haunches, embroidering them on their charioteers' sleeves, choosing auspicious names for their steeds and drivers.

Aggressive magic against the client's rivals commonly consisted in two kinds of binding spells used in combination: a strategic one, in which a curse tablet was placed outside the circus, within the grave of one who had died prematurely; and a tactical one, in which the curse tablet was concealed as close as possible to the most dangerous areas of the track (starting gates and turning posts). To protect the teams against misfortunes either from retaliatory witchcraft or from some other source of evil, magicians had horses and drivers not only fitted with phylacteries but also fumigated and sprinkled with cleansing liquids.

In the fourth century, part of the civic duties of young city councilors, when they took up their functions on the day of the New Year's festival, was to sponsor chariot races and other games. Their families would buy the required number of horses and hire the charioteers, veterinarians, and others needed to put together a racing team. As they were about to compete, the magistrates participated in public ceremonies at local temples, "sacrificing and praying to the gods for victory" (Lib. *Progymn.* 12.5.8).

Magistrates who were unafraid of stepping over the line between sanctioned and unsanctioned religious practices, between legality and illegality, would also go secretly to magicians to ask them to perform divination and to find out whose charioteer was fated to win. They would then hire a ritual specialist to try and influence the outcome of the race. Magicians would secure accomplices among circus employees and train them to recite spells in the horses' ears shortly before they left the starting gates. Even years after being relieved of their duties of public benefaction, magistrates would continue to favor individual charioteers and often maintained strong ties to their magicians (Lib. *Or.* 35.13–14).

Because Roman law punished magic with the utmost severity, circus magic, and especially the nocturnal burial of curse tablets within the circus arena, was risky business indeed. In one witchcraft trial in Antioch a retired charioteer was tried as a magician, while a group of circus employees in charge of opening the starting gates were accused of being his accomplices; a third party, a former teaching assistant of Libanios's and probably a racing fan, seems to have been charged with commissioning the whole operation (Lib. *Or.* 1.161–62). In another case, rumors that a star charioteer had come under a spell quickly led to public outcry across the city (Lib. *Or.* 36.20) and exposed the magician responsible for the binding spell (and its advertising) to lynching even before he could be brought to trial (*Cod. Theod.* 9.16.11). During his stay in Antioch, Valens, who had a dread of magic, issued decrees that resulted in the execution or exile of many innocent men, even philosophers, who were merely suspected of practicing magic related to determining his successor (Amm. Marc. 29.1.5).

For the Christians of Antioch, circus magic, at least according to their bishops and orators, was yet another reason to shun chariot races, which promoted nothing but madness and unrest, and to avoid the hippodrome as a "Satanodrome" (John Chrysostom *PG* 59.567): "Though you ought to spend your entire life in prayers and supplications, you waste your life, fruitlessly and for your damnation, amidst shouting, tumult, base words, and quarreling, in untimely pleasure, and in deeds that are the product of sorcery" (John Chrysostom *PG* 59.321).

1. On curse tablets in general, see Gager 1992.

2. The tablets are normally kept at the Art Museum, Princeton University. They are briefly catalogued in Jordan 1985, 194, no. 167. Five of these tablets have been unrolled and are currently being deciphered by the author and Alexander Hollmann. Anthony Sigel, of the Straus Conservation Center of the Fogg Museum at Harvard University, is providing technical support and studying the tablets' manufacture and conservation. The technical and philological study resulting from this project should be published in the near future.

3. On shopkeepers in Antioch, see Liebeschuetz 1972, 52–61, 222.

4. On phylacteries, see Kotansky 1991, 107–37; and Kotansky 1994.

5. Heintz 1996, 297.

6. On circus magic, see Brown 1970, 25–27; Cameron 1973, 173 n. 3, 245; Cameron 1976, 345; Clerc 1995; Pavis 1987, 447–67; Faraone 1991, 11–13; Gager 1990, 215–28; Gager 1992, 43–77; Graf 1994, 178–81; and Heintz 1998, 337–42.

7. *Expositio totius mundi et gentium*, 32. On the circus at Antioch, see Humphrey 1986, 444–61. On the organization of chariot racing in Antioch, see Liebeschuetz 1972, 146–48; and Petit 1955, 140–41.

8. On circus factions in late antiquity and Byzantium, see Cameron 1976; and Roueché 1993, 143–56.

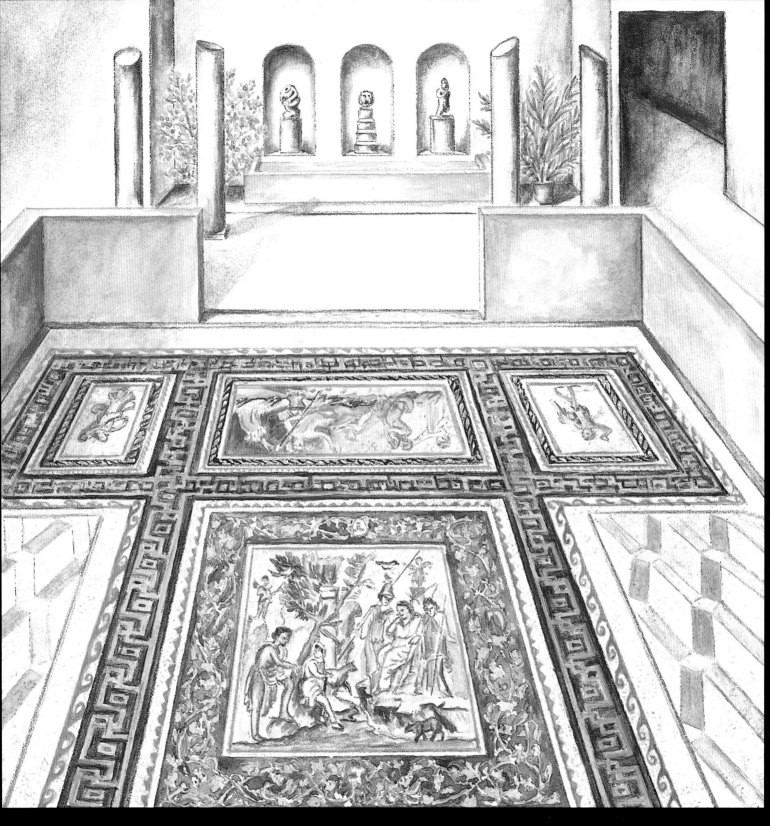

IV The Roman House

This watercolor by Victoria I illustrates the installation for the "Roman House" section of the exhibition. It is a view from within the dining room *(triclinium),* looking out through a porticoed space to a fountain beyond.

Aside from the *triclinium* floor mosaics from the Atrium House at Antioch, reunited for the first time since they were excavated (see p. 62), the installation does not reproduce any particular setting or archaeological find. Rather, it is based on the close observation of several house plans from Antioch in which dining rooms frequently opened onto porticoes that led to open courtyards and pools. Reclined diners thus could enjoy extended views through a columnar curtain into a pseudo-peristyle adorned with garden and fountain. For the exhibition installation, broken columns and potted plants evoke the remains of such a setting. The enclosing walls of the dining room are kept low to allow the museum visitor to view the reassembled mosaics and to evoke a visit to a Roman ruin.

Water appointments, ornamental fountains and basins, were a consistent feature of Antiochene houses. *Nymphaea,* fountains with architectural settings for statuary, were popular in Antioch and often employed in several versions within one house, especially in the house of Menander (see p. 50). *Nymphaea* were usually set against a wall with niches filled with marble statuettes which were placed according to the sight lines of the reclined guests. The exhibit installation as seen in this rendering offers an opportunity to present some of the sculpture finds from Antioch in their most likely context. Roman garden statuary favored the use of animal heads as fountain pieces. For example, water flowed from the fierce mouth of the lion head (cat. no. 64) onto a series of channeled marble steps placed just below, which produced a miniature waterfall. Garden sculptures in the form of plump boys (cat. no. 62), frolicking satyrs and maenads, and bathing Aphrodites captured the fantasy of woodlands and streams.

The sound of falling water, views to an open vista, and high quality works of art created a luxurious setting for leisurely entertainment.

Design of the Atrium House *triclinium* installation for the Antioch exhibition, Worcester Art Museum. View is from within the *triclinium* toward the *nymphaeum* and statues in niches. (watercolor: Victoria I)

55 Mosaic of the Drinking Contest of Herakles and Dionysos

Early second century C.E.
Antioch, Atrium House
Marble, limestone, and glass *tesserae*, 72¼ × 73⅞ × 3 in.
(183.5 × 186.4 × 7.6 cm)
Worcester Art Museum, 1933.36

PUBLISHED: Antioch I 1934, 42–45; Levi 1947, 21–24, pl. Ia; Morey 1938, 28; Campbell 1988, 20–21, pl. 72

This was the first panel that the guests saw upon entering the dining room of the Atrium House (see p. 62). It was originally flanked by two Dionysiac panels, one with a dancing satyr (cat. no. 57), the other with a dancing maenad (cat. no. 56). The scene is of the rarely depicted Drinking Contest between Herakles and Dionysos, which is well suited to the reception function of the room.[1] In the center of the panel is Dionysos, in a light tone of flesh, who turns over his empty cup to show he has won. The triumphant god rests on his elbow propped upon cushions and reclines on a long green cushion (with many, now lost, glass highlights). In contrast, Herakles, depicted in ruddy brownish red tones of flesh, seems tipsy as he leans backwards on his knees, grabs at the drapery around his legs, and lifts the wine cup to his lips. The composition captures the essence of the struggle between mortal and immortal, the elegant repose of the god and the unbalanced human.

At the left side of the scene, in keeping with the flanking panels of Dionysiac celebrants, a young woman plays the double flutes into the ears of Herakles. A young boy, an Eros-type figure, rushes with outstretched hand toward Dionysos as if to point out the winner. A Silenos with white hair and beard sits behind Dionysos and raises his right arm in a triumphant gesture.

The five figures are convincingly arranged from foreground to background within an interior space characterized by graded areas of light and dark *tesserae*. The darkest area, almost all of it black, is in the right background behind the seated Silenos. The lighter areas (white and off-white, pale yellows, and grays) are in the foreground and left side of the panel. An array of drinking vessels, including the krater for mixing wine and water, a ryhton, and several drinking cups, are spread out across the middle foreground where they each cast a shadow. Large sections of glass *tesserae* expand the palette to include red, orange, yellow, and a range of blues and greens (both translucent and opaque). The painterly effects of shadows and spatial recession, not especially well suited to a floor composition, indicate that this mosaic may ultimately derive from a lost painting of an earlier date.

The borders framing the three panels at the entrance to the room are from outside in, a band of wave crest (red on white), a meander (black on yellow), a narrow band of stepped triangles (dark red on white), and a two-strand braid (gray and pink). The multiplication of borders enhances the effect of a framed floor painting.

The meaning of this mosaic within its context and as part of the entire ensemble of figural panels is discussed in the essay on mosaics in this catalogue (see above, pp. 66–71). CK

1. Only three other Drinking Contest mosaics are inventoried in Augé and Linant de Bellefonds 1986, 524, nos. 104–6.

56 Mosaic of Dancing Maenad

Early second century C.E.
Antioch, Atrium House
Marble, limestone, and glass *tesserae*, 74½ × 44 in.
(189.2 × 111.8 cm)
The Baltimore Museum of Art, 33.52.1

PUBLISHED: Antioch I 1934, 42, pl. 5; Levi 1947, 15, 22–24; Campbell 1988, 21, pl. 73

This is one panel of a three-part composition with the Drinking Contest at its center; it was on the right side as one entered the Atrium House dining room. A dancing maenad who plays the cymbals *(cymbalistria)* is a standard type found in the Dionysiac processions reproduced in all media of Roman art. Whirling on her toes on a strip of grey ground, she twists her body to the right while her head turns in toward the central panel. Her light blue chiton and brown mantle swirl in the motion of her dance, adding a graceful animation to the whole ensemble.

The panel is set within a series of frames, from the inside out: a twisted rope of red and light gray strands; stepped red and white triangles; a meander of black on yellow; and a red-and-white wave crest. CK

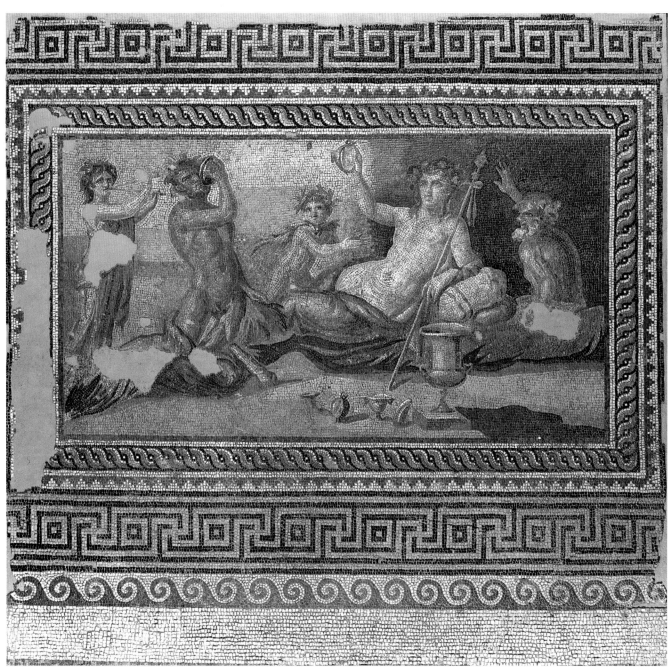

55

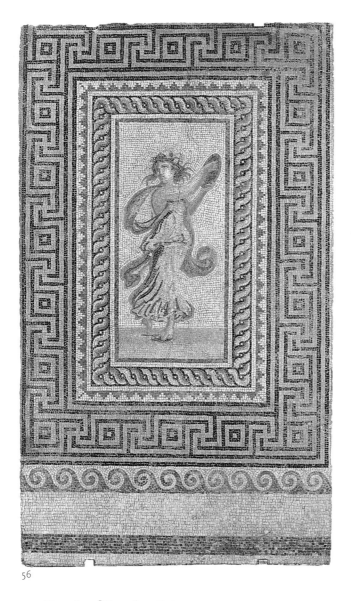

56

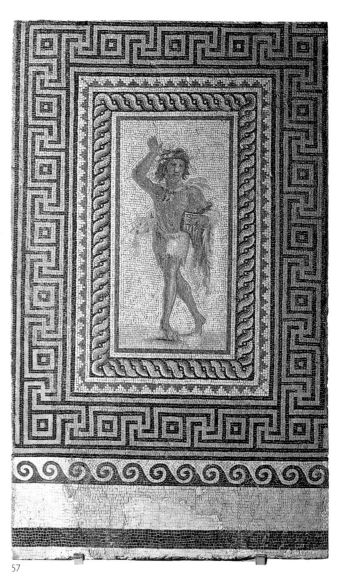

57

57 Mosaic of Dancing Satyr

Early second century C.E.
Antioch, Atrium House
Marble, limestone, and glass *tesserae*, 76 × 54 in. (193 × 137.2 cm)
The Baltimore Museum of Art, 33.52.2

PUBLISHED: Antioch I 1934, 42, pl. 5; Levi 1947, 15, 22; Campbell 1988, 21–22, pl. 74

This panel was on the left side of the Drinking Contest as one entered the Atrium House dining room. The satyr holds the pan pipes in one hand and raises his other hand in the air. In the midst of a dance, he twists his body and stands on his toes on a narrow band of gray ground. He can be identified as a Dionysiac follower by the skin wrapped about his hips *(nebris)*, the spotted skin tied around his neck, and his vine wreath.

The panel is set within a series of frames, from the inside out: a twisted rope of red and light gray strands; stepped red and white triangles; a meander of black on yellow; and a red-and-white wave crest. CK

58 Mosaic of the Judgment of Paris

Early second century C.E.
Antioch, Atrium House
Marble, limestone, and glass *tesserae*, 73¼ × 73¼ in.
(186.1 × 186.1 cm)
Musée du Louvre, Paris, Ma 3443

PUBLISHED (selected): Antioch I 1934, 42–49; Morey 1938, 28–29, pl. 1; Levi 1947, 16–21; Baratte 1978, 87–92; Campbell 1988, 19–20, cat. no. 7i, pl. 70

The Judgment of Paris panel is the most elaborate of the five figural panels that formed the T-shaped composition of the dining room in the Atrium House (see p. 62). It was oriented towards the rear of the room, just as the Aphrodite and Adonis (cat. no. 59) panel, so that diners reclined on the couches could view the panel. This was clearly intended to be the highlight of the ensemble because it is situated at the center of the room.

The scene illustrates the mythic origins of the Trojan War when Paris is called upon by Zeus to give the Golden Apple of

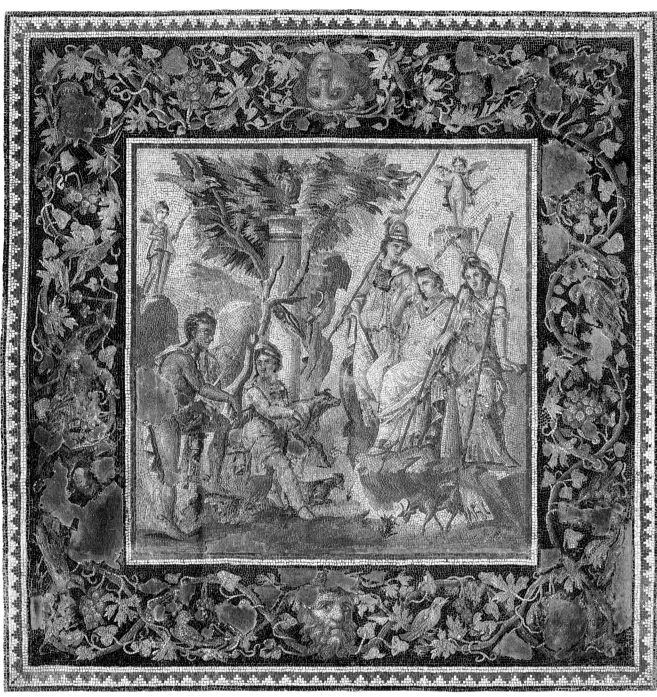

58

Discord to the most beautiful of the three goddesses who claimed the title. Although he is tempted by the seductions of Hera and Athena, he chooses Aphrodite, who offers him the most beautiful mortal, Helen. Five large figures are comfortably arranged in a lush sylvan landscape. To the right are Athena and Aphrodite who stand on either side of the enthroned Hera. The goddesses are elevated upon a rocky hill, while below them is the youth Paris, dressed in Phrygian garb, watching over a flock of oxen, sheep, and goats. He turns to confer with Hermes who stands in a relaxed pose in the left foreground. A winged Psyche with her lighted torch stands high on a rock behind Hermes. She looks across to the right side of the panel at a winged Eros perched even higher on a pedestal. At the center to the left is a large leafy green tree in front of which stands a column with a golden vase. Glass *tesserae* are used generously for green, yellow, and blue highlights. The dress worn by Aphrodite is filled with blue glass *tesserae* and may be seen to distinguish her as the winner.

Elements, such as the large central tree, tall pillar-altar, statues of Eros and Psyche on pedestals, and the flock drinking water from a rocky pool, produce the effect of a sacro-idyllic landscape painting so well-known in Campanian painting of the earlier century. There are at least half a dozen extant examples of the scene preserved in Pompeian murals, but only two others in mosaic.[1] The artistic style of the Atrium House panels was characterized as "impressionistic" by Doro Levi who noted that the compositions were filled with coloristic effects and the plays of light and shade found in Fourth Style Pompeian painting.

The painterly effects and rich glass highlights (green, blue, yellow, orange, red) are extended into the border, where a vine garland laden with grapes and other fruit is set against a black ground. Entwined in the leafy border are a mask of a bearded male at the bottom, and one of a female at the top. All manner of creatures, including a chameleon and a cricket, perch and play in the vines; birds rest on tendrils and peck at grapes.

The meaning of this mosaic within its context and as part of the entire ensemble of figural panels is discussed in the essay on mosaics (see above, pp. 66–71). CK

1. One example was found at Kos and dates to the third century; there it is framed by Apollo and the Muses and surrounded by gladiatorial scenes (see Kondoleon 1995, 282–85). The other example is of a later date and from Casariche, Spain (see Lancha 1997, pl. 94, nr. 101).

59 Mosaic of Aphrodite and Adonis

Early second century C.E.
Antioch, Atrium House
Marble, limestone, and glass *tesserae*, 63 × 74⅞ in. (160 × 190.2 cm)
The Art Museum, Princeton University, 40.156

60 Border Fragment, Aphrodite and Adonis Mosaic

Early second century C.E.
Antioch, Atrium House
Marble, limestone, and glass *tesserae*, 28 × 73 in. (71.1 × 185.4 cm)
Wellesley College Museum, Wellesley, Massachusetts, 1933.10

PUBLISHED: Antioch I 1934, 42, 47–48, fig. 9; Levi 1947, 24–25, pl. 2a; Campbell 1988, 20, pl. 71

This panel was situated at the rear of the room, where it faced the diners reclined on the middle couch of the *triclinium*, or dining room with three couches. Unfortunately, the upper portion of the panel was destroyed when it was covered by a later wall; the uppermost portion of the mosaic is preserved as a fragment at the Wellesley College Museum (cat. no. 60).[1] The panel was framed by the same inhabited vine scroll against a black ground that is described for the Judgment of Paris mosaic (cat. no. 58).

A large, draped female figure is seated on a throne to the left; she wears a white chiton and a yellow himation, as well as a purple veil, which she gathers in her right hand. At her side is a seated nude male figure with one leg extended holding a long

Fig. 1. Detail of a drawing taken from the Vatican sarcophagus

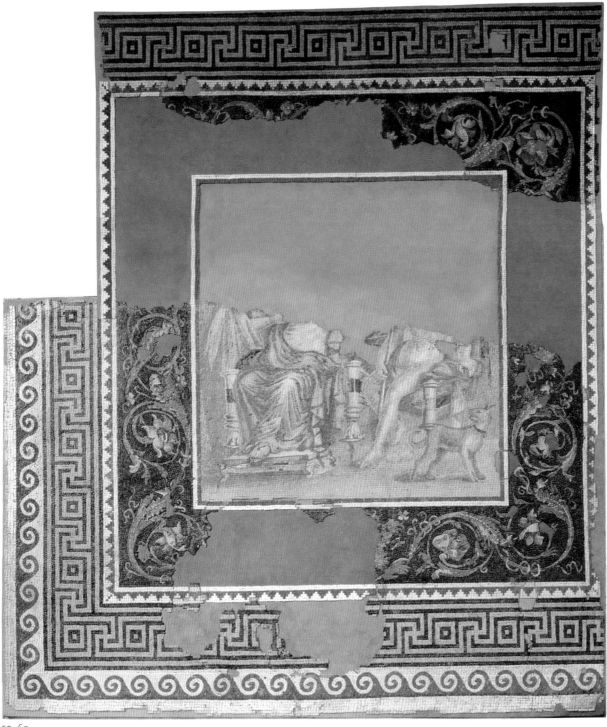

59–60

spear. The presence of a dog and the spear identifies him as a heroic hunter type. The closest comparisons for the composition are found on sarcophagus reliefs illustrating the myth of Adonis, the handsome youth beloved of Aphrodite who was fatally wounded by a boar (see fig. 1).[2] As on the sarcophagi, to the far left of the mosaic can be seen part of a curtain, which typically indicates an interior space. The pair of lovers is represented at a moment of languid repose before Adonis departs for the hunt.

The mosaic is treated as part of the ensemble of five myth panels in the essay on the mosaics (see above, pp. 66–71). CK

1. Antioch I 1934, 47.
2. Especially an early-third-century example in the Vatican (see Koortbojian 1995, 50–53, fig. 7).

61

61 Thorn-puller

Second century C.E.
Daphne, Yakto Complex (DH 17/18)
Marble, 17 × 11 in. (43.2 × 27.9 cm)
The Baltimore Museum of Art, 37.124

PUBLISHED: Antioch II 1938, 170, no. 104; Hill 1981, 92, fig. 14

This marble statuette belongs to a series of copies of a Hellenistic genre sculpture known as the "thorn-puller" *(spinario)*. A nude young man seated on a rock with an overturned jug at his right side attempts to extract a thorn from his left foot. The missing head was originally attached with a dowel. The thorn-puller is usually presented as a young boy, but in the Antioch example he is a full-bodied rustic.[1] The sculpture functioned as a fountain by the use of a jug pierced to allow water to run constantly from the mouth.

Inspired by the arrangement of Pompeian statuary in garden fountains, the Baltimore thorn-puller was placed in the left niche of a reconstructed *nymphaeum* in the exhibition installation (see p. 168). In a similar vein—that is, of playful genre imagery—is an inebriated Silenos from the garden of the House of Marcus Lucretius at Pompeii; the figure holds the neck of a wineskin that opens as the spout for a fountain.[2] CK

1. See the Cornelius Vermeule essay herein for a discussion of this sculptural interpretation.
2. See Dwyer 1982, 47, fig. 51; and the statuette from the House of Fortuna of a Silenos astride a wineskin that spouts water (ibid., 77, fig. 116).

62 Statue of a Young Boy

Second century C.E.
Daphne, House of Menander
Marble, height (as fragment) 20⅛ in. (51.1 cm)
Worcester Art Museum, 1940.9

PUBLISHED: Antioch III 1941, 120, no. 288, pl. 4; Mango 1986, 272, no. 99, fig. 99.1

The statuette represents a young boy as evidenced by his plump facial features and his pot belly. His hair is gathered in a knot at the top and falls in heavy locks down to the end of his neck. His right hand grasps the handle of an object that was held over his left shoulder. His head is turned up and toward his right side and he has a dreamy and pleasant expression. His left arm, left leg, and the lower half of his right leg have broken off.

The knot of hair at the top of the boy's head led to his tentative identification as Harpocrates, the child Horus who was worshipped with his parents Isis and Osiris. However, the absence of the lotus from his hair and the long side lock of hair required for young devotees of the Egyptian cults, as well as the lack of Harpocrates' signature gesture, namely the holding of the right hand to his lips, undermine this suggestion. The Worcester torso of a nude boy who stands with right hand on the left shoulder is very close to the "Boy with Jumping Weights," a series of Roman copies based on a late Hellenistic original of a child attendant to an athlete.[1] While it is true that the end of the object held by the Worcester boy does not correspond to the shape of jumping weights, the pose and treatment of the body connect it to this series and more broadly with portrayals of youths derived from Hellenistic art.

The Worcester statuette was discovered in the cache of statuary found in the foundations of a late pool in the House of Menander at Daphne. The find included twelve other fragments of small-scale marble sculpture, including Dionysos (cat. no. 63), Hygeia, Tyche, and a sleeping shepherd boy, which were probably displayed in the niches of the three *nymphaea* located in rooms 1, 13, and 17 of this house (see p. 50). The context of the find and the subject strongly indicate that the boy belongs to the repertory of charming small statues that were popular for the adornment of Roman private houses. The gardens of Pompeii were filled with such boys who, originally based on Hellenistic Eros types, become in the hands of Roman sculptors toddlers playing with geese, wrestling with and riding on a variety of animals. The sleeping shepherd boy found with the Worcester boy was in fact used as a fountain device. These figures were meant to entertain and set a relaxing tone amidst the colorful mosaics and sounds of the decorative pools. CK

1. See Herrmann 1993 for the identification of the type and its extant replicas.

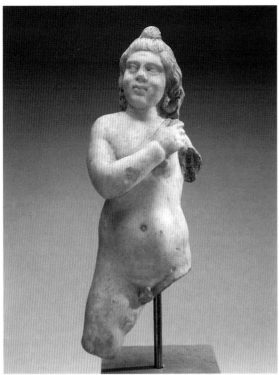

62

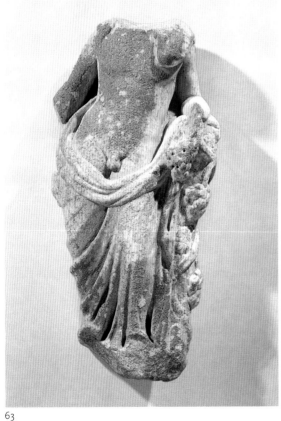

63

63 Dionysos

Second century C.E.
House of Menander, Daphne
Marble, height 18½ in. (47 cm)
Worcester Art Museum, 1940.10

PUBLISHED: Antioch III 1941, 120, no. 290, pl. 3.

This headless statuette represents the god Dionysos half-draped and leaning on a trunk entwined with vines and grape clusters. Appropriately, the god of wine holds a bunch of grapes in his left hand; the attachment for the object in his right hand, probably a drinking cup or *kantharos*, is partially preserved. The drapery covers his lower body and wraps around his back and falls over his left shoulder. There is a trace of his long locks on the right shoulder. Both his hands and his feet are broken off. The head seems to have been attached with a dowel. The piece is discolored with incrustations on the front because it was oriented face up during burial, so that precipitation of calcarious material occurred predominantly on this surface. There are remains of a lime-based white ground layer over the whole piece, as well as isolated traces of iron-red pigment.

The type of the leaning Dionysos belongs to a popular series reproduced by Roman sculptors for household decoration from a Hellenistic original attributed to Praxiteles. Among the many copies, a torso in the Hermitage Museum and one in the Corinth Museum are especially close to the Worcester Dionysos.[1]

The Worcester Dionysos was found buried in the foundations of a late pool with twelve other fragments of sculpture in the House of Menander at Daphne. The other pieces in the cache include fragments of male and female statuettes that might have represented satyrs, maenads, and perhaps a Silenos and a Priapos.[2] This find of statuary corresponds to the ensembles of domestic sculpture in Campanian houses which include Dionysiac themes. For example, among the sculptures found in the garden of the House of Marcus Lucretius are a striding satyr, several Dionysiac/Bacchic herms, and a Silenos.[3] Probably, this statuette of Dionysos adorned one of the niches in the *nymphaea* of the House of Menander (see p. 50). CK

1. For these two examples, see Gasparri 1986, 436, nos. 126b and 126c respectively, and for a listing of the others in the series, *ibid.*, 434–37, nos. 117–28.
2. For the list of fragments with some suggested identifications, see Antioch III 1941, 119–21, nos. 285–97.
3. See Dwyer 1982, 38–48, for an inventory of finds in the garden.

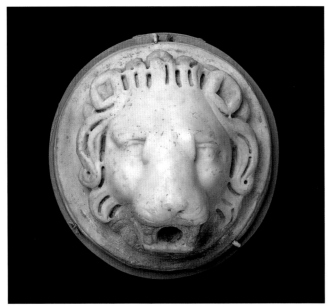

64

65

64 Lion Head Waterspout

C. 200 C.E.

Marble, height 8½ in. (21.6 cm)

The Art Museum, Rhode Island School of Design, Providence, 14.039

Reportedly from Antioch

PUBLISHED: Ridgway 1972, 224–26, no. 45

The fountain spout is in the shape of a marble disk with the face of a lion carved in relief. The water would have flowed through the open mouth of the lion. The back is hollowed out into a funnel shape for the lead pipe, now lost, that conducted the water. Such spouts were designed to fit flush into the wall of a basin and were affixed with cement.

Lion heads were used as gutter spouts on the roofs of late Archaic buildings and continue to be a favorite device for water technology throughout antiquity. In fact, terracotta gutter spouts were found in Pompeii decorated with the foreparts of lions and other beasts.[1] Perhaps this was how their open mouths came to be appreciated as well suited to convey water to or from an ornamental pool. Marble waterspouts became common in the Hellenistic period for public buildings, and by the Roman period were used in private houses. The fashion for dramatic water displays is clear in a letter of Sidonius Apollinaris (*Epist.* II, 2,8) of the fifth century who refers to a pool with six water outlets in the shape of lions' heads. Representations of similar fountains occur in Campanian paintings. For example, a fresco from the House of Diomedes, Pompeii, illustrates a side wall of a fictive *nymphaeum* with a row of lions' heads issuing water into a collective water basin.

The random finds of such devices, both in marble and bronze, can only hint at the animated embellishments of domestic gardens and their widespread popularity. Although from Antioch, the plastic modelling and frontality of the Providence piece parallel fountainheads from other parts of the Mediterranean, for example one in the form of Oceanus found in Pompeii.[2] The use of struts in between the deeply undercut locks of hair in the mane suggests a date in the late second or early third centuries. CK

1. For example, the corner roof tile that ends in a spout in the shape of the forepart of a lion from the house of C. Iulius Polybius, Pompeii IX, 13, 1.3, Ciarallo and De Carolis 1999, 175, no. 200. See also the gutter in the form of a Molossian hound at the Art Museum, Princeton University, y1989-51.
2. New York 1990, 263, no. 184, ill.

65 Marble Revetment Panel

C. 450–500 C.E.

Daphne, House of Menander

Marble, 25¾ × 27⅝ in. (65.4 × 70.2 cm)

The Baltimore Museum of Art, 1940.170A

PUBLISHED: Antioch III 1941, 169–70; Weitzmann 1979, 667–68, no. 594; Strube 1983, 79–81, pl. 18c; Mango 1986, 272–73, no. 100

The decoration of a well-appointed Antiochene house would have included a quantity of architectural sculpture, the most luxurious versions of which were made in imported marble. Unlike the wealth of the finds of floor mosaics, most of the

architectural sculpture did not survive the many disasters that befell the city. This fragmentary marble was found in the House of Menander, one of the largest houses excavated in Daphne (see p. 50), in a somewhat confusing archaeological context. According to its excavator, William Campbell, the slab "may have formed the parapet decoration of a fountain" next to which it was found.[1] It is likely that the slab was first intended as a revetment panel since it is carved only on one side, while the other side is flat and plain, and the upper ledge is rough and has a hole for a wall clamp.

The main field, which originally extended to several rows of acanthus stems in a staggered arrangement, now only consists of two registers. Each stem issues from calyxes (only the top row has complete elements) and is wrapped by leaves that extend into three pairs of leafy volutes, the lower pair curling out, the two upper ones curling in. The leaves of the lower row of stems project outward in the manner characteristic of Corinthian capitals. The overall effect is that of continuous movement of turns and counterturns. The panel is framed at the top by two bands, the lower one composed of a continuous scroll of acanthus leaves with drilled outlines like the main field; and the top one of a plain scroll interrupted by pairs of projecting volutes. The appearance of the slab, with its continuous covering of acanthus-leaf motif, only barely acknowledges the organic nature of the design element. In this respect, it corresponds to the treatment of similar motifs in the architectural sculpture of the late fifth and early sixth centuries. It is executed in the early Byzantine technique of drilling out the outlines of the design which produces an openwork, lace-like appearance.

Decorated slabs similar to this one are known from both secular and ecclesiastical contexts. Because of the shortage of comparable sculptural material from Antioch proper, it is hard to determine whether the slab was made in Antioch or whether it was imported. The closest comparisons are from sixth century church decorations in Northern Syria.[2] The use of local limestone and sandstone in these sites, however, required a different handling of the stone, so that the openwork effects of the Antioch panel are difficult to match in the region. The Antioch slab demonstrates that styles of architectural sculpture kept up with the design trends known from other parts of the empire, especially in the East. AG

1. Antioch III 1941, 170.
2. Strube 1983, esp. 75–103.

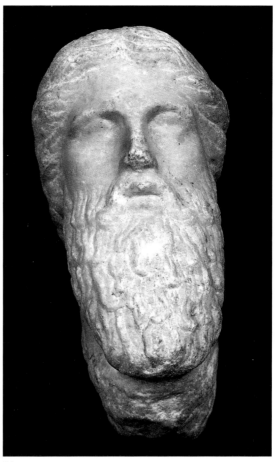

66

66 Bearded Male Head (Dionysos?)

Second century C.E.
Found at Antioch
White marble, $4 \times 2\frac{1}{2}$ in. (10.2 × 6.4 cm)
The Baltimore Museum of Art, 1938.715

PUBLISHED: Antioch III 1941, 118, no. 257

The miniature male head is characterized by an expressionless frontal gaze, wavy hair, a pronounced long beard that reaches past the neckline, and a moustache with turned-up ends. The hair is gathered in a wavy roll on each side of the part down the middle of the crown and bound by a fillet. There is some damage to the nose area.

While not identical, this head can be associated with the same series of herm types as the black stone head from Antioch (cat. no. 67). Whether they represent Dionysos or Hermes is difficult to determine, but both heads seem to derive from the Hermes Propylaios of Alkamenes, of about 430 to 420 B.C.E. Both are marked by an archaizing style, especially the regularized linear treatment of the hair and beard. Like its darker counterpart, this head was undoubtedly part of the sculpture inventory of an Antiochene house, perhaps occupying a niche or mounted on a pillar. CK

67 Bearded Male Head (Dionysos?)

Second century C.E.
Found at Antioch, apart from the excavations
Black stone, height 6 in. (15.2 cm)
The Baltimore Museum of Art, 1937.125

PUBLISHED: Antioch II 1938, 178, no. 232, pl. 22

The upper part of the face above the left eye and most of the top of the head are missing, but enough remains to associate the head with a well-known series. The severity and symmetry of his countenance, the sleepy eyes, and the regular linear markings of the long beard and moustache, with ends turned up, are matched by the bearded male heads found on several double-headed herms. The combination of a young beardless head joined at the back to an older bearded one was a favorite conceit of the Roman imperial period. These heads have been identified as either Dionysos or Hermes, but a degree of uncertainty remains. The iconographic confusion is due in part to the fact that one type, similar to the Antioch head, seems to be a free Roman invention that combines a prototype from the late fifth century B.C.E., namely, the Hermes Propylaios of Alkamenes, with a Dionysos identified with the workshop of Praxiteles.[1] The massing of his wavy hair on the extant right side suggests that he wore a fillet; some sort of turban may also be indicated.

The finishing at the back suggests that the Antioch head was not joined to another head. The highly polished black surface recalls the darkened appearance of bronze herms found in Campanian domestic settings; it closely recalls the earlier Mahdia and Getty Dionysiac bronze herms.[2] Similar types of double-headed herms and single herms were mounted on marble pillars in Pompeian gardens, such as that of Marcus Lucretius.[3] The miniature scale of the Antioch head suggests its use as a table or garden ornament. CK

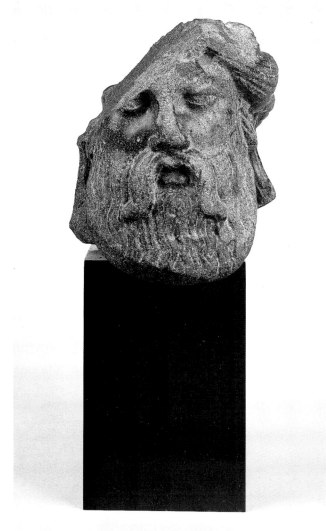

67

1. Waldhauer 1928, 70 n. 3.
2. For the Mahdia and Getty herms, see Mattusch 1994, 796–97, figs. 8–9. Perhaps the black marble head in the Hermitage Collections also attempts to imitate the darkened bronze herms (see Waldhauer 1928, 70, no. 55, pl. 33, which dates the herm by its style to the Antonine period).
3. See Dwyer 1982, 43–44, figs. 36–38 and 39–41, which describes two herms of Bacchus among the contents of the house; and New York 1990, 264, no. 186.

Dining as a Fine Art:
Tablewares of the Ancient Romans

Sandra Knudsen

When a wealthy citizen of Antioch dined, the possibilities were as luxurious as the city's reputation. Not only what was available to eat but also how it was prepared, how it was served, and the vessels and implements used for its presentation were important pleasures of daily life.[1] Opportunities to flaunt wealth and sophistication through house architecture and the furniture of dining are discussed elsewhere in this catalogue; my comments will focus on the silver and glass vessels that enriched the experience. The large quantity of tablewares surviving from the Roman Empire includes an impressive variety of serving and personal vessels and utensils ranging in materials from gold to clay and from utilitarian to preposterously sophisticated. The concept is not foreign: etiquette guides today advise on the placement and use of flatware. The formalities could be much more complex, and more of a barrier between classes, a century ago, when a banquet silver service might include thirty or more different personal table utensils, from spoons for clear soups to knives for hard cheeses.

Remove Your Shoes

Dining was an important part of the day. Although Antioch was a city of the Greek East, the inhabitants early adopted Roman imperial fashions for dining with guests in a special room, the *triclinium,* usually built with a view of a garden, slightly away from the entrance and public areas of the house. Three couches, each large enough for up to three diners, were arranged close together around three sides of a table. The fourth side, facing the view, remained open for serving the meal. Most of the couches illustrated or excavated have the edge nearest the table slightly raised. The couch was ascended by guests on the lower side, the gap between the table and the couches being too narrow. Guests rested with the left arm on cushions, using the right hand to eat. Precedence determined where guests reclined. The guest of honor was seated at the left side of the middle couch *(lectus medius),* and closest to him was the host, on the left couch *(lectus imus).* Other guests sat at the right *(lectus summus).*

In later antiquity, after the beginning of the third century, aristocratic houses in the provinces began to be designed to accommodate the *stibadium,* a semicircular dining couch, and the *sigma,* a semicircular table. The position of the guest of honor was at the right corner *(in cornu dextro).*[2] The mosaic of an outdoor banquet (cat. no. 68) represents lounging on the *stibadium* out-of-doors under canopies, which may have been

the origin of this alternative form of couch. The room set aside for formal dining was approached through an entrance made as impressive as possible, including wall paintings and floor mosaics oriented so as to be seen from the door. Serving tables were set up in the front third of the room, displaying the food to be enjoyed and the owner's silver service.[3] Writing about the Romanized lifestyle of the Ostrogoth king Theodoric II (453–66 C.E.), the Gallo-Roman aristocrat Sidonius used the king's manner of dining as a metaphor for his old-fashioned Roman unpretentiousness; what is *not* offered in the way of food, entertainment, or tablewares is presented as virtue: "When one joins him at dinner (which on all but festival days is just like that of a private household), there is no unpolished conglomeration of discolored old silver set by panting attendants on sagging tables; the weightiest thing on these occasions is the conversation. . . . The viands attract by their skillful cookery, not by their costliness, the platters by their brightness, not by their weight" (Sid. Apoll. *Epist.* 1.2, to Agricola).[4] The middle third of the room was left clear for food service and the entertainment that followed. The back third of the room was filled by the *stibadium* and the *sigma*-shaped table, large furniture that could not be rearranged for other daily uses. Couch and table were illuminated by a chandelier *(polycandelon)* suspended overhead. The semicircular shape created a tighter, perhaps more intimate arrangement for the diners than the *triclinium*; where the positions of the diners are marked on mosaics, they show that each diner had only 50 to 75 centimeters of space next to the table.[5] The table was at most a meter in diameter; large late-antique silver plates nearly filled the center of the table (cat. no. 72), leaving room only for very small individual dishes.[6]

Many Servants

It was servants, usually slaves, who made the lavish but intimate dining experiences of the *triclinium* and the *stibadium* possible.[7] First the guests' shoes were removed, their hands were washed by water ceremoniously poured over them from special ewers into basins, perfumed oils were anointed on their hair, and wreaths of fragrant flowers and herbs were tied on their heads. Food was prepared and brought to the table ready to eat, requiring little more than fingers or tiny spoons as implements. Many dishes were presented, the food divided into individual portions and replaced as soon as each diner had consumed his morsels.

The emperor Lucius Verus, in banquets he gave as he lingered in Antioch for several years while conducting the war against the Parthians in the 160s, is credited with taking the banquet to new heights of luxury:

Verus' most notorious banquet is said to have been one at which couches were set for twelve—for the first time, it is said—although

there is a very well-known saying about numbers of diners that "seven make a dinner, but nine make a din." Moreover, the handsome boys who were serving were presented one each to the guests, and carving-servants and dishes were given, one to each as well, and live animals, either tame or wild, birds or quadrupeds, the same kind as the meats which had been served. Cups were presented too, one to each guest for each drink, of fluorspar or of Alexandrian crystal, as often as they drank; gold and silver and jeweled goblets were also given. . . . Even carriages were given, with mules and muleteers, and with silver mountings, so that the guests might return from the banquet with them.[8]

From Eggs to Apples

Food was seasonal, although the rich frequently imported delicacies preserved in snow, honey, clay, or brine. After wheat, the most important foodstuffs traded all around the Mediterranean Sea were olive oil, wine, and *garum* (fermented fish sauce). The produce of some areas—Falernian wine, Numidian oil, Campanian *garum*, Black Sea smoked fish, British oysters—was particularly savored and fetched high prices. In addition to its envied location at the nexus of the spice roads, Antioch's multinational population, with its many traditional foods and cooking styles, stimulated its people's taste buds. The city was also blessed by immense neighboring marshes teaming with freshwater fish and migratory birds, all of which were appreciatively represented in mosaic.

The ancient Greeks and Romans were famous for gourmet (and gourmand) dishes. Some of the most admired recipes masqueraded as what they were not, such as turnip slices soaked in *garum* presented as anchovies, and dramatically roasted beasts were stuffed with unusual plants, sausages, or live birds (Petron. *Sat.* 49). Cookbooks were best-sellers; more than twenty survive, most only as excerpts except for one, *De re coquinaria*, by a man named Apicius, probably a professional cook who lived in the fourth century C.E.

An early-third-century mosaic from the House of the Buffet Supper in Daphne represents a luxurious meal for discerning guests (fig. 1). The mosaic was designed to be surrounded by a *stibadium*.[9] In the center, facing the diners, is a medallion of Ganymede serving wine to Zeus in his eagle shape. This convivial image would have been obscured by the table, but it was doubtless visible after the meal, when the table was removed so that serious drinking and entertainment could begin. Encircling the Ganymede scene are the courses of a splendid meal set out on a trompe l'oeil *sigma*-shaped table. These dishes would have been served in sequence rather than grazed as in a modern buffet. Starting from the upper right corner, the place of the host, the courses are laid out on silver platters, whose blue and gray tints reveal the Roman preference for tarnished silver. First a silver *trulla* for washing hands and a pink (rose?) flower wreath for a diner to don face the arriving guests. Next a round

tray with the first course: eggs, of course, in this case boiled and presented in silver eggcups, with cold pickled pigs' feet and artichokes, served with small spoons with pointed handles and a bowl of red sauce. Then a rectangular tray with elaborate handles (*lanx*) holding the second course, a whole poached fish served with round rolls of bread. Next a round tray with a beaded rim bearing the third course, a leg of pink ham. The next objects that are decipherable are another pink floral wreath and the side of a large silver two-handled goblet; the goblet is in the elegant style of first-century silver and glass vessels, suggesting that this mosaic may copy an earlier painting of a banquet buffet. Proceeding past a damaged section, we come to a round platter with a whole roast fowl (perhaps the peafowl that the boys in the adjacent mosaic are force-feeding), two more round loaves, and what seem to be shellfish next to another floral wreath overlapping the table edge. In the upper left the final course is served in a large transparent bowl, perhaps of glass, on a large silver plate; the contents may be fruit, the traditional close to a Roman meal. The final items in the corner are another *trulla* and another floral wreath.

Silver Plate

The importance of silver plate in the later Roman Empire cannot be overstated. Weight mattered more than anything; descriptions in letters, wills, and votive inscriptions mention weight as well as design. A complete set of silver plate for use in the home was called a *ministerium*. It was subdivided into silver for eating, *argentum escarium*, and silver for drinking, *argentum potorium*. Most of the recovered large groups of silver seem to have been hoards concealed during times of trouble and never reclaimed.[10]

Argentum escarium, tablewares, were made in sets. Propriety recommended that dinner guests number nine (as mentioned above, the number was increased to twelve in the mid-second century). Thus, in addition to trays and plates for presenting food (fig. 1) and assorted serving and condiment vessels, matching sets of nine eggcups, nine rectangular plates, nine bowls, and so on, have been identified. *Argentum potorium* included mixing bowls, ewers, ladles, spoons, containers for flavorings, small plates on which to set food, and cups of various shapes. In the Drinking Contest mosaic from the Atrium House at Antioch, Herakles quaffs heroically from a horn-shaped rhyton (*cornu*), which cannot be set down until it is drained (cat. no. 55). Dionysos calmly gestures with a two-handled *kantharos*, a shape associated with him from at least the sixth century B.C.E.

The Roman passion for ceremonious dining extended to dining at the tomb and to the celebration of the Christian Eucharist. Funeral meals were important family and public occasions. Chairs, benches, and couches could be brought to the tomb; often they were part of the tomb. At Pompeii, the first-century C.E. tomb of the young aedile C. Vestorius Priscus

Fig. 1. Plate of appetizers arranged on large silver tray with two artichokes, two boiled eggs in their cups, two pigs' feet. A rose garland is set above to perfume the table. Detail from dining room mosaic, House of the Buffet Supper, Daphne, third century. Hatay Archaeological Museum, Antakya, inv. 937

includes masonry couches on which comfortable cushions could be arranged and a wall painting of a funerary banquet at which at least five people recline on a *sigma*. There is also a painting of a side table covered with a generous silver drinking service of cups, ladles, and vessels for mixing and pouring.[11] Similarly, the Funerary Banquet mosaic from the necropolis in Antioch (cat. no. 9) shows a group of women dining in commemoration of the deceased. In the fifth century, Saint Pancratius listed the basic items for furnishing a church as two sets of silver *diskopoteria* (the chalice and paten used to serve the wine and bread of the Eucharist), two wooden processional crosses, and the holy scriptures. Even small village churches

received gifts and bequests of valuable chalices, patens, ewers, amphorae, bowls, boxes, flasks, ladles, strainers, and spoons (cat. nos. 101–3). They also received lamps and other lighting equipment, such as chandeliers and candlesticks.

Glasswares

It has been proposed, sometimes seriously, sometimes almost facetiously, that in antiquity there was a "hierarchy of materials . . . central to the conduct of civilized life,"[12] with precious stones at the top, followed by metals (gold, silver, bronze, lead); glass and ceramics were at the bottom, considered cheap substi-

tutes for the truly desirable materials that only the royal or the rich could afford. In fact, there is no doubt that ancient craftsmen copied luxurious items in less costly materials, and vice versa.

By the first century C.E., thanks to the invention of glassblowing, glass cups and vessels were as inexpensive as traditional vessels made of ceramic, wood, or leather. "At Rome a bowl or drinking cup may be purchased for a copper coin," wrote Strabo (*Geographia* 16.2.25). Glass had the immense advantage of not changing the taste of food and drink. In fact, the fictional host Trimalchio sheepishly tells his guests that he prefers cheap glass vessels to bronze: "It doesn't stink like bronze, and if it weren't so breakable, I'd prefer it to gold. Besides its's cheap as cheap" (Petron. *Sat.* 50).

Throughout the first century the new technique of glassblowing existed side by side with the centuries-old but declining luxury glass industry.[13] Brightly colored small bottles and pitchers to hold cosmetics were made using core-forming techniques. Casting, grinding, and wheel-cutting produced luxury tablewares, some decolorized to resemble rock crystal (cat. no. 77), others colored to look like semiprecious stones, or mosaic wares made by fusing glass canes.[14] Free blowing was used to imitate popular forms of silver tablewares (cat. no. 78). Because glass could be shaped by blowing it into decorated molds, the production of shapes with designs like those on contemporary relief-decorated ceramic and metalwares was also possible. Molds could be used over and over since a model could be used to create any number of molds to make identical cups or vessels. The shapes of vessels reveal that glassworkers responded to local customers' desires.[15] Although blowing glass vessels in fullsize decorated molds was an efficient method of mass production (see cat. nos. 79, 80), the technique was fashionable for only a generation. Pliny the Elder provides one possible expla-

nation: "There is a story that in the reign of Tiberius [14–37 C.E.] there was invented a method of blending glass so as to render it flexible. The artist's workshop was completely destroyed for fear that the value of metals such as copper, silver and gold would otherwise be lowered" (*HN* 36.46.195–97).[16]

1. I am greatly indebted to Kurt T. Luckner, my deeply admired predecessor as curator of ancient art at the Toledo Museum and the inspiration for the 1977 exhibition *Silver for the Gods: 800 Years of Greek and Roman Silver.*
2. Dunbabin 1991, 135.
3. Ellis 1997a, 41–51.
4. Sidonius Apollinaris 1936–65, 2:341.
5. Ellis 1997a, 49.
6. Mango and Bennett 1994, 58.
7. D'Arms 1991.
8. *Scriptores Historiae Augustae: Lucius Verus* 5.2–5. The translation is from Birley 1976, 142.
9. Hatay Archaeological Museum, Antakya, inv. no. 937; Levi 1947, 127–41, pls. 23a–b, 24, 152, 153a.
10. Kent and Painter 1977, 53; Micheli 1991; Stefanelli 1991; Strong 1966. The Hildesheim Treasure, now in the Berlin Antikensammlung, includes sets of three of many shapes, prompting the suggestion that the original booty was divided into thirds by its captors (Gertrud Platz, conversation with author, Berlin, January 1999).
11. Dentzer 1962, 542–47; Stefanelli 1991, fig. 1.
12. Vickers 1996, 48–65, quotation on 48. Stern 1997, 196–206, refutes the prestige of rock crystal as recorded by Pliny the Elder.
13. Harden 1987, 15–52 (cast and polished glass), 151–77 (mold-blown glass); Grose 1989; Stern 1995; Whitehouse 1988.
14. Grose 1989.
15. Price 1991, 56–75; Stern 1995.
16. Petronius 1959, 10:15. Petronius puts an exaggeration of this anecdote in the mouth of Trimalchio (*Sat.* 51). For the technology, see Stern 1995, 95–96.

68 Mosaic of an Outdoor Banquet

Fourth century C.E.
Italy
Marble and glass *tesserae* backed by original terracotta mount, 23 × 22⅞ in. (58.4 × 58.1 cm)
The Detroit Institute of Arts. Purchased with funds from the Sarah Bacon Hill Fund, 54.492

Reportedly found in Ostia

This little-known, previously unpublished mosaic of an outdoor banquet is exceptional for both its technique and its

theme. The size, the terracotta mount, and the black dentil border connect it to a group of mosaic *emblemata* prepared as independent panels in workshops, where they were set into portable terracotta trays. This small group of *emblemata* were mostly found out of context, but evidence suggests that they were probably made for walls rather than floors.[1] The Detroit panel is said to have been found in Ostia with another panel representing a fishing and offering scene.[2]

The panel is divided into three registers, with the diners in the middle ground below a canopy stretched between two trees; in the upper left corner, the farthest zone, is a tower with tur-

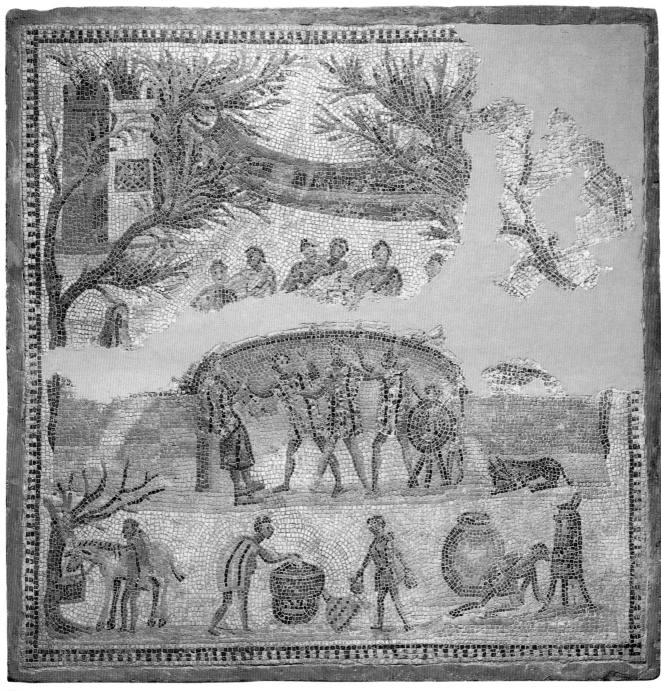

68

rets and latticed window, and in the foreground, or lowest register, are three servants involved in the preparation of food and drink and one tending to a tethered horse who feeds from a bag in the tree at the left. At least six diners—we cannot be sure of the number because the panel is damaged most in the central zone—recline on a curved couch, or *stibadium*, which appears by the alternating yellow and white grid of blocks to be a masonry structure. Similar masonry couches were found in the excavations of the gardens of Pompeii, and it seems probable that the Detroit mosaic represents a permanent outdoor dining area on the grounds of a private villa.[3] The tower in the back-

ground is a feature typical of late Roman villas as represented in several fourth- and fifth-century mosaics.[4]

In terms of dining customs, the Detroit mosaic illustrates several trends. In the fourth century the fashion for dining at curved couches for up to seven guests replaced the earlier three-couch arrangement of *triclinia*. It is likely that in this mosaic the seventh diner was a victim of the damage incurred during shipment to Detroit. The group of entertainers—three dancers, a flutist who also plays a foot organ, and another musician standing by a shieldlike object on a tripod stand(?)—is positioned in the open area marked out by the semicircular couch. To the right of the

performers rests a black dog who appears inured to the rowdy proceedings. The Detroit mosaic offers important material evidence that dinner theater, which could include musicians, dancers, jugglers, and actors, formed part of Roman hospitality. Several texts refer to such entertainments, but there are few artistic representations of them.[5] Also interesting are the depictions of vessels for mixing and heating wine. For example, the tall cylinder set on a three-legged stand in the lower right corner appears to be a vessel employed for the heating of water, which was mixed with the wine according to the tastes of the guests.[6] This interpretation is reinforced by the figure who is on his hands and knees blowing on the flames below the cylinder.[7]

The Detroit mosaic reflects the taste for genre scenes and country life especially popular in the art of the fourth and fifth centuries. That this fashion was widespread is obvious from two outdoor dining scenes produced in the fourth century, an outdoor picnic of a hunting party represented on the fourth-century silver plate from the Sevso Treasure and a roughly contemporary scene in the mosaic from the Villa of Piazza Armerina.[8] The Detroit panel is unusual for its detailed depiction of dining and entertainments and is matched only by a unique mosaic found in an outlying neighborhood of Carthage (Douar-ech-Chott), Tunisia.[9] While the Carthage mosaic presents a different sort of banquet, perhaps a public banquet *(epulum)* with a large group of diners seated upright at benches, some details similar to those found in the Detroit panel can be noted: a flutist, dancers, wine jars, and food attendants. Moreover, the style of diminutive and animated figures, as well as the costume of tunic with vertical clavii, connect these mosaics chronologically. As many of the early Roman *emblemata* were still lifes, the focus on genre, especially dining scenes, in later examples of this mosaic technique seems a natural development.[10] CK

1. When a context is known for these *emblemata* it is usually funerary or from a *nymphaeum* (Donderer 1983).
2. I thank William Peck, of the Detroit Institute of Arts, for this information.
3. Jashemski 1979, esp. 89–97, lists fifty-six outdoor dining rooms found in Pompeii.
4. For the buildings of a country estate shown on three mosaics from Tabarka, Tunisia, dated to the late fourth or early fifth century, see Dunbabin 1978, 271–72, figs. 111–13.
5. Rossiter 1991, esp. 203 nn. 24–26; Jones 1991.
6. On this drinking practice and the terminology applied to such vessels, see Dunbabin 1993.
7. Similar figures are found in hunt mosaics with outdoor picnic scenes (see Dunbabin 1993, 133–34, figs. 22–24).
8. For the plate, see Mango and Bennett 1994, 86–87, fig. 1-37; for the Small Hunt mosaic from the villa at Piazza Armerina, see Carandini 1982, 178, fig. 94.
9. See Dunbabin 1978, 124, fig. 116; Dunbabin dates it to the mid-fourth century.
10. The putative pendant panel of a fishing scene fits into this category as well.

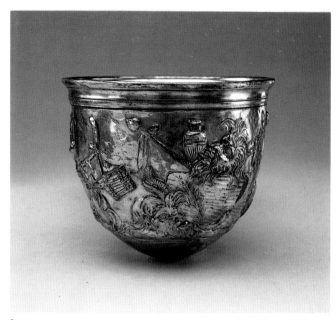

69

69 Cup with Dionysiac Motifs

C. 10–50 C.E.

Eastern Mediterranean

Silver, $2\frac{3}{4} \times 3\frac{1}{2}$ in. (7×8.9 cm), weight 152 g, capacity 238 ml

The Toledo Museum of Art. Purchased with funds from the Libbey Endowment, gift of Edward Drummond Libbey, 1961.9

Reportedly found in Asia Minor[1]

PUBLISHED: Toledo 1962, 54; Vermeule 1963, 33–35, pls. 14.1, 14.3, 14.5; Strong 1966, 143 n. 5, 214; Vermeule 1968, 128, 140–41, fig. 72a–c; Baltimore 1975, no. 66; Oliver 1977, 116–18, no. 76; Stefanelli 1991, 10–11, figs. 9–12, 254, no. 14

This silver cup was originally crafted in five parts: the thin exterior casing with relief decoration raised by hammering; the plain liner of slightly thicker sheet silver with a solid rim; a pair of simple vertical handles (now lost); and a cast stem and foot (also lost). The low-relief decoration features five theater masks in a landscape strewn with musical instruments (a tambourine, cymbals, a syrinx or panpipes, and a tortoise-shell lyre) and wine vessels (a mixing bowl, a pitcher, a two-handled cup, and a horn-shaped rhyton) associated with Dionysos.

Theater masks, as well as scenes from classical Athenian and contemporary Roman plays, which were reproduced in all media, are found on many examples of Roman tableware, particularly in the Greek-speaking cities of the Syro-Palestinian region and Asia Minor.[2] The two masks visible in the photograph are a goat-horned Pan and a bearded satyr. The other masks represent a beardless youthful satyr, a balding snub-nosed silen, and a front-face wild-haired young man, probably

another satyr. Satyrs and silens are mythical males with an uncontrolled desire for wine and sex who live in the wild. These five masks set beside four wine containers and musical instruments, may be associated with the festivities of Dionysos. Similar drinking vessels with relief decoration—masks, animals, and instruments—that suggest the realm of Dionysos include the silver cups in the Hildesheim Treasure and the silver *kantharoi* found in the House of Menander at Pompeii.[3] This cup undoubtedly was used for drinking wine; whether it was part of a domestic silver service or part of a set used for Dionysiac rituals cannot be determined.

The common features on many of these tablewares of glass, metal, and ceramic fabrics may be due to the practice in the first century of the Roman Empire of making copies (plaster casts) of well-known works of art.[4] A silversmith used the copy to guide his repoussé decoration or to prepare a mold in which to cast a replica. Pliny notes, however, that about the mid-first century "all of a sudden this art [of repoussé] declined that is now valued only in old specimens and authority attaches to examples worn with use even if the very design is invisible" (*HN* 38.157).[5] SK

1. The cup was found with a silver ladle, now in the Museum of Fine Arts, Boston (see Oliver 1977, 115, no. 75), and three silver cups with relief decoration that also lack feet and handles, now in the British Museum, one with scenes from the Orestes myth and the others with floral scrolls (see Corbett and Strong 1961).

2. Bieber 1961. For glass hexagonal vessels with masks, see Stern 1995, 79–81, 84–86, nos. 41 and 42; for an altar, see ibid., 84, fig. 56.

3. For the Hildesheim cups, see Berlin 3779.13/14 in Stefanelli 1991, 178, figs. 169–71, 272, no. 93; for the House of Menander cups, see Naples 145508 and 145509 in ibid., 159, figs. 142–43, 267, no. 72.

4. Plaster casts of metal vessels have been found at Mit Rahina (Memphis), Begram, and Chersonnesus (Strong 1966, 139).

5. Ibid., 140.

70 Candlestick

c. 602–10 C.E.

Antioch

Silver, height 8⅜ in. (21.3 cm)

Dumbarton Oaks, Washington, D.C., 38.83

Found during excavations of 1938

PUBLISHED: Ross 1952, 30ff.; Dumbarton Oaks 1955, no. 130; Gettens and Waring 1957, 89, no. 20; Dodd 1961, no. 90; Ross 1962, no. 15; Boyd and Mango 1992, 212, fig. 5

The candlestick has been recomposed from more than a dozen fragments excavated together with several pieces of gold jewelry. With its tripod base, baluster stem, round catchplate, and tall pricket, it resembles other silver candlesticks from the sixth and seventh centuries. A date for this deluxe item is secured by one of several impressed stamps on the underside of the apron, which refers to the emperor Phocas (602–10 C.E.). Of particular interest is another impressed stamp, which includes the name Theopolis, an early Byzantine name for Antioch.

The function of the stamps is uncertain: they may have been an official means of controlling the distribution of silver, guaranteeing the accurate weight of a piece, or, in the case of the "Theopolis" stamp, identifying where the candlestick was made. Whatever their purpose, a wealthy Antiochene must have proudly displayed this costly candlestick in a house in the years just before the Persian invasion of the city in 610. SRZ

70

71

The ewer was a standard element of a dining service, known as a *ministerium*. Ewers such as this one may have been used to serve wine or to hold water, which was poured over diners' hands for washing. The deep bowl found with this ewer is of the type used to catch the water below the guests' hands, strongly supporting the latter function. SRZ

72 Hunt Plate

Fourth century C.E.
Eastern Mediterranean
Silver, diamter 16⅛ in. (41 cm), weight 1.5 kg
Virginia Museum of Fine Arts, Richmond. Purchased with funds from the Adolph D. and Wilkins C. Williams Fund, 66.77

Reportedly from a "North Syrian Treasure"[1]

EX COLL.: Mallon, Paris

PUBLISHED: Ross 1967–68, 56–59, figs. 1–2; Mango 1986, 273–74, no. 101, fig. 101.1; Toynbee and Painter 1986, 20, 41, no. 49, pl. 20b; Gonosová and Kondoleon 1994, 180–83, no. 58

The large size of the plate and the convex central figural medallion suggest that it was intended as a display piece. The hunter, dressed in a short tunic, mid-calf laced boots, and a flying cloak, rides on horseback in pursuit of a lion. The scene captures a moment when the hunter, whose shield has fallen (in the left foreground), thrusts his spear into the face of the growling lion. The setting is simple, featuring only a tree with two branches to the right side of the circular field and two hillocks below the lion.

71 Ewer

Fourth century C.E.
Daphne, House of Menander
Silver, height 7⅞ in. (20 cm)
Dumbarton Oaks, Washington, D.C., 40.24

PUBLISHED: Ross 1953, 40–41; Dumbarton Oaks 1955, no. 123; Ross 1962, no. 1; Mango 1986, no. 97

The handle, with scalloped edges, a curled thumbrest at the top, and a leaf-shaped ornament at the bottom, is the only decorated part of this ewer. The contrast of the decoration and the angle of the handle with the plain, curved body gives the ewer an elegant yet sturdy character. Notably, the ewer was found in the remains of the dining room of the House of Menander, the most extensive dwelling excavated in the Antioch region, which was rich in floor mosaics, fountains, and marble revetments. The ewer was discovered with three other silver objects, part of what is known as the Daphne Treasure: a plate, a bowl, and a statuette of Aphrodite. These items may well represent an attempt to hide some of the family treasure at a time of grave instability and danger.

72

The plate has a broad flat rim engraved with five turned lines and edged with beads; it stands on a low foot ring. In both profile and ornamentation the plate is close to the silver sets in the fourth-century treasures—Mildenhall, Traprain, and Kaiseraugst. However, because large silver treasures of the late Roman period comprise items produced in several parts of the empire, it is not possible to postulate an exact place of manufacture for this plate. A plate of similar size from the Berthouville Treasure, now in Paris, also features a lion hunt in the central medallion, but the scene has a deeper spatial setting and the horse and rider are seen from the rear, naturalistic features more in keeping with its earlier dating.[2]

The popularity of hunting scenes in late Roman domestic decorations is obvious from the floor mosaics of Antioch, which range from the fourth-century hunting episodes found in the Constantinian Villa, now in the Louvre, to the hunters in the Worcester Hunt (p. 66, fig. 2) of the early sixth century. The Virginia hunt plate may well have complemented such exuberant hunting mosaics in the dining rooms of the Roman elite of Syria. CK

1. See Ross 1967–68, 56–59, figs. 1–5, which identifies and describes the contents of the "treasure," which included six pieces of silver. There is, however, some debate over whether this was an actual treasure or one put together for the art market (see Gonosová and Kondoleon 1994, 180 n. 3). 2. The plate is in the Cabinet des Médailles, Bibliothèque Nationale (see Baratte and Painter 1989, 93–95, no. 24, where it is dated to the late second or early third century).

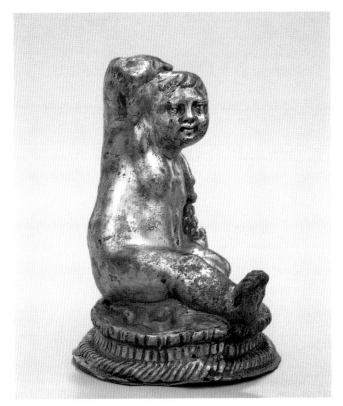

73

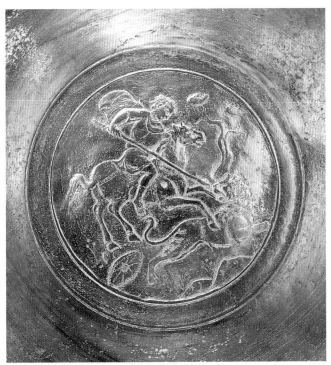

Detail of cat. no. 72

73 Pepper Castor

C. 200–230 C.E.

Eastern Mediterranean

Silver, height 3¾ in. (9.5 cm), weight 109 g

Museum of Fine Arts, Boston. Purchased with funds from the Helen and Alice Colburn Fund, 1972.863

Reportedly from Sidon

EX COLL.: De Clercq-de Boisgelin, Paris

PUBLISHED: De Ridder 1905b, 106, no. 164; Vermeule 1974, 8, no. 15 ill.; Oliver 1977, 155, no. 102

This small silver vessel has three elliptical holes on its base, which suggests that it was a pepper dispenser *(piperatorium)*. It is cast in the shape of a young boy, most likely the infant Dionysos since he holds a bunch of grapes under his cloak. An inner disk with matching openings and three other perforated areas is attached to the disk at the base. A toggle pin allows the user to line up the larger holes for pouring quickly or to turn to the perforated area for shaking the pepper out more slowly.

The device on the base of the Boston vessel is like that on two vessels dated by the coins found with them to the first half of the third century. One, in the shape of a boy holding a dog, was found in Bulgaria; the other, in the shape of an African slave in a hooded cloak, seated and asleep, is from the Chaourse Treasure.[1] Pepper, according to Pliny (*HN* 12.28), was first

imported to the Roman world from India during the first century C.E. The soft modeling of the Boston boy is reminiscent of the styles of sculpture of the early Severan period, which may indicate a date in the early part of the third century.[2] CK

1. For the Bulgarian piece, now in the Archaeological Museum in Sofia, see Oliver 1977, 155, no. 102 ill.; for the slave boy, now in the British Museum (GR 1889.10-19.16), see Baratte and Painter 1989, 133, no. 81 ill.
2. See Mandel 1988, 37–38 n. 261.

74 Jar with Bacchic Decoration

Third century (before 256 C.E.)
Dura-Europos, Syria, House of the Large Atrium
Silver, with gilding in the decorative bands, 8¾ × 8⅜ in.
(22 × 16 cm)
Yale University Art Gallery, New Haven. Yale-French Excavations at
Dura-Europos, 1931.585

PUBLISHED: Baur, Rostovtzeff, and Bellinger 1933, 229–31, pl. 12; Strong 1966, 162; Oliver 1977, 160–61, no. 106

Seven actors' masks appear among the leaves and fruit of the grapevine that encircles the body of this large silver vase, while a band of acanthus plants rings the neck. There are four female and three male masks, their hair enriched by gilding. The male masks represent a satyr, an old silen, and apparently a Pan, with his ass's ear turned downward. The combination of the masks and the grapevine confirms the Bacchic associations implicit in the identities of the masks. Such masks appear on silver vessels from other parts of the empire, beginning with an elaborate first-century B.C.E. drinking cup from Hildesheim (now in Berlin) and continuing on cups and plates from the first and second centuries C.E. from Asia Minor (now in Toledo) and Gaul (the Chaourse Treasure, now in the British Museum). Both the Dura-Europos jar and the treasure from Chaourse were found in domestic contexts, where their Bacchic iconography would have been suitable for use at dinner parties.

There is little evidence for the manufacture of silver vessels of this quality in the eastern Roman provinces. Few of the vessels found in the region are sufficiently distinctive in style to suggest local work; most are typical of the stylistically uniform products that were traded throughout the empire. The Dura-Europos jar and the finds from Daphne, near Antioch, are exceptions, and it has been suggested that this jar, the only silver vessel found at Dura, was made in the workshops of Antioch, Dura's larger and artistically more prominent neighbor. SM

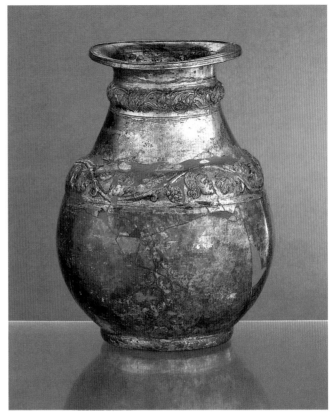

74

75

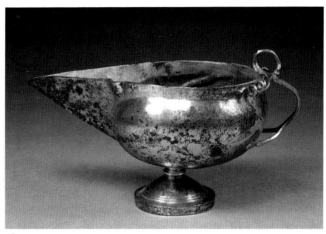

76

75 Plate

Fourth century C.E.

Daphne, House of Menander, room 3

Silver, diameter 13 in. (33.2 cm), weight 860 g

Worcester Art Museum, 1940.17

PUBLISHED: Ross 1953, 40, ill.; Dresser 1954, 15–16, ill.; Mango 1986, 268–69, no. 95, fig. 95-1

The plate was first cast and then hammered into a concave shape with a flat outer rim. It rests on a footring that was soldered on as a separate piece. The decoration is restrained, with a fluted rim and a central geometric medallion composed of a twelve-petal rosette within an eight-pointed star. The medallion is outlined by three concentric grooved circles with punched leaf, dot, and line decorations within them. All the decorations on the plate are combinations of punched and engraved designs.

There is a scratched quatrefoil design and graffito inscription on the reverse: MAKAP[IOY?] It is unclear whether this name refers to the owner or to the maker.

The plate was found together with a bowl, a ewer, and a statuette—all of silver—beneath a limestone drain in the northeast corner of a dining room in the House of Menander. The so-called Daphne Treasure may have been buried when the house collapsed during an earthquake in 485 or 526.[1] Apparently, the objects were not retrieved, for they were excavated from below the floor of the rebuilt house.

Similarly decorated pieces, with fluted rims and central star motifs, have been found in other silver treasures dated to the fourth century—especially close are the bowls from the Kaiseraugst and Mildenhall Treasures,[2] supporting the fourth century date given to this find. CK

1. See Antioch III 1941, 155, no. 49, which proposes the two possible earthquake dates for the destruction of the rebuilt, fourth-century phase of the House of Menander.

2. Strong 1966, 201, pls. 65a and b.

76 Spouted pitcher

Fourth century C.E.

Eastern Mediterranean

Silver, 3⅞ × 4½ in. (9.8 × 11.4 cm), length with handle 7 in. (17.8 cm), weight 298 g

The Cleveland Museum of Art. Purchased with funds from the J. H. Wade Fund, 56.32

Reportedly found near Latakia, Syria

PUBLISHED: Milliken 1958; Downey 1963, fig. 76

The shape of this silver pitcher has no known parallels. It consists of a plain bulbous bowl with an outwardly turned rim and a long spout. Two vine tendrils curl out from where the handle is attached to the flared rim, and two leaves are soldered where the handle connects to the body. There is a ball stem and a foot with a flaring base.

The pitcher, which has received some modern repair, was found with other silver objects now in the Cleveland Museum of Art, including a jug and a mirror that have been connected by their decoration to a bowl and ewer, also from Syria, now in Berlin.[1] The Berlin bowl bears a late-fourth-century stamp. If they form a group, the Berlin and Cleveland pieces are part of a domestic silver service.[2] The handle of the Berlin jug is attached by means of two leaf-shaped soldering plates close in type to the handle attachments on this pitcher.[3] The foot is close to one found on a fourth-century ewer also from Syria and now at the Louvre.[4] CK

1. Strong (1966, 190) suggests that the Cleveland silver "said to come from Syria" dates to the late Roman period.

2. Downey (1963, 214) identifies the Cleveland pitcher as illustrating work done in Antioch and groups it with liturgical pieces, but it does not belong to an altar service.

3. Strong (1966, 189–90, pl. 56A, n. 5) dates the Berlin jug to the fourth century.

4. Baratte 1971, 320–21, pl. 29.

Glass Tableware

The glassworking industry was transformed by the invention of the blowpipe in about 50 B.C.E. somewhere on the coast of Syria or Palestine. During the reigns of Augustus and his successor, Tiberius (30 B.C.E.–29 C.E.), glassworkers from the coastal cities of Syria and Palestine immigrated to Rome and the cities of Campania, bringing this revolutionary technique with them.[1] Antioch probably was at least a regional center for glass production. Some square bottle bases bear inscriptions giving the name of Paulinos (and others) of Antioch, presumably glassworkers or glass workshops.[2] As most of the glasswares found in Antioch are intact and little weathered, they most likely came from tombs (fig. 1). The identification of glass workshops has been aided occasionally by the incorporation into the mold design of the signature of an artist or workshop owner, such as Neikais (cat. no. 80).

In the late imperial period glass was both commonplace and inexpensive. In Diocletian's edict on maximum prices, issued in 301, glass products are divided into three categories: Alexandrian glass, Judean glass, and window glass. The edict lists the maximum official prices of unworked glass, followed by the prices of the same glass made into tablewares. The designations *Alexandrian glass* and *Judean glass* describe two different kinds of glass material rather than glass imported from the two locations. It has been suggested that the term *Judean glass* refers to the invention of glassblowing in the region and particularly to common household wares blown of naturally colored bluish green and greenish glass. Alexandrian glass, on the other hand,

cost twice as much as Judean for the raw material and half again as much for the finished vessels, and so its name probably describes high-quality decolorized glass.[3] The cost of an Alexandrian glass was twenty-four *denarii*; in comparison, a pint of ordinary olive oil cost twelve *denarii*, and a pint of ordinary wine was eight *denarii*. Daily wages were regulated, ranging between twenty-five *denarii* for an unskilled farm laborer and one hundred fifty *denarii* for a skilled figure painter. Thus, glass vessels were affordable. Interestingly, it is presumed that both finished products and unworked glass were sold by weight, like metal, suggesting that a heavy object such as the ewer (cat. no. 82) was more costly, and hence more valued, than the thin-walled bowls and cups admired today for the technical skill of the glassblower.

Glassmaking continued to be a vital craft in the eastern provinces of the Roman Empire long after the political and economic systems of the West collapsed during the fifth century, and the artisans continued to develop the industry for the next thousand years, during the Byzantine and Islamic Empires, as evidenced by the dromedary flask of the sixth to eighth century (cat. no. 84). SK

1. Harden 1960; Scatozza Höricht 1991; Stern 1995, 34–96.
2. Jennifer Price, letter to author, 14 July 1997.
3. On the 1970–72 discovery at Aphrodisias, in Caria, of fragments of the imperial decree with the hitherto unknown section on glass, first published by Dorothy Charlesworth in Erim and Reynolds 1973, 109–10, see Barag 1988.

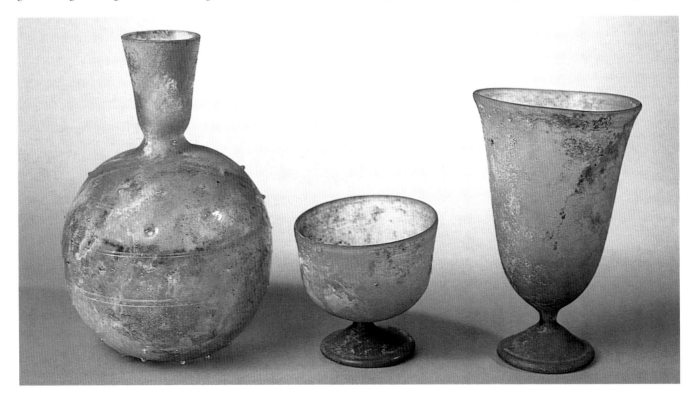

Fig. 1. Free-blown glasswares from the fourth and fifth centuries include this bottle with six rows of pinched projection knobs and six wheel-cut horizontal lines (inv. no. 13649), a stemmed cup (2.25 in., inv. no. 9165), and a footed beaker (4.5 in., inv. no. 9167). Hatay Archaeological Museum, Antakya

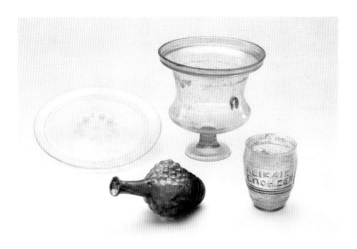

77–80

In its shape, its pronounced folded rim, and the wheel-cut grooves around its body this elegant bowl imitates metal tablewares of the first century C.E. The tiny coil handles, applied to the side at the point where the diameter is narrowest and folded upward to form omega-shaped loops, emphasize the precision of the shape and the perfection of the colorless glass. SK

77 Plate

Late first to early second century C.E.
Cast decolorized glass, cut and polished, 7½ in. (19.1 cm)
The Toledo Museum of Art. Purchased with funds from the Libbey Endowment, gift of Edward Drummond Libbey, 1948.15

EX COLL.: Brummer Gallery, New York

PUBLISHED: Grose 1978, 85, fig. 22

This plate belongs to a large class of cast, intentionally decolorized fine glass tablewares found in both the western and eastern provinces of the Roman Empire—the last class of glass made in large numbers using the technique of casting, at the time when Roman glassmakers were converting to free-blowing and mold-blowing as their primary means of manufacture.[1] Made to be perfectly colorless and transparent by the addition of a decolorant (e.g., a small amount of manganese), this flat plate stands on a low base ring. On the underside are engraved eight rosettes interspersed with four ovals surrounding a central rosette. Such cast, colorless, engraved tablewares were probably intended as imitations of more expensive rock crystal, as indicated by Pliny (*HN* 37.10.29). SK

1. Grose 1991.

78 Footed Bowl (Carchesium)

First century C.E.
Transparent natural, slightly green glass, free-blown and tooled, with a band of wheel-cut incisions about 1¼ in. (3.2 cm) below the rim, 6 × 4¾ in. (15.2 × 12.1 cm)
The Toledo Museum of Art. Gift of Edward Drummond Libbey, 1923.2404

EX COLL.: Thomas E. H. Curtis

PUBLISHED: Toledo 1969, 14; Grose forthcoming

79 Bottle Shaped Like a Cluster of Grapes

Late second century to third century C.E.
Eastern Mediterranean
Translucent manganese-colored glass, mold-blown, 5½ × 3 in. (14 × 7.6 cm)
The Toledo Museum of Art. Purchased with funds from the Libbey Endowment, gift of Edward Drummond Libbey, 1951.373

Reportedly from Aleppo

PUBLISHED: Stern 1995, 190–91, no. 119.

Glass bottles in the shapes of fruit—dates, pinecones, and pomegranates, as well as bunches of grapes—are common (such shapes were also frequently fashioned in clay, metal, and stone). As a tableware, this bottle was perhaps used to hold flavorings or *mulsum* (concentrated sweet grape juice) to be added to wine just before it was drunk. Glass examples found in the western provinces of the Roman Empire usually have two handles, while those from eastern sites have none.[1] SK

1. Examples of the same type, several with eastern Mediterranean provenances, including the caravan cities of Hama and Dura-Europos, are listed in Stern 1995, n. 4.

80 Barrel-Shaped Cup Signed by Neikais

c. 50 C.E.
Eastern Mediterranean
Transparent natural grayish-green glass, mold-blown glass, 3½ × 2⅝ in. (8.9 × 6.7 cm)
The Toledo Museum of Art. Purchased with funds from the Libbey Endowment, gift of Edward Drummond Libbey, 1930.5

Reportedly found in a tomb at Aleppo (ancient Beroea); Fr. von Gans Collection, Frankfurt (second collection); Bachstitz Gallery Collection, The Hague; Fahim Kouchakji (until 1928)

PUBLISHED: Froehner 1913, 5–8, ill.; Stern 1995, 100–102, no. 5

The inscriptions neatly cut into the mold for this cup in order to produced raised letters read "NEIKAIS EPOESEN" (Neikais made [it]) on one side and "MNESTHE HO AGORASAS" (May the buyer be remembered) on the other side. Neikais may be the name of the designer, the moldmaker, or the individual glass-

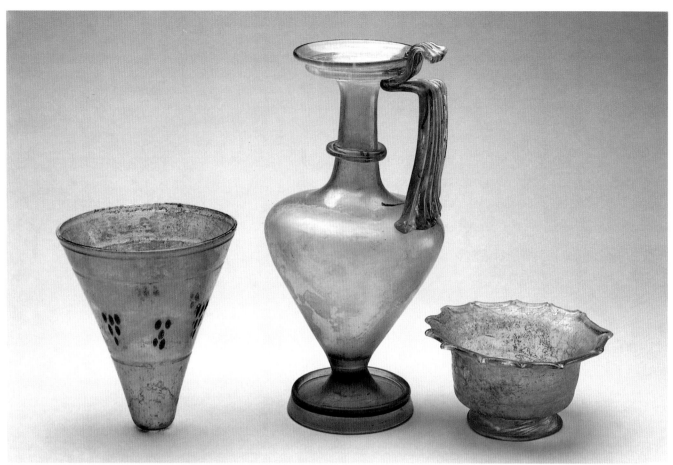

81–83

blower, but it is most likely that the name served as an advertisement for the owner of the workshop in which the vessel was produced. Marianne Stern suggests that Neikais may be the name of a woman. The second phrase appears to be a Greek translation of a Semitic blessing, the complete formula of which is "may [name] be remembered before the god [name]."

That seven similar beakers were found on the Syro-Palestinian coast and one was found on Cyprus, together with the inscription, suggests a strong association with the coast of the eastern Mediterranean and its polyglot population. Ancient Beroea, where this cup was found, was on one of the great caravan routes between the Euphrates and the Mediterranean and was a Macedonian Greek city founded, like Antioch, by Seleukos I Nikator about 300 B.C.E. SK

81 Conical Beaker or Lamp

Fourth century C.E.
Free-blown transparent decolorized glass with groups of applied dark blue blobs and horizontal wheel-cut grooves, 6⅞ × 6 in. (17.5 × 15.2 cm)
The Toledo Museum of Art. Gift of Edward Drummond Libbey, 1923.1220

EX COLL.: Thomas E. H. Curtis

PUBLISHED: Grose forthcoming

Many glass vessels of this conical shape with a small flattened base survive; the shape seems to have been used for both drinking vessels and lamps. Transparent drinking vessels, probably of glass, are hoisted by carousing banqueters in a wall painting from a fourth-century tomb at Ostia.[1] A lamp of this shape was found in a wooden stand at Karanis, a site in the Fayum of Egypt.[2] The conical shape could also fit into wheel-shaped chandeliers suspended from chains;[3] the wheel-cut horizontal lines on many examples may indicate the level of water and oil on which a wick was to be floated. SK

1. Now in the Vatican Museum, inv. 10786 (Fleming 1997, fig. 18).
2. Gazda 1983, 25, fig. 41, right; see also Steckner 1990.
3. Fleming 1997, 33, fig. 19.

82 Ewer with Circular Mouth

Fourth century C.E.
Free-blown thick, transparent yellow-green glass with similarly colored handle and added coils, 12⅝ × 6 in. (32.1 × 15.2 cm)
The Toledo Museum of Art. Purchased with funds from the Libbey Endowment, gift of Edward Drummond Libbey, 1979.54

EX COLL.: Mr. and Mrs. Andrew Constable-Maxwell

PUBLISHED: Toledo 1979; Grose forthcoming

The tall, inverted conical body with sides tapering to a point, a high base with concave sides, a ribbed handle with thumbrest, and heavy neck and rim coils imitate silver vessels from the fourth century.[1] Similarly articulated details can be found on the silver ewer from Dumbarton Oaks (cat. no. 71).

The ewer (Gr., *xestes;* Lat., *urceum*) had two functions. As a wine pitcher it was used to store and serve wine. As a water pitcher it was usually paired with a pot with a single handle (Gr., *chernibon;* Lat., *trulla*) and used for washing hands.[2] SK

1. For instance, the Hippolytus ewer and the pair of ewers decorated with interlaced medallions with geometric motifs in the Sevso Treasure (Mango and Bennett 1994, 364–401, no. 10, and 402–26, nos. 11–12).
2. Mango 1986, 107; fig. 14.6 illustrates both uses of ewers at the banquet of Dido and Aeneas in the *Vergilius Romanus* (Vatican Lib., cod. Lat. 3867, fol. 100v), where the wine ewer is shown with a round rim like that in cat. no. 71, while the water ewer is shown with a trefoil-shaped mouth.

83 Bowl with Scalloped Rim

Fourth century C.E.
Eastern Mediterranean
Free-blown transparent glass of pale yellow-green, 3⅜ × 6½ in. (8.6 × 16.5 cm)
The Toledo Museum of Art. Museum purchase, 1916.75

Reportedly from Mount Carmel, Syria

PUBLISHED: Harden 1936, 97, 111 n. 2, fig. 2g; Grose forthcoming

The glassworker bent the rim out horizontally, rounded and thickened it in flame, then pinched and pulled to form thirteen scallops with rounded tips. The shape of the body and the pearl-knobbed rim closely copy those of silver bowls of the same period. Although it has been suggested that this vessel is of Egyptian manufacture, similar glass examples are known from Adana and Anamur in Asia Minor, suggesting that the shape, both in metal and glass, may have been typical of a regional style of the eastern Mediterranean.[1] SK

1. Berlin, Antikensammlung Misc. 10175, from Karnak.

84 Bottle in the Shape of a Caravan Dromedary

Sixth to eighth century C.E.
Eastern Mediterranean
Free-blown and tooled glass, height 5 in. (12.7 cm)
The Toledo Museum of Art. Gift of Edward Drummond Libbey, 1923.2044

EX COLL.: Thomas E. H. Curtis

PUBLISHED: Toledo 1969, 21; Harden 1971, 93, 115, pl. 9d; Grose forthcoming

The Toledo Museum of Art has six glass bottles in the shape of dromedaries laden with caravan trade goods (acc. nos. 1923.2045–49). Because of centuries of slow corrosion, this is the best-preserved example in the exhibition, with no damage, no weathering, and only minute pitting, inside and outside.

Dromedary bottles scarcely function as vessels because of the elaborate hot-tooled network that represents a swollen load of packs; however, they could have held small amounts of liquid or powder. They must have served as whimsical cosmetic or spice containers, perhaps to contain the perfumed oil, cassia, or pepper transported by the endless camel caravans that crisscrossed the northern Syrian desert to Palmyra, Antioch, and the cities of the Mediterranean coast. It is tempting to imagine a colorful caravan train of these bottles arranged on a table, each dispensing a different spice or condiment—but that is doubtless a vision based on the modern practice of serving oneself table flavorings. SK

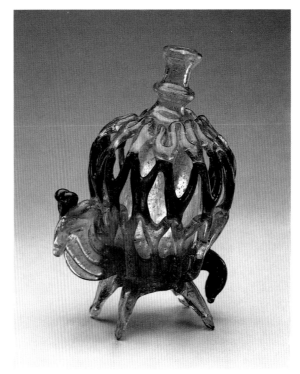

84

V Religions: Pagan, Jewish, Christian

The great number of languages spoken and variety of religions practiced in Antioch reflect the diversity of its population. From its Hellenistic origins, the city worshipped the Olympian gods. The oldest temples were those of Ares and Athena, but none was more important than the famed oracular shrine of Apollo at the springs of Daphne. The nymph Daphne, after all, was transformed into a laurel tree while fleeing the advances of Apollo (see p. 196).

During the Roman period, the city became home for many new peoples and faiths from around the Mediterranean. The attraction to Egyptian cults was especially pronounced, as it also was in Rome. Local Syrian cults remained active as evidenced in their fusion with Greco-Roman divinities. The common language for many of these diverse religious liturgies was Greek. While occasional rioting and disharmonies should not be overlooked, these disparate religious communities also shared many cultural values in addition to the Greek language. As citizens of a Roman metropolis, they participated in the many pagan festivals that marked the civic calendar, and they learned Greek philosophy and rhetoric.

The Jews, a significant and prosperous community who settled in Antioch from the time of Seleukos, conducted their synagogue services in Greek and maintained close contacts with Jerusalem. It is in these synagogues, not yet discovered, that gentiles and Christians alike heard passages of the Hebrew scriptures in Greek. Numerous gentile conversions followed the visits of Paul, Peter, and Barnabas. So much so that it was "in Antioch they first called the disciples Christians" (Acts 11:26). In honor of this fact, Constantine the Great built a famous cathedral in Antioch called the "Golden House." For Christians of the eastern Roman Empire, especially, Antioch had a unique religious authority. The influence of the sermons and writings of its great theologians and bishops, for example, Ignatius and John Chrysostom, are still in evidence today.

Great martyrs and saints were associated with Antioch: Babylas, Thecla Equal-to-the-Apostles, Pelagia the Penitent Harlot, Simeon the Stylite, and Simeon the Younger. Their extreme expressions of Syrian piety were enacted against the backdrop of a cosmopolitan city with many worldly distractions.

Apollo and Daphne Mosaic. House of Menander, room 16. Daphne, third century. The Art Museum, Princeton University. Gift of the Committee for the Excavations of Antioch to Princeton University, y1965-219

Pagan Cults at Antioch

Sarolta A. Takács

From the beginning the history of Antioch was linked with gods and religious rituals. According to the sixth-century chronicler Malalas (Malal. 200), when the city's Macedonian founder, Seleukos, offered a sacrifice to Zeus the Thunderer in the city of Antigonia, where he intended to build a new city, an eagle swooped down and snatched a piece of meat from the altar. Seleukos and his men pursued Zeus's bird, which had headed off toward Mount Silpios. When they found the eagle standing on the piece of meat, the priests and augurs who had accompanied Seleukos concluded that the eagle's action was a divine sign: the new settlement was to be built where the eagle had landed, on the valley floor near Mount Silpios. The foundations for the walls of this new city, which would be named for Seleukos's son Antiochos were marked out on the site of an already existing village, Bottia. Seleukos also built a temple to Zeus Bottios there.

Later, Malalas states, Seleukos sacrificed Aimathe, a virgin, between the city and the river Orontes. Above the river Antioch's founder placed a statue of the sacrificed girl as the Tyche (deity of good fortune). Human sacrifice as part of a city's foundation strikes us as gruesome and futile, an act we might be able to envision in a very distant past but not in the Hellenistic period. It is possible that Christian chroniclers such as Malalas in the war of words against paganism exaggerated the use of human sacrifice to mark a city's foundation. In many foundation myths human sacrifice and the shedding of sacrificial blood at the moment of foundation feature prominently. Pausanias, a second-century Greek traveler, describes a later version of this Tyche of Antioch (Paus. 6.2.7), the original for which was fashioned by the third-century B.C.E. sculptor Eutychides. The goddess's representation could also serve as a personification of the city. We know of such depictions from other Greco-Roman cities and especially from coinage. In the case of Antioch, it was Demetrios I (162–150 B.C.E.) who first issued coins featuring Tyche, shown seated on a throne, nude to the waist.

On Roman coin issues from Antioch the Tyche by Eutychides is shown within a temple structure and represents a statue with active cultic power. She stood in the most sacred part of the temple, the cella, and commanded the room from the back wall forward, in direct alignment with an altar that stood outside the temple. Here the public ritual in honor of the city's Tyche would take place.

Recurring cultic rituals generally functioned as temporal markers and also shaped the daily and yearly routines. They forged comprehension of the self within the community and helped link the community as a whole to its shared past, present, and future. Thus, abstract time was translated into something visually concrete, that is, cultic ritual.

Just as the goddess Tyche was important to Antioch, so Athena was important to the Athenians. When Greeks and Macedonians migrated to Antioch from Antigonia, which Seleukos had destroyed (Malal. 201), perhaps in anticipation of founding a new city in its place, the king erected a huge bronze statue of the goddess Athena for the Athenians. Seleukos understood that a powerful divine link to the newcomers' past would facilitate their integration and further legitimize his power. In addition, Seleukos invited Cretans, whom Kasos, the son of Inachos, had once left behind in the area, into his new city. Seleukos even planted cypresses descended from those Herakles had planted in his eponymous city Herakleia, near the temple of Apollo Daphneios. This city was later known as Daphne, a garden suburb of Antioch.

Myths and their visual representations are often closely connected to place. The most famous myth about Antioch is linked to Daphne (Ov. *Met.* 1.452ff.). The first woman Apollo fell in love with was the daughter of the river god Peneus, the nymph Daphne. Cupid shot one of his sharp arrows at Apollo, piercing him. The arrow he directed at Daphne, on the other hand, was a blunt arrow, which drove away all love. Thus, lovestruck Apollo pursued unwanting Daphne until her prayers for help were heard and she was turned into a laurel tree (see p. 196). While Apollo could not possess Daphne, he could own laurels, which were the most prominent adornment of his hair, his lyre, and his quiver. He grieved the loss of Daphne and shot all his arrows. Seleukos's horse found one of the arrowheads, on which the god's name was inscribed, prompting the king to build a sanctuary for Apollo at this site. A spring with oracular powers was close to this temple. Since spring water is the domain of nymphs, it might be argued that, as in the case of the Delphic Pythia, Apollo had appropriated the sphere of a female, prophesying deity. That Zeus and Apollo feature dominantly in the foundation myth of Antioch and its most famous suburb is no surprise. Seleukos, one of Alexander the Great's successors, followed in the footsteps of the great conqueror in embracing Zeus as his guardian deity. As with Alexander, there was a story of Seleukos's divine parentage. A founder of an empire could but be the offspring of a god; in Seleukos's case his divine parent was Apollo (Lib. *Or.* 11.94).

Like Apollo and Daphne, gods were often deeply attached to a place, and images of them often seem to embody these longings. The Egyptian pharaoh Ptolemy Philadelphos, who was the father of Antiochos II's second wife, Berenice, visited Antioch and became enchanted with a statue of the goddess Artemis (Lib. *Or.* 11.109). Ptolemy received the statue as a gift and took it with him to Egypt. The goddess Artemis, however, longed for Antioch, and after Egypt's queen fell ill and learned in a dream of Artemis's wish to return to her original dwelling place in Antioch, the goddess's wish was granted. Libanios relates another story of traveling deities in which the oracle at Delphi instructed the emissaries from Antioch to bring Cypriot gods to

Antioch in order to quell the city's problems. This was done and the problems subsided (*Or.* 11.110–13).

As one of the most important economic centers and one of the largest cities in the Roman Empire, Antioch was home to many gods. Gods like the all-powerful Egyptian mother goddess Isis appeared in a dream to Seleukos IV (187–175 B.C.E.) and asked to be moved from Memphis to Antioch. The Egyptian pharaoh granted her wish readily (Lib. *Or.* 11.114). Memphis was a sacred city, the home of Ptah and his manifestation Apis. According to Ptolemaic tradition, Sarapis, a variant of Apis, was the consort of Isis. Some scholars have thought that Libanios placed the introduction of an Egyptian cult too early and as a result have judged his account suspect. Isis appeared on coins of Antioch during the reign of Seleukos IV's successor, Antiochos IV (175–163 B.C.E.). Looking to the Greek world, to one of its premier cities, Athens, and to one of its most active cult centers, Delos, we find that Egyptian cults were introduced about the time of Alexander the Great. Priesthoods, which Egyptians held originally, were in Greek hands a generation after Alexander's death. In these terms, then, Isis's introduction to Antioch seems rather late. On the other hand, Isis and especially her consort Sarapis were closely connected with the Ptolemies. A Seleucid ruler's hesitancy to have a rival dynasty's guardian deity officially in its pantheon would be understandable, especially at a time when they were claiming each other's territory. The political conditions were different in the second century B.C.E.

Greco-Roman religion, the totality of all cults, however, was very much oriented toward the civic sphere. Cultic rituals had to be performed properly on established days during the year in state-built temples and along specific routes. An example is the procession organized by Antiochos IV (175–163 B.C.E.) for Antioch, which was to rival one held by the Roman general Aemilius Paullus celebrating Roman victory over the Macedonians at Pydna (Polyb. 30.25; Ath. 195a-b). The pageant included representations of all the gods and spirits mentioned or worshipped by men and of all heroes, some gilded and others draped in garments embroidered with gold. Moreover, the effigies were accompanied by representations, executed in precious materials, of their respective myth narratives. Behind them came images of Night and Day, Earth and Heaven, and Dawn and Midday. An early-second-century C.E. inscription from Ephesos, another important eastern Mediterranean urban center, describes a procession of statues carried through the city streets. Passing from temple to temple, the parade of citizens and priests linked the sacred sites of the city and the present to the divine and to the legendary past.

Unfortunately, we know far less of religious activities within the home than we do of public displays. Yet we can safely assume that individuals addressed specific household gods and perhaps prayed regularly to one or more of the gods of the pantheon. Excavations of ancient houses have revealed representations of various deities in spaces identified as household shrines,

lararia, which could be a simple niche in the wall or an elaborate cabinet resembling a miniature temple. While there are no finds indicating that the *lares*, protective household gods, were worshipped in the Roman East, numerous small statuettes of terracotta, bronze, marble, and silver have been excavated in Hellenistic Greek and Roman private houses. Savior deities such as Herakles (cat. no. 90), Zeus, Asklepios, and Isis (cat. no. 87) were popular throughout the empire, as were Hermes, patron of trade, and personifications of forces such as Tyche or Fortuna. Apparently, individuals performed specific rituals and addressed specific prayers to these representations. Cults fulfilled a social purpose: they linked people and gave each person a place in society. Mystery cults, among them Christianity, were open to all, not restricted to certain individuals, families, clans, or even classes. Once admitted to a cult of their choice, individuals gained an added role in society and perhaps even the security of faith.

One such mystery cult was that of the goddess Isis. Some inhabitants of the empire had a genuine affection for Isis and Aphrodite/Venus, whose protections for marriage, family, and fertility were equally sought. Because of the inclusiveness of polytheism, a bronze or silver Aphrodite might be placed next to a representation of the Egyptian goddess Isis in the household shrine (cat. nos. 86, 87, and 89). The all-powerful Isis, devoted to her murdered husband, Osiris, stands as a paragon of marital devotion. Her love for him drove her search for the pieces of his dismembered body. For the one piece she could not find she fashioned a replacement. While the various assimilations of Isis and Aphrodite represent love, both are also divinities of immense power over human life.

Isis's search for her husband's body parts was featured in her cult and was relived every year in October. While the second-century C.E. Latin writer Lucius Apuleius gives a humorous account of the Isiac initiations in his novel *Metamorphoses*, or *The Golden Ass*, a mosaic from Antioch provides a more tempered version. A man about to be initiated, a *mystes*, stands between Isis and the leader of the soul, Hermes (the equivalent of the Egyptian dog-headed god Anubis). The central component of a mystery-cult initiation was the "voluntary death" and subsequent rebirth. The Eleusinian mysteries in honor of Demeter, the goddess Greek writers equated with Isis, furnished the basic structure for the Hellenistic Isiac mysteries and for those of Dionysos. All these divinities were linked to the fertility cycle of the earth. Evidence of the adherence to fertility rites as late as the 380s can be found in a passage from Libanios (*Or.* 30, 35) in which he chides the Christians for continuing their sacrifices for the Nile festival. Clearly, agricultural rites were among the last vestiges of paganism to be purged.

The house that gave us the "initiation rite" mosaic also yielded a mosaic representing the *navigium Isidis*, a festival celebrated on 5 March with the launching of a small decorated ship that symbolically opened the sailing season. Apuleius describes

such a festival in his novel. His protagonist, the ass-shaped Lucius, happened to be in Corinth, where he observed the *navigium Isidis* procession. Women crowned with flowers led the Isiac procession train, initiates without special cultic duties formed the middle, and various priests, each carrying a specific symbol of the cult, came at the end. Isiacs wore white dresses, women sported headdresses, and men had clean-shaven heads. The procession ended at the beach, where a small replica ship consecrated to Isis was launched. The participants then returned to the temple of Isis, where they recited prayers for the well-being of the state. In this public festival Isis functioned as the protector of the lifeline that guaranteed the shipment of wheat, so important for the effective control of the empire's urban populace.

A third mosaic, a random find in Antioch, gives further information about Isiac attire and attributes (fig. 1). The most prominent attribute is the *sistrum*, the sacred rattle. One of the persons in the mosaic wears a white robe with a stole on which there are sun and moon ornaments. Both celestial bodies are connected with the more Egyptian Isis, who was equated to Hathor, the sky goddess, and was the cunning conqueror of Re, the sun god. Isis also had cosmic relevance, as Sothis or Sirius, the Dog Star; and Orion is Osiris. In a Ptolemaic text she addresses her husband in the following way: "Your sacred image, Orion in heaven, rises and sets every day; I am Sothis, following after him, and I will not forsake him" (*P. Berol.* 3008).

In the Syrian pantheon many goddesses were equal to Isis, such as Atargatis, whom the Greeks and Romans knew as Dea Syria. Sometimes she is represented as half woman, half fish, for a myth tells of Atargatis falling into a lake and being rescued by a fish. In astrology she is represented by the constellation Virgo. Her consort is the weather god Hadad, who is equated to Zeus or Jupiter. He might be represented as a bull or flanked by bulls or by mountains, lightning, thunderbolts, or an axe. In Western civilization the joining of a weather god with the image of a bull goes as far back as the epic of Gilgamesh. Stable weather patterns and the physical strength of cattle were guarantors of survival in early society. For example, Baal, a weather god from the Phoenician area of Syria, was worshipped as the protector of crops and livestock. An annual ceremony that was part of the Canaanite fertility rituals remembered his death and celebrated his resurrection.

Mithras, another deity connected with a bull, is more elusive and not directly linked with an agricultural fertility cycle. His realm is of a cosmological nature, and his companions in slaying the bull are a dog, a raven, a snake, and a scorpion. Each of these, including the bull, has been identified as a constellation. Rome and frontier areas where Roman soldiers were stationed provide most of the evidence for the cult of Mithras (cat. no. 95). This is not to say, however, that local individuals did not embrace Mithras.

Greco-Roman religion was an open system, free of dogma. It was very much embedded in the civic sphere. Its basic tenet was that one should observe prescribed rituals in order to guarantee human existence within prescribed cultural parameters.

85 Altar of the Lares

Early third century C.E.
Antaradus (modern Tartus, Syria)
Bronze, overall height 11⅜ in. (28.9 cm): Tyche, 8 in. (20.3 cm),
lower base, 2 in. (5.1 cm), lower base width 8 in. (20.3 cm),
lower base diameter 6¼ in. (15.9 cm)
Musée du Louvre, Paris. Gift of Henri de Boisgelin, Br 4455

EX COLL.: De Clercq-de Boisgelin, Paris

PUBLISHED: De Ridder 1905a, 55–67, and 1905b, 233–35, no. 328, pl. 52;
Fleischer 1983b, 254, 256–58, fig. 2

This "altar of the Lares" belonged to Louis de Clercq (1836–
1901), who had received it from his friend Aimé Pérétié, of the
French Consulate in Beirut. De Clercq discovered Syria in 1856,
and his ensuing fascination with the country led him over time
to acquire a remarkable collection of terracottas, jewelry, glass,
and bronzes, most of which came from the region's archaeologi-
cal sites.

As soon as the piece was first published, in 1905, it was
pointed out that the upper tier of the exedra-shaped base was
modern. The female figure wearing a turreted crown, clad in
Amazon costume and probably identifiable as Tyche, was there-
fore originally placed, together with the trophy and winged
Victory, on the same level as the two putti standing at the front

on top of ship prows. The original composition must have been
even more tightly knit since the Tyche's right hand likely held a
long object whose extremity is still visible within the trophy's
outer arm; moreover, the figure of Victory would originally
have held a crown above the turreted crown. The semicircular
platform of the original base resembles the types found in the
Antioch excavations and the base with the Aphrodite and Eros
from the Louvre (cat. no. 86).[1]

It is likely that this ensemble, wrongly called an "altar of the
Lares" (i.e., Roman household deities), is loosely based on a
group of cult statues whose iconography originated in the Hel-
lenistic era, probably within the first years of autonomy of
Phoenician cities such as Aradus or Tyre, and was later revived
under the Severan dynasty. Tyche, who was identified with
Astarte in the Syro-Phoenician world, appears crowned with
the ramparts of her city on the reverse of several coins of Bery-
tus, Sidon, and Tyre, all of them issued from the end of the sec-
ond to the beginning of the third century C.E. The deity, which
on most examples is housed in a temple, is crowned by a Vic-
tory standing on a column. Sometimes she is surrounded by
putti and holds a cross-shaped *stilus*, or stern mast (Berytus,
coins of Diadumenianus, 217–18). In other specimens she is
also flanked by a trophy, over which she extends her arm while
holding either a spear or a scepter in her left hand (Tyre, colo-
nial and imperial coins from Julia Domna to Elagabalus and
from Severus Alexander to Gallienus). SD

1. See above, p. 88, fig. 12.

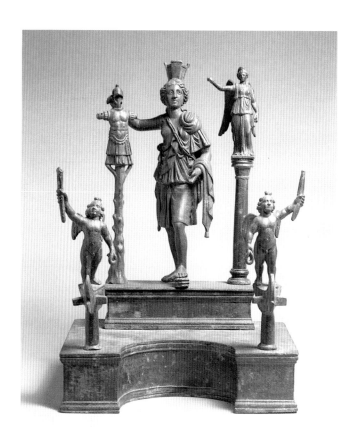

85

86 Aphrodite with Eros

Roman imperial period
Pompeiopolis (modern Viransehir, Turkey)
Bronze, eyes inlaid with white enamel and with a dark sub-
stance for the iris, arms soldered under the armbands, height
17¼ in. (43.8 cm)
Musée du Louvre, Paris. Gift of Henri de Boisgelin, Br 4414

EX COLL.: De Clercq-de Boisgelin, Paris

PUBLISHED: De Ridder 1905b, 21–22, no. 113, pl. 24; Fleischer 1983a, 34,
no. 18, pl. 12-b; Jentel 1984, 159, no. 112

It has been suggested that the claw-footed base with the winged
Eros, although ancient, does not belong with the statuette. It is,
however, entirely in keeping with the characteristic shape of
Aphrodite bases produced in the Syro-Phoenician world. With
their steps and central niche, they were designed to recall the
adyton (sanctuary) of a temple. In fact, two such bases were
found in the Antioch excavations.[1]

The goddess is naked, wearing diadem, necklace, and ear-
rings, and would originally have held a mirror in her left hand

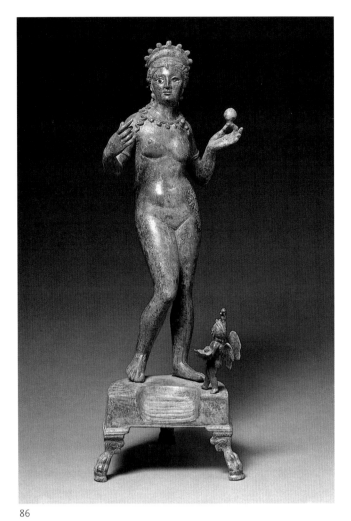

86

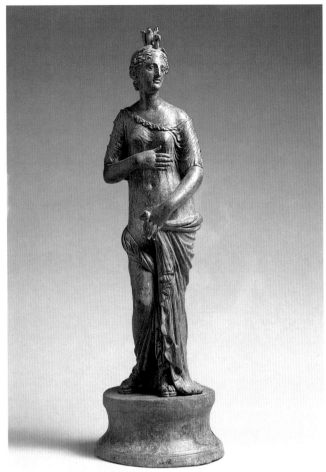

87

and an apple or makeup ball in her right hand. Her posture recalls that of the *Psêlioumênê* or "Aphrodite Fastening Her Necklace," attributed to Praxiteles. This statuette is therefore part of a large series of locally produced Aphrodite figures adapted from the famous statue types of the goddess devised especially from the fourth century into the Hellenistic era (Knidian Aphrodite; Aphrodite Anadyomene, or Hairbinder; Aphrodite the Sandalbinder; Crouching Aphrodite; Modest, with pudic gesture; and *Psêlioumênê*).

Based on contemporary Egyptian documents such as marriage and mortgage contracts, these effigies of the goddess accompanied the bride in her daily life so as to guarantee her happiness and prosperity.[2] Throughout the Mediterranean in the Roman period, brides and mothers made offerings to similar statuettes for the blessings of Aphrodite, such as those guaranteeing fertility and harmony, on their married lives. SD

1. Today they are in object storage at the Art Museum, Princeton University (see p. 88, fig. 12).
2. Burkhalter 1990.

87 Isis-Aphrodite

Roman imperial period
Antaradus (modern Tartus, Syria)
Bronze, eyes of inlaid silver, arms soldered underneath the chiton's sleeves, height 13⅜ in. (34 cm)
Musée du Louvre, Paris. Gift of Henri de Boisgelin, Br 4409

EX COLL.: De Clercq-de Boisgelin, Paris

PUBLISHED: De Ridder 1905b, 42, no. 39, pl. 6; Jentel 1981, 153–54, pl. IV-3; Tinh 1990, 780, no. 255; Milan 1997, 110, no. III.25

The statuette adopts the modest attitude of the Capitoline Aphrodite, a Roman marble copy of a now lost Greek original made during the Hellenistic era that showed the goddess caught in the middle of her ablutions, trying to hide her nudity from prying glances. In this example, however, she is clad in a himation, which she holds in her left hand, as well as in a thin linen chiton whose sleeves are fastened on the arms by means of small rounded fibulae. Her hair is partly obscured by the outspread wings of a brooding vulture, on top of which stand six uraei in the shape of a flower. From this corolla originally emerged the

basileion, the Isiac symbol made of a solar disc flanked by two horns and surmounted by two large feathers.

This is the Isis-Aphrodite type, one among many expressions of Greek-Egyptian religious syncretism, born when the Lagids ruled the land of the Pharaohs. Isis was identified with Aphrodite as early as the third century B.C.E. in Alexandria, but the Syrian iconographic type of Isis-Aphrodite, shown as both modest and clothed, seems to be unknown in Egypt, and one may therefore assume that this bronze from the De Clercq collection is a product of the Syro-Phoenician world.

This statuette originally may have been part of an altar of the Lares, as attested by certain finds from Pompeii. But it is much more likely to have belonged to the *parapherna*, the objects that were part of a bride's dowry and meant for her daily use.[1] Aphrodite's presence in the domestic realm guaranteed happiness and prosperity. SD

1. Burkhalter 1990.

The statuette displays highly refined workmanship, as evidenced by the fine chasing of the locks of hair held by a band before flowing with natural grace over the scale-shaped motifs that form the decoration of the aegis. Such refinement in the treatment of details has led some specialists to conclude that the work should be dated to the Hellenistic period. It is more likely, however, to have been manufactured during the Roman imperial era, when many statuettes of the patroness of skilled craftsmen, soldiers, and the like were included in private households. It stands as the prime representative of a small series of Roman bronze statuettes, among which one comes from Delphi and another from the area of Stara Zagora in Bulgaria.[1] Their chief characteristic is the way the aegis is disposed obliquely, a feature rarely seen elsewhere; they most closely resemble the statue entitled *Athena with a Cist*, a copy based on a work of the Attic sculptor Kephisodotos from the beginning of the fourth century B.C.E. SD

1. Penkova 1981, 1049, no. 3.

88 Athena

First or second century C.E.

Antaradus (modern Tartus, Syria)

Bronze, eyes inlaid with silver, owl's beak of silver; tip of helmet's plume broken, fastening holes for earrings; overall height 12⅞ in. (32.7 cm); statuette height, 9¾ in. (24.8 cm)

Musée du Louvre, Paris. Gift of Henri de Boisgelin, Br 4450

EX COLL.: Pérétié and De Clercq-de Boisgelin, Paris

PUBLISHED: De Ridder 1905b, 205, no. 295, pl. 57; Rolley 1969, 168; Boucher 1976, 139, 140, 382, map 19, pl. 51 (on the type)

Athena/Minerva holds a globe on which stands an owl wearing a cylindrical headdress. The goddess, helmeted, wears sandals and a *peplos* with a long flap that is open on the right side and held tight under the breast by a wide belt. She wears the aegis—her father's gift, adorned with the head of Medusa—fastened at the shoulder just like a *chlamys*. Originally she would have held a spear pointed downward. This reconstruction is based on the presence of both a groove in the palm of her hand and a quadrangular notch on the lower edge of the aegis that was meant to receive the extremity of the lance.

The restrained arrangement of the tunic's folds matches the figure's harmonious weightiness. She stands on a quadrangular base decorated with a continuous egg-and-dart pattern. The way the figure is presented on the base is original, except for the direction: the nineteenth-century restorer neither understood nor followed the solder marks that are still visible on the top of the base. On the front side of the base several striations are discernible under the corrosion layer, indicating that a first inscription may have been erased in antiquity.

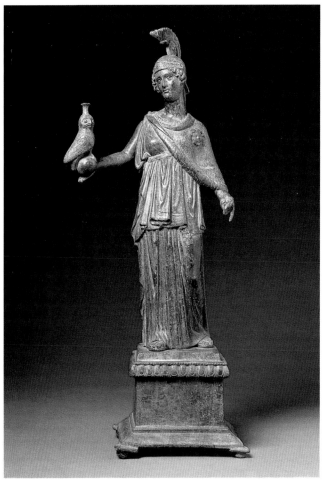

88

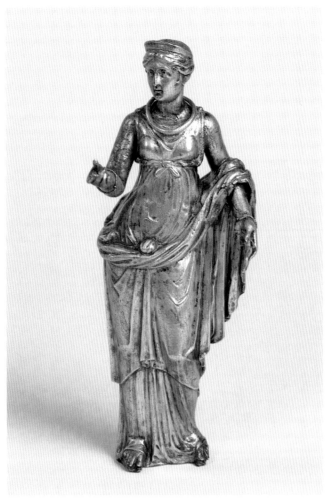

89

This goddess belongs to a large group of silver and bronze statuettes made for private use throughout the Mediterranean. Many of these draped females are based on earlier Greek models, but in pose, dress, and drapery they vary greatly. The swaying drapery that reveals her sensuous torso may support identification with the goddess of love. The added necklace and bracelets of gold hint that her owner was grateful for her blessings and rewarded her with thank offerings. SK

90 Herakles and the Nemean Lion

Fifth century C.E.
Roman or Syrian
Bronze, 6¾ × 2¾ in. (17.1 × 7 cm)
Yale University Art Gallery, New Haven. Maitland F. Griggs Fund, 1960.57

PUBLISHED: Uhlenbrock 1986, pl. 59; Providence 1987, 56–57, no. 16

Wrestling the Nemean Lion was the first of Herakles' twelve labors and is the most popular subject associated with Herakles in Greek art. The lion skin that he preserved as a trophy from this encounter became one of his two primary attributes, the other being a wooden club. Herakles continued as a popular figure in Roman art.

89 Statuette of a Goddess

Late second to early third century C.E.
Lebanon or Syria
Silver, with gold necklace and bracelets, height 12⅛ in. (30.8 cm)
The Toledo Museum of Art. Purchased with funds from the Libbey Endowment, gift of Edward Drummond Libbey, 1971.131

EX COLL.: De Clercq-de Boisgelin, Paris

PUBLISHED: De Ridder 1905b, 201–2, no. 291, pl. 46.3 (before conservation); Reinach 1913; Vermeule 1974, 23–24, no. 75; Oliver 1977, 157, no. 103; Luckner 1978

This hollow-cast statuette is one of the largest such images to survive in precious metal. Like much of his collection, it was acquired while Louis de Clercq was French consul in Beirut. Although her diadem suggests that she is a goddess, possibly Hera, Aphrodite, or Fortuna, she lacks the attributes to identify the divinity securely. Her lowered left arm may have supported a rudder, a palm, or a cornucopia, but her head is turned to contemplate her cupped right hand, which seems more likely to have held a fruit than a cup. She wears chiton and himation, with sandals on her feet.

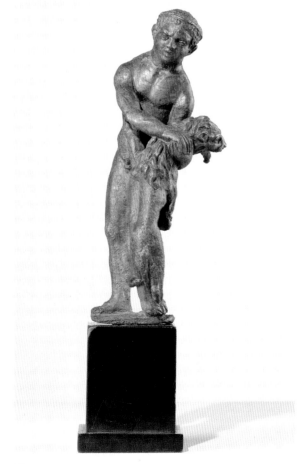

90

Herakles was worshipped as a god in Antioch, where a temple to him is recorded (Malal. 246.13–19), and in other eastern Roman cities. One ancient writer cites Herakles as the founder of Daphne, near Antioch (Malal. 204.9–16), and other sources give Herakleia as an early name for the suburb, although this identification is uncertain. Games in honor of Herakles at Daphne are recorded.

In Palmyra, Herakles takes his place among the local pantheon in reliefs showing images or statues of the gods. He seems to have been equated with Nergal, a god originally imported from Babylonia. In Palmyrene art Herakles appears nude, a sign of divinity in males, standing and bearing his usual attributes. Herakles was especially popular at Dura-Europos, where numerous representations of Herakles and the lion and of the standing Herakles with his lion skin and club adorned houses and military barracks. The hero's popularity with soldiers is not hard to understand. In a domestic context he seems to have been invoked as a protector of property. Small bronze statuettes installed in a household shrine would have served the same purpose. SM

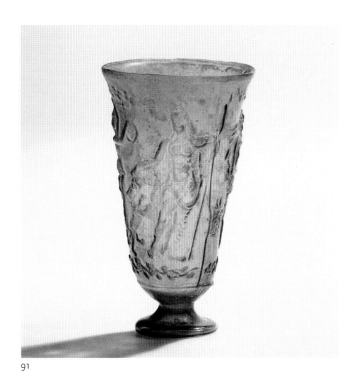

91

91 Drinking Cup with Dionysiac Revel

First century C.E.
Syrian
Mold-blown glass, 6½ × 3¾ in. (16.5 × 9.5 cm)
Yale University Art Gallery, New Haven. The Hobart and Edward Small Moore Memorial Collection, 1955.6.50

Reportedly found in the necropolis of Beroea (modern Aleppo, Syria)

EX COLL.: Kouchakji Frères, New York, 1911; von Gans, 1912; Galerie Bachstitz, The Hague, 1921; Fahim Kouchakji, 1935; Mrs. William H. Moore

PUBLISHED: Matheson 1980, 54–56, no. 136

Dionysos is the focus of this scene of wine-inspired revel. Standing half-draped and leaning on his thyrsus, he gives wine from a jug to the spotted panther at his side. Both the pose and the frontal view of the figure suggest a cult statue. The god's young, effeminate body is typical of representations in Roman art, echoing a Greek statue type current by the fourth century B.C.E. Surrounding Dionysos are three dancing figures: Pan, prancing on his goat legs with his lyre and his pipes; a hermaphrodite with gracefully extended arms; and a maenad, shaking her tambourine while her drapery swirls around her flying feet.

Dionysiac revels with dancing figures like these occur in a variety of decorative art forms from the Roman period, including Neo-Attic marble reliefs and stone relief kraters as well as vessels of silver and pottery. Typically found in domestic contexts, these objects reflect the wine-rich nature of Roman dinner parties. Such revels were also part of Dionysiac religious ritual, however, and the exceptional size of this cup, combined with its evocation of cult statues of Dionysos, suggests that it may have had a ceremonial function. SM

92 Mosaic Bust of Dionysos

c. 325–30 C.E.
Daphne, Constantinian Villa, room I
Marble, limestone, and glass *tesserae*, 46¼ × 46¼ in.
(117.5 × 117.5 cm)
Museum of Art, Rhode Island School of Design, Providence, 40.195

PUBLISHED: Antioch II 1938, 199, pl. 67, no. 87; Morey 1938, 39; Levi 1947, 244–48; Jones 1981, 22; Winkes 1982, 73

The bust of Dionysos was one of eight circular or oblong medallions that served as filling motifs for a meander-and-square pattern that formed the rectangular section of a large pavement covering the reception hall of a house in Daphne; the square segment of the floor is now at the Louvre (Ma 3444). The first image the visitor beheld upon entering the room was that of Dionysos, identified by the spotted skin worn over one shoulder and by the vine wreath (green glass *tesserae*) with a yellow pointed conical headdress.[1]

His followers—-dancing maenads and satyrs, along with Silenos-—fill the other medallions and emphasize the Dionysiac theme of this part of the room. Just at the entrance, right below the bust of Dionysos, was an elliptical medallion depicting the resting Herakles, today in the Princeton Art Museum. Together they form a pendant image related to those of the Drinking Contests represented in two mosaics at Antioch (see cat. no. 55). The prominence of Dionysos is clear from his placement at the center of the room on axis with the octagonal pool at the center of the square composition. The abundance of the earth is lushly illustrated by four standing females bearing the fruits of the four seasons and by sections of pastoral

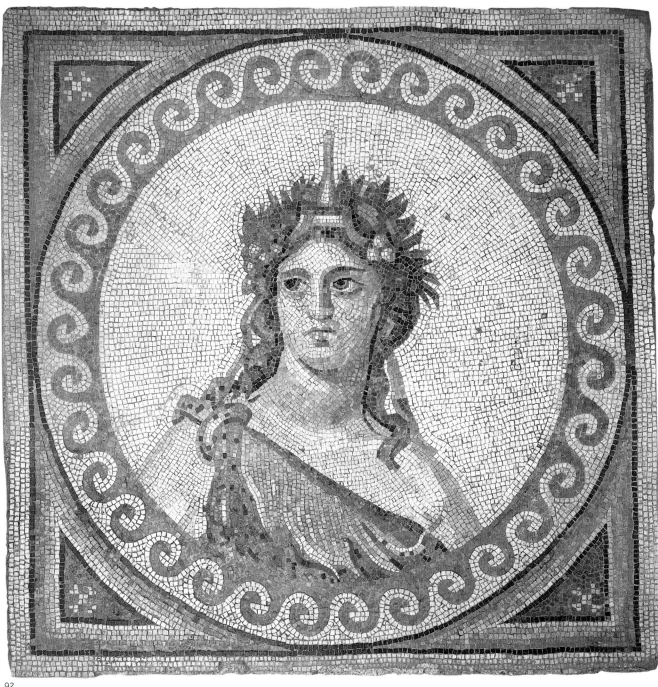

92

and hunting scenes. In this grand two-part scheme the earth and its crops, the seasons, and water are presented as the domain of Dionysos. That the gods are to be thanked for these blessings of fertility is obvious from the scene depicting offerings being made to Artemis, goddess of the hunt, placed directly above the bust of Dionysos. While a floor mosaic was probably not the object of pious worship, such images can reflect the traditions of the inhabitants and their cultural attitudes. The unusual depiction of Dionysos with a conical headdress alludes to his role as renewer of nature. CK

1. Levi 1947, 246–48, examines various elaborate headdresses worn by Dionysos and concludes that this mosaic illustrates the golden miter associated with his mystic cult. More convincing because of its shape and the context provided by the whole mosaic is the identification of the conical projection with a *baetylos* (altar) (ibid., 246). Similarly shaped conical objects are held by members of Dionysiac processions in paintings, mosaics, and reliefs. Its shape and function are related to the phallus and connote fertility. Or perhaps it is an elongated *kalathos*, a vase-shaped basket typically worn by river gods and representations of Earth, which are especially popular in Syrian art.

93 Cult Relief of Atargatis/Cybele and Hadad

Second century C.E.

Dura-Europos, Temple of Atargatis, courtyard

Gypsum with traces of paint, 16⅛ × 11 in. (41 × 27.9 cm)

Yale University Art Gallery, New Haven. Yale-French Excavations at
Dura-Europos, 1930.319

PUBLISHED: Baur 1932, 100–139, pl. 14; Perkins 1973, 94–96, pl. 38;
Downey 1977, 9–11, 173–77, no. 2; Millar 1993, 246–47, cover illustration;
Matheson 1994, 25, fig. 8, no. 56

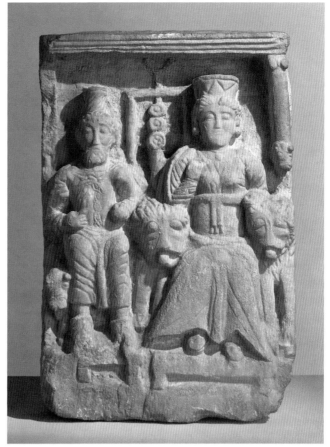

93

The city of Dura-Europos, on the Euphrates River in Syria, was
founded about 300 B.C.E. by one of Alexander the Great's gen-
erals, prospered as a caravan trading city under Parthian rule for
about three hundred years, and served as a Roman military out-
post on the eastern frontier of the empire from 165 C.E. until its
capture by the Sasanians in 256 C.E. The Sasanian Persians
needed to capture Dura in order to get to Antioch, the real
objective of their third-century campaigns. Dura had close eco-
nomic and artistic ties with Palmyra and more limited contact
with Antioch.

Dura-Europos embodied the fusion of Greco-Roman and
Parthian civilizations with indigenous Semitic cultures, a fusion
represented in its mix of religions, languages, and arts. The multi-
cultural nature of the city and its arts offers a view into the wor-
ship of local Syrian deities—Atargatis, Aphlad, Hadad—and fills
a gap in the record for similar practices in Antioch.

As part of the tendency in the Greco-Roman East to con-
flate the Great Syrian Mother goddess—Cybele, or Magna
Mater—with her local manifestations, she is fused in this cult
relief with Atargatis, the version of the Syrian goddess especially
worshipped at Dura-Europos. The Temple of Atargatis at
Dura, from which the relief comes, was a prominent building
in the center of the city built in the first century C.E. Reflecting
the syncretic nature of religion at Dura, the temple incorpo-
rated shrines to numerous other deities within its sanctuary
walls, and it was physically connected with the neighboring
Temple of Artemis, the city's other major civic shrine.

In this relief Atargatis is enthroned beside her consort, the
storm god Hadad, who is shown at a slightly smaller scale. Both
wear the *polos* headdress, symbolic of their fertility aspect. The
goddess's throne is flanked by lions, which were sacred to
Cybele and associated with the Great Mother goddess in the
Near East from the Bronze Age on. Hadad's throne is flanked
by bulls. Between the two figures is a standard similar to that
associated with the cult images of this pair in the principal
sanctuary of the Syrian goddess at Hierapolis. The appearance
of the Dura relief is believed to echo that of the Hierapolis cult
images, and the relief is believed to have served the same ritual
function in the Temple of Atargatis at Dura. SM

94 Relief of Tyche/Atargatis

First century C.E.

Dura-Europos, Temple of Adonis, portico

Limestone, 5⅛ × 10 in. (13 × 25.4 cm)

Yale University Art Gallery, New Haven. Yale-French Excavations at
Dura-Europos, 1935.46

PUBLISHED: Baur 1939, 163–65, pl. 31.1; Perkins 1973, 103–4, pl. 44;
Downey 1977, 47–48, 172–73, no. 33; Matheson 1994, 25, fig. 7, no. 55

The goddess Tyche grew in popularity throughout the Roman
period, when she was often equated with Fortuna. In the east-
ern provinces of the empire Tyche was frequently fused with
Cybele, the eastern Mother Goddess, or with locally favored
manifestations of her, such as Isis in Egypt, Aphrodite at Ephe-
sos, Artemis at Gerasa, and Atargatis at Dura-Europos.

The merging of Tyche with other deities is particularly vivid
in art, where representations combine the attributes of the
deities. This fragmentary relief of Tyche/Atargatis combines
Tyche's city-wall crown with the doves sacred to Atargatis. The
goddess originally sat on a throne, of which only the tops of the
posts on which the doves perch survive. The mural crown indi-
cates that Atargatis served as the Tyche of the city, revealing the

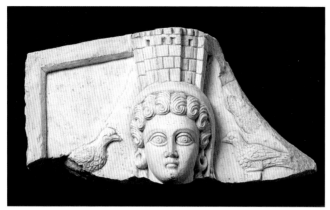

94

ates him with cosmology, astrology, and the constellation named for the Greek hero Perseus. SM

96 Mosaic with Peacocks

c. 526–40 C.E.

Daphne, House of the Bird Rinceau, Upper Level
Marble and limestone *tesserae*, 46 in. × 12 ft. 6 in.
(116.8 × 381 cm)
Worcester Art Museum, 1936.23

PUBLISHED: Antioch II 1938, 186–87; Levi 1947, 366, pl. 181d

This is one of six extant fragments that formed part of the border of a large floor mosaic, nearly 700 square feet in size. The fragments were dispersed to various museums but are here reunited in a computer reconstruction which includes a replication of the interior floral design, rosebuds set against a scale pattern (fig. 1). The other fragments show the continuous vine scroll that grows out of an urn in each corner. Various birds and animals playfully leap within the elliptical compartments created by the turns of the vine. An inside border comprised of twisting ribbon in gray, pink, and yellow is set against a black background. The graded treatment of the colors and the dark background produces a three-dimensional illusion of a fluttering ribbon, which echoes the curves of the scrolling vine.

In the Worcester fragment, two brilliantly colored peacocks face a basket laden with grapes. As they are the only peacocks in this border, the mosaicists intended to highlight their importance. In the Roman world peacocks were linked with immortality and eternal life, probably because they shed their tail feathers in winter and renew them each spring. The overall effect of the animated vine scroll bordering a field of scattered rosebuds is one of abundance.

Although from a private house in Daphne, this colorful mosaic border offers a vivid example of motifs, inhabited vine,

nature of the syncretism between the two goddesses. Dura-Europos also had an unembellished, unsyncretized Tyche, parallel in function to the Tyche of Antioch and probably less powerful than the fused Tyche/Atargatis. Dura's unfused Tyche was portrayed once as male but otherwise as female. Her female manifestations in painting and sculpture show her in a pose derived from Eutychides' statue of the Tyche of Antioch. SM

95 Wall Painting Fragment Showing Mithras and Sol

c. 210 C.E.

Dura-Europos, Mithraeum
Paint on plaster, 23⅝ × 18¾ in. (60 × 47.6 cm)
Yale University Art Gallery, New Haven. Yale-French Excavations at Dura-Europos, 1935.99A

PUBLISHED: Rostovtzeff, Brown, and Welles 1939, 102–3, pl. 13.3; Cumont 1975, 176–77, pl. 29c

Shrines to the god Mithras, called Mithraea, have been found throughout the Roman Empire, from London to Dura-Europos on the Euphrates. The cult was especially popular with soldiers and merchants. The Mithraeum at Dura-Europos was founded by a group of archers from Palmyra in the first century C.E. They may have been influenced by Parthian or other soldiers, for we know of no worship of Mithras at Palmyra. The shrine was remodeled twice, each time with increasingly elaborate wall paintings surrounding the central sculptural representations of Mithras killing the bull. This fragment is from the second phase of the decoration. It shows Mithras dressed in Persian garb, at right, reclining at a banquet with Sol, the sun god.

The Mithraic cult was a mystery religion that featured initiation, a ritual banquet, and the promise of salvation after death. It was open only to men. Mithraic iconography is only imperfectly understood today since without ancient written documentation, interpretation must be based on evidence drawn from archaeology and the art itself. Early interpretations linked Mithras to the Persian god of light, while recent research associ-

95

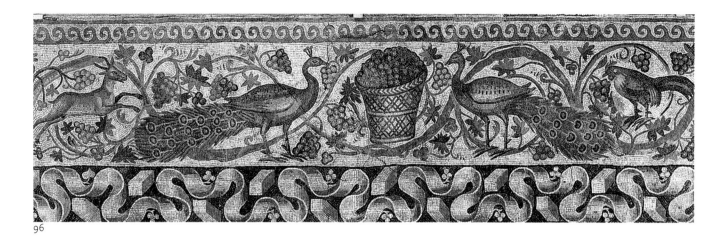

96

Fig. 1. Reconstructed "carpet" mosaic based on the surviving fragments, which were distributed among sponsoring institutions at the time of excavation: *(clockwise from top left)* Baltimore Museum of Art, Worcester Art Museum, Baltimore Museum of Art, Saint Louis Art Museum, Princeton University Art Museum, and the Musée du Louvre. The Worcester fragment (cat. no. 96) is outlined in red and clearly shows that the peacocks were the focus of the design (computer reconstruction: Wes Chilton)

paired peacocks flanking baskets of grapes or wine vessels, which were popular in early Christian art. The motif can be read as a sign of the beauty of God's creation and as a promise of salvation. The frequent appearance of vine scrolls in churches and tombs suggests that the words of John 15:1–5, "I am the true vine . . . the faithful are the fruitful branches in the Lord's vineyard," were echoed in such imagery.[1] Scrolling vines filled with the creatures from land, air, and sea, become the central designs for church floors, especially in the fifth and sixth centuries as illustrated by the nave pavement of the Justinianic Basilica at Sabratha, Libya.[2]

While the mosaic pavements are the most monumental, the motif of inhabited vines appears on precious objects, such as the Antioch Chalice (cat. no. 104), and carved into the stone

Fig. 2. Revetment Panel with Birds, sixth century (Syria). Limestone, 34½ × 31 × 6 in. (87.6 × 78.7 × 15.2 cm). Williams College Museum of Art, Williamstown, Massachusetts, 64.27

reliefs that covered the vertical surfaces of these churches. For example, the limestone revetment panel with two confronted birds within a deeply cut vine was probably part of an altar enclosure from a sixth-century Syrian church (fig. 2).³ Christians must have found in this imagery, repeated in different media throughout church interiors, the signs of God's creation and his deliverance of paradise. CK

1. A Greek inscription "I am the true vine" accompanies a mosaic of a vine loaded with grapes in the fourth-century Basilica of Chrysopolitissa in Nea Paphos; see Maguire 1987, 10, fig. 3.
2. For a discussion about several examples see ibid., 60–66, figs. 68–72.
3. A deeply cut Greek cross (12 in. high) appears on the reverse. Similar openwork effects can be found on the fifth-century architectural fragments from El Bara, see Strube 1983, 595, fig. 25.

97 Head of a Philosopher

c. 275–325 C.E.
Greece (Attica)
Marble, height 18¼ in. (46.4 cm)
Museum of Fine Arts, Boston. J. H. and E. A. Payne Fund, 62.465

PUBLISHED: Comstock and Vermeule 1976, no. 381; Weitzmann 1979, no. 270; Smith 1990, 144 n. 70

"In pagan society of the fourth and fifth centuries C.E., leading philosophers were prominent, influential, even glamorous figures. Cities might turn to them as advisors or spokesmen. . . . Philosophers were also radical defenders of pagan religion."¹ Athens remained the leading center for philosophical training, and many of the prominent philosophers of late antiquity, including Libanios of Antioch, studied there.

Athens also had a major role in formulating and diffusing images of philosophers. Not only were portraits of famous intellectuals of the past copied but a new variation on tradition was developed. Such portraits show aged men with an intensely concentrated expression and elongated proportions—emphasized by their long philosophers' beards. Shaggy eyebrows and short hair or partial baldness are usually a part of the formula. Similar though less powerful portraits are in the museums of Athens and Sparta.² The Boston philosopher's short hair and deeply indented hairline recall fashions during the time of the Soldier Emperors and the Tetrarchy. The combination of beard, shaven head, and indented hairline, in fact, was worn by the emperor Pupienus (238 C.E.). All three of these Greek philosopher portraits, however, show a rough spontaneity and an unacademic quality that suggest an origin after the Herulian sack of Athens in 267 C.E. They have pronounced bags under their eyes, and their lips virtually disappear under their facial hair. The locks of their beards are harshly gouged. The abrupt incisions texturing the hair of the portrait in Sparta, on the other hand, indicate a date no later than the Tetrarchic period, about 285 to 320 C.E. The cross-hatched texturing of hair in the Boston portrait can also be connected with the third-century tradition.³

This type of image was taken over for representations of Saint Paul, who was described as bald and long-bearded. In some small-scale Christian works of the sixth century Paul is shown with this kind of high forehead.⁴ Small marble heads excavated in Constantinople, probably of apostles, show a simplified version of the typology in the late fourth or early fifth

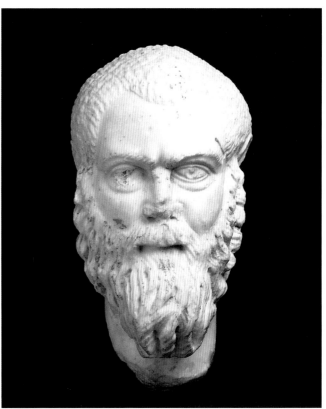

97

century.[5] There is, however, no evidence that the early Christians made such large-scale statues of their saints, and for all their austere intensity, these life-size (in the present case slightly more than life-size) marble portraits from Greece must be considered pagan philosophers. JH

1. Smith 1990, 127.
2. Datsouli-Stavridi 1985, 89–90, no. 2143, fig. 133, and 1987, 24–25, no. 343, fig. 52. For a later descendant of this Athenian tradition, see Meischner 1991, 386, pl. 87; and Rhomiopoulou 1997, no. 144.
3. Cf. Datsouli-Stavridi 1987, fig. 51γ.
4. Weitzmann 1979, nos. 474, 554.
5. Harrison 1986, 157–60, figs. 207–13.

98

98 Chalice

Sixth to seventh century C.E.
Part of the Beth Misona treasure, from Syria
Silver, height 6⅞ in. (17.5 cm), diameter cup rim 5⁷⁄₁₆ in. (13.8 cm)
The Cleveland Museum of Art. Purchase from the J. H. Wade Fund, 50.378

PUBLISHED: Bréhier 1951, figs. 1–2, pls. 18.1, 19.1, 20.2; Milliken 1951; Downey 1953; Ross 1962, 11; Dodd 1973, 18, fig. 9; Weitzmann 1979, 608–9, no. 544; Mango 1986, 228, no. 57; Mango 1992, fig. 12

INSCRIPTION: + ΠΡΕΣΒΥΤΕΡΟΣ ΚΥΡΙΑΚΟΣ ΥΙΟΣ ΔΟΜΝΟΥ ΤΩ ΑΓΙΩ ΣΕΡΓΙΩ ΕΠΙ ΖΗΝΩΝΟΣ ΠΡΕΣΒΥΤΕΡΟΥ (The priest Kyriakos, son of Domnos, [gave this chalice] to Saint Sergios, in the time of Zeno the priest)

This chalice was part of a set of ecclesiastical altar wares that included two other silver chalices and a silver paten in the Cleveland Museum of Art. The inscription on the paten indicates that the set belonged to a church of Saint Sergios in the small Syrian village of Beth Misona, recorded only in this inscription.

All three chalices from the treasure are decorated with similar medallion busts executed in the repoussé technique with chasing and engraving. They represent Christ, Peter and Paul, and the Virgin. Both apostles preached in Syria in the first century C.E. and were particularly venerated there afterwards. This might account for the prominent display of their images on several of these Syrian vessels, as well as on the silver book cover (cat. no. 99).

The chalice featured in the exhibit differs from the other two in the group in three main aspects. The decorated knob that separates the cup from the foot is placed slightly lower, the foot has a narrower flare, and an inscription, rather than a decorative egg-and-palmette frieze, runs around the rim.

The weight of the piece (305 g), as well as that of the two other chalices (332 g and 330 g), is very close to the Roman pound, or libra, of which every single coin denomination in the empire was a given fraction. This should remind one that silver plate in the late Roman and early Byzantine periods was often

Detail of cat. no. 98

used in lieu of state currency, even when it did not bear official stamps. In other words, even sacred objects could, when necessary, serve as a means of payment: this chalice, for example, could have been used to pay for a transaction requiring four gold *solidi* in official coinage.[1] FH

1. On the monetary value of ecclesiastical silver objects, see Mango 1992.

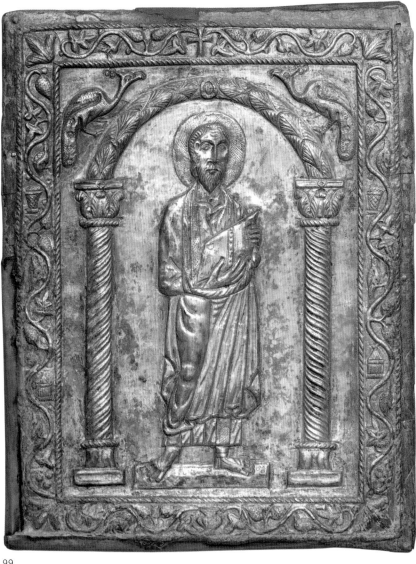

99

99 Plaque with Saint Paul Holding an Open Book

c. 550–600 C.E.

Antioch or Kaper Koraon (?)

Silver with traces of gilt, 10⅝ × 8½ in. (27 × 21.6 cm)

The Metropolitan Museum of Art, New York. Fletcher Fund, 1950, 50.5.1

PUBLISHED: Paris 1931, 127, no. 394; Morey 1937, 36, no. 84; Miner 1947, 86, no. 390; Kent and Painter 1977, 86, no. 149; Weitzmann 1979, 618–19, no. 554; Mango 1986, 199–201, no. 44, with earlier bibliography; Effenberger 1991; Frazer 1992

Saint Paul, like Saint Peter, was honored in Antioch, where they both preached.[1] In the New Testament, Acts 11:26, Saint Paul is described as having taught there for a year, during which time "the disciples were first called 'Christians,'" and at Galatians 2:14 he is described as arguing there with Peter over the nature of the mission to the gentiles. In the Orthodox Church, Saint Paul is considered coequal to Saint Peter and they share the same feast day, 29 June. This plaque is meant to be paired with that of Saint Peter (cat. no. 100); in both size and the design of the border and arch they are nearly identical. Saint Paul can be identified by his long face, receding hairline, and pointed beard. He holds open a book, as if reading rather than preaching, an appropriate image for the author of much of the New Testament.

Since the borders of the two plaques are bent back, possibly to cover a wooden core, they may have formed the covers of a text, possibly one of the epistles written by Paul, such as Galatians, which refers to the presence of both men at Antioch. If the plaques were the covers of a book, it was a highly honored text used in a church. It has recently been suggested that they were part of the treasure of the church of Saint Sergios at Kaper Koraon, or they may have belonged to a church in or near Antioch. If they were used as votive plaques, they may have flanked an image of Christ, for they are turned toward each other, as if to the sides of a central figure. HE

1. See Susan Harvey's essay above, pp. 39–49.

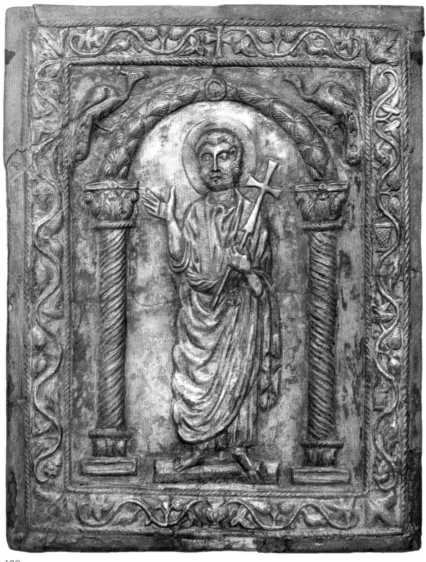

100

100 Plaque with Saint Peter Carrying a Cross

c. 500–600 C.E.

Antioch or Kaper Koraon (?)

Silver with traces of gilt, 10¾ × 8½ in. (27.3 × 21.6 cm)

The Metropolitan Museum of Art, New York. Fletcher Fund, 1950, 50.5.2

PUBLISHED: Paris 1931, 127, no. 393; Morey 1937, 36, no. 83; Miner 1947, 86, no. 390; Kent and Painter 1977, 86, no. 148; Weitzmann 1979, 618–19, no. 554; Mango 1986, 202–5, no. 45, with earlier bibliography; Effenberger 1991; Frazer 1992

On the plaque stands a man recognizable as Saint Peter by his round face and short hair and beard. Although martyred in Rome, Peter, like Paul, was intimately associated with Antioch, where both preached.[1] Here he appears with his right hand raised as if speaking. The cross he carries in his left hand is of the type used in church processions and may identify him as preaching in a church. At his waist is a set of keys, the keys to the kingdom (of Heaven) given him by Christ (Matt. 16:19). Since the honorific arch beneath which he stands, topped by a small cross and flanked by peacocks, is of the type often identified as symbolic of heaven, the whole may represent a promise of access to heaven (salvation) through the teachings of Peter and the church. The vine scroll decorating the border of the plaque is inhabited with open bird-cages and birds, images often identified as representing saved souls. Traditionally this plaque and that of Saint Paul (cat. no. 99) have been identified as a pair of book covers. Recently it has been suggested that they and similar plaques in the Sion Treasure, from the village of Kumluca (ancient Korydalla) in southern Lycia in present-day Turkey, perhaps were used as revetments on church furnishings or as individual votive plaques. Metal votive plaques, or icons, of the period are known from other regions of the Byzantine world. HE

1. See Susan Harvey's essay above, pp. 39–49.

101–3

ing platters, plates (cat. nos. 72 and 75), bowls, ewers (cat. no. 71), and dishes and cups of many other shapes to accommodate the serving and consumption of food and drink, were grand displays of the owner's taste and wealth. By including the names of apostles on these spoons, Domnos expressed his Christian faith, in no way to be seen in conflict with the costliness of the silver itself. It is also possible that he intended to donate the spoons to a church, perhaps in his will, and the apostles' names arguably would have made the transfer from secular to ecclesiastical ownership not only appropriate but praiseworthy as well. SRZ

101–3 Three Inscribed Spoons

Sixth or seventh century C.E.
Constantinople or Antioch (?)
Silver, length 10½ in. (26.7 cm); weight, from top to bottom, (Peter) 83.3 g, (Paul) 77.7 g, (Matthew) 85.5 g
Dumbarton Oaks, Washington, D.C., 37.38, 37.39, 37.41

Reportedly found near Antioch

PUBLISHED: Diehl 1930; Paris 1931, no. 375; Fogg 1945, 108; Dumbarton Oaks 1955, no. 131; Ross 1962, no. 13; Dumbarton Oaks 1967, no. 72; Bruce-Mitford 1983, no. 1, 137; Cahn and Kaufmann-Heinimann 1984, p. 80, figs. 46.5 and 46.6, p. 84, fig. 48, no. 81, p. 86; Mango 1986, nos. 52, 53, 55; Hauser 1992, 43–44, nos. 139, 140, 142

These elegant spoons are composed of three parts: a slender handle ending in a boar's head, an elongated bowl, and an intermediary disk. Whereas all three disks display the same engraved monogram (deciphered as "of Domnos") between small crosses, inscriptions just behind the boars' heads are different, conveying "the Blessing of Saint Peter," "the Blessing of Saint Matthew," and "the Blessing of Saint Paul."

These are three of seven matching spoons, all originally the property "of Domnos" and presumably made for him. The inscriptions on the four other spoons mention the blessing of Saints Thomas, Luke, Mark, and Philip. There were probably several more spoons, naming other apostles, perhaps enough to make up a set of twelve. Although Paul and Mark were not among the original twelve apostles, their missions and writings were of such import that they were often included in groups of Christ's disciples. Antioch had early ties to the disciples of Christ, especially Peter, Paul, and Matthew, who surely remained preeminent for the Christian community there.

Spoons were a usual part of the luxury tableware used throughout the Roman Empire. These luxury services, includ-

104 Antioch Chalice

c. 500–550 C.E.
Antioch or Kaper Koraon (?)
Silver and silver gilt, height 7¾ in. (19.7 cm), diameter cup rim 7⅛ in. (18.1 cm), diameter foot rim 2⅞ in. (7.3 cm)
The Metropolitan Museum of Art, New York. The Cloisters Collection, 1950, 50.4

Reportedly found at Antioch in 1910; restored by Leon André, Paris, in 1913; displayed by its owners, Kouchakji Frères, as the Holy Grail at the Chicago World's Fair in 1933; sold to The Cloisters in 1950

PUBLISHED: Eisen 1923; Weitzmann 1979, 606–8, no. 542; Mango 1986, 183–87 no. 40, with earlier bibliography; Effenberger 1991

When it was discovered at the beginning of the twentieth century, the "chalice" was reported to have been found in Antioch, a city so important to the early Christians that it was recognized with Rome and Alexandria as one of the great sees of the church. Its plain silver interior bowl was identified as the Holy Grail, the cup used by Christ in the Last Supper. The elaborate gilded rinceau-patterned, footed shell enclosing it was thought to have been made within the first century after the death of Christ to encase and honor the Grail.

The fruited grapevine forming the rinceau pattern of the shell is inhabited by birds, including an eagle with wings spread; animals, including a lamb and a rabbit; and twelve human figures holding scrolls and seated in high-backed chairs. Two of the figures are thought to be images of Christ. The other ten figures have been variously identified as ten of the twelve apostles or philosophers of the classical age who, like the prophets of the Old Testament, foretold the coming of Christ. The sixth-century chronicler Malalas of Antioch was among those who sought to make such links between Christianity and classical philosophy.

While the identification of the "Antioch chalice" as the Holy Grail has not been sustained and its authenticity has even been challenged, the work has traditionally been considered a sixth-century chalice meant to be used in the Eucharist. Most

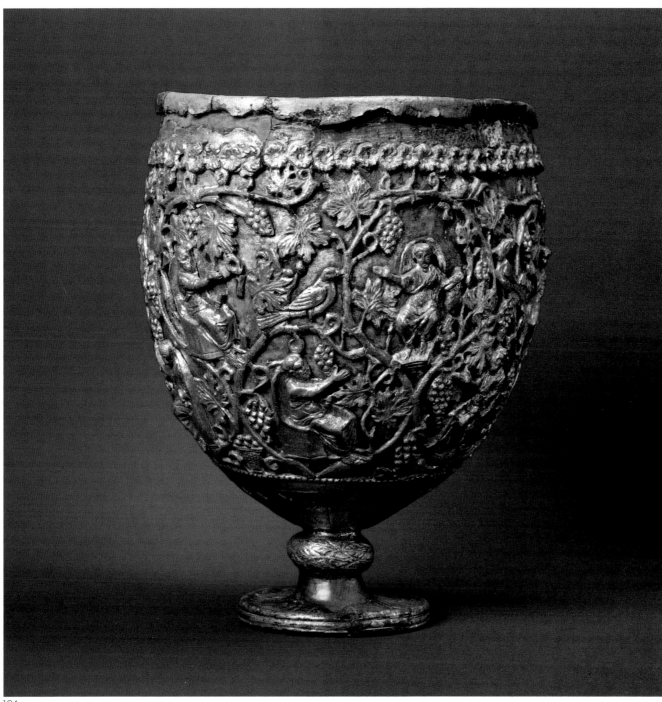

104

recently its shape has been recognized as more closely resembling that of sixth-century standing lamps and decorated possibly in recognition of Christ's words "I am the light of the world" (John 8:12). It has been argued that the chalice was part of a treasure of liturgical objects belonging to the church of St. Sergios in the town of Kaper Koraon, southeast of Antioch, found in 1908. If this is true, the church's parishioners may well have traveled to Antioch to purchase such an item for their church as a type of tithing. Or it may have been used in one of the churches in or near Antioch. HE

105

two men, as shown in a silver plaque from the "Antioch Trea-sure" that is now in the Metropolitan Museum of Art.

The fragments of the silver revetments for the large cross, restored first in 1913 and again in 1953, have now been remounted by the Objects Conservation Department of the Metropolitan Museum of Art. (They are shown here before this latest restoration.) The arms of the cross have been extended to accommodate the full text of the original inscriptions and the once gilded medallions featuring busts of Christ, now in the Louvre (cat. no. 106), that originally decorated each face at the crossing of the arms. The inscription on the face of the cross (illustrated) is the Trisagion, the thrice-holy hymn referring to the Trinity that the Monophysites argued was developed in Antioch. The inscription on the reverse records the gift of the cross as the fulfillment of a vow by Herodotos and Komitas, sons of Pantaleon. Many Byzantine crosses carry similar dedica-tory inscriptions. HE

105 Monumental Cross

Sixth century C.E.
Antioch or Kaper Koraon (?)
Silver over wood, 58½ × 38½ in. (148.6 × 97.2 cm)
The Metropolitan Museum of Art, New York. Fletcher Fund, 1950, 50.5.3

Reportedly found in Antioch in 1910 along with the other works of the "Antioch Treasure" including the "Antioch chalice" (cat. no. 104); sold to the Metropolitan Museum of Art by the Kouchakji Frères in 1950.

PUBLISHED: Paris 1931, 128, no. 397; Morey 1937, 35, no. 82; Miner 1947, 86, no. 389; Downey 1954; Mango 1986, 192–97, with earlier bibliography, no. 42a–c; Effenberger 1991; Meyers 1992

INSCRIPTION: Side 1, "God is Holy, the All-Powerful is Holy, the immortal is Holy, Have mercy on us"; side 2, "In fulfillment of a vow of Herodotos and Komitas [sons] of Pantaleon."

This cross is one of the largest to survive from the early Byzan-tine period. Only descriptions remain of the contemporary monumental crosses recorded in travelers' accounts of Jerusalem. At the Holy Monastery of St. Catherine in Sinai there is a large brass sixth-century cross. Archaeological evi-dence in Syria suggests that monumental crosses were mounted to be displayed before church altars. This cross may have been similarly located if, as recently suggested, it was part of the treasure of the city of Kaper Koraon. If it was carried in church processions, its weight may have required that it be carried by

106a

106b

106 Medallions

Sixth century C.E.
Antioch or Kaper Koraon (?)
Silver, diameter 5¼ in. (13.3 cm); and 5 in. (12.7 cm)
Musée du Louvre, Paris, Bj 2258, Bj 2259

PUBLISHED: Mango 1986, 192–97; Paris 1992, 119, no. 66

Two medallions showing busts of Christ in relief once marked the center of each side of the monumental cross now at the Metropolitan Museum of Art (cat. no. 105). The projections along the vertical axis reveal the system by which the medal-lions were fitted over the silver sheathings of the cross arms. The busts are set within a circle of large beads and conform to what is known as the Syrian type of Christ, with a triangular face and curly hair, but only one has the characteristic short beard; the other is beardless. Traces of gold leaf remain on the halo, garments, books, and beads. CK

The Church Building at Seleucia Pieria

W. Eugene Kleinbauer

A large central-plan building some 120 feet in diameter was excavated in 1938 and 1939 at Seleucia Pieria, the harbor of Antioch.[1] Located just inside the Roman walls of the city, it occupied a prominent position, a short distance west of the principal colonnaded street leading to the harbor and not far from the Market Gate. The building had been razed almost to its foundation, but its plan could be reconstructed from the excavated remains (fig. 1). It can be described as a freestanding double-shelled tetraconch, with a sizable square presbytery and apse projecting toward the east. The interior shell of the tetraconch consisted of four columnar exedrae more than twenty-six feet wide with L-shaped piers at the corners. The piers, none of which formed a true right angle, supported a pyramidal timber roof, or more likely a wooden dome, about forty-one feet in diameter and of indeterminate height. Timber ceilings covered the ambulatories. The eastern exedra featured eight columns, while each of the other three contained seven columns.

The columns bore capitals carved with windblown acanthus leaves. The perimeter walls of the structure were concentric with the inner shell, and the outer faces of its curved walls were articulated by applied columns placed upon pedestals; capitals were carved with angels, chalices, or birds. The excavations brought to light numerous fragments of marble revetments, some with champlevé decoration, which display standing figures and Old and New Testament themes (see cat. nos. 107–12). The inner tetraconch was paved in marble, while the ambulatories were decorated with splendid mosaics of animals. No discernible traces of wall mosaics turned up at the site.

The tetraconch witnessed two building periods. It was originally constructed near the end of the fifth century and was rebuilt once, probably immediately after nearby Antioch was devastated by a great earthquake in 526. The rebuilding of the tetraconch included the additions of a baptistery on the north side of the eastern chancel and a sacristy on the south side.

The most prominent liturgical feature of the church was a U-shaped marble bema about fifty feet long that was raised inside the inner tetraconch, on the longitudinal axis of the

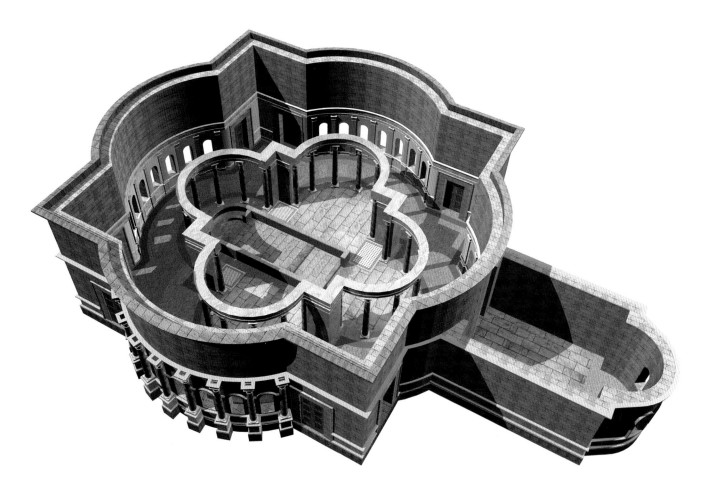

Fig. 1. Axonometric plan of the church building at Seleucia Pieria, based on the excavated plan of the now-buried building. Architectural details are taken from comparable sites in the region (computer model: James Stanton-Abbott)

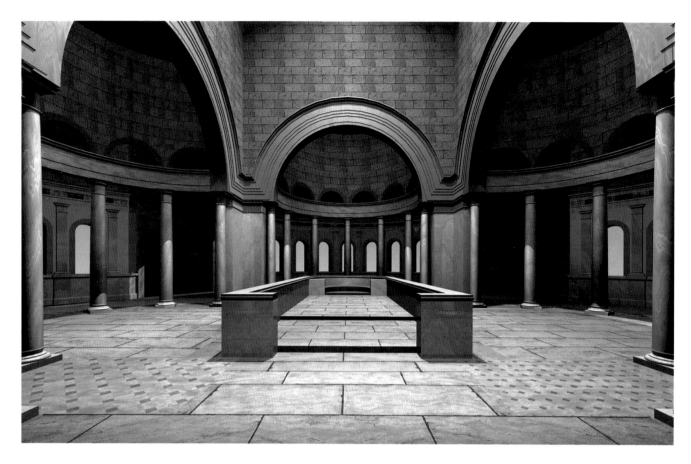

Fig. 2. Reconstructed view into the center of the church building, which contained a U-shaped marble altar, or bema (computer model: James Stanton-Abbott)

structure, facing west (fig. 2). Such bemas are widely known in church buildings in northern Syria, and their precise liturgical functions continue to be debated. Although the structure is often called a martyrion, denoting a building honoring Christ or a saint, no evidence of a body or relics is associated with the site. It is more likely that the edifice served as the local cathedral.

1. This description draws from Kleinbauer 1973.

The Mosaic Pavement of the Church Building at Seleucia Pieria

Christine Kondoleon

A reconstructed plan with the floor mosaic inserted has been produced for the church building at Seleucia Pieria, the port city of Antioch (fig. 1). The plan allows us to visualize the immense scale and the rhythm of the original mosaic pavement relative to the size and shape of this aisled tetraconch church of the late fifth or early sixth century. Only the pavement of the north side of the

ambulatory and a part to the east survived in fragmentary condition.[1] The mosaic portrays a continuous procession of animals loosely arranged in two rows, with the quadrupeds along the outside edge facing toward the exterior walls of the church and the creatures toward the center, mainly birds, facing the columnar exedrae; trees, scattered roses, and shrubs punctuate the parade. In their sheer variety the birds (peacocks, flamingos, cranes, swans, ducks, parrots) and animals (elephants, gazelles, zebras, hyenas, giraffes, deer, horses, a lioness with her cubs) seem to offer a catalogue of species. The composition recalls several earlier mosaics in North Africa enumerating the beasts gathered for spectacles in the amphitheater. The elephant and the zebra, for example, could well have been excerpted from compositions of staged hunts, but given the context of an ecclesiastical structure, they are here inflected with a Christian meaning.

Sermons on Genesis, several written by church fathers residing in Antioch, from Theophilus of Antioch in the second century to John Chrysostom in the fourth century, provide a compelling correspondence with the composition of this mosaic.[2] Many of these commented extensively on man's relationship to the earth and its creatures and reflected on life before Adam's Fall. The parade of animals may be a reference to paradise, where all beasts are tame and peaceable and subject to Adam's command (sermon on Genesis 1:28 by John Chrysostom); even the large-scale ele-

phant, nearly five feet high, seems very benign. Moreover, such a collection of beasts evokes the game parks *(paradeisoi)* kept by Roman aristocrats and the representation of them on the garden walls of Roman townhouses.

A slight variation on this interpretation might be sought in the *Hexaemeron*, a commentary on the first six days of Creation, first preached in 378 by Saint Basil the Great, who described the wonders of Creation in order to convey the greatness of the Creator. An analogy to this text can be found in the nave mosaic of Saints Cosmas and Damian at Gerasa, in Jordan, dated by inscription to 533 C.E., which includes a large collection of species that inhabit the land and air, including many of the same birds and beasts shown on the Seleucia floor.

Among the works produced by the Antioch workshop, the Seleucia church pavement belongs compositionally to the group of great hunt floors found in private houses and represented in this exhibition by the Honolulu Hunt (cat. no. 43) and the Worcester Hunt (p. 66, fig. 2). Animal "carpet" mosaics first appeared in the third century in North Africa (Carthage, El Jem); they probably did not appear in the Roman East before the second half of the fifth century (Apamea and Antioch). The evolution of this spectacular and inventive series of mosaic floors, certainly the most celebrated of the Antioch mosaic finds, was ambitiously and thoroughly laid out by Irving Lavin in 1963.[3] Whereas Lavin was more concerned with tracing the development of the figure and animal

carpets as compositional types, other scholars found the hunt mosaics intriguing in terms of what the owners wanted to say about themselves. The courage *(virtus)* of the hunter, hunting as a sport of the wealthy, and the ownership of game parks are all implied in these large-scale hunting pavements and associated with the *dominus*. In animal carpets adapted to Christian buildings the beasts are often tame, and the meaning transfers rather easily to imply the domain of the Lord, the world of Creation. The Seleucia mosaic represents a rather seamless transition of the hunt theme from the house of the Roman *dominus* to the house of the Christian Lord. The boundaries between secular and religious imagery were quite permeable in this transitional phase of art.[4]

1. Today this mosaic is set into the courtyard of the Hatay Museum in Antakya; its condition is poor due to weathering.
2. Maguire 1987 provides a well-documented survey of the common pattern of ideas that underlies both these Christian textual traditions and selected early Byzantine pavements. Although it fits well into his discussion, Maguire did not include the Seleucia mosaic in his analysis.
3. Lavin 1963 is still the definitive study.
4. This is well demonstrated by the fragment of a border mosaic from Daphne, now at the Worcester Art Museum, showing the two peacocks at either side of a basket of grapes (see cat. no. 96). This theme appears frequently in Roman art and was easily adapted by the Christians because of Christ's statement, "I am the true vine" (John 15:1).

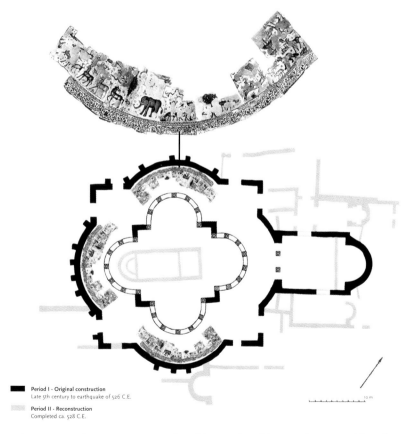

Period I - Original construction
Late 5th century to earthquake of 526 C.E.

Period II - Reconstruction
Completed ca. 528 C.E.

Fig. 1. Plan of the church building at Seleucia Pieria, showing a reconstruction of the remains of the mosaic pavement from the north aisle, or ambulatory. The mosaic pavement would have continued around the entire ambulatory; the remainder of the building, including the area in front of the east chancel, was paved with marble (plan and photo composite: Wes Chilton, Mary Todd, and Victoria I)

The Relief Decoration of the Church Building at Seleucia Pieria

Susan Boyd

Among the more distinctive discoveries of the Antioch excavations were the large number of low-relief inlaid marble revetments carved in the champlevé technique. These were found in and around the city of Antioch, but the largest and most important group was found in the ruins of the large aisled tetraconch church at Seleucia Pieria that continues to be known as the Martyrion even though there is no firm evidence to confirm its function as a memorial church, as described by Kleinbauer, above.[1]

Champlevé revetments were apparently one of the principal means of mural decoration in this church, and the importance of these reliefs rests both on their unusual inlaid technique and the fact that many of them are decorated with Christian subjects. These once colorful two-dimensional reliefs were created by carving the outline of the main design on a thin marble plaque (about two to six centimeters thick) and then roughly chiseling away the background to a depth of two to three millimeters, leaving the design reserved in flat relief. Details were then incised, and the rough background was filled with a colored material (a mixture of lime, resin, and natural pigments) in red, black, green, or blue, producing a highly decorative effect, as seen in the color reconstructions for cat. nos. 107 and 110.[2] While many fragments bear traces of either red or black color, none of the inlaid material is preserved. Evidence from sites other than Antioch indicates that parts of these reliefs were once gilded, which was not uncommon in early Byzantine architectural sculpture.

The interior walls of the Martyrion were originally sheathed in marble, into which the polychrome champlevé reliefs were placed, serving to accent and enliven the expanse of plain marble revetment (see fig. 1). Champlevé carving clearly imitated the more precious and more costly *opus sectile* technique, in which pieces of colored marble were cut to make up the design. In the Martyrion, architectural features such as capitals and bases for pilasters were carved in the champlevé technique, as were friezes of several different sizes, individual plaques, and coping blocks. Although archaeological evidence for the original placement of the champlevé reliefs is lacking, they were probably placed on the interior walls of the ambulatory and the bema, and some of the friezes may have been placed on the entablature of the inner colonnade.

The majority of the champlevé reliefs have as their subject matter a wide variety of birds, fish, and animals, the latter including lions, tigers, leopards, rabbits, horses, deer, goats, and rams (including the exceptional example with three bodies and one head, cat. no. 109). Most of the animals are from friezes, sometimes arranged within vegetal scrolls, sometimes as a single animal separated from the next by an intricate meander design. What is exceptional, however, is that figural subjects constitute roughly a third of the fragments, some of which are pastoral scenes (cat. no. 110), and many of the fragments have specifically Christian subjects, including biblical scenes drawn from the Old and New Testaments. Based on the Old Testament is the scene of Joseph in prison (cat. no. 108), which was clearly part of a longer narrative because the arches of the architectural background continue left and right to frame additional scenes. Drawn from the New Testament are figures of standing archangels, figures of saints identifiable by their halos, a plaque with the apostle Paul standing beside a wreath enclosing a cross that presumably had Saint Peter on the other side (cat. no. 107), and an imposing life-size icon of Christ. These reliefs, which rely on a complex and wide-ranging selection of Old and New Testament subjects, represent the earliest program of Christian figural decoration discovered at Antioch.

The date of these reliefs depends on the building phase of the church they are associated with. The original church was most likely constructed in the last quarter of the fifth century, sometime after 458, when a severe earthquake struck the city. About fifty years later, in 526, an even more severe earthquake destroyed a large part of the walls and superstructure of the church; and a less severe quake followed in 528. Archaeological evidence demonstrates that the reconstruction of the church commenced after the 526 earthquake but that additional damage resulted from the second. If the champlevé revetments had belonged to the late-fifth-century construction of the church, these thin plaques, attached only with mortar and clamps to the surface of the wall, would surely have been destroyed in the earthquakes of 526 and 528. Therefore, they must have been carved to decorate the interior of the church when it was rebuilt in the second quarter of the sixth century.[3]

When the Martyrion was excavated in 1938 and 1939 champlevé carving was virtually unknown as a means of interior mural decoration, and these reliefs were considered to be exceptional. Since that time a great many examples of this technique have been discovered in Syria and Palestine, as well as throughout the Mediterranean basin, dating from the third to the seventh century. A very large number of champlevé fragments have been discovered in recent years at numerous sites in Cyprus, especially Kourion and Amathus, where several workshops were active from the early fifth century through the sixth century.[4] The technique clearly had a long history before champlevé was produced at Antioch. Nevertheless, Christian figural subjects like those on the Antioch champlevé are relatively rare even in Cyprus, where champlevé carving was such a popular sculptural technique. On the other hand, in view of the two impressive champlevé reliefs with Christian subjects in the Louvre, one with the standing figure of Saint Leontius in a richly decorated chlamys, the other with a figure of an archangel, the apparent rarity of Christian subjects may be due to the accident of survival.[5]

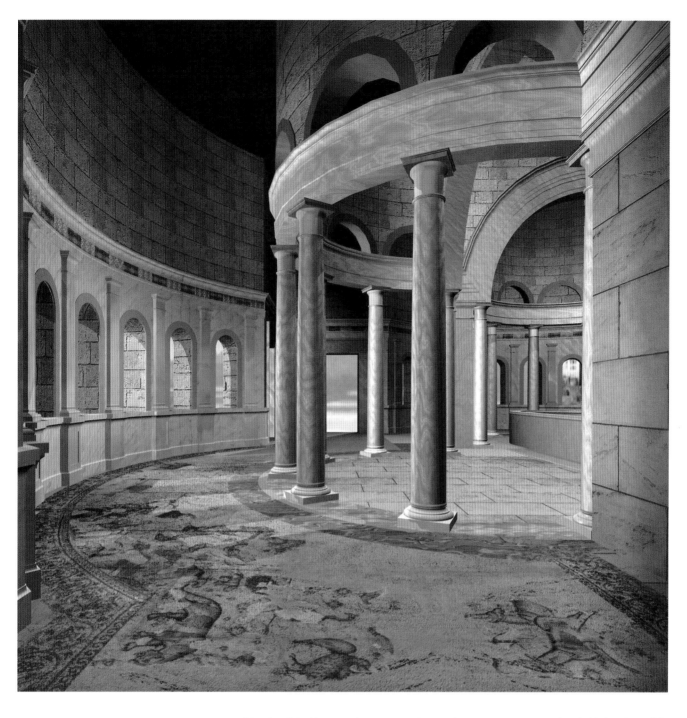

Fig. 1. Reconstructed view of the south ambulatory of the church building at Seleucia Pieria, showing the mosaic pavement and probable locations of decorative reliefs. The entablatures likely held colorful marble reliefs in the champlevé technique (see cat. nos. 107–10), while the bases of pilasters were decorated with raised reliefs (see cat. nos. 111–12) (computer model: James Stanton-Abbott)

In addition to the numerous champlevé revetments, bas-relief revetments also revetted the Martyrion.[6] These included a wide range of biblical figures and scenes drawn exclusively from the Old Testament, of which only two examples figure in the exhibition: the standing figure of the prophet Daniel praying (cat. no. 111) and a warrior with shield and spear, possibly Goliath (cat. no. 112). Because several of these reliefs functioned as pilaster bases and would thus have been located on the lower walls of the church, Richard Stillwell suggested that they decorated the late-fifth-century church and were replaced by the champlevé revetments in the sixth century.[7]

The bas-relief and the champlevé carvings are of great interest

because they form the only extant program of Christian figural sculptures found at Antioch and because such a variety of themes from the Old and the New Testament are represented.

1. Campbell 1941, 35–54; Richard Stillwell, "Catalogue of Sculpture," in Antioch III 1941, 124–25, 127–34, nos. 390–522, pls. 17–29, and 133, figs. 94–98 (the Martyrion champlevé reliefs); Weitzmann 1941, 135–49. For the champlevé reliefs from Antioch and nearby, see Antioch III 1941, 169, nos. 216–18, pl. 43 (Antioch); 123, cat. nos. 333–35, pl. 13; 155, no. 49, pl. 34; 169, nos. 220–29, 232a–b, 234, 235, pl. 43 (Daphne-Harbie); 170, nos. 237–38, pl. 43 (without provenance). See also Ćurčić and St. Clair 1986, 43ff., nos. 7–14 (with earlier bibliography); and Dresken-Weiland 1995, 719–26, pls. 94 and 95c–d.

2. Substantial fragments of inlay survive on a group of champlevé reliefs found at Resafa-Sergiopolis. Samples of red and black were analyzed, and the results indicate that they were a mix of lime and resin with organic pigments (see Ulbert 1986, 67 n. 117).

3. Campbell 1941, 53.

4. Boyd 1999, 49–70 (with bibliography). A listing of all sites where champlevé reliefs have been found (with bibliography) will appear as an addendum to Boyd forthcoming.

5. Metzger 1980, 545–61. Other champlevé reliefs with Christian subjects have been found in Cyprus, Asia Minor, and Chersonesus.

6. Antioch III 1941, 124–27, nos. 368–89, pls. 17–19; Ćurčić and St. Clair 1986, nos. 5–6.

7. Antioch III 1941, 125.

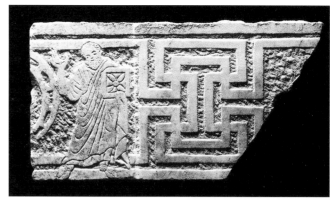

107

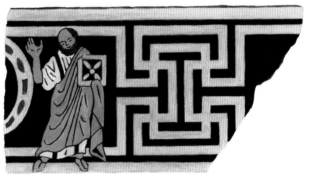

Computer reconstruction of cat. no. 107 showing polychrome decoration

107 Meander Frieze with Saint Paul

c. 525–50 C.E.

Marble, 19½ × 10¼ in. (49.5 × 26 cm)

The Art Museum, Princeton University, c543-S650

108 Joseph in Prison

c. 525–50 C.E.

Marble, 17½ × 10¼ in. (44.5 × 26 cm)

The Art Museum, Princeton University, c515-S630

109 Three Rams

c. 525–50 C.E.

Marble, 10¼ × 1½ in. (26 × 3.8 cm)

The Art Museum, Princeton University, c769-S769

108

109

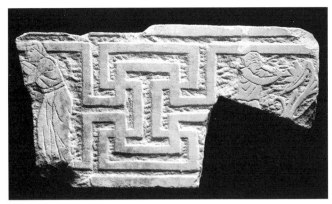

110

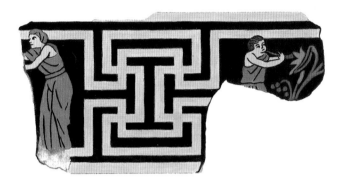

Computer reconstruction of cat. no. 110 showing polychrome decoration

111

112

110 Meander Frieze with Shepherd Playing Flute and Female Figure

c. 525–50 C.E.
Marble, 10¼ × ½ in. (26 × 3.8 cm)
The Art Museum, Princeton University, c671-S691

111 Daniel

c. 525–50 C.E.
Marble, 18¼ × 10¼ in. (46.4 × 26 cm)
The Art Museum, Princeton University, c503-S623

112 Goliath

c. 525–50 C.E.
Marble, 13 × 9 in. (33 × 22.9 cm)
The Art Museum, Princeton University, c799-S799

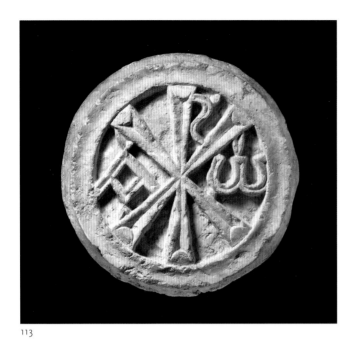

113

113 Architectural Boss with Christogram

Late fifth or early sixth century C.E.

Northern Syria

Limestone, 14 × 2⅝ in. (35.6 × 6.7 cm);

depth of relief ⅝ in. (1.6 cm)

Dumbarton Oaks, Washington, D.C., 45.7

Acquired in Beirut

PUBLISHED: Dumbarton Oaks 1946, no. 40; Dumbarton Oaks 1955, no. 46; Dumbarton Oaks 1967, no. 25; Vikan 1995, no. 32

This impressive roundel is deeply carved with the Christogram, the symbol formed by superimposing the first two Greek letters of Christ's name: X *(chi)* and P *(rho).* To it are added the first and last letters of the Greek alphabet, *alpha* and *omega,* alluding to the resonant verse in Revelation 21:6: "I am the Alpha and the Omega, the beginning and the end." Taken together, the letters express one aspect of the Christian understanding of Christ's unity with God, the creator of humankind and the judge at the Last Judgment.

Similar medallions are found carved into a variety of locations in central and northern Syria. They appear in churches, baptistries, homes, and shops, as well as on fortifications and tombs. They were located on door lintels, arches, columns, capitals, friezes, and walls. Because of its thickness, this roundel presumably was placed on a wall. What the different locations of the medallions share is their high visibility, intended to show both any passerby and especially any malevolent spirit(s) in the vicinity that the site was under the protection of Christ. Some examples of this symbol are accompanied by inscriptions that make their amuletic function explicit. The invocations mention protection, victory,

and related concepts, revealing that the Christogram with *alpha* and *omega* was considered a powerful emblem of physical and spiritual safety in this area of Syria. SRZ

114 Reliquary Lid

Late fifth to sixth century C.E.

Antioch

Marble, 3⅝ × 10½ × 14 in. (9.2 × 26.7 × 35.6 cm)

Dumbarton Oaks, Washington, D.C., 40.46

Acquired by gift or purchase during the Antioch excavations

PUBLISHED: Antioch III 1941, 124, no. 362; Dumbarton Oaks 1946, no. 16; Dumbarton Oaks 1955, no. 20; Vikan 1995, no. 30

The two equal-armed crosses in relief on the sides of this marble "roof" signify its Christian character. In shape it imitates the lid of a full-size sarcophagus with gable ends and corner acroteria. The size of this lid indicates that it originally covered a small marble box known as a reliquary, which held the remains of one or more saints. A hole on one side of the lid allowed oil or balm to be poured into the reliquary; contact with the holy remains gave the substance special spiritual and healing qualities. The enriched oil was released through a hole near the bottom of the box and distributed to those who worshipped at the site of the reliquary.

In and around Antioch such box reliquaries were often displayed in chapels dedicated to martyr saints, presumably the saints whose remains the reliquary held. For example, the remains of local Antiochene saints, such as Babylas, Thecla, or the Stylites, may well have been interred in this manner. Christians prayed to these saints for succor and protection, and if they visited the sites where their reliquaries were kept, they might on occasion take away some of the sanctified oil as a memento of the visit or as medication for healing physical ailments. The beneficent results expected from being in the "presence" of a saint encouraged pilgrimage, and this network of travels extended the influence of many "local" saints to far-flung parts of the late Roman and early Byzantine empire. SRZ

114

Illustration of a reliquary with its lid in place

115 Revetment

Late fifth to sixth century C.E.
Seleucia Pieria (near Antioch)
Marble, 15¼ × 8¾ × 1⅞ in. (38.7 × 22.2 × 4.8 cm);
depth of relief 2⅛ in. (5.4 cm)
Dumbarton Oaks, Washington, D.C., 40.48

Purchased in Seleucia Pieria in 1939

PUBLISHED: Antioch III 1941, 170, no. 236; Dumbarton Oaks 1955, no. 22; Vikan 1995, no. 29

This shallow relief of a cross within circular and square moldings was found in Seleucia. Because the back of this marble slab is roughly finished, it is clear that the relief was not freestanding but employed as a wall revetment. In its scale and simple multiple moldings the relief closely resembles those found in the excavations of the church building at Seleucia in 1939. Other architectural revetments found on the site included not only similar crosses[1] but also figured reliefs of animals, birds, and fish, as well as scenes from the Old and New Testaments. The extant relief fragments reflect a program for the interior of the church building that joined religious history and the hope for paradise, symbolized by the peaceful animals on the pavement mosaics (see p. 219, fig. 1). Although the cross was but one element in the highly pictorialized environment created in this church, it was nonetheless one of the most profound Christian symbols used in it. SRZ

1. Antioch III 1941, nos. 513–14.

115

116 Saint Thecla in the Arena

Fifth century C.E.
Egypt (Oxyrhynchos or Ahnas)
Limestone roundel, diameter 25½ in. (64.8 cm)
Nelson-Atkins Museum of Art, Kansas City, Missouri. Nelson Fund, 48.10

PUBLISHED: Buschhausen 1962–63, 11, 12, 148, fig. 6; Boston 1976, no. 236; Weitzmann 1979, no. 513; Nauerth and Warns 1981, 31–34, fig. 14

Saint Thecla exemplified for later ages both heroic chastity and miraculous escapes from persecution. Her adventures took place during wanderings through Asia Minor after her conversion by Saint Paul. Her stories are told in the *Acts of Paul and Thecla,* a section of the *Acts of Paul* that took on an independent existence.[1] These writings originated in the last decades of the second century and survived in Greek, Latin, Syriac, Slavic, and Arabic versions.

Although condemned by theologians such as Tertullian and Jerome, the *Acts* must have had a broad popularity. The existence of Thecla's cult is attested from the mid-fourth century in Asia Minor. It had as its center a pilgrimage site in Meryamlik, near Silifke (ancient Seleucia), where the remains of a fifth-century church of Saint Thecla survive. Already at an early time her popularity spread to other parts of the ancient world; churches far to the west, in Milan, Italy, and Tarragona, Spain, were dedicated to her. Her connection with Antioch is mentioned in the *Acts* themselves, but it is not clear which Antioch is meant, since at least two other cities of that name existed in Asia Minor. Some later traditions strongly connect her with Antioch in Syria, as is clear from Photius, the ninth-century patriarch and scholar.[2]

According to the legend, she was exposed to a succession of dangerous animals in the amphitheater because she had rejected the advances of a politically powerful suitor. In one episode a lioness kills a lion that is about to attack her. In another, Thecla is bound to bulls who are to pull her apart, but the ropes miraculously part. In the sculpture shown here the two episodes are conflated: Thecla is tied to male and female lions rather than bulls. Her hands are bound behind her, and ropes cross her breast. She wears a necklace with a pendant amulet and a long skirt, which may be an elongated, feminized version of the gladiator's loincloth, the *subligaculum.*[3] Her head is haloed, and busts of angels appear beside her. The scene is enclosed in a laurel wreath. JH AND AVDH

1. Schneemelcher 1991–92, 2:213ff.; Von Gebhardt 1902.
2. Phot. *Panegyric on the Holy First Martyr Thecla.* For the text, see Von Gebhardt 1902, 178.
3. *Acts of Paul and Thecla,* ch. 33; the Latin texts speak of Thecla being stripped naked, whereas the Greek has her putting on a loincloth (*diazōstra*).

117 Bowl with Saint Thecla in the Arena

c. 350–430 C.E.
Tunisia
African Red Slip ceramic, 1¼ × 6½ in. (3.2 × 16.5 cm)
Private collection

PUBLISHED: Harlan J. Berk, Ltd., *Sale 85* (Chicago, 9 March 1995), lot 622

African Red Slip pottery was widely exported and was the principal tableware throughout the eastern Mediterranean in the third and fourth centuries. It continued to be popular at Antioch through the sixth century. In this example, decorated with applied reliefs, a persecuted female stands stripped to the waist with her hands spread in prayer, her long hair undone (Hayes, form 53A).[1] She wears a kind of skirt, probably a long loincloth, which is essentially a female version of the *subligaculum* of a gladiator. Two lions—one male, the other, only partially preserved, of unknown gender—sit gazing at her.

A *tabula ansata* beside her is inscribed DOMINA VICTORIA. Salomonson identified another fragmentary example of this type of bowl as an obscure North African martyr named Victoria.[2] There are, however, many reasons to identify the figure as the popular Thecla. First, a reading of the inscription as "Lady Victoria" implies a form of polite address known in a few letters by literati of the time but uncommon before the Middle Ages.[3] It is more likely to be an abbreviated acclamation, such as "Lady, victory is yours!"[4] Second, the Christian subject matter of North African pottery was primarily biblical scenes of deliverance. Victoria had perished in the relatively recent persecution of Diocletian (in 304) among the martyrs of Abitina (not shown in the bowls). Thecla, on the other hand, was blessed with a gratifying and entertaining escape.

As a convert and companion of Paul, moreover, she had virtually biblical standing in late antiquity. For example, she was included again and again in the long lists of Old and New Testamental personages invoked in the so-called *Cena Cypriani* and in prayers of Ps-Cyprian of Antioch.[5] A gold glass bowl from Cologne includes her in an assemblage of biblical figures, including Adam and Eve, Isaac, Moses, Jonah, the Hebrews in the fiery furnace, Susannah, and Daniel.[6] The symmetrically posed lions on this bowl were probably inspired by the representations of Daniel. JH AND AVDH

1. Hayes 1972, 78–82.
2. Salomonson 1979, 82–90.
3. *Thesaurus Linguae Latinae,* s.v. "domina," lists some examples of titles and proper names in inscriptions, but the usage remains relatively rare. The title *domina* on its own, however, is strongly connected to martyrdom (see *Acts of Perpetua and Felicitas* 4.1, 5.5).
4. See Lewis and Short, *A Latin Dictionary,* s.v. II B. Augustine gives an example when he refers to a famous prophecy given to Sulla, "Victoria tua est, Sylla!" (August. *De civ. D.* 22.24).
5. See *Patrologia Latina* 4.925ff., 905–7; these texts have been dated to the fourth and fifth centuries.
6. Nauerth and Warns 1981, 22–24, pl. 3.

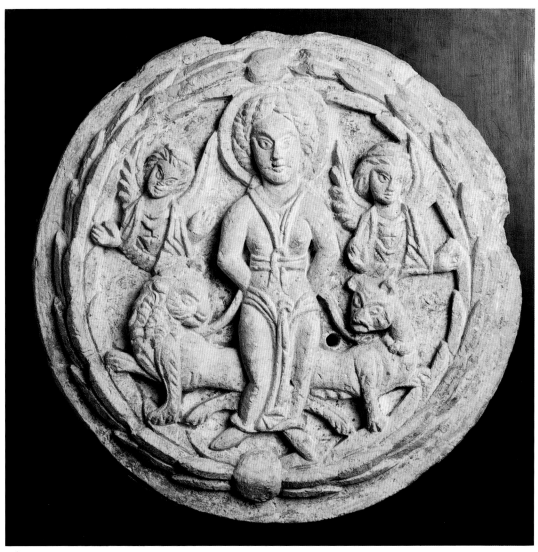

116

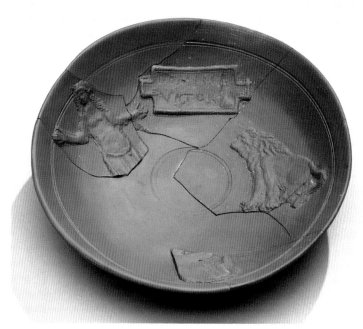

117

118 Bottle with Two Applied Faces

Mid-fifth to sixth century c.e.
Palestine (?)
Free-blown and tooled glass, height 4 in. (10.2 cm)
The Toledo Museum of Art. Gift of Edward Drummond Libbey,
1923.2042

EX COLL.: Thomas E. H. Curtis

118

The globular shape of this bottle, the division of its surface into oval sections by flattened trails of glass, and the trails of thread decoration (rigaree) on its sides and around the neck make it look very much like silver vessels of the fifth through early seventh centuries made in the Sasanian Empire, east of the Euphrates River.[1] Each side is decorated with a masklike face. These are not appliqués; that is, the glass was not shaped in a mold and later attached to the bottle with a bit of hot glass. Instead the glassworker quickly finished the bottle and its medallion-like frames, then dropped a blob of hot glass on each side, into which he quickly pressed an intaglio design, such as a metal ring bezel, to impart the pattern.[2]

The distinctive features are the elongated face and the dramatic treatment of the hair to form a stiff, wide wreath above the forehead. The contours of the blob of glass suggest, perhaps misleadingly, a longish beard and a mantle covering the head. A few marble heads of men found in Asia Minor seem to reflect the same type of image; these life-size portraits all have a stiff wreath of curly hair, a longish beard, and a pensive, staring expression.[3] It has been suggested that they are portraits of magistrates; similarities to the long-lived tradition of Greek philosopher portraits (pensive expressions, flowing beards) may argue that they are portraits of Christian leaders, perhaps living bishops or dead saints.

This bottle was probably intended as a souvenir, designed to hold water, oil, or soil from a site important to the visitor. A memory of a living or deceased human would be indicated by the faces. The fifth-century date corresponds to a popular surge in pilgrimages to Christian sites and to the homes of holy men, such as Saint Simeon Stylites. Mold-blown hexagonal and octagonal glass pilgrim flasks and bottles, with Christian and Jewish symbols, were produced in the sixth and early seventh centuries in or near Jerusalem, hundreds of miles to the south of Antioch.[4] sk

1. Kent and Painter 1977, 152–54, no. 320.
2. Leonard Marty, Director, Glass-Crafts Studio, The Toledo Museum of Art, pers. comm.
3. Kiilerich 1993, 237ff.; Boston 1976, 174–75, no. 192A; Ortiz 1996, no. 248.
4. Barag 1970, 1971; Stern 1995, nos. 168–93.

Bibliography

The abbreviations used for periodicals and reference works are those recommended by the *American Journal of Archaeology* 95 (1991): 4–16, and for primary sources, the lists of abbreviations in *The Oxford Classical Dictionary,* 3rd ed., ed. S. Hornblower and A. Spawforth (Oxford and New York, 1996), and *The Oxford Dictionary of Byzantium,* ed. Alexander P. Kazhdan (Oxford, 1991).

Abdul-Hak 1951
Abdul-Hak, Selim, and Andrée Abdul-Hak. *Catalogue illustré du Département des antiquités gréco-romaines au Musée de Damas.* Damascus, 1951.

Alföldi 1975
Alföldi, Elisabeth. "The Muses on Roman Game Counters." *Muse* 9 (1975): 13–20.

Anderson 1985
Anderson, H. "4 Maccabees." In *The Old Testament Pseudepigrapha.* Vol. 2., ed. James Charlesworth, 531–64. New York, 1985.

Antioch I 1934
Elderkin, George W., ed. *Antioch-on-the-Orontes I: The Excavations of 1932.* Princeton, 1934.

Antioch II 1938
Stillwell, Richard, ed. *Antioch-on-the-Orontes II: The Excavations of 1933–1936.* Princeton, 1938.

Antioch III 1941
Stillwell, Richard, ed. *Antioch-on-the-Orontes III: The Excavations of 1937–1939.* Princeton, 1941.

Athenaeus 1927–41
Athenaeus. *The Deipnosophists.* Ed. Charles Burton Gulick. Loeb Classical Library. London and Cambridge, Mass., 1927–41.

Augé and Linant de Bellefonds 1986
Augé, Christian, and Pascale Linant de Bellefonds. "Dionysos (in peripheria orientalia)." In *LIMC* III, no. 1 (Zurich 1986): 514–31.

Baginski and Tidhar 1980
Baginski, Alisa, and Tidhar, Amalia. *Textiles from Egypt, 4th–13th Centuries C.E.* Exh. cat. Jerusalem, 1980.

Balicka-Witakowska 1997
Balicka-Witakowska, Ewa. *La crucifixion sans crucifié dans l'art éthiopien: recherches sur la survie de l'iconographie chrétienne de l'Antiquité tardive.* Bibliotheca nubica et aethiopica, Schriftenreihe zur Kulturgeschichte des Raumes um das Rote Meer, no. 4. Warsaw, 1997.

Balsdon 1969
Balsdon, John P. V. D. *Life and Leisure in Ancient Rome.* London, 1969.

Baltimore 1975
Walters Art Gallery. *Greek and Roman Metalware.* Exh. cat. Baltimore, 1975.

Balty 1977
Balty, Janine. *Mosaïques antiques de Syrie.* Brussels, 1977.

Balty 1986
Balty, Janine. *Mosaïques d'Apamée.* Brussels, 1986.

Balty 1981a
Balty, Jean Ch. "Agora." In *LIMC* I.1 (Munich 1981): 305–6.

Balty 1981b
Balty, Jean Ch. "Antiocheia." In *LIMC* I.1 (Munich 1981): 840–51.

Balty 1995
Balty, Janine. *Mosaïques antiques du Proche-Orient.* Centre de recherches d'histoire ancienne, no. 140. Paris, 1995.

Barag 1970
Barag, Dan. "Glass Pilgrim Vessels from Jerusalem, Part I." *JGS* 12 (1970): 35–63.

Barag 1971
Barag, Dan. "Glass Pilgrim Vessels from Jerusalem, Parts II and III." *JGS* 13 (1971): 45–63.

Barag 1988
Barag, Dan. "Recent Important Epigraphic Discoveries Related to the History of Glassmaking in the Roman Period." *Annales du 10e congrès de l'Association internationale pour l'histoire du verre, Madrid–Ségovie, 23–28 septembre 1985* (Liège 1988): 113–16.

Baratte 1971
Baratte, François. "Argenterie du IVe siècle." *Bulletin de la société nationale des antiquaires de France* (1971): 318–21.

Baratte 1978
Barratte, François, and Kenneth Painter. *Catalogue des mosaïques romaines et paléochrétiennes du Musée du Louvre.* Paris, 1978.

Baratte and Painter 1989
Baratte, François, and Kenneth Painter. *Trésors d'orfèvrerie gallo-romains.* Paris, 1989.

Barr-Sharrar 1996
Barr-Sharrar, Beryl. "The Private Use of Small Bronze Sculpture." In *The Fire of Hephaistos: Large Classical Bronzes from North American Collections,* ed. Carol C. Mattusch, 104–21. Exh. cat. Cambridge, Mass., 1996.

Barthes 1997
Barthes, Roland. "Semiology and the Urban." In *Rethinking Architecture: A Reader in Cultural History,* ed. Neil Leach, 166–72. London and New York, 1997.

Bartman 1991
Bartman, Elizabeth. "Sculptural Collecting and Display in the Private Realm." In *Roman Art in the Private Sphere,* ed. Elaine K. Gazda, 71–88. Ann Arbor, 1991.

Baur 1932
Baur, Paul V.C. *The Excavations at Dura-Europos. Preliminary Report of the Third Season of Work, November 1929–March 1930.* New Haven, 1932.

Baur, Rostovtzeff, and Bellinger 1933
Baur, Paul V.C., Michael I. Rostovtzeff, and Alfred R. Bellinger, eds. *The Excavations at Dura-Europos: Preliminary Report of the Fourth Season of Work, October 1930–March 1931.* New Haven, 1933.

Baur 1939
Baur, Paul V.C. *The Excavations at Dura-Europos. Preliminary Report of the Seventh-Eighth Seasons of Work, 1933–1935.* New Haven, 1939.

Bellinger 1940
Bellinger, Alfred R. *The Syrian Tetradrachms of Caracalla and Macrinus.* American Numismatic Society, Numismatic Studies, no. 3. New York, 1940.

Berger 1982
Berger, Albrecht. *Das Bad in der Byzantinischen Zeit.* Munich, 1982.

Bergmann 1991
Bergmann, Bettina. "Painted Perspectives of a Villa Visit: Landscape as Status and Metaphor." In *Roman Art in the Private Sphere*, ed. Elaine K. Gazda, 49–70. Ann Arbor, 1991.

Bergmann 1994
Bergmann, Bettina. "The Roman House as Memory Theater: The House of the Tragic Poet in Pompeii." *ArtB* 76, no. 2 (1994): 225–56.

Bieber 1961
Bieber, Margarete. *The History of the Greek and Roman Theater.* 2nd ed. Princeton, 1961.

Bieber 1977
Bieber, Margarete. *Ancient Copies: Contributions to the History of Greek and Roman Art.* New York, 1977.

Birley 1976
Lives of the Later Caesars: The First Part of the Augustan History. Trans. Anthony Birley. Harmondsworth, 1976.

Boston 1976
Museum of Fine Arts. *Romans and Barbarians.* Exh. cat. Boston, 1976.

Boucher 1976
Boucher, Stéphanie. *Recherches sur les bronzes figurés de Gaule pré-romaine et romaine.* BEFAR, no. 228. Paris, 1976.

Bouchier 1921
Bouchier, Edmund Spenser. *A Short History of Antioch, 300 B.C.–A.D. 1268.* Oxford, 1921.

Bowersock 1969
Bowersock, Glen. *Greek Sophists in the Roman Empire.* Oxford, 1969.

Bowersock 1990
Bowersock, Glen. *Hellenism in Late Antiquity.* Ann Arbor, 1990.

Bowersock 1994
Bowersock, Glen. "Roman Senators from the Near East: Syria, Judaea, Arabia, Mesopotamia." In *Studies on the Eastern Roman Empire: Social, Economic, and Administrative History, Religion, Historiography*, 141–59. Goldbach, 1994.

Bowman 1996
Bowman, Alan K. "Provincial Administration and Taxation." In *CAH.* 2nd ed. Vol. 10, *The Augustan Empire, 43 B.C.–A.D. 69*, ed. Alan K. Bowman, Edward Champlin, and Andrew Lintott, 344–70. Cambridge, 1996.

Boyce 1975
Boyce, Mary. *A History of Zoroastrianism.* Handbuch der Orientalistik. Erste Abteilung, Der Nahe und der Mittlere Osten. Vol. 8, Abschnitt 1. Lfg. 2 Heft 2A. Leiden, 1975.

Boyd 1982
Boyd, Susan. "A Little-Known Technique of Architectural Sculpture: Champlevé Reliefs from Cyprus." *JÖB* 32, no. 5 (1982): 313–25.

Boyd 1999
Boyd, Susan. "Champlevé Production in Early Byzantine Cyprus." In *Medieval Cyprus. Studies in Art, Architecture, and History in Memory of Doula Mouriki*, ed. Nancy Sevčenko and Christopher Moss, 49–70. Princeton, 1999.

Boyd forthcoming
Boyd, Susan. "The Champlevé Revetments." In *Kourion: The Episcopal Center*, ed. A. H. S. Megaw. Washington, D.C., forthcoming.

Boyd and Mango 1992
Boyd, Susan A., and Marlia Mundell Mango, eds. *Ecclesiastical Silver Plate in Sixth-Century Byzantium.* Washington, D.C., 1992.

Bréhier 1951
Bréhier, Louis. "Un Trésor d'argenterie ancienne au Musée de Cleveland." *Syria* 27 (1951): 256–64.

Brinkerhoff 1970
Brinkerhoff, Dericksen M. *A Collection of Sculpture in Classical and Early Christian Antioch.* New York, 1970.

Brock 1994
Brock, Sebastian. "Greek and Syriac in Late Antique Syria." In *Literacy and Power in the Ancient World*, ed. Alan K. Bowman and Greg Woolf, 149–60. Cambridge, 1994.

Brock 1998
Brock, Sebastian. "Syriac Culture, 337–425." In *CAH.* 2nd ed. Vol. 13, *The Late Empire, A.D. 337–425*, ed. Averil Cameron and Peter Garnsey, 708–19. Cambridge, 1998.

Brock and Harvey 1987
Brock, Sebastian, and Susan Harvey, eds. *Holy Women of the Syrian Orient.* The transformation of the classical heritage, no. 13. Berkeley, 1987.

Brooten 1982
Brooten, Bernadette J. *Women Leaders in the Ancient Synagogue: Inscriptional Evidence and Background Issues.* Chico, Calif., 1982.

Brown 1936
Brown, Frank. "The Roman Baths." In *The Excavations at Dura-Europos. Preliminary Report of Sixth Season of Work, October 1932–March 1933*, ed. Michael Ivanovitch Rostovtzeff, Alfred R. Bellinger, C. Hopkins, and C. B. Welles, 84–106. New Haven, 1936.

Brown 1970
Brown, Peter. "Sorcery, Demons, and the Rise of Christianity." In *Witchcraft: Confessions and Accusations*, ed. Mary Douglas, 17–45. London, 1970.

Brown 1992
Brown, Peter. *Power and Persuasion in Late Antiquity: Towards a Christian Empire.* Madison, Wis., 1992.

Brown 1998
Brown, Peter. "Christianization and Religious Conflict." In *CAH.* 2nd ed. Vol. 13, *The Late Empire, A.D. 337–425,* ed. Averil Cameron and Peter Garnsey, 632–64. Cambridge, 1998.

Brown and Meier 1983
Brown, Raymond E., and John P. Meier. *Antioch and Rome: New Testament Cradles of Catholic Christianity.* New York, 1983.

Bruce-Mitford 1983
Bruce-Mitford, Rupert. *The Sutton Hoo Ship-Burial.* Vol. 3. London, 1983.

Brussels 1993
Musées Royaux d'Art et d'Histoire. *Splendeur des Sassanides: l'empire perse entre Rome et la Chine (224–642).* Exh. cat. Brussels, 1993.

Bryson 1990
Bryson, Norman. *Looking at the Overlooked: Four Essays on Still Life Painting.* Cambridge, Mass., 1990.

Buckler and Robinson 1913
Buckler, William H., and David M. Robinson. "Greek Inscriptions from Sardes II. Honorific Inscriptions." *AJA* 17 (1913): 29–52.

Buckler and Robinson 1932
Buckler, William H., and David M. Robinson. *Sardis.* Vol. 7, *Greek and Latin Inscriptions.* Leiden, 1932.

Buckton 1994
Buckton, David, ed. *Byzantium: Treasures of Byzantine Art and Culture from British Collections.* London, 1994.

Bühl 1995
Bühl, Gudrun. *Constantinopolis und Roma. Stadtpersonifikationen der Spätantike.* Akanthus crescens, no. 3. Zurich, 1995.

Burkert 1985
Burkert, Walter. *Greek Religion.* Cambridge, Mass., 1985.

Burkhalter 1990
Burkhalter, Fabienne. "Les statuettes en bronze d'Aphrodite en Egypte romaine d'après les documents papyrologiques." *RA* (1990): 51–60.

Burnett, Amandry, and Ripollès 1992
Burnett, Andrew, Michel Amandry, and Pere Pau Ripollès. *Roman Provincial Coinage I: From the Death of Caesar to the Death of Vitellius.* London, 1992.

Buschhausen 1962–63
Buschhausen, Helmut. "Frühchristliches Silberreliquiar aus Isaurien." *JÖBG* 11–12 (1962–63): 137–68.

Butler 1903
Butler, Howard C. *Architecture and Other Arts.* New York, 1903.

Cahn and Kaufmann-Heinimann 1984
Cahn, Herbert A., and Annemarie Kaufmann-Heinimann, eds. *Der Spätrömische Silberschatz von Kaiseraugst.* Derendingen, 1984.

Cambridge 1954
Fogg Art Museum. *Ancient Art in American Private Collections.* Exh. cat. Cambridge, Mass., 1954.

Cameron 1973
Cameron, Alan. *Porphyrius the Charioteer.* Oxford, 1973.

Cameron 1976
Cameron, Alan. *Circus Factions.* Oxford, 1976.

Campbell 1985
Campbell, Sheila, ed. *The Malcove Collection.* Toronto, 1985.

Campbell 1988
Campbell, Sheila, ed. *The Mosaics of Antioch.* Toronto, 1988.

Campbell 1941
Campbell, William. "The Martyrion at Seleucia Pieria." In *Antioch-on-the-Orontes III,* ed. Richard Stillwell, 35–54. Princeton, 1941.

Carandini 1982
Carandini, Andrea, Andreina Ricci, and Mariette de Vos. *Filosofiana: la villa di Piazza Armerina. Immagine di un aristocratico romano al tempo di Constantino.* Palermo, 1982.

Carne 1836–38
Carne, John. *Syria, the Holy Land, Asia Minor.* 3 vols. London, 1836–38.

Cassas 1799
Cassas, Louis François. *Voyage pittoresque de la Syrie, de la Phénicie, de la Palestine et de la Basse-Egypte.* 3 vols. Paris, 1799.

Cavafy 1972
Cavafy, Constantine P. *Selected Poems.* Trans. Edmund Keely and Philip Sherrard. Princeton, 1972.

Chronique 1987
"La Chronique des Arts. Principales acquisitions des musées en 1986." *GBA* 109, no. 1418 (1987).

Chrysos 1996
Chrysos, Evangelos. "The Roman Political Identity in Late Antiquity and Early Byzantium." In *Byzantium: Identity, Image, Influence,* ed. Karsten Fledelius, 7–16. Copenhagen, 1996.

Ciarallo and De Carolis 1999
Ciarallo, Annamaria, and Ernesto De Carolis, eds. *Homo faber: natura, scienza e tecnica nell'antica Pompei.* Exh. cat. Milano, 1999.

Cimok 1995
Cimok, Fatih. *Antioch Mosaics.* Istanbul, 1995.

Clarke 1991
Clarke, John R. *The Houses of Roman Italy, 100 B.C.–A.D. 250: Ritual Space and Decoration.* Berkeley, 1991.

Clerc 1995
Clerc, Jean-Benoît. *Homines magici: étude sur la sorcellerie et la magie dans la société romaine impériale.* Bern, 1995.

Colledge 1976
Colledge, Malcom A.R. *The Art of Palmyra.* London, 1976.

Comstock and Vermeule 1976
Comstock, Mary B., and Cornelius C. Vermeule. *Sculpture in Stone: The Greek, Roman, and Etruscan Collections of the Museum of Fine Arts, Boston.* Boston, 1976.

Corbett and Strong 1961
Corbett , Peter E., and Donald E. Strong. "Three Roman Silver Cups." *BMQ* 23, no. 3 (1961): 68–86.

Cott 1939
Cott, Perry B. "A Sasanian Stucco Plaque in the Worcester Art Museum," *Ars Islamica.* 6, no. 2 (1939): 167–68.

Crawford 1990
Crawford, J. Stephens. *The Byzantine Shops at Sardis.* Cambridge, Mass., 1990.

Cumont 1975
Cumont, Franz. "The Dura Mithraeum." In *Mithraic Studies I,* ed. John R. Hinnells, 151–214. Manchester, 1975.

Ćurčić and St. Clair 1986
Ćurčić, Slobodan, and Archer St. Clair, eds. *Byzantium at Princeton: Byzantine Art and Archaeology at Princeton University.* Exh. cat. Princeton, 1986.

Dalton 1901
Dalton, Ormonde M. *Catalogue of Early Christian Antiquities and Objects from the Christian East, British Museum.* London, 1901.

D'Arms 1991
D'Arms, John H. "Slaves at Roman *Convivia.*" In *Dining in a Classical Context,* ed. William J. Slater, 171–84. Ann Arbor, 1991.

D'Arms 1995
D'Arms, John H. "Heavy Drinking and Drunkenness in the Roman World: Four Questions for Historians." In *In Vino Veritas,* ed. Oswyn Murray and Manuela Tecuşan, 304–17. Rome, 1995.

Daszewski 1985
Daszewski, Wiktor A. *Dionysos der Erlöser. Griechische Mythen im Spätantikern Cypern.* Mainz am Rhein, 1985.

Datsouli-Stavridi 1985
Datsouli-Stavridi, A. *Rhômaika portraita sto Ethniko Arkhaiologiko Mouseio tês Athênas* (Roman portraits in the Athens Archaeological Museum). Athens, 1985.

Datsouli-Stavridi 1987
Datsouli-Stavridi, A. *Rhômaika portraita sto Mouseio tês Spartês* (Roman portraits in the Sparta Museum). Athens, 1987.

Davidson 1952
Davidson, Gladys. *Corinth.* Vol. 12, *The Minor Objects.* Princeton, 1952.

Davidson 1997
Davidson, James. *Courtesans and Fishcakes: The Consuming Passions of Classical Athens.* New York, 1997.

Demir 1996
Demir, Attaman. *Antakya through the Ages.* Istanbul, 1996.

Dentzer 1962
Dentzer, Jean Marie. "La tombe de C. Vestorius dans la tradition de la peinture italique." *Mélanges d'archéologie et d'histoire,* no. 74 (1962): 542–47.

Deppert-Lippitz 1993
Deppert-Lippitz, Barbara. "A Group of Late Antique Jewelry in the Getty Museum." In *Studia Varia from the J. Paul Getty Museum.* Vol. 1. Occasional Papers on Antiquities, no. 8. 107–40. Malibu, Calif., 1993.

De Ridder 1905a
De Ridder, André. "Bronzes syriens." *Monuments et mémoires* (1905): 55–78.

De Ridder 1905b
De Ridder, André. *Collection de Clercq.* Vol. 3, *Les Bronzes.* Paris, 1905.

De Ridder 1911
De Ridder, André. *Collection de Clercq.* Vol. 7, pt. 1, *Les bijoux.* Vol. 7, pt. 2, *Les pierres gravées.* Paris, 1911.

De Ridder 1913
De Ridder, André. *Les bronzes antiques. Musée du Louvre.* Paris, 1913.

Diehl 1930
Diehl, Charles. "Argenteries syriennes." *Syria* 11 (1930): 209–15.

Dobbins 1982
Dobbins, John J. "Pictures for the Floor: The Virginia Museum's Roman Mosaics." *Arts in Virginia* 22, no. 1 (1982): 2–13.

Dodd 1961
Dodd, Erica Cruikshank. *Byzantine Silver Stamps.* Washington, D.C., 1961.

Dodd 1973
Dodd, Erica Cruikshank. *Byzantine Silver Treasures.* Monographien der Abegg-Stiftung, no. 9. Bern, 1973.

Dohan 1936
Dohan, Edith Hall. "Two Syrian Sculptured Portraits." *The University Museum Bulletin* 6, no. 5 (1936): 20–22.

Dohrn 1960a
Dohrn, Tobias. "Antike Flussgötter." In *Mouseion, Studien aus Kunst und Geschichte für O. H. Förster,* ed. Heinz Ladendorf and Horst Vey, 69–72. Cologne, 1960.

Dohrn 1960b
Dohrn, Tobias. *Die Tyche von Antiochia.* Berlin, 1960.

Donceel-Voûte 1988
Donceel-Voûte, Pauline. *Les pavements des églises byzantines de Syrie et du Liban.* Vol. 1, *Décor, archéologie, et liturgie.* Publications d'histoire de l'art et d'archéologie de l'Université catholique de Louvain, no. 69. Louvain-la-Neuve, 1988.

Donderer 1983
Donderer, Michelle. "Ein verschollenes römisches Mosaik und die Gattung der Wandemblemata." *Mosaique: Recueil d'hommages à Henri Stern,* 123–28. Paris, 1983.

Doran 1992
Doran, Robert. *The Lives of Simeon Stylites.* Cistercian studies series, no. 112. Kalamazoo, Mich., 1992.

Downey 1940
Downey, Glanville. "Representations of Abstract Ideas in the Antioch Mosaics." *Journal of the History of Ideas* 1, no. 1 (1940): 112–13.

Downey 1953
Downey, Glanville. "The Dating of the Syrian Liturgical Silver Treasure in the Cleveland Museum." *Art Bulletin* 35, no. 2 (1953): 143–45.

Downey 1954
Downey, Glanville. "A Processional Cross." *The Metropolitan Museum of Art Bulletin* 12, no. 9 (1954): 276–80.

Downey 1959
Downey, Glanville. "Libanius' Oration in Praise of Antioch (Oration XI)." *ProcPhilSoc* 103, no. 6 (1959): 652–86.

Downey 1961
Downey, Glanville. *A History of Antioch in Syria: From Seleucus to the Arab Conquest.* Princeton, 1961.

Downey 1962
Downey, Glanville. *Antioch in the Age of Theodosius the Great.* Norman, Okla., 1962.

Downey 1963
Downey, Glanville. *Ancient Antioch.* Princeton, 1963.

Downey 1977
Downey, Susan B. *The Excavations at Dura-Europos, Final Report III, Part I, Fascicle 2: The Stone and Plaster Sculpture.* Monumenta archaeologica, no. 5. Los Angeles, 1977.

Dresken-Weiland 1995
Dresken-Weiland, Jutta. "Zur Ikonographie und Datierung der Champlevé-Reliefs." *JAC* 20, no. 2 (1995): 719–26.

Dresser 1954
Dresser, Louise. "A Silver Plate from Antioch." *News Bulletin and Calendar* (Worcester Art Museum) 19, no. 4 (1954): 15–16.

Dumbarton Oaks 1946
Dumbarton Oaks. *Dumbarton Oaks Research Library and Collection of Harvard University, Handbook of the Collection.* Washington, D.C., 1946.

Dumbarton Oaks 1955
Dumbarton Oaks. *Dumbarton Oaks Collection, Harvard University, Handbook.* Washington, D.C., 1955.

Dumbarton Oaks 1967
Dumbarton Oaks. *Dumbarton Oaks, Handbook of the Byzantine Collection.* Washington, D.C., 1967.

Dunbabin 1978
Dunbabin, Katherine M. D. *The Mosaics of Roman North Africa: Studies in Iconography and Patronage.* Oxford, 1978.

Dunbabin 1989
Dunbabin, Katherine M. D. "*Baiarum Grata Voluptas*: Pleasures and Dangers of the Baths," *PBSR* 57 (1989): 6–46.

Dunbabin 1991
Dunbabin, Katherine M. D. "*Triclinium* and *Stibadium*." In *Dining in a Classical Context*, ed. William J. Slater, 121–48. Ann Arbor, 1991.

Dunbabin 1993
Dunbabin, Katherine M. D. "Wine and Water at the Roman *convivium*." *JRA* 6 (1993): 116–41.

Dwyer 1982
Dwyer, Eugene. *Pompeian Domestic Sculpture: A Study of Five Pompeian Houses and Their Contents.* Rome, 1982.

Effenberger 1991
Effenberger, Arne. "Bemerkungen zum 'Kaper-Koraon-Schatz.'" *Tesserae: Festschrift für Josef Engemann, JAC* 18 (1991): 241–77.

Eisen 1923
Eisen, Gustavus A. *The Great Chalice of Antioch.* 2 vols. New York, 1923.

Elbern 1998
Elbern, V.H. "Beobachtungen zur Morphologie Frühchristlicher Kelche." *Acta XIII Congressus Internationalis Archaeologiae Christianae, Split-Poreč (25.9–1. 10. 1994)*, 499–522. Studi di Antichità Christiana, no. 54. Vatican, 1998.

Ellis 1997a
Ellis, Simon P. "Late-Antique Dining: Architecture, Furnishings, and Behaviour." In *Domestic Space in the Roman World: Pompeii and Beyond*, ed. Ray Laurence and Andrew Wallace-Hadrill, 41–51. Portsmouth, R.I., 1997.

Ellis 1997b
Ellis, Simon P. "Late Antique Houses in Asia Minor." In *Patron and Pavements in Late Antiquity*, ed. Signe Isager and Birte Poulsen, 38–50. Odense, 1997.

Elsner 1995
Elsner, Jas. *Art and the Roman Viewer. The Transformation of Art from the Pagan World to Christianity.* Cambridge, 1995.

Elsner 1996
Elsner, John. "Naturalism and the Erotics of the Gaze: Intimations of Narcissus." In *Sexuality in Ancient Art*, ed. Natalie B. Kampen, 247–61. Cambridge, 1996.

Erim and Reynolds 1973
Erim, Kenan T., and Joyce Reynolds. "The Aphrodisias Copy of Diocletian's Edict on Maximum Prices." *JRS* 63 (1973): 99–110.

Faraone 1991
Faraone, Christopher. "The Agonistic Context of Early Greek Binding Spells." In *Magika Hiera*, ed. Christopher Faraone and Dirk Obbink, 3–32. New York, 1991.

Ferguson 1997
Ferguson, Everett, ed. *Encyclopedia of Early Christianity.* 2nd ed. 2 vols. New York, 1997.

Festugière 1959
Festugière, André Jean. *Antioche païenne et chrétienne: Libanius, Chrysostome, et les moines de Syrie.* BEFAR, no. 194. Paris, 1959.

Fleischer 1983a
Fleischer, Robert. "Eine Gruppe Syrisch-phönikischer Bronzestatuetten-Basen." *DM* 1 (1983): 32–42.

Fleischer 1983b
Fleischer, Robert. "Gott oder Herrscher? Zwei syrische Denkmäler der Kleinkunst severischer Zeit." *AA* (1983): 253–71.

Fleming 1997
Fleming, Stuart J. "Late Roman Glass at the University of Pennsylvania Museum: A Photo Essay." *Expedition* 39, no. 2 (1997): 32–33.

Fogg 1945
"Dumbarton Oaks, Exhibition at the Fogg Museum." *Bulletin of the Fogg Museum of Art* 10, no. 4 (1945): 108–23.

Foss 1995
Foss, Clive. "The Near Eastern Countryside in Late Antiquity: A Review Article." In *The Roman and Byzantine Near East: Some Recent Archaeological Research.* Vol. 1, ed. J. Humphrey, 213–34. Ann Arbor, 1995.

Foss 1996
Foss, Clive. "Dead Cities of the Syrian Hill Country." *Archaeology* 49, no. 5 (1996): 48–53.

Foss 1997
Foss, Clive. "Syria in Transition, A.D. 550–750: An Archaeological Approach." *DOP* 51 (1997): 189–269.

Fowden 1998
Fowden, Garth. "Polytheist Religion and Philosophy." In *CAH.* 2nd ed. Vol. 13, *The Late Empire A.D. 337–425*, ed. Averil Cameron and Peter Garnsey, 538–58. Cambridge, 1998.

Frankfurt 1983
Liebieghaus Museum alter Plastik. *Spätantike und frühes Christentum.* Exh. cat. Frankfurt, 1983.

Frazer 1992
Frazer, Margaret. "Early Byzantine Silver Book Covers." In *Ecclesiastical Silver Plate in Sixth-Century Byzantium*, ed. Susan A. Boyd and Marlia M. Mango, 71–76. Washington, D.C., 1992.

Frey 1952
Frey, Jean Baptiste. *Corpus inscriptionum iudicarum. Receuil des inscriptions juives qui vont du IIIe siècle avant Jésus-Christ au VIIe siècle de notre ère.* Vol. 2, *Asie, Afrique.* Sussidi allo studio delle antichita cristiane, no. 3. Vatican City, Rome, 1952.

Friend 1941
Friend, Albert Mathias, Jr. "Menander and Glykera in the Mosaics of Antioch." In *Antioch-on-the-Orontes III: The Excavations 1937–1939*, ed. Richard Stillwell, 248–51. Princeton, 1941.

Froehner 1913
Froehner, W. *Verre antique de la collection F. von Gans.* Paris, 1913.

Gager 1990
Gager, John. "Curse and Competition in the Ancient Circus." In *Of Scribes and Scrolls*, ed. Harold W. Attridge, John J. Collins, and Thomas H. Tobin, 215–28. Lanham, 1990.

Gager 1992
Gager, John. *Curse Tablets and Binding Spells from the Ancient World.* New York, 1992.

Galsterer 1986
Galsterer, Hartmut. "Roman Law in the Provinces: Some Problems of Transmission." In *L'Impero Romano e le Strutture Economiche e Sociale delle Provincie*, ed. Michael H. Crawford, 13–27. Como, 1986.

Gasparri 1986
Gasparri, Carlo. "Dionysos" *LIMC* III, no. 1 (Munich 1986): 414–514.

Gazda 1983
Gazda, Elaine K., ed. *Karanis, an Egyptian Town in Roman Times: Discoveries of the University of Michigan Expedition to Egypt (1924–1935).* Exh. cat. Ann Arbor, 1983.

Gazda 1991
Gazda, Elaine K., ed. *Roman Art in the Private Sphere: New Perspectives on the Architecture and Decor of the Domus, Villa, and Insula.* Ann Arbor, 1991.

Gettens and Waring 1957
Gettens, Rutherford J., and Claude L. Waring. "The Composition of Some Ancient Persian and Other Near Eastern Silver Objects." *Ars Orientalis* 2 (1957): 83–90.

Ghedini 1984
Ghedini, Francesca. *Giulia Domna tra Oriente e Occidente. Le fonti archeologiche.* La Fenice, no. 5. Rome, 1984.

Ghirshman 1962
Ghirshman, Roman. *Persian Art, Parthian and Sassanian Dynasties 249 B.C.–A.D. 651.* New York, 1962.

Gonosová and Kondoleon 1994
Gonosová, Anna, and Christine Kondoleon. *The Art of Late Rome and Byzantium in the Virginia Museum of Fine Arts.* Richmond, Va., 1994.

Grabar 1971
Grabar, André. "Le Rayonnement de l'art sassanide dans le monde chrétien." *Convegno Internazionale sul tema: La Persia del Medioevo*, 679–707. Accademia nazionale dei Lincei, problemi attuali di scienza e di cultura, no. 160. Rome, 1971.

Grabar 1968
Grabar, Oleg. *Sasanian Silver: Late Antique and Early Mediaeval Arts of Luxury from Iran.* Exh. cat. Ann Arbor, 1968.

Graf 1994
Graf, Fritz. *La magie dans l'antiquité gréco-romaine.* Paris, 1994.

Grancsay 1961
Grancsay, Stephen V. *Catalogue of Armor: The John Woodman Higgins Armory.* Worcester, Mass., 1961.

Greatrex 2000
Greatrex, Geoffrey. "Roman Identity in the Sixth Century." In *Race, Religion and Culture in Late Antiquity*, ed. Stephen Mitchell and Geoffrey Greatrex. London, 2000.

Green 1994
Green, J. R. *Theatre in Ancient Greek Society.* London, 1994.

Grose 1978
Grose, David F. "Ancient Glass." *Museum News: The Toledo Museum of Art*, n.s. 20, no. 3 (1978): 67–90.

Grose 1989
Grose, David F. *Early Ancient Glass: Core-Formed, Rod-Formed, and Cast Vessels and Objects from the Late Bronze Age to the Early Roman Empire, 1660 B.C. to A.D. 50.* New York, 1989.

Grose 1991
Grose, David F. "Early Imperial Roman Cast Glass: The Translucent Coloured and Colourless Fine Wares." In *Roman Glass: Two Centuries of Art and Invention*, ed. Martin Newby and Kenneth Painter, 1–18. Occasional Papers from The Society of Antiquaries of London, no. 13. London, 1991.

Grose forthcoming
Grose, David F., et al. *The Toledo Museum of Art: Roman and Early Byzantine Glass.* Toledo, forthcoming.

Gruen 1996
Gruen, Erich S. "The Expansion of the Empire under Augustus." In *CAH.* 2nd ed. Vol. 10, *The Augustan Empire, 43 B.C.–A.D. 69*, ed. Alan K. Bowman, Edward Champlin, and Andrew Lintott, 147–97. Cambridge, 1996.

Gunter and Jett 1992
Gunter, Ann C., and Paul Jett. *Ancient Iranian Metalwork in the Arthur M. Sackler Gallery and the Freer Gallery of Art.* Washington, D.C., 1992.

Haddad 1949
Haddad, George. *Aspects of Social Life in Antioch in the Hellenistic-Roman Period.* New York, 1949.

Hanfmann 1955–56
Hanfmann, G. "A Bronze Portrait of Julia Domna." *Fogg Art Museum Annual Report* (1955–56): 42–43.

Harden 1936
Harden, Donald B. *Roman Glass from Karanis.* University of Michigan Studies, Humanistic Series, no. 41. Ann Arbor, 1936.

Harden 1960
Harden, Donald B. "Glass-Making Centres and the Spread of Glass-Making from the First to the Fourth Century A.D." *Annales de l'Association internationale pour l'histoire du verre* 1 (1960): 47–62.

Harden 1971
Harden, Donald B. "Ancient Glass, III: Post-Roman." *The Archaeological Journal* 128 (1971): 78–117.

Harden 1987
Harden, Donald B. *Glass of the Caesars.* Exh. cat. Milan, 1987.

Harper 1978
Harper, Prudence Oliver. *The Royal Hunter: Art of the Sasanian Empire.* New York, 1978.

Harper 1981
Harper, Prudence Oliver. *Silver Vessels of the Sasanian Period.* Vol. 1, *Royal Imagery.* New York, 1981.

Harrison 1986
Harrison, R. Martin. *Excavations at Saraçhane in Istanbul.* Vol. 1, *The Excavations, Structures, Architectural Decoration, Small Finds, Coins, Bones and Molluscs.* Princeton, 1986.

Harvey 1990
Harvey, Susan Ashbrook. *Asceticism and Society in Crisis: John of Ephesus and the "Lives of the Eastern Saints".* The Transformation of the Classical Heritage, no. 18. Berkeley, 1990.

Hauser 1992
Hauser, Stefan R. *Spätantike und Frühbyzantinische Silberlöffel, Bermerkungen zur Produktion von Luxusgütern im 5. bis 7. Jahrhundert.* JAC Ergänzungsband, no. 19. Münster, 1992.

Hayes 1972
Hayes, John W. *Late Roman Pottery.* London, 1972.

Heather 1994
Heather, Peter. "New Men for New Constantines? Creating an Imperial Elite in the Eastern Mediterranean." In *New Constantines: The Rhythm of Imperial Renewal in Byzantium, Fourth–Thirteenth Centuries*, ed. Paul Magdalino, 11–33. Aldershot, 1994.

Heintz 1996
Heintz, Florent. "A Greek Silver Phylactery in the MacDaniel Collection." *ZPE* 112 (1996): 295–300.

Heintz 1998
Heintz, Florent. "Circus Curses and Their Archaeological Contexts." *JRA* 11 (1998): 337–42.

Hengel and Schwemer 1997
Hengel, Martin, and Anna Maria Schwemer. *Paul Between Damascus and Antioch: The Unknown Years.* Louisville, Ky., 1997.

Hennecke and Schneemelcher 1963–65
Hennecke, Edgar, and Wilhelm Schneemelcher. *New Testament Apocrypha.* 2 vols. Philadelphia, 1963–65.

Herrmann 1993
Herrmann, Ariel. "The Boy with the Jumping Weights." *The Bulletin of the Cleveland Museum of Art* 80, no. 7 (1993): 299–323.

Hiesinger 1969
Hiesinger, Ulrich W. "Julia Domna: Two Portraits in Bronze." *AJA* 73 (1969): 39–44.

Hill 1981
Hill, Dorothy K. "Some Sculpture from Roman Domestic Gardens." In *Ancient Roman Gardens*, ed. Elisabeth B. MacDougall and Wilhelmina F. Jashemski, 81–94. Dumbarton Oaks Colloquium on the History of Landscape Architecture, no. 7. Washington, D.C., 1981.

Hoke 1974
Hoke, Victoria. "Portrait of Ummabi." *Museum News: The Toledo Museum of Arts* n.s. 17, no. 3 (1974): 51–53.

Houghton 1990
Houghton, Arthur. "The Antioch Project." In *Mnemata: Papers in Memory of Nancy Waggoner*, ed. William E. Metcalf, 73–97. New York, 1990.

Howard 1981
The Teaching of Addai. Trans. George Howard. Texts and Translations, no. 16. Early Christian Literature Series, no. 4. Chico, Calif., 1981.

Humphrey 1986
Humphrey, John H. *Roman Circuses: Arenas for Chariot Racing.*
London, 1986.

Isaac 1998
Isaac, Benjamin. "The Eastern Frontier." In *CAH.* 2nd ed. Vol. 13,
The Late Empire, A.D. 337–425, ed. Averil Cameron and Peter Garnsey,
437–60. Cambridge, 1998.

Jashemski 1979
Jashemski, Wilhelmina. *The Gardens of Pompeii.* Vol. 1, *Herculaneum
and the Villas Destroyed by Vesuvius.* New Rochelle, N.Y., 1979.

Jashemski 1981
Jashemski, Wilhelmina. "The Campanian Peristyle Garden." In
Ancient Roman Gardens, ed. Elisabeth B. MacDougall and Wilhelmina
F. Jashemski, 29–48. Dumbarton Oaks Colloquium on the History of
Landscape Architecture, no. 7. Washington D.C., 1981.

Jentel 1981
Jentel, Marie-Odile. "Quelques aspects d'Aphrodite en Egypte et en
Syrie à l'époque hellénistique et romaine." In *Mythologie gréco-romaine,
mythologies périphériques: Etudes d'iconographie,* ed. Lilly Kahil and
Christian Augé, 151–55. Paris, 1981.

Jentel 1984
Jentel, Marie-Odile. "Aphrodite (in peripheria Orientalia)." In *LIMC*
II, no. 1 (Zurich 1984): 154–66.

Jones 1940
Jones, Arnold Hugh Martin. *The Greek City from Alexander to
Justinian.* Oxford, 1940.

Jones 1964
Jones, Arnold Hugh Martin. *The Later Roman Empire 284–602:
A Social, Economic, and Administrative Survey,* 2 vols. Oxford, 1964.

Jones 1971
Jones, Arnold Hugh Martin. *Cities of the Eastern Roman Provinces.*
2nd ed. Oxford, 1971.

Jones 1991
Jones, Christopher P. "Dinner Theater." In *Dining in a Classical
Context,* ed. William J. Slater, 185–98. Ann Arbor, 1991.

Jones 1981
Jones, Frances F. "Antioch Mosaics in Princeton." *Record of the Art
Museum, Princeton University* 40, no. 2 (1981): 2–27.

Jordan 1985
Jordan, D. "A Survey of Greek Defixiones Not Included in the Special
Corpora." *GRBS* 26 (1985): 151–97.

Jucker 1959
Jucker, Hans. "Verkannte Köpfe." *MusHelv* 16, no. 4 (1959): 275–91.

Jucker 1967
Jucker, Hans. "Zwei konstantinische Porträtköpfe in Karthago: Beitrag
zur Ikonographie Konstantins des Großen und seiner Söhne." *Gestalt
und Geschichte. Festschrift K. Schefold,* ed. M. Rohde-Liegle, Herbert A.
Cahn, and Hans Chr. Ackermann, 121–32. Bern, 1967.

Julian 1949
Julian. *The Works of the Emperor Julian.* Trans. Wilmer Cave Wright.
3 vols. Loeb Classical Library. Cambridge, Mass., 1949.

Kelly 1995
Kelly, John Norman Davidson. *Golden Mouth: The Story of John
Chrysostom—Ascetic, Preacher, Bishop.* Ithaca, N.Y., 1995.

Kennedy 1996
Kennedy, David. "Syria." In *CAH.* 2nd ed. Vol. 10, *The Augustan
Empire, 43 B.C.–A.D. 69,* ed. Alan K. Bowman, Edward Champlin,
and Andrew Lintott, 703–36. Cambridge, 1996.

Kent and Painter 1977
Kent, J. P. C., and Kenneth S. Painter, eds. *Wealth of the Roman
World: A.D. 300–700.* London, 1977.

Kiilerich 1993
Kiilerich, Bente. *Late-Fourth-Century Classicism in the Plastic Arts:
Studies in the so-called Theodosian Renaissance.* Odense University
Classical Studies, no. 18. Odense, 1993.

Kitzinger 1973
Kitzinger, Ernst. "Observations on the Samson Floor at Mopsuestia."
DOP 27 (1973): 133–44.

Klauck 1989
Klauck, Hans-Josef. *4. Makkabäerbuch.* Jüdische Schriften aus
hellenistisch-römischer Zeit, vol. 3, no. 6. Gütersloh, 1989.

Kleinbauer 1973
Kleinbauer, Eugene. "The Origin and Functions of the Aisled Tetraconch
Churches in Syria and Northern Mesopotamia." *DOP* 27 (1973): 89–114.

Kondoleon 1991
Kondoleon, Christine. "Signs of Privilege and Pleasure: Roman
Domestic Mosaics." In *Roman Art in the Private Sphere,* ed. Elaine K.
Gazda, 105–15. Ann Arbor, 1991.

Kondoleon 1995
Kondoleon, Christine. *Domestic and Divine: Roman Mosaics in the
House of Dionysos.* Ithaca, N.Y., 1995.

Koortbojian 1995
Koortbojian, Michael. *Myth, Meaning, and Memory on Roman
Sarcophagi.* Berkeley, 1995.

Korres 1970
Korres, Georgios Styl. *Ta meta kephalôn kriôn krane: hê kephalê driou
hô emvlêma archês.* Athens, 1970.

Kotansky 1991
Kotansky, Roy David. "Incantations and Prayers for Salvation on
Inscribed Greek Amulets." In *Magika Hiera,* ed. Christopher A.
Faraone and Dirk Obbink, 107–37. New York, 1991.

Kotansky 1994
Kotansky, Roy David. *Greek Magical Amulets.* Vol 1, *Published Texts of
Known Provenance.* Papyrologica coloniensia, no. 22. Opladen, 1994.

Kraeling 1932
Kraeling, Carl H. "The Jewish Community at Antioch." *JBL* 51 (1932):
130–60.

Kraeling 1956
Kraeling, Carl H. *The Synagogue*. Vol. 8, pt. 1 of *The Excavations at Dura-Europos: Final Report*. New Haven, 1956.

Kröger 1982
Kröger, Jens. *Sasanidischer Stuckdekor*. Baghdader Forschungen, no. 5. Mainz am Rhein, 1982.

Lancha 1997
Lancha, Janine. *Mosaïque et culture dans l'empire romain (1ᵉʳ–4ᵉ s.)*. Rome, 1997

Lassus 1934
Lassus, Jean. "La Mosaïque de Yakto." In *Antioch-on-the-Orontes I: The Excavations of 1932*, ed. George W. Elderkin, 114–56. Princeton, 1934.

Lassus 1935
Lassus, Jean. "Dans les rues d'Antioche." *BEO* 5 (1935): 121–24.

Lassus 1983
Lassus, Jean. "Le Fouilleur et les Mosaïques." In *Mosaïque: Recueil d'hommages à Henri Stern*, 253–58. Paris, 1983.

Lassus 1984
Lassus, Jean. "Sur les maisons d'Antioche." In *Apamée de Syrie. Aspects de l'architecture domestique d'Apamée*, ed. Janine Balty, 361–72. Brussels, 1984.

Laurence and Wallace-Hadrill 1997
Laurence, Ray, and Andrew Wallace-Hadrill, eds. *Domestic Space in the Roman World: Pompeii and Beyond*. JRA supplementary series, no. 22. Portsmouth, R.I., 1997.

Lavin 1963
Lavin, Irving. "The Hunting Mosaics of Antioch and Their Sources: A Study of Compositional Principles in the Development of Early Medieval Art." *DOP* 17 (1963): 179–286.

Levenson 1980
Levenson, David B. "A Source and Tradition Critical Study of the Stories of the Emperor Julian's Attempt to Rebuild the Jerusalem Temple." Ph.D. diss., Harvard University, Cambridge, Mass., 1980.

Levi 1947
Levi, Doro. *Antioch Mosaic Pavements*. 2 vols. Princeton, 1947.

Libanius 1977
Libanius. "Oration 30, For the Temples." In *Libanius, Selected Works*. Vol. 2, 91–151. Trans. A. F. Norman. Cambridge, Mass., 1977.

Liebeschuetz 1972
Liebeschuetz, J. H. W. G. *Antioch: City and Imperial Administration in the Later Roman Empire*. Oxford, 1972.

Liebeschuetz 1992
Liebeschuetz, J. H. W. G. "The End of the Ancient City." In *The City in Late Antiquity*, ed. John Rich, 1–49. London, 1992.

Linder 1987
Linder, Amnon. *The Jews in Roman Imperial Legislation*. Detroit, 1987.

Lissarrague 1990
Lissarrague, François. *The Aesthetics of the Greek Banquet: Images of Wine and Ritual*. Princeton, 1990.

Liversidge 1955
Liversidge, Joan. *Furniture in Roman Britain*. London, 1955.

L'Orange 1984
L'Orange, Hans Peter. *Das spätantike Herrscherbild von Diokletian bis zu den Konstantin-Söhnen, 284–361 n. Chr.* Das Römische Herrscherbild, no. 3, pt. 4. Berlin, 1984.

Luckner 1978
Luckner, Kurt T. "A Silver Goddess." *Museum News: The Toledo Museum of Art*, n.s. 20, no. 2 (1978): 56–62.

MacDonald 1986
MacDonald, William L. *The Architecture of the Roman Empire*. Vol. 2, *An Urban Appraisal*. New Haven, 1986.

Mackay 1949
Mackay, Dorothy. "The Jewellery of Palmyra and Its Significance." *Iraq* 11, no. 2 (1949): 160–87.

Maguire 1987
Maguire, Henry. *Earth and Ocean: The Terrestrial World in Early Byzantine Art*. New York, 1987.

Maguire 1999
Maguire, Eunice Dauterman. *Weavings From Roman, Byzantine and Islamic Egypt: The Rich Life and the Dance*. Exh. cat. Urbana-Champaign, Ill., 1999.

Malalas 1986
Malalas, John. *The Chronicle of John Malalas*, ed. Elizabeth Jeffreys, Michael Jeffreys, and Roger Scott. Byzantina Australiensia, no. 4. Melbourne, 1986.

Manchester 1994
Manchester, Karen. "A Bronze Statuette Representing the Tyche of Antioch: Roman Copy or Roman Original?" In *RE/Collections* 1 (1994).

Mandel 1988
Mandel, Ursula. *Kleinasiatische Reliefkeramik der mittleren Kaiserzeit*. Pergamenische Forschungen, no. 5. Berlin, 1988.

Mango 1977
Mango, Cyril. "Storia dell'arte." In *La Civiltà Bizantina dal IV al IX Secolo. Aspetti e Problemi*, 285–350. Bari, 1977.

Mango 1986
Mango, Marlia Mundell. *Silver from Early Byzantium: The Kaper Koraon and Related Treasures*. Baltimore, 1986.

Mango 1992
Mango, Marlia Mundell. "The Monetary Value of Silver Revetments and Objects Belonging to Churches, A.D. 300–700." In *Ecclesiastical Silver Plate in Sixth-Century Byzantium*, ed. Susan A. Boyd and Marlia M. Mango, 123–36. Washington, D.C., 1992.

Mango and Bennett 1994
Mango, Marlia Mundell, and Anna Bennett. *The Sevso Treasure: Art Historical Description and Inscriptions*. JRA supplementary series, no. 12, pt. 1. Ann Arbor, 1994.

Mango, Scott, and Greatrex 1997
Mango, Cyril, Roger Scott, and Geoffrey Greatrex, eds. *The Chronicle of Theophanes the Confessor: Byzantine and Near Eastern History, A.D. 284–813*. Oxford, 1997.

Markus 1990
Markus, Robert. *The End of Ancient Christianity*. Cambridge, 1990.

Martiniani-Reber 1986
Martiniani-Reber, Marielle. *Lyon, Musée historique des tissus: soieries sassanides, coptes, et byzantines, Ve–XIe siècles*. Inventaire des collections publiques françaises, no. 30. Paris, 1986.

Martiniani-Reber 1997
Martiniani-Reber, Marielle. *Textiles et mode sassanides. Les tissus orientaux conservés au Département des antiquités égyptiennes*. Inventaire des collections publiques françaises, no. 39. Paris, 1997.

Matheson 1980
Matheson, Susan B. *Ancient Glass in the Yale University Art Gallery*. New Haven, 1980.

Matheson 1994
Matheson, Susan B. "The goddess Tyche." In *An Obsession with Fortune: Tyche in Greek and Roman Art* (*YaleBull* 1994), ed. Susan B. Matheson, 19–33. Exh. cat. New Haven, 1994.

Mattusch 1994
Mattusch, Carol. "The Production of Bronze Statuary in the Greek World." In *Das Wrack. Der antike Schiffsfund von Mahdia*. Vol. 2, ed. Gisela Hellenkemper Salies et al., 789–800. Cologne, 1994.

Mattusch 1996
Mattusch, Carol C. *The Fire of Hephaistos: Large Classical Bronzes from North American Collections*. Exh. cat. Cambridge, Mass., 1996.

Mazar 1973
Mazar, Benjamin. *Beth She'arim*. Vol. 1, *Report on the Excavations during 1936–1940: Catacombs 1–4*. Jerusalem, 1973.

Meeks and Wilken 1978
Meeks, Wayne A., and Robert L. Wilken. *Jews and Christians in Antioch in the First Four Centuries of the Common Era*. Missoula, Mont., 1978.

Meischner 1990
Meischner, Jutta. "Das Porträt der theodosianischen Epoche I (380 bis 405 n. Chr.)." *JdI* 105 (1990): 303–25.

Meischner 1991
Meischner, Jutta. "Das Porträt der theodosianischen Epoche II." *JdI* 106 (1991): 385–407.

Metcalf 1977
Metcalf, William E. "The Antioch Hoard of Antoniniani and the Eastern Coinage of Trebonianus Gallus and Volusian." *ANSMN* 22 (1977): 71–94.

Metzger 1980
Metzger, Catherine. "Exemples d'iconographie de mosaïque appliquée à la sculpture. A propos de deux plaques à décor "champlevé" du Musée du Louvre." *MEFRA* 92, no. 1 (1980): 545–61.

Meyers 1992
Meyers, Pieter. "Elemental Compositions of the Sion Treasure and Other Byzantine Silver Objects." In *Ecclesiastical Silver Plate in Sixth-Century Byzantium*, ed. Susan A. Boyd and Marlia M. Mango, 169–91. Washington, D.C., 1992.

Micheli 1991
Micheli, Maria Elisa. "Il servizio della tavola, il *ministerium: argentum escarium, argentum potorium*." In *L'argento dei Romani: Vasellame da tavola e d'apparato*, Lucia Pirzio Biroli Stefanelli et al., 111–250. Rome, 1991.

Milan 1990
Palazzo Reale. *Milano Capitale dell'Impero romano, 286–402 d.c.* Exh. cat. Milan, 1990.

Milan 1997
Palazzo Reale. *Iside: Il Mito, il Mistero, la Magia*. Exh. cat. Milan, 1997.

Millar 1993
Millar, Fergus. *The Roman Near East, 31 B.C.–A.D. 337*. Cambridge, Mass., 1993.

Milliken 1951
Milliken, William M. "The Cleveland Byzantine Silver Treasure." *Bulletin of the Cleveland Museum of Art* 38, no. 6 (1951): 142–45.

Milliken 1958
Milliken, William M. "Early Byzantine Silver." *The Bulletin of the Cleveland Museum of Art* 45, no. 3 (1958): 35–41.

Miner 1947
Miner, Dorothy B., ed. *Early Christian and Byzantine Art: An Exhibition Held at the Baltimore Museum of Art*. Exh. cat. Baltimore, 1947.

Moffatt 1990
Moffatt, Ann. "A Record of Public Buildings and Monuments." In *Studies in John Malalas*, ed. Elizabeth Jeffreys, 87–110. Sidney, 1990.

Morey 1936
Morey, Charles Rufus. "The Excavation of Antioch-on-the-Orontes." *ProcPhilSoc* 76, no. 5 (1936): 637–51.

Morey 1937
Morey, Charles Rufus. *Art of the Dark Ages*. Exh. cat. Worcester, Mass., 1937.

Morey 1938
Morey, Charles Rufus. *The Mosaics of Antioch*. New York, 1938.

Müller 1839
Müller, Karl Otfried. *Antiquitates antiochenae: Commentationes duæ*. Göttingen, 1839.

Müller 1927
Müller, Valentin. *Zwei syrische Bildnisse römischer Zeit*. Winckelmannsprogramm der archäologischen Gesellschaft zu Berlin, no. 86. Berlin, 1927.

Nagy 1996
Rebecca M. Nagy, Carol L. Meyers, Eric M. Meyers, and Zeev Weiss, eds. *Sepphoris in Galilee: Crosscurrents of Culture*. Exh. cat. Raleigh, N.C., 1996.

Nauerth and Warns 1981
Nauerth, Claudia, and Rudiger Warns. *Thekla: Ihre Bilder in der Frühchristlichen Kunst*. Wiesbaden, 1981.

Newell 1978
Newell, Edward T. *The Coinage of the Western Seleucid Mints from Seleucus I to Antiochus III*. Numismatic Studies, no. 4. New York, 1978. Augmented reprint of 1941 edition.

New York 1990
IBM Gallery of Science and Art. *Rediscovering Pompeii*. Exh. cat. New York, 1990.

Nilsson 1940
Nilsson, Martin P. *Greek Popular Religion*. New York, 1940.

Nock 1954
Nock, Arthur Darby. "The Praises of Antioch." *JEA* 40 (1954): 76–82.

Obermann 1931
Obermann, Julian. "The Sepulchre of the Maccabean Martyrs." *Journal of Biblical Literature* 50 (1931): 250–65.

Ogden and Schmidt 1990
Ogden, Jack, and Simon Schmidt. "Late Antique Jewellery: Pierced Work and Hollow Beaded Wire." *Jewellery Studies* 4 (1990): 5–12.

Oikonomides 1990
Oikonomides, Nicolas. "The Contents of the Byzantine House from the Eleventh to the Fifteenth Century." *DOP* 44 (1990): 205–14.

Oliver 1977
Oliver, Andrew, Jr. *Silver for the Gods: 800 Years of Greek and Roman Silver*. Exh. cat. Toledo, 1977.

Oliver 1996
Oliver, Andrew, Jr. "Honors to Romans: Bronze Portraits." In *The Fire of Hephaistos: Large Classical Bronzes from North American Collections*, Carol C. Mattusch et al., 138–60. Exh. cat. Cambridge, Mass., 1996.

Ortiz 1996
Ortiz, George. *In Pursuit of the Absolute: Art of the Ancient World: The George Ortiz Collection*. Bern, 1996.

Ostrow 1979
Ostrow, Steven E. "The Topography of Puteoli and Baiae on the Eight Glass Flasks." *Puteoli* 3 (1979): 77–140.

Özgan and Stutzinger 1985
Özgan, Ramazan, and Dagmar Stutzinger. "Untersuchungen zur Porträtplastik des 5. Jhs. n. Chr. anhand zweier neugefundener Porträts aus Stratonikeia." *Istanbuler Mitteilungen* 35 (1985): 237–74.

Painter 1975
Painter, Kenneth. "Roman Flasks with Scenes of Baiae and Puteoli." *JGS* 17 (1975): 54–67.

Paris 1931
Musée du Lourvre. *Exposition internationale d'art byzantin*. Exh. cat. Paris, 1931.

Paris 1991
Musée du Louvre. *Le trésor de Saint-Denis*. Exh. cat. Paris, 1991.

Paris 1992
Musée du Louvre. *Byzance: L'art byzantin dans les collections publiques françaises*. Paris, 1992.

Parlasca 1961
Parlasca, Klaus. "Die Tyche von Antiochia und das sitzende Mädchen im Konservatorenpalast." *JRGZM* 8 (1961): 84–95.

Paul 1991
Paul, George. "*Symposia* and *Deipnia* in Plutarch's Lives and in other Historical Writings." In *Dining in a Classical Context*, ed. William J. Slater, 157–70. Ann Arbor, 1991.

Pavis 1987
Pavis d'Escurac, Henriette. "Magie et cirque dans la Rome antique." *Byz. Forsch.* 12 (1987): 447–67.

Payne 1939
Payne, Elizabeth H. "A Mosaic from the Antioch Region." *Bulletin of the Smith College Museum of Art* 20 (1939): 10–16.

Penkova 1981
Elka Penkova. "Athena (in Moesia, Thracia)." *LIMC* II (Munich 1981): 1049–50.

Perkins 1973
Perkins, Ann L. *The Art of Dura-Europos*. Oxford, 1973.

Peterson forthcoming
Peterson, Sigrid. "Martha Shamuni: A Jewish Syriac Liturgical Poem of the Maccabean Martyrs." Ph.D. diss., University of Pennsylvania, forthcoming.

Petit 1955
Petit, Paul. *Libanius et la vie municipale à Antioche au IVe siècle après J.-C.* Paris, 1955.

Petronius 1959
Petronius. *The Satyricon of Petronius*. Trans. William Arrowsmith. Ann Arbor, 1959.

Philostratus 1979
Philostratus. *Philostratus: Imagines*. Trans. Arthur Fairbanks. Loeb Classical Library. Cambridge and London, 1979.

Ploug 1995
Ploug, Gunhild. *Catalogue of the Palmyran Sculptures. Ny Carlsberg Glyptotek*. Copenhagen, 1995.

Pollitt 1986
Pollitt, Jerome J. *Art in the Hellenistic Age*. Cambridge, 1986.

Price 1991
Price, Jennifer. "Decorated Mould-Blown Glass Tablewares in the First Century A.D." In *Roman Glass: Two Centuries of Art and Invention*, ed. Martine Newby and Kenneth Painter, 56–75. Occasional Papers from the Society of Antiquaries of London, no. 13. London, 1991.

Providence 1987
David Winton Bell Gallery, Brown University. *Survival of the Gods: Classical Mythology in Medieval Art*. Exh. cat. Providence, R.I., 1987.

Pseudo-Dionysius 1996
Pseudo-Dionysius of Tel-Mahre. *Pseudo-Dionysius of Tel-Mahre Chronicle, Part III*. Trans. Witold Witakowski. Liverpool, 1996.

Purcell 1995
Purcell, Nicholas. "Literate Games: Roman Urban Society and the Game of Alea." *Past and Present* 147 (May 1995): 3–37.

Rautman 1995
Rautman, Marcus L. "A Late Roman Townhouse at Sardis." In *Forschungen in Lydien*, ed. Elmar Schwertheim, 49–66. Asia Minor Studien, vol. 17. Bonn, 1995.

Rea 1980
Rea, Josef R. "A Gold Ring with a Horoscope of A.D. 327." *ZPE* 39 (1980): 155–58.

Rey-Coquais 1978
Rey-Coquais, Jean-Paul. "Syrie romaine, de Pompée à Dioclétien." *JRS* 68 (1978): 44–73.

Rhomiopoulou 1997
Rhomiopoulou, Katerina. *Ellênorhomaika glupta tou Ethnikou Arkhaiologikou Mouseou* (Greco-Roman sculptures of the National Archaeological Museum). Athens, 1997.

Ridgway 1972
Ridgway, Brunilde Sismondo. *Classical Sculpture: Catalogue of the Classical Collection*. Providence, R.I., 1972.

Ridgway 1994
Ridgway, Brunilde Sismondo. *Greek Sculpture in the Art Museum, Princeton University: Greek Originals, Roman Copies, and Variants*. Princeton, 1994.

Roberts 1995
Roberts, Michael. "Martin Meets Maximus: The Meaning of a Late Roman Banquet." *Revue des Etudes Augustiniennes* 41, no. 1 (1995): 91–111.

Robinson 1975
Robinson, H. Russell. *The Armour of Imperial Rome*. New York, 1975.

Rolley 1969
Rolley, Claude. *Fouilles de Delphes*. Vol. 5, *Monuments figurés–Les statuettes de bronze*. Paris, 1969.

Ross 1941
Ross, Marvin C. "The Collection." *Bulletin of the Fogg Museum of Art: A Special Number Devoted to the Dumbarton Oaks Research Library and Collection* 9, no. 4 (1941): 69–81.

Ross 1952
Ross, Marvin C. "A Small Byzantine Treasure found at Antioch-on-the-Orontes." *Archaeology* 5, no. 1 (1952): 30–32.

Ross 1953
Ross, Marvin C. "A Silver Treasure found at Daphne-Harbié." *Archaeology* 6 (1953): 39–41.

Ross 1962
Ross, Marvin C. *Catalogue of the Byzantine and Early Medieval Antiquities in the Dumbarton Oaks Collection*. Vol. 1, *Metalwork, Ceramics, Glass, Glyptics, Painting*. Washington, D.C., 1962.

Ross 1965
Ross, Marvin C. *Catalogue of the Byzantine and Early Medieval Antiquities in the Dumbarton Oaks Collection*. Vol. 2, *Jewelry, Enamels, and Art of the Migration Period*. Washington, D.C., 1965.

Ross 1967–68
Ross, Marvin C. "Luxuries of the Eastern Empire." *Arts in Virginia* 8, nos. 1–2 (1967–68): 56–65.

Ross 1968
Ross, Marvin C. "Jewels of Byzantium." *Arts in Virginia* 9, no. 1 (1968): 12–31.

Rossiter 1991
Rossiter, Jeremy. "*Convivium* and Villa in Late Antiquity." In *Dining in a Classical Context*, ed. William J. Slater, 199–214. Ann Arbor, 1991.

Rostovtzeff, Brown, and Welles 1939
Rostovtzeff, Michael I., Frank E. Brown, C. Bradford Welles, eds. *The Excavations at Dura-Europos. Preliminary Report of the Seventh and Eighth Seasons of Work 1933–1935*. New Haven, 1939.

Rouché 1993
Rouché, Charlotte. *Performers and Partisans at Aphrodisias in the Roman and Late Roman Periods. JRS* monographs, no. 6. London, 1993.

Rouché 1998
Rouché, Charlotte. "Provincial Governors and their Titulature in the Sixth Century." *Antiquité Tardive* 6 (1998): 83–89.

Russell 1982
Russell, James. "Byzantine *Instrumenta Domestica* from Anemurium: The Significance of Context." In *City, Town, and Countryside in the Early Byzantine Era*, ed. R.L. Hohlfelder, 133–63. New York, 1982.

Russell 1995
Russell, James. "The Archaeological Context of Magic in the Early Byzantine Period." In *Byzantine Magic*, ed. Henry Maguire, 35–50. Washington, D.C., 1995.

Rutgers 1998
Rutgers, Leonard V. "The Importance of Scripture in the Conflict Between Jews and Christians: The Example of Antioch." In *The Use of Sacred Books in the Ancient World*, ed. L.V. Rutgers et al., 287–303. Contributions to Biblical Exegesis and Theology, no. 22. Louvain, 1998.

Salomonson 1979
Salomonson, J.W. *Voluptatem spectandi non perdat sed mutet: Observations sur l'iconographie du martyre en Afrique romaine*. Amsterdam, 1979.

Scatozza Höricht 1991
Scatozza Höricht, Lucia A. "Syrian Elements among the Glass from Pompeii and Herculaneum." In *Roman Glass: Two Centuries of Art and Invention*, ed. Martin Newby and Kenneth Painter, 76–85. Occasional Papers from The Society of Antiquaries of London, no. 13. London, 1991.

Schlüter 1971
Schlüter, Rendel. "Die Bildnisse der Kaiserin Iulia Domna." Ph.D. diss. Münster, 1971.

Schmidt-Colinet 1997
Schmidt-Colinet, Andreas. "Aspects of Romanization: The Tomb Architecture at Palmyra and its Decoration." In *The Early Roman Empire in the East*, ed. Susan Alcock, 157–77. Oxford, 1997.

Schneemelcher 1991–92
Schneemelcher, Wilhelm, ed. *New Testament Apocrypha*. 2 vols. Cambridge, 1991–92.

Schneider 1983
Schneider, Lambert. *Die Domäne als Weltbild: Wirkungsstrukturen der spätantiken Bildersprache*. Wiesbaden, 1983.

Schoedel 1985
Schoedel, William R. *Ignatius of Antioch: A Commentary on the Letters of Ignatius of Antioch*. Ed. Helmut Koester. Philadelphia, 1985.

Schwabe and Lifshitz 1973–74
Schwabe, Moshe, and Baruch Lifshitz. *Beth She'arim*. Vol. 2, *The Greek Inscriptions*. Jerusalem, 1973–74.

Schweitzer 1954
Schweitzer, Bernhard, "Altrömische Traditionselemente in der Bildniskunst des dritten nachchristlichen Jahrhunderts," *Nederlands Kunsthistorisch Jaarboek* 5 (1954): 173–90.

Seipel 1996
Seipel, Wilfried, ed. *Weihrauch und Seide: Alte Kulturen an der Seidenstrasse*. Vienna, 1996.

Severus 1902–4
Severus of Antioch. *The Sixth Book of the Select Letters of Severus Patriarch of Antioch, in the Syriac version of Athanasius of Nisibis*. Ed. and trans. E. W. Brooks. 2 vols., each in two parts. London, 1902–4.

Seyrig 1946–48
Seyrig, Henri. "Poids antiques de la Syrie et de la Phénicie sous la domination grecque et romaine." *Bull.Mus.Beyrouth* 8 (1946–48): 37–79.

Seyrig 1952
Seyrig, Henri. "Antiquités syriennes. 53: Antiquités de la nécropole d'Emèse." *Syria* 29 (1952): 204–50.

Shelton 1981
Shelton, Kathleen J. *The Esquiline Treasure*. London, 1981.

Shelton 1988
Shelton, Jo-Ann. *As the Romans Did: A Source Book in Roman Social History*. New York, 1988.

Shepherd 1966
Shepherd, Dorothy G. "Two Silver Rhyta." *Bulletin of the Cleveland Museum of Art* 53 (Oct. 1966): 289–311.

Shepherd 1961
Shepherd, Massey H., Jr. "The Formation and Influence of the Antiochene Liturgy." *DOP* 15 (1961): 23–44.

Sherwin-White 1972
Sherwin-White, Adrian N. "The Roman Citizenship: A Survey of Its Development into a World Franchise." *ANRW* 1, no. 2 (1972): 23–58.

Sherwin-White 1973
Sherwin-White, Adrian N. *The Roman Citizenship*. 2nd ed. Oxford, 1973.

Sidonius Apollinaris 1936–65
Sidonius Apollinaris. *Poems and Letters*. Trans. W. B. Anderson. Loeb Classical Library. London and Cambridge, Mass., 1936–65.

Simpson 1997
Simpson, C. J. *The Excavations of San Giovanni di Ruoti*. Vol. 2, *The Small Finds*. Toronto, 1997.

Slater 1976
Slater, William J. "Symposium at Sea." *HSCP* 80 (1976): 161–70.

Smallwood 1976
Smallwood, Mary. *The Jews under Roman Rule: From Pompey to Diocletian*. Studies in Judaism in Late Antiquity, no. 20. Leiden, 1976.

Smith 1990
Smith, R. R. R. "Late Roman Philosopher Portraits from Aphrodisias." *JRS* 80 (1990): 127–55.

Sodini 1980
Sodini, Jean Pierre, et al. "Déhès (Syrie du nord), Campagnes I–III (1976–1978): Recherches sur l'habitat rural." *Syria* 57 (1980): 1–304.

Stansbury-O'Donnell 1994
Stansbury-O'Donnell, Mark D. "Reflections on the Tyche of Antioch in Literary Sources and on Coins." In *An Obsession with Fortune: Tyche in Greek and Roman Art* (*YaleBull* 1994), ed. Susan B. Matheson, 51–63. New Haven, 1994.

Stauffer 1991
Stauffer, Annemarie. *Textiles d'Egypte de la collection Bouvier. Textilien aus Agypten der Sammlung Bouvier*. Fribourg, 1991.

Steckner 1990
Steckner, Cornelius. "Pharokantharoi und Kylikeia: Dionysische Lichtgefässe in architektonischem Kontext." In *Annales du 11e Congrès de l'association internationale pour l'histoire du verre, Bâle, 29 août–3 septembre 1988*, 257–70. Amsterdam, 1990.

Stefanelli 1991
Stefanelli, Lucia Pirzio Biroli, et al. *L'argento dei Romani: Vasellame da tavola e d'apparato*. Rome, 1991.

Stern 1995
Stern, E. Marianne. *Roman Mold-blown Glass: The First through Sixth Centuries*. Exh. cat. Toledo, 1995.

Stern 1997
Stern, E. Marianne. "Glass and Rock Crystal: A Multifaceted Relationship." *JRA* 10 (1997): 196–206.

Stichel 1982
Stichel, Rudolf. *Die römische Kaiserstatue am Ausgang der Antike. Untersuchungen zum plastischen Kaiserporträt seit Valentinian I (364–375 n. Chr.)*. Archaeologica, no. 24. Rome, 1982.

Stillwell 1961
Stillwell, Richard. "Houses of Antioch." *DOP* 15 (1961) 45–57.

Strong 1966
Strong, Donald E. *Greek and Roman Gold and Silver Plate*. London, 1966.

Strube 1983
Strube, Christine. "Die Kapitelle von Qasr ibn Wardan: Antiochia und Konstantinopel im 6. Jahrhundert." *JAC* 26 (1983): 59–106.

Tanabe 1986
Tanabe, Katsumi. *Sculptures of Palmyra.* Tokyo, 1986.

Tate 1992
Tate, Georges. *Les campagnes de la Syrie du nord du IIe au VIIe siècle.* Bibliothèque archéologique et historique, no. 133. Paris, 1992.

Tchalenko 1953
Tchalenko, Georges. *Villages antiques de la Syrie du nord.* Bibliothèque archéologique et historique, no. 50. Paris, 1953.

Teitz 1971
Teitz, Richard Stuart. "The Antioch Mosaics." *Apollo* 94 (Dec. 1971): 438–44.

Thébert 1987
Thébert, Yvon. "Private and Domestic Architecture in Roman Africa." In *A History of Private Life.* Vol. 1, *From Pagan Rome to Byzantium,* ed. Paul Veyne, 313–409. Cambridge, Mass., 1987.

Theodoret 1985
Theodoret of Cyrrhus. *A History of the Monks of Syria.* Trans. R. M. Price. Cistercian studies series, no. 88. Kalamazoo, Mich., 1985.

Theophanes 1963
Theophanes. *Chronographia.* Ed. and trans. Carolus de Boor. 1883. Repr., Hildesheim, 1963.

Thompson 1961
Thompson, Mary L. "Programmatic Painting in Pompeii: The Meaningful Combination of Mythological Pictures in Room Decoration." Ph.D. diss., New York University, 1961.

Thurman 1970
Thurman, William S. "The Application of *Subiecti* to Roman Citizens in the Imperial Laws of the Late Roman Empire." *Klio* 52 (1970): 453–63.

Tinh 1990
Tinh, Tran Tam. "Isis." In *LIMC* 5 (Zurich 1990): 761–96.

Toledo 1962
Toledo Museum of Art. "New accessions." *Museum News: The Toledo Museum of Art,* n.s. 5 (1962): 51–70.

Toledo 1969
Toledo Museum of Art. *Art in Glass: A Guide to the Glass Collections.* Toledo, 1969.

Toledo 1979
Toledo Museum of Art. *1979 Annual Report.* Toledo, 1979.

Toledo 1986
Toledo Museum of Art. *1986 Annual Report.* Toledo, 1986.

Toledo Museum of Art 1995
Toledo Museum of Art. *Toledo Treasures: Selections from The Toledo Museum of Art.* New York and Toledo, 1995.

Toynbee and Painter 1986
Toynbee, J. M. C., and K. S. Painter. "Silver Picture Plates of Late Antiquity: A.D. 300 to 700." *Archaeologia* 108 (1986): 15–65.

Uhlenbrock 1986
Uhlenbrock, Jaimee, ed. *Herakles: Passage of the Hero through 1000 Years of Classical Art.* Exh. cat. New Rochelle, N.Y., 1986.

Ulbert 1986
Ulbert, Thilo. *Resafa.* Vol. 2, *Die Basilika des Heiligen Kreuzes in Resafa-Sergiupolis.* Mainz, 1986.

Van den Ven 1962
van den Ven, Paul. *La vie ancienne de S. Syméon Stylite le Jeune (521–592).* 2 vols. Subsidia Hagiographica, no. 32. Brussels, 1962.

Vermaseren 1977
Vermaseren, Maarten Jozef. *Cybele and Attis: The Myth and the Cult.* London, 1977.

Vermeule 1960
Vermeule, Cornelius C. "A Roman Silver Helmet in the Toledo (Ohio) Museum of Art." *JRS* 50 (1960): 8–11.

Vermeule 1963
Vermeule, Cornelius C. "Augustan and Julio-Claudian Court Silver." *AntK.* 6 (1963): 33–40.

Vermeule 1968
Vermeule, Cornelius C. *Roman Imperial Art in Greece and Asia Minor.* Cambridge, Mass., 1968.

Vermeule 1974
Vermeule, Cornelius C. *Greek and Roman Sculpture in Gold and Silver.* Boston, 1974.

Vermeule 1981
Vermeule, Cornelius C. *Greek and Roman Sculpture in America.* Malibu, Calif., 1981.

Vickers 1996
Vickers, Michael. "Rock Crystal: The Key to Cut Glass and *Diatreta* in Persia and Rome." *JRA* 9 (1996): 48–65.

Vikan 1982
Vikan, Gary. *Byzantine Pilgrimage Art.* Washington, D.C., 1982.

Vikan 1995
Vikan, Gary. *Catalogue of the Sculpture in the Dumbarton Oaks Collection from the Ptolemaic Period to the Renaissance.* Washington, D.C., 1995.

Vikan and Nesbitt 1980
Vikan, Gary, and John Nesbitt. *Security in Byzantium: Locking, Sealing, and Weighing.* Washington, D.C., 1980.

Von Gebhardt 1902
von Gebhardt, Oscar. *Passio S. Theclae Virginis, die lateinischen Übersetzungen der Acta Pauli et Theclae: Nebst Fragmenten, Auszügen und Beilagen.* Texte und Untersuchungen zur Geschichte der Altchristlichen Literatur, n.f. 7.2. Leipzig, 1902.

Waagé 1941
Waagé, Frederick O. "Lamps." In *Antioch-on-the-Orontes III: The Excavations of 1937–1939,* ed. Richard Stillwell, 55–82. Princeton, 1941.

Waagé 1948
Waagé, Frederick O. "Hellenistic and Roman Tableware of North Syria." In *Antioch-on-the-Orontes IV. Part One: Ceramics and Islamic Coins,* ed. Frederick O. Waagé, 1–60. Princeton, 1948.

Waagé 1952
Waagé, Dorothy B. *Antioch-on-the-Orontes IV. Part Two: Greek, Roman, Byzantine and Crusaders' Coins.* Princeton, 1952.

Wages 1986
Wages, Sara M. "A Note on the Dumbarton Oaks *TETHYS* Mosaic." *DOP* 40 (1986): 119–28.

Waldbaum 1983
Waldbaum, Jane C. *Metalwork from Sardis: The Finds through 1974.* Cambridge, Mass., 1983.

Waldhauer 1928
Waldhauer, Oskar, ed. *Die Antiken Skulpturen der Ermitage.* Vol. 1. Berlin and Leipzig, 1928.

Wallace-Hadrill 1994
Wallace-Hadrill, Andrew. *Houses and Society in Pompeii and Herculaneum.* Princeton, 1994.

Wallace-Hadrill 1982
Wallace-Hadrill, David Sutherland. *Christian Antioch: A Study of Early Christian Thought in the East.* Cambridge, 1982.

Ward 1987
Ward, Benedicta. *Harlots of the Desert: A Study of Repentance in Early Monastic Sources.* Cistercian studies series, no. 106. Kalamazoo, Mich., 1987.

Ward-Perkins 1981
Ward-Perkins, John Bryan. *Roman Imperial Architecture.* The Pelican History of Art. Middlesex, 1981.

Ward-Perkins 1998
Ward-Perkins, John Bryan. "The Cities." In *CAH.* 2nd ed. Vol. 13, *The Late Empire, A.D. 337–425,* ed. Averil Cameron and Peter Garnsey, 371–410. Cambridge, 1998.

Weir forthcoming
Robert Weir. *Antiochene Grave Stelai in Princeton.* Princeton, forthcoming.

Weitzmann 1941
Weitzmann, Kurt. "The Iconography of the Reliefs from the Martyrion." In *Antioch on the Orontes III: The Excavations 1937–1939,* ed. Richard Stillwell, 135–49. Princeton, 1941.

Weitzmann 1979
Weitzmann, Kurt, ed. *Age of Spirituality: Late Antique and Early Christian Art, Third to Seventh Century.* Exh. cat. New York, 1979.

Whitehouse 1988
Whitehouse, David. *Glass of the Roman Empire.* Corning, N.Y., 1988.

Whittow 1990
Whittow, Mark. "Ruling the Late Roman and Byzantine City: A Continuous History." *PastPres* 129 (Nov. 1990): 3–29.

Wiles 1991
Wiles, David. *The Masks of Menander: Sign and Meaning in Greek and Roman Performance.* Cambridge, 1991.

Wilken 1983
Wilken, Robert. *John Chrysostom and the Jews: Rhetoric and Reality in the Late Fourth Century.* Berkeley, 1983.

Wilken 1984
Wilken, Robert. *The Christians as the Romans Saw Them.* New Haven, 1984.

Williams 1999
Williams, Dyfri. "The Warren Cup." *Minerva* 10, no. 4 (July/August 1999): 33–35.

Winkes 1982
Winkes, Rolf. *Roman Paintings and Mosaics: Catalogue of the Classical Collection.* Providence, R.I., 1982.

Winkler 1985
Winkler, John J. *Auctor and Actor: A Narratological Reading of Apuleius' Golden Ass.* Berkeley, 1985.

Worcester 1948
Worcester Art Museum. *Art through Fifty Centuries.* Worcester, Mass., 1948.

Wrede 1972
Wrede, Henning. *Die Spätantike Hermengalerie von Welschbillig.* Römisch-Germanische Forschungen, no. 32. Berlin, 1972.

Yarshater 1983
Yarshater, Ehsan, ed. *Cambridge History of Iran.* Vol. 3, *The Seleucid, Parthian, and Sasanian Periods.* Cambridge, Mass., 1983.

Yegül 1992
Yegül, Fikret. *Baths and Bathing in Classical Antiquity.* New York, 1992.

Yegül 1993
Yegül, Fikret. "The Roman Baths at Isthmia in their Mediterranean Context." In *The Corinthia in the Roman Period,* ed. Timothy E. Gregory, 101–13. *JRA* supplementary series, no. 8. Ann Arbor, 1993.

Yeroulanou 1999
Yeroulanou Aimilia. *Diatrita: Gold Pierced-Work Jewellery from the Third to the Seventh Century.* Athens, 1999.

Young 1983
Young, Frances M. *From Nicaea to Chalcedon: A Guide to the Literature and Its Background.* Philadelphia, 1983.

Young 1991
Young, Robin Darling. "The 'Woman with the Soul of Abraham': Traditions about the Mother of the Maccabean Martyrs." In *Women Like This: New Perspectives on Jewish Women in the Greco-Roman World,* ed. Amy-Jill Levine, 67–81. Atlanta, 1991.

Index

Beirut, 15; synagogue of, 34

bearded male head (Dionysos?), 95, 179 (cat. no. 66)

bearded male head (Dionysos?), 95, 179, 180 (cat. no. 67)

Benjamin of Tudela, 29, 34

Beroea (Aleppo), 24, 25, 126, 194

Bliss, Robert Woods, 5

Boat of the Psyches. *See* mosaic of Boat of the Psyches

Bosra, South Baths of, 146, 150

Bottia, 198; temple of Zeus Bottios, 198

bottle in the shape of a caravan dromedary, 192, 195 (cat. no. 84)

bottle shaped like a cluster of grapes, 193 (cat. no. 79)

bottle with two applied faces, 228 (cat. no. 118)

bowl with Saint Thecla in the Arena, 226–27 (cat. no. 117)

bowl with scalloped rim, 195 (cat. no. 83)

boy with jumping weights, 98, 176

Briseis, 156

buckles, 84, 85 (fig. 8); belt buckle, 125 (cat. no. 14)

Building 25-H, Antioch, cache of sculptures in, 93, 95–98, 101

Butler, Howard Crosby, 5

Byblos, 15, 70; Temple of Aphrodite, 70

Byzantine stadium, Antioch, 9, 150

Caesarea Maritima, 96, 101

Cafavy, C. P., 3

Caius Terentius Rufus, 142

Calliope, 65; temple of, Antioch, 65

Campbell, William A., 5, 6 (fig. 3), 7, 179

candlestick, 187 (cat. no. 70)

Caracalla, emperor, xiii, 16, 17, 127; coinage under, 109, 118; on coins, 101

Carthage, mosaics, 160n.1, 186, 219

Cassiopeia, 70

censer, 162 (cat. no. 49)

Cerdo, 41

Ceres, 127

chalices, 211 (cat. no. 98); Antioch chalice, 162, 209, 214–15 (cat. no. 104); *diskopoteria* (chalice and paten), 183, 211

chariot races, 155, 162, 166–67

Chosroes I, king of Persia, 24–26, 130–31, 135

Chosroes II, king of Persia, 132

Christianity in Antioch, xii, 10, 13–14, 17–21, 39–49, 61n.1, 162, 167, 197, 211, 217–28

Christianity in Roman Empire, 14, 18–21, 29, 32–33, 61n.1, 76, 116, 146, 199, 209, 210–11, 217–28; as state religion, 18, 32, 42, 102

Christogram, architectural boss with, 224 (cat. no. 113)

Christological doctrines, 20, 40, 42, 43, 45, 47–48, 126, 224; *see also* Monophysitism; orthodox doctrine

church building, Seleucia Pieria, 217 (fig. 1), 218 (fig. 2), 219–22; mosaic pavement of, 9, 218, 219 (fig. 1), 221 (fig. 1); relief decoration of, 217, 220, 221 (fig. 1), 222–23 (cat. nos. 107–12)

Church of the Virgin, Antioch, 7

Cicero, 161

Cilicia, 5, 33, 94, 106; personification of, 121

circus factions, xiii, 24, 25, 31, 166–67

Claudius, emperor, 15, 16; coinage under, 108

Cleopatra, xii, 107

Cleopatra Thea, 106, 107 (fig. 3)

Clercq, Louis de, 201, 203, 204

coins, 101–2, 104–11, 201; in Antioch excavations, 79, 105, 106–8; of Sasanians, 131, 132; *see also* coins, images on; mint of Antioch

coins, images on: Apollo, 101, 105, 106 (fig. 2); Athena Nikephoros, 101; bull, 110 (fig. 13); Christian motifs, 102, 110 (fig. 14); city wall, 110; Constantinopolis, 110 (fig. 14); eagle, wings spread, 108 (fig. 8), 109 (fig. 9); emperor and female figure, 109 (fig. 10); Herakles, 105, 106 (fig. 1); inscriptions, 106–7, 109; Isis, 199; legionary standards,

109 (fig. 11); Nike-Victoria, 102; ram, 108 (fig. 7); Roman emperors, 101–2, 103, 104, 108 (figs. 6, 8), 109 (figs. 9–10), 110 (figs. 12–13), 116, 126, 127, 201; seated Zeus, 101, 105, 106 (fig. 1); kings of Syria, 101–2, 104, 105, 106 (fig. 2), 107 (figs. 3–5); Tyche, 116, 118; Tyche head, 108 (fig. 7); Tyche of Antioch, 101–2, 106, 107 (fig. 5), 108 (fig. 6), 198

colonnaded street, great, Antioch, xii, 7, 8–9, 15–16, 25, 103, 148, 155, 217

Column of Trajan, 157, 158

Commagene, 15, 101, 158

Commodus, emperor, 148; Commodiana (baths of Commodus), 147 (fig. 1), 148–49; coinage under, 108

conical beaker or lamp, 194 (cat. no. 81)

Constans II, emperor, 111

Constantine the Great, xiii, 9, 18, 19, 101, 102, 157, 159, 197; and Christianity, xiii, 18, 42; on coins, 101; coin portraits of sons, 126

Constantinian Villa, Daphne, 69; hunt mosaic, 189; medallion with Herakles, 205; mosaic bust of Dionysos, 69, 205–6 (cat. no. 92)

Constantinople, 93, 155; baths of, 147, 149; as capital of empire, 14, 19, 110; Church of Saint Polyeuktos, 133; as ecclesiastical capital, 10, 39, 42, 214,; as great episcopal see, 20, 39, 42; Hagia Sophia, 102; as New Rome, 21, 101, 116; as one of four great cities, 3, 116–17; personification of, 102, 110 (fig. 14), 116; Tyche of, 116–17

Constantinopolis, personification of Constantinople, 102, 110 (fig. 14), 116

Constantius I. *See* Constantine the Great

Constantius II, emperor, 9, 126; on coins, 105, 126

Constantius II (?), head of, 126 (cat. no. 16)

Corinth, 159, 200

cross, monumental, 216 (cat. no. 105); medallions from, 216 (cat. no. 106)

crouching Aphrodite, Antioch, 96 (fig. 7)

Ctesiphon, 24, 135; Antioch of Chosroes, 24

cult relief of Atargatis/Cybele and Hadad, 207 (cat. no. 93)

Cupid, 58, 61n.8, 198

cup with Dionysiac motifs, 186–87 (cat. no. 69)

curse tablets, 162, 163, 164–65 (cat. nos. 50–51, 53–54), 166–67

Cybele (Magna Mater), 89, 207

Cyril, bishop of Alexandria, 47–48

Damascus, 13, 15, 48, 91

Daniel, 226

Daniel (marble relief), 217, 221, 223 (cat. no. 111)

Daphne, 10, 108; and Apollo, 75, 197, 198; in art, 71, 75, 77n.24, 196

Daphne, houses of. *See* Constantinian Villa; House of Ge and the Seasons; House of Menander; House of the Boat of Psyches; House of the Buffet Supper; House of the Phoenix; House of the Rams' Heads; House of the Worcester Hunt

Daphne, suburb of, 9–10, 11, 23, 30, 33, 44, 48, 51, 60, 63, 91, 92, 94, 95, 98, 114, 148, 163; cult of Apollo at, 105; grove of Apollo and Daphne, 9–10, 44; Matrona Synagogue, xiii, 33; sanctuary of Apollo, 145; shrine of Apollo, 197; springs of, 51, 60, 71, 75, 77n.21, 115, 145, 152–53, 197, 198; Temple of Apollo, 44, 75, 198; theater at, xiii, 7, 77n.19; Theater of the Olympian Zeus, 155, 159; *see also* Daphne, houses of

Daphne-Harbie, 7; theater of, 92

Decius, emperor, 101

Dehes, excavation of, 26

Delos, 96, 199

Demeter, 199

Demetrios I, king of Syria, 198

Demetrios II Nikator, 31, 36

Demir, Ataman, 8

Diadumenian, Caesar, on coins, 109

Diocletian, emperor, 9, 17–18, 41, 65, 102, 109, 146, 149, 192, 226; on coins, 101

Diodalsas of Bithynia, crouching Aphrodite, 96

Diodore of Tarsus, 47

Dionysiac/Bacchic herms, 177, 180

Dionysiac mosaic, Chania, Crete, 64–65

Dionysiac mosaic, Sepphoris, Israel, 68, 69 (fig. 4)

Dionysos, 89, 91, 96, 99, 110, 187, 199, 205; in art, 53, 55, 65, 68–69, 74, 76, 77n.24, 95, 98–99, 132, 162, 170, 172, 177, 179, 180, 186, 187, 189, 205, 206

Dionysos sculptures: statuette, 98, 176, 177 (cat. no. 63); bearded male head (Dionysos?), 95, 179 (cat. no. 66); bearded male head (Dionysos?), 95, 179, 180 (cat. no. 67)

Dioscuri, 103

disc with sphinx, Antioch, 98 (fig. 12)

Domitian, emperor, 148, 158; coinage under, 108

Downey, Glanville, 8, 126

drinking cup with Dionysiac revel, 205 (cat. no. 91)

Dura-Europos, 109, 190, 205, 207; sculpture of, 91, 101; Mithraeum, 208; synagogue of, 33; Temple of Atagartis, 207; Tyche of, 120, 207–8; wall paintings of, 33, 118

Edessa, 24, 42, 45; church of, 41, 42; theological school of, 48

Egyptian cults, 10, 88, 176, 197, 199; see also Isis

Elagabalus (sun god), 127

Elagabalus, emperor, 93, 201; coinage under, 109, 201

Eleazar, 33–34

Eliezer, Rabbi, 36

Elsner, John, 77n.26

Emesa (Homs), 42, 91, 93, 127, 158

Ephas, Rabbi, 36

Ephesos, 4, 9, 60, 92, 94, 100–101, 103, 156, 160, 199, 207; churches of, 40; villa over the theater, 61nn. 8 and 10

Ephrem of Antioch, bishop, 46, 48

Eros, 7, 71, 73 (fig. 6), 74, 98, 118, 152, 153, 170, 174, 176, 201; Attis as, 88 (fig. 12), 89

erotes, 60, 71, 94

Eudocia, empress, xiii

Euphrasius, bishop of Antioch, 48

Euripides, 70

Europa and the Bull, 60, 71

Eusebius of Caesarea, 18, 41

Eutychides of Sicyon, Tyche of Antioch, ii (frontispiece), xii, 91, 102, 116, 118, 119, 120, 139, 198, 208; see also Tyche of Antioch

Eve, 226

Evil Eye, counters to, 89, 163 (fig. 1), 166; see also magic and magicians

ewer, 188, 195, 214 (cat. no. 71)

ewer with circular mouth, 195 (cat. no. 82)

excavations of Antioch, 5–8, 9, 10, 14, 24, 25, 33, 51–52, 63, 65, 79–80, 85, 87, 103, 106, 139, 142, 150, 155, 163–66, 220; see also individual houses, buildings, city features

Fisher, C. H., 150

Flavian, bishop of Antioch, 19, 45

Flavius Josephus, 30, 35, 37n.3

food, 181–82

footed bowl (carchesium), 184, 193 (cat. no. 78)

Forbes, Edward W., 5

Fortuna, 120, 199, 204, 207

Forum of Valens, Antioch, 7, 148, 159

funerary monument of Umm'abi, 122 (cat. no. 10), 129

funerary relief of men playing a board game, 160–61 (cat. no. 45)

funerary sculpture, 122 (cat. no. 10), 129; funerary reliefs, 129, 139–41 (cat. nos. 27–32), 160–61 (cat. no. 45); grave stelae, 95, 101, 139, 140

funerary symposium, mosaic of a, 80, 121–22 (cat. no. 9), 161, 183

furniture, 80–82; chairs, 80; decorative elements on, 78, 81 (figs. 1–2), 82 (fig. 3); klinai (dining couches), 52–61, 67, 69, 70, 134, 181; sigma (round table), 121, 181, 182, 183; stibadium (curved couch), 121, 181, 182, 185; tables, 80–81

Gabinius, proconsul, 107

Gaius (Caligula), emperor, 31–32, 145; coinage under, 108

Galerius Maximianus Caesar, emperor, 110 (fig. 12)

Galilee, 29–30, 36, 65; necropolis of Beth She'arim, 34

Gallienus, emperor, on coins, 101; coinage under, 103, 201

gambling. See games; magic and magicians

game counters, 86 (fig. 9), 161–62 (cat. nos. 46–48)

games: board games, 86, 160–61; dice, 86 (fig. 9), 114–15, 160; Duodecim Scripta, 86, 160, 161; game boards, 86, 160, 161; knucklebones, 86 (fig. 9); Latrunculi, 161

games, athletic, 155, 166, 205; see also gladiatorial games; Olympic Games; races

Ganymede, 37n.12, 74, 182

Garrett, Robert, 5

gates of Antioch, 8; Aleppo (East) Gate, 8, 148; Daphne Gate, 9, 24, 93, 103; Market Gate, 217

Gerasa, 15, 207

Germanicus (Agrippina the Elder), 163

gladiator helmet, 157 (cat. no. 41)

gladiatorial games, xii, 155, 157, 159, 174n.1, 226

glassblowing, 118, 184, 192, 193–94, 228

glass bottles: with applied faces, 228 (cat. no. 118); in the form of Tyche, 118; shaped like a cluster of grapes, 193 (cat. no. 79); in the shape of a caravan dromedary, 192, 195 (cat. no. 84); souvenir, 118, 148, 228

glass casting, 184, 193

glassware, 182, 183–84, 187, 192 (fig. 1), 193–95, 226; Alexandrian and Judean glass, 192; barrel-shaped cup signed by Neikais, 192, 193–94 (cat. no. 80); bowl with scalloped rim, 194–95 (cat. no. 83); conical beaker or lamp, 194 (cat. no. 81); ewer with circular mouth, 194–95 (cat. no. 82); footed bowl (carchesium), 184, 193 (cat. no. 78); plate, 184, 193 (cat. no. 77)

Glykera, 74, 156

Golden Church of Constantine, Antioch, xiii, 7, 9, 23–24, 46, 63, 114–15, 126, 197; cathedral (new), 25

Goliath (marble relief), 217, 221, 223 (cat. no. 112)

Gordianus III, emperor, 93–94; coinage under, 103, 109

Gordianus III (man in military costume), bust of, 93, 94 (fig. 4)

grave reliefs: of Cacsianus, 140 (cat. no. 28); of Claudius, 140 (cat. no. 29), 161; of a reclining diner, 140 (cat. no. 30), 161; with a reclining man and cup, 141 (cat. no. 31), 142, 161; with a table, 141 (cat. no. 32), 161; of Tryphê, 139 (cat. no. 27), 141

Gundeshapur, king of Persia, 131

gymnasium, Antioch, 149

Hadad, 200, 207

Hadrian, emperor, xiii, 32, 145, 148, 158; in art, 92–93; coinage under, 108

Hadrian (statue), Seleucia Pieria, 92–93

Hadrian's Villa, Tibur (Tivoli), 77n.4, 92

Hamman, 33

Harpocrates, 10, 98, 174

Hathor, 200

head of an old, bearded satyr, Antioch, 98 (fig. 11)

head of a philosopher, 210–11 (cat. no. 97)

head of a youthful satyr, 96, 97 (fig. 9)

Hekate, 91, 166

Helen, 70, 174

helmets: for a gladiator, 157 (cat. no. 41); parade helmet, 157–58 (cat. no. 42)

Hera, 69–70, 174, 204

locks and keys, 82 (fig. 4), 83

Lucian, 69, 70

Lucius Verus, emperor, xiii, 158, 181–82

Luke, Saint, 10, 214

Lycurgus, 37n.12, 71

Lysippos, 102

Macedonius, 19

Macrinus, emperor, 127; on coins, 109

maenads, 68, 132, 169, 170, 177, 205

magic and magicians, 89, 162, 163–67, 224, 226; magic workshops, 163, 166; spells, binding, 162, 163–67; victory charms, 167

Magnesia, 91, 100; churches of, 40

Malalas. See John Malalas

Marcus Aurelius, emperor, 93, 152; coinage under, 108

Mark, Saint, evangelist, 214

Martyrion of Saint Babylas, 9, 44, 114–15, 220; see also church building, Seleucia Pieria

martyrs: of Antioch, 33–34, 41–42, 44, 143, 197, 226; Christian, 34, 40, 226; Jewish, 33–34; see also Babylas, Saint; Thecla, Saint

Matthew, Saint, evangelist, 10, 214; Gospel of Matthew, xiii, 39–40

meander frieze with Saint Paul, 217, 220, 222 (cat. no. 107)

meander frieze with shepherd playing flute and female figure, 217, 223 (cat. no. 110)

medallions, 216 (cat. no. 106)

Medusa, 203

Megalopsychia hunt mosaic, Yakto, 8 (fig. 6), 11, 65, 114–15

Meleager, 95

Meletius, bishop of Antioch, 43, 44

Menander, 74, 156

Meryamlik, 226

Minerva, 158, 203

mint of Antioch, 101–2, 104–11, 119; *argenteus*, 110 (fig. 12); *aurei*, 109 (fig. 10); bronze, 102, 106 (fig. 2), 107, 108 (fig. 7), 110 (fig. 13); Byzantine issues, 110–11; *denarii*, 109 (fig. 11); *foles*, 110 (fig. 14), 111; mint marks, 106, 108; municipal issues, 106, 107; *nummi*, 110–11; *Orichalcum asses*, 108; *Orichalcum semis*, 108 (fig. 7); Roman issues, 101–2, 103, 104, 105, 107–10; Seleucid issues, 101–2, 104, 105–7; *solidus*, 104, 110–11, 211; *tetradrachms*, 101–2, 104, 106 (fig. 1), 107 (figs. 3–5), 108 (figs. 6, 8), 109 (fig. 9)

mint of Caesarea, 109

mint of Rome, 105, 106, 109

Mithras, 200, 208

Mithras and Sol (mural fragment), Mithraeum, Dura-Europos, 200, 208 (cat. no. 95)

Monophysitism, 20–21, 47–48, 216

monumental cross, 216 (cat. no. 105); medallions from, 216 (cat. no. 106)

Morey, Charles Rufus, 5

mosaic bust of Dionysos, Constantinian Villa, Daphne, 69, 205–6 (cat. no. 92)

mosaic bust of the Pyramos River, House of Cilicia, Seleucia, 71, 152 (cat. no. 38)

mosaic medallion of Herakles, Constantinian Villa, Daphne, 205

mosaic of Aion, House of Aion, Antioch, 64 (fig. 1)

mosaic of Aphrodite and Adonis, Atrium House, Antioch, 67, 70–71, 74, 76, 172, 174–75 (cat. nos. 59–60)

mosaic of beribboned parrots, Daphne, 65, 132, 138 (cat. no. 25)

mosaic of Boat of the Psyches, House of the Boat of Psyches, Daphne, 7, 59–60, 65, 71, 73 (fig. 6), 76

mosaic of dancing maenad, Atrium House, Antioch, 68, 170 (cat. no. 56)

mosaic of dancing satyr, Atrium House, Antioch, 68, 170, 172 (cat. no. 57)

mosaic of a dining room, House of the Buffet Supper, Daphne, 183 (fig. 1)

mosaic of Drinking Contest between Herakles and Dionysos, House of the Drinking Contest, Seleucia Pieria, 54, 55 (fig. 3)

mosaic of Drinking Contest of Herakles and Dionysos, Atrium House, Antioch, 53, 55 (fig. 3), 67–68, 70–71, 170–71 (cat. no. 55), 172, 182, 205

mosaic of an Evil Eye, House of the Evil Eye, Antioch, 77n.20, 163 (fig. 1)

mosaic of a gaming board, necropolis, Antioch, 86 (cat. no. 44)

mosaic of Ge, House of the Worcester Hunt, Daphne, 159 (fig. 1)

mosaic of the Judgment of Paris, Atrium House, Antioch, 7, 67, 69–71, 77n.4, 172–74 (cat. no. 58)

mosaic of Kticic, House of Ge and the Seasons, Daphne, 67 (fig. 3)

mosaic of Menander and Glykera, Achilles and Briseis, House of Aion, Antioch, 156

mosaic of Opora, Agros, and Oinos at dinner, House of the Boat of Psyches, Daphne, 71, 73 (fig. 7)

mosaic of outdoor banquet, Ostia, 181, 184–86 (cat. no. 68)

mosaic of rams' heads, House of the Rams' Heads, Daphne, 132, 133 (cat. no. 20), 134 (fig. 1), 135

mosaic of peacocks, House of the Bird Rinceau, Daphne, 208 (cat. no. 96), 209 (fig. 1), 210, 219n.4

mosaic of Peddlar of Erotes, Antioch, 65

mosaic of Tethys, House of the Boat of Psyches, Daphne, 71, 152–53 (cat. no. 39)

mosaic of theatrical masks, House of the Triumph of Dionysus, Antioch, 154

mosaics: Antioch workshop, 63–65, 67, 219; in Apamea, 33, 35, 64, 70, 77n.17, 219; in Bishapur, 131, 132; carpet mosaics, 158–59, 160n.1, 209 (fig. 1), 219; in Carthage, 160n.1, 186, 219; in Chania, 64–65; *emblemata*, 64; emblemata, in terracotta mounts, 184–86 (cat. no. 68); in excavations, 7, 8 (fig. 6), 9–10, 25, 33, 51–61, 62–77, 79, 80, 114–15, 130, 147, 158, 169; inscriptions in, 34–35, 64; in Jordan, 219; in Knossos, 65; in Mytilene (Lesbos), 156; in Ostia, 184–86; in Palmyra, 64, 70; in Paphos, 65, 70, 77n.24; in Sepphoris, 65, 68, 69 (fig. 4); in Shahba-Philoppopolis, 64; signatures in, 64–65; in Soran, 137n.1; in Tarsus, 37n.12; in Thessaloníki, 133; in *triclinia*, 52–61, 62, 66–71, 74, 153, 169, 170–74 188; in Yakto, 160; *see also* mosaics, hunt; mosaics, Sasanian influence; *also individual mosaics listed and mosaics within houses*

mosaics, hunt: from Constantinian Villa, Daphne, 189; Dumbarton Oaks hunt mosaic, 135, 137; small hunt mosaic, Villa of Piazza Armerina, 186; Honolulu hunt mosaic, 8, 158 (cat. no. 43), 159 (fig. 1), 160, 219; from House of the Ostriches, Sousse, 160n.1; Megalopsychia hunt mosaic, 8 (fig. 6), 11, 65, 114–15; Worcester hunt mosaic, 66 (fig. 2) 158, 159 (fig. 1), 189, 219

mosaics, Sasanian influence, 64, 65, 66, 132, 133–35, 136–37; country life, 65, 71, 185; hunt scenes, 65, 66 (fig. 2), 130, 158, 159 (fig. 1), 160, 188, 219; *see also* Sasanian Persian art

mosaic with Baths of Ardaburius, house in Daphne, 148 (fig. 2)

Moses, 35, 226

Müller, Karl Otfried, 8

muses, 65, 92, 174n.1

mystery cults, 88, 199, 208

Narcissus, 74, 76, 77n.26

necklace, 125 (cat. no. 15)

necropolis, Antioch, 9, 121; funerary relief of men playing a board game, 160–61 (cat. no. 45); mosaic of funerary symposium, 80, 121–22 (cat. no. 9), 161, 183; mosaic of a gaming board, 86 (cat. no. 44)

Negral, 205

Neikais, barrel-shaped cup signed by, 192, 193–94 (cat. no. 80)

nereids, 70

Nero, emperor, 101, 105, 108 (fig. 8)

Nerva, emperor, 108

Nestorianism, 21

Nestorius, bishop of Constantinople, 47–48

Nicephoros (martyr), 143

Nike (Victory), 88, 201; on coins, 102, 105, 106 (fig. 1), 107 (figs. 3–4)

Sources
for the Illustrations

Permission to reproduce illustrations is provided by courtesy of the owners as listed in the captions. Additional photography and source credits are cited by page number, figure number, and/or catalogue number as follows:

Courtesy of The American Numismatic Society, New York: 106 (figs. 1, 2), 108 (fig. 7), 109 (figs. 10, 11), 110 (figs. 13, 14)

Courtesy of the Arthur M. Sackler Gallery, Smithsonian Institution, Washington, D.C.: cat. nos. 23, 24

The Art Museum, Princeton University, Gift of the Committee for the Excavation of Antioch to Princeton University, photo Tony Sigel: cat. nos. 50, 51, 53, 54; photo Bruce M. White, © 1993: 97 (fig. 10), © 1997: 196, and © 1999 Photo: Trustees of Princeton University: 78 (bottom), 81 (figs. 1, 2), 82 (figs. 3, 4), 83, 84, 85 (figs. 7, 8), 86, 87, 88 (figs. 11, 12), cat. nos. 27, 30, 31, 32, 33, 34, 35, 36, 37, 40, 44, 46, 47, 107, 108, 109, 110, 111, 112

The Baltimore Museum of Art: 73 (fig. 7), 99 (fig. 13), cat. nos. 39, 56, 57, 61; Antioch Subscription Fund: 95, 130, cat. nos. 65, 66, 67

Steve Briggs: cat. no. 117

Howard C. Butler, *Architecture and Other Arts* (New York, 1903): 151

Byzantine Collection, Dumbarton Oaks, Washington, D.C.: cat. nos. 14, 15, 49, 70, 71, 101, 102, 103, 113, 114, 115

Courtesy of the Trustees of The British Museum, © The British Museum: cat. nos. 1, 2, 3, 4

Courtesy of Fatih Cimok: 8, 73 (fig. 6), 75, 76, 154, 163, 183, 200

© The Cleveland Museum of Art, 2000: cat. nos. 76, 98

John Dean: 4, 47, 93, 94 (figs. 3, 4), 96 (figs. 6, 7), 97 (figs. 8, 9), 98 (figs. 11, 12), 99 (fig. 14), 100, 148 (fig. 2B), 192, cat. nos. 55, 59, 96

Courtesy of the Department of Art and Archaeology, Princeton University: 2, 6 (figs. 3, 4), 7, 28, 55, 56 (figs. 4, 5), 57, 59, 64, 145 (top)

Founders Society Purchase, Sarah Bacon Hill Fund, Photograph © The Detroit Institute of the Arts: cat. no. 68

John Dobbins: 54, 58

The Field Museum of Natural History, Chicago, Illinois, neg. no. A111964c, photo James Balodimas: cat. no. 21

© President and Fellows of Harvard College, Harvard University: 145 (bottom); photo Michael Nedzweski: cat. nos. 17, 52; Courtesy of the Fogg Art Museum, Harvard University Art Museums, Transfer from the Fine Arts Library, Gift of Belinda L. Randall from the collection of John Witt Randall: 5, 22

Courtesy of Hatay Archaeological Museum, Antakya: 103, 114

Higgins Armory Museum, Worcester, Massachusetts: cat. no. 41

Honolulu Academy of Arts Purchase, 1937: cat. no. 43

Doro Levi, *Antioch Mosaic Pavements*, 2 vols. (Princeton, 1947): 150 (fig. 5)

All Rights Reserved, The Metropolitan Museum of Art: cat. no. 105; Photograph © 1985: cat. no. 104, and © 1999 The Metropolitan Museum of Art: cat. nos. 99, 100

Courtesy of Eric M. Meyers: 69

Musée du Louvre, Paris: 134 (fig. 2)

Museum of Art, Rhode Island School of Design; photo Del Bogart, By exchange with the Worcester Art Museum: cat. no. 92; photo Erik Gould, Georgianna Sayles Aldrich Fund: cat. no. 48; Gift of Mrs. Gustav Radeke: cat. no. 64, Museum Works of Art Fund: cat. no. 19

Courtesy, Museum of Fine Arts, Boston, © 1999 All rights reserved: cat. nos. 45, 73, 97

The Nelson-Atkins Museum of Art, Kansas City, Missouri, Purchase: Nelson Trust: cat. no. 116

© Photo RMN; photo Ch. Larrieu: cat. no. 25; photo Hervé Lewandowski: 12, 38, cat. nos. 6, 7, 85, 86, 87, 88, 106A, 106B; photo Jean Schormans: cat. no. 58

Smith College Museum of Art, Northampton, Massachusetts. Purchased, Drayton Hillyer Fund, 1938: cat. no. 38

Courtesy of the Toledo Museum of Art, Ohio: cat. nos. 18, 42, 69, 84, 118; photo Image Source, 1/2000: cat. nos. 10, 89; photo Tim Thayer 6/99: cat. nos. 77–80, 81–83

University of Pennsylvania Museum, Philadelphia, neg. no. T4-1012: cat. no. 16

Courtesy of the Vatican Museum, photo A. Bracchetti: ii (frontispiece)

© Virginia Museum of Fine Arts, Richmond; photo Ron Jennings: cat. nos. 11, 13; Katherine Wetzel: cat. nos. 12, 72

Courtesy of Wellesley College Museum, Wellesley, Mass.: cat. no. 60

Williams College Museum of Art, Museum purchase, Karl E. Weston Memorial Fund: 210

The Worcester Art Museum, Worcester, Massachusetts: 66, 78 (top), 104, 107 (figs. 3, 4, 5), 108 (figs. 6, 8), 109 (fig. 9), 110 (fig. 12), 131, 134 (fig. 1), cat. no. 8; excavation at Antioch: 67, 92, cat. nos. 9, 20, 75; museum purchase: 90, cat. nos. 22, 28, 29, 62, 63; computer model James Stanton-Abbott: 149 (fig. 4), 217, 218, 221; plan Wes Chilton, Victoria I, and Mary Todd: 50, 219; plan Wes Chilton and Victoria I: 72; plan Victoria I and Mary Todd: 53; plan James Stanton-Abbott: 149 (fig. 3); plan Mary Todd: 159; reconstruction Wes Chilton: 209, and Victoria I: 62; watercolor Victoria I: 168

Yale University Art Gallery, New Haven: cat. nos. 5, 74, 90, 91, 93, 94, 95

Fikret Yegül after Frank Brown, "The Roman Baths," *The Excavations at Dura-Europos. Preliminary Report of Sixth Season of Work, October 1932–March 1933*, ed. Michael I. Rostovtzeff et al. (New Haven, 1936): 150 (fig. 6); after Glanville Downey, "A Professional Cross," *The Metropolitan Museum of Art Bulletin* 12, no. 9 (1954): 147; after Fisher in George W. Elderkin, ed., *Antioch-on-the-Orontes I: The Excavations of 1932* (Princeton, 1934): 150 (fig. 7); after Charles Rufus Morey, *The Mosaics of Antioch* (New York, 1938): 148 (fig. 2A)

All rights reserved: cat. no. 26